From a Mighty Fortress

Prints, Drawings, and Books in the Age of Luther
1483-1546

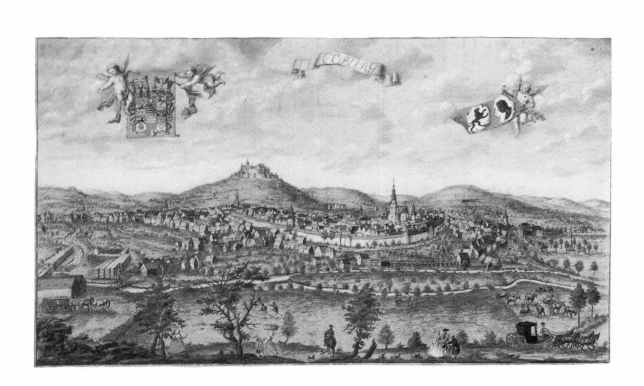

From a Mighty Fortress

Prints, Drawings, and Books in the Age of Luther
1483-1546

Christiane Andersson

Charles Talbot

Published by The Detroit Institute of Arts

1983

This book and the exhibition it accompanies have been
supported by grants from the National Endowment for the
Arts and the National Endowment for the Humanities, Fed-
eral Agencies, and by the Federal Council on the Arts and
Humanities, Arts and Artifacts Indemnity Act, as well as a
generous grant from the Federal Republic of Germany.

This book is published in connection with the exhibition
"From a Mighty Fortress: Prints, Drawings, and Books in the
Age of Luther 1483-1546," organized by the Detroit Institute
of Arts with the cooperation of the Kunstsammlungen der
Veste Coburg and the Landesbibliothek Coburg and
presented at:

The Detroit Institute of Arts
October 3-November 22, 1981

The National Gallery of Canada, Ottawa
December 4, 1981-January 31, 1982

Kunstsammlungen der Veste Coburg
July 18-August 5, 1982

ISBN 0-89558-091-8
© by The Detroit Institute of Arts
All rights reserved. Printed in the United States of America.

Designed by Michael Glass Design, Inc., Chicago, Illinois.
Typeset in Palatino by Craftsman Type Inc., Dayton, Ohio.
3,000 copies were printed on 80 lb. Mohawk Superfine by
Eastern Press, New Haven, Connecticut.

Library of Congress Cataloging in Publication Data
From a mighty fortress.
 Catalog of an exhibition presented at the Detroit Institute
of Arts, Oct. 3-Nov. 22, 1981; National Gallery of Canada,
Ottawa, Dec. 4, 1981-Jan. 31, 1982; Kunstsammlungen der
Veste Coburg, July 18-Aug. 5, 1982.
 Consists of works from the collections of the Landes-
biblothek Coburg and the Kunstsammlungen der Veste
Coburg, West Germany.
 Bibliography: p. 394
1. Art, German—Exhibitions. 2. Art, Renaissance—Germany
—Exhibitions. 3. Reformation—Germany—Influence—
Exhibitions. 4. Kunstsammlungen der Veste Coburg—Exhi-
bitions. 5. Landesbibliothek Coburg—Exhibitions. I. Luther,
Martin, 1483-1546. II. Andersson, Christiane. III. Talbot,
Charles W. IV. Detroit Institute of Arts. V. National Gallery
of Canada.
N6865.F76 1983 760'.0943'074 83-1990
ISBN 0-89558-091-8

Cover. Colophon with Luther rose (detail) from *Das Ander
teyl des alten Testaments* (cat. no. 209) (see p. 48).

Frontispiece. Johann Friedrich Hermann, 1730-1809, *View
from the South of the City and the Veste Coburg*, 1762,
etching with hand-coloring, 229 x 384 mm. Kunstsammlungen
der Veste Coburg (Inv. no. IIa/11b).

Table of Contents

Authors' Acknowledgments

We are very grateful to Dr. Joachim Kruse, Director of the Kunstsammlungen der Veste Coburg, and to Dr. Jürgen Erdmann, Director of the Landesbibliothek Coburg, and to their staffs, not only for the cooperation that made this exhibition possible but also for their cordial hospitality while the planning and preparations were underway in Coburg. The staff of the Veste Coburg bore the brunt of our requests and inquiries, and we extend our thanks to Dr. Minni Maedebach, Leopold Viktor von Parnegg, Harry Herr, Ruth Asmalsky, Marianne Bauer, Rudolf Schäfer, and Johann Carl Hentsch. For their excellent photography we thank Klaus Leibing at the Veste Coburg and Eberhard Schmidt at the Landesbibliothek. We are grateful to Herbert Appeltshauser of Coburg for kindly sharing with us his extensive knowledge of the city and its history, to David Landau, who happened to visit the Veste during the time that this exhibition was being planned and who offered excellent suggestions and information, especially in the area of 16th-century German woodcuts, and to Ruth-Maria Muthmann, Director of C. G. Boerner in Düsseldorf, who deserves special appreciation for her gracious and expert advice.

We also wish to acknowledge the many others who kindly responded to various requests for assistance with this project, including Dr. Fedja Anzelewsky (Kupferstichkabinett, Staatliche Museen Preussischer Kulturbesitz, Berlin), Robert Baldwin (Harvard University), Dr. Ulrich Barth (Staatsarchiv, Basel), Dr. Johann E. von Borries (Kupferstichkabinett, Staatliche Kunsthalle Karlsruhe), Dr. Tilman Falk (Kunstsammlungen der Stadt Augsburg), Dr. Gottfried Frenzel (Institut für Glasgemäldeforschung, Nuremberg), Dr. Heinrich Geissler (Graphische Sammlung, Staatsgalerie Stuttgart), Professor William V. Harris (Columbia University), Dr. Michael Jaffee (The Waverly Consort), Penny Jones (Columbia University), Dr. Dieter Kuhrmann (Staatliche Graphische Sammlung, Munich), Dr. Lester Little (Smith College), Baron Wilhelm Löffelholz von Colberg, Dr. Elizabeth McGrath (Warburg Institute, London), Ruth Mortimer (Curator of Rare Books, Smith College), Professor Keith P. F. Moxey (University of Virginia, Charlottesville), Dr. Helmut Nickel (Dept. of Arms and Armor, The Metropolitan Museum of Art), Professor Gert von der Osten, Audrey Pomeroy (Smith College), Carol Schuler (Columbia University), Ernestine Stieber (Smith College), Professor Elaine Tennant (University of California, Berkeley), Sara Upton (Amherst College), and Dr. Leonie von Wilckens (Germanisches Nationalmuseum, Nuremberg).

Foreword

Frederick J. Cummings

"From a Mighty Fortress: Prints, Drawings, and Books in the Age of Luther 1483-1546" is a unique exhibition of works drawn from two magnificent collections of late Gothic and early Renaissance graphic art: the Kupferstichkabinett of the Kunstsammlungen der Veste Coburg and the Landesbibliothek Coburg in West Germany. The 216 works in the exhibition were executed by Northern European artists during one of the most crucial periods in the history of Western civilization. In these years, Germany experienced both the turmoil of the Protestant Reformation and an artistic renaissance that encompassed significant developments in printmaking. The graphic arts played a decisive role in disseminating the ideas of the Reformation, and many of the best artists of the time devoted a large measure of their creative energies to the making of prints and the illustration of books.

The works in the exhibition, most of which have never before been seen outside Germany, were chosen not only for their artistic quality but also because they reflect so cogently the life of the period—its political realities, social mores, religious beliefs, and intellectual concerns. It is particularly fitting that these works should come from Coburg. In the late 15th and early 16th centuries, Coburg was a thriving economic center controlled by the Dukes of Saxony. Supporters and protectors of Martin Luther, these Saxon princes played a vital role in the Reformation. In 1530, during one of the most difficult times of his life, Luther found a secure retreat in the Veste Coburg, the imposing hilltop fortress above the city, which commands a breathtaking view of the valleys and forests of Franconia. The title of the present exhibition, "From a Mighty Fortress," refers to the Veste Coburg itself, which today houses the Kunstsammlungen, and is taken from the famous hymn written by Luther, "A Mighty Fortress is Our God."

Assembling an exhibition of this size and complexity requires the talents, skills, and generosity of many people. Among those whose efforts should be acknowledged are Ellen Sharp, Curator of Graphic Arts, who organized the exhibition, and the staff of the Graphic Arts department, Marilyn F. Symmes, Associate Curator; Kathleen A. Erwin, Research Assistant; Douglas G. Bulka and Diana M. Bulka, Preparators; and Yvette Coneal,

Receptionist. Crucial to the realization of the exhibition was the encouragement and assistance of the German Consulate in Detroit. Consul Dirk Pauls personally facilitated the early negotiations with Coburg, and the Consul General, Dr. Josef Deutz, has continued to be most supportive. We are indebted to the trustees of the Coburger Landesstiftung and the officials of the Generaldirektion der Bayerischen Staatlichen Bibliotheken in Munich for consenting to lend some of the finest and rarest works from the respective collections under their care. We would also like to extend our appreciation to Dr. Joachim Kruse, Director of the Kunstsammlungen der Veste Coburg, Dr. Jürgen Erdmann, Director of the Landesbibliothek Coburg, and the staffs of both institutions, who have been most liberal with their time and assistance. Special thanks are due Ruth-Maria Muthmann, who contributed her considerable expertise in appraising the works preparatory to their shipment to America, and to Theodore Smithey, both for the loan of a rare printed indulgence from his own collection and for his efforts on behalf of the exhibition, particularly among the various organizations of the Lutheran Church.

I would also like to thank the authors of the catalogue, Christiane Andersson of Columbia University and Charles Talbot of Smith College, who undertook extensive research in Coburg and who assisted in the final selection of works for the exhibition, as well as Drs. Kruse and Erdmann, who contributed the historical essays introducing the Coburg collections, and Lewis W. Spitz of Stanford University, whose essay on Luther's stay at Coburg reveals the human side of the great Reformer.

At the Detroit Institute of Arts, the following staff members assisted in various ways: Marianne DePalma, Associate Director of Development; Patricia L. Miller, Development Coordinator; Dirk Bakker, Museum Photographer; Susan Kalb Weinberg, Assistant Administrator and Registrar; Karen Serota, Associate Registrar; Michele Smith Peplin and Patricia Lawrence, Assistant Registrars; Cydna Mercer, Assistant Cataloguer; Valerie Baas, Paper Conservator; Uziel Sason, Mount Fabricator; and Patience Young, Associate Curator of Education. For their work on the catalogue we would like to thank Sheila

7

Schwartz, Andrea P. A. Belloli, former Coordinator of Publications; Cynthia Newman Helms, Associate Editor; Cynthia Jo Fogliatti, Secretary, and Gail Schrott, Research Assistant, Graphic Arts.

Finally, we wish to express our gratitude to the National Endowment for the Arts, the National Endowment for the Humanities, and the Federal Republic of Germany for grants in support of this exhibition and the catalogue which accompanies it. The Detroit Institute of Arts, in cooperation with the National Gallery of Canada, is pleased to present "From a Mighty Fortress: Prints, Drawings, and Books in the Age of Luther 1483-1546."

I. School of Lucas Cranach the Elder, *Tournament Book of Duke Johann Friedrich the Magnanimous of Saxony,* cat. no. 16
 a. *Fools Riding in a Wheelbarrow*
 b. *Wheel of Fortune with Fools*
 c. *Fanning the Fires of Love*

9

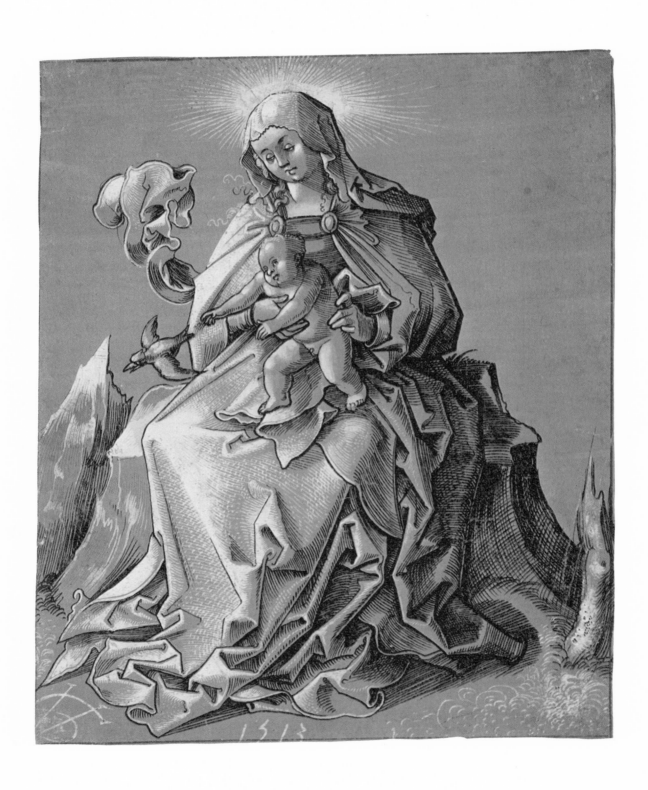

II. Urs Graf, *Virgin and Child with a Bird,* cat. no. 24

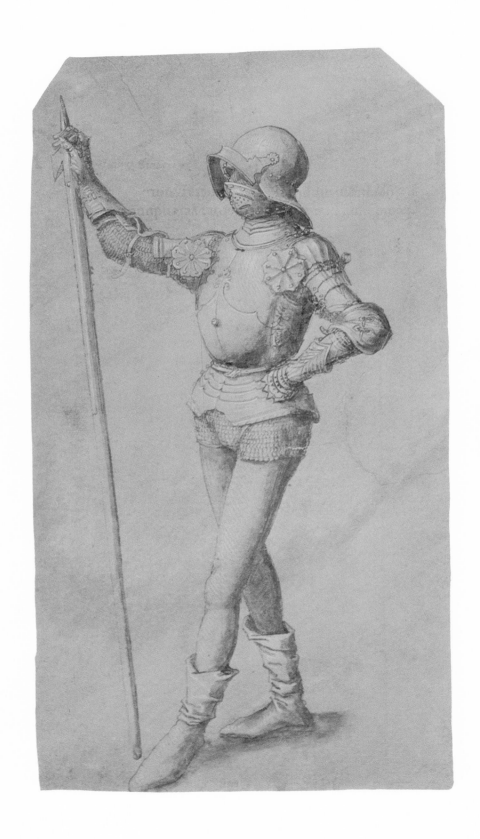

III. Swabian Master, *Standing Foot Soldier*, cat. no. 47

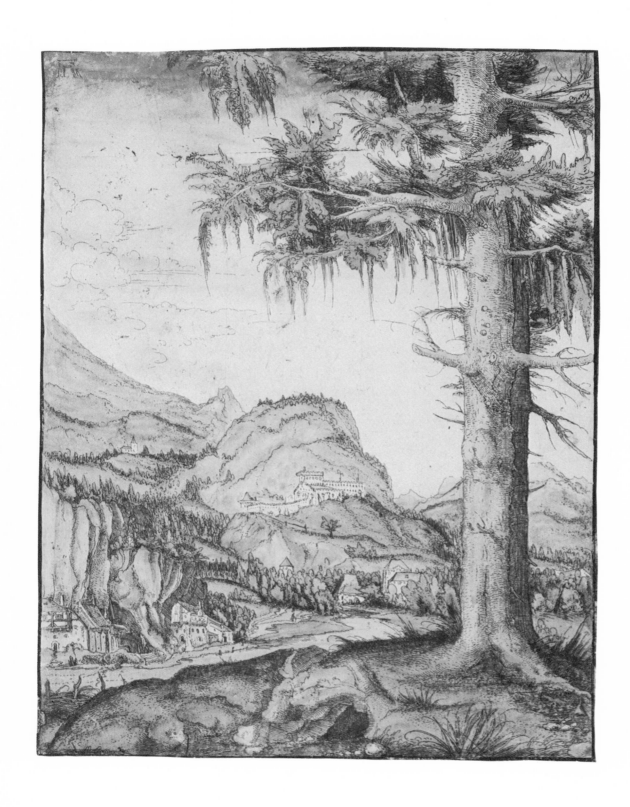

IV. Albrecht Altdorfer, *Landscape with a Large Pine*, cat. no. 101

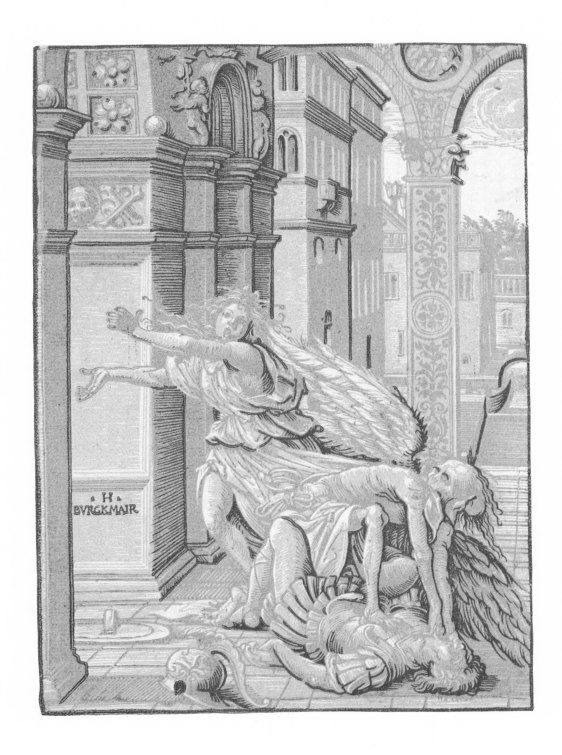

V. Hans Burgkmair, *Lovers Surprised by Death*, cat. no. 115

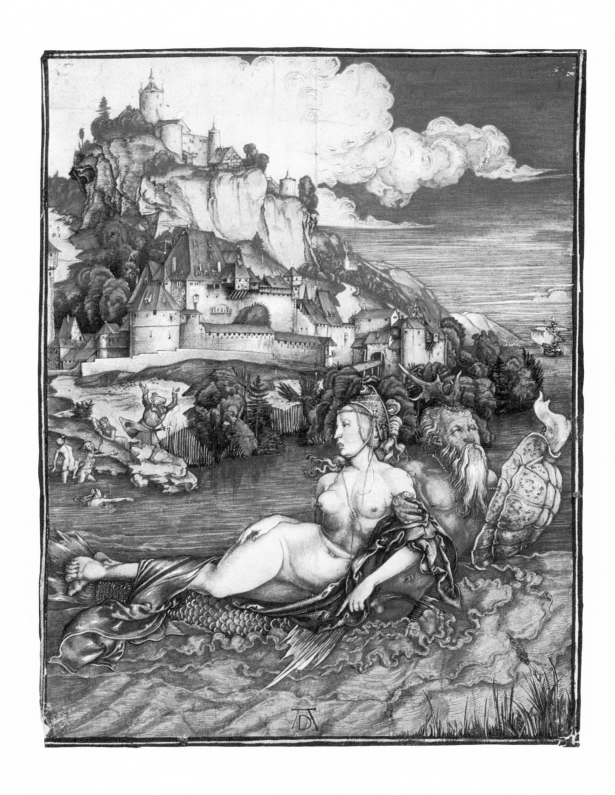

VI. Albrecht Dürer, *The Sea Monster*, cat. no. 134

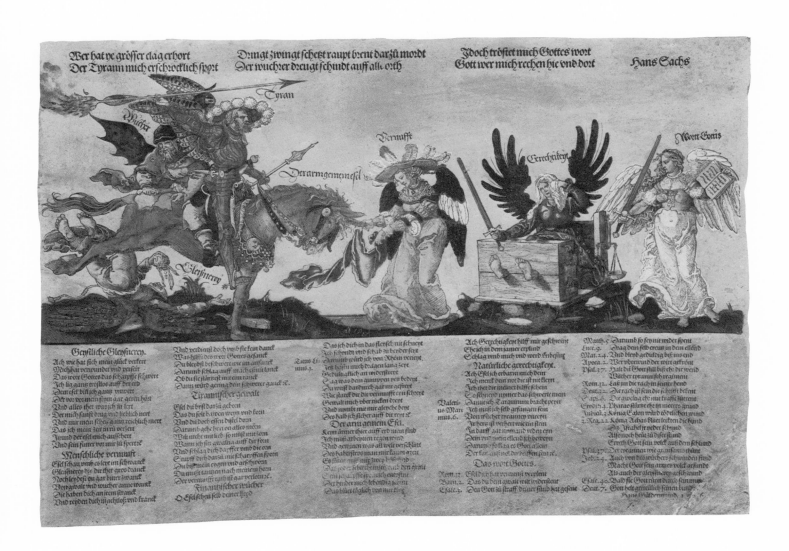

VII. Peter Flötner, *The Poor, Common Ass*, cat. no. 163

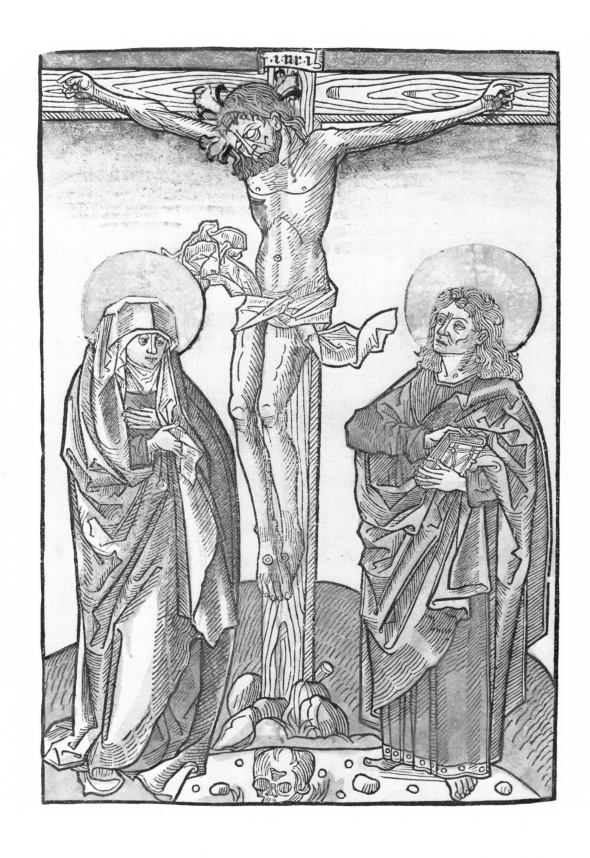

VIII. *Crucifixion* from *Missale Basiliense*, cat. no. 197

IX. Lucas Cranach the Elder, *David and Bathsheba* from
Das Ander teyl des alten Testaments, cat. no. 209

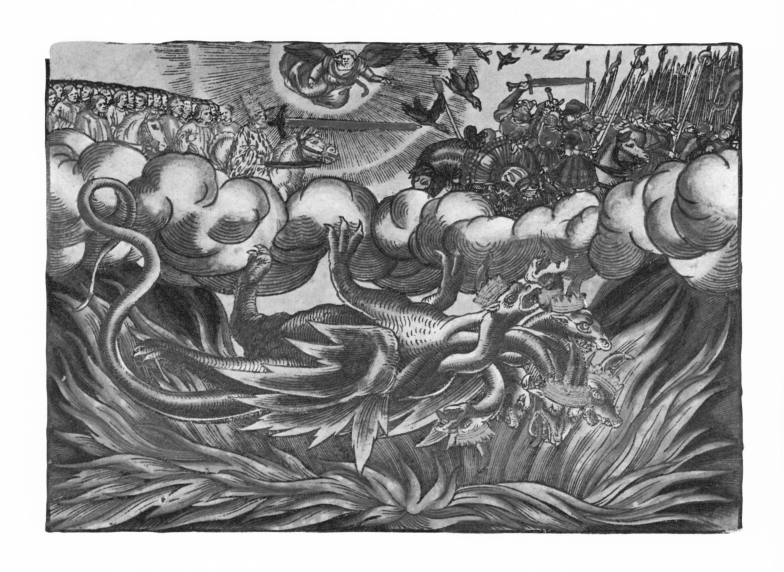

X. Master MS, *The Great Beast Thrown into the Lake of Fire* from *Biblia . . .*, cat. no. 211

Notes to the Catalogue

This catalogue is divided into three sections: drawings, prints, and illustrated books. In the first two sections, entries are arranged alphabetically by the artist's surname (or accepted cognomen) or by nationality when the artist is not known. If two or more works by an artist are included, the entries are in chronological order. In the final section, entries are arranged by category: incunabula, Protestant books and pamphlets, Luther Bibles, and works of interest as social history. Unless otherwise indicated, entries in the first section are by Christiane Andersson, those in the last two sections by Charles Talbot.

Works from the Kunstsammlungen der Veste Coburg are identified by the abbreviation VC, followed by an inventory number; those from the Landesbibliothek Coburg by LbC and the library's catalog number. In all dimensions height precedes width. The use of a slash in the date of a work indicates the range of years within which it is believed to have been created, a hyphen indicates that the execution of a work took more than one year.

Bibliographic abbreviations are used throughout the catalogue; full titles can be found in the Bibliography. Meder numbers for watermarks refer to Joseph Meder's Dürer catalogue (Meder 1932).

The History of the Veste Coburg Kupferstichkabinett

Joachim Kruse

The history of the Veste Coburg Kupferstichkabinett, or print room (the term "print room" is generally used not only to refer to the room that houses a graphics collection —both prints and drawings—but also to the collection itself), began in the late 18th century, when Coburg was part of the Duchy of Saxe-Coburg-Saalfeld, one of the many sovereign duchies in a land then, most appropriately, known as "the Germanies." The dukes of Saxe-Coburg-Saalfeld belonged to the so-called Ernestine branch of the illustrious Wettin dynasty of German rulers. Three hundred years earlier, the Wettin family holdings had been divided and two lines established: the Ernestine and the Albertine, so named after the two sons of a 15th-century Wettin Elector of Saxony. In the 16th century the Ernestine line included the Electors Friedrich the Wise and Johann the Steadfast, both of whom were protectors and supporters of Luther and the Reformation. The next Ernestine elector, Johann Friedrich, joined the Schmalkaldic League, an alliance of Protestant princes formed to oppose the Holy Roman Emperor Charles V, who was determined to stamp out Lutheranism. When the Schmalkaldic League met defeat at the Battle of Mühlberg in 1547, Johann Friedrich's title and most of Saxony passed to the Catholic Albertine line of the family. The Ernestine branch retained its possessions in the region of Thuringia, but split them up into several collateral duchies, all of which remained under the authority of the Holy Roman Emperor. For the next two centuries, these duchies—among them, Saxe-Coburg, Saxe-Gotha, and Saxe-Weimar—were frequently rearranged due to the vicissitudes of marriage, inheritance, and politics.

It is one of the ironies of history that in the late 18th century two great graphics collections were formed by rival members of the Wettin dynasty: one in Coburg by an Ernestine duke, the other in Vienna by a scion of the Albertine family. The latter, Duke Albert of Saxe-Teschen (1738-1822), assembled his collection with relative ease. As the son-in-law of Empress Maria Theresa, he had considerable sums of money at his disposal over a period of several decades, and his travels and duties often took him on lengthy trips to the art centers of Europe. His collection subsequently became the Graphische Sammlung Albertina in Vienna. For Duke Franz Friedrich Anton of Saxe-Coburg-Saalfeld (1750-1806; r. 1800-06), however, the formation of a collection—that which is now the Veste Coburg Kupferstichkabinett—was

a more difficult task. From the second half of the 18th century on, the Duchy of Saxe-Coburg-Saalfeld (established in 1735) constituted only 1,000 square kilometers and had a total population of just slightly over 45,000. Coburg, the capital—known for its beautiful architecture (frontispiece)—was the home of less than 7,000 people. The ruler of such a small principality could not possibly afford to purchase lavish treasures. Moreover, until well into the 19th century, the dukes of Coburg were plagued by debts that were at times enormous. In conjunction with a general economic recession that began in the mid-18th century, the financial situation of the duchy became critical, so critical that from 1773 to 1801, an imperial commission took control of Coburg's entire financial system. As a result, in any given year the duke could count on only a small sum with which to maintain himself in a manner befitting his nobility, and he dared not incur any new debts. This suggests that any thought of collecting books or works of art would have been out of the question. Nonetheless, Franz Anton managed to assemble a collection of prints and drawings that compares most favorably with any others in the world. Precisely how he accomplished this feat remains a mystery, explained only by his great love for art, in particular the graphic arts, that enabled him to overcome all practical obstacles.

Strangely enough, to this day there exists no biography that explores in depth the spirit, goals, and accomplishments of this most human, and perhaps most intelligent, of the dukes of Coburg. The role played by his tutor, Johann Gottlieb Aulig, was certainly important, although this fact is seldom mentioned. Somewhat more is known about Franz Anton's friendship with the poet and statesman Moritz August von Thümmel (1738-1817), who lived in Coburg from 1761 to 1783, serving first as chamberlain to Franz Anton (1761-68) and then as privy councilor and minister (1768-83) to his father, Duke Ernst Friedrich (r. 1764-1800). Von Thümmel, in every way a typical 18th-century figure, was a rationalist, devoted to order, cynical, and frank. Franz Anton's acquaintance with this extremely gifted man lasted for several decades. They were friends in the exuberant style of the Sentimentalists and the dawning *Sturm und Drang* literary movement, which emphasized intense subjectivity and the rebellion of youthful genius against convention. In one of his notebooks Franz Anton jotted down the rough draft of a letter to von Thümmel as follows:

If lovers can speak solely of love in their letters without getting bored, so too can good friends speak of friendship without becoming tired of it. Even as others fill their letters with bits of daily news, we wish to begin and end ours with the perceptions of our hearts. For me, it is a matter of great importance to be your friend, and I feel so much happiness when I tell you about this that I shall surely repeat myself at least many hundred times more.

There emerges from other letters, especially from those of von Thümmel, a concurrence of opinion about persons and events that is only possible between friends of equal intellectual ability. Since von Thümmel was himself an art collector, it may have been as a result of his influence that Franz Anton began his own collection, probably around 1775. By the time he actually inherited the dukedom in 1800, Franz Anton had ties throughout German-speaking Europe with art dealers, agents, collectors, and artists, who kept their eyes open on his behalf—buying, bidding at auctions, and negotiating art deals, particularly in Frankfurt and Leipzig, then the most important art markets in Germany. Several of these assistants were also his friends. When, in 1803, Franz Anton became convinced that his death was near, Baron Hans Albrecht von Derschau, a well-known Nuremberg collector, connoisseur, and authority on German woodcuts, wrote movingly and with real feeling to one of the duke's servants:

> If you believe that his Serene Highness would be diverted by the possibility of adding new examples of old art forms to his collection, write of it—I want no money for these selected works—rather would be content with some of the duke's duplicates, of which he has many; if only the good gentleman can be given some little distraction.

A Frankfurt art dealer by the name of von Plitt did more than merely negotiate art transactions with Franz Anton. He reported to him conscientiously and in detail on how the disturbances brought about by the French Revolution and the subsequent Napoleonic era influenced the art market. As is usually the case during and after a war, in this period the bottom fell out of the art market, and, on von Plitt's advice, Franz Anton was often able to acquire works relatively cheaply. A number of artists whose works he purchased constantly voiced their thanks and esteem. Even if we discount flowery, obsequious rhetoric as the requisite form for addressing a Serene Highness, a kind of personal and very real respect for Franz Anton is still apparent, which suggests that he was not only a well-known German collector of prints and drawings, but a good man as well. (His reputation as a collector was such that in later years he scarcely dared to appear personally at auctions for fear of ruining the prices, allowing himself instead to be represented by agents.)

Without a doubt, the collecting of prints and drawings stood at the center of Franz Anton's life, taking precedence over almost everything else. One notable exception was the education of his family. He and his second wife, the Duchess Auguste, had seven children who reached adulthood and whose upbringing was overseen by their father, who set up guidelines for their tutors. There is ample evidence of his pedagogical zeal, which suggests that education was perhaps his second greatest passion and a means by which he could fully express his humanity and his conviction that life could be ordered in a rational fashion. As was true of many of his rationalist contemporaries, however, Franz Anton had an especially difficult time with the practical aspects of his own existence. In 1802 he issued a decree stating that more funds had to be scraped together because he was "suffering true want," and as late as 1805, just a year before his death, he ordered a brochure from a Leipzig book dealer entitled *The Art of Succeeding in the World*. It is not altogether surprising that he worked out a scheme for holding off his creditors or that he tried his luck at lotteries in Frankfurt, Hamburg, and elsewhere. When his daughter Juliane became the bride of the Imperial Prince Constantin in St. Petersburg in 1796, Franz Anton's interest turned to the proceeds of Russian silver and gold mines. Even his interest in the Rosicrucian order, which he joined in 1781, may have had at least a minor connection to his shortage of money (the Rosicrucians claimed to be able to manufacture gold), although he feared that he might acquire the odious reputation of an alchemist through his association with them.

Franz Anton was also inclined toward self-scrutiny, which may have been related to his activities as a Freemason, since that order advocated this activity. Early in 1803, for example, he wrote a detailed history of his illnesses. Another time, he glanced into a mirror, remarking:

> How extraordinarily I've changed, if I compare myself as I now am with my childhood. My body has devel-

oped in a totally different fashion than expected, my facial features are strangely altered, my thought processes and insights are astonishingly different (fig. 1.)

Despite the inauspicious state of his finances, nearly all of the drawings and prints in this exhibition were acquired by Franz Anton. The bulk of his collection consisted of prints, especially engravings and etchings in their various states, and, to a lesser degree, drawings. The collection includes a very strong section of German graphics from the 15th through the 18th centuries, as well as (in order of importance) Dutch, French, English, and Italian sections. Franz Anton also took an avid interest in the art of his own time, collecting complete sets of prints by the more important artists of his generation. It is difficult to say exactly how many works Franz Anton acquired; estimates range from 190,000 to 300,000 items. He realized that his graphics collection should be made accessible to the public, and affirmed in his will of 1799 as follows:

> Everything that I possess in the way of collections and such shall remain unaltered in the possession of the duchy, unless my debts require that a portion be sold for settlement, if no other means can be found, and then, shall only the least possible change in the appearance of the collection be made. Each person wishing to use the library and collections for the expansion of his knowledge, for his enjoyment, or more importantly for his studies must not be denied access to them.

The first itemized catalogue of Franz Anton's collection was compiled while the Kupferstichkabinett was still under his direction. Although he was fully capable of preparing such a catalogue and spoke several times of doing so, this first handwritten list (destroyed in World War II) was actually the work of the Coburg sexton, Heinrich Popp, who over the years had been entrusted with much of the duke's correspondence dealing with art matters. Popp's catalogue, although full of errors, served as the basis for a second, still reliable handwritten catalogue, produced about 1865, when the Kupferstichkabinett was under the supervision of the distinguished architect and painter Georg Rothbart (1817-1896). The 14 oversized volumes are the work of August Sollman, one of Popp's successors, who had been working with the collection since 1864 in an unofficial capacity—arranging, restoring, and cataloguing it. Neither Popp nor Sollman was a scholar in today's sense of the word, but they nonetheless deserve credit for laying the foundations for the modern scholarly study of Franz Anton's collection.

The importance of the collection was taken for granted both by Franz Anton's heirs and by the civil servants entrusted with its care, but for nearly a century, no serious endeavors were undertaken to complete or expand it. Duke Ernst I (1784-1844), Franz Anton's oldest son (fig. 2), attempted on several occasions to procure expert direction for the Kupferstichkabinett, which until 1854 was lodged, together with the ducal library and coin collection, in two rooms of the city armory. During the Napoleonic Wars—from the death of Franz Anton in 1806 until about 1816/17—the collection lay dormant. In 1817 Ernst asked Baron Christoph Haller von Hallerstein to appraise several sheets that he was considering for acquisition and later tried (through the art dealers Artaria & Fontaine in Mannheim) to obtain the services of an expert for the collection. He also undertook negotiations with the well-known graphics scholar Joseph Heller in Bamberg. But all of these efforts failed. Until 1838, the court painter, Sebastian Eckardt, supervised the Kupferstichkabinett; he was succeeded for a brief period by Dr. Eduard Praetorius. In 1840 the duke's son, Albert, left for London to marry his cousin Queen Victoria, and Praetorius accompanied him as private secretary. Thereafter, Dr. Carl von Schauroth (a scientist and later director of the Coburg Naturkundemuseum) took charge of both the graphics and coin collections.

Ernst I did make some purchases of graphics for his own personal collection. From about 1816 on, he ordered for inspection numerous consignments of books and graphics from the Mannheim art dealer Dominique Artaria (later Artaria & Fontaine) and others. From these shipments he selected much for his personal collection and little or nothing for the Kupferstichkabinett (although some duplicate prints were sold from the latter in Leipzig in 1818, a scheme that had been in the mind of Franz Anton as early as 1805). The character of Ernst's collection was quite different from that of Franz Anton. Although Ernst inherited a rather considerable array of older graphic art in 1830 from the Abbey of Gandersheim, on his own he appears to have focused his attention exclusively on the graphics of his contemporaries. What distinguished his collecting from that of his father—who, as we have seen, also made considerable efforts to collect contemporary graphics—was his tendency to acquire prints and drawings less for their own intrinsic value (although he too valued artistic quality) than for their subject matter. Ernst showed a particular preference for scenes relating to the history of architecture, to practical constructions such as fortifications and bridges, to theatrical and military themes, and to the *voyages pittoresques*, or picturesque travel scenes, so popular at the time. It is impossible to deny Ernst a certain collector's courage. He did not

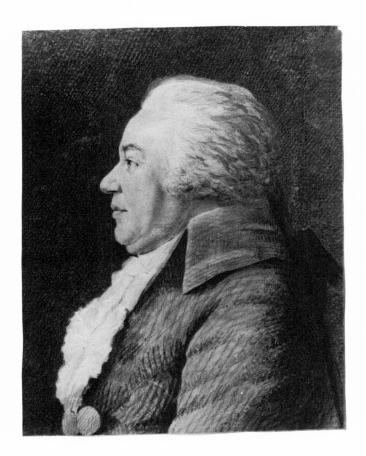

Figure 1. Daniel Nikolaus Chodowiecki, 1726-1801, *Duke Franz Friedrich Anton von Sachsen-Coburg-Saalfeld*, black chalk with gray and black wash, heightened with white chalk, 489 x 379 cm. Kunstsammlungen der Veste Coburg (Inv. no. Z 2861).

Figure 2. Christian Inger, active in Coburg 1800-50, *Duke Ernst I of Saxe-Coburg-Gotha*, c. 1830/40, lithograph, 212 x 156 mm. Kunstsammlungen der Veste Coburg (Inv. no. L 22).

hesitate, for example, to purchase the works of Johann Nepomuk Strixner, a pioneering German lithographer, when this medium was in its infancy. Nevertheless, the significance of Ernst's collecting has gone unrecognized, in part because he did not contribute directly to the growth of the ducal collection (only recently has a large part of his private collection, which had been in storage in the Veste's Fürstenbau, been formally acquired by the Kupferstichkabinett), but primarily because almost all the prints he acquired were reproductive—images etched or engraved after original paintings and drawings. Although these were the characteristic prints of his time, they suffer, to this day, a poor reputation.

The Kupferstichkabinett was not forgotten during the reign of the next duke, Ernst II (1818-1893), although it was placed in serious jeopardy. It was then, under the direction of Georg Rothbart, that August Sollman produced the second catalogue of the collection mentioned above. By this time, the collection had already been transferred from the armory within the city of Coburg up to the Veste Coburg, where a ducal collection of art and antiques had been in the process of being formed since the late 1830s. In 1882 Ernst II announced his decision "to sell, at the suggestion of the art dealers Amsler & Ruthardt in Berlin, the contents of the Kupferstichkabinett of the Veste Coburg, with the exception of the drawings, plates, photographs, and the work concerning the antiquities in Rome presented to us as a gift." The actual reason for this decision was the everpresent lack of funds. But the kind of arguments offered by Ernst II for his decision are those that constantly endanger print rooms:

1. The individual leaves are closed up in folders, drawers, and cupboards the collection constitutes therefore a rarified possession, which is not accessible to anyone. The other collections, however, consist of numerous treasures of weapons, coins, antiques, paintings, etc., which can be visited year-in and year-out by the local population and foreigners alike. . . .

2. As valuable as the art collection may be (one hopes to obtain about one million marks for it), it still lacks that completeness which is required these days for a first-rate collection. Nothing has been added for decades and there appears to be little hope that a time will come again when we can work toward its completion.

3. The collection is not totally safe at the Veste. As a rule it is guarded by only a single official, who, should he prove to be dishonorable, could easily steal or exchange the valuable sheets without being readily discovered. In addition, there is the danger implicit in the total lack of water at the Veste.

The sale of the collection never came to pass. It was blocked by the opposition of Ernst II's English nephews (the sons of his brother Albert), who, as parties to his will, had to be consulted in all matters concerning entailed property. The leading opponent of the sale was Prince Alfred, the Duke of Edinburgh, who most certainly had the backing of his mother, Queen Victoria. Both had often provided money and prints in an effort to revise and expand the graphics collection at the Veste.

The existence of the Kupferstichkabinett was never again placed in jeopardy. In 1897, for the first time, a qualified art historian, Karl Koetschau, was selected to be director of the art and antiques collections of the Veste Coburg, including the Kupferstichkabinett. He had a good personal relationship with Alfred, who as successor to his heirless uncle, Ernst II, had become Duke of Saxe-Coburg-Gotha in 1893. Koetschau, in rivalry with other great European graphics curators—Max Lehrs in Berlin, Joseph Meder in Vienna, and others—attempted within the means of his limited budget to fill the gaps in the historical section of the Kupferstichkabinett. However, nothing of importance in contemporary graphics was acquired, so that in this respect a large, irreparable lacuna exists in the collection.

In the early 20th century comprehensive renovations of the Veste Coburg were begun, prompted by the last reigning Duke of Saxe-Coburg-Gotha, Carl Eduard (1884-1954). But, in 1918, before this work could be completed, Carl Eduard abdicated, giving control of the ducal art and antiques collections as well as the natural science collections and ducal library (see p. 27) to the Coburger Landesstiftung, a foundation he had created for this purpose. The foundation undertook to complete the renovations, and, for a time, large portions of the art collections had to be warehoused. In the early '20s, the Kupferstichkabinett was moved into its new (and, for the first time, suitable) quarters in the Herzoginbau (the former residence of the dowager duchess). By 1924, the rest of the art and antiques collections (now officially known as the Kunstsammlungen der Veste Coburg) was again on display in the Veste Coburg. Since that time, several directors and staff members have worked to record and expand the contents of the graphics collection. Around 1930, for example, Dr. Oskar Lenz catalogued the drawings collection, which contains approximately 3,500 items. In the early '60s there began the systematic publication of a series of catalogues of selected works from the Kupferstichkabinett. Credit for this achievement belongs to Drs. Heino Maedebach and Minni Maedebach-Gebhardt, who are also responsible for the graphic collection's new convenient housing in an area that includes specially built storage facilities and a convenient study room, as well as exhibition galleries. Recently, the Kupferstichkabinett has received considerable attention from international scholars. It is hoped that the exhibition and catalogue will give further impetus to the scholarly investigation of the collection.

The History of the Landesbibliothek Coburg

Jürgen Erdmann

The Landesbibliothek Coburg, or state library of Coburg, today housed in the Schloss Ehrenburg, former palace of the dukes of Coburg, has a collection of approximately 300,000 volumes. A major research facility for northern Bavaria, it serves a large community of scholars, and its specialized divisions—including manuscripts, early prints and music, historical maps and almanacs, as well as sections devoted to humanism, the Baroque era, the Enlightenment, Classicism, and popular 19th-century literature—contain many rare and unique items, all acquired over the past 500 years.

The earliest reference to a ducal book collection in Coburg occurs in 1547, when Duke Johann Ernst of Saxony (1521-1553) took up residence at the Ehrenburg and apparently brought with him the rudiments of a library. This was not, however, the first instance of book collecting in Coburg. The Ehrenburg palace had been built on the ruins of a 13th-century Franciscan monastery, which had possessed a typical monastic library, including a parchment edition of the 36-line Bible formerly attributed to Gutenberg and probably printed in Bamberg around 1459/60. However, the monastery was disbanded in 1525 at the instigation of Protestant reformers, who—indifferent to the cultural value of the books—broke up the library so that virtually nothing remained in Coburg. (Only a fragment of the 36-line Bible survives in the collection of the Landesbibliothek.)

The first significant additions to the ducal collection were made during the reign of Duke Johann Casimir (1564-1633), under whom Coburg first became an independent duchy. In the interest of the city's cultural development, Johann Casimir became the patron and founder of three book collections that still exist today as parts of the Landesbibliothek. In 1588 he helped establish a library in the city's principal church, Saint Moriz, and in 1590 substantially expanded the palace library, when he brought to Coburg a collection of some 1,234 volumes inherited from his father, including *The Chronicle of the Saxons and Thuringians*, a three-volume manuscript by Georg Spalatin, completed before 1535 and decorated with nearly 1,400 colored pen-and-ink drawings by artists of the School of Cranach and others (fig. 3). The library at the palace was plundered in 1632 during the Thirty Years War, and until recently its holdings were thought to have been completely lost. In 1961, however,

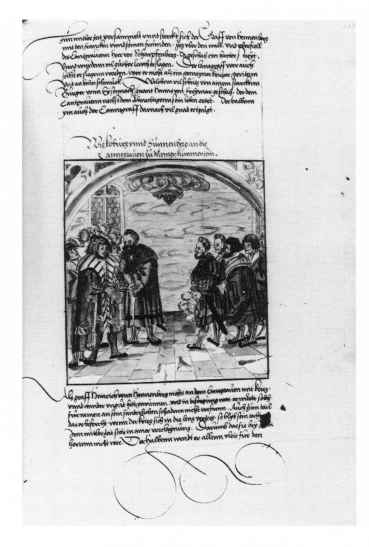

Figure 3. Page 218ʳ from *The Chronicle of the Saxons and Thuringians*, handwritten by Georg Spalatin before 1535. Landesbibliothek Coburg (Ms. Cas 11, B1). Photo: Eberhard Schmidt.

19 volumes, including the above-mentioned *Chronicle,* were discovered in the Casimiriana section of the Landesbibliothek, and another volume was found in the Landesbibliothek in Württemberg.

In 1607 Johann Casimir began a third library, this time in a recently founded secondary school, the Gymnasium Casimirianum. Later in the century, Johann Casimir's successor, Duke Albrecht (1648-1699), made a substantial addition to the number of books at the Casimirianum. As a result of his literary, musical, and scientific interests, Albrecht assembled 4,500 volumes for the Ehrenburg library as well, placing them in galleries equipped in Baroque fashion with stucco and gold bookcases. He subsequently bequeathed many of these books to the Gymnasium, and in 1953 they were returned—as the Bibliotheca Casimiriana—to the Schloss Ehrenburg and became part of the Landesbibliothek. (Works in the present exhibition with "Cas A" inventory numbers come from this collection; see cat. nos. 212, 214, 216.)

Although Albrecht was one of the more enthusiastic book-lovers among the Coburg dukes, he found a worthy successor in Duke Franz Friedrich Anton. Along with his fame as the founder of the Veste Coburg Kupferstichkabinett, Franz Anton also deserves great credit for his contributions to the Coburg book collections. All of the incunabula in the present exhibition (cat. nos. 196-200), the various editions of the Old and New Testaments (cat. nos. 209-211), and the *Hortulus animae* (cat. no. 208) were acquired by Franz Anton. The five incunabula, representing only a small portion of the nearly 100 such volumes purchased by the duke, testify to his desire, characteristic of the Enlightenment philosophy that he embraced, to make possible—for his contemporaries in Coburg no less than for ourselves—a direct confrontation with the spirit of the Middle Ages.

The richness of the Coburg book collection in the area of Protestant theology also traces its beginnings to Franz Anton, who assembled a collection of Martin Luther's works that numbered about 130 items, in addition to the Bibles mentioned above. These precious 16th-century works, together with those in the Bibliotheca Casimiriana and the library of the Church of Saint Moriz, document the history of German biblical texts and Bible translations. That history can be traced from the fragment of the 36-line Bible to the so-called Eggestein Bible, a German translation published in Strasbourg no later than 1470, and, finally, to Luther's own translations (cat. nos. 209-211), made to correct errors he found in the Vulgate and to provide the people with a proper vernacular text.

Luther's translations can be almost completely documented through the Landesbibliothek's collection, from the September Testament of 1522 to the first complete Luther Bible of 1534 and the revised edition of 1541. Equally large is the number of Luther's pamphlets and polemical writings. The exhibited works (cat. nos. 201, 203-204) represent a collection of around 700 such publications preserved in the Landesbibliothek. Many of them were acquired in the 19th century; in 1861 Prince Albert of Saxe-Coburg-Gotha, husband of Queen Victoria, decided to assemble a comprehensive Luther library in memory of the Protestant leader's sojourn at the Veste Coburg. Unfortunately, this ambitious project came to a halt when the prince died before the year was out. Nevertheless, approximately 280 publications had already been gathered together, not including those originally from Franz Anton's collection or 54 from the Bibliotheca Casimiriana. Some of most substantial addditions to the Coburg collection of Luther texts, however, were made later by Albert's son, Alfred, Duke of Saxe-Coburg-Gotha, who, by 1881, while still an English prince, had already donated 126 books and pamphlets.

As collectors of Luther texts, both Albert and Alfred were in a sense following the example of Franz Anton, whose understanding of the importance of these 16th-century works has already been made clear. Franz Anton can justifiably be called the greatest bibliophile in the history of the Coburg book collections and libraries, but an investigation into his life leads inevitably to the question: why did this impoverished German duke, ruler of a state of little political consequence at the time, feel the need to become involved in such extensive collecting activities? The reasons can be found in the philosophy and politics of the time, as well as in the duke's own personality and experience. On the political level, the fragmentation of Germany into many sovereign principalities led to the development of numerous courts and cultural centers. Often these centers engaged in veritable competitions with one another over the promotion of science and art, with the smaller states and courts following the example set by the larger ones. Hence, in establishing himself as a collector—of prints and drawings no less than of books —Franz Anton was attempting to keep up with the collectors of rival German houses (see p. 20).

Another reason for Franz Anton's rise to prominence as a great German collector lay in his upbringing and his scholarly, artistic inclinations. Franz Anton's father, Duke Ernst Friedrich, was also a book collector. From 1760 on, he gave his son the sum of 100 *thaler* per year for

the "development and improvement of the Ehrenburg library." An appreciation for the world of books also came to Franz Anton from his mother, Sophie Antoinette, who, as Princess of Braunschweig-Wolfenbuttel, hailed from a ducal house that looked back on a glorious tradition of book collecting.

In addition to such familial influences, Franz Anton's book-collecting fervor was given impetus by the encyclopedic tendencies of the Enlightenment, in which books played a pivotal role. In this age of great and optimistic ideas about the progressive education of the human race, books were considered the ultimate pedagogical tool. Franz Anton's advisers were all men of the Enlightenment: his chamberlain, Moritz August von Thümmel, was an internationally known writer, and his tutor, Johann Gottlieb Aulig, was described as a man of "exceptional humanity, worthiness of spirit, and infinite wisdom." Aulig attended Franz Anton as his scholarly and artistic adviser and as librarian until after the turn of the century, when he was succeeded in the latter position by Karl Friedrich Forberg, an apostle of the German philosopher Johann Fichte. It was Forberg who, after Franz Anton's death, compiled the catalogue of the Hof- und Staatsbibliothek, or Court and State Library, as the ducal book collection came to be known. This catalogue was completed in 1823 and is still in use today. The majority of the 60,000 volumes enumerated in Forberg's catalogue were acquired by Franz Anton. These works cover an astonishingly broad range of subjects and time periods and represent a variety of formats, from pamphlets to multi-volume works. It is Franz Anton's accumulation of this collection, which today forms the nucleus of the Landesbibliothek Coburg, that serves to establish him as a scholarly bibliophile in the European tradition.

Germany in the Age of Luther

Ellen Sharp

> Germany is without a head. Philipp [Melanchthon] has said that Germany is a blind Polyphemus. That is the greatest burden a country must bear, to be without a ruler (Ozment 1980: 260).

These words, uttered by Martin Luther in 1540, were intended as a comment upon the character of the emperor, Charles V, and the political situation in 16th-century Germany. During Luther's lifetime (1483-1546), the feudal relationships that had begun to dissolve throughout Europe as early as the 13th century were disrupted even further. Although the modern concept of separation of church and state did not yet exist, the traditional medieval hierarchy of church, nobility, and laity was no longer viable as the political and social structure of Europe changed. Society and politics were no longer controlled exclusively by the church and the feudal lords. Strong monarchies were developing whose dynastic ambitions were supported by prosperous merchants and international financiers.

The Holy Roman Empire

By the middle of the 16th century, England, France, and Spain had each become a unified nation under a strong monarch. This was not the case with Germany, however. It remained a loose federation of independent duchies, archbishoprics, and free cities, all under the aegis of the Holy Roman Empire, giving nominal allegiance to the emperor.

Politically and geographically, Germany did not become the country we know today until the end of the 19th century. Devout Christians of the late medieval and Renaissance periods perceived the Holy Roman Empire as a magisterial, somewhat mystical, institution presiding over most of Christian Europe. In reality, it was confined in Luther's day to the German-speaking lands of Austria, Saxony, Bohemia, and Switzerland, as well as sections of the Netherlands and northern Italy (fig. 4). This sprawling conglomerate, constantly embroiled in internal skirmishes and international wars, was thus aptly personified by the great humanist scholar and theologian Philipp Melanchthon (1497-1560) as Polyphemus, one of the Cyclopian giants of classical mythology, who, having been blinded by Odysseus, cried out in rage and frustration at his powerlessness.

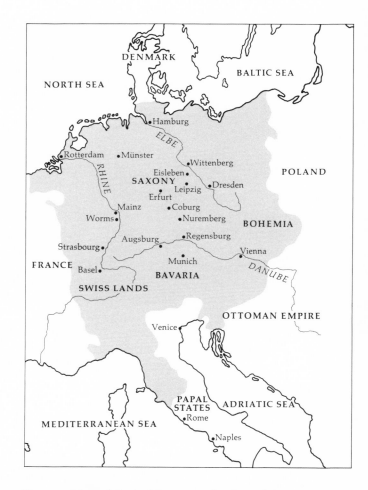

Figure 4. Map of Central Europe at the time of the Reformation.

Since 1356, when an imperial decree known as the Golden Bull had recognized the autonomy of the various German territories, there had been no direct papal involvement in the election of the emperor. Rather, the election was in the hands of several electoral estates, or territories, four of which—the Palatinate, Saxony, Brandenburg, and Bohemia—were secular, and three—the archbishoprics of Mainz, Trier, and Cologne—were ecclesiastical. Inevitably, there was a great deal of pressure brought to bear upon these electors, and an elaborate system of power politics developed. Neighboring princes and even the popes offered enormous bribes to obtain votes for the candidates of their choice.

With the election of the Hapsburg Maximilian I as emperor in 1493 and that of his grandson Charles V in 1519, the Holy Roman Empire assumed a political aspect completely opposite to that of the other European kingdoms, where strong rulers were forging unified nations out of former feudal territories. During Maximilian's reign, the term "Holy Roman Empire" was qualified by the addition of the phrase "of the German Nation." However, only two years after his election, the emperor, at a general assembly, or Diet, in Worms of the principal political constituencies of the empire (the seven electors, numerous non-electoral princes, and approximately 75 imperial free cities), made concessions that gave the various German principalities even greater independence, thus precluding the development of a true German nation. Although Maximilian, whose reign (1493-1519) spanned Luther's formative years, when the future reformer was studying in Magdeburg, Eisenach, and Erfurt and teaching in Wittenberg, undertook erratic and largely unsuccessful campaigns to revive the empire's ancient claims to such farflung territories as the duchy of Milan, he had little influence on the German estates at its core.

Maximilian was a colorful, quixotic figure, imbued with outdated romantic notions about the age of chivalry, and for that reason was often called by his contemporaries, perhaps derisively, "the last knight of Europe." He epitomized the typical German prince. A sportsman and warrior, he was also an enthusiastic supporter of the arts and sciences. His interest in the age of chivalry led him to stage tournaments with all the gorgeous trappings of medieval pageantry and to commission artists to com-

memorate these events in elaborate tournament books. The lesser German princes emulated the emperor by staging their own tournaments, and such books became popular throughout Germany (see cat. no. 16). No doubt due to his love of jousting, Maximilian was a patron of armorers. Artists of the stature of Dürer and the Burgkmairs, father and son, designed and decorated the emperor's armor. There was even a type of armor known as "Maximilian armor" (see cat. no. 10) that was fashionable in Germany between 1500 and 1530. (Also popular in the 16th century were elaborate dress weapons— daggers or short swords richly gilded and etched with Renaissance motifs [see cat. nos. 56-58].) Another activity advocated by Maximilian was hunting. One of the principal occupations and prerogatives of the nobility, it was a popular subject for decorative works, including woodcuts, murals, and tapestries such as those created by Lucas Cranach the Elder for Duke Johann Friedrich the Magnanimous of Saxony (cat. nos. 120, 124).

However, the courtly tournaments fostered by Maximilian were anachronisms. They could only be considered sporting events, for the first successful explosion of gunpowder in Europe in the 13th century and the development of cannon and musketry in the 14th and 15th centuries had completely changed the art of waging war. Knightly rules of conduct for personal combat no longer prevailed. In Erhard Schön's seven-part woodcut, *Siege of Münster*, of 1534/35 (cat. no. 189), both the defenders and the besieging army are depicted as relying heavily on the use of cannon. Not only had the rules of war changed, so had the makeup of the armies. The infantrymen in attack formation behind the bristling battery of cannon in Schön's woodcut are not noble knights and their retainers but lansquenets (from *Landsknecht*, or mercenary). The omnipresence of these swaggering figures and their colorful standard-bearers on the European scene in Luther's time is well documented by the numerous depictions of them by all the leading artists. With their elaborate uniforms and plumed hats, the lansquenets were favorite subjects for prints and stained-glass windows (see cat. nos. 7, 55).

Other picturesque personalities began to appear in European art as a result of increased contact with countries to the east. Usually described in contemporary accounts,

rather vaguely, as Oriental, these figures, with their exotic features and dress (see cat. no. 174), are most often depictions of the Ottoman Turks who, after the capture of Constantinople in 1453, became a threat to Europe as the sultan extended his power over the Mediterranean and through Hungary toward Austria.

In 1519 Maximilian died and his grandson Charles, heir to the Hapsburg lands of Austria, Bohemia, Hungary, Burgundy, Spain, and Naples, was elected emperor. Raised in the Burgundian court in Ghent, Charles' mother tongue was French (at the time of his election he spoke no German) and his most pressing concerns lay outside the confines of the Holy Roman Empire. Shortly after his election, concerned about the growing controversy over Luther's religious reforms, Charles V convened the Diet of Worms (1520-21) and declared Luther an outlaw. For the next nine years, however, occupied with the defense of the eastern borders of his hereditary lands against the Turks and his continuing struggles with the French over his Italian territories as well as the border lands of Burgundy and Flanders, Charles never set foot in the empire. When the Turks besieged Vienna in 1529 (see cat. no. 210), he had to beg the German princes for military assistance instead of prosecuting them for aiding the heretic Luther.

Social Upheaval

While the emperor's absence and his consequent inability to control his German subjects allowed the Reformation to take root, changing social conditions in Luther's time played just as important a role in the creation of a favorable climate for the advancement of the Protestant cause. Europe was in the process of changing from an agrarian system dependent on feudal responsibilities and duties to a capitalist economy based on the exchange of money for goods and services. A middle class was developing, and individual enterprise was gradually replacing the medieval guild system. Such conditions flourished in areas of population concentration. In fact, the towns with their busy merchants and developing universities were bright spots in a society plagued by social conflict and economic dislocation. In Germany nascent cities such as Nuremberg, Strasbourg, and Augsburg doubled in size in the 16th century. The newly wealthy residents of these growing metropolises provided a new source of patronage for artists, who had heretofore depended on the nobility and the Catholic Church for commissions. Albrecht Dürer in Nuremberg, Hans Baldung Grien in Strasbourg, Hans

Burgkmair in Augsburg, and Lucas Cranach the Elder in Wittenberg—cradle of the Reformation—were among the great artists whose careers thrived in the lively atmosphere of the towns.

As fixed as the levels of society might still have seemed in late medieval times, a certain amount of mobility existed as noble families died out and enterprising peasants prospered and advanced on the social scale. For example, Luther's father, who elevated himself to a position of power and wealth as a mine operator, was only a generation removed from the peasant class. (Mining became a thriving industry in late 15th-century Europe, especially in Germany, where improved methods of timbering and draining were first developed.) Perhaps the prevalence of heraldic coats of arms in the art of this period can be explained in part by increased snobbery on the part of the nobility as members of the lower classes advanced and began to claim their hereditary prerogatives. This emphasis on displays of rank was carried to such extremes that by the mid-15th century, a knight might ride into the lists displaying as many as 30 coats of arms. In his engraved portrait of *Duke Johann Friedrich the Magnanimous of Saxony* (1543; cat. no. 186), Georg Pencz surrounded his subject with 14 magnificent escutcheons identifying the duke's principal territorial titles. The survival of numerous designs for stained-glass windows with coats of arms, such as those done for Strasbourg and Augsburg patrons by Baldung and Hans Weiditz (see cat. nos. 2-7, 11-12, 52-55), indicate the noble pretensions of the influential citizens of these German cities. In his drypoint *Coat of Arms with Boy Standing on His Head* (c. 1490; cat. no. 173) the Housebook Master satirized a topsy-turvy world in which the lower classes aspired to privileges beyond their proper station in life.

Although the success of the Protestant Reformation in Germany was in part due to the absence of a strong Catholic ruler who might have quickly suppressed such a revolutionary movement, Luther clearly recognized that the Germans were suffering because of the lack of a central government. There was no single authority to administer a coordinated system of legal justice, to eliminate the barriers to trade caused by innumerable toll roads and bridges set up by the petty principalities, or to provide a rallying point around which the various classes could unite. In addition to needing a powerful political leader, however, Germany also needed a spiritual one. But at a time when its moral and spiritual leadership was most needed, the Church was unable to supply it. It was

trapped in a structure of its own devising—an extended bureaucracy headed by a dissolute and extravagant papacy that required vast sums of money to support an elaborate system of canon law, ambitious building programs, and especially to maintain the pope's lavish standard of living. In its ever-increasing need for money, the papacy had to resort to all sorts of ingenious devices to fill its coffers, not the least of which were the sale of church offices to the highest bidder and the direct sale of indulgences—a monstrous abuse of the Church's power to remit punishment for confessed sins.

Not only were reforms needed at the top of the church hierarchy; they were also required at the lowest level. The rural priest often lived in dire poverty. He had little formal education and was poorly equipped to attend to the needs of his parishioners. That many members of the clergy violated their vows of celibacy was common knowledge. Their vices were often a subject for ridicule as in Schön's woodcut *The Monk and Cleric Hunt* (c. 1525; cat. no. 188), which illustrates a satirical text by Hans Sachs (1494-1576), poet, playwright, and Meistersinger of Nuremberg. Bishops and other prelates frequently held multiple offices, resulting in an absentee clergy who could not supply proper guidance to their individual bishoprics.

Instead of correcting its weaknesses, the Church had responded to earlier cries for reform from such preachers as Jan Hus (c. 1369-1415) and Savonarola (1452-1498) by branding them as heretics and executing them. By failing to react in a constructive manner to the need for spiritual and moral regeneration within its ranks, the Church advanced Luther's cause. Oblivious to the growing demand for reform, the Church of Rome perversely steered a stormy course. In his woodcut *Shipwreck of the Catholic Clergy* (1545; cat. no. 165) Matthias Gerung borrowed his imagery without doubt from a stanza in Sebastian Brant's widely read *Ship of Fools,* first published in Basel in 1494:

> St. Peter's ship is swaying madly
> It may be wrecked or damaged badly,
> The waves are striking 'gainst the side
> And storm and trouble may betide (Brant 1944 : 333).

The subject of Brant's book is a ship peopled with fools and steered by them to a fool's paradise. Illustrated with woodcuts, this book had a pervasive impact throughout Europe, both visually and verbally; the fool motif in various forms can be found throughout the art and litera-

ture of the Reformation period. In this exhibition some of the most delightful images utilize the figure of the jester. The court fool was, of course, a familiar figure long before the publication of Brant's book, but his frequent appearance in works of art from this period is indicative of a similar consciousness on the part of artists concerning mankind's follies in a world of turmoil.

One particularly popular use of the fool was as a reminder of the ability of an attractive woman to make fools of men, such as in the *Tournament Book of Johann Friedrich Magnanimous of Saxony* (c. 1535; cat. no. 16) or in Weiditz's inventive drawing the *Tree of Fools* (c. 1525; cat. no. 51). In the latter a shapely and fashionably dressed maiden shakes a tree in full bloom so that its strange fruit—fools wearing pointed caps and bells, either fully developed figures or mere buds with tiny heads—tumbles to the ground in playful profusion. The theme of the power of women over men was often presented in the guise of an appropriate religious subject or story from classical antiquity, such as Solomon's Idolatry, Samson and Delilah, David and Bathsheba, or Aristotle and Phyllis. A unique woodcut (cat. no. 164) by Peter Flötner dated about 1534, which combines all four of the incidents cited above, is evidence of the persistent popularity of the subject well into the third decade of the 16th century.

Luther was successful as a reformer not only because he was a great leader but also because he was a profound, original theologian. Through his own personal search for the assurance of salvation, he developed a new theology that stood in distinct contrast to the oppressive religious atmosphere of the late 15th century. Luther's belief that man is justified, or saved, through faith alone was in direct opposition to the doctrines of the late medieval Church, which taught that God's wrath was not easily appeased and that man with his inherent sinful nature could only attain salvation by the performance of a multitude of good works. The fear of eternal damnation was paramount in the late medieval mind and compounding this apprehension was the feeling among many that they were living in the last age before the end of the world and the second coming of Christ. (The belief that the end of the world would occur around 1500 was based on a medieval scholastic tradition, derived from the Book of Daniel and the Revelation of Saint John.) The apocalyptic warnings of the Book of Revelation seemed particularly compelling during this period of spiritual unrest, and the Apocalypse theme was dramatically depicted in

some of the great publications of the day, of which Dürer's magnificent series of woodcuts of 1498 (see cat. nos. 130-132) was unquestionably the finest artistic achievement.

These fears of doomsday contributed to the dark mood of late medieval Europe, which was enveloped in an economic depression that had begun in the 14th century as a result of the erosion of the feudal system and the decimation of large sections of the population by the bubonic plague. After the first terrible outbreak in 1347-50, the "black death" developed a persistent strain; Europe continued to be terrorized by periodic reoccurrences well into the 16th century. By 1440, the European population had sunk to its lowest level since the advent of the plague and only started to rise in the years after Luther's birth. The daily reality of death was made vivid by artists of the period, such as Mair von Landshut, whose engraving *Hour of Death* (1499; cat. no. 169), shows Death as a lethal archer, lurking in the shadows ready to strike down at any moment the men and women engaged in worldly pursuits who are oblivious to his presence. In Burgkmair's chiaroscuro woodcut *Lovers Surprised by Death* (1510; cat. no. 114), Death, depicted as a skeletal winged angel, has already claimed a young warrior as victim and prevents a maiden from escaping his clutches by snatching a corner of her gown with his teeth.

The traumas suffered by all levels of society as a result of these interacting factors—the plague, the economic recession, the disruption of the feudal system, the fear of Turkish invasion—may have contributed to the religious fanatacism rampant in Luther's age. The worship of the Virgin Mary and a multitude of saints was extended beyond all reason. Prints showing every aspect of Mary's life were immensely popular. The Marian cult was extended to include other members of Christ's family, especially Saint Anne, the Virgin's mother (see cat. nos. 49, 150). The proliferation of the worship of saints in the late 15th and early 16th centuries is well illustrated in this exhibition by images ranging from Dürer's engraving of the vision of the aristocratic Saint Eustace, with its emphasis on an incredibly detailed landscape setting (cat. no. 135), to Cranach's woodcut showing the gruesome martyrdom of Saint Erasmus presided over by sadistically intent executioners (cat. no. 118).

A veritable cult of death developed. Macabre relics of saints and horrible tales of martyrdom held a special fascination for a large section of the public. The popular craze for pilgrimages demonstrated the great need of a

vast majority of the people for some kind of spiritual surcease. Penitents hoping for salvation, as well as the sick and crippled hoping for a miracle, crowded into shrines all over Europe. Such pilgrimages seemed misguided to those with Protestant sympathies such as Albrecht Dürer, who noted his dismay at the excesses that resulted from such fanaticism at the bottom of the famous Coburg impression of Michael Ostendorfer's woodcut *Pilgrimage to the Church of the Beautiful Virgin* (c. 1520; cat. no. 184).

The confusion of the faithful was understandable. Through the centuries since apostolic times, theologians had woven such a thick web of confusing and conflicting doctrines that there was no clear definition of such matters as the relative importance of faith and good works for the salvation of mankind. Luther's carefully reasoned doctrine provided the faithful, for the first time, with a simple and clear prescription for spiritual grace.

Luther and Humanism

Luther received his master's degree from the University of Erfurt in 1505 and planned to study law as his parents wished. But, while returning to Erfurt from his parent's home in Mansfield in July of that year, he was caught in a thunderstorm. Terrified, he appealed to Saint Anne, vowing to become a monk if his life was spared. Shortly thereafter he entered the Augustinian monastery at Erfurt, and his ordination to the priesthood took place in the cathedral there two years later. Burdened with an acute sense of sin and an overwhelming sense of his own unworthiness, Luther was tormented by the contrast between divine mercy and divine wrath and the Church's emphasis on the individual's fallibility in placating the latter or insuring the former. Luther's neurotic anxieties were not relieved by monastic life. Although he enforced upon himself the most rigorous discipline, including special fasts, long periods of prayer, and severe physical discomfort, none of these helped to subdue his own personal demon. He continued to suffer agonies of doubt and inadequacy. In 1508 Luther was assigned to the Augustinian order in Wittenberg to teach moral philosophy at the university there, which had been founded in 1502 by Friedrich the Wise, Elector of Saxony. After a journey to Rome in 1510-11, he returned to Wittenberg, where he received his doctoral degree in 1512 and joined the faculty again as a professor of theology.

Sometime between 1513 and 1515, after a long period of meditation in the tower room of the Augustinian cloister

in Wittenberg, a great revelation came to Luther. While reading Saint Paul's Epistle to the Romans, he came to the realization that man receives God's grace through faith alone. This new understanding constituted a religious breakthrough for Luther and he experienced an enormous sense of physical and emotional relief. The logical development of this fundamental doctrine negated the Church's whole system of sacraments and its insistence that the clergy had spiritual powers denied to other men. Instead, Luther promulgated the doctrine of the priesthood of all believers in Christ and Scripture alone as the sole authority for Christians.

Crucial to the development of Luther's new theology was his exposure, in his first years as a university student, to humanist philosophy. At the end of the 14th century and the beginning of the 15th, Italian intellectuals began to look beyond medieval traditions of study. Believing that the intellectual and social freedom of the republics of Greece and Rome had made possible the brilliant creativity of their citizens, these scholars wished to rediscover and revive the wisdom of the ancients. This conscious return to classical ideals in art and literature is referred to as the Renaissance. Because of their emphasis on the individual and on human interests as opposed to other worldly concerns, these scholars came to be called humanists and their intellectual and cultural movement, humanism. The humanists undertook the rediscovery of classical antiquity by developing methods of critical analysis that could be applied to all branches of knowledge and by utilizing linguistic skills to consult basic source material, thereby replacing medieval modes of learning that relied on established dogma.

By the end of the 15th century, humanist scholars were making their presence felt in Northern Europe. The University of Erfurt, where Luther began his studies in 1501, was the first north German university to introduce humanist ideals. At various times, the Erfurt faculty included such distinguished humanist scholars as Conrad Celtis (1459-1508) and two of Luther's most influential professors, Jodocus Trutfetter (c. 1460-1519) and Bartholomaeus von Usingen (c. 1465-1533). Both of these men, although trained in the medieval scholastic tradition, were sympathetic to humanist educational reforms. At Erfurt, Luther was exposed to Renaissance ideas that stressed the importance of the individual human being and his development; to the most modern scientific ideas through Trutfetter's lectures on physics; and to the tenets of biblical humanism, which encouraged the study of

Greek and Hebrew so that the writings of the early fathers of the Church could be studied in the original. In fact, biblical humanism paved the way for Luther's work as a reformer. Scholars such as Johann Reuchlin (1455-1522), who published his *Hebrew Grammar and Dictionary* in 1506, and the Dutch humanist Desiderius Erasmus (1467-1536), whose Greek New Testament appeared in 1516, pioneered the scientific approach to the study of the Old and New Testaments.

The humanists' insistence on consulting original sources rather than relying on established dogma was to have critical consequences for the Reformation. In the four years after he transferred to Wittenberg, Luther became the spiritual leader of the university. In 1518, as a result of Luther's request to Elector Friedrich the Wise that "a real teacher in Greek and Hebrew" be sent to the university, Philipp Melanchthon, great-nephew of Reuchlin (who had recommended him as the best Greek scholar in Europe, excepting the great Erasmus) arrived in Wittenberg. Luther and Melanchthon immediately established what was to become a lifelong friendship. Together, they made the University of Wittenberg a center of biblical humanism and, with their brilliant lectures, attracted students from all over Europe. By 1520, Luther had himself become an able linguist and felt ready to begin translating the Bible into German. His translation of the New Testament was completed during his enforced stay on the Wartburg in 1521-22 after he was outlawed by the Edict of Worms. His next major undertaking was the translation of the Old Testament (see cat. no. 209), which he worked on while confined to the Veste Coburg and which was completed in 1534.

During the Renaissance, a climate in which scientific discovery could flourish was created. The research of humanist scholars made accessible the remarkable geometry and astronomy of the ancient Greeks and furthered the development of such concepts as the theory that the world was not flat but rather round. During Luther's lifetime, the great voyages of discovery enlarged the known world by as much as three times its size as it had been conceived of in medieval times. The leaders in the voyages of exploration were the Portuguese, who in the first half of the 15th century explored the nearby coast of Africa. Seeking more direct routes to the Indies—source of precious spices and other valuable products—Portuguese ships went further and further, until, in 1486, Bartholomeu Diaz rounded the tip of South Africa. In 1492 Christopher Columbus, flying the flag of Spain, tried

another route by sailing west and inadvertently discovered the American continent when he landed on an island in the Bahamas. Vasco da Gama sailed across the Indian Ocean to Calcutta in 1498, and in 1519 Ferdinand Magellan, a Portuguese in the service of Spain, sailed around Cape Horn and became the first European to sail on the Pacific. Although Magellan died before the voyage was completed, by 1522 his ship had circumnavigated the globe.

The King of Cochin (cat. no. 113), a woodcut frieze by Georg Glockendon after Hans Burgkmair, illustrates a report of the first German expedition to India in 1505-06, when a group of German merchants joined a Portuguese trading expedition to the Malabar coast. Such subjects were extremely popular. To satisfy the public's thirst for the novel and sensational, Columbus's report of his discoveries, *De Insulis*, was immediately translated into several languages; the German edition was published in 1494-97. Albrecht Dürer expressed the fascination of his contemporaries with the exotic artifacts brought back from the New World in his description of the triumphal entry of Emperor Charles V into Antwerp in 1521, which included a display of objects from Mexico:

> Further I have seen things brought to the King from the new golden land: a sun wholly of gold, wide a whole fathom, also a moon, wholly of silver and just as big; also two chambers full of their implements, and two others full of their weapons, armor, shooting engines, marvelous shields, strange garments . . . I have seen nothing which has gladdened my heart as much as these things. For I have seen therein wonders of art and have marveled at the subtle *ingenia* (cleverness) of people of far-off lands (Panofsky 1948, I: 209).

This interest in all aspects of the natural world was typical of the artist who introduced the Renaissance into German art. Dürer was active in humanist circles in Nuremberg, one of the German cities most deeply influenced by the Renaissance, and at about the same time that Luther was developing his new theology, Dürer was creating his great master prints, the so-called *Meister-stiche: Knight, Death and the Devil* (1513; cat. no. 153), *Melencolia I* (1514; cat. no. 154), and *Saint Jerome in his Study* (1514; cat. no. 155). Humanist ideas permeate these three prints, especially the engraving of the scholarly Saint Jerome. Dürer's representation of the scholar in his study so effectively captures the beatific calm of a dedicated theologian that it remains the definitive depiction of the scholarly saint. The identification of Luther with the translator of the Vulgate was perhaps inevitable. An

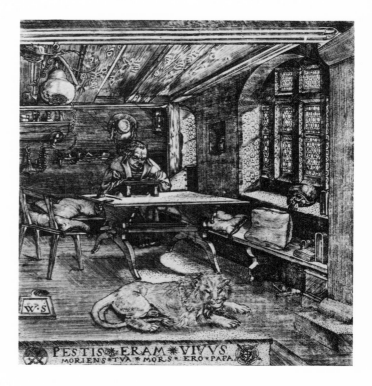

Figure 5. Monogrammist WS, *Martin Luther as Saint Jerome in his Study*, engraving, 138 x 126 mm. Kupferstichkabinett, Staatliche Museen Preussischen Kulturbesitz, Berlin.

engraving by the anonymous printmaker Monogrammist WS, for example, *Martin Luther as Saint Jerome in his Study* (fig. 5), incorporates most of the details of the setting of Dürer's print, but is merely a primitive pastiche of its prototype.

In their search for the means to realistically depict natural objects, Renaissance artists found it necessary to become familiar with scientific theory. Dürer, for example, strove to recreate the ideal male and female form based on a theory of proportion derived from the canons of Vitruvius, a Roman writer of the first century before Christ (see cat. no. 138). In addition to natural phenomena, artists were concerned with the representation of three-dimensional objects on a two-dimensional surface and, as a result, had to concern themselves with the study of mathematics, particularly geometry. These investigations gave rise to a discipline that has become closely identified with Renaissance art—the science of perspective.

One of Dürer's earliest known sketches in which he used a correctly constructed one-point system of perspective is the *Flagellation of Christ* (1502; cat. no. 21). His final conclusions on how to achieve one-point perspective were presented in 1525 in the fourth book of his treatise on geometry, *Underweysung der Messung mit Zirckel un Richtscheyt (Course in the Art of Measurement with Compass and Ruler)*. In the same vein is Lorenz Stoer's title-page design (c. 1555; cat. no. 45) for *Geometria et Perspectiva . . . ,* a book containing 11 woodcut designs (see cat. nos. 194-195), in which the artist used three-dimensional shapes not just as vehicles for decorative display but also to create imaginary landscapes in which geometric shapes are intertwined with architectural ruins.

A further development that indicated the influence of biblical humanism in general, and of Luther's transformation of the University of Wittenberg into a humanistic center in particular, was the establishment of a library in the Castle of Wittenberg. Georg Spalatin (1484-1545), court preacher, secretary, and special adviser to Friedrich the Wise, recorded that the Elector of Saxony created this facility in 1512 and made him librarian. The range of reading materials available in the library became increasingly diversified in the 20 years after its founding. In 1532, when Johann Friedrich became elector, he took special interest in the library and allocated substantial amounts for the acquisition of books. Spalatin, Melanchthon, and other professors were always looking for opportunities to acquire whole collections and they searched the fairs at Leipzig and Nuremberg for rare volumes. Spalatin even journeyed to Venice, site of the famous Aldine press.

The Reformation and the Printing Press

The significance of scholarly libraries, and of books in general, in this period cannot be overestimated. By the end of the 15th century, books, once a rarity because they had to be written out laboriously by hand on costly parchment, began to multiply rapidly due to the successful combination of several innovations in the art of printing. One of the first books printed on a press with movable type was the Latin Bible issued by Johann Gutenberg in Mainz in 1454. Within a few decades, printing had spread from Germany to all the countries of Europe. By the end of the century, printing presses existed in over 200 cities and towns, and an estimated six million books had been printed (half of them on religious subjects). More books were printed in the 40 years

between 1460 and 1500 than had been produced by scribes and monks during the entire Middle Ages (Ozment 1980: 199). Although books did not immediately become available to the vast majority of people, they were no longer a luxury reserved for the nobility or the wealthy clergy. Publishers all over Europe soon discovered that there was a broad market in the cities and at the universities for the printed word, and they began to fulfill the demand for books printed, not in Latin but in the various European vernaculars. A powerful tool had become available for the spread of knowledge and the promotion of ideas, and it was quickly put to use by Luther and his contemporaries. The polemical tract, a short printed pamphlet 14 to 40 pages in length, with a decorative title page, became the vehicle for the spread of Reformation theology. Luther, who wrote brilliantly and with astounding speed, produced about 30 such tracts, which were distributed quickly in editions of 300,000 copies. His celebrated treatises of 1520, *Address to the Christian Nobility of the German Nation* and *The Liberty of the Christian Man* (cat. no. 201), reached 16 and 19 editions, respectively, within the space of a year.

There is a long-standing tradition that on October 31, 1517, Luther nailed his *Disputation on the Power and Efficacy of Indulgences* (usually referred to as the ninety-five theses) to the door of the Castle Church in Wittenberg. Such an action was a means of inviting debate. Indeed, the October date is celebrated today as the birthday of the Reformation. The scholarly controversies over whether Luther actually nailed the theses to the door of the Castle Church, whether they were first printed in Wittenberg or in Leipzig, by whom they were first printed and the actual date of printing, or when they were translated into German are not crucial issues to the birth of the Reformation. What is most significant is the theses' immediate and resounding impact on all levels of society. They were quickly circulated—throughout Germany in a fortnight, throughout Europe in a month. In December 1517, three separate editions were printed simultaneously in three different cities in Germany. A convincing case has been made for the probability that Luther's theses were first read, not by a small group of scholars and students gathered about a church door, but in the printers' workshops where learned laymen gathered to check copy, read proof, and exchange gossip and news (see Eisenstein 1979). Printers consulted with professors, physicians, artists, translators, libraries, and other scholars, and their workshops, as focal points for cultural and intellectual exchange, served as incubators for the Re-

Figure 6. Printed Indulgence. Collection of Theodore Smithey.

formation. Ironically, the printing press also served to increase the traffic in indulgences since it made possible their mass production. In fact, the first dated product from the Gutenberg press was an indulgence. Illustrated here is a typical printed indulgence (fig. 6), issued by Pope Leo X (1513-21) in 1517, the same year as Luther's theses. This example was printed on vellum in Gothic type with a woodcut of the papal arms in the upper left margin. Space was left on the document to write in by hand the name of the seller, place of sale, and the date.

Luther's theses, written in Latin and meant for discussion among theologians, were mild in tone for he had as yet no thought of breaking with the Church of Rome. Later, as his confidence in his positiion increased, he became more vehement. Matthias Gerung's woodcut *Sale of Indulgences* (1546; cat. no. 166), in which two devils dressed as cardinals are shown selling indulgences, while the pope with another little devil perched on his lap rakes in the money, might have served as a visual counterpart to Luther's words as he replied to a papal bull of 1520 condemning his stand against the practice:

> The Indulgences are not a pious fraud but an infernal, diabolical, anti-christian fraud, larceny and robbery, whereby the Roman Nimrod and teacher of sin peddles sin and hell to the whole world and sucks and entices away everybody's money at the price of this unspeakable harm (Luther 1958, 32/II: XI).

While the reading audience was still pretty much confined to the cities and the upper classes in the Lutheran era (it was only with the advent of the railway in the 19th century that the rural population of Europe would readily overcome its isolation and become literate), nevertheless Luther's teachings reached all levels of the German population. Credit for this is in part due to the preachers who—like Balthasar Düring in Coburg—advanced Luther's cause in the small towns. Of even greater importance in spreading his message were the crude but visually effective woodcuts that accompanied contemporary anti-papal broadsheets.

Peasants, Knights, and Witches

In Peter Flötner's woodcut (1525; cat. no. 163) *The Poor, Common Ass*, the ass of the title is the peasant, who suffers greatly at the hands of Clerical Hypocrisy, Tyranny, and Usury. From the 12th century on, the lot of the peasants had steadily grown worse, aggravated by

the declining economy, outbreaks of the plague, and the advent of syphilis in Europe. The peasant was subject to onerous regulations, including the payment of tithes and the performance of obligatory services to his lord; his condition in most areas of Germany was one of serfdom. He was most often portrayed as stupid, stubborn, gluttonous, and hard-drinking, little more than an animal, like the common donkey in the Flötner woodcut. The peasants bitterly resented their menial status and harsh treatment. Beginning with the Hussite Wars of the early 15th century, there were repeated peasant uprisings in Germany, including the so-called Peasants' Revolt in 1525, the same year that Flötner's broadsheet was published.

The peasants felt that Luther's writings applied especially to them. They found encouragement in the Lutheran emphasis on the apostolic age of Christianity, since the Apostles were, after all, chosen by Christ from among common people. They interpreted Luther's tract *The Liberty of the Christian Man* (cat. no. 201) to mean freedom from the bonds of feudal society. Poor harvests and the intolerable conditions of daily life, combined with hope for the brighter future that Luther seemed to promise, led the peasants of southern and central Germany to band together into armed groups that roamed the countryside, burning villages, sacking monasteries, committing murder and mayhem. Violence erupted in virtually all sections of the empire. When Luther decided to make a trip through Saxony to try to restore peace, he was jeered by hecklers. Soon the situation was beyond control, and the princes of the various regions of Germany, united, raised an army to suppress the rebels, and completely routed the peasants by May 1525. A terrible blood bath of reprisal against the insurgents followed. Luther was appalled at the vengeful actions of the princes, but he also denounced the rebellious actions of the peasants. In his writings Luther reveals a constant sympathy for the poor and oppressed, but he was, outside of his religious views, a conservative man to whom revolution against the established social order was anathema.

Other members of medieval society whose position was changing, like that of the peasant, were the knights. These lesser members of the aristocracy were also suffering because of the erosion of the feudal system, the depressed economy, and rising inflation. They saw the growth of large urban centers with a wealthy merchant class as a threat to their existence, and in retaliation, adopting the tactics of highwaymen, they attacked merchant wagon trains and seized their rich cargo. The rider in Dürer's master print *Knight, Death and the Devil* (1513; cat. no. 153) has been identified with an infamous robber baron who engaged in such plunder. The German knights, in particular, were not willing to accept the fact that the power of the hereditary aristocracy was being diminished. In 1523, led by Franz von Sickingen (1481-1523), and supported by the humanist Ulrich von Hutten (1488-1523), the knights united in war against the princes. Their campaign, however, was a dismal failure. Thus, while the age of Luther was a time of optimism and of the emergence of belief in a benevolent God, it was also a time of conflict and bloody confrontations, which would continue after Luther's death in 1546. Although the Peace of Augsburg in 1555 legalized the division of the German empire into Lutheran and Catholic states, with the adherents of each faith agreeing to respect the other's right to worship according to their own beliefs, the religious conflicts were not completely resolved. In the first part of the 17th century, the controversary flared up again, and Europe was devastated by the Thirty Years War.

In this age of growing religious enlightenment, Renaissance humanism, and scientific discovery, there was also, paradoxically, a rise of interest in the occult and a fascination with witches and other minions of Satan. Indeed, Renaissance scholarship included investigations of the supernatural. Alchemy, astrology, the study of the Cabala, and similar subjects were cultivated by scholars like the legendary Dr. Faustus who made a pact with the devil. Printing itself was regarded as a magical invention —Gutenberg's associate, Johann Fust, has by legend been identified as Dr. Faustus. Among the early products of the printing press were several that helped to stimulate the craze for witchcraft; one of the most popular publications in late medieval Europe was the *Malleus Maleficarum*, or *Hammer of Witches*, an encyclopedia of demonology compiled by two Dominicans who had been appointed as inquisitors for northern Germany. First published in 1486, it went through nine editions in six years (Eisenstein 1979: 436). Protestants, while attacking the cult of saints, nevertheless accepted the views of the Dominican friars on demonology. A belief in the devil was shared by churchmen who might not agree on other issues. To early 16th-century man, the devil was still a very real presence.

The artist in whose work this dichotomy between an acceptance of Renaissance ideals and a preoccupation

with the occult is most apparent is Hans Baldung. Baldung could create delightful designs, using the new decorative vocabulary introduced from Renaissance Italy (see cat. no. 2) or drawings that evoke the harmony between man and nature (see cat. no. 12). But it is the darker side of Baldung's art that has left the deeper impression and has intrigued modern viewers. His best-known print, *The Bewitched Groom* (c. 1544; cat. no. 108), can obviously be related to witches, devils' steeds, and other aspects of the interest in demonology prevalent in 16th-century Germany.

The World of Nature

Just as the supernatural world held a fascination for artists of the Reformation period, so too did the world of nature. Since the 14th century, Northern European artists had had a special affinity for the depiction of nature and its flora and fauna. Unlike his Italian counterpart, the Northern European artist approached the representation of landscape in an additive fashion, piling detail upon detail, rather than organizing his compositions according to rules of classical order and Renaissance perspective. In the late medieval and early Renaissance periods, landscape was a necessary accessory in works depicting religious subjects, such as the *Saint Christopher* of Martin Schongauer (c. 1480; cat. no. 192) with its precisely rendered iris plant in the right-hand corner of the engraving (fig. 7). In the drypoint by the Housebook Master entitled *Turk on Horseback* (c. 1490; cat. no. 174) there is a similarly placed detail of a flowering plant, but here flower and leaves have the soft texture characteristic of the drypoint medium that is quite different from the pure linear grace of Schongauer's plant. The landscape background of the Housebook Master's print presents a panoramic view over a lake and distant hills and creates an impression of vast depth, and the foliage of the trees that enframe this view have a soft texture that is almost palpable. A similar density of foliage is seen in the forest (fig. 8) that rises above Saint Eustace in Dürer's engraving (c. 1500/01; cat. no. 135). Dürer's use of the engraver's burin is as much a virtuoso performance as that of the Housebook Master with the drypoint needle, however, it surpasses the work of the Housebook Master in wealth of detail and solidity of form. Dürer appears to have reveled in his ability to depict animal and plant forms. He built a landscape that evokes the lush complexity of the German countryside, but left little room for the soft, airy atmosphere that

Figure 7. Detail (cat. no. 192).

Figure 8. Detail (cat. no. 135).

envelops the tranquil landscape in which the Housebook Master's Turkish rider has momentarily paused to rest.

The first generation of humanists in Germany, especially the poet Conrad Celtis, studied such ancient writers as Tacitus, whose treatise on the early Germans, *Germania,* was used to promote a sense of Germanic identity and national pride (see Spitz 1957). Germany's greatness, past and present, is a recurrent theme in Celtis' work; he and the other humanists of his generation glorified what they saw as the primitive valor and simplicity of the Teutonic tribes and the beauty of the ancient forested lands of Germany. They advocated a return to a romantic idyll of simplicity and austerity. Literature in this mode was especially prevalent during Luther's formative years and had a direct influence on the development of his theology. Luther's own deep-seated love of his country and pride in its technical accomplishments is apparent in his writings and in his colleague's written records of his informal talks. (From the time of his marriage in 1525 until his death in 1546, Luther maintained a large household, which included not only his own family but also student lodgers. This group was often joined at the evening meals by visitors—university colleagues or travelers from abroad. There was much spirited conversation and some of the men who were present took notes that were later published as *Tischreden,* or table talks.)

There was in the philosophy of the German humanists more than a hint of the cult of the noble savage. They wished to evoke a time when man lived in harmony with nature without the constraints of civilization, as in Lucas Cranach's engraving *Penance of Saint John Chrysostom* (1500; cat. no. 122), where the naked princess (whose curls are like some luxuriant plant growth) and her child recline peacefully and comfortably in a woodland setting watched over by a benevolent stag and deer. Similarly, in Cranach's woodcut *Saint Jerome in Penitence* (cat. no. 121), created in the same year as the engraving, the woodland setting envelops the saint and his attributes. His crucifix is not merely affixed to a tree; it seems to be growing out of it. In the Lutheran era, this organic view of nature culminated in the first etchings of pure landscape by Albrecht Altdorfer. In his *Landscape with Large Pine* (c. 1520/23; cat. no. 101), Altdorfer not only recreated the beauty of an alpine landscape, he also infused the scene with a sense of the magic of nature. Altdorfer's etching needle has animated the trees and forested hills, evoking a sense of some all-encompassing presence residing in nature and presiding over it.

The Altdorfer etching is a striking contrast to the landscape in the background of Dürer's engraving of the same period, *Virgin with Swaddled Child* (1520; cat. no. 159). A nocturnal scene, Dürer's landscape has faded into the gathering darkness; there is no tender communication between mother and child, no sense of a world in which people exist in harmony with their surroundings as in his earlier depictions of this theme.

The disparity between the lyrical landscape of Altdorfer and the mournful one of Dürer is symptomatic of the position in which many artists of the late Lutheran era found themselves. The interplay of religious and artistic ideas inevitably resulted in conflict. How were the artists to reconcile somber Protestant theology and simple religious services with their humanistic, even hedonistic, pleasure in the visual delights of the natural world? The humanists and the Protestant reformers had enjoyed a positive association in the early years of the Reformation, when Luther's revolt had promised a release from the oppression of the Church and the acceptance of a more humane theology. This optimism soon faded.

Historians have suggested that the Reformation required too much from the majority of people in the way of radical religious change and moral transformation (Ozment 1980: 434-438). Without the comforting support of such traditional institutions as confession, the veneration of the saints and relics, pilgrimages, indulgences, monasteries, nunneries, the pageantry and mysticism of the Latin Mass, all the rich panoply of worship built up over the centuries by the Church of Rome, they had to face sin, death, and the devil supported only by simple faith in the Bible and service to one's fellow man. It may be that Luther demanded more of men in the way of self-reliance than they were capable of sustaining. It is ironic that the austere life demanded by puritanical Protestant reformers often provoked a repressed hostility that found expression in erotic fantasies and the spread of superstitions. Thus, humanists like Erasmus eventually came to see Lutheranism as a threat to the liberal arts and the development of the individual. The rigid position that Protestants eventually assumed vis-a-vis Catholicism was to undermine the visual arts and to subvert for several centuries true enlightenment. However, before this occurred, German artists had created a visual legacy of unsurpassed beauty and strength that was to survive as testimony to one of the greatest periods in the history of the graphic arts.

Luther at Coburg

Lewis W. Spitz

On the wall of his chamber in the Veste Coburg in the year 1530, Martin Luther (fig. 10) wrote the words: "I shall not die but live and declare the works of the Lord!" (Psalm 118:17). From April 24 to October 4 of that year, while the Diet of the Holy Roman Empire was meeting in Augsburg to decide the fate of the Reformation, Luther lived in the fortress (fig. 11; see cat. nos. 118-119). Legally an outlaw—nine years earlier he had been excommunicated by the Church and placed under ban of the empire by the Edict of Worms—Luther could not attend the diet to defend his views. Thus, when his supporters, including his lord and protector, the Elector of Saxony, stopped in Coburg on their way to Augsburg in answer to the imperial summons, he remained there, secure in the fortress above the city.

During the six months of the diet, Luther kept in touch with his colleagues in Augsburg and with his family and friends at home in Wittenberg (some 171 of the 200 letters that he wrote during this period are extant). In addition, he continued to work on his translation of the Bible, which he had begun in 1522, as well as producing many important reformatory treatises and printed sermons. Although not so powerfully etched on the popular mind as Luther at Worms or Luther disguised as *Junker Jörg* (Squire George) on the Wartburg (see cat. no. 128), the Luther of Coburg is nevertheless an unforgettable figure.

Figure 9. Hans Brosamer, c. 1500-1552, *Katherine von Bora*, 1530, woodcut, 371 x 289 mm. Schlossmuseum, Gotha. Photo: Photoarchiv Marburg.

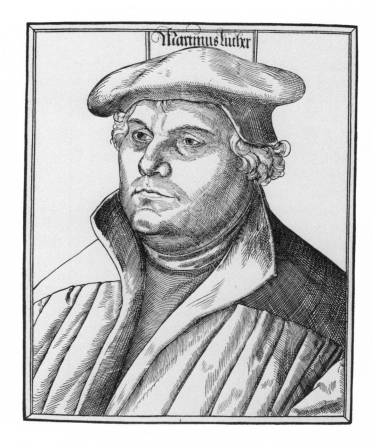

Figure 10. Hans Brosamer, *Martin Luther*, 1530, woodcut, 364 x 284 mm. Schlossmuseum, Gotha. Photo: Photoarchiv Marburg.

The Early Days of the Reformation

Although Luther gave it an eloquent and compelling voice, the desire for religious reform was widespread in late 15th-century Europe. The Church no longer enjoyed the unquestioned devotion that had characterized the earlier Middle Ages, nor was its power as all-encompassing as it once had been. From 1309 to 1377, the papacy had fallen under the domination of the kings of France and was moved from Rome to Avignon. This "Babylonian Captivity," so called because the popes, like the children of Israel, had been carried off into a foreign land, was followed by the "Great Schism" of the Church (1378-1415), during which two and even three rival popes competed for the allegiance of the faithful. The Council of Constance finally resolved the latter controversy, but serious damage had been done to the concept of papal infallibility. Even below the level of the papacy, the church hierarchy had degenerated. Nepotism and simony (the selling of church offices) were widespread. The continuing struggles between the Church and the emerging nations of Europe resulted in an increasingly secularized clergy as kings and princes sought to circumvent the pope's power by appointing men of their own choosing to the bishoprics and other ecclesiastical positions within their domains. Finally, the condition of the common clergy became more and more scandalous. Usually poor men with little formal education, many parish priests did not truly understand either the teachings of the Church or its language. They learned the Latin Mass and other parts of the liturgy by rote and were ill-equipped to explain the teachings of Christ to their congregations. Thus, the ordinary believer often had a very distorted view of proper religious practice, and the abuses that resulted were a constant source of concern not only to the church hierarchy but to educated laymen as well. It was in such an atmosphere that Luther undertook his training as a monk.

As a young monk in the Saxon town of Wittenberg, Luther became painfully aware of the moral and financial abuses in the church, but his basic objection to late medieval church practice lay at a deeper level: he believed that the Church no longer taught the Word of God, but rather the doctrines of men. While serving as a lecturer on the Bible at the University of Wittenberg, where he himself had won his doctoral degree in 1512 (see cat. no. 127),

Luther carefully studied the Psalms and the Epistles of Saint Paul and in them discovered that God forgives man's sins and bestows righteousness upon him freely out of His own goodness, grace, and mercy. Luther could find nothing in the Scriptures to support the Church's doctrines, built up over centuries, that salvation could be earned by good works and penitential offerings or that the Church alone had the power to intercede on behalf of sinners. Luther pointed out that according to the Gospel, salvation was obtained by faith alone, that all one need do was believe in Christ as the Son of God and the savior of mankind. At first, Luther's expositions of his theological position were confined to the realm of scholarly debate. He had no intention of rebelling against the Church; like many others, laymen as well as clergy, he wanted only to reform it from within. But in October 1517, when a so-called hawker of indulgences, a Dominican friar by the name of John Tetzel, approached the borders of Saxony, the attempt at reformation that had begun in the professor's study flared into a public controversy.

The sale of indulgences had had its origins in the sacrament of penance, whereby the Church had assumed the power—upon a sinner's oral confession, admission of guilt, and sincere repentance—to impose a punishment, or penance, on the sinner and, when the penance was fulfilled, to grant absolution for the sin. The concept of indulgences was based on the supposed existence of a treasury of merit stored up by Christ, Mary, and the saints, upon which the Church could draw on behalf of the sinner in order to remit his punishment. Writs of indulgence granted by the Church served to shorten or ameliorate a sinner's penance, which in the case of a major offense might consist of a holy pilgrimage (see cat. no. 184), fasting, flogging, or imprisonment. The first indulgences were granted in return for participation in the Crusades. Later, good works or prayers and, finally, money payments were accepted as a means of obtaining an indulgence. By Luther's day, the sale of indulgences had become the subject of much abuse. Extravagant claims were made that, in addition to the remission of punishment on earth, the purchase of an indulgence could free a sinner, or even the souls of those already dead, from suffering in purgatory. The traffic in indulgences provided an ever-increasing share of the Church's income, drained money away from Europe into the coffers of

Rome, and had become a burden on the faithful, whose fear of the wrath of God made them easy targets for ecclesiastical salesmen like Tetzel.

The proceeds from the indulgences being sold by Tetzel were to go in part for the building of Saint Peter's Cathedral in Rome and in part to repay the debts of the Archbishop of Mainz, Luther's ecclesiastical superior, who had paid an enormous sum for the papal dispensation that allowed him to hold more than one high church office at a time. Concerned for the welfare of his parishioners in Wittenberg, Luther felt compelled to protest. In an attempt to provoke open debate, he posted 95 theses, or arguments, questioning the theology used to justify the selling of indulgences, on the north door of the castle church in Wittenberg. Luther's arguments against the sale of indulgences immediately captured the imagination of the public. In a matter of weeks his thesis had been published in towns and cities throughout Germany. The great indulgences controversy had begun and the Reformation was launched.

Luther now began to pour forth tracts and sermons, amplifying and explaining his views; between 1517 and 1520, over 300,000 copies of his books and treatises were published. Finally, Pope Leo X, whose initial reaction to the situation had been to view Luther's theses as the irresponsible work of a drunken German monk who would

eventually sober up, sent Cardinal Cajetan, an eminent member of the Curia, to arrest Luther and bring him to Rome. Luther appealed for protection to the Elector of Saxony, Friedrich the Wise, who, reluctant to deliver one of his professors into the hands of the Italians, refused to let Cajetan arrest Luther and insisted instead that a hearing be held in Augsburg. The pope, who at this time favored Friedrich as a claimant to the imperial throne, agreed. The meeting between Luther and the cardinal in October 1518 left Luther steadfast in his beliefs. Cajetan was furious, but for the moment, no further action was taken against the reformer.

In 1519 Luther went to Leipzig to debate with Dr. Johannes Eck, a formidable scholar and an advocate of Catholic orthodoxy, and in 1520 he wrote his most famous treatises: the *Address to the Christian Nobility of the German Nation*, rejecting papal supremacy and urging that since the Church had failed to reform itself, the secular government should come to its rescue and save it from the widespread abuses; *The Babylonian Captivity of the Church*, attacking the whole sacramental structure of the Church and stating that there were only three sacraments, not seven; and the treatise on *The Liberty of the Christian Man* (see cat. no. 201), setting forth his central creed, that man cannot save himself through good conduct nor through the sacraments, but rather *is* saved as soon as

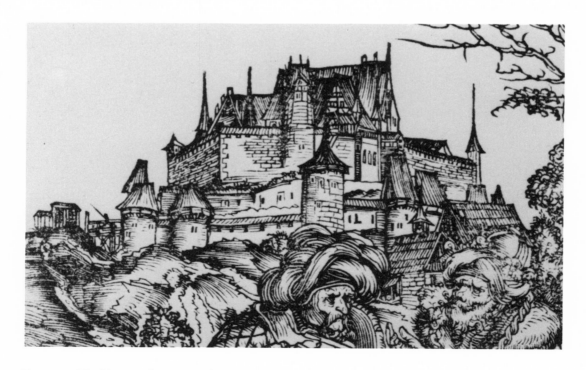

Figure 11. The Veste Coburg. Detail (cat. no. 118).

he throws himself on God's mercy and believes in His promises. In the same year, citing 41 heresies in Luther's writings, the pope took the first step toward his excommunication with the papal bull of June 15, 1520, *Exsurge Domine (Rise up, O God)*. The pope gave Luther 60 days in which to recant and demanded that his books be burned. Luther refused to recant, however, and in January 1521 he was declared a heretic and expelled from the Church.

In the meantime, Charles V (fig. 12), who had been elected emperor of the Holy Roman Empire in 1519 (although he was not crowned by the pope until ten years later), called for a meeting of the Diet, or general assembly, of the Holy Roman Empire to be held in Worms, in order to discuss the spreading reform movement. Luther was summoned to the diet to defend himself, but when it convened in April 1521, he again refused, as he put it, to "rechant," that is, to renounce his convictions and sing a new song. In May Charles V issued the Edict of Worms, declaring Luther an outlaw. Friedrich the Wise, fearing for the reformer's safety, spirited him away to the Wartburg, a castle deep in the Thuringian forest. Not for several months did Luther return to Wittenberg. Then, with Philipp Melanchthon (fig. 13) at his side, he transformed the University of Wittenberg into the center of a reform movement that was eventually to win over half of Europe.

For several years, the political controversy that arose as a result of Luther's proposed reforms was held in abeyance. Charles V had other worries—war with France, the advance of the Turks on the eastern borders of the empire, the Peasants' Revolt of 1525—and he had little time to pursue his opposition to Luther. In fact, in 1526 at the Diet of Speyer, the emperor's preoccupation with his other troubles enabled the estates to establish the right of discretion regarding reformation, meaning that within his own realm a prince could decide to what extent he wished to institute reform. By 1529, however, the tide had turned in the emperor's favor. He had made his peace with Francis I, King of France, the Turks had been driven back from the gates of Vienna, and on Christmas Day 1529, he was officially crowned emperor of the Holy Roman Empire by Pope Clement VII (having finally made his peace with the pope after the sack of Rome by imperial troops in 1527). The emperor now demanded that the privilege of discretion in the matter of Lutheran reform be rescinded. Four of the estates—Electoral Saxony, Brandenburg, Hesse, and Anhalt—as well as fourteen of the free imperial cities under the leadership of Strasbourg "protested." (Thenceforth, these estates were known as

Figure 12. Monogrammist MR, active mid-16th cent., *Emperor Charles V*, woodcut, 316 x 255 mm. Kunstsammlungen der Veste Coburg (Inv. no. I 211, 7 K831).

Figure 13. Albrecht Dürer, *Philipp Melanchthon*, 1526, engraving, 172 x 130 mm. Kunstsammlungen der Veste Coburg (Inv. no. K441-K111).

Figure 14. Hans Brosamer, *Martin Luther in the Pulpit*, woodcut, 129 x 118 mm. Kunstsammlungen der Veste Coburg (Inv. no. I 215, 175).

Caspar Lindemann, the elector's personal physician, the theologians Philipp Melanchthon, Justus Jonas, Georg Spalatin, Anton Musa of Jena, Johann Agricola, and, of course, Luther, as well as 120 soldiers and over 300 horses. The entourage arrived in Neustadt on Maundy Thursday, and on Good Friday, Luther preached a sermon (fig. 14) in the Neustadt church before they proceeded to Coburg.

While waiting to move on to Augsburg, Luther displayed his remarkable energy and dedication by preaching seven times in Coburg's Saint Moriz Church in less than a week. The elector and his retinue were still in Coburg when Johann learned that Johannes Eck, Luther's old opponent, had published 404 theses against Luther in preparation for the diet. In his treatise, Eck charged that the reformers planned to reject basic articles of the Christian faith. Luther thought it necessary not only to answer Eck but to do so in a way that would serve to present a written confession (in addition to the previously prepared Torgau Articles) of the Protestants' beliefs to the diet. Melanchthon was selected as the chief author and began work while still at Coburg. On April 15, he put down the first of 21 articles of what would come to be known as the Augsburg Confession, the first Protestant confession and the model for many Protestant confessions in later centuries.

It had been hoped that Luther would be able to stay in Nuremberg during the diet, but on April 16, a messenger from that city came to report that although the city council was generally favorable to Luther's cause, its members had decided that it would be impolitic for Luther to stay in their city. Luther expressed his desire to return to Wittenberg to continue his teaching and scholarly work, but the elector wished him to be as close as possible to the diet. So, while Johann the Steadfast and his retinue continued on to Augsburg, Luther, early on the morning of April 24, moved up to the Veste Coburg, the mighty fortress high above the city, where he would be secure from assassination or arrest.

Luther at Coburg

The Veste Coburg was a formidable redoúbt, with thirty people in residence, in addition to twelve nightwatchmen and two tower keepers. Nevertheless, the elector advised Luther to keep his location as secret as possible, and Luther signed his letters written from the castle "from the wilderness," "from the kingdom of the birds," or "from Gruboc." Soon after he moved to the fortress, where he occupied two rooms (fig. 15) in the *Steinerne*

the "protestant estates" and the term Protestant was applied to all those who rejected the Catholic Church in favor of a reform movement.) In the face of this revolt, the pope and emperor agreed that it was time to settle the question of Lutheranism once and for all. The emperor summoned the diet to meet in Augsburg in June 1530, stating that in the interest of preserving the peace he wished to hear everyone's point of view.

The Diet of Augsburg

In preparation for the diet, Johann the Steadfast, who had succeeded his brother Friedrich as Elector of Saxony, summoned his theologians to the town of Torgau to discuss a plan of action. They met in March and prepared the Torgau Articles, which rejected papal abuses and cited ten reasons (articles) why the Elector of Saxony had instituted Luther's reforms, with the intention that these articles be presented to the diet as a rationale for the Protestant cause.

On April 3, Johann began his journey to the Diet of Augsburg, accompanied by a retinue of 70 nobles, such prominent laymen as Gregorius Bruck, former chancellor of Saxony, Christian Baier, the present chancellor,

Figure 15. The Luther Room at the Veste Coburg. Photo: Fremdenverkehrsamt, Coburg.

Kemenate (Stone Chamber), he wrote to Jonas and Spalatin that he had observed a "diet of birds in the tree tops, dressed in shiny black with grey eyes, much chatter but no resolutions."

Luther found it impossible to sit idly by while his colleagues carried on the negotiations in Augsburg. His six months on the Coburg were among the most productive of his life. Almost immediately, he began work on his *Exhortation to All Clergy Assembled at Augsburg*, saying that ideas crowded in on him as he wrote like a company of mercenaries. The text laid out the whole range of ecclesiastical abuses that Luther believed to be in need of correction. On May 12, he sent the text to a printer in Wittenberg. When a bookdealer brought the first 500 copies to Augsburg on June 7, they were quickly sold out. A few days later, in response to a demand made by the imperial government, the Augsburg city council forbade the republishing and selling of this book. Nevertheless, sales continued. "Your truly prophetic book is read by all the pious . . ." wrote Jonas from Augsburg on June 12 (Luther 1955-76, xxxiv: 7). Even the papal nuncio, Cardinal Lorenzo Campeggio, was impressed and commanded a secretary in his service to translate the *Exhortation* into Latin.

The Book of Psalms had always been one of Luther's favorite books of the Bible. His first glimmerings of insight had come to him while he was lecturing on the Psalms. Through the years, they had helped cheer his spirit when he was most depressed. He now wished to do a German translation of the Psalms so that they could be sung in German rather than in Latin. While on the Coburg, by way of preparation for that work, he wrote the *Coburger Psalms*, a commentary composed of brief explanations of the first 25 Psalms. Like Erasmus, who had dedicated one of his essays to a boatman who had taken him safely across the Rhine, Luther dedicated some of his works to common folk such as his own favorite barber. His exegesis of Psalm 117, the shortest in the psalter, he dedicated to the knight, Hans von Sternberg, who was the caretaker of the Coburg fortress, and the exegesis of Psalm 118, Luther's favorite psalm, which he called the "beautiful *Confetimini* (Confess You All)," to Abbott Friedrich Pistorius of the Church of Saint Giles in Nuremberg. In his beautiful commentary on this psalm, Luther reveals his abiding trust and faith even in the perilous days of his confinement in the castle:

My venerable and dear Lord and patron:
. . . These thoughts of mine I decided to send you as a

gift. I have nothing better. Though some may consider this a lot of useless drivel, I know it contains nothing evil or unchristian. This is my own beloved psalm. Although the entire Psalter and all of Holy Scripture are dear to me as my only comfort and source of life, I fell in love with this psalm especially. . . . When emperors and kings, the wise and the learned, and even saints could not aid me, this psalm proved a friend and helped me out of many great troubles. As a result, it is dearer to me than all the wealth, honor, and power of the pope, the Turk, and the emperor. . . . But lest anyone, knowing that this psalm belongs to the whole world, raise his eyebrow at my claim that this psalm is mine, may he be assured that no one is being robbed. After all, Christ is mine and yet He belongs to all believers. I will not be jealous but will gladly share what is mine. Would to God all the world would claim this psalm for its own, as I do! Peace and love could not compare with such a friendly quarrel. Sad to say, there are few, even among those who should do better, who can honestly say even once in their lifetime to Scripture or to one of the psalms: 'You are my beloved book; you must be my very own psalm.' The neglect of Scripture, even by spiritual leaders, is one of the greatest evils in the world . . . (Luther 1955-76, XIV: 45-46).

Luther also continued to work on his translation of the Bible, which has remained the definitive German version —it is still in use in German churches. Luther's Bible also influenced early English translations such as those by Tyndale and Coverdale and so fed into the grandeur of the King James Version (1611). So important was Luther's Bible that he has often been called the father of the German language. In his famous treatise *On Translating: An Open Letter*, Luther stressed the need to convey the *meaning* of the passage, not merely transcribe literally word for word:

> We do not have to inquire of the literal Latin as to how we are to speak German as these papal asses do. Rather we must inquire about this of the mother in the home, the children on the street, the common man in the marketplace. We must be guided by their language, the way they speak, and do our translating accordingly. That way they will understand it and recognize that we are speaking German to them. . . . Because someone has the gift of languages and understands them, that does not enable him to turn one into the other and to translate well. Translating is a special grace and gift of God (Luther 1955-76, XXXV: 188-189).

The two Hebrew prophets that Luther first began to translate during his Coburg stay (see cat. no. 209), trying to make them "speak German," were Jeremiah and Eze-

kiel, men who witnessed difficult times for the children of Israel, just as Luther was himself a witness to contemporary upheavals. However, his trunk of books had been slow in coming to the Coburg from Wittenberg so he began work on Hosea, the first of the so-called minor prophets, instead, and by September, he had finished translating all 12. In addition, he produced glosses to the Decalogue and the New Testament.

The variety and volume of Luther's other writings during his Coburg stay are staggering, especially since he referred to himself—at the time—as merely a "lazy idle onlooker." During the first half of July, in his *Sermon on Keeping Children in School*, he argued for compulsory education for all children and pointed out society's need for educated people. Luther also completed a treatise entitled *Admonition Concerning the Sacrament of the Body and Blood of our Lord*, which discusses in a detailed and moving manner the Lord's Supper and its central meaning in the faith and life of the Christian community. He took sharp issue with the Catholic view of the mass and participation in Communion as good works, meritorious as contributions toward one's salvation. The sacrament, he held, was not a good work offered to God by the priest both for himself and for others, but rather an act of remembering Christ's death on the cross and of thanksgiving to God for his gift of forgiveness and love in Christ (Luther 1955-76, XXXVIII: 91-145). In all, Luther wrote some 20 reformatory works during his months at Coburg.

Besides his letters of encouragement to his colleagues in Augsburg, Luther was in constant touch with his wife Kathe (fig. 9), his children, and his friends in Wittenberg. These private letters reveal the human side of the great reformer, his doubts and anxieties as well as his good humor and tenderness. His health was never robust, due perhaps to the rigors of his early monastic life, and the forested climate of the Coburg was none too benign. The tension of his situation and perhaps his incipient angina pectoris gave him many severe headaches, and occasionally he was afflicted with a ringing and roaring sound in his ears. He also suffered from head colds and flu. Although not yet 50, Luther was feeling his years. One evening, when he looked out of the window of the Veste, he thought he saw the devil in the form of a fiery ball or snake. Occasionally, when depressed, he felt tired of living and longed for the "beloved last day." He even found the place where he wished to be buried, under the crucifix in the fortress chapel, now known as the *Lutherkapelle*, where he prayed daily and communed regularly.

Luther also had times of joy and hope, however. His wife sent him a picture of their infant daughter Magdalen or "Lenchen." This picture gave Luther much joy and he had it mounted on the wall opposite the table where he ate his meals. During Luther's stay at Coburg, two brothers, Jerome and Peter Weller, moved into Luther's house to be with his family. Jerome took care of the education of Luther's four-year-old son Hans and reported to Luther on the progress of his studies and his diligence in saying his prayers. Around June 19, Luther wrote a letter to his son:

To my beloved son Hänschen Luther at Wittenberg. Grace and peace in Christ! . . . I know of a pretty, beautiful, and cheerful garden where there are many children wearing little golden coats. They pick up fine apples, pears, cherries, and yellow and blue plums under the trees; they sing, jump, and are merry. They also have nice ponies with golden reins and silver saddles. I asked the owner of the garden whose children they were. He replied: "These are the children who like to pray, study, and be good." Then I said: "Dear sir, I also have a son, whose name is Hänschen Luther. Might he not also be permitted to enter the garden, so that he too could eat such fine apples and pears, and ride on these pretty ponies, and play with these children?" Then the man answered: "If he too likes to pray, study and be good, he too may enter the garden, and also Lippus and Jost. And when they are all together there, they will also get whistles, drums, lutes, and all kinds of other stringed instruments; and they will also dance, and shoot with little crossbows." And he showed me there a lovely lawn in the garden, all prepared for dancing, where many gold whistles and drums and fine silver crossbows were hanging. But it was still so early in the morning that the children had not yet eaten; therefore I couldn't wait for the dancing. So I said to the man: "Dear sir, I shall hurry away and write about all this to my dear son Hänschen so that he will certainly study hard, pray diligently, and be good in order that he too may get into this garden. But he has an Aunt Lena, whom he must bring along." "By all means," said the man, "go and write him accordingly."

Therefore, dear son Hänschen, do study and pray diligently, and tell Lippus and Jost to study and pray too; then you boys will get into the garden together. Herewith I commend you to the dear Lord's keeping. Greet Aunt Lena, and give her a kiss for me (Luther 1955-76, XLIX: 321-324).

Luther was devoted to music as one of the most powerful and beautiful of the arts. He wrote hymns, composed and played music, and used the Psalter, sung according to liturgical regulations and in the musical settings of the Church, for prayer and meditation. While at Coburg, Luther thought much about music and its importance for the Church and theology. He wrote a short piece entitled *On Music* and a famous letter in praise of music to the Bavarian court musician Ludwig Senfl, which illustrates clearly his dedication to "Frau Musica:"

Grace and peace in Christ!
Even though my name is detested so much that I am forced to fear that this letter I am sending may not be safely received and read by you, excellent Ludwig, yet the love for music, with which I see you adorned and gifted by God, has conquered this fear. This love also has given me hope that my letter will not bring danger to you. For who, even among the Turks, would censure him who loves art and praises the artist? . . .

There is no doubt that there are many seeds of good qualities in the minds of those who are moved by music. Those, however, who are not moved by music I believe are definitely like stumps of wood and blocks of stone. For we know that music, too, is odious and unbearable to the demons. Indeed I plainly judge, and do not hesitate to affirm, that except for theology there is no art that could be put on the same level with music, since except for theology music alone produces what otherwise only theology can do, namely, a calm and joyful disposition . . . (Luther 1955-76, XLIX: 426-429).

The Diet of Augsburg had opened on June 20. Five days later the Protestants presented their statement of faith. When Luther heard that the Augsburg Confession had been read, he exulted, "I am tremendously pleased to have lived to this moment when Christ has been publicly proclaimed by his staunch confessors in such a great assembly by means of this really most beautiful confession" (Luther 1955-76, XLIX: 354). The Confession, however, was rejected by the emperor and the Catholic majority. The compromise solutions that Melanchthon had worked for came to nothing; the diet would not even consider his *Apology*, written to further explain the Protestant position. The arguments continued until summer had passed into autumn, and, on September 22, Johann the Steadfast, convinced that all attempts at reconciliation would fail, petitioned the emperor for permission to leave the diet. In the final decree of the diet, the emperor commanded the Protestants to accept the Catholic confutation of their confession by April 15, 1531, and indicated that in the meantime all innovations in matters of doctrine and church practice were strictly forbidden.

On October 2, Luther preached his final sermon in the chapel where he had spent so many hours in prayer, and, two days later, the entire company began the return trip via Neustadt to Wittenberg. Luther's long ordeal was over.

On the very day that the Augsburg Confession was presented to the diet—June 25, 1530—Justus Jonas had written to Luther that the Electoral Prince Johann Friedrich (later called the Magnanimous; see cat. no. 186) had ordered that Luther's seal (a roselike form based on his family escutcheon) be executed in "beautiful stone and mounted in gold." This golden signet ring was made in Nuremberg and given to Luther. The "Luther rose" came to be closely associated with Luther's writings, often appearing as an identifying emblem on the title pages or endpapers of his books and pamphlets (cover, fig. 16). In a letter written to his friend Lazarus Spengler on July 8, 1530, Luther explained how the rose symbolized his religious beliefs:

> . . . Since you ask whether my seal has come out correctly, I shall answer most amiably and tell you of those thoughts which now come to my mind about my seal as a symbol of my theology.
>
> There is first to be a cross, black and placed in a heart, which should be of its natural color, so that I myself would be reminded that faith in the Crucified Christ saves us. For if one believes from the heart, he will be justified. Even though it is a black cross, which mortifies and which also should hurt us, yet it leaves the heart in its natural color and does not ruin nature; that is, the cross does not kill but keeps man alive. For the just man lives by faith, but by faith in the Crucified One. Such a heart is to be in the midst of a white rose, to symbolize that faith gives joy, comfort, and peace; in a word it places the believer into a white joyful rose. . . . Such a rose is to be in a sky-blue field, symbolizing that such joy in the Spirit and in faith is a beginning of the future heavenly joy: it is already a part of faith, and is grasped through hope, even though not yet manifest. And around this field is a golden ring, symbolizing that in heaven such blessedness lasts forever and has no end . . . (Luther 1955-76, XLIX: 358-359).

Figure 16. Title page from Martin Luther's *Ein Sendbrief von Dolmetschen*, Wittenberg, 1530. Landesbibliothek Coburg (Sig. LuIa 1530, 16).

Early German Drawings at Coburg

Christiane Andersson

Drawing occupies a special place in the history of German art. Early on, it developed a character of its own and an unrivaled variety. In the German cultural milieu, a particular affinity seems to have existed for the relatively abstract qualities of line as opposed to the more realistic and sensuous qualities of color. Thus it is not in the realm of painting but rather in the graphic arts—in drawing and engraving—that German artists have made their most significant and lasting contributions to the history of European art. There was hardly a German artist of importance during the late Middle Ages and early Renaissance who was not a distinguished draftsman, and some, such as Urs Graf (see cat. no. 24), created their most important work in this medium.

Drawing has long been valued as the most spontaneous and personal of all artistic media. Due to its minimal material obstacles, artists can bring their initial creative impulses to realization more easily and quickly in a drawing than in any other technique. Nowhere, therefore, can an artist reveal his intentions with greater immediacy and intimacy than in his drawings. However, artists only gradually learned to exploit the potential of this medium. During the Middle Ages, drawings that display a high degree of spontaneity were still comparatively rare, since at that time drawings served relatively rigid functions: as designs for goldsmith's work or stained glass, as studies for paintings, as records of an artist's own compositions or of foreign models, and the like. These functions generally required precision rather than freedom of *ductus* (the manner in which the drawing instrument is handled). Nevertheless, late Gothic draftsmen occasionally made use of the speed of execution that the pen put at their disposal and created sketches in an astonishingly free style (see cat. no. 42). So long as works of art were expected to conform to established traditions of use and meaning, however, as was generally the case throughout the Middle Ages, such works remained exceptions to the rule. But with the advent of the Renaissance and its concomitant emphasis on artistic individuality and originality, artists came to rely less on the models and patterns they had gathered as workshop aids and more on their own expressive impulses. It was at this juncture that drawing truly came into its own and began to reflect the creative process in its various stages (see cat. no. 22).

Contemporary with the Renaissance draftsman's growing freedom of expression, and closely allied to it, was the emergence of drawing as an autonomous art form—one of the crucial milestones in the history of the medium. Around the year 1500, drawings in Germany were gradually liberated from their former subsidiary function as preparatory studies for works in other media and began to be created as an independent form of expression (see cat. no. 24). Although this development had originated in Italy, drawing south of the Alps generally remained more exclusively in the service of painting than in the German-speaking areas of Northern Europe.

The Coburg Drawings

The late Middle Ages and the early Renaissance constitute the period of greatest fertility in the history of German drawing prior to the 19th century. The Kupferstichkabinett of the Kunstsammlungen der Veste Coburg, one of the most important and varied collections of German master drawings in Europe, is particularly rich in examples from this extraordinarily creative early period. The collection includes both a representative sampling of the many kinds of drawings produced during the late Middle Ages and Renaissance in German-speaking countries, and a number of highly distinguished groups of drawings by such artists as Albrecht Dürer, Hans Baldung Grien, Hans Weiditz, and the Master of the Coburg Roundels. The drawings at Coburg from this period, however, are poorly known and inadequately studied relative to their importance, with the exception of those by Dürer, Baldung, Weiditz, and Hans von Kulmbach. The drawings by Jörg Breu, Hans Traut, Hans Holbein the Younger, and the anonymous Swabian and Swiss masters have remained virtually unknown, while those by the Master of the Coburg Roundels have not received serious scholarly attention since the early 1940s. Although the Coburg collection has generously lent to exhibitions in the past, usually only a few famous pieces were requested. Only on two occasions, in 1933 and 1947 (see Muchall-Viebrook 1933; Munich 1947), has a substantial selection of the drawings at Coburg been shown. Due to the unfavorable circumstances of those years, no scholarly catalogues accompanied these exhibitions.

The most important drawings from this period at Coburg are doubtless the nine works by Dürer, seven of which have been selected for the exhibition (cat. nos. 17-23). Superlative examples of his early and late styles, the drawings suggest the extraordinary range and spiritual dimensions that determine Dürer's place in the history of Western art. The *Nativity* and *Elevation of the Magdalen* (cat. nos. 17-18) are crucial to our understanding of Dürer's development as a draftsman in the 1490s. By 1502, as can be seen in the *Flagellation of Christ* (cat. no. 21), Dürer had already achieved his superbly rational, analytical style and almost classical economy of line. The chalk portrait of Anton Fugger (cat. no. 23), created about three years before the artist's death, belongs at the other end of the chronological spectrum. Not a life study for a painted portrait, it is rather a characteristic example of the type of autonomous portrait drawings Dürer began to make late in his career.

The most gifted of Dürer's numerous pupils active in Nuremberg, Hans von Kulmbach, is represented at Coburg by two lovely drawings (cat. nos. 26-27), which are the only life studies preserved from his early period. The use of colored wash in life studies is relatively unusual in German drawing as a whole around 1500, but it is quite typical of Kulmbach's personal style. A drawing also made at Nuremberg shortly after those by Kulmbach, but in a less progressive style, is the *Holy Kinship* by Hans Traut (cat. no. 49). This lively composition is a valuable addition to our fragmentary knowledge of drawing as practiced in that city around the turn of the century by artists not connected with Dürer's workshop. Compared with the drawings being made at this time by Dürer and his pupils, the *Holy Kinship* seems somewhat old fashioned. This may, however, be due to the requirements of a highly traditional commission. An anonymous drawing (cat. no. 47) that also originated in southern Germany, but in the previous generation, is that of a foot soldier, formerly attributed to Mair von Landshut. This life study is a work of high quality, which has consistently been overlooked in the art historical literature. Finally, Hans Holbein the Younger, who was trained in Augsburg and thus also originally belonged to the South German School, is represented at Coburg by a drawing made when he was court painter to King Henry VIII of England (cat. no. 25). Executed in the pen-and-wash technique which the artist preferred for utilitarian work, this sketch is one of his most elaborate and complex designs for jewelry. It is typical of many of his designs in that the expressive beauty of the drawing far surpasses the requirements of a mere model for a goldsmith.

In addition to Nuremberg and southern Germany, the Upper Rhine is abundantly represented in the collection at Coburg by drawings of the highest quality. The most important of these are works by Hans Baldung Grien, Dürer's only follower of truly outstanding talent. Since Baldung entered Dürer's workshop at age 19 as a journeyman rather than as an apprentice, he was not one of Dürer's pupils in the narrow sense. However, he quickly learned the latter's particular modes of drawing in pen, brush, and chalk, while retaining his personal preference for calligraphic line. This characteristic is particularly obvious in Baldung's sketches made from memory rather than from models, such as the *Head of a Bearded Man* (cat. no. 9). The collection at Coburg also owns the largest and most important extant group of Baldung's designs for stained glass, a type of drawing in which he was quite prolific and which was obviously in great demand among the glass painters at Strasbourg for whom he produced the designs. Of the fourteen stained glass designs by Baldung at Coburg, nine have been chosen for the exhibition (cat. nos. 1-7, 11-12). Ranging in date from about 1510 to about 1530, this selection displays an extraordinary richness and variety within the formal constraints of the genre and illustrates Baldung's ever more consistent use of Renaissance decorative motifs.

Another group of stained-glass designs of major importance is that Hans Weiditz, also known as the Petrarch Master. Coburg owns the largest collection of such designs by Weiditz, a total of seven drawings, of which four are included in the exhibition (cat. nos. 52-55). Although this group is much smaller than that by Baldung, it is even more important within Weiditz's oeuvre, since so few other drawings by him have survived. Those at Coburg date from after his return from Augsburg to the Upper Rhine in 1523 and thus all but one are later than those by Baldung. The later date of execution meant that when he created them, Weiditz was able to profit from the greater freedom gradually accorded designers of stained glass by about 1530. The customary collaboration between artist and glass painter had become less common in Strasbourg, and by about 1530 the artist usually executed the entire design himself. This applies to the latest design by Baldung in the exhibition (cat. no. 12) and to the three designs Weiditz created in the 1530s (cat. nos. 53-55).

Three anonymous stained-glass drawings in the exhibition show how profoundly the graphic style of this type of design at Strasbourg was influenced by its two major exponents in that city, Baldung and Weiditz. Whereas the

two roundels with Saints Philip and Peter (cat. nos. 13-14) display a style derived from Baldung, the *Fishing and Boating Party* (cat. no. 46) shows a hybrid style that combines his figural and physiognomic types with Weiditz's pen and wash technique, but with a more abundant use of gray wash and contours applied with the point of the brush.

A final drawing generally attributed to Weiditz, the *Tree of Fools* (cat. no. 51), is by far the most original creation among Weiditz's work in this medium at Coburg. Clearly not a stained-glass design, it may well have been intended as an autonomous work of art. It has the wit and spontaneity of a spur-of-the-moment inspiration and is one of the most amusing commentaries this generation produced on the power women wield over the men who succumb to their attractions. The conflict between the sexes, with the woman usually in the victor's role, was one of the most common satirical themes in the visual arts and popular literature during the late Middle Ages and Renaissance in Germany (Smith 1978).

Another showpiece of the Coburg collection is the *Virgin and Child with a Bird* by Urs Graf (cat. no. 24), the most original artist active in German-speaking Switzerland during the Renaissance. Dated 1513, this chiaroscuro drawing on paper prepared with a reddish brown ground is a particularly fine, early example of the kind of drawings that German artists began to make at this time as independent works of art. Graf's elaborate color scheme of white, pink, and yellow heightening—pigments added to enhance the pen drawing—on the dark ground is a technique that was especially popular in Swabia (Falk 1978: 217-223, nos. 5-7). Its appearance suggests the often intentional similarity of such chiaroscuro drawings to small-format paintings.

Most of the unusually large and rich assortment of Upper Rhenish drawings at Coburg must have once belonged to the Strasbourg collector and occasional artist, Sebald Büheler (1529-1595). Best known as the author of the *Chronicle of Strasbourg*, which he began writing in 1586 (Dacheux 1888: 23ff.), Büheler inherited Baldung's estate through Nicolaus Kremer, Büheler's brother-in-law and a pupil of Baldung active in Strasbourg who had purchased the contents of Baldung's studio from the artist's widow (Wescher 1938: 204ff.). The sequence of inheritance is known from Büheler's own testimony, recorded in a letter he wrote in 1550 to accompany the famous lock of Dürer's hair that was sent to Baldung from Nuremberg after Dürer's death in 1528 (Martin 1950, I: 5, fig. 1). In

addition to the Baldung material he inherited, Büheler succeeded in acquiring other large groups of drawings, some of which were perhaps from other artists' estates.[1] The drawings Büheler once owned have today been dispersed among many collections but can still be identified by the spurious artists' monograms he inscribed on them in his somewhat nervous handwriting, usually along the lower edge of the sheet. On the basis of these monograms, it is known that the drawings at Coburg by Baldung, Dürer, Weiditz, the Master of the Coburg Roundels, and several glass painters with whom Baldung collaborated (Koch 1941: 52, n. 15) once belonged to Büheler's collection.

Büheler was sufficiently familiar with the monograms of Baldung, Dürer, and Schongauer to imitate them with deceptive accuracy, but he was far less knowledgeable in questions of style, and his attributions of the drawings he owned are far from being universally accurate. He added Baldung's monogram not only to all the Baldung drawings at Coburg but also to those by Weiditz (cat. nos. 52-55) and other artists working along the Upper Rhine (cat. nos. 46, 50; fig. 20). He correctly inscribed the early Dürer drawings at Coburg (cat. nos. 17-19, 22) with the appropriate "tossed" monogram,[2] but incorrectly added it as well to the *Crucifixion with the Virgin and Saint John*, a composite sketch by the Master of the Coburg Roundels with later additions by a glass painter of Strasbourg (cat. no. 29). Büheler's attributions grow less plausible in proportion to the amount of time separating him from the artist's period of activity. Büheler's misattribution of all the Weiditz drawings to Baldung is somewhat comprehensible due to their formal similarity. Further off the mark, however, are his attributions of the earliest group in his collection, the drawings by the Master of the Coburg Roundels and his workshop assistants. Büheler designated the master's *Crucifixion*, copied from Schongauer, as a work by Dürer (cat. no. 29), and the *Virgin and Child Enthroned*, copied from Master E.S., as the work of Schongauer himself (cat. no. 39). Büheler's errors, however, should not be taken as reflecting the general historical situation of the connoisseurship of early German drawing during the later 16th century. An instructive comparison is the case of Büheler's contemporary at Basel, the collector Basilius Amerbach (1533-1591), who during the same years made considerably more accurate attributions while compiling inventories of his own collection (Basel 1979: 20).

Büheler's inscriptions on the drawings he owned also demonstrate his interest in heraldry. It is probably not

fortuitous that so large a part of his collection consisted of designs for stained glass bearing the coats of arms of Alsatian nobility. The designs were presumably useful to Büheler in the creation of the armorial albums that he compiled in the 1580s (Martin 1950, 1: 6), and his expertise in this field in turn enabled him to identify the escutcheons shown in the drawings. In addition to the artist's monogram, Büheler inscribed on each design the name of the patron whose arms appear in the drawing. The only exceptions are those on which the family name had already been mentioned in the glass painter's instructions to the artist at the lower edge of the sheet (see cat. nos. 7, 12, 52).

Except for the work of Dürer, all the Coburg drawings for which the Büheler provenance is certain are by artists active in Strasbourg, whose work the collector was presumably able to acquire locally. It is unclear how Büheler came to own the Dürer drawings now in the Coburg collection, of which four bear the Dürer monogram added by the collector (cat. nos. 17-19, 22), one was signed by the artist himself (cat. no. 21), and four (cat. no. 20) bear no monogram (in the case of the chalk portrait of Anton Fugger [cat. no. 23], it was presumably trimmed away). The Dürer drawings inscribed by Büheler are all early works, which could have been brought to Strasbourg by Baldung after his departure from Dürer's studio and which later would have passed with Baldung's estate into Büheler's collection. However, this explanation does not account for Dürer drawings of later date in other collections that also bear the monogram added by Büheler.

Winkler believed that the corpus of drawings by the Master of the Coburg Roundels at Coburg (cat. nos. 28-44) also came into Büheler's possession through Baldung's estate and deduced from the fact of Baldung's ownership that the Coburg Master may have been Baldung's teacher, the pupil having inherited the teacher's work (Winkler 1930: 146). On stylistic grounds, this is very unlikely. Winkler's view was based primarily on a misattribution (see cat. no. 29) and must be rejected, since it is quite evident that Büheler owned drawings from sources other than Baldung's estate. The Weiditz drawings, for example, must have been acquired from a different source. The existence of the large group of drawings by the Master of the Coburg Roundels in Büheler's collection does not justify an association with Baldung, as Winkler proposed, but it does buttress the more recent scholarly opinion that the master's place of activity was indeed Strasbourg rather than the Middle Rhine (see "Excursus: The Master of the Coburg Roundels," pp. 388-393).

The Coburg collection possesses the largest extant group of drawings by the Master of the Coburg Roundels, including the two roundels from which the master derives his name (cat. nos. 28, 43). These two designs for stained glass are the showpieces of the largest and most varied surviving corpus of drawings by a German artist of the 15th century.[3] The drawings are of eminent historical interest, since they offer valuable insights regarding late medieval artistic practice. Most of them are still studies in the medieval sense, made to provide an artist with aids for his work, rather than images created for their own sake. Executed exclusively with pen and ink, they are for the most part rapidly sketched records of works by other artists. The master employed them as models and as potential inspiration for his own work. He chose his sources with great discrimination from among the best works of art created in Germany and the Netherlands during the 15th century, including paintings, stained glass, engravings (cat. no. 40), sculpture (cat. no. 36), and perhaps murals (cat. nos. 30-31), by artists such as Roger van der Weyden (van Gelder 1966: fig. 15), Dirk Bouts (cat. no. 38), Albert van Ouwater (Rotterdam 1974; no. 7), Peter Hemmel von Andlau, the Master of the Karlsruhe Passion, Martin Schongauer (cat. no. 29; Naumann 1935: figs. 78-79, 115-118), Master E. S. (cat. nos. 39-40; Naumann 1935: figs. 20-21; Los Angeles 1976: no. 168; Berlin 1921: pl. 100, no. 4618), and the Master of the Banderoles (Parker 1928: pl. 17). In some cases, the master's drawings are the only, or most faithful, surviving records of lost compositions, as for instance Roger van der Weyden's images of Justice, formerly in the Town Hall of Brussels (see cat. no. 34), or the Boutsian version of Hugo van der Goes' famous *Virgin and Child* (cat. no. 38) at Pavia (Museo Civico). Copies after foreign prototypes are only one aspect of the master's work, however. The Coburg collection owns a number of drawings showing the master's own inventions, such as the lovely studies of drapery (cat. nos. 34-35), presumably created as preparatory drawings for paintings, and his designs for stained glass (cat. nos. 28, 43), very few of which have survived. The corpus of the master's drawings has grown considerably since Buchner first attempted to define his style in 1927, but a critical reassessment of attribution problems requires that some drawings be omitted from the oeuvre and others added.

The series of drawings that comprise the Saxon *Tournament Book* (cat. no. 16) are totally different in technique, purpose, place of origin, and time of execution from the Coburg Master's sketches and illustrate a regional style

quite at variance with the Upper Rhenish drawings just discussed. The book is a particularly sumptuous example of a type of illustration (see cat. no. 124; Lüdecke 1953: fig. 152) commonly made in Saxony to record all manner of activities at court. The substantial number of similar commemorative books made in different parts of the German empire and their elaborate decoration in many colors including silver and gold reflect the great prestige inherent in the events they illustrate.

Techniques and Functions of Drawing

This exhibition offers a representative sampling of the media artists in the German-speaking countries used in their drawings during the late Middle Ages and the Renaissance. Pre-eminent among these is pen and ink drawing, the most frequently employed technique, due to its unrivaled flexibility. All but four of the exhibited drawings (cat. nos. 3, 23, 26-27) were executed with pen, some in combination with other media. With the more or less finely cut point of this instrument, an artist could achieve an extraordinary range of effects, from an extreme delicacy of line to the most striking chiaroscuro contrasts. The exclusively linear quality of pen drawing—in contrast to the more tonal, painterly effect of chalk or wash—renders it the quintessential medium of the draftsman. It was precisely this emphatic linearity that suited the aesthetic of Schongauer, Dürer, and their contemporaries so well. The pen was the ideal instrument for creating linear patterns with strong contrasts between the dark color of the ink and the light paper. The inks used at this time were made either from chimney soot, resulting in a black or brown ink that became somewhat lighter in time, or lampblack, producing what is usually called India ink, a deep black ink that turns gray when diluted (see cat. no. 18).

Pen drawing was also the preferred medium of the age because it could be combined easily with other media. The most common of these combined techniques was pen and wash, in which an area of diluted ink was applied with a brush over contours sketched with a pen. The pen lines provided the outlines and the wash rendered the contours of the three-dimensional forms. The illusionistic effect thus achieved was customarily used for preliminary studies for painting (cat. no. 47), for copies from painting or sculpture (cat. no. 36), and for designs to be executed by goldsmiths (cat. no. 25) or glass painters (cat. no. 12). The pen-and-wash technique remained closely linked with particular workshop functions which it performed so well. In fact, the practical uses artists associated with this type of drawing may be in part responsible for its infrequent use in creating finished drawings intended as autonomous works of art. Such a subsidiary status, however, was not necessarily an inherent aesthetic limitation, as the virtuoso pen-and-wash achievements of Holbein the Younger demonstrate. Pen and wash had been the most common medium employed in his father's workshop at Augsburg, where it was used in a rather dry and impersonal manner befitting its utilitarian function in a painter's studio (Basel 1979: pls. 43-47). By contrast, in Holbein the Younger's sketches for jewelry, metalwork, and stained glass, this medium was used with a vivacity unparalleled in his century (cat. no. 25).

After about 1520, pen and wash became the most common technique employed in making designs for stained glass. It possessed the dual capacity to organize and clarify the composition and to indicate chiaroscuro values. This type of drawing attained its artistic perfection in the generation of Baldung and Weiditz. Their designs at Coburg, as well as those of two followers, provide an overview of the development of stained-glass design as practiced in Strasbourg between about 1510 and 1532 (cat. nos. 1-7, 11-14, 46, 52-55). Work of the generation active there prior to the turn of the 16th century is exemplified by three designs by the Master of the Coburg Roundels (cat. nos. 28, 43-44), of which only the latest in date displays the use of wash.

The stained-glass designs by Baldung, Weiditz, and the Coburg Master were not intended for large church windows, but rather for small, secular glass panels. These so-called *Kabinettscheiben* (cabinet pieces) decorated civic halls, guild chambers, and private dwellings and were usually gifts from the person or organization whose arms appear in the stained-glass panel. Mostly rectangular in format, the panels were traditionally divided into a central image with a coat of arms supported by a heraldic figure and a second, smaller scene located above an architectural or arbor-like frame. Thanks to their secular purpose and often secular subject matter, they were not endangered by the iconoclast tendencies of the Reformation. In fact, like the graphic arts, stained glass thrived as a result of the reduction of images in other sectors; it was particularly popular in the Protestant areas of Germany and Switzerland.

Designs for stained glass during the period prior to about 1530 were generally produced on a collaborative basis by an artist and a glass painter. The rules of the glass painters' guild at Freiburg im Breisgau, dated 1484, specifically

stipulate that designs had to be made by the artist according to the glass painter's instructions, and the same procedure is described in a book on the subject published in 1519 (Perseke 1941: 95-96). What this actually meant was that the glass painter determined how the panel should look in consultation with the patron, while the artist was responsible for executing the figural and architectural parts of the design. The artist usually received from the glass painter a sheet on which the design was to be sketched, already prepared with the coat of arms (cat. no. 7), although occasionally the sequence was reversed (cat. no. 2). Sometimes the architectural division between the two parts of the image was also lightly indicated with pen or black chalk (cat. no. 5). Often the glass painter's instructions were inscribed along the lower edge of the sheet (cat. nos. 5-7, 52), and where they do not appear, they were presumably given orally (or in some cases trimmed off). Other practical requirements resulting from this type of collaborative work can be observed in the artist's occasional decision to offer various options[4] to the glass painter, as for example in the different length of the sun's rays around Baldung's *Virgin and Child* (cat. no. 3). The glass painter in turn did not hesitate to make corrections in the design he received, as can be seen in the red chalk lines added to indicate the location of the leading along the wreath in Baldung's Bärenfels design (cat. no. 11). Up to four stages of work were required to complete more complex designs (cat. no. 6), of which the last stage prior to the drawing's execution in glass was always the application by the glass painter of red chalk contours for leading. In assessing the evolution of a given design, the parts carried out by the glass painter and by the artist can usually be easily distinguished by the difference in style.

These drawings were valued by stained-glass painters primarily for their utility, not as works of art as they are regarded today. This attitude is clearly reflected in their appearance and in their subsequent fate. For example, it was customary for the artist to omit repetitive parts of the image. In sketching the architectural frame, one column was drawn in great detail, while the other was commonly left as a mere contour (cat. no. 6). There was no necessity to execute more fully a second column that was no more than a mirror image of the first. Furthermore, once such a design had taken its place among a glass painter's workshop materials, it was often reused. Baldung's Bärenfels design (cat. no. 11), for instance, still displays bits of paper pasted above the coat of arms, which are presumably the remains of additional sheets bearing different

escutcheons. These must have been temporarily fastened over the Bärenfels arms so that a glass painter could reuse Baldungs' design to produce another stained-glass panel from it, one with a different heraldic motif for a different patron. In other cases, parts of a design were trimmed off for reuse in another design, as perhaps happened in the Bärenfels design, or they were traced onto a new design from the old one. For example, tracings after the heraldic figures in Baldung's Uttenheim and Wittelshausen designs (cat. nos. 4, 12) are preserved in Vienna (Graphische Sammlung Albertina) and Berlin (Kupferstichkabinett) (Koch 1941: pl. A23, figs. II-III).

The utilitarian nature of designs for stained glass is also evident in the minimal care taken by the glass painter in determining the outlines of the design and in making corrections. In Baldung's design for a saddler (cat. no. 1), the glass painter laid down the thick round contours with so little attention to symmetry that they had to be "erased" with lead white and redrawn. In Baldung's Ziegler design (cat. no. 7), the glass painter had to apply lead white over an error in the lower right quadrant of the coat of arms. The attempts at correction are more obvious today than when they were carried out, since the layer of lead white has worn off, revealing the pen lines below it. In Baldung's Prechter design, however (cat. no. 5), the misplaced lines were simply crossed out in an effort to correct the perspective of the shield. Such careless attempts at erasure differ radically from those employed in drawings valued as works of art in their own right, such as Dürer's *Portrait of Anton Fugger* (cat. no. 23), which shows how carefully the artist scratched away the chalk lines before redrawing the sitter's left eye.

In addition to stained-glass panels of rectangular format, round ones were also quite common in Germany and Switzerland during this period, and the Coburg collection owns several important designs made for this type of glass painting. In particular, the round type with four images grouped in a quatrefoil around a central heraldic shield is represented in the exhibition by Baldung's superb design for a saddler (cat. no. 1), one of the most charming examples of this genre. Although mostly given over to secular subjects, the roundel ultimately derives its form from a religious precedent, the stained-glass windows in Gothic churches. The Housebook Master is generally credited with the invention of the roundel inscribed with a quatrefoil in about 1480, and by 1530, the fashion had died out. Its popularity in Nuremberg around 1510, the approximate date of Baldung's drawing, is attested to

by a series of designs of identical configuration and similar subject made by his contemporaries in Dürer's workshop, Hans von Kulmbach and Hans Schäufelein. The glass panels made from them, attributed to Veit Hirsvogel, show approximately how a roundel made from Baldung's drawing at Coburg would have looked (Winkler 1941: figs. 1, 5-6).

The stained-glass panel with a quatrefoil inscribed in a roundel gradually gave way to undivided roundels, usually executed in grisaille, which called for a more linear style. This is presumably the reason why Jörg Breu, a major exponent of this type, used only pen and ink, without wash, in his designs (cat. no. 15). Since the circular compositions were not subdivided with leading, as they did not require different colors of glass, there are no distracting red or black chalk lines delineating the leading in Breu's drawings. Fortunately, a number of stained-glass roundels made from his designs have been preserved (Schmitz 1923: figs. 40-45; Witzleben 1977: figs. 155-156, 159-163).

Another variant of pen drawing is the use of pen with watercolor. This technique was occasionally applied in stained-glass designs in which the watercolor took the place of written color notations indicating the hues in which the glass panel was to be executed (cat. no. 55). Since the application of colored wash renders a drawing visually more "presentable," such colored designs may have been made as presentation drawings to be submitted to patrons. Drawings in pen and watercolor often have a certain visual affinity with manuscript illumination, especially when body color (opaque pigment as opposed to transparent wash) is also used, and this similarity was consciously exploited to create particularly lavish drawings intended as autonomous works of art for an aristocratic public. The *Tournament Book* made for the Duke of Saxony (cat. no. 16) is a fine example of this type of work.

Compared with pen drawing, sketches made with the point of a brush are relatively rare in German art during this period. According to how it is used, the brush can produce both very fine lines and broader, softer ones. Artists employed brush drawing for studies from nature, such as the two early works by Kulmbach (cat. nos. 26-27), and sometimes for virtuoso exercises in drawings that could just as well have been executed with a pen. Baldung's *Stained-Glass Design with the Virgin and Child* (cat. no. 3) is a lovely example of the latter category. Occasionally, the brush was wielded with such delicacy that the very fine lines produced in this manner become difficult to distinguish from pen lines (cat. no. 47).

Whereas a broad, painterly effect could be easily achieved with a brush, German artists did not often exploit this option. For this kind of work, chalk was preferred. This medium has a vigorous, expressive quality; its rough, broad line generally requires larger formats than are necessary for pen or brush drawings. The soft modeling produced by black chalk was considered ideal for portraiture. Dürer was the first to explore the use of chalk and charcoal for autonomous portrait drawings, of which a characteristic example is that of Anton Fugger (cat. no. 23). Black chalk was also a convenient medium for underdrawing, because it could be rapidly and lightly applied and erased with relative ease (cat. no. 8). Red chalk, however, appears in the exhibited drawings only as a practical, highly visible means of delineating the leading on designs for stained glass (cat. nos. 2-7, 11-12).

A drawing's effect is, of course, determined not only by the draftsman's choice of instrument but also by the choice of support. Among the most sumptuous works of this period are the chiaroscuro drawings sketched on paper on which a colored ground, or coating, had first been applied (cat. no. 48). This practice had its origins in the mid-15th century, when a light, watercolor-like wash was sometimes used under pen drawings (cat. no. 35). Around 1500, an opaque ground employing darker colors came into use. The dark color of the ink on the medium tone of the ground was balanced against white highlights, generally applied with the point of the brush. In his *Virgin and Child with a Bird* (cat. no. 24), Urs Graf used not only the customary heightening in lead white but also pink and yellow. By 1513, when Graf created this unusually lavish work, chiaroscuro drawings had achieved the status of independent works of art, valued no longer for their practical utility as preparatory studies but rather for their intrinsic artistic merit.

NOTES

1. Purchasing an entire estate soon after an artist's death was an effective method of acquiring a large number of works by a single artist and was a well-known practice both in Italy and in the North. See Basel 1979: 15-18.

2. On Dürer's so-called "tossed" monogram, see Oehler 1959: 57ff. The present author does not share Oehler's views.

3. A comparable but smaller group are the drawings in Basel by Hans Holbein the Elder and members of his workshop. See Basel 1979: nos. 145-232.

4. This writer does not concur with Koch's assertion that whenever Baldung drew two different columns in his designs, they were intended as options from which the glass painter could choose. See Koch 1941: 58, n. 26.

Hans Baldung Grien

1484/85 Schwäbisch-Gmünd—Strasbourg 1545

Along with Hans Holbein the Younger, Hans Baldung Grien is one of the most important German artists of the generation after Dürer. Active primarily in Strasbourg as a painter, engraver, and designer of woodcuts and stained glass, Baldung was the first German Renaissance artist to choose his profession freely rather than to adopt it because it was his family's trade. He was born into a family of physicians, lawyers, and scholars whose learning and social connections had a significant impact on his career. Neither the location of Baldung's early training nor the identity of his teacher is known. Of far greater importance for his development were the years (1503-07) he spent as a journeyman in Dürer's workshop, although by the time he arrived in Nuremberg, he was already an artist of considerable capabilities, as is evident in his youthful self-portrait (Oettinger/Knappe 1963: frontispiece). In 1505-06 Dürer even left the shop in Baldung's care during his second trip to Venice. Baldung may have been given his nickname Grien, or Green, while a member of Dürer's shop, perhaps referring to his favorite color and perhaps to distinguish him from several other artists named Hans, including Dürer's younger brother, Hans Schäufelein, and Hans von Kulmbach (see cat. nos. 26-27). In any case, it soon became an accepted part of his name, and he in-corporated it into his monogram (Washington/New Haven 1981:6).

Baldung's earliest major commissions were two altar-pieces made about 1507 for churches in Halle (Saxony). By 1510, Baldung had married, acquired citizenship, and established his workshop in Strasbourg. Awarded the prestigious commission to paint the high altarpiece for Freiburg Cathedral, he spent five years (1512-17) of intense productivity in that city. In 1517 he returned to Strasbourg, where he remained until his death. For almost 30 years, he continued to receive commissions from the local nobility and clergy, occasionally working for patrons in other cities as well. The *Baptism of Christ*, for example, a major altarpiece of about 1520, was executed for the Dominican church at Frankfurt.

Baldung's work is especially noteworthy for its innovative, highly subjective, and dramatic treatment of secular and allegorical subjects. His illustrations of the power of women, of the transitoriness of feminine beauty, of themes of love and death, and of superstition and the demonic are among the most powerful creations in Northern European art.

1

Stained-Glass Design for a Saddler, c. 1510

Pen in black ink with red chalk and lead white, 271 x 278 mm

Watermark: Bull's head with serpent and cross (similar to Briquet 15445 and Piccard 1966, III: sect. XVI, no. 75)

Trimmed at top and bottom edges; horizontal and vertical creases along center; tiny holes from point of compass at center of left roundel and middle shield; extraneous spots at upper and lower left; slight foxing

Monogram added in dark brown ink by Sebald Büheler, recto, lower right: *HBG*

VC: Inv. no. Z 14

References: Térey 1894-96: no. 142; Stiassny 1896: 36, no. 24; Schmitz 1913, I: 156, fig. 259; Koch 1941: no. 73; Winkler 1941: 245-246; Munich 1947; no. 187; Washington 1955: no. 30; Karlsruhe 1959: no. 223, fig. 40; Coburg 1970: no. 9, fig. 7; Witzleben 1977: 42, fig. 13

This early stained-glass design illustrating the work of saddlers must have been commissioned by a practitioner of the craft, whose coat of arms would have been added later by the glass painter in the empty central shield of the glass panel executed from this design. Stiassny has pointed out that the design was not made for a guild, as stained-glass panels depicting a particular craft generally were, but rather for an individual, since saddlers did not have their own guild. In Strasbourg, where this design was presumably made, as in most other German cities at this time, they belonged to the tanners' guild.

The activities and products of saddlers are summarized here by Baldung in four lively and succinct illustrations. In the roundel below the shield, two artisans surrounded by the materials and utensils of their trade are at work in their shop. One hammers soft leather over a wooden armature, while his companion applies a coat of glue or paint. (Saddles were normally painted and often gilded.) Scattered in the foreground are bits of wool used as padding, a thin leather strap resembling reins, a knife, and a small ax with a round blade (the latter was evidently a basic tool of this craft, which it symbolizes in a Belgian seal of the leather workers at St. Trond in 1481 [Bravo 1964: fig. 58]). Baldung's other three roundels illustrate the saddle makers' products being put to use: the finished saddle, reins, and collar are placed on the horse, which in the left roundel is yoked to an unseen wagon.

It is instructive to compare Baldung's fine pen work in the roundels with the sloppy outlines of the quatrefoil. Although

the glass painter used a compass, which left a hole still clearly visible in the center of the sheet, he laid these outlines down with so little attention to symmetry that he had to apply white body color over the offending contours of all four roundels and then make the necessary adjustments. With the passing of time, the white has worn off, rendering the "erased" contours visible again. The triangular areas between roundels and the circular band around the edge, which were left empty on the sheet, were customarily filled in by the painter from a standard repertory of floral or abstract decorative motifs, as surviving glass panels made from similar designs testify. (If

such a panel was ever executed from this sheet, it has evidently not survived.)

The Coburg drawing can be dated on the basis of its stylistic affinities with Baldung's design for the title-page woodcut (Mende 1978: fig. 318) for an edition of Till Eulenspiegel's pranks *(Ein kurtzweilig lesen von Dyl Vlenspiegel. . . .* [Strasbourg, 1515]) and with his engraving *Groom Bridling a Horse* (Washington/New Haven 1981: no. 34)—both of which have been convincingly dated about 1510. Thus the Coburg sketch was probably made soon after Baldung settled in Strasbourg.

2

Stained-Glass Design with the Arms of Wilhelm von Honstein, c. 1511

Pen in brown ink over black chalk with light and dark brown wash and red chalk, 292 x 211 mm

Small holes near base of right column and at bottom right of coat of arms; extraneous spots in upper left and right corners; foxing at lower left

Monogram added and coat of arms identified in dark brown ink by Sebald Büheler, recto, lower center: *Hundtsteÿnn, HBG*

Color notations added by glass painter: upper left, *blo*; at antlers, *w[eiss], rott*; in checkerboard of arms, *w[eiss], r[ott]*; on tile below arms, *w[eiss]*

Blind collection stamp of 1840s at lower right

VC: Inv. no. Z 25

References: Térey 1894-96; no. 152; Stiassny 1896: no. 15, pl. IV; Koch 1941: no. 76; Karlsruhe 1959: no. 226; von Tavel 1978: 229-230, fig. 13

Among Baldung's most delightful inventions are the frolicking, vivacious music-making putti that were so important a part of the new decorative vocabulary of the Renaissance. They lend a whimsical charm to many of Baldung's early compositions, while in his late works they appear mannered and coy. The putti in the upper area of this stained-glass design are certainly its most fascinating component and, in addition to the columns and arch that support them, are the only part Baldung executed himself. The nervous, schematic handling of the domesticated lions and of the surrounding foliage indicates that the entire heraldic portion was added in the glass painter's studio. Since the contours of the lions and foliage carefully respect those of the columns, Baldung's architectural frame and its lively inhabitants must have been executed first.

Baldung's drawing can be reliably dated around 1511 on the basis of stylistic analogies to his early woodcut book illustrations, whose dates of publication are known. A striking similarity is evident, for example, in the putti playing among the boughs of two trees in the title-page woodcut of Poggio Bracciolini's *Historiae convivalis disceptativae* of 1511 (Mende 1978: no. 402). Stylistically analogous and equally captivating are the winged putti who, as in the Coburg sketch, play the drum and lute in the *Virgin and Child in a Landscape,* a single-sheet woodcut of about 1511 (Mende 1978: no. 20).

Wilhelm, Count of Honstein, who commissioned the stained-glass panel, was consecrated Bishop of Strasbourg by Duke Ernst of Saxony, Archbishop of Magdeburg, in the presence of Emperor Maximilian and a multitude of aristocratic and ecclesiastical dignitaries in Strasbourg Cathedral in 1507. It was an event of great political import, since the consecration—usually performed by a German archbishop in his home cathedral—had not been held in Strasbourg for over 200 years. (Honstein's ecclesiastical rank is indicated in Baldung's design by the two diagonal stripes on a brown background in the upper left quadrant of the shield; these are the arms of the bishopric of Strasbourg.) Honstein's term of office was fraught with difficulties created by the upheavals of the Reformation. As bishop, Honstein was associated with two publishing projects for which Baldung designed the title-page woodcuts. Honstein's coat of arms surmounted by a bishop's mitre appears next to the Virgin and Child on the frontispiece of the *Strasbourg Breviary* of 1511 (Mende 1978: no. 405), and on the title page of the *Missal of the Strasbourg Diocese,* published in 1520, Honstein himself is represented kneeling in his bishop's garb, flanked by his coat of arms (Mende 1978: no. 435; see Habich 1929-34, I/2: fig. 5a; Térey 1894-96: no. 122).

3

Stained-Glass Design with the Virgin and Child, c. 1511

Point of the brush in grayish brown ink over black chalk with red chalk, border in pen and brown ink, 319 x 237 mm (largest dimensions)

Watermark: High crown (similar to Briquet 4952)

Central fragment of larger sheet, trimmed on all sides; horizontal center fold and crease across Virgin's knees; stain at upper left

Monogram added in dark brown ink by Sebald Büheler, recto, lower right: *HBG*

VC: Inv. no. Z 5

References: Térey 1894-96: no. 105; Stiassny 1895: col. 327; Koch 1941: no. 77; Munich 1947: no. 188

This early stained-glass design by Baldung shows the Virgin on the Crescent Moon, an iconographic type developed from the Apocalyptic Woman described in Revelation 12:1-16 (see cat. no. 129). Surrounded by the rays of the sun, she wears a crown with twelve stars (five of which are visible). The Virgin in this visionary role was one of the most popular devotional images of the 15th and 16th centuries and one that Baldung used in almost every medium he employed.

This drawing is the only surviving stained-glass design that Baldung executed with the point of the brush—an unusual technique that he may well have learned from Dürer (Winkler 1936-39: no. 241; see cat. nos. 26-27). The soft touch of the brush lends the composition a subdued, poetic quality appropriate to its theme. The sketch is typical of Baldung's early style, as can be seen in the Virgin's physiognomy, especially the deep-set eyes with rounded, heavy lids, the thin lines of the eyebrows connected to a narrow, straight nose, and the small rounded chin (see Washington/New Haven 1981: ill. 21a). The plasticity suggested by the bold, angular folds of the Virgin's drapery is mitigated somewhat by the flat, parallel hatching. The sword-like rays that emanate from the figure were delineated with the aid of a straightedge and are longer on the left than on the right. This disparity was presumably intended to offer two options to the glass painter, who, after choosing one or the other, would have executed the rays in uniform length on the glass panel. However, no panel made from this design is known.

The Coburg drawing is a fragment, presumably the central part of a larger design, whose corners have been trimmed. Its original appearance cannot be reconstructed with certainty. Surviving stained-glass panels and designs of this subject preserved intact show the Virgin and Child surmounted by angels and, in some cases, adored by a kneeling donor or accompanied by a saint. In each of two such stained-glass designs that Baldung executed about 1520 (Koch 1941: nos. 145-146), the Virgin and Child appear, as here, in a mandorla, flanked by the figure of a saint that overlaps the edges of the mandorla. Since on the Coburg sheet no trace of a subsidiary figure is visible, and since the Virgin's full attention is focused on the Child, the composition seems self-contained and it would appear unlikely that it once included either a saint or a donor figure. However, a recently published stained-glass panel in the church at Kirchberg, near Bern, believed to be based on a lost design by Baldung (von Tavel 1978: fig. 5), shows the Virgin and Child standing inside an architectural frame, surmounted by putti playing instruments. Likewise, musical angels appear above the Virgin in Baldung's two designs of 1520. Thus, the Coburg Virgin may once also have been surrounded by angels, a motif well suited to the central theme. These all-purpose decorative figures could have subsequently been trimmed away for re-use in a new composition. Indeed, several such fragments with figures of putti, cut from a round rather than oval central composition, are known in Baldung's oeuvre (Koch 1941: nos. 154-155).

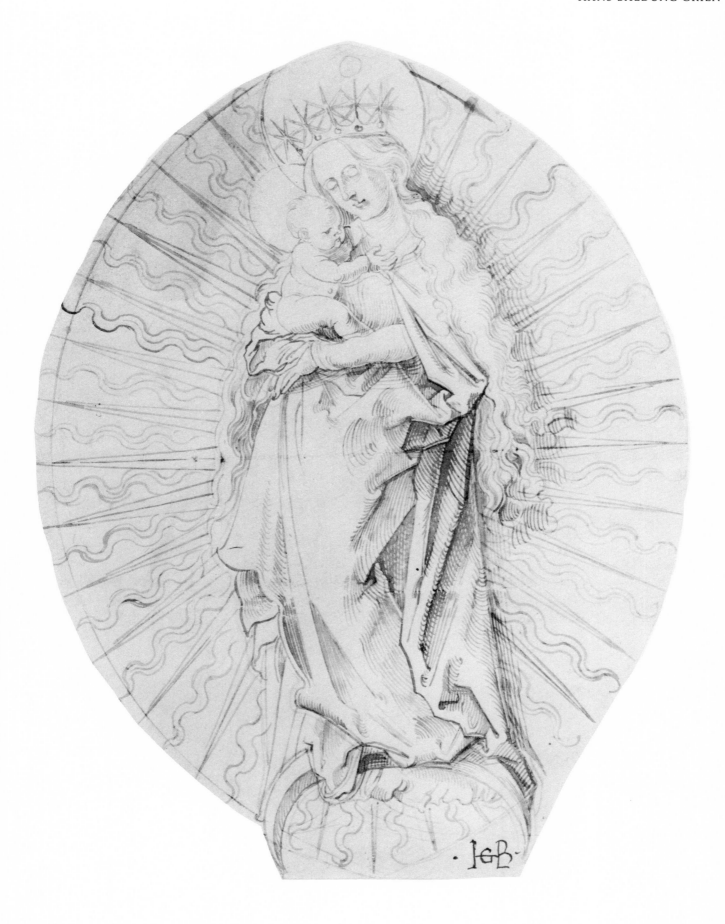

4

Stained-Glass Design with the Uttenheim Arms, c. 1511

Pen in brown ink over black chalk with red chalk, 263 x
186 mm (largest dimensions)

Fragment of larger sheet, trimmed on all sides; small hole
above head of man; extraneous spots on head of man and
lower edge of shield; light foxing at upper right and bottom
edge

Monogram added and coat of arms identified in dark brown
ink by Sebald Büheler, recto, lower center: *Uttenheim, HBG*

Color notations in red chalk: on skirt, *r[ott]*; lower right
corner, ♧ (green)

Blind collection stamp of 1840s at lower right

VC: Inv. no. Z 60

References: Térey 1894-96: no. 135; Stiassny 1896: no. 31,
pl. IX; Koch 1941: no. 78; Möhle 1941/42: 217; Karlsruhe
1959: no. 229; Coburg 1970: no. 10, fig. 8

This fragment of a larger composition is the most amusing of
Baldung's drawings for stained glass. The artist has deftly
exploited the humorous potential of the Uttenheim heraldry,
which calls for a head biting into a helmet. By bringing the
heraldic device to life, Baldung has set the stage for a witty
interchange between the curious head and the lovely young
woman who contemplates her disembodied companion with
bemused sympathy.

To enliven heraldic formulas, which could easily become dull
and repetitive, Baldung often established a rapport between
the figures (see cat. no. 12). His humorous approach to such
themes is rooted in a late 15th-century tradition. In a manu-
script illumination of 1493, for example, a droll heraldic figure
in the guise of a wild woman feeds a flower to a goat's head
surmounting the crest of a rector of the University of Basel
(Ganz 1905: pl. 46). Similarly, some of the most amusing
inventions of the Housebook Master are to be found among
his heraldic prints (see cat. no. 173). The success of Baldung's
lighthearted approach can be fully appreciated by comparing
this drawing with another stained-glass design bearing the
Uttenheim arms, dated 1531 and attributed to Hans Weiditz
(Buchner 1924: fig. 13), in which the head biting into the
helmet looks merely outlandish, not funny.

Baldung's drawing preserves only the central part of what
must have been a larger design, including an architectural

frame and presumably some subsidiary image above it, as was
the standard arrangement (see cat. nos. 5-7, 11-12). The pres-
ent drawing is one of a few surviving examples in which Bal-
dung executed both the heraldic figure and the coat of arms
himself (see cat. no. 12). Only when Baldung was free to create
all parts of the composition himself could he achieve the
whimsical humor and psychological interrelationships that
constitute the special charm of this drawing. In this instance,
the glass painter merely indicated the general location of the
shield—note the short, dark brown contour below the shield to
the left. Although Baldung omitted the foliage that custo-
marily surrounds the helmet, the head's abundant curly hair
and the exuberant ostrich feathers adorning the woman's hat
achieve a similar effect. Her lavish attire and jewelry, as well
as her bemused expression, recall his small woodcut *Salome*,
which has been convincingly dated to about 1511/12 (Wash-
ington/New Haven 1981: no. 27), thereby suggesting a similar
date for the Coburg drawing. A reversed copy of this drawing
exists at the Albertina in Vienna (Koch 1941: no. A 23 II).

The patron for whom this design was executed cannot be iden-
tified with certainty, but it has been plausibly proposed that it
may have been Heinrich von Uttenheim, who in 1507 par-
ticipated in the triumphal entry of Wilhelm von Honstein into
Strasbourg on the occasion of the latter's consecration as
bishop of that city (see cat. no. 2).

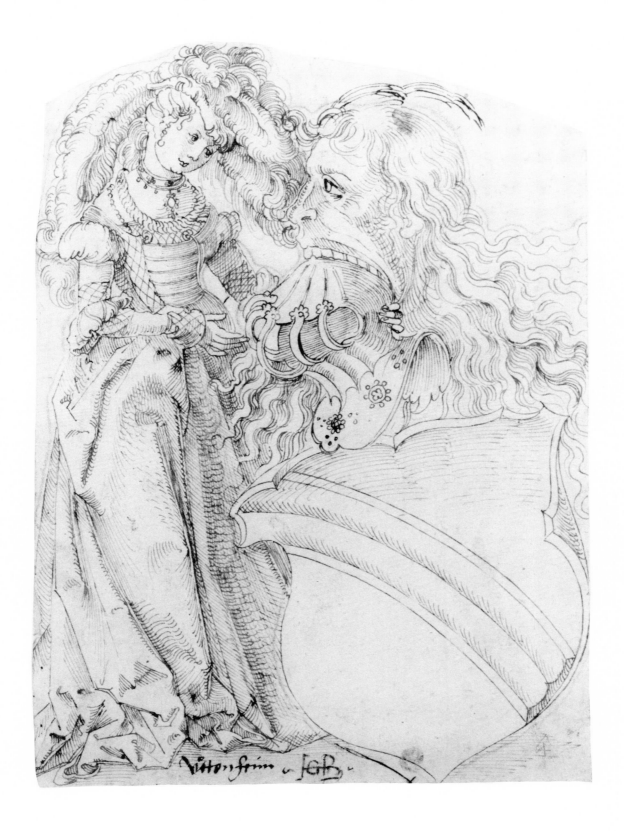

5

Stained-Glass Design with the Prechter Arms, c. 1512

Central image: Pen in dark gray ink, crest in brown ink, with red chalk, 258 x 151 mm (largest dimensions)

Frame: Pen in gray and black ink, 162 x 220 mm

Shafts of columns trimmed away at left and right; frame trimmed at top, left, and right; small hole at center of shield's upper edge; slight extraneous spots at top

Monogram added and coat of arms identified in dark brown ink by Sebald Büheler, recto: lower left, *HBG*; lower center, *Brechter*

Inscribed by glass painter at bottom: *In dyss eyn wybly mit einem büsch und eyn frenckyschen rock an haben/ In das*

gehuss etwas von bülschafft . . . hierauss sehen, followed by a sketch of the heraldic figure's head

Color notations in red chalk: under the word *Brechter*, (green); left above foliage of arms, *b[lo]*; on woman's skirt, *r* (?)

Blind collection stamp of 1840s below heraldic figure's foot

VC: Inv. no. Z 49 (central image) and Z 32 (frame)

References: Térey 1894-96: no. 113; Stiassny 1896: no. 25, pl. VIII; Koch 1941: no. 79; Möhle 1941/42: 217; Munich 1947: no. 189; Karlsruhe 1959: no. 230; Coburg 1970: no. 11, fig. 9; Witzleben 1977: 46

Among Baldung's stained-glass designs, this is his earliest use of secular imagery, which later came to play such an important role in his oeuvre. The upper part of the drawing illustrates two groups of lovers enjoying their wine and the outdoors. The young woman in the upper right foreground raises a glass to her lips, while other wine vessels occupy the space between the two groups of figures. The beverage has more than passing significance in this context, since in 16th-century Germany an offer of wine was understood as an amorous invitation. In popular parlance the expression "drinking the cool wine together" referred to love-making. Although this drawing has received considerable scholarly attention, it has never been noted that Baldung appears to be making a moralistic distinction between the couples. The matron's bonnet worn by the woman seated at the left shows that she is married, while the uncovered hair of the young women at the right indicates that they are not. Baldung thus differentiates between the amusements of unattached women in the legitimate pursuit of spouses and the apparently adulterous activity of a married woman, whose folly is revealed by the presence of a fool who seems to be encouraging the adulterers. Normally a comic character, the fool was first employed in a moralizing context in Sebastian Brant's satirical treatise *The Ship of Fools* (see p. 31). In Baldung's sketch, the fool both promotes the couple's philandering and draws attention to their folly, implying that they will come to a bad end.

The upper and lower parts of this drawing, probably cut apart by the glass painter who once owned it and formerly mounted separately at Coburg, were recognized as parts of the same composition by Stiassny and Térey. The tips of the armorial wings and their red chalk lines for leading, which overlap the present division between the sheets, provide compelling evidence for this reconstruction. Even with these parts reassembled, however, the composition has not survived intact, since the missing column shafts at the lower left and right edges have evidently not been preserved. The fragments of leaves visible near the lower edges of the central sheet suggest that the bases might once have resembled the one surrounded by vine leaves in the Eberstein and Sonnenberg design (cat. no. 6).

The missing columns may have been purposefully removed. Cutting stained-glass designs apart was a common practice of glass painters in Baldung's day, which enabled the constituent parts to be reused when inserted into a new composition.

Baldung received the sheet bearing the glass painter's indications in brown ink for the coat of arms and the single contour of the arch, along with two lines of instructions stipulating an image of lovers at the top. But since nothing further is specified, it may be assumed that the distinction made between the two groups and the addition of the fool were Baldung's inventions. As for the rest of the design, the glass painter's instructions called for a figure supporting the arms, who was to wear Franconian costume and a feathered beret, and to stand facing right. Instead of following the glass painter's instructions regarding the headdress, however, Baldung, using gray ink, adorned her more simply in a matron's bonnet. Why the feathered beret, which the artist did use in the Uttenheim design (cat. no. 4), was omitted here is unclear. Certainly the simpler bonnet achieves a more coherent effect next to the abundance of feathers and foliage. The glass painter's small sketch of a face and the adjacent words, *hierauss sehen* (facing out here), at the lower right corner determined the orientation of the standing figure, whose attention is directed out of the picture. This highly unusual pose suggests that the design may originally have been conceived as one of a facing pair. If a pendant by Baldung did exist, however, it has evidently not survived.

The Prechters (old German: Brechter) were a family of merchants from Hagenau in Alsace, who resided in Strasbourg during the last quarter of the 15th century. Perhaps this design was made for Friedrich Prechter, who purchased citizenship in Strasbourg in 1485, served as a judge in Hagenau, and died in 1528. An unfinished drawing in Vienna by a Strasbourg glass painter (Térey 1894-96: no. 235), inscribed with the name of Friedrich Prechter the Younger, may have been made for the same patron. The association of the Coburg design with Friedrich Prechter, however, remains conjectural.

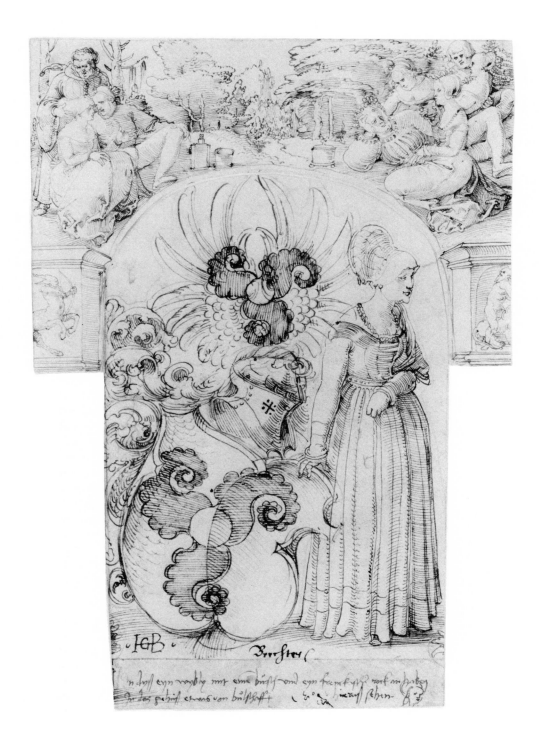

6

Stained-Glass Design with the Arms of Bernhard von Eberstein and Kunigunde von Sonnenberg, c. 1515

Pen in brown and black ink with gray and grayish brown wash and red chalk over black chalk, 396 x 310 mm

Watermark: High crown (similar to Briquet 4956)

Trimmed on all four sides; horizontal crease along center; repaired hole under Baldung's monogram; two tiny holes in shield and center of arched boughs; hole and tear at lower right corner; tear at center of right edge; light foxing along edges

Monogram added and coats of arms identified in dark brown ink by Sebald Büheler, recto, under shields: *Ebersteÿnn, HBG, Sunenberg*

Glass painter's instructions in brown ink below *Ebersteynn*: *Item eyn hirss jagens zů wald*

Color notations added by glass painter: right of mitre, *blo bütz, v*; below miter, *w[eiss]*; on left shield, *r[ott], b[lo], w[eiss]*; on right shield, *b[lo]*; in red chalk under arch, *B*; at lower left corner, ⚬ (green)

Blind collection stamp of 1840s at bottom right

VC: Inv. no. Z 27

References: Térey 1894-96: no. 118; Stiassny 1896: no. 18, pl. VI; Parker 1928: no. 37; Koch 1941: no. 81; Karlsruhe 1959: no. 232; Coburg 1970: no. 12, fig. 10

Baldung's illustration of the climactic moment of a stag hunt at the top of this drawing is one of his most vivid and compelling renderings of men and animals engaged in sport. So successfully does he convey the tense atmosphere of the chase and so realistic is the depiction of the yelping dogs closing in on their prey that one would hardly suspect Baldung's image to be derivative. Hunting scenes were among the most popular subjects used in stained-glass panels, however, and Baldung's version borrows most of its figures from an established tradition, including the hunter clad in a short tunic and fur cap, who holds a spear while blowing his horn, the leaping stag with forelegs extended, the net preventing the stag's escape, the dogs held on a leash, and the running greyhounds. A round stained-glass panel of about 1505 (Schmitz 1923: pl. 22), believed to be based on a design by Hans von Kulmbach, typifies the pictorial sources for hunting scenes that Baldung must have known. But whereas the earlier stained-glass panel divides the image into four roundels in a quatrefoil arrangement, identical to that of Baldung's design for a saddler (cat. no. 1), Baldung's rendering of the hunt conveys the animals' movement far more powerfully by illustrating this in a single, continuous image. His simplified pen work and reliance on gray wash to suggest the three-dimensionality of the men and animals enhance the visual impact of the scene. However, the application of spots to the fur of the lowering dog with the point of the brush shows that in this design, Baldung used gray wash not only for its chiaroscuro effect but also to articulate details. The dual function of this wash may also be observed on the upper part of the left column, whose organic forms reflect the theme of nature in the hunting scene above.

Only the architectural frame and the image above the arch are Baldung's work, while the escutcheons were subsequently added by the glass painter. Although the drawing appears unfinished, no further execution of the right column was intended. The glass painter had sufficient information to execute the "missing" column by simply reversing its counterpart at the left. Before transferring the design to glass, the painter corrected in red chalk the lack of symmetry in Baldung's profile of the right column, executed in black ink, which includes one more boss than the corresponding profile on the left.

The sequence of work on the design can be reconstructed by observing which lines respect others that must have preceded them. Baldung received the sheet from the painter presumably bearing only the three ruled lines with six words of instructions at the bottom and the black chalk underdrawing indicating the position of the crests. Once Baldung had added the hunting scene and architectural frame in black ink and gray wash, the glass painter applied the red chalk lines along the columns and arch, which determine the divisions of the leading. Then he added in brown ink and wash the heraldic devices with their foliage, whose curly edges respect the red lead lines along the right column, not Baldung's rough contour in black ink. The escutcheons having been completed, the remaining red chalk lines around them were applied last.

The elaborate coats of arms of the Ebersteins and Sonnenbergs identify the patrons for whom this composition was created. The only union between members of these families during Baldung's activity as a stained-glass designer was the marriage in 1494 of the Swabian count Bernhard III von Eberstein to Kunigunde von Sonnenberg. Bernhard was a vassal of Baldung's faithful patron, Margrave Christoph of Baden (Washington/New Haven 1981: no. 79). The commission for the glass panel may have been arranged by Bernhard's son, who was a student in Freiburg during the years Baldung spent there (see cat. no. 52). The drawing was probably executed about 1515, judging by its stylistic kinship with another design dated in that year (cat. no. 7).

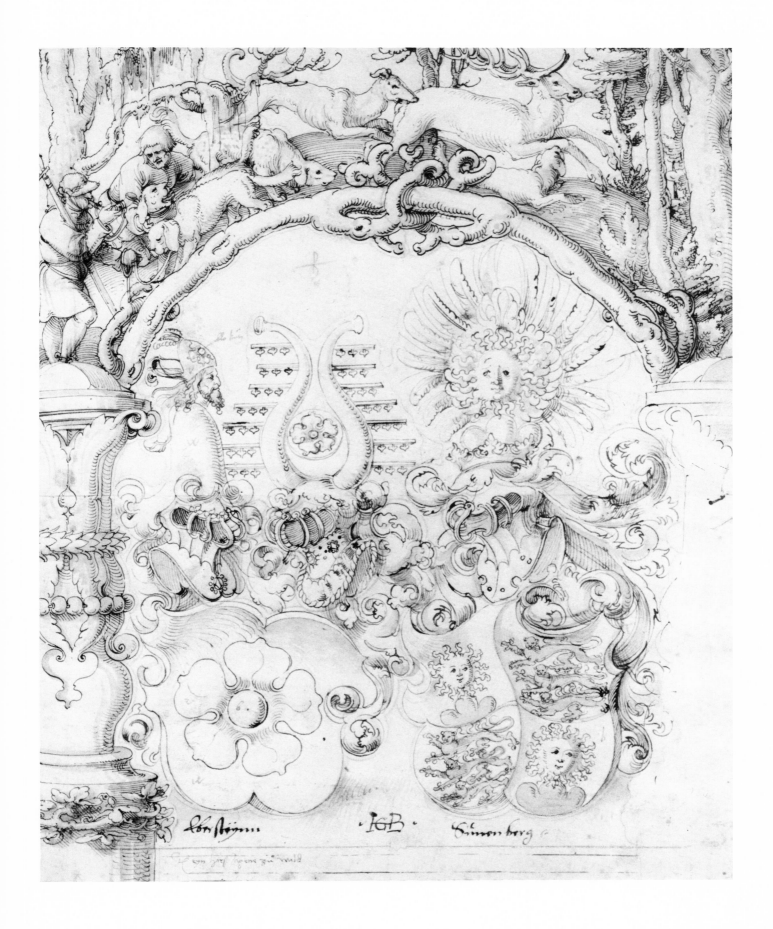

7

Stained-Glass Design with the Arms of Nikolaus Ziegler, 1515

Pen in brown and gray ink with brown and gray wash and red chalk over black chalk with lead white, 402 x 298 mm

Watermark: High crown (similar to Briquet 4924)

Trimmed on all four sides; horizontal and vertical creases along center; vertical tear at lower edge near left corner; small hole in lansquenet's skirt; two small compass holes to right of center crease; red chalk somewhat faded; lead white on shield partly rubbed off; extraneous ink spots; very light foxing

Monogram added in dark brown ink by Sebald Büheler, recto, lower left: *HBG*

Glass painter's instructions in light brown ink near lower edge: *Niclaus Ziegeler herr zů Barr 1515 Jor. Item eyn rÿngens von Bossen vnd j Landts Knecht mit eynem / wapen rock*

Color notations added in light brown ink by glass painter: on large lion, *s[chwarz]*; right of lion's paw, *gel*; background left of lion, *blo*; on helmet, *gel*; on shield, *s[chwarz]*, *g[old]*; the preceding two colors repeated on shield; on small lion in shield's upper right quadrant, *s[chwarz]*; next to lion, *g[old]*; on lansquenet's bodice, *r[ott]*; left of monogram, ⚘ (green)

Blind collection stamp of 1840s at lower right corner

VC: Inv. no. Z 69

References: Térey 1894-96: no. 137; Stiassny 1896: no. 19, pl. VII; Winkler 1939: 22, no. 29; Koch 1941: no. 82; Perseke 1941: 107, no. 1, fig. 20; Munich 1947: no. 190; Karlsruhe 1959: no. 233; Oehler 1959: 100; Coburg 1978: 117

This drawing is the most impressive surviving stained-glass design Baldung made during his sojourn at Freiburg (1512-17). The powerful figure of the lansquenet is a much more compelling presence than the generic heraldic figures Baldung usually created in such designs (see cat. no. 5). The soldier's expertly foreshortened right arm realistically defines the space under the arch, while the cramped area in which he stands and from which his bayonet protrudes makes him appear all the more massive. Similarly, in the minimal space above the arch, Baldung chose to omit the legs and feet of the figures rather than to reduce their overall size. The sparsely articulated background, common in his later stained-glass designs, effectively throws the wrestlers into relief. The athletes are not shown in any of the standard positions recommended in the wrestling manuals of this period (see cat. no. 215).

The glass painter carried out in brown ink the faint lines blocking out the composition, the instructions along the lower edge, the coat of arms, and the rather unimaginative architectural frame. After Baldung had added the lansquenet and wrestlers in gray ink, the glass painter employed a slightly darker brown ink to integrate the main figure and the escutcheon by inserting additional foliage between them. Substantial changes were made in the shield, whose finished form is a simplified version of the lightly sketched initial contours visible around it. Pentimenti also appear in the bayonet near its base and in the lower right quadrant of the shield.

As one of only two dated stained-glass designs by Baldung, this drawing of 1515 provides stylistic evidence crucial for the dating of the artist's other works of this kind. A comparison with the roundel in Berlin (Kupferstichkabinett) dated 1517 (Koch 1941: no. 84) reveals that in the later work Baldung achieved greater plasticity in his figures by minimizing the contours and pen hatching, while adding larger areas of wash. This development suggests that his *Stained-Glass Design with the Arms of Eberstein and Sonnenberg* (cat. no. 6) must have

been created at the same time as the Ziegler drawing, whereas the design for Wolfgang von Landsberg at the Albertina, Vienna (Koch 1941: no. 83) occupies a position approximately equidistant from the works at Coburg and Berlin. Furthermore, the sketch bearing the Wittelshausen arms (cat. no. 12) more closely resembles the example at Berlin. Comparison of the Ziegler and Wittelshausen designs shows how much more fully Baldung exploited the technical advantages of wash in the latter. In the Ziegler design, on the other hand, there is such extensive pen hatching that the application of wash seems almost an afterthought. Indeed, Baldung omitted it altogether on the wrestlers at the upper right.

Baldungs' extensive pen work in this sketch shows a degree of detail, freedom, and spontaneity that are more characteristic of his independent drawings than of his stained-glass designs. These qualities are especially strong in the lansquenet's face. The furrowed brow, prominent cheek bone, and curly beard recall Baldung's *Head of a Bearded Man* of about 1519 (cat. no. 9). The lansquenet thus represents an early instance of the artist's preoccupation with expressive male visages.

Nikolaus Ziegler was senior secretary of the imperial chancery under Emperor Maximilian, vice-chancellor under Charles V, and finally head of the chancery in 1520-21, critical years for the Lutheran Reformation. Ziegler has long been credited with having had a substantial impact on the evolution of the German language, through the linguistic reforms transmitted by the many documents he drew up in his administrative capacity, which were circulated throughout the Holy Roman Empire. Recent research, however, has minimized his philological role (Tennant 1981). In 1522, in recompense for his loyal service, Charles V raised him to the status of an hereditary aristocrat. A silverpoint drawing by Baldung records his newly upgraded coat of arms (Koch 1941: no. 144).

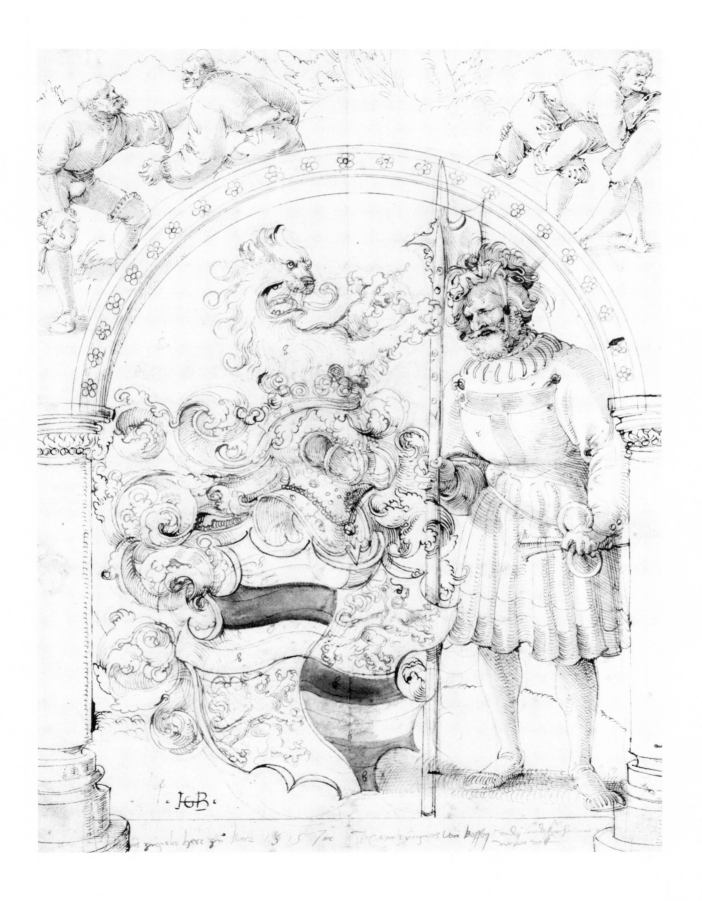

Portrait of Sebastian von Blumenegg, c. 1516

Pen in grayish brown ink over black chalk, 253 x 194 mm

Trimmed on all four sides; repair of upper left and lower right corners; light foxing; extraneous spot at lower right

Monogram added in dark brown ink by Sebald Büheler, recto, right edge: *HBG*

VC: Inv. no. Z 8

References: Térey 1894-96: no. 106; Stiassny 1895: col. 325; Schmid 1898: 307 (not Baldung); Baumgarten 1904: 44, fig. 6; Curjel 1923: 68, 74; Muchall-Viebrook 1933: 134; Winkler 1939: 17-18, no. 15; Koch 1941: no. 45; Perseke 1941: 53-54, 210; Washington 1955: no. 32; Karlsruhe 1959: no. 153, fig. 51; Möhle 1959: 129, no. 153 (not Blumenegg); Coburg 1970: no. 13, fig. 11; von der Osten 1981: no. 26

Since the end of the last century, this drawing has been generally assumed to be a portrait of Sebastian von Blumenegg, made as a study for the half-length figure that appears on the rear predella of Baldung's Freiburg Altarpiece (fig. 17). The association between the drawing and the portrait on the altarpiece was first cautiously suggested by Stiassny and reaffirmed by all later writers, except Koch and Möhle. Koch did not comment on the identity of the drawing's sitter, thus implying doubt of the proposed identification. Yet, although significant aspects distinguish the drawing from the painted portrait, the basic structure of the face, the high forehead, and the prominent nose are identical. In the painted version, Baldung rotated the head rearward, rejuvenated the sitter by omitting the heavy jowls and double chin, lengthened the hair to fall over the fur collar, and raised the eyebrows. The arched brows might record a characteristic personal mannerism, while the artistic "face-lift" may have been prompted by Blumenegg's vanity. However that may be, such marked differences between preparatory study and final work are unique in Baldung's oeuvre. A close correspondence between the study and

Figure 17. Hans Baldung Grien, *Portrait of Sebastian von Blumenegg* (detail from predella of altarpiece), 1516, oil on panel. Cathedral, Freiburg im Breisgau.

the painted portrait, even when several years separate them, is the norm (see Washington/New Haven 1981: no. 79).

Equally unusual is the technique Baldung chose for the execution of this drawing. The analytical stroke of the pen is far less suited to capturing the tonal subtleties of the human physiognomy than the more expressive and suggestive media of chalk or silverpoint, which Baldung used in virtually all his other surviving portrait studies (Koch 1941: no. 89). Sensing the unorthodox technical means of the Blumenegg sketch, Perseke postulated that it is a simplified, second version of a lost portrait study done in chalk. Although portrait studies in pen executed after a study in chalk do exist, they are preparatory work for prints (see Winkler 1936-39: no. 911) not for painting. What Perseke and all other writers have overlooked is the existence of an initial underdrawing in black chalk, still visible on the Coburg sheet along the contours of the nose, jowls, and left shoulder, as well as in the hair near the forehead. This cursory underdrawing suggests that the Coburg portrait is a rare study executed from life in an unusual medium rather than a derivative sketch.

Despite its simplicity of means, the masterfully free pen work captures the essence of the man and powerfully suggests the sitter's serious, self-assertive character. As in many portrait studies by Hans Holbein the Younger, the light touch visible in the rest of the drawing is slightly disrupted by the heavy contouring of the nose and corner of the mouth. However, these areas are crucial to the characterization of the face and therefore they are precisely the ones that Baldung reproduced most faithfully in the Freiburg panel. Like the *Head of a Bearded Man* (cat. no. 9) of about three years later, the Blumenegg study demonstrates Baldung's preference for an overall light tonality and his expert use of empty paper to suggest light, as in the hair above the ear.

Sebastian von Blumenegg belonged to a prominent patrician family of Freiburg that had married into several royal houses of Europe. His portrait on the rear predella of the cathedral's altarpiece appears along with those of two colleagues from the town council; the three men are represented in their capacity as secular overseers of the cathedral workshop. By 1516, when Baldung painted this group portrait, Blumenegg had held this office for five years. He had also donated a chapel, which bears his name and which again includes his portrait, kneeling in full armor, in one of its stained-glass windows. Unfortunately, the original glass panels (Perseke 1941: fig. 43) executed from Baldung's designs are so poorly preserved that they do not supply additional evidence for the identification of Blumenegg in the Coburg portrait study.

9

Head of a Bearded Man, c. 1519

Pen in dark gray ink, 86 x 68 mm

Trimmed on all four sides; stain and extraneous spot of gray wash in curls of hair above left eyebrow; very light foxing

Monogram added in dark brown ink by Sebald Büheler, recto, lower right: *HBG*

Verso: 11 handwritten lines of a letter (see cat. no. 10)

VC: Inv. no. Z 6

References: Térey 1894-96: no. 149; Koch 1941: no. 107

Despite its unusually small size, Baldung's *Head of a Bearded Man* is one of his most remarkable and expressive drawings. The vitality and psychological presence conveyed by the man's stern, intense gaze are rarely equaled in Baldung's drawings. The remarkably free but perfectly disciplined ductus contrasts short, rounded lines in the hair and beard with longer parallel hatching in the face and in the shadow adjoining the beard. Light and volume are effectively suggested by the areas of paper left in reserve. Overall, the sketch possesses a directness, simplicity, and light tonality that result from the economy of line typical of Baldung's mature style and from his avoidance of cross-hatching, except in the deep shadows at the temple and nape of the neck.

Studies of bearded heads are common in Baldung's oeuvre and survive in every medium he used as a draftsman. Relatively few of these, however, are life studies. With one exception (cat. no. 8) he always executed these in the tonal, painterly media of chalk or silverpoint, while for drawings done from memory he used many different graphic media. Without a live model, Baldung had greater freedom and potential for experimentation, as is apparent here in the exuberant calligraphic flourishes at the extremities of the hair and beard and in the uncertain rendering of the tip of the nose.

In Baldung's time it was a well-established workshop practice to make and preserve such studies of heads as a means of recording facial types, which could later be adapted to a variety of uses, mostly in painting and stained glass. The proliferation of drawings of bearded heads in Baldung's oeuvre around 1518-19 may have been prompted specifically by the artist's need to develop a dozen different physiognomies for his woodcut series, the *Large Apostles,* on which he was at work during these years (cat. nos. 102-105). However, in at least two instances—a woodcut and a painting on paper (Washington/New Haven 1981: no. 58, ill. 58a), both contemporaneous with the Coburg drawing—he depicted heads of men with flowing beards as independent subjects. Devoid of any narrative context, the original meaning and purpose of these works remain somewhat mystifying.

Baldung's interest in physiognomy in the narrow sense—as studied by Leonardo da Vinci and transmitted to Germany by Dürer—spanned his entire career, and resulted in numerous

series of expressive visages sketched in profile, from his early study sheets (Koch 1941: no. 33) to the silverpoint drawings of the late 1530s (Koch 1941: no. 237). The drawing at Coburg bears a considerable similarity to two other drawings of bearded heads, which provide grounds for dating it. The prominent nose and deep-set eyes of the Coburg head appear in a chiaroscuro brush drawing at the Moravian Gallery in Brno, Czechoslovakia (Koch 1941: no. 108). In the Coburg sketch, however, thick, curly hair was added, the cheek bone received greater emphasis, the upper chin is clean-shaven, and the raised eyebrow enhances the intensity of the gaze. The Brno drawing may be dated 1519 on the basis of its close stylistic, technical, and physiognomic affinity to a second chiaroscuro drawing by Baldung in the same collection (Koch 1941: no. 109), which carries that date.

10

Armor Studies, c. 1524
(illustrated on pp. 74-75)

Pen in gray ink with red chalk, 221 x 159 mm

Watermark: Fragment of crowned serpent

Trimmed on all four sides; small ink spot under year 1524, recto; bit of modern paper with number "13" added lower right, recto; ink bleeds through paper slightly; two ink spots lower right, recto; slight discoloration, top recto

Monogram added in dark brown ink by Sebald Büheler, verso, lower left corner: *HBG*

Glass painter's instructions, recto, right edge: *Fr[ater] Blasius De zabernia ordinis carmelitarum 1524 / Item Helm by seine knieen lign vnde eyn wein Kolter stëndn und eyn / flaschly by im und ein stenden Engel by ym Also sagende etc.*

Baldung's annotations: recto, near right shoulder harness, *Disser ryffen xiij*; at elbow, *xiij ryffen*; below gauntlet, *Das halb thyl xv ryffen*; verso, at knee guard, *Dysse ryffen xiij*; at thigh of right leg harness, *xiij ryffen*; above shoe, *ix ryffen vff dem schuch*; above helmet visor, *nur ij sch* (indecipherable); on breastplate, *Dis ist eyn glatter uberschafften*

VC: Inv. no. Z 17

References: Térey 1894-96: nos. 143-144; Parker 1928: no. 39; Koch 1941: nos. 120-121; Oehler 1943: 209-220; Karlsruhe 1959: no. 168; Martin 1968: 163, fig. 12

On both sides of a single sheet, Baldung sketched eight parts of a suit of fluted military armor, seen from different angles and supplemented with written notations. As studies for later use in painting, these sketches ultimately served the same purpose as the Swabian *Standing Foot Soldier* (cat. no. 47), but the fragmented appearance of objects on this study sheet is fundamentally different from the single, unified view of the Swabian figure. Baldung's immediate purpose was to record specific information, while the Swabian draftsman went one step further, depicting the armor as it is actually worn. Both drawings must have been executed directly from a model, perhaps in an armorer's workshop.

Baldung's sketches—in frontal and three-quarter views, in profile and even in a kneeling pose—provided the raw material from which he could develop the figure of a knight in any view but from the rear. The artist executed two studies of the breastplate, armet (helmet), and right leg harness to clarify details not evident from a single view. For example, since the breastplate is obscured by the gauntlet on the front of the sheet, Baldung repeated it in frontal view on the verso, being careful to specify in his annotation that "this is a smooth two-part breastplate *(Dis ist eyn glatter uberschafften)*," lest the hatching over its shaded area be misunderstood as fluting. His other annotations designate the number of flutes on a given surface. When sketching the leg harness in a kneeling position, Baldung surely had one of the traditional poses of donor figures in mind, such as the armored Sebastian von Blumenegg kneeling in adoration of the crucified Christ in the stained-glass windows Baldung designed for Freiburg Cathedral (see cat. no. 8). However, these studies are not connected to any known painting or glass panel by Baldung.

Taken together, the parts of armor distributed over both sides of the sheet constitute a complete suit of the type called Maximilian armor after the German emperor of that name (Nickel 1969: 59; London 1951: fig. 5). The prevailing fashion in Germany between about 1500 and 1530, Maximilian armor is characterized by extensive fluting, which increases the metal's tensile strength without adding to the suit's weight—often 50 or 60 pounds. The fluting is set off by rope-like borders, which, unlike the fluting, had an exclusively decorative function. The armored footgear, or sabatons, imitate a type of broad, flat shoe, common after about 1505, called "cow's muzzles *(Kuhmäuler)*," a satirical term suggesting the derision with which new fashions are often received.

The inscription along the right edge of the recto demonstrates that this sheet of paper was originally intended for a stained-glass design. In three lines the glass painter briefly described what Baldung was to sketch inside the area bordered by the red chalk lines. The commission seems to have been canceled or changed before Baldung executed the painter's instructions. The almost empty sheet was then put to a different use, presumably still in 1524, the date given in the inscription. The clear difference in handwriting between the glass painter's instructions and Baldung's own annotations to the armor demonstrates—contrary to Oehler's assertion—that the instructions were written by the glass painter, not by Baldung. The artist's decision to use the remaining space on the sheet for armor studies illustrates the value of paper during this period. Similarly, Baldung used both sides of the sheet in his *Head of a Bearded Man* (cat. no. 9), which bears on the verso the fragmentary remains of a letter concerning the purchase of paint.

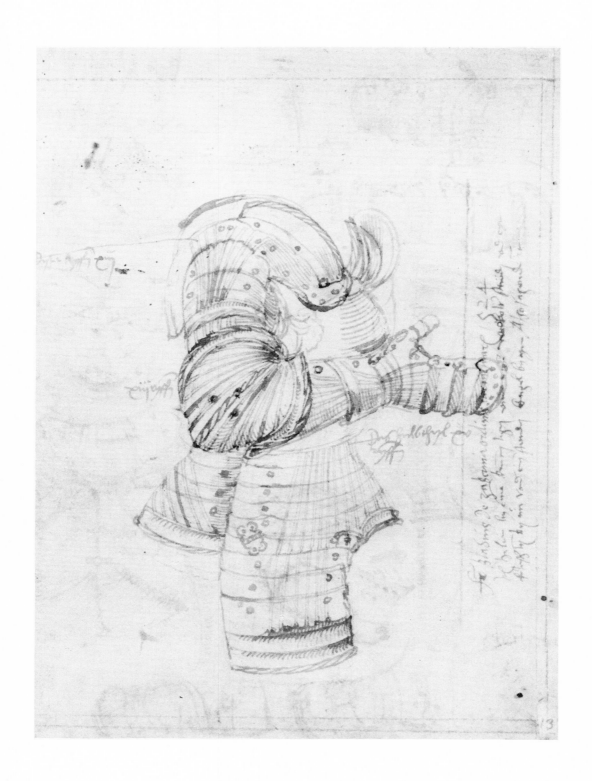

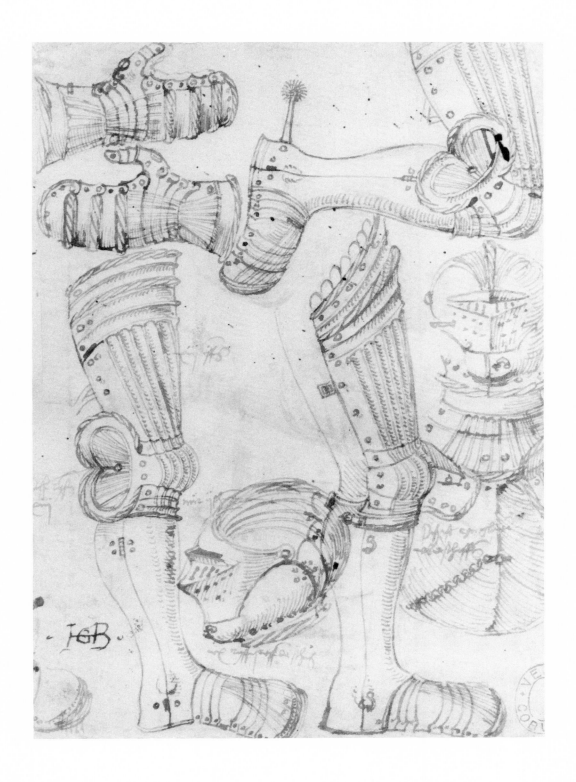

11

Stained-Glass Design with the Arms of Adelberg III von Bärenfels, c. 1525/26

Pen in black and brown ink over black chalk with red chalk, 435 × 337 mm

Trimmed on all four sides, particularly at right; three horizontal creases; slight foxing at edges of sheet; remains of two pieces of paper pasted above feathers; damage in center of upper edge

Monogram added and arms identified in dark brown ink by Sebald Büheler, recto, lower left: *Berenfelsz, HBG*

Color notations inscribed in black ink by glass painter: recto, at left, *linde blatt, gel, g[el]*; left of feathers, *Deck ganz schwartz*; in feathers, *w[eiss], 8[schwarz]*; inside crest, *rot perg, g[old], 8 [schwarz]*; throughout foliage, ♧ (green); in red chalk along wreath: *1, 2, 3, 4, 5*

Blind collection stamp from 1840s at lower right

VC: Inv. no. Z 33

References: Térey 1894-96: no. 111; Stiassny 1896: no. 48, pl. XIII; Koch 1941: no. 150; Karlsruhe 1959: no. 238; Basel 1978: 32

Of all the surviving stained-glass designs Baldung made between about 1510 and 1535, only the Bärenfels (old German: Berenfelsz) sketch shows his use of fully developed Renaissance decorative imagery. The wreath of leaves and fruit supported by corner figures is a standard Italian Renaissance device of classical origin, which was transmitted to Germany primarily through Italian engravings (see Hind 1938: pl. 155b). Comparison of the Bärenfels drawing with Baldung's design for a saddler, a much earlier circular composition (cat. no. 1), reveals a considerable stylistic and formal advance over the late Gothic quatrefoil arrangement derived from the Housebook Master. The small, symmetrically subdivided roundel has given way to a larger format with a single, unified image. Baldung's departure from the indigenous German type in favor of the newer Italian arrangement is also evident in the placement of the female figures. In his earlier designs they had always supported the coat of arms (cat. nos. 4, 5, 12). Now located outside the wreath, they have been removed from their former heraldic function and instead suggest decorative nudes of classical derivation.

Unfortunately, the Bärenfels design has not survived intact. Approximately a quarter of the composition was cut away at the right, but the hand, fingers, and strands of hair that remain confirm that two corresponding female figures originally occupied the upper and lower right corners. The missing area may have been trimmed off so it could be reused in another design, a common practice in glass painters' studios. Indeed, a number of such sketches detached from the corners of Baldung's wreath composition have survived (Koch 1941: nos. 151-155).

Other evidence of workshop practice are the two small fragments of paper pasted along the upper edge of the feathers. These are presumably the remains of a sheet bearing a different heraldic device that was placed over the Bärenfels escutcheon, thus allowing the glass painter to reuse Baldung's wreath as part of a design for a different patron. Fortunately for Baldung's drawing, pasting over was evidently preferred to cutting away and replacing so large an area.

Three stages of work can be distinguished in the drawing. Baldung must have received the sheet with the coat of arms already executed and the corresponding color notations (*rot perg; Deck ganz schwartz*) indicated in black ink. He then drew the wreath and female figures in brown ink and returned the design to the glass painter, who in the final stage of work added the red chalk lines to delineate the leading. He also "corrected" Baldung's occasional asymmetry, as in the extension inward of the leaves of the wreath at the lower center over the fruit, making it correspond to the smaller bunches of fruit elsewhere on the wreath.

Stylistically, the Bärenfels design has much in common with Baldung's *Nude Young Woman Holding an Apple* of c. 1525 (Washington/New Haven 1981: no. 76), especially in the almost total absence of cross-hatching, which suggests a similar date for the Coburg drawing. Generally believed to have been commissioned by Adelberg III von Bärenfels, it must therefore have been executed approximately when Baldung painted his portrait, which is dated 1526 (Basel 1978: pl. 16). Adelberg was one of the less illustrious members of the Bärenfels family, which had played an important political and philanthropic role in the history of Basel since the tenth century, and of which five members had held the office of burgomaster.

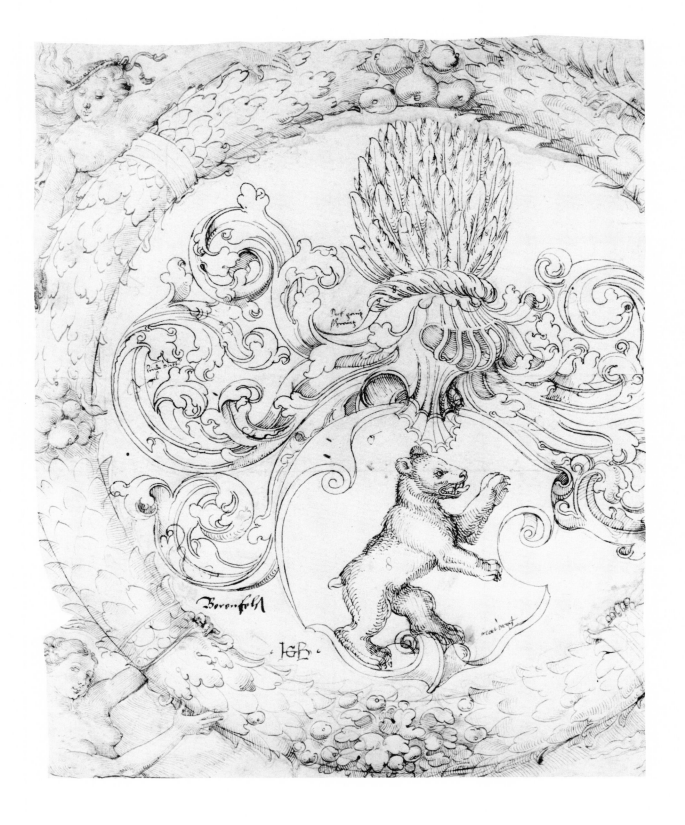

12

Stained-Glass Design with the Arms of Jörg von Wittels-hausen, c. 1530

Pen and brush in grayish brown ink with grayish brown wash and red chalk over black chalk, 328 x 241 mm

Trimmed slightly on all four sides; small hole at top left of center and on left edge of shield; horizontal and vertical creases; extraneous spots; shield in dark brown ink within larger shield added later

Monogram added in dark brown ink by Sebald Büheler, recto, lower right: *HBG*

Glass painter's instructions in brown ink along lower edge: *Die lyst Jorg von wytoltzhussen R[ömisch] K[aiserlicher] M[ajestät] thûr hûter*

Blind collection stamp of 1840s at lower right corner

VC: Inv. no. Z 45

References: Térey 1894–96: no. 136; Stiassny 1896: no. 47, pl. XII; Schmitz 1922: 41, fig. 46; Winkler 1939: 22, fig. 28; Koch 1941: no. 147; Möhle 1941/42: 217; Munich 1947: no. 191; Karlsruhe 1959: no. 244; Coburg 1970: no. 14, fig. 12

The loveliest and best preserved of Baldung's stained-glass designs at Coburg, this drawing is remarkable for the marvelously subtle and spontaneous rendering of the stag hunt above the arch. The rapid, delicate strokes of Baldung's pen and the suggestive effect produced by the slight bleeding of contours gone over with wash are a virtuoso achievement, which evokes the atmosphere of the outdoors and the harmony between man and nature more successfully than does his earlier rendition of this theme (cat. no. 6). The figure that accompanies the heraldic shield exudes exceptional charm and grace, qualities emphasized by the inclination of her head, which in turn is accentuated by the flowing mass of ostrich feathers. In this figure and escutcheon, Baldung varied the tonal spectrum from very light wash to dark brown pen lines, using a range of values calculated to set the central image apart from the subsidiary scene above, in which he adhered to a consistently light tonality.

This drawing has the added distinction of being the only stained-glass design preserved intact that was executed almost entirely by Baldung himself. Here none of the elaborate heraldic flourishes, red chalk lead lines, and color notations customarily added by the glass painter (see cat. nos. 6, 7, 11) detract from the drawing's visual coherence. Complete command of all aspects of the design has enabled the artist to establish psychological contact between the modest, graceful young woman and the bearded head staring intently at her, a device he had used earlier in the fragmentary stained-glass design bearing the Uttenheim arms (cat. no. 4). Only the

small shield inscribed within the larger one and the artist's monogram below are later additions.

Whereas the beauty and importance of this drawing have been universally acclaimed, its date has been the subject of considerable disagreement. Various proposals ranging from Baldung's years in Freiburg (1512–17) to the early 1530s have been advanced. The drawing offers somewhat disparate stylistic evidence. The woman does not firmly grasp the escutcheon she is intended to support, her gesture seems rather stiff, and volume is less successfully rendered than in the radically foreshortened right arm of the mercenary in the Ziegler design (cat. no. 7). These factors might be cited in support of an earlier date, were it not for the drawing's masterful harmony and restraint, qualities that are characteristic of Baldung's mature work. Moreover, a considerable stylistic and technical similarity may be observed between the Wittelshausen (old German: Wytolzhausen) hunting scene and the landscape in a drawing of about 1530, *The Procession Before a Castle in a Lake*, in Berlin (Kupferstichkabinett) (Koch 1941: no. 132). First recognized by Möhle, this connection suggests a similar date for the Coburg drawing, which shares with the Berlin sheet a grand view of nature, a vibrant, sketchy line, and a superbly evocative handling of wash.

Almost nothing is known about Jörg von Wittelshausen, who held the office of imperial gatekeeper when the design was executed. A single archival document of 1539 records only that he made a donation to the collegiate church at Saverne (Zabern) in Alsace.

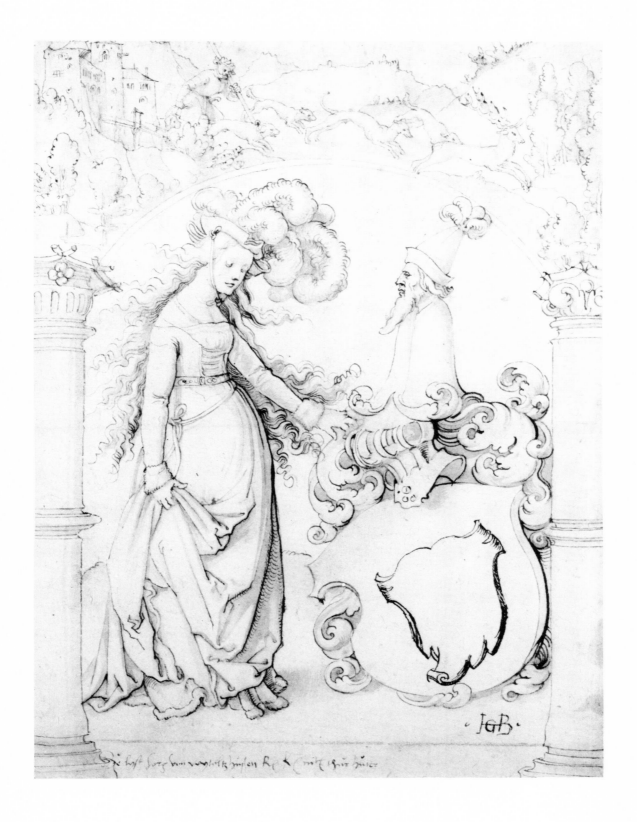

Hans Baldung Grien, Circle of

13

Stained-Glass Roundel with Saint Philip, c. 1520

Pen in grayish brown ink over black chalk, 94 mm (largest diameter)

Trimmed all around, leaving intermittent border line; several horizontal lines in red chalk on verso

VC: Inv. no. Z 253

14

Stained-Glass Design with Saint Peter, c. 1520

Pen in grayish brown ink over black chalk, 93 mm (largest diameter)

Trimmed all around, leaving intermittent border line; several horizontal lines in red chalk on verso; loss at lower right repaired with paper bearing fragment of a drawing; compass hole at center

VC: Inv. no. Z 254

Reference: Munich 1947: nos. 211-212 (as German master)

These drawings, *Saint Philip* and *Saint Peter*, exemplify the type of stained-glass designs made in great number at Strasbourg under the influence of Baldung and Hans Weiditz (see cat. nos. 51-55) in the early 16th century. Most of the surviving sketches from the glass painters' workshops reveal all too clearly their hasty execution and purely functional nature. The two roundels at Coburg, however, display an artistic quality well above the norm and deserve to be rescued from their present obscurity. Although Térey and Stiassny published innumerable workshop designs of this kind, most incorrectly attributed to Baldung, they both omitted the diminutive Coburg roundels, which have received their only public attention in a small exhibition held in Munich in 1947.

The figures of the two saints are rendered in a somewhat dry, deliberate style, perhaps motivated in part by the need for precision in so unusually small a format. Presumably each sketch was originally inscribed within a circular band that has been trimmed away, in which case they would have resembled the four round images with narrow borders in Baldung's design for a saddler (cat. no. 1). Such bands were usually drawn around a composition to provide an extra margin that would prevent the thick lead frame of the stained glass from obscuring any part of the image. As another stained-glass roundel (Ames 1944: fig. 2) made in Strasbourg and preserved intact demonstrates, it was not uncommon for parts of the design to overlap onto the empty margin. In the Coburg roundels the hem of Saint Philip's mantle and the ends of Saint Peter's cross extend beyond the present borders.

The small size of the drawings suggests that the final stained-glass roundel was intended for domestic use rather than for a church window. So diminutive a format also obviated the need for leading, which explains the absence of red chalk lines, which in such designs normally delineate the divisions between pieces of glass. The artist fully exploited the minimal space available to him; the saintly figures fill the field entirely. Moreover, the unused spaces surrounding the figures are given over to banderoles, a somewhat archaic motif in designs executed about 1520. This favorite device of 15th-century artists originally carried an inscription (see cat. no. 49), but was increasingly put to purely decorative use. In both the *Saint Peter* and the *Saint Philip*, the arrangement of the banderole reveals a certain *horror vacui*.

The roundels' stylistic derivation from the work of Baldung is abundantly evident in the stocky proportions of the saintly figures, in the choice of rays rather than halos, in the arrangement and rendering of the drapery, and in the physiognomies, particularly the deep-set eyes, the articulated bridge of the nose, and the shadow on the neck and cheek. Also related to Baldung's work is the way the figures fill the available space and the minimal grassy plot used to "anchor" them (see cat. no. 104). Although no other roundels from the same series have come to light, a stained-glass design in Vienna, consistently misattributed to Baldung, is manifestly the work of the same artist (Térey 1894-96: no. 257; Ames 1944: fig. 4; Vienna 1971: no. 47). The Vienna sketch, more than twice the size of the Coburg roundels, is more freely executed but in less pristine condition.

A final note of cultural and historical interest: the Munich catalogue of 1947 identified the *Saint Philip* as Martin Luther. Indeed, Luther was invariably shown holding a Bible and sometimes even given a halo, as in Baldung's woodcut (cat. no. 106). Also, Luther's meditations on the Crucifixion were well known. Nonetheless, the book, halo, and cross are the traditional attributes of Saint Philip (see cat. no. 161), and this image was surely intended as one of a series of Apostles. (Its companion is clearly recognizable as Saint Peter due to the oversized keys carried by the figure.)

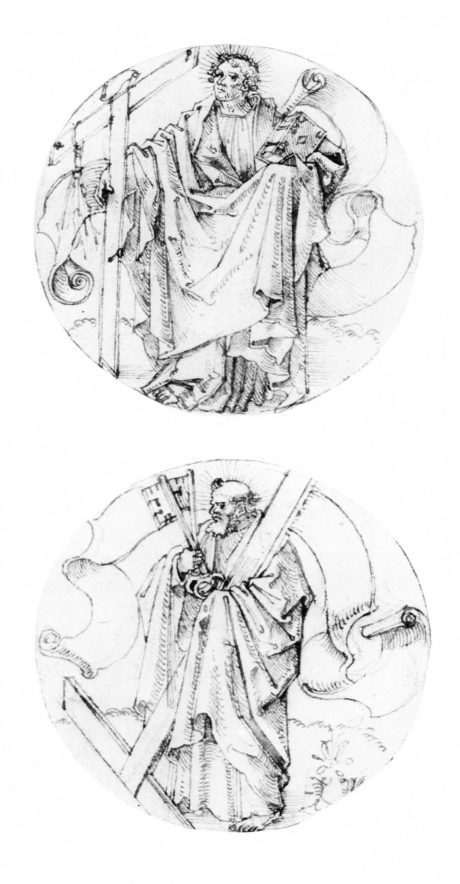

Jörg Breu the Elder

c. 1475/76 Augsburg 1537

Jörg Breu was a panel and fresco painter and designer of book illustrations and stained glass. His most important paintings, the large altarpieces at Zwettl (1500), Herzogenburg (1501), and Melk (1502), executed during his journeyman's years in Austria, are among the seminal works of the Danube school, typified by its dynamic new vision of nature. By 1502, Breu had established his workshop in Augsburg, although he seems to have departed again, traveling to Italy in 1508 and again in 1514. After settling permanently in Augsburg, he received commissions for a number of decorative cycles: he is responsible for the pen drawings adorning 22 of the pages in the *Prayerbook of Maximilian I*, for the Augsburg town hall frescoes (now destroyed), and the designs for a stained-glass series commemorating the emperor's wars and hunting expeditions. In the 1520s he painted the organ shutters for the Fugger Chapel (Augsburg, Saint Anne) and contributed the *Lucretia* and two of the eight famous battle scenes believed to have been made as decorations for the private chalet (*Lusthaus*) in Munich of Duke Wilhelm IV of Bavaria. These works reflect Breu's study of Italian art and epitomize his Mannerist style. His work as a designer of woodcuts spans most of his career after 1504, the illustrations to *Vartoman's Travels* being the most successful and best known. Breu customarily turned out his designs in thematically unified series, such as the months of the year, the children of the planets, various professions, episodes from the *Gesta Romanorum*, or legends of heroes and heroines of classical antiquity. Breu was avidly patronized and quite prolific as a stained-glass designer, and his designs were frequently copied. His compositions for a stained-glass cycle illustrating the twelve months of the year enjoyed great popularity and were even monumentalized in a series of large format paintings (Augsburg 1980-81, I: color pl. I and nos. 5-8). However, by 1524 Breu had become an adherent of the Reformation and repudiated much of his earlier work. The chronicle Breu compiled from 1512 to his death records his active support of iconoclasm in Augsburg (Augsburg 1980-81, III: 115-133). His son, Jörg the Younger, took over the workshop in 1534, three years before his father's death.

Breu's design for a stained-glass roundel illustrates the imminent execution of a nude man hanging upside down between two trees, which have been tightly bound together so that the victim will be torn asunder when the ropes are released. The scene evidently illustrates the martyrdom of Saint Victor of Egypt, a third-century saint put to death by Sebastian, an Egyptian governor of Alexandria during the reign of Antoninus Pius V. Saint Corona, a bystander who had been converted by Saint Victor's courage in the face of torture, was martyred on the same occasion. The hagiographic sources state that Saint Victor was left hanging upside down from a tree for three days prior to his death by decapitation, while Saint Corona was attached upright to two trees and torn apart by the force of the branches. Breu's victim is not Saint Corona: not only is the figure upside down, but the muscular anatomy is clearly that of a man. In fact, there are indications that during the 16th century, the sufferings of Saint Victor and Saint Corona, whose dual veneration was particularly popular in southern Germany and Austria, were interchanged and conflated (see Antonio Tempesta's illustration in Gallonio 1591: pl. 133). Perhaps Saint Victor, so that he would not be upstaged by an 11th-hour convert, was given Saint Corona's more exotic and horrifying form of death and thereby a more heroic martyrdom. Obviously the sole purpose of such gruesome martyrdoms, which often have little foundation in historical fact, was to demonstrate exemplary saintly endurance in adversity.

On the whole, Breu's drawings are more highly prized than his paintings, since he rarely succeeded in transposing his subtlety of line and force of facial expression from pen to brush. Despite its unpleasant subject, the Coburg sketch is an impressive and typical example of Breu's best work. Characteristic traits are the high horizon, the dense grouping of figures in the foreground, the almost total absence of cross-hatching in shaded areas, the stocky, muscular figure type, and the facial features—deep-set eyes, single dark dots as pupils, the emphatic delineation of the eye socket, and downturned mouths. Breu employed shadows not only for a more realistic portrayal of an outdoor scene, but also to clarify spatial relationships and to silhouette figures. His evenly spaced parallel hatching over certain background figures keeps each one distinct within the crowd.

Breu usually produced his designs for stained glass in the small, round format seen here, with no leading to subdivide the composition. His designs were carried out in grisaille, using yellow and gray. A few glass panels executed from Breu's models have survived (Schmitz 1923: figs. 40-45; Witzleben 1977: figs. 155-156, 159-163), but none made from the Coburg drawing is known.

15

Martyrdom of Saint Victor, c. 1515/20

Pen and black ink, 242 mm (horizontal diameter)

Watermark fragment: right edge of Gothic P (?)

Trimmed along left and right edges; paper slightly yellowed; horizontal crease along center; compass hole visible in center; ink spot at bottom left; extraneous spot of red wash above heads at right; light foxing

VC: Inv. no. Z 80

References: Thieme/Becker IV (1910): 595; Muchall-Viebrook 1933: 133

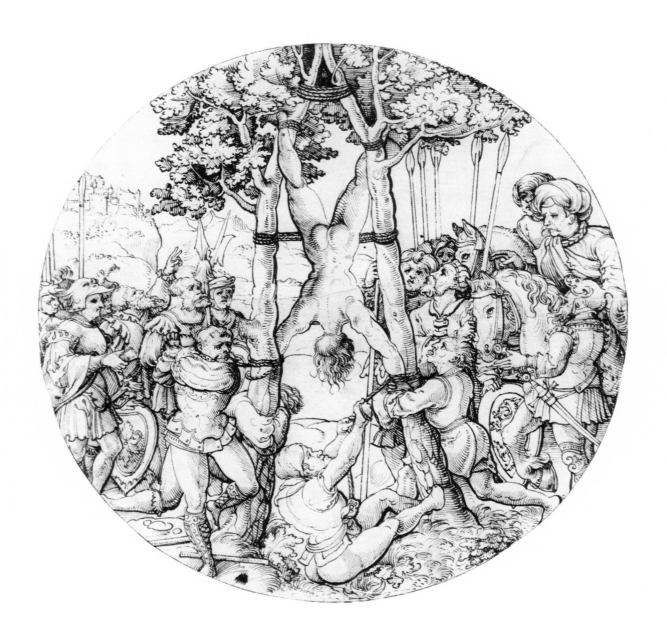

Lucas Cranach the Elder, School of

(for biography of Cranach the Elder, see p. 215)

16

Tournament Book of Duke Johann Friedrich the Magnanimous of Saxony, c. 1535

Pen in black and light brown ink with watercolor and body color over black chalk, heightened with gold, 223 x 317 mm

Contemporary binding in calf over wooden boards

Trimmed on all four sides during rebinding of 1543; dirt and water stains

Watermark: Double eagle with Hapsburg-Burgundian arms (Briquet 1457-59)

VC: Inv. no. Ms. 2

References: Schuchardt 1851-71, II: nos. 73-218; Haenel 1910: no. 116 pl. 22; Coburg 1968: no. 9; Coburg 1970: no. 18; Ulrich 1972: nos. 181-182; Coburg 1978: 118
 a. *Fools Riding in a Wheelbarrow*, fols. cxvv and cxvir
 b. *Wheel of Fortune with Fools*, fols. cxiiv and cxiiir
 c. *Fanning the Fires of Love*, fols. cxxxivv and cxxxvr

Color plate I

This book commemorates Duke Johann Friedrich's prowess in jousting in a series of colorful illustrations that record the results of 146 competitions in which he participated between 1521 and 1534. Each page opening of the book shows the Duke of Saxony challenging an aristocratic opponent and includes an inscription identifying the participants, location, and date of the competition.

The art of jousting, essentially a medieval activity, owed its popularity at the beginning of the 16th century primarily to the Emperor Maximilian, who revived the by then archaic sport as the central attraction of lavish court festivities. He himself invented over a dozen new forms of competition. The German princes followed the emperor's lead and staged tournaments of their own, no doubt feeling that participation in a sport actively fostered by the emperor lent weight to their own dynastic claims and ambitions. Thus, the *Tournament Book* conveys a more subtle message than mere glorification of Duke Johann Friedrich's athletic skill or of his generosity as a host.

The drawings, executed by at least two artists from the school of Lucas Cranach the Elder, capture the decisive moment of the joust, when one party has usually just fallen, while the other raises his right arm in a gesture of victory (see pl. I). In the competition shown here, however, both opponents have been unseated and thus neither has won. The series of inherently repetitive images is enlivened by the varying scenes that decorate the horses' blankets. The amusing subjects are especially appropriate for the occasion: whereas medieval tournaments had been serious matters in which the participants competed for honor and their ladies' favors, tournaments as revived by Maximilian were viewed more as amusements. They were often held during Carnival time, and thus satire was allowed free reign in both the literary and visual works created to commemorate them. Often, the relations between the sexes were lampooned in images that illustrate the power of women to beguile, enslave, and make fools of men (see cat. no. 51), a subject on which entire books were written in the early 16th century. The verbal imagery contained in such satirical treatises as Thomas Murner's *Narrenbeschwörung (Exorcism of*

Fools), where men who fall prey to women's charms are described as captives in sacks or baskets, or Sebastian Brant's *Ship of Fools*, in which men appear as fools riding in a wheelbarrow, inspired the humorous scenes that decorate the *Tournament Book*. Other pages in the book depict male admirers who "burn" with desire (Haenel 1910: pl. 7) while the object of their devotion fans the fires of love (see pl. Ic), or the plight of lovelorn fools through an analogy with the Wheel of Fortune (see pl. Ib). The latter scene depicts fools clinging to a wheel; as a fickle young woman turns it, the fools' positions change, rising and falling like their place in her affections. The identity of gesture between the fool at the height of his luck on top of the wheel and the duke victorious in competition adds an ironic note, hinting that the duke's fortunes will also decline, as indeed they did in a later contest shown here.

Although it records jousts that occurred over a period of years, the *Tournament Book* was evidently executed all at one time after the last tournament shown (1534). The stylistic homogeneity of the images suggests a short period of work, while the fact that the underdrawings on the sheets not infrequently differ from the completed images indicates that so much time had elapsed between the actual event and its illustration in the book that the artists no longer accurately recalled the results, and corrections were often necessary. That the book was periodically brought up to date by those who looked at it can be seen from the pious inscription "may God have mercy on you" later added to the images of participants who had died in the meantime (Coburg 1970: pl. following p. 24).

The *Tournament Book of Duke Johann Friedrich* has as its direct antecedents the commemorative tournament books commissioned by the emperor and members of the imperial court. One of the earliest surviving examples from the Hapsburg court is the *Tournament Book of Caspar von Lamberg* (Lamberg was Maximilian's field marshall), which was illustrated at the end of the 15th century with 88 jousts in the same configuration and technique as the Coburg *Tournament Book* (Innsbruck 1969: pl. XII). A more immediate precedent, however, is the *Freydal* (von Leitner 1880-82), a book of drawings commissioned about 1512 by the emperor himself.

Sustained by their imperial associations, such tournament books were so popular at the Saxon court that copies of existing ones were made for other members of the ducal family (a copy of the Coburg *Tournament Book,* made after 1543, is preserved in the Staatliche Kunstsammlungen, Dresden), and at the end of the 16th century, 29 of the pictures in the tournament book made for Elector August of Saxony were enlarged as oil paintings by court painter Heinrich Göding the Elder and used to decorate an entire gallery in the ducal castle at Dresden (Washington 1978: nos: 134-137).

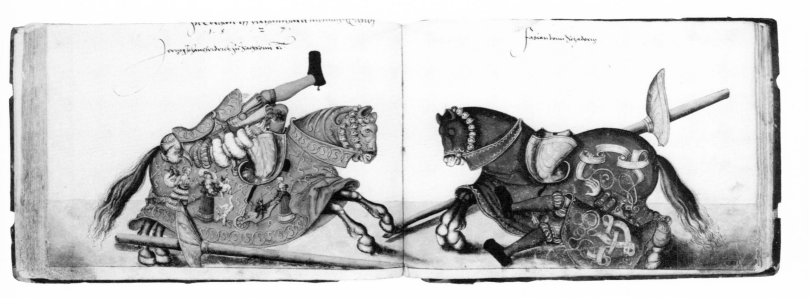

a. *Fools Riding in a Wheelbarrow,* fols. cxv^v and cxvi^r

Albrecht Dürer

1471 Nuremberg 1528

The most prodigious talent in Northern European art at the beginning of the 16th century, Albrecht Dürer introduced the forms and ideas of the Italian Renaissance into German art. He was first trained as a goldsmith by his father (1485-86), and then as a painter by Michael Wolgemut (1486-89). Dürer's travels as a journeyman between 1490 and 1494 took him first to Colmar (he had hoped to study with Martin Schongauer, whose engravings he much admired, but by the time he arrived Schongauer had died), then Strasbourg, and finally Basel, where he produced some of the masterpieces in the history of printed book illustration for local publishers, such as the woodcuts for Sebastian Brant's *Ship of Fools*. Dürer's trip to Venice in 1494-95 was crucial for his entire subsequent development. What Dürer learned from Italian art brought Gothic art to an end in Germany. After his return to Nuremberg, he created the first of a series of woodcut cycles that were to occupy him for nearly two decades. His famous *Apocalypse* (see cat. nos. 130-132), published in 1498, is the first major expression of his newly evolved style. A second trip to Venice followed in 1505-07, during which Dürer was celebrated as a distinguished guest and honored with the coveted commission to paint the *Feast of the Rose Garlands* for Saint Bartholemew, the church of the local community of German merchants. The year 1511 saw the publication of Dürer's *Large* and *Small Passion* series, the *Life of the Virgin*, and a second edition of the *Apocalypse*. From 1515 on, the artist was granted a yearly pension of 100 gulden by the Emperor Maximilian. The renewal of this pension by Emperor Charles V in 1520 offered Dürer a pretext for a trip to the Netherlands. During the early 1520s a consuming religious crisis, prompted by Luther's new theology, paralyzed much of the artist's creative energy. In 1526 he gave powerful expression to his Lutheran convictions in his paintings of the *Four Holy Men* (see cat. nos. 160-161). These two panels, which Dürer donated to Nuremberg's town council, were intended to warn the city fathers against false prophets and to exhort them to support Luther's teachings.

During the last decade of his life, Dürer devoted himself more actively to his theoretical interests, especially his studies of human proportion. His works on mathematics and geometry for artists and on fortifications were published in 1525 and 1527, but he did not live to see the publication of his *Four Books on Human Proportion* in 1528. Dürer also left behind an extraordinarily rich self-documentation in his letters and diaries. Thanks to his keen self-awareness and concern for posterity, more is known about him than about any other Northern Renaissance artist.

17

Nativity, c. 1492

Pen in black ink, 275 x 213 mm

Trimmed on all four sides; repaired hole at center of left edge; paper dirty; light foxing

Spurious monogram added in grayish brown ink, recto, lower right: *AD*

VC: Inv. no. Z 98

References: Pauli 1910: 57-58; Lippmann/Winkler 1883-1929, VI: no. 606; Tietze/Tietze-Conrat 1928-38, I: no. 25; Flechsig 1928-31, II: 391; Winkler 1936-39: no. 37; Schürer 1937: 193-194; Winkler 1957: 37; Winzinger 1968: 160, fig. 6; Coburg 1970: no. 20, fig. 14; Nuremberg 1971: 74, no. 135; Winzinger 1972: 185; Strauss 1974, I: no. 1493/24

This rapidly executed sketch is a prime example of Dürer's draftsmanship during his travels as a journeyman. It synthesizes what the young artist learned from the art of Flanders with what he surely already knew of the engravings of Martin Schongauer. The drawing is replete with Flemish motifs, some of which were available to Dürer in Germany through the intermediary of Schongauer's engraved *Nativity* (Washington 1967: pl. 38), for example, the Virgin's pose, the Child nestled in the folds of her mantle, and the shepherds looking in through the arch, while the Annunciation to the Shepherds takes place on a distant hilltop. Other Flemish motifs in the drawing, such as the adoring angels surrounding the Child, which also appear in Roger van der Weyden's *Nativity* from the Bladelin altarpiece (Panofsky 1953, II: fig. 337), must have come to Dürer's attention through other sources. Dürer also seems to have incorporated into his composition a number of Schongauer's own inventions, such as the location of the scene inside the stable rather than in front of it, as was the Flemish tradition (Washington 1967: pl. 38). In addition, Dürer borrowed the ox seen in profile behind the Virgin from another Schongauer engraving of this theme (Washington 1967: pl. 74) and used it in his drawing for the same effect—to interpose a light form between the shaded areas of the Virgin and the stable wall.

This youthful work displays none of the precision and care typical of Dürer's later drawings. The composition was sketched with such exuberant haste that the initial lines blocking it out and a number of pentimenti in the articulation of details are visible. These are especially evident around the Virgin's head, shoulders, and hands, and in Joseph's head-

dress, left shoulder, and right leg. A single, semicircular stroke of the pen rising above the central arch from the left side shows that initially the arch was intended to be slightly higher. Also, the inaccurately foreshortened arch at the right was meant to be more substantial, as the contour extending up from Joseph's head demonstrates. But once Dürer had finished drawing the head, he realized that it would be thrown into relief more effectively before a light background. This required a reduction in the width of the cross-hatched part of the arch behind Joseph. The visual device of silhouetting the saint's expressive visage against a light background is repeated at the left, where Dürer placed the light animals behind the shaded figure of the Virgin. Dürer often used light and dark in this manner to provide contrast and to clarify forms. In his mature drawings, too, he used light as a means of visual organization, even when doing so contradicted the realistic appearance of objects. Dürer did not use this technique consistently in the present drawing, however. In fact, consistency is not one of its virtues—note the uneven execution of the figures' faces. Such traces of the artist's relative inexperience make this sketch an important and eloquent example of his early development.

18

Elevation of the Magdalen, c. 1493

Pen in gray ink, 241 x 178 mm

Watermark: Gothic P with flower (similar to Piccard 1977, III: sect. IX, nos. 1516-1520)

Trimmed on all four sides; repaired hole at upper left

Spurious monogram added in brownish gray ink, recto, lower left: *AD*

Modern inscription added in pencil at upper right: *Nº 3*

VC: Inv. no. Z 97

References: Pauli 1910: 57; Lippmann/Winkler 1883-1929, VI: no. 605; Weinberger 1921: 129, pl. XII (Schäufelein); Tietze/Tietze-Conrat 1928-38, I: nos. 37-38; Flechsig 1928-31, II: 391 (Schäufelein); Winkler 1936-39: no. 38; Panofsky 1943, I: 23; Winkler 1957: 37; Coburg 1970: no. 19, fig. 13; Nuremberg 1971: 74, no. 139; Landolt 1971/72: 146, fig. 3; Strauss 1974, VI: no. XW 38 (not Dürer); Coburg 1978: 105

According to the 13th-century *Golden Legend,* a popular compendium of saints' lives, after Christ's death Mary Magdalen lived for many years as a hermit in the wilderness near Marseilles. Seven times a day, angels came to the entrance of her cave and bore her aloft to hear the heavenly choirs; she was sustained only by this spiritual nourishment. Dürer's drawing shows the Magdalen being raised up to hear the celestial music. As in Dürer's later woodcut of this theme (cat. no. 141), the drawing originally indicated the saint's distance from the earth through the diminution of the landscape and view of the Mediterranean below. Most of this, however, has unfortunately been trimmed away, leaving only a mountain peak at the right and the upper masts and sails of several ships at the left.

Just as Dürer's *Nativity* (cat. no. 17) reflects the young artist's admiration of Schongauer's engravings, the *Elevation of the Magdalen* demonstrates his careful study of the drypoints by the Housebook Master (see cat. nos. 170-174). The pensive expression of Dürer's Magdalen and the number and arrangement of the angels in the Coburg sketch were clearly inspired by the Housebook Master's drypoint of the same theme (Lehrs 1908-34, VIII: no. 48; Hutchison 1972: fig. 49). Furthermore, the form in the upper left corner of the drawing, always interpreted as a cloud, may more likely be the trimmed remains of decorative foliage, similar to that which frames the drypoint. Dürer's rendering of the angels' draperies, however, suggests their movement through the air more forcefully than does the Housebook Master's relatively static treatment. Perhaps in order to practice his hand at drawing a female nude, Dürer omitted the Magdalen's traditional hairy skin and lowered her hands to reveal her breasts. The drawing is typical of Dürer's work of the early 1490s in its uneven execution—some areas are handled more successfully than others. The wavering, uncertain ductus in the rendering of the legs shows the artist's inexperience, while other details demonstrate his precocious talent, such as the expertly foreshortened head of the left lower angel.

Dürer's contemporaneous study of a female nude at Bayonne, dated 1493 (Winkler 1936-39: no. 28), offers an instructive comparison. The latter demonstrates by its much greater precision that it was sketched from a live model, while for the Magdalen, Dürer obviously depended solely upon his memory of human anatomy. Furthermore, the Bayonne work reveals quite a different graphic style. As Landolt has pointed out, the short, fine, rounded flicks of the pen in the Bayonne study are much closer to the style of the Housebook Master's drypoints than is the Coburg drawing. This rather curious fact bears eloquent witness to how varied a graphic style the youthful Dürer already had at his command. The style he learned from the Housebook Master's drypoints effectively conveys tactile and plastic qualities, and therefore during the ensuing years Dürer used it consistently for studies of the nude. In the *Elevation of the Magdalen,* however, his intention was altogether different. The drawing is a rare example of a primarily expressive style that Dürer used only briefly, which originated in the Wolgemut workshop where he had been apprenticed, and in which linear calligraphy is paramount.

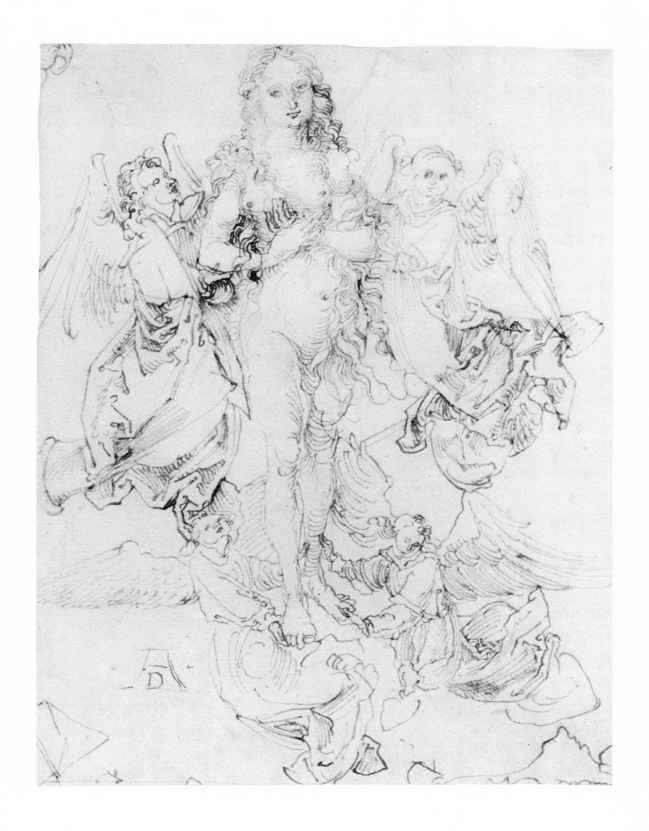

19

Young Woman Offering a Carnation, c. 1495

Pen in gray ink, 211 x 114 mm (largest dimensions)

Trimmed irregularly to a seven-sided format; extraneous spots; stains; repaired hole at lower right; paper dirty; foxing

Spurious monogram added in brown ink, recto, lower center: *AD*

VC: Inv. no. Z 99

References: Dodgson 1911: 8; Lippmann/Winkler 1883-1929, VI: no. 680; Kaemmerer 1925: 49-50; Baldass 1928: 399 (Baldung); Tietze/Tietze-Conrat 1928-38, I: 121, no. A 102 (not Dürer); Flechsig 1928-31, II: 426; Winkler 1936-39: no. 169; Coburg 1970: no. 21, fig. 15; Winzinger 1971: 67-68, fig. 21 (Kulmbach); Strauss 1974, VI: no. xw 169 (not Dürer)

This irregularly trimmed sketch of a young woman glancing coquettishly at the viewer is quite an unusual creation among Dürer's drawings of the 1490s. The precise, deliberate ductus and simplified forms differ considerably from the far more freely and experimentally sketched works characteristic of this period (see cat. no. 18). Consequently, a number of authors have questioned its authenticity. Baldass' attribution to Baldung, however, has found little favor, since his stylistic arguments are not convincing in themselves and are also based on comparison with two sketches in Berlin (Kupferstichkabinett) and Braunschweig (Herzog Anton Ulrich-Museum) that are no longer considered to be Baldung's work. Winzinger's recent attribution to Kulmbach is also not persuasive. His comparison of this drawing with an early Kulmbach sketch in London (British Museum), the *Woman at the Well* (Winzinger 1971: fig. 22), misses the particular qualities of both works. The Coburg sketch is indeed uneven in execution, but Winzinger's criticism focuses too narrowly on the "formal weaknesses" in the rendering of the banderole without mentioning, for example, the superbly sketched hand with the carnation. Both Flechsig and Winkler, however, recognized that the lack of spontaneity in the drawing's execution, which caused the Tietzes also to reject it, resulted from its particular purpose rather than from any absence of skill on the part of the artist. The banderole, the woman's glance at the viewer, and the careful execution suggest that the drawing was intended as an object of practical use rather than of private study. Winkler thought it may have been an *ex libris* (bookplate) or a 16th-century equivalent of a greeting card.

In view of the skepticism with which scholars have viewed the Dürer attribution, it is noteworthy that the artist's costume studies of 1500 in Vienna (Graphische Sammlung Albertina) (Koschatzky/Strobl 1971: pls. 19-20) have shared the same critical fate—they were initially rejected by the Tietzes and others on similar grounds, until the preliminary sketches for them, undeniably by Dürer, came to light. These sketches proved the authenticity of the Vienna studies by revealing them to be "cleaned-up" second versions *(Reinzeichnungen)* which, not surprisingly, lacked some of the vitality of the initial sketches. The Vienna costume studies show that during these early years, Dürer's effort to produce a precise, presentable drawing had a somewhat inhibiting effect on his freedom of execution, as it had also on later scholarly judgment.

The ample literature on the Coburg drawing offers no explanation of the subject. To Dürer's contemporaries, the young woman's intentions must have been unambiguous, conveyed by a language of gestures whose meaning was much more specific than it is today. The woman's sidelong glance and offer of a flower must have been understood as an amorous invitation. German 15th- and 16-century moralistic tracts and codes of conduct specifically proscribe such suggestive glances and warn men against their dire consequences. In contemporary works of art, the sidelong glance was frequently used to heighten a woman's erotic appeal, as in Hans Baldung's *Nude Woman Holding an Apple* (Washington/New Haven 1981: no. 76) or Urs Graf's *Camp Follower Stepping into a Brook* (Andersson 1978: fig. 41). The offer of a flower in the Coburg drawing was intended to convey an equally suggestive message (see Frankfurt 1973, II: fig. 119). The gesture's meaning was based on the popular association of flowers as a symbol of a woman's virginity, a concept still current today in terms such as "deflower." In late medieval and Renaissance art, women are frequently portrayed giving a flower or an entire wreath of flowers to their lovers. The significance of the offer is more directly expressed in a sketch made around 1515 by the Basel goldsmith Jörg Schweiger (Basel 1979: fig. 274). Schweiger's drawing shows a woman holding a flower, who is nude except for a matron's bonnet.

A relatively precise date for the present drawing is difficult to establish, since no others of comparable technique and function are known. Its creation certainly predates 1500, since the high-waisted dress, the pointed shoe, and the drapery cascading in front and back are typical both of a Gothic graphic style and of a feminine fashion that did not continue beyond the turn of the century. The young woman's similarity to the female figure in Dürer's *Ill-Assorted Couple,* an engraving usually dated about 1496 (Washington 1971: pl. 3), has generally been cited in support of a date in the mid-1490s.

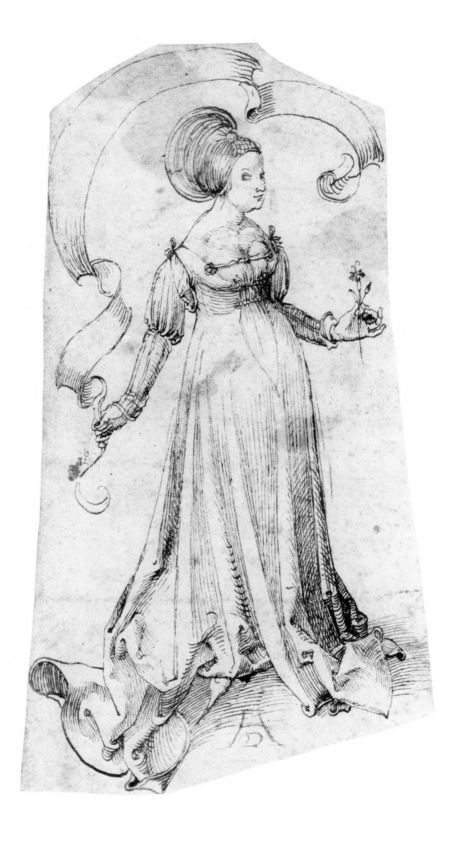

20

Horse and Rider in Rear View, c. 1497

Pen in gray and light brown ink, 193 x 79 mm

Trimmed along left and right edges; ink faded; light foxing

VC: Inv. no. Z 100

References: Lippmann/Winkler 1883-1929, VI: no. 618; Dodgson 1911: 7-8, pl. II; Weixlgärtner 1920: 37; Tietze/ Tietze-Conrat 1928-38, I: no. 59; Flechsig 1928-31, II: 399; Winkler 1936-39: no. 171; Winzinger 1971a: 7-8, figs. 9, 12; Strauss 1974, I: no. 1497/6

This rather slight, rapidly executed drawing seems to have been created in two stages: first, Dürer sketched the rump of the horse, and then—perhaps as an afterthought—he added the faint outline of the horse's head and forelegs rearing toward the right and of a rider leaning to the left. It is unclear what the round form added in brown ink to the left of the croup was intended to represent.

Weixlgärtner believed that the drawing was made as a study for the rider seen from the rear in Dürer's *Crucifixion,* a wood-cut designed around 1497 for the *Large Passion* (Washington 1971: pl. 129). The horse in the drawing does correspond to the woodcut in the proportions of the croup, in the rendering of shadow, in the turning motion of the horse's head, and in the claw-like configuration of the hooves. But the Coburg horse is smaller in format and rears up, while the horse in the woodcut stands placidly. Also, the croup in the drawing is shown *en face,* but in the woodcut it appears in three-quarter view. It seems improbable that Dürer would have contemplated a rearing horse in so crowded and complex a composition as his *Crucifixion.* Given these differences, it seems more likely that when designing the woodcut, Dürer merely referred back to an already existing study and adapted it to a new purpose.

In a recent article Winzinger has asserted that the horse's croup in the Coburg drawing is based on a sketch by Leonardo da Vinci and that the *Horse and Rider* is thus one of Dürer's earliest studies of the proportions of the horse. Winzinger deduced the dependence on Leonardo from a comparison of the Coburg horse with one dated 1517 in Dürer's Dresden sketch-book, which indeed displays a great similarity to a sketch of a horse by Leonardo and which, according to Winzinger, Dürer traced from another work by his own hand, made "considerably earlier" (Winzinger 1971a: 19, n. 20, figs. 10-11). This putative earlier work, however, is not known. Although Winzinger may be correct in perceiving that the Dresden sketch-book horse can be traced to an earlier work by Dürer, there is no firm evidence that as early as 1497, when the Coburg drawing was probably made, Dürer had already come into contact with Leonardo's proportion studies. For example, in about the the year 1500, Dürer did not yet apply Leonardo's canon of proportions consistently to Saint Eustace's horse in his well-known engraving (cat. no. 135; David 1910: 316-317). The visual evidence is also problematic, since the dimensions of the Coburg horse differ from those of the Leonardesque horse to which Winzinger compares it, the croup of the Coburg example being considerably broader. On these grounds, the association of the Coburg drawing with Leonardo's proportion studies must at present be regarded as hypothetical.

21

Flagellation of Christ, 1502
(illustrated on p. 94)

Pen in gray and black ink, 285 x 197 mm

Watermark: Trident with circle (see Strauss 1974, VI: 3289)

Trimmed along left, right, and lower edges; extraneous stains of brown ink on leg of tormentor in right foreground; light foxing on upper half of sheet

Monogram and date, recto, lower center: *1502 / AD*

VC: Inv. no. Z 96

References: Pauli 1910: 58; Lippmann/Winkler 1883-1929, VI: no. 706; Tietze/Tietze-Conrat 1928-38, I: no. 201; Flechsig 1928-31, II: 436; Winkler 1936-39: no. 185; Panofsky 1948: 105, fig. 145; Washington 1955: no. 52; Winkler 1957: 149, 152; Coburg 1970: no. 23, fig. 17; Strauss 1974, II: no. 1502/21; Coburg 1978: 106

This magnificent drawing, which delights the eye with its extraordinary freedom of ductus and powerful rendering of figures in motion, is one of the earliest known sketches in which Dürer used a correctly constructed one-point system of perspective. The orthogonals, drawn in black ink with a ruler, all converge on a single vanishing point marked by a dot on the head of Christ's tormentor in the left foreground. Evidently, Dürer first sketched the space freehand and then added the constructed orthogonals for greater accuracy. The corrections reduced the space slightly, since the constructed ground line running through Christ's left foot is placed somewhat lower than the freely drawn one behind it. The rounded frame within which the scene is set was also mechanically drawn with the aid of a ruler and compass, but it must have been executed before the figures were sketched in.

The grandiose interior is crucial to the drawing's powerful effect. The space is largely determined by three receding arches drawn with a compass, articulating three rectangular areas, whose vaulting Dürer added freehand. A doorway at the right gives access to a fourth chamber occupied by spectators, in which the arch motif is repeated. In creating a rational space through the use of receding arches and a subsidiary room at the right, Dürer applied the same principle he used in his *Perspective Study* in Hamburg (Staatliche Kunsthalle) (Winkler 1936-39: no. 259), a constructed drawing without figures made at about the same time.

The lofty interior in the Coburg drawing seems to anticipate those in the *Life of the Virgin* woodcut series (Washington 1971: nos. 134-154), on which Dürer began working concur-

rently. This similarity is particularly intriguing, since the *Flagellation* was obviously made as a design for a print—note that Christ's tormentors are all left-handed, anticipating the reversal of the image in printing. Panofsky regarded the time of execution and the similarity of the architecture and dimensions between the drawing and the *Life of the Virgin* woodcuts as evidence that the *Flagellation* was originally intended as one of a series of Passion images, which were to be appended to the Mariological cycle. However, there is no firm evidence that Dürer ever planned to add any woodcuts illustrating the Passion to the *Life of the Virgin*, and the presence of a diaphragm arch in both the drawing and the woodcuts does not necessarily mean that they ever belonged together, as Panofsky postulated.

The print envisaged in the drawing was never executed. Perhaps Dürer belatedly realized that his ingeniously constructed space would look strange when reversed in the reproductive process, since in the woodcut the space would recede to the left rather than to the right, the direction in which the eye is accustomed to moving. The same problem of orientation applies to the use of light, which in Dürer's prints normally falls from the left. Had a print been made from the drawing, the light would have fallen on the "wrong" side. The column to which Christ is bound may have presented another potential difficulty. Isolated in the center of this elaborate space, it forms no coherent union with the surrounding architecture. Perhaps Dürer recognized these obstacles when he added his monogram and the date, since he did not bother to inscribe them in mirror image.

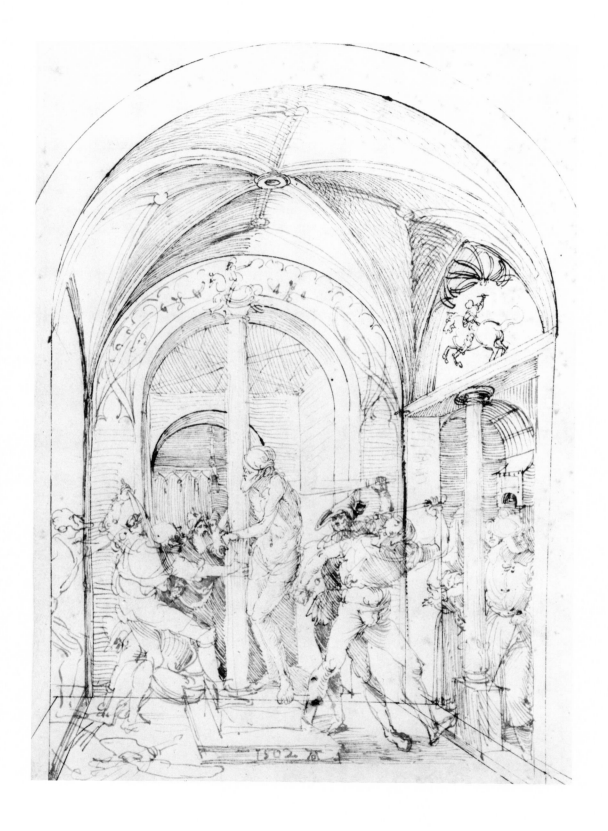

22

Study for the *Large Calvary*, c. 1505

Verso: *Centauress Suckling Her Young*
(illustrated on pp. 96-97)

Pen in brown ink, 226 x 211 mm

Watermark: Trident with circle (see Strauss 1974, VI: 3289)

Trimmed on all four sides; repaired hole above center of left edge; tear at left edge; extraneous smudges of black chalk at lower right; foxing

Spurious monogram added in grayish ink, recto, lower center: *AD*

Inscribed by later hand, recto, lower right corner: *B, D*

Inscribed by Dürer, verso, upper left: *schteffen folkamer / jorg haller / nicklas grolant / pirkamer*

VC: Inv. no. Z 95

References: Peartree 1906: 13-14, pl. XVIII; Peartree 1906a: 14-15, pl. XX (verso); Lippmann/Winkler 1883-1929, VI: no. 731; Tietze/Tietze-Conrat 1928-38, I: no. A 100 (Baldung); Winkler 1929a: 160-161, 164; Flechsig 1928-31, II: 449; Winkler 1936-39: nos. 315, 344; Winkler 1949: no. 28; Winkler 1957: 175; Coburg 1970: no. 22, fig. 16; Strauss 1974, II: no. 1505/1

This study is a typical example of Dürer's preliminary compositional sketches, with its extraordinarily rapid execution and summary treatment of figures and landscape. In creating this work Dürer was concerned only with recording as quickly as possible a compositional idea, which could be developed further in subsequent drawings. Dürer's whirlwind style seems especially appropriate to the theme, since it expresses with unusual force the brutality of the events on Golgotha.

This drawing, which has been trimmed on all four sides, combines several episodes of the Passion in a single composition. In the right foreground, the figure of Christ is shown being stripped of his clothes by a soldier in armor, while others seize him around the waist, by the hair, and by the beard, preparing to strike. At the extreme right, two men discuss the pitiful scene but do not intervene. In the left foreground, a child raises its arms in reaction to the scene it witnesses. Behind the grassy bank at the left, a skeleton lifting its right arm appears in half-length behind a coffin on which lies a skull. The entire background is devoted to the Crucifixion, with two of the crosses already raised. Below and to the left of Christ's cross are the centurion and his henchman. On the right, two other henchmen pull a rope to raise the cross of the good thief, while others support it from below with poles. Under the bad thief's cross at the right, the mourning Virgin and Saint John stand looking up at Christ, while the Magdalen seated on the ground nearby wrings her hands in despair. In the upper right corner, a soldier drives back a group of grieving women and children.

Mediating between the foreground and background scenes are three men contemplating the Crucifixion.

Both the Coburg drawing and a second compositional sketch in Berlin (Kupferstichkabinett) (Winkler 1936-39: no. 316) served as preliminary studies for Dürer's magnificent but poorly preserved *Large Calvary*, a chiaroscuro drawing of large format in Florence (Uffizi) (Winkler 1936-39: no. 317; see also cat. no. 139). In the Berlin sketch, made at the same time as the Coburg composition but with greater emphasis on light and shade, Dürer jotted down additional episodes of the events on Calvary, which are lacking in the Coburg drawing. Winkler has analyzed in detail how Dürer subsequently reassembled the component parts of the preliminary sketches for the final chiaroscuro drawing. In essence, he separated the upper and lower halves of the Coburg composition, leaving the Crucifixion above and the disrobing below, and inserted motifs from the Berlin study between them. The obvious dependence of the *Large Calvary*, dated 1505, on the Coburg composition enables a precise dating by association for the drawing.

The verso of this sheet shows an ink sketch of a female centaur suckling her young. The inscription by Dürer names four well-known citizens of Nuremberg, Stefan Folkamer, Jörg Haller, Nicklas Grolant, and Willibald Pirckheimer. Peartree (1906a: pl. xx) proposed that the subject of the sketch was inspired by Pirckheimer's translation of a passage from the work of the Roman satirist Lucian.

23

Portrait of Anton Fugger, c. 1525

Black chalk, 365 x 263 mm

Watermark: Cardinal's hat (similar to Briquet 3498)

Trimmed on all four sides; chalk faded; surface rubbed; horizontal creases across forehead, cheek, beard, shoulders, and breast; extraneous spot near temple at edge of cap; several tears along upper edge; small tear on forehead; light foxing at lower right corner

VC: Inv. no. Z 4

References: Ephrussi 1882: 300; Lippmann/Winkler 1883-1929, VII: no. 812; E. Buchner in Thieme/Becker XXII (1907): 94 (Kulmbach); Dodgson 1911: 8; Lossnitzer 1913a: no. 53 (Cranach); Flechsig 1928-31, II: 463; Muchall-Viebrook 1933: 134 (close to Dürer); Stadler 1936: 115, no. 59 (Kulmbach); Winkler 1936-39: no. 915; Tietze/Tietze-Conrat 1928-38, II/2: A 332 (not Dürer); Lieb 1958: 292, 464; Coburg 1970: no. 24, fig. 18; Strauss 1974, IV: no. 1525/16

This sensitively sketched portrait of a member of the famous Augsburg banking family belongs to a group of large-format portrait studies that Dürer made during the last years of his life. (His portrait of Fugger's future wife, Anna Rehlinger, also belongs to the Coburg collection but is too fragile to be exhibited [Winkler 1936-39, no. 910].) They were all executed in chalk, a medium customarily used in portraiture due to its unrivaled capacity for subtle modeling and for rendering the texture of skin, hair, fur, and so on. Like several of his other late portraits, this is not one of Dürer's most telling characterizations. Its overall quality also suffers somewhat from its less than pristine condition. The reworking of Fugger's left eye, however, which has been erased and gone over, is by Dürer's own hand. Very likely the sheet bearing Fugger's portrait originally included a band along the upper edge inscribed with the artist's monogram and the date, as may be seen on the untrimmed chalk portraits Dürer made a few years earlier during his trip to the Netherlands (Winkler 1936-39: nos. 810-811).

Winkler had accurately observed the Coburg drawing's close stylistic connection to Dürer's portrait of Raymund Fugger in Darmstadt (Hessisches Landesmuseum) even before Lieb discovered that the sitters in these two portrait studies were in fact brothers (Winkler 1936-39: no. 916). Although the date on the Darmstadt sketch is no longer legible, a faithful copy in Berlin (Kupferstichkabinett) records it as 1525. The Coburg portrait must have been created at about the same time, given its great stylistic similarity—especially in the delicate rendering of the moustache, beard, eyebrows, eyes, and ears.

Thus, Dürer sketched the Coburg portrait around the time that Anton Fugger took over the management of the family business in late 1525, immediately following the death of his uncle, Jakob Fugger "the Rich." Anton had spent the previous years in Rome, where he gained experience in the local branch office and cultivated the company's contacts with the papal court. Anton managed the family's far-flung commercial empire until his death in 1560 and, with the support of Emperor Charles V, was responsible for opening up lucrative markets in South America, extending from Buenos Aires to Mexico. Under Anton's aegis, the Fuggers maintained their position as the principal financiers of the Holy Roman Empire. In particular, the successful campaign against the Turks and the liberation of Vienna in 1529 under the emperor's brother, Ferdinand, would have been impossible without the Fuggers' financial backing and arms deliveries.

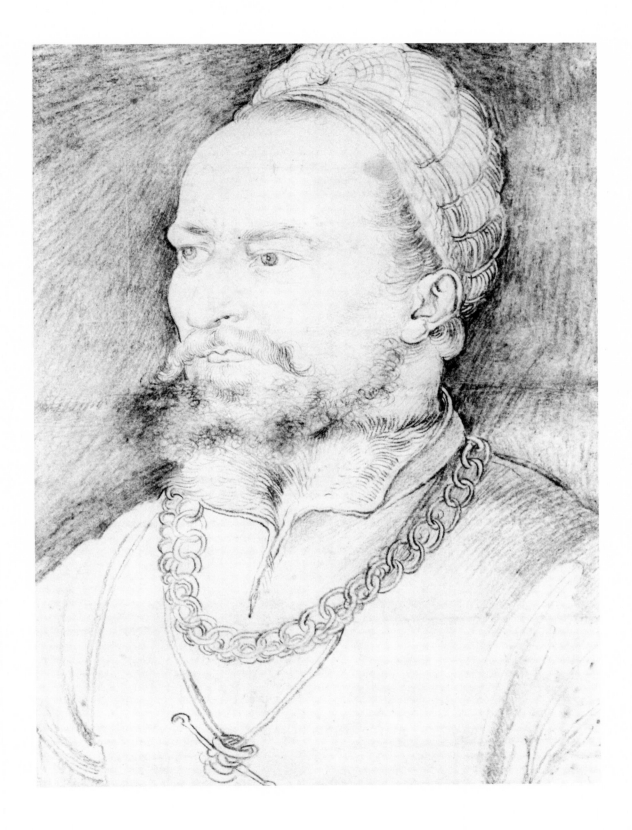

Urs Graf

c. 1485 Solothurn—Basel 1528/29

The most original artist of the Swiss Renaissance, Urs Graf was active in various media of the graphic and applied arts, but his pen drawings are his most memorable work. Trained as a goldsmith by his father in Solothurn and as a glass painter by Hans Heinrich Wolleb in Basel, Graf also designed book illustrations for printers in Strasbourg and Basel, made numerous engravings and etchings, and even wrote a love song, which was published as a broadsheet. Although only a single fragment of Graf's stained-glass paintings has survived, he was probably very prolific in this medium, for which—unlike Dürer, Baldung, and the Master of the Coburg Roundels (see cat. no. 43)—he both drew and executed the designs.

Graf's early work betrays close study of the graphic art of Dürer, Mantegna, Schongauer, Baldung, and Master D.S., but his mature drawings are quite unlike the work of his predecessors and contemporaries. His rapidly sketched inventions were primarily autonomous works of art used as vehicles of personal expression. Employing traditional imagery in unorthodox ways, he created highly revealing commentaries on social and political issues of his time, which provide fascinating glimpses of contemporary life and of the artist's own mentality. In particular, Graf's drawings reflect his service as a mercenary in the military campaigns that played so pivotal a role in European history around 1500. He participated in at least four campaigns between 1510 and 1521 and was present at the humiliating defeat of the Swiss at Marignano in 1515. His firsthand experience of the gruesome fate of mercenaries and camp followers resulted in his *misères de la guerre*, a group of drawings that constitutes his best-known and most timeless work (Andersson 1978: pls. 15, 24-27).

24

Virgin and Child with a Bird, 1513

Pen in black ink with gray wash on reddish brown grounded paper, heightened with white, yellow, and pink, 221 x 180 mm

Trimmed on all four sides; framing line in black ink along edges added later; oxidation of lead white at hem of gown, monogram, and tree trunk

Monogram in white, recto, lower left: *VG*

VC: Inv. no. Z 126

References: Basel 1926: no. 141; Washington 1955: no. 63; Coburg 1970: no. 28, fig. 19; Rowlands 1976: 268

Color plate II

Graf's *Virgin and Child* is an exceptionally well-preserved drawing which exudes a captivating charm, a trait not often found in the artist's later work. By comparison to his mature drawings, known for their superbly spontaneous draftsmanship and trenchant commentary on current events, this composition appears a bit timid in style and expression. Its importance, however, lies precisely in its status as a characteristic but rare drawing from the transitional period during which the artist's mature style gradually emerged. Although by 1513 Graf was already producing some independent and original work (Major/Gradmann 1941: fig. 69), other efforts of this period still strongly reflect his study of foreign prototypes (Parker 1922: 234-235). The Coburg drawing combines traces of the work of Schongauer, Master D. S., and Baldung with such typical features of Graf's personal style as the configuration of the Virgin's left hand. Her figural type and physiognomy reveal the influence of Master D. S., whose woodcuts (Bock 1924: pl. xvi) Graf must have known at the latest by 1509, when he settled in Basel. The jagged mountain peak at the left, the rocky plateau on which the Virgin is seated, and the disparity of scale between the landscape and figures recall Schongauer's engravings (cat. no. 193; Shestack 1969: nos. 73, 75). The veil that billows outward at the Virgin's right as well as the triangular tips of drapery at the lower left and in her lap are also adapted from Schongauer, who in turn appropriated these motifs from Roger van der Weyden. Graf's use of yellow and pink heightening in addition to white is common in Swabian drawings, while the choice of grounded paper shows an initial instance of Graf's fascination with Baldung's chiaroscuro drawings. This fascination appears full-blown in a later drawing by Graf of the same year, also executed on reddish brown grounded paper, the *Virgin and Child with a Putto* in Zurich (Hugelshofer 1928: pl. 25). The closest stylistic analogy to the Coburg *Virgin and Child* in Graf's own work is not a chiaroscuro drawing but a pen-and-ink sketch of a secular theme, *Centaur with a Woman and Child*, dated 1513 (Koegler 1947: pl. 18). Secular subjects were generally more congenial to the artist's satirical temperament, which on occasion, however, asserted itself just as powerfully in his treatment of religious themes—such as his spoofs of saints or attacks on the morals of the clergy (Major/Gradmann 1941: figs. 55, 49).

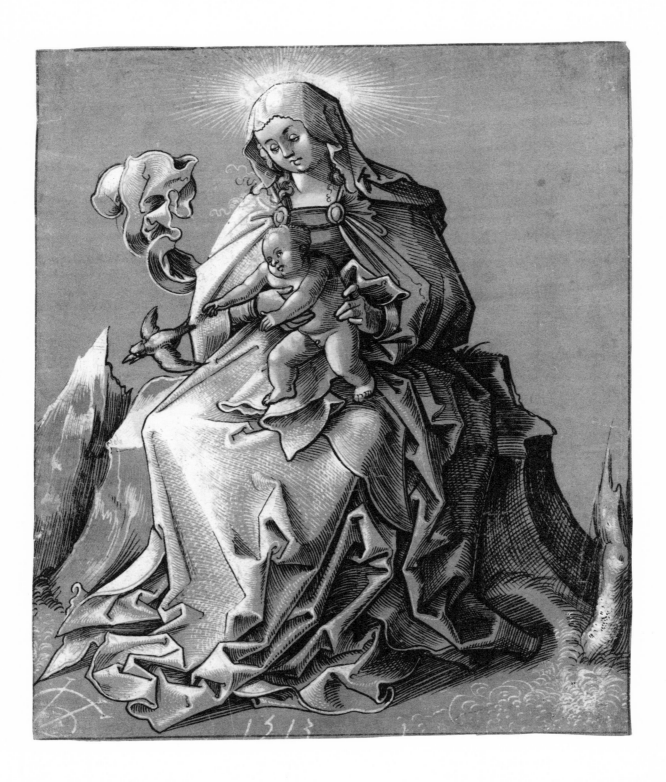

Hans Holbein the Younger

1497/98 Augsburg—London 1543

One of the foremost painters and draftsmen of the Northern Renaissance, Hans Holbein's life and pictorial subject matter underwent major changes as a result of the Reformation. Trained in his father's large and prosperous studio in Augsburg, he moved about 1515 to Basel, where local printers employed him as a designer for book illustrations. His best and most famous work in this medium is the *Dance of Death*, expertly cut in wood by Hans Lützelberger about 1525. Holbein's association with local publishers and humanists resulted in the superb, witty pen drawings decorating the margins of the Protestant theologian Myconius' copy of Erasmus' satirical treatise, *In Praise of Folly*, and in several painted portraits of Erasmus himself. In 1517 Holbein was called to Lucerne to decorate the Hertenstein house with illusionistic frescoes in the new Renaissance style. Capitalizing on his proximity to the Alps, he continued south to Italy. By 1519 he had established his workshop in Basel and joined the painters' guild. Iconoclast riots there and the promise of commissions from Erasmus' humanist friends in England led Holbein to travel to London via the Netherlands in 1526. As Erasmus succinctly summarized the situation in Basel: "here the arts are freezing." During the years 1528 to 1532, Holbein returned to work in Basel, but local religious ferment and the city's official embrace of Protestantism in 1529 prompted a final move to England. There, in 1536, Holbein became court painter to King Henry VIII, a position he held until he died of the plague in 1543. While in England, the large-scale altarpieces that occupied him during the first half of his career gave way almost entirely to secular works of art, including a vast array of designs for the applied arts valued at court and the restrained but compelling portraits for which he is justly famous.

25

Two Designs for Pendants, c. 1536/43

Pen in dark brown ink with brown wash, 104 x 150 mm

Trimmed at top edge; creased horizontally and vertically along the center; several tiny holes; light foxing

VC: Inv. no. Z 262

References: Baumeister 1924: 185, fig. 111; Muchall-Viebrook 1933: 133; Coburg 1970: no. 29, fig. 22; Munich 1972: no. 605; Coburg 1978: 119; Hackenbroch 1979: 123, fig. 307.

Among the loveliest and best preserved of Holbein's many designs for jewelry, these two sketches for pearl-studded pendants display the precision of draftsmanship necessary for execution by a goldsmith, but retain the fluid ductus characteristic of Holbein's best drawings. The meticulous rendering of the figures contrasts effectively with the broadly applied wash, which lends the designs a pronounced three-dimensionality. Holbein employed a number of motifs from the Italian Renaissance decorative vocabulary, commonly used in the applied arts throughout Northern Europe at this time, arranging them into highly imaginative and witty inventions. The Coburg drawing offers a fascinating glimpse into the evolution of Holbein's decorative designs and demonstrates his impressive capacity for subtle variations on standard motifs, which in the hands of lesser artists became lifeless and repetitive (Hackenbroch 1979: figs. 305A, B).

This sheet shows Holbein experimenting with the decorative possibilities of figures combined with vegetal arabesques: on the right the tail of the dolphin carrying a horn-playing putto turns into acanthus leaves, which the putto grasps to maintain his balance on the slippery mount. The mermaid at the left also undergoes successive metamorphoses: her fish tail sprouts leaves, becomes a tendril, and finally blossoms into a large pearl. She dominates the design of the lefthand pendant and determines its asymmetrical form, while at the right, the predominant vegetal motif completely encloses the figure and produces a more regular, rounded outline. The mermaid seems to be playing a zurna, a double-reed wind instrument of Middle Eastern origin related to the shawm. Her winged headdress, to which the chain is attached, has recently been interpreted as a symbol of women's erotic power over men (Koepplin 1980: 271ff.; Ganz 1937: no. 434).

The Coburg sheet occupies a special place among Holbein's jewelry designs because it preserves the original arrangement of the design on the sheet. Other such designs by the artist in Basel and London have been cut apart and trimmed, often to the edges of the image. A few are preserved on the original sheet in the margins of Holbein's portrait drawings, such as that of William Parr at Windsor Castle (Parker 1945: no. 57)— evidently to record an alternative design for painted jewelry in the portrait—but one cannot be sure whether these were Holbein's own inventions or a favorite jewel belonging to the sitter. The fine state of preservation of the Coburg sheet makes this drawing all the more valuable, because the visual quality of a number of Holbein's most sumptuous designs has been impaired by certain workshop practices commonly employed by goldsmiths. For example, a second impression of a design could be taken by applying milk to the original, then pressing

another sheet onto it so as to transfer the design (*Abklatsch*). This practice (Ganz 1937: no. 290) and that of trimming and of silhouetting the contours in black ink have marred many of Holbein's jewelry sketches. Despite the Coburg drawing's importance, it has not received the scholarly attention it deserves. First published by Baumeister in 1924, the drawing is not mentioned in Ganz's catalogue of 1937.

Working from Holbein's designs, a goldsmith would have executed the flesh areas of the figures in enamel, the centers of the blossoms and the dolphin's eye in pearls, and the rest in gold. Three pendant pearls, which were very fashionable in England at this time (Ganz 1937: nos. 323-328), would have been attached by hooks to the ends of the acanthus leaves growing out of the marine creatures. (Only in very elaborate presentation drawings for the king did Holbein distinguish the enameled and gold areas with watercolor and gold wash, as in the final version of the design for a chalice given by Henry

to Jane Seymour in 1536 or 1537 [Ganz 1937: no. 208].) It is not known whether the Coburg designs were ever executed. Not a single piece of jewelry whose design can definitely be attributed to Holbein has survived, all having presumably been lost or melted down by subsequent owners, and only a single example of metalwork—a rock crystal bowl that Holbein designed for the king about 1540—is preserved (Hayward 1965: 82, fig. 4; Hackenbroch 1979: figs. 135-136).

In addition to stylistic considerations, the unusually elaborate designs and precious materials called for in the Coburg sketches indicate that they must have been executed during Holbein's tenure as court artist to Henry VIII, presumably for a member of the court or the royal family. At the British court, gifts of jewelry were customarily offered in public on special occasions, such as on New Year's Day (London 1980: 10-11), and particular favors or services were expected by the giver in return.

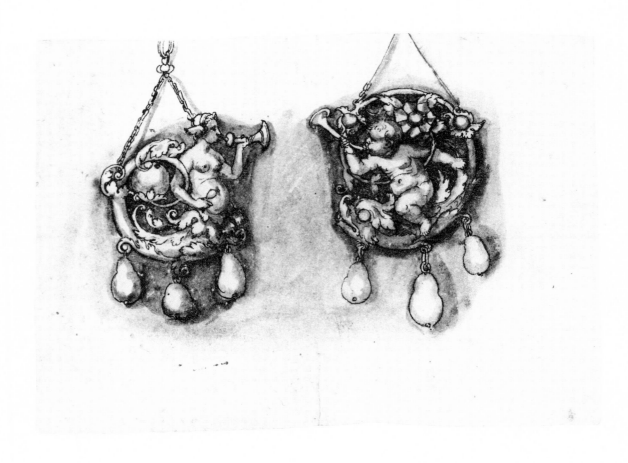

Hans von Kulmbach

c. 1480 Kulmbach—Nuremberg 1522

Next to Baldung, Hans von Kulmbach, whose family name was actually Süss, was Dürer's most important follower. Presumably born in Kulmbach, Hans must have come to Nuremberg about 1500 to study with the master. The mid-16th-century chronicler Neudörfer, however, states that Kulmbach was apprenticed to Jacopo de' Barbari, who was only in Nuremberg from 1500 to 1503. The capacity in which Kulmbach served either master remains unknown, but nonetheless, his early graphic work offers clear evidence of the influence of both artists. Dürer must have had a high regard for Kulmbach's work, since he handed on a number of commissions—including one from Emperor Maximilian himself—to the younger artist during the first decade of the 16th century.

In 1511 Kulmbach acquired citizenship in Nuremberg and established his own workshop. During the second decade of the century, his altarpieces and portraits were in great demand there, and commissions came from as far away as Cracow. Between 1511 and 1516, he produced three altarpieces for churches in that city, which was then one of the cultural and economic centers of eastern Europe. His *Adoration of the Magi* of 1511 (Berlin, Gemäldegalerie) shows several members of the Magi's retinue wearing Polish costume, perhaps indicating that Kulmbach visited Cracow at least once in connection with this commission. In Nuremberg he was active as a designer of stained-glass panels and of woodcuts for book illustrations. The majority of his drawings are stained-glass designs; he was certainly Nuremberg's most important and successful artist in this medium.

26

Seated Bearded Man Holding a Stool, c. 1501
(illustrated on p. 106)

Point of the brush in light brown and gray ink with gray wash, 135 x 163 mm

Trimmed at right; repair of missing corners at top and bottom right; minimal foxing along edges

VC: Inv. no. Z 2321

27

Standing Man Drawing a Sword, c. 1501
(illustrated on p. 107)

Point of the brush in brown and gray ink with gray, light blue, and pink wash, 272 (height at center) x 183 mm

Watermark: Fragment of bunch of grapes (similar to Briquet 12989-13008)

Sheet rounded off at upper corners; small hole at lower right; repair of lower left corner

VC: Inv. no. Z 2320

References: Winkler 1929: 24; Stadler 1936: 80 (Baldung); Paris 1937-38: no. 254 (cat. no. 26, copy); Winkler 1942: nos. 14-15; Winkler 1959: 21-22; Nuremberg 1961: no. 194, pl. 36 (cat. no. 26 only); Coburg 1970: nos. 31-32; Holl 1972: 10, fig. 5 (cat. no. 27 only)

Coburg's two drawings by Kulmbach are the only life studies preserved from the artist's early period, around 1500. Closely related in technique, function, time of execution, and iconographic details, these brush drawings vividly illustrate the young draftsman's rapid progress in realistically rendering the human anatomy and the spatial relationship of a figure to its surroundings. In both works Kulmbach chose a predominantly three-quarter view of a male figure frozen in action while grasping an object with both hands. Despite the inclusion of workshop implements and the figures' scanty garb, which suggest a possible narrative content, the primary function of these sketches is unambiguous: they are studies of figures in movement executed from the live model. An improvement in technique between the drawing of the seated figure and the standing one can be observed: although the upper arm is anatomically awkward in both, the standing figure shows a more refined use of light and shade, resulting in a far greater plasticity, particularly in the upper torso, whose somewhat flabby skin texture is expertly conveyed. The seated figure's foreshortened right leg is successfully handled, but the anatomy of the musculature of the upper body seems poorly understood. Kulmbach neglected to allot space for the stool's legs at the hip and buttock—a lack of artistic foresight remedied in his rendering of the standing figure. However, the overlapping of forms in the seated figure is of interest in that it reveals the sequence of work in this part of Kulmbach's design: the torso was sketched in first, then the stool's legs over it, and finally, the right hand was added.

In the standing figure Kulmbach demonstrates a more advanced understanding of the nature of light by his rendering of shadow. Whereas the seated figure casts a shadow of uniform hue and uncertain contour, in the other drawing the shadow more realistically varies in size and hue, being broadest and darkest at the leg and growing thinner and lighter as the distance from the figure increases. With indications of locale and objects placed as points of reference at varying distances from the standing figure, Kulmbach firmly located it within the pictorial space of the drawing, an aspect entirely lacking in the other drawing. And whereas the physiognomy of the seated figure appears rather summarily treated in comparison to the rest of the body, in the standing figure Kulmbach explored all parts of the model with equal care.

Winkler's suggestion that the two figures are conceptually related seems possible but not particularly likely. The two sheets are certainly not parts of a single composition that was later cut apart, as occurred in Kulmbach's sheet of studies formerly in the Koenigs and Witt collections (Winkler 1942:

nos. 10-11)—the lay lines of the papers do not correspond. That the Coburg studies were conceived as separate entities is also evident from the notable differences in execution, color of ink, and spatial articulation. When the Coburg drawings are viewed side by side, the standing man may at first appear to be drawing his sword in a gesture of attack against the seated figure. Closer inspection, however, reveals that the standing man's glance is not directed down at his putative opponent, but rather straight ahead. The workshop paraphernalia—the stool, chisel, and wooden tub for preparing gesso, glue, and the like—that seem to be unifying features in these sketches were probably included only as compositional "props," not as narrative details.

In the more successful and finished of these two life studies, the figure wears a rather unusual hat. Perhaps Kulmbach chose a black as his model; the figure's mouth resembles that of the Moorish king in Kulmbach's *Adoration of the Magi* in Allentown (Nuremberg 1961: pl. 21). The model's injured nose may be the result of an earlier battle using his curious weapon, which, lacking a hilt, resembles a sword cane. Its spiral carving recalls the famous weapon of Charles the Bold, Duke of Burgundy, which is supposedly made of unicorn's horn and hence is also twisted in this manner (Thomas/Gamber/Schedelmann 1964: pl. 7). However, the spiral carving of swords with hilts fashioned from other materials was not uncommoon in Germany and Flanders during the 15th and 16th centuries.

The point-of-the-brush technique used in both drawings shows Kulmbach to have been an exceptionally talented and observant pupil of Dürer, who had learned the technique during his first trip to Venice in 1494-95 (see cat. no. 3). A characteristic example is Dürer's *Greyhound* at Windsor Castle (Winkler 1936-39: no. 241), sketched with the brush about 1500 after his return to Nuremberg. Like the Kulmbach drawings, this is also a life study, used for the greyhound facing right in Dürer's *Saint Eustace* (cat. no. 135). Kulmbach's studies at Coburg must have been executed soon after Dürer's study at Windsor. Winkler has convincingly dated them to about 1501 by comparing them to other early drawings and to the artist's woodcut illustration of *Apollo and Daphne* in the 1502 edition of Conrad Celtis' *Quator libri amorum (The Four Books of Love)* (Nuremberg 1961: 109). Kulmbach's quick adoption of Dürer's newly acquired technique attests to his strong painterly, rather than graphic, orientation. In this instance, Kulmbach went beyond Dürer in exploiting the full potential of the brush: the marvelously suggestive gray wash rendering the abstract hillocks in the background of no. 27 offers an attractive contrast to the very fine brushwork elsewhere in the drawing.

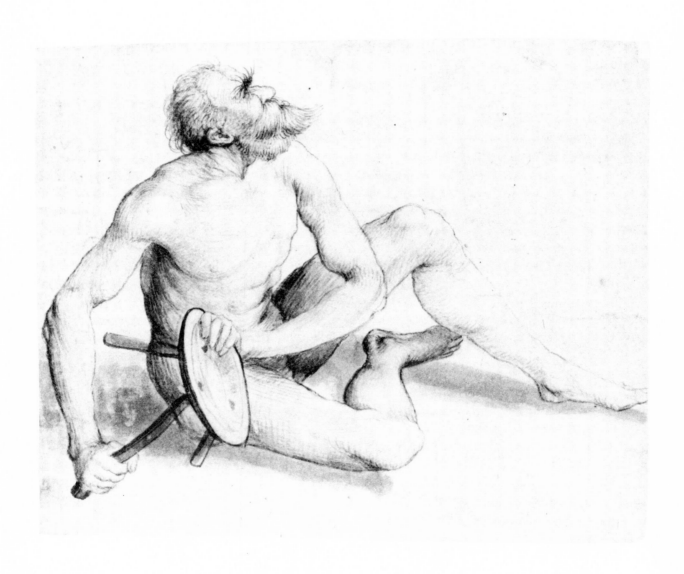

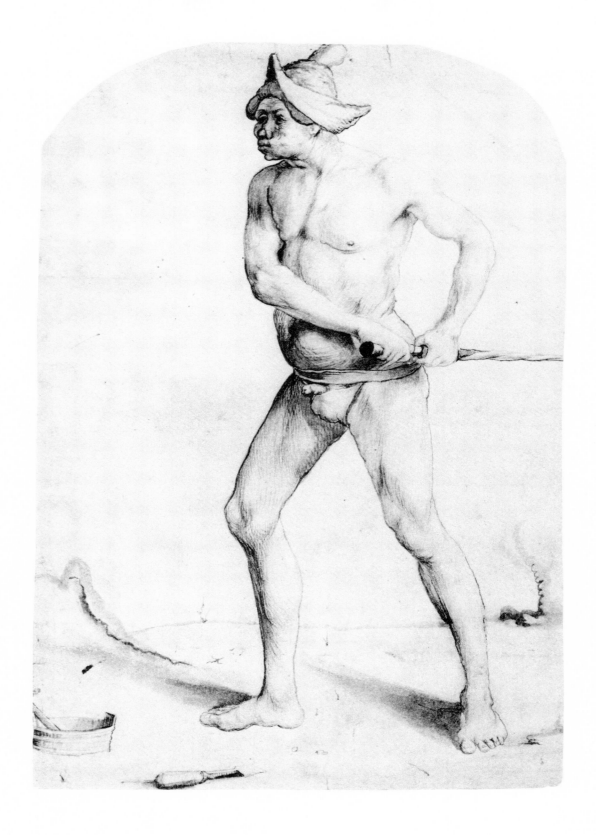

Master of the Coburg Roundels

Active c. 1475-1500

The Master of the Coburg Roundels, also known as the Master of the Drapery Studies, was active in Strasbourg as a painter and stained-glass designer during the last quarter of the 15th century. The artist takes the former name from two drawings of round format at Coburg (cat. nos. 28, 43). The latter name is derived from the most common motif in the master's over 150 drawings: studies of drapery. His work as a draftsman is far larger than his painted oeuvre and outweighs it considerably in importance. Over 30 surviving panel paintings and fragments of fresco decorations in the Church of the Magdalen in Strasbourg reveal him to have been a gifted and prolific but not highly original painter. He seems to have been one of the major exponents of a popular type of small altarpiece with movable wings, in which the tall, narrow panels were folded around a central sculpted figure (Fischel 1934: figs. 2-3). His paintings show a detailed knowledge of the work of the Master of the Karlsruhe Passion, the most important mid-century artist in Strasbourg, who is now generally thought to be identical with Hans Hirtz. In fact, the Master of the Coburg Roundels may well have been Hirtz's pupil. In addition to Hirtz, he drew, although to a lesser extent, on the work of Martin Schongauer (cat. nos. 28-29) (see also "Excursus: The Master of the Coburg Roundels," pp. 388-393).

28

Adoration of the Magi, c. 1480

Pen in brown ink with black chalk lead lines, 220 mm (vertical diameter)

Watermark: Gothic P with flower (similar to Briquet 8765)

Trimmed slightly along left; right and lower edges, repaired horizontal break along center; repaired compass hole at center; repaired hole at center of upper edge; repaired hole under Moorish king's right hand; damage at Virgin's breast; gray ink stain on kneeling king's collar; small extraneous spot of red wash on Moorish king's sword; light foxing

VC: Inv. no. Z 187

References: Geisberg 1908: 302; Kehrer 1909: 112 with pl.; Storck 1909: 264-265, no. 7; Buchner 1927: 284, 287, fig. 52; Winkler 1930: 148; Winkler 1932: 11, pl. 26; Fischel 1934: 33; Naumann 1935: 36, 82; Coburg 1970: no. 2, fig. 3

This design for stained glass was first published in 1908 as the work of the Housebook Master, an attribution upheld until 1927, when Buchner cited it as his prime evidence for the identification of the Middle Rhenish artist whom he called the Master of the Coburg Roundels after this drawing and another sketch of round format, the *Virgin and Child with Angels in a Rose Arbor* (cat. no. 43). Buchner regarded this artist as a close follower of the Housebook Master, whose influence he observed in the *Adoration*. The putative stylistic similarity, however, is only a superficial one and barely extends beyond the fine, rapid, and very dry pen work with its meticulous cross-hatching. Since the Housebook Master appears to have worked in Colmar at the outset of his career, and since the Master of the Coburg Roundels is now believed to have been active in nearby Strasbourg rather than in the Middle Rhine region, the similarity of drawing technique need not be explained by the direct influence of the Housebook Master.

As was pointed out when this drawing was first published, the Upper Rhenish artist whose influence it shows most clearly is Martin Schongauer. His engraving of the *Adoration* (Lehrs 1908-34, v: no. 6; Shestack 1969: no. 8) suggested the general arrangement of the figures in the Coburg roundel and also provided specific details: the pose of the standing king clutch-ing his hat, the monstrance he holds, and the flourish of drapery over his shoulder. Also, the Virgin's features, the chalice of the turbaned Magus, and the right hand holding it aloft are borrowed directly from the engraving.

Although this composition incorporates borrowed motifs, they have been fully integrated, and the roundel may justly be considered one of the master's few surviving independent creations as a draftsman. Many elements typical of his early maturity are assembled here: for example, the physiognomy of the standing bearded king, used again for Pilate in a panel at Mainz (Fischel 1934: fig. 4), and in the *Saint Jerome* drawing in Berlin (Kupferstichkabinett) (Winkler 1930: fig. 133). Characteristic, also, is the profile of the kneeling Magus with the bulbous nose and full lips, the unmistakable legacy of the Master of the Karlsruhe Passion, who employed this facial type in the tormentor on Christ's left in the Karlsruhe *Crowning with Thorns*, a panel the Coburg Master is known to have studied carefully (Fischel 1952: pls. 5, 38). The physiognomic type in the *Adoration* drawing, the use of dots to mark pupils, and the emphatically contoured eyelids are among the hallmarks of his style, hallmarks that facilitate the identification of his hand in other, less independent, drawings.

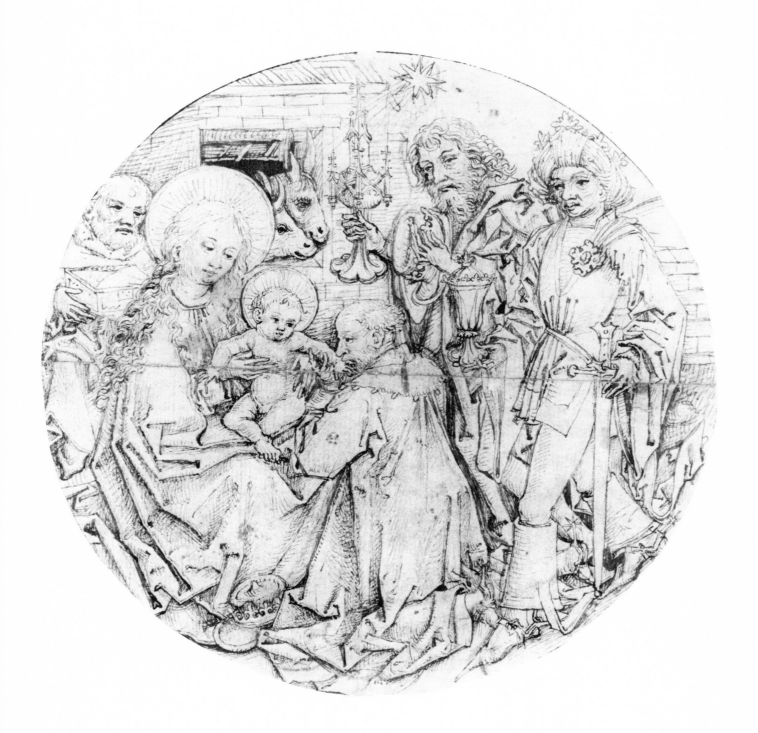

109

29

Crucifixion with the Virgin and Saint John

Christ and cross: Master of the Coburg Roundels, c. 1480

Virgin, Saint John, landscape: Strasbourg Glass Painter, c. 1520

Christ and cross: pen and black ink; Virgin, Saint John, and landscape: pen and grayish brown ink with red and black chalk, 157 mm (horizontal diameter)

Trimmed unevenly to round border, cropping red chalk line in places
Spurious Dürer monogram added in brown ink by Sebald Büheler, recto, near lower center: *AD*

VC: Inv. no. Z 255

References: Winkler 1930: 146; Fischel 1934a: 48; Munich 1947: no. 210 (Nuremberg School, c. 1470)

This stained-glass design is a rare example of a composite drawing produced by two artists belonging to different generations. The crucified Christ was sketched in black ink with a fine pen about 1480 by the Master of the Coburg Roundels, while the Virgin, Saint John, and the surrounding landscape were added in brown ink with a broader pen, probably around 1520, by a glass painter whose style betrays the influence of Baldung. Then the design was squared with black chalk, traces of which are visible around the figure of Christ. The later additions were made in order to transform a quick sketch into a finished composition, which could then be put to practical use. That the resulting drawing was intended as a design for stained glass is evident from its round format, its similarity to other stained-glass designs at Coburg by the same Strasbourg glass painter, and the black chalk lines for squaring. This type of grid over the composition was commonly used to help the glass painter enlarge the composition to the dimensions of the window to be glazed.

The stylistic evidence shows that the artist who fleshed out the master's sketch was one of the glass painters working at Strasbourg under Baldung's influence and adds credence to the view that the Master of the Coburg Roundels worked primarily in that city. Winkler suggested that the glass painter's possession of the Coburg Master's drawing may indicate a teacher-pupil relationship, the pupil having inherited and completed the master's sketch. He erroneously surmised that Baldung may have been a pupil of the Master of the Coburg Roundels, since he believed the later additions to be the work of Baldung—an attribution he attempted to buttress by assuming that the drawing had once belonged to Baldung himself. Winkler misinterpreted the evidence on both counts, however. The later additions are clearly not Baldung's work, and the spurious Dürer monogram added by Sebald Büheler, who inherited the contents of Baldung's workshop after the artist's death (see p. 52), are not sufficent grounds to assume such a provenance. Büheler acquired and monogrammed in similar fashion not only stained-glass designs by Baldung (cat. nos. 1-7, 11-12) but also many designs from the workshops of stained-glass painters in Strasbourg, and it is from the latter source that this sketch must have entered Büheler's collection. Baumeister's assertion (Munich 1947: nos. 211-212) that the later additions to this drawing were made by the same artist who sketched the *Saint Philip* and *Saint Peter* (cat. nos. 13-14) also does not stand up to critical scrutiny.

For his drawing, the Coburg Master copied to scale the Christ in Schongauer's engraved *Crucifixion* (Lehrs 1908-34, V: no. 27; Shestack 1969: no. 32) in every detail but for the drawing's more elaborate rendering of the billowing loincloth, a motif that held particular fascination for the Coburg Master (Buchner 1927: figs. 58-59). The master then adapted Schongauer's figure of Christ for his own painting, *Last Communion of the Magdalen,* now in the M. H. de Young Memorial Museum, San Francisco (Stange 1934-61, VII: pl. 66).

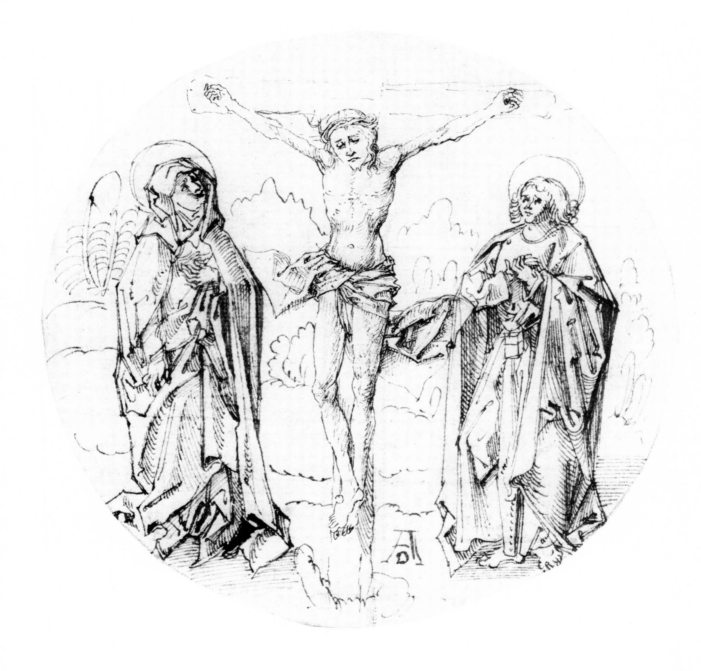

30

Symbolum Apostolicum, c. 1480
(illustrated on pp. 114-115)

Recto: *The Creation, with Jeremiah and Saint Peter*

Verso: *The Last Judgment, with Malachi and Saint Philip*

Pen in brown ink, with inscriptions in red and black ink,
285 x 161 mm

Watermark: Gothic P with flower (Piccard 1977, III: sect. IX,
no. 1142)

Trimmed along upper edge; repaired damage at lower left
edge, recto; water stains along upper left, recto; foxing

Inscribed, recto: in the landscape at left, *erd wiss, pferd, bock,
kugr, su, schaff, sten*; at right, *ber, hirtz, gru*; on Jeremiah's
clothing, *wiss, rot, gl, g, r*; to the right of his head, *gru*; on the
cartellino between the figures, *Jheremie. xxxj.c.* (over crossed
out *v*) / *factus sum isra- / heli. pater.- / Sanctu[s] petrus /
Credo in deu[m] patre[m] / omnipotentem / creatorem celi /
et terre- / A*

Piece of paper glued under the preceding with inscription in
late 16th- or early 17th-century hand: *Patiens vocabis me / et
post me ingredi no[n] / cessabis Hieronymus*

Inscribed, verso: on the cartellino, *Malachie iij c. / Et accedam*
(over crossed out *Ascendam*) *ad vos / in judicio et ero / testis
fidelis velox / maleficis / Sanctu[s] philippus / mathea / Inde
venturus est / judicare vivos / et mortuos / H*; at the upper
right, *a*

VC: Inv. no. Z 218

31

Symbolum Apostolicum, c. 1480
(illustrated on pp. 116-117)

Recto: *Christ in Limbo, with Jonah and Saint Thomas*

Verso: *The Church, with Zephoniah and Saint Simon*

Pen in brown ink, with inscriptions in red and black ink,
286 x 164 mm

Watermark: Gothic P with flower (Piccard 1977, III: sect. IX,
no. 1142)

Trimmed along upper edge; water stains along entire left edge,
recto; extraneous spot of brown wash at center of left edge;
paper dirty; foxing

Inscribed, recto: near Christ's foot, *gel*; on Jonah's right sleeve,
gl; on the cartellino between the figures: *Jone iji* • (?, crossed
out) *c* • / *descendit ad i[n] teriora / navis, et dormivit / sopore
gravi / philippus / Sanctu[s] thomas / descendit ad in- / ferna.
/ E*; at upper left of sheet, *c*

Inscribed, verso: in the portal, *bapst / cardinal epc
[episcopus], bischoff, mu[n]ch*; in rose window, ⌂ [green],
wyss; on clothing of man at right, *golt, wis, r*; on the cartellino
between the figures, *Saphonie iij.c* (over crossed out *v*) /
Invocent om[n]es [in] nom[in]e / nome (crossed out) *domini
et / serviant ei humero vno / Sanctu[s] Symon. / Sanctam
ecclesiam / catholicam s[an]ctor[u]m / communione[m] /
K*; at upper right of sheet, *b*

VC: Inv. no. Z 217

References: Winkler 1930: 136-137, fig. 143 (cat. no. 30), 128,
148 (cat. no. 31); Sonkes 1969: 180-181, 186-187, pls. XLIVa,
XLVIIb (cat. no. 30), 184, 188-189, pls. XLVIa, XLVIIIb (cat. no.
31); Coburg 1970 (inaccurate regarding Sonkes' attribution):
4 (cat. no. 31), no. 7, figs. 4a, 4b (cat. no. 30)

The *Symbolum Apostolicum* illustrates, in a cycle of 12 images with texts, the 12 articles of the Apostles' Creed. It is a typical invention of the Middle Ages in its effort to transpose the central precepts of Christian belief into easily comprehensible serial images and in its typological association of the Apostles with 12 Prophets of the Old Testament. Intended as a means of popular instruction, the *Symbolum* became one of the period's most popular blockbooks, three editions of which are known (Kristeller 1907), and was a common theme in vernacular German plays (Mone 1841: 16).

The Coburg drawings of the *Symbolum Apostolicum* are among the Master's most beautiful creations, executed with a fine pen in the dry, rapid, and restrained ductus and light tonality typical of much of his early work, thus suggesting a date of approximately 1480 for the series. A similarly light tonality and quick, shorthand execution may be observed in the master's sketch after an altarpiece of unknown origin (cat. no. 32), which seems to have been made during the same period, or slightly later. The four *Symbolum* images on two sheets, illustrating the first, fifth, eighth, and tenth articles of the Creed, respectively, belong to a complete series of 12, of which the others are preserved in Berlin (Kupferstichkabinett), Chantilly (Musée Condé), and Hamburg (Staatliche Kunsthalle) (Sonkes 1969: pls. xlivb–ilb). These sketches were long considered to be the work of a Flemish or Dutch master until Winkler pointed out that the numerous inscriptions they carry are written in German; he then attributed the entire series to the Master of the Coburg Roundels. Winkler's suggestion that a drawing formerly in the Wauters collection (Sonkes 1969: pl. lixa) could be a fragment of a further composition belonging to the series is erroneous, since the Wauters sketch is not by the master and the series of drawings Winkler had cited is complete in itself. Each of the compositions devotes the upper, rounded area to an illustration of an article of faith and the lower, niche-like rectangle to the Apostle who ostensibly contributed this article to the Creed, accompanied at the left by his typological counterpart from the Old Testament, a Prophet On the cartellino between them, their names are inscribed in red ink with brief texts of their writings in black ink, and a guide letter below to indicate the sequence of images.

All 12 drawings are copies, as the occasional omission of details demonstrates. For example, the cartellino in *Christ in Limbo* is slightly different in form and was added by another hand, and the triangular form at the top of the cartellino in *The Creation* and *The Last Judgment* is missing in *The Church*. The use of words rather than images to record parts of the composition, as for the animals in *The Creation*, is also typical of a copy instead of an independently created drawing. The master's source, however, has not been identified. Winkler's assumption that it was an illuminated manuscript has been disproved by Sonkes, who observed that the only drawing in the series that records the original frame—otherwise rendered only as a simple semicircle—shows a Gothic column from

which arches spring in both directions (Sonkes 1969: pl. xlivb). The 12 original images must therefore have appeared in an arcade, adjacent to one another on the same surface. This reconstruction precludes a model in manuscript, blockbook, engraving, and any other art form that would not allow all 12 compositions to be seen simultaneously. The prototype could have been a mural, a painting on canvas, a tapestry, or stained glass. The guide letters at the bottom of the drawings, however, cannot have been copied from such a model, since they are necessary only when a sequence of images is broken. As a means of "numbering" pages, guide letters commonly appear in books and manuscripts, and their presence on the drawings probably influenced Winkler's assumption that the prototype had been an illuminated manuscript.

The Coburg sheet illustrates the beginning and end of man's earthly existence as the first and eighth articles of the Apostles Creed. In *The Creation*, God hovers above the newly created earth, which is dotted with the names of animal species, and surmounted by the sun, moon, and six stars. Seated below is Saint Peter, the supposed author of the first article of faith, recorded in Latin on his right: "I believe in God the Father Almighty, maker of heaven and earth." Seated opposite is Jeremiah, whose prophecy of the coming of the Lord is also called to mind by the adjacent text; Jeremiah cites God's words: "I am the father of the Israelites." The *Last Judgment* on the verso most clearly reflects the influence of Roger van der Weyden in its similarity to his Beaune Altarpiece. For this reason, the *Symbolum Apostolicum* copied by the Coburg Master may have been the work of an artist who knew Roger's painting well but who presumably belonged to a younger generation.

The relatively early date and presumably Flemish prototype suggest that these drawings may have been created during the artist's journeyman years, during a trip that may have taken him to the Netherlands, like many other German artists of the period. This hypothesis also raises the vexing question whether the master's over 150 drawings, today dispersed among many collections, once belonged to one or more sketchbooks, as Winkler believed, and if so, to which works this might apply. Artists often made drawings in sketchbooks, especially while traveling, for reasons of practicality, although they were usually executed in silverpoint. The preservation of all 12 drawings of the *Symbolum Apostolicum* allows at least a limited verification of Winkler's view, but the verdict is ultimately negative. The master did sketch on the fronts and backs of all sheets, but not in a recto-verso sequence as they would have presented themselves bound into a sketchbook. If one follows the guide letters that appear on the drawings, the images sketched on the same sheet are: A and H, B and G, C and M, D and L, E and K, F and I. This haphazard order makes it rather unlikely that the *Symbolum Apostolicum* drawings were ever part of a sketchbook.

32

Altarpiece with God the Father, the Virgin, and Three Female Saints, c. 1480

Pen in dark brown ink, 257 x 275 mm

Watermark: Gothic P (similar to Piccard 1977, II: sect. III, no. 131)

Trimmed along upper edge; two pieces of paper joined at level of figures' heads; glue stains along division between sheets

VC: Inv. no. Z 241

References: Huth 1923: 47-48, fig. 19; Winkler 1930: 148, 151

Many sheets of sketches by the Master of the Coburg Roundels consist of a random assortment of copied figures with no indication of their original context (cat. nos. 33, 40). This drawing, however, records the framework in which the figures originally appeared. The sketch was made after an altarpiece of unknown origin, in which the massive central figure of God the Father, enthroned in a fenestrated alcove and holding a scepter, sword, and book, is flanked by smaller figures of the Virgin and Child at his right and three female saints. Although the master employed no wash to indicate plasticity, as was his practice in drawings after sculpture (cat. no. 36), the projection of God the Father beyond the frame confining the other figures shows that at least the central figure of the model must have been three-dimensional. This is consistent with a similar sketch of an altarpiece at Berlin, also devoid of wash, on which the master's notations of the depth and width of the central wooden shrine demonstrate unambiguously that the figures of the Virgin and Child placed within it also must have been works of sculpture (Huth 1923: pl. 18). As for the altarpiece wings recorded in the Coburg drawing, it is likely that they were painted, since altarpieces of the latter half of the 15th century often combined painted wings with a sculpted central group. Coherence between the parts was achieved by decorating the painted wings with dia-phragm arches of real or simulated sculpture, such as appear in the Coburg drawing in rather summary form above the Virgin and Saint Barbara to her right and as a semicircular contour on the other wing.

The varying precision of execution between the left and right sides of the drawing is typical of the Master's rapid, economical manner of copying. Recording only the essentials of the composition and avoiding unnecessary repetition, he thus rendered only minimally or omitted altogether the finials and tracery on the right half of the design, since their configuration was clear from the corresponding details in the left half. This shorthand approach, common also in stained-glass designs (cat. no. 6), demonstrates the primarily utilitarian, rather than aesthetic, purpose of the drawing—evident also in the rather haphazard joining of two sheets of paper at the level of the figures' heads. This division, however, has the advantage of preserving the upper sheet's original beveled edge. It remained untrimmed, just as it was produced in the paper-making process, a state rarely seen on 15th-century laid paper. The very fine, restrained, and even-handed ductus, stylistically similar to that of the *Symbolum Apostolicum* (cat. nos. 30-31), suggests a relatively early date of about 1480.

33

Study Sheet with Kneeling Figures, a Woman's Head, and a Loincloth, c. 1490

Verso: *A Kneeling Female Donor, a Torso of a Praying Woman, and the Head of a Woman*
(illustrated on p. 122)

Pen in dark brown ink and black ink with light brown wash over black chalk, 281 x 212 mm

Trimmed on all sides, irregularly at lower edge and lower right corner; repaired loss at right edge near lower corner; several small holes; faint stain of red wash over kneeling figure at bottom right; lower border line in brown ink along three sides added later

Inscribed, recto: between the lower figures, xı *stöck mit all*; at upper right corner, *damast*

VC: Inv. no. Z 236

References: Buchner 1927: 293, no. 4; Winkler 1930: 148; Naumann 1935: 122 (Grünewald); Anzelewsky 1964: 47

This attractive sheet of studies combines in a random arrangement and in different techniques several standard motifs that the master frequently sketched to serve as models for his paintings. Kneeling figures lend themselves to a great variety of uses: as donor figures, for a Saint Barbara praying before her decapitation or, with the addition of a cloak, as the Virgin at the Nativity, and so forth. Donors kneeling in prayer often appear as diminutive figures in the foregrounds of the master's paintings, and in some instances these figures replicate almost exactly those sketched on the master's study sheets. For example, the matronly donatrix of the *Christ Nailed to the Cross* in Old Saint Peter's at Strasbourg (Fischel 1934: fig. 5) is nearly identical to a donor figure sketched on the verso of this sheet. The donatrix of the *Crowning with Thorns,* also at Strasbourg, displays the same fashionable headdress and braided hair visible in the upper right corner of the recto of this sketch. Christ's loincloth at the upper left is a particularly common motif in the master's drawings and one to which he devoted several study sheets exclusively (Buchner 1927: figs. 58-59). Often these sketches show the loincloth draped over the upright figure of Christ, but in the Coburg drawing a reclining posture is illustrated, suitable for adaptation in paintings of Christ being nailed to the cross, the Lamentation, or the Pietà. The usefulness in a painter's workshop of such an assortment of partial figures is evident also from the existence at Coburg of an early copy (Z 237) of this study sheet, in which the kneeling figures and the woman's head were traced from it.

Compared with the thematically and functionally similar sketches of a kneeling deacon (cat. no. 34), the kneeling figures in the present sketch are more timidly drawn. A certain rigidity of ductus and the discontinuous contours suggest that these motifs were assembled from other sources, which in this case have not yet been identified.

The inscription interposed between the lower figures—*xi stöck mit all*—has not been correctly read or plausibly interpreted. Neither Buchner's nor Naumann's reading is accurate (*xi strich mit all* and *pi stich mit all* respectively), and Naumann's suggestion that the sketch was intended for execution as an engraving is rather fanciful. The work *stöck* (as in *Bildstöcke,* literally: images on podests), presumably refers to sculpture, and the entire phrase seems to indicate that 11 was the total number of sculptures in the work of art from which these individual figures were copied. It is noteworthy that the inscription was not correctly understood by the copyist who traced the drawing, suggesting that the copy (Z 237) was not made in the same workshop. Inscribed *xi stech mir all,* it may have originated in the workshop of the glass painter who was responsible for the later additions to the master's *Crucifixion* (cat. no. 29).

34

Study Sheet with Kneeling Deacon, c. 1490

Pen in dark brown ink with brownish gray wash over black chalk, 182 x 242 mm

Trimmed along upper, lower, and left edges; several repaired holes along upper edge and near lower left corner; small re- paired hole in center of sheet between two figures; tears at upper edge; border line in different shade of brown ink added later; foxing

VC: Inv. no. Z 2310

References: Winkler 1930: 148; van Gelder 1966: 134, fig. 18

This sketch, executed with masterfully spontaneous pen work, presents a lively contrast between two different views of the same kneeling figure drawn in different techniques. The figure at the right was rendered exclusively in pen and ink with extensive hatching, while at the left, fewer strokes of the pen are complemented with wash applied with a brush to suggest the figure's plasticity. In its varied technical means, indicative of the artist's search for different solutions to representing the same figure, this sketch has much in common with the master's studies of a standing female figure (cat. no. 35). Similar also is the rudimentary treatment of faces and hands. Like the benches on which the figures kneel, anatomical forms were of negligible importance in what is basically a drapery study. The most extreme demonstration of this is found in the right fig- ure's hands. They are not rendered descriptively, but rather as an abstract calligraphic flourish.

The cowl on the chasuble and the cross on its back identify the figures as deacons. Their kneeling pose of adoration or prayer suggests that like the figures in cat. no. 33 they were intended as donor figures (see Paris 1937-38: pl. CXXVII, fig. 402). Van Gelder has proposed that they were copied from two figures of Pope Gregory in Roger van der Weyden's images of Justice, formerly in the Town Hall at Brussels. Now destroyed, they are known through a number of copies, including a tapestry at Bern (van Gelder 1966: fig. 3) and a drawing by the Coburg Master in the Bibliothèque Nationale, Paris (van Gelder 1966: fig. 15). Van Gelder believes that the Paris drawing is the most faithful of the surviving copies. However, the deacons in the Coburg sketch display no particular similarity to the figures of Gregory in that drawing. Gregory wears papal garb while the deacons are shown in the traditional attire of their office, and whereas the deacons kneel on benches, in the Paris drawing Gregory stands in an attitude of prayer at the left and kneels on a wooden chapel floor at the right. The figures at Coburg are also reversed from those in the Paris drawing. Given how precisely the master recorded compositions or parts thereof in other instances (cat. no. 39; van Gelder 1966: figs. 13-14), van Gelder's association of the deacons with Roger's lost composi- tion does not seem plausible.

35

Study Sheet with Four Standing Female Figures, c. 1490

Pen in grayish brown and black ink with light gray wash on reddish prepared paper, 208 x 254 mm

Trimmed along right, upper, and lower edges; repaired loss rising about 2 cm from lower edge near center; repaired tear at top of left edge; several repaired holes near heads of two figures right of center

VC: Inv. no. Z 247

References: Berlin 1921: 92, no. 1917 (note); Buchner 1927: 295, no. 10; Winkler 1930: 151

These four simple sketches are among the master's finest drapery studies. The execution of the figures, carried to various stages of completion, seems to have progressed from left to right. The study at the left edge of the sheet differs from the other three in the lighter color of ink, the absence of wash, and the more detailed hatching. The two central figures constitute partial variations on the initial sketch, emphasizing tone rather than line, while the figure at the right offers another variant of the entire figure, rendered in a slightly smaller scale and with a more elaborate train.

The summarily articulated figures were sketched from memory rather than from a model and they display the master's typically selective treatment of his subject. Omitting all extraneous elements, he focused exclusively on the distribution and arrangement of the folds of an ample cloak around a standing figure turned slightly to the right. The face and hands received only the most rudimentary treatment. The stumps of arms and hands visible in all four figures seem mere props, intended to hold up the drapery, which bunches under the right hand and flows over the left. This particular arrangement, often employed for the Virgin Mary, enjoyed great popularity in Upper Rhenish art during the second half of the 15th century. It appears frequently in the work of artists the master admired, for example, in Master E. S.'s engraved *Crucifixion* (Lehrs 1908-34, II: no. 31; Geisberg 1924a: pl. 26) and in the *Disrobing of Christ* by the Master of the Karlsruhe Passion (Fischel 1952: pl. 7). The graceful gesture of the right hand clasping a length of drapery against the body is a Flemish motif, which ultimately derives from Roger van der Weyden's *Christ Appearing to His Mother* in the Miraflores Altarpiece (Panofsky 1953: fig. 321). The motif recurs often in the master's own paintings, such as the *Saint Conrad* in Strasbourg (Musée des Beaux-Arts) (Stange 1934-61, VII: pl. 70).

36

Adoration of the Magi, c. 1490

Pen in gray ink with light gray wash, 266 x 184 mm

Watermark: Gothic P with flower (similar to Piccard 1977, III: sect. x, no. 91)

Trimmed along upper, left, and right edges; large greasy stain bleeding through paper from verso above head of kneeling Magus; extraneous ink spot on kneeling Magus' gown; repaired loss at left side of lower edge; paper soiled

VC: Inv. no. Z 245

References: Nuremberg 1910: 271, pl. 51 (Saxon or Thuringian); Huth 1923: 50, fig. 40; Winkler 1930: 136; Huth 1935: 74, fig. 5; Wittkower 1977: 73-74, fig. 14

Sculptors during the 15th century often used engravings as models for their compositions. This drawing was made after a relief sculpture, which in turn was based on a lost engraving by Master E. S. The existence of the engraving may be assumed on stylistic grounds, particularly the similarity of the relief's design to a known engraving of the same theme by Master E. S. (Lehrs 1908-34, II: no. 27; Geisberg 1924a: pl. 21). The prototype by Master E. S. can only have been an engraving, since the design is used in at least eight other relief sculptures made in various parts of Germany and France during the last third of the 15th century (Huth 1923: pls. 41-42; Huth 1935: figs. 1-8) and thus must have been available in many impressions. One such relief created in Saxony reveals the nature of its compositional source quite explicitly: the goldsmith punches which Master E. S. used as a decorative pattern are rendered in the relief as small wooden knobs (Huth 1923: pl. 42).

The sculpture after which the Master of the Coburg Roundels executed his drawing is an Upper Rhenish *papier mâché* relief, formerly in the Figdor Collection in Vienna (von Falke 1930,

IV: pl. XCVI, no. 214). The Coburg drawing records the relief precisely but for the omission of the fourth window on the tower behind the Magus tipping his turban. Comparison with the relief shows that very little of the tower was lost when the drawing was trimmed at the upper edge. The relief also reveals that the flower hovering in the right background of the drawing is actually an abbreviated tree.

The drawing's technique unambiguously demonstrates its dependence on the relief rather than on the lost engraving by Master E. S. The reliance on wash as the drawing's dominant effect is typical of drawings after sculpture, since wash is the most successful means of suggesting three-dimensionality in the medium of drawing. In order not to detract from this effect, achieved by varying concentrations of gray wash, pen lines were sparingly employed, almost without hatching. This particular combination of delicate contours with broad washes is characteristic of almost all the Coburg Master's surviving sketches after sculpture (Naumann 1935: figs. 24-25; Winkler 1930: fig. 141).

37

Angels with the Instruments of the Passion, c. 1490

Verso: *Three Angels Holding an Orb and Two Angels Displaying Christ's Robe*
(illustrated on p. 130)

Pen in dark brown ink with brownish gray wash, 378 x 275 mm

Watermark: Gothic P with flower (Piccard 1977, III: sect. IX, no. 810)

Trimmed along left and right edges; strip of paper added at left edge; repaired loss near upper left corner; horizontal crease below center; diagonal crease from upper left to lower right in upper half of sheet; border line in dark brown ink at lower and right edges added later; foxing along bottom of recto; fragment of an engraving pasted onto verso at upper right

VC: Inv. no. Z 2311

References: Winkler 1930: 136, fig. 140; Coburg 1970: no. 4

This drawing, with its judicious use of wash and carefully balanced arrangement of figures, is the largest among the master's works at Coburg. The deliberate ductus of the angels' bodies and drapery and the occasional omission of a detail, such as the left wing of the angel holding the crown of thorns, reveal the drawing to be one of the master's many sketches after works by other artists. As in the *Adoration of the Magi* (cat. no. 36), the use of wash suggests a relief sculpture as the drawing's model, but unlike the *Adoration,* the precise work of art the master recorded here has not been identified. The subject and style would seem to indicate that it was an Upper Rhenish devotional image of the type that enjoyed phenomenal popularity during the 15th century. The instruments of Christ's sufferings, described in biblical and apocryphal accounts of the Passion as well as in popular legends, were commonly illustrated in such works of art, which had relatively small formats and which served as devotional aids in meditations on the Passion. The instruments of the Passion were considered to be the Church's most precious relics, and such commemorative images encouraged their veneration. Christ's robe is displayed by angels in a cruciform arrangement, while one of the dice used by the soldiers to determine its next owner appears below the bottommost angel. The objects held by this angel seem to be the shroud and a skull cap. Other angels exhibit the cross; the crown of thorns, scepter, and whip; the nails, lance, and spear; and the column of Christ's flagellation surmounted by the cock that crowed when Saint Peter betrayed him. Three smaller angels react to Christ's sufferings with gestures of grief, an emotion that such devotional images were calculated to elicit from the viewer.

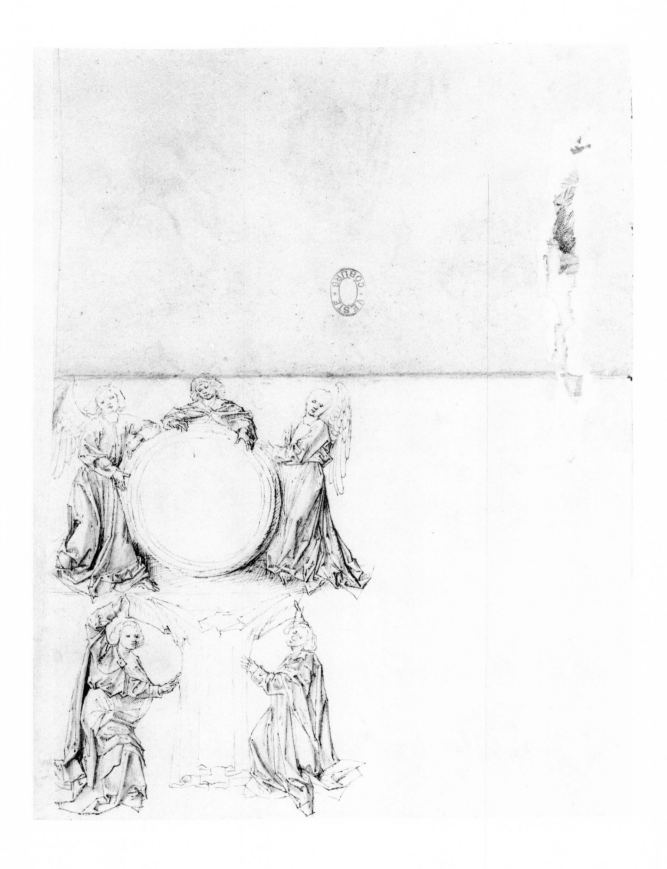

Virgin and Child, c. 1490
(illustrated on p. 132)

Pen and light brown ink, 252 x 166 mm

Trimmed on all four sides

Four color notations, recto, lower left corner (trimmed): *purp-*

rot; near Virgin's sleeve, *vech, bru[n]*; at Virgin's left thumb, *bru[n]*

VC: Inv. no. Z 216

References: Winkler 1930: 132, fig. 129; Schöne 1937: 167, fig. 13; Winkler 1964: 81; Arndt 1964: 96, n. 65

The *Virgin and Child* illustrates the importance of the Coburg Master's drawings as records of lost works by other artists. The sketch is the only known version of a lost painting closely based on the *Virgin and Child* at Pavia attributed to Hugo van der Goes (fig. 18). The lost composition, believed by Schöne to have been the work of a pupil of Dirk Bouts, constitutes the "missing link" between Hugo's small canvas and a host of later copies and adaptations by German and Flemish artists (Schöne 1938: no. 63), and it was the putative Boutsian painting the Coburg Master recorded rather than Hugo's canvas itself. The latter work, like many of Hugo's pictures on canvas, has an Italian provenance and was presumably made for one of his Italian patrons. The choice of lightweight, portable canvas for the painting suggests that it was transported to Italy. If this occurred soon after its completion, the inaccessibility of Hugo's work in the North may explain why the later versions of the image consistently derive from the Boutsian composition preserved in the Coburg drawing rather than from Hugo's own painting.

That the Coburg drawing is a copy after a lost work rather than after Hugo's painting itself is evident from the differences between the drawing and Hugo's painting. The drawing differs from the painted composition in that the Virgin's hands do not overlap, the Child's head is smaller and surrounded by a halo, the drapery folds of the Virgin's gown are arranged differently between her hands, the white swaddling cloth enveloping the Christ Child protrudes further from the Virgin's gown, and her right wrist displays a tight-fitting, patterned sleeve. So reliable a copyist as the Coburg Master would

not have made such substantive and willful changes in a copy, since this would have defeated the purpose of his sketch.

The drawing is of greater interest as an important link in the chain of Hugo's influence on other artists than as a work of art in its own right. What life it possesses derives chiefly from the extraordinary quality of its Flemish model. It is unusual among the master's copies after foreign sources in that no single aspect of the borrowed composition receives particular emphasis. Its homogeneous character renders it one of the master's most objective sketches.

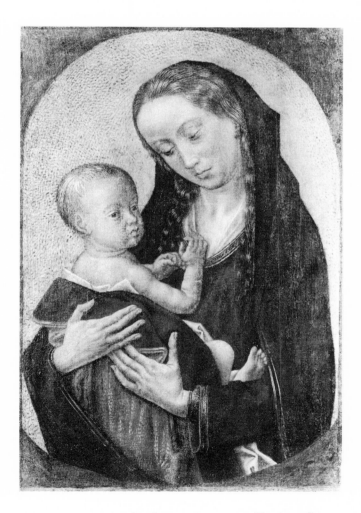

Figure 18. Hugo van der Goes, c. 1435-1482, *Virgin and Child*, c. 1480, tempera on canvas, 405 x 270 mm. Museo Civico, Pavia.

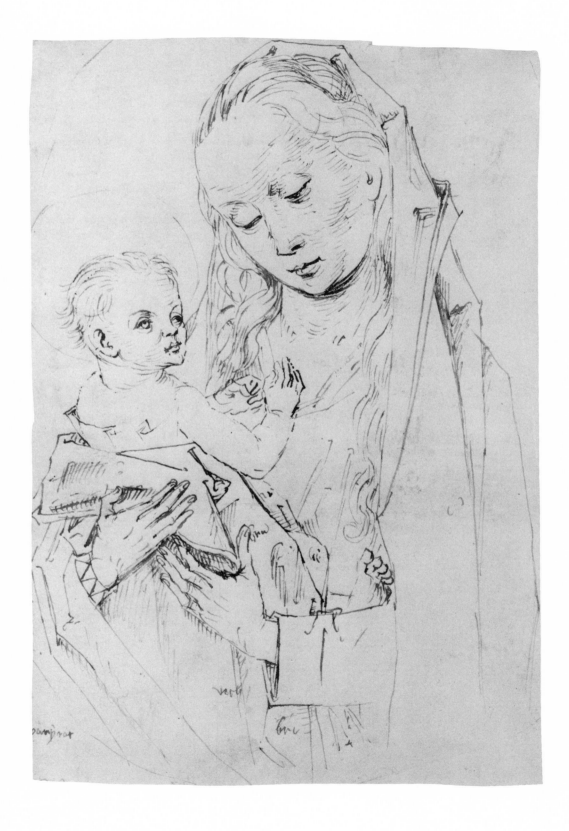

39

Virgin and Child Enthroned, c. 1490
(illustrated on p. 134)

Pen in light and dark gray ink over black chalk, 136 x 211 mm

Trimmed along border line of composition on all four sides; light foxing

Spurious monogram of Martin Schongauer added by Sebald

Büheler, recto, lower right: M⊄†S

The Lord's Prayer inscribed in German on verso, with first word of each line trimmed away

VC: Inv. no. Z 117

References: Winkler 1930: 151

Among the Coburg Master's numerous copies of engravings made for use as models in the workshop (see also cat. no. 40) is the present rendering of the *Virgin and Child Enthroned.* It is based on an engraving of 1466 by Master E. S. (fig. 19). The drawing was executed in the same dimensions as the engraved prototype to facilitate accurate copying. In fact, the principal contours of the drapery in the drawing, executed in dark gray ink, appear to have been traced from the engraving.

A considerable variety of execution may be observed among the Coburg Master's surviving copies after engravings. Unlike the fine cross-hatching with which he attempted to imitate the stippled effect of Master E. S.'s engravings in some of his other works (Naumann 1935: figs. 20-21; Berlin 1921: pl. 100, no. 4618), this drawing displays minimal affinity with the finesse of engraved lines. Nor does it reproduce the vibrant ductus and harmonious quality of the prototype as does the master's copy after three male saints by Schongauer (Naumann 1935: figs. 115-118). By contrast, in the Coburg *Virgin and Child,* the artist applied different artistic means according to his relative interest in various parts of the design. Characteristically, he lavished attention on the Virgin's drapery, while the two angels had no significance for him beyond their general location within the composition. Hence, the master recorded the Virgin's drapery folds with the lifeless precision which suggests tracing, whereas the angels are rendered with a spontaneity bordering on the abstract. Indeed, Christ's crown held by the angel at the right cannot be recognized as such without recourse to Master E. S.'s original composition. The disparate handling of different areas is also evident in the two sides of the throne: having sketched the finials and crockets surmounted by a bird on the left, the master saw no need to repeat them on the right. Even the Christ Child seems to have held no particular interest for the artist beyond his pose; in fact, the blessing gesture of his right hand was changed. The

master also did not record the brocade pattern that Master E. S. used to adorn the Virgin's gown and the back of the throne, since every workshop employed its own patterns (see cat. no. 43).

The master's highly selective rendering of the various parts of his model have produced a less harmonious work of art but a more interesting artistic document. The Coburg drawing is most revelatory of the artist's *modus operandi* regarding the use of foreign prototypes, so characteristic an element of his oeuvre as a draftsman. Rarely does one find the function of a drawing so clearly reflected in its style as here.

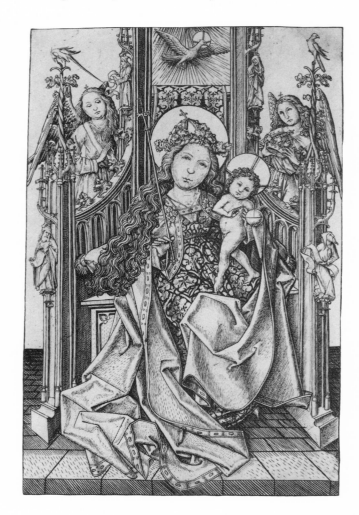

Figure 19. Master E.S., *Virgin and Child Enthroned with Two Angels,* c. 1466, engraving, 137 x 211 mm. Rosenwald Collection, National Gallery of Art, Washington, D.C.

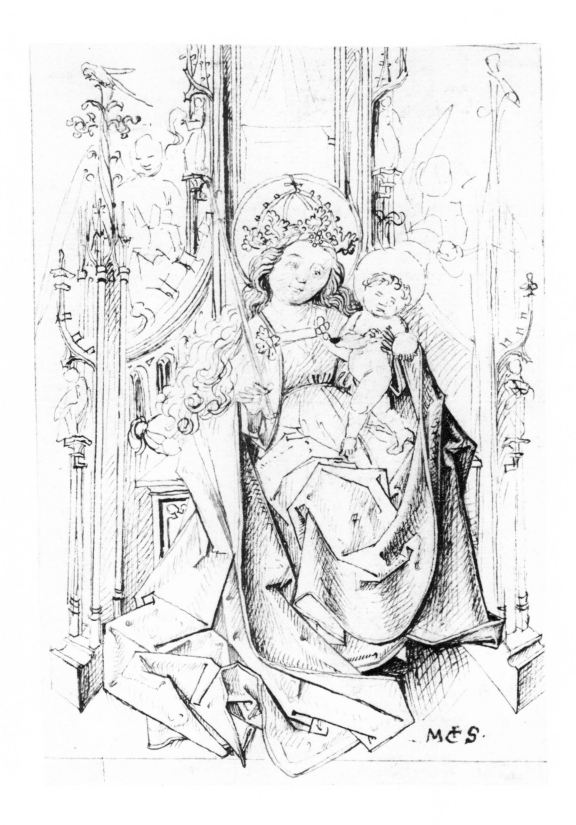

40

Saints James, Philip, and Bartholomew, c. 1490

Verso: *Saints Simon, Paul, and Peter*
(illustrated on p. 136)

Pen in black ink over black chalk, with gray wash on four of six figures, 265 x 198 mm

Watermark: Bull's head with star on staff (similar to Briquet 15096)

Trimmed along upper and lower edges; extraneous spots on James and Bartholomew; extraneous red wash on James; one-centimeter strip of glue along right edge of verso; slight foxing

VC: Inv. no. Z 118

References: Winkler 1930:151; Naumann 1935:22, fig. 16

On both sides of this sheet and a second one at Coburg (Z 119), the Master of the Coburg Roundels recorded the entire series of Master E. S.'s large engravings of Apostles (Lehrs 1908-34, II: nos. 124-136; Geisberg 1924: pls. 89-95) omitting only the figure of Christ, who was traditionally included in such cycles. Unlike the *Virgin and Child* after Master E. S. (cat. no. 39), the Apostles were not executed to scale, the sketched figures being approximately one fourth larger than the engraved ones. In this instance, the artist worked with greater freedom from the prototype and exploited it fully, capturing the essential forms with a few rapid strokes. His economy of line is enhanced by spare applications of wash, employed to suggest the darkest tones in the engravings. This means of emphasizing plasticity, however, was inconsistently used. For example, the absence of wash below Saint Simon's left hand makes this figure look very flat. Such an omission may have resulted from the master's habitual speed of execution.

The Apostles, like the *Virgin and Child*, reveal the Coburg Master's selective approach to his model. Quite predictably, the drapery forms and figural poses interested him most, while the tile floor on which the Apostles of Master E. S. stand was omitted altogether, making the figures appear to hover on the page, as is typical of such random groupings that do not constitute finished compositions. Among the Apostles' varied physiognomies, the clean-shaven, bespectacled Saint Philip evidently offered a subject worthy of considerable detail, unlike the visage of Saint James at the left, whose summary treatment demonstrates that the master felt there was little to be gained from recording yet another bearded head. The halos worn by E. S.'s Apostles were also treated with indifference. Although half a halo is faintly visible in the chalk underdrawing adjacent to Saint Philip's cross, it was not executed in ink. Only three Apostles on the other sheet at Coburg retain the halos of the prototypes fully executed (Fischel 1935: fig. 16). Attributes, too, sometimes receive cursory treatment, as in Saint Simon's cross and Saint Paul's book and sword. Saint Matthew's attribute was left out entirely, rendering his gesture meaningless.

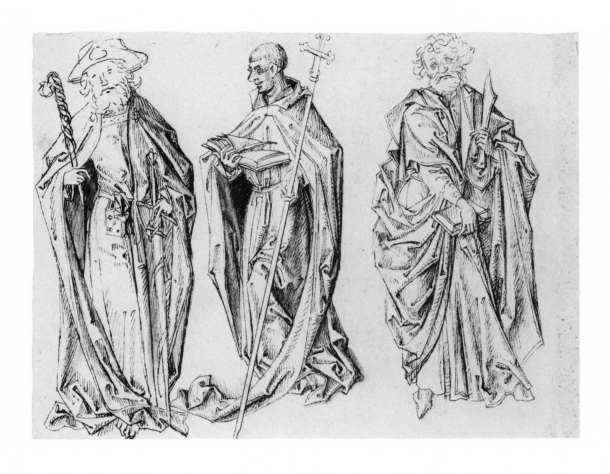

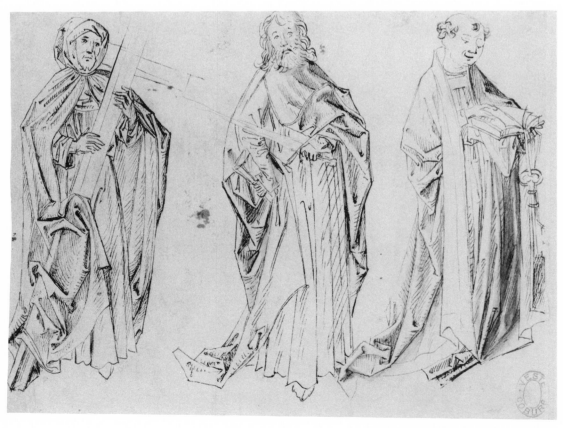

136

41

Presentation of the Virgin, c. 1490

Verso: *Birth of the Virgin*
(illustrated on p. 138-139)

Pen in black ink, 275 x 192 mm

Trimmed on all four sides; two extraneous spots of red wash at left edge, recto; extraneous spot on steps; extraneous red chalk marks at upper right, verso

VC: Inv. no. Z 219

References: Winkler 1930: 141, fig. 148 (verso); Anzelewsky 1964: 50, fig. 8 (verso)

This quick sketch shows the Virgin about to enter the temple, where she was to spend her youth in study and meditation until the day of her betrothal. The event is rendered in the customary medieval fashion, with the expanse of steps as the dramatic focal point of the composition. The Virgin ascends piously, her hands in a gesture of prayer, as her parents and a servant woman take their leave. Joachim holds the traditional offering of doves brought to the temple. The Virgin's future calling is suggested by the two girls seated beside the altar reading their devotions. The scene is succinctly and eloquently rendered with a broad-tipped pen and relatively little ink, giving the black lines a dry, scratchy appearance. The elongated proportions of the figures, the tipped-forward perspective of the architecture, and the minimal articulation of volume and depth suggest that the master's source was a panel painting from a mid-15th-century German altarpiece. Winkler believed that the *Presentation of the Virgin* was copied from the same altarpiece as the *Birth of the Virgin* sketched on the verso of this sheet, the *Meeting at the Golden Gate* (Z 220; Anzelewsky 1964: fig. 7), and *Christ with the Doubting Thomas* (Z 221), also at Coburg. The group is stylistically homogeneous, and altarpieces uniting scenes from the life of the Virgin with those from the Passion are not uncommon. Winkler's view has not been verified, however, since the master's model(s) for these sketches are still unknown. Indeed, neither of the works proposed as sources by Winkler (the Lichtenthaler Altarpiece; Curjel 1923: pl. 1ff.) and Anzelewsky (Peter Hemmel's stained-glass window at Tübingen; Frankl 1956: pl. 82) is convincing.

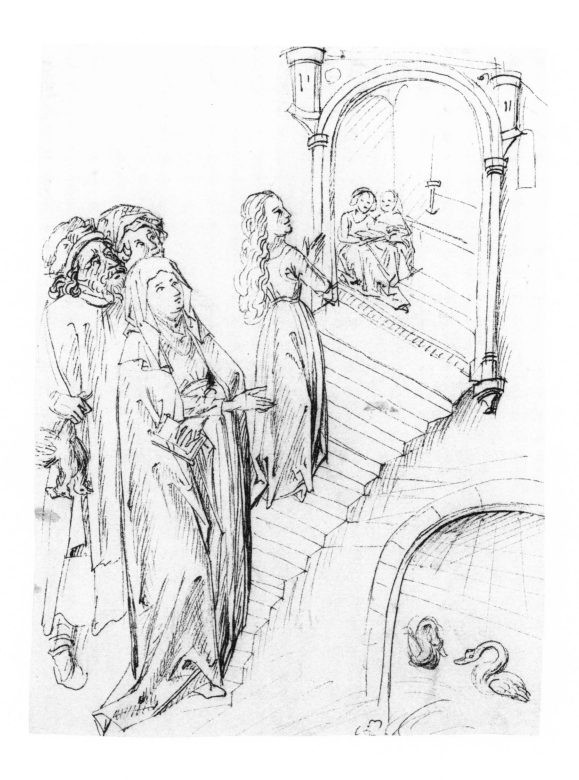

42

Christy Crowned with Thorns, c. 1490

Pen in gray ink, 193 x 279 mm

Trimmed on all four sides; vertical crease at center visible on verso; extraneous ink spot below Christ's drapery

VC: Inv. no. Z 222

References: Winkler 1930: 141, fig. 144; Fischel 1934a: 44, no. 12, 51, fig. 7; Bergsträsser 1941: 62-64, pl. IX; Bergsträsser 1942/43: 7

Perhaps inspired by the violent action inherent in the subject, this drawing is the most extreme expression of the free and spontaneous ductus characteristic of the master's mature work. The ridicule of Christ as king of the Jews is forcefully conveyed by the master's emphatic rendering of the brutal gestures and grotesque physiognomies of the tormentors. The psychology of human cruelty is the actual theme of the sketch; thus, in the master's habitually selective manner, the bystanders and even Christ's expression of humility are only roughly sketched. While the tormentors above Christ use sticks to thrust the crown of thorns into his flesh, those kneeling in the foreground mock the heavenly king: one of them offers Christ a branch as a scepter, while the other doffs his hat in derision while sticking out his tongue. The mocking gesture of the kneeling figure at the left, and the scalloped sleeves and hem of the kneeling tormentor at the right call to mind a similar figure in the *Christ Crowned with Thorns* by the Master of the Karlsruhe Passion, which the Coburg Master copied in a sketch now in the Louvre (Fischel 1952: pls. 5, 38).

The existing literature on this drawing has focused primarily on efforts to identify the source of the composition. Citing stylistic evidence, Winkler and Fischel both associated this sketch with the master's drawing in Berlin (Kupferstich-kabinett), which shows the *Flagellation* and *Christ Bearing the Cross* together on the recto of a single sheet (Winkler 1930: fig. 145) and *Christ Being Nailed to the Cross* on the verso. Fischel believed that the Coburg drawing and the Berlin sketches recorded lost compositions from a putative Passion cycle by the Master of the Karlsruhe Passion, the group of

frescoes formerly in the Dominican Church at Strasbourg, now destroyed. Fischel's identification of the drawing's composition with the Master of the Karlsruhe Passion was probably accurate, but the source she suggested was not. The prototypes for the Berlin sketches and for a series of drawings at the Biblioteca Nacional, Madrid, first published in 1942 by Bergsträsser, are now recognized to be the Passion scenes of a stained-glass window preserved in the church at Walburg in Alsace. The window has been attributed to the Master of the Karlsruhe Passion. The Walburg *Christ Crowned with Thorns* is recorded in one of the Coburg Master's sketches in Madrid (Bergsträsser 1942/43: fig. 2), but this composition is not identical with the one in the present drawing, which has no connection with the Walburg windows and thus no relationship to the Berlin sketches. In 1941 Bergsträsser attempted to locate the drawing's source elsewhere. She saw in it a record of a lost painting by the Colmar artist Caspar Isenmann, citing alleged similarities between the Coburg sketch and Isenmann's *Christ Crowned with Thorns*, a panel from the high altarpiece made in 1465 for the Church of Saint Martin at Colmar (Bergsträsser 1941: pl. III). The suggestion seems plausible, since another sketch by the Master of the Coburg Roundels records a detail from one of Isenmann's panels (Bergsträsser 1941: pls. II, VI). However, Isenmann's work seems rather tame when compared to the brutal gestures and vivid physiognomies of Christ's tormentors in the *Christ Crowned with Thorns* by the Master of the Karlsruhe Passion (Fischel 1952: pl. 5) and it would seem to be these qualities, so eloquently represented in the latter's paintings, that inspired the Master of the Coburg Roundels to create this powerful image.

43

Virgin and Child with Angels in a Rose Arbor, c. 1495

Pen in light and dark brown ink with light gray wash over black chalk, 313 mm (horizontal diameter)

Watermark: Bull's head with staff (fragment similar to Briquet 15122)

Trimmed inside of border line along top and right edge; vertical crease along center; two horizontal creases near center; two parts of sheet glued together horizontally at lower third; glue stains along horizontal division between sheets; small hole near hair of angel in left foreground; damage along vertical and horizontal creases

Inscribed in black ink on small piece of paper glued on verso: *kensterlin / spanbet / bet / küssen*

Two additional pieces of paper, detached from verso and mounted alongside: on the first [Z 233], rough sketch of angel; the inscription *gantz riht*, next word crossed out and replaced with *alleyn ym hīmelrich /* (indecipherable) *nzamss*; on the second [Z 234], *pfannen / becken / bechtstock / hack messer*

Color notation upper right of Virgin's halo: *b*; eight other color notations in black chalk, indecipherable

VC: Inv. no. Z 232

References: Buchner 1927: 298-300, fig. 64; Winkler 1930: 142, 148, 151; Winkler 1932: 11, pl. 27; Naumann 1935: 135, fig. 127 (Grünewald); Haug 1936: fig. 19 (Grünewald); Coburg 1970: no. 1, pl. 2

This and the other stained-glass roundel (cat. no. 28) at Coburg are the two drawings from which the Master of the Coburg Roundels takes his name. Although they differ in size, technique, and date of execution, they count among the few surviving drawings by the master that can be considered his own inventions and they provide an instructive comparison. Although at least 15 years separate the two, the hallmarks of the artist's style are clearly recognizable in both: the slim, tapered fingers, the heavy contour of the eyelids with large dots for the pupils, the fine hatching rendering the planes of the faces, the corkscrew curls of various figures, and the lively articulation of the brooches and crowns worn by the Virgin in the rose arbor and by the Moorish king. As to physiognomic type, the Virgin in the later drawing appears to be a direct descendant of the Virgin of the *Adoration*. In both sketches, too, anatomical accuracy is abandoned where the figures must conform to the round format. The legs and abdomen of the angel holding the Virgin's scepter in the later drawing are abbreviated, as is the lower body of Joseph—condensed into a single foot and a few folds of drapery—in the *Adoration*. Both roundels show the master's propensity for going over the contours a second time in order to silhouette the figures more clearly and to darken the shaded areas. In the later work, however, the fine, rounded flicks of the pen reminiscent of Schongauer have given way to a more schematic treatment, with generally straight, parallel hatching and wash to suggest volume.

The lines for leading and the nine color notations, both applied in black chalk to the *Virgin and Child with Angels*, were added to prepare the roundel for execution in stained glass. Presumably, the Master of the Coburg Roundels was not a glass painter himself and was responsible only for producing the design. A contemporary copy of the roundel exists at Coburg (Z 235), perhaps made by an assistant, possibly due to the master's wish to keep a record of the composition. The absence of color notations on the copy conforms with its putative documentary function.

Another of the master's stained-glass roundels, the *Coronation of the Virgin* in the Ashmolean Museum, Oxford (Oxford 1949: pl. XII), executed in the same technique and having identical dimensions as the *Virgin and Child with Angels*, may have belonged to the same series of designs. The Oxford roundel has not been considered in this context, but it also carries color notations in black ink added by a glass painter and was inscribed by the master on the cloth of honor above the figures: "silk cloth with flowers" *(siden dŏch mit blome[n])*. Although in other drawings by the master such explanatory inscriptions are usually a sign that the composition was copied from another work of art, here it seems more likely that these words are instructions to the glass painter to add a brocade pattern with flowers in this part of the composition. The master's design does not indicate the pattern, since brocades were so ubiquitous a type of decoration that each workshop employed its own (see cat. no. 39). If indeed the inscription on the design in Oxford was intended as instructions to the executing artist, it proves that the Master of the Coburg Roundels was not a glass painter himself, since there would have been no need to give instructions to himself.

Master of the Coburg Roundels (Attrib.)

44

Christ with the Doubting Thomas, c. 1480

Pen in light brown ink, 117 x 100 mm

Trimmed along left and right edges; repaired damage at upper left corner; slight foxing over upper part of recto

VC: Inv. no. Z 243

References: Winkler 1930: 151

This little stained-glass roundel seems to be another of the master's sketches made after an unidentified source. The attribution is uncertain, however, because the composition probably derives from the work of another artist, and because it may belong to the master's early period, about which we have insufficient knowledge. The roundel was listed without comment in Winkler's corpus of the master's drawings. A number of factors tend to support Winkler's attribution. Saint Thomas' large eye with the dot-like pupil, the emphatic contour of his

eyelid, the articulation of his cheek, and the long, tapered fingers of both figures call to mind the master's handling of such details in works like the *Adoration of the Magi* (cat. no. 28). The angular rendering of the fingers of Christ's right hand resembles that of God the Father's right hand in the master's sketch of an altarpiece (cat. no. 32). Finally, the dry, rather scratchy strokes and the contours gone over a second time to render them clearer and darker are also characteristic of the master's technique.

Lorenz Stoer

c. 1530 Nuremberg (?)—Augsburg after 1621

Stoer seems to have lived a long life, although it is illuminated by few known facts. In 1557, when he could not have been much more than 25, he gave up his Nuremberg citizenship and moved to Augsburg, where he was still living in 1621. His known work consists of a handful of drawings, a few designs etched in stone, and his book of 12 geometric designs, including the title page, in woodcut, *Geometria et Perspectiva*.

45

Title-Page Design, c. 1555
(illustrated on p. 146)

Pen and brown ink, with washes in blue, red, green, and brown, 380 x 281 mm

Laid down on sheet of backing paper; two horizontal creases along center; creases at upper right and lower right corners; numerous small tears along edges, especially right edge; long horizontal tear at center, extending inward from left edge to point of star; small holes above *G* in *GEOMETRIA* and above one of points of star at left; water stains at left and right lower corners; brown stains at left; light foxing

Monogram at lower center with city of residence below: *LS / Augustanus* [Augsburg]

Inscribed with title at upper left: *GEOMETRICA ET PERSPECTIVA / CORPORA REGULATA ET / IR REGULATA*

Inscription, lower right: *CVM GRATIA ET PRIVLEGIO S. CAESAREAE /MAIESTATIS*

VC: Inv. no. Z 3901

References: Coburg 1970: no. 39; Augsburg 1980-81: no. 661

Although this design for a title page was never used as such, it was probably intended for Stoer's own book of solid geometric forms, *Geometria et Perspectiva* (cat. nos. 194-195). The actual title page, a chiaroscuro woodcut, was not based on this design, but it nevertheless bears a resemblance to it, since the technique used to create such prints results in a tonal range similar to that achieved by the application of wash to the drawing. Stoer received an imperial privilege for the book in 1555, a date which probably pertains to the drawing as well since the inscription at the bottom of it reads: "with grace and privilege of his majesty, the [Holy Roman] Emperor."

Moreover, the complicated geometric forms, such as the scrolls and the star-shaped polyhedrons standing on one point, correspond to certain objects in the 11 woodcut illustrations in the book. The principal object in the drawing, constructed of a base and vertical stem with projecting arms, bears some resemblance to a cross or a chalice stem of the elaborate kind manufactured by goldsmiths in Augsburg and Nuremberg. In fact, Stoer's closest competitors in the design of books with fantastic geometric shapes in perspective were Wentzel Jamnitzer (*Perspectiva corporum regularium . . .*, Nuremberg, 1568) and Hans Lencker (*Perspectiva . . .*, Nuremberg, 1571), both of whom were goldsmiths (Descargues 1977: 58-60, 63-64; Nuremberg 1980: nos. 16, 18). It seems that those whose professional calling was to delight the eye by fashioning precious metals and gems into fantastic forms had an affinity for the optical wizardry involved in portraying intricate geometric solids by means of *trompe-l' oeil* perspective. (C.T.)

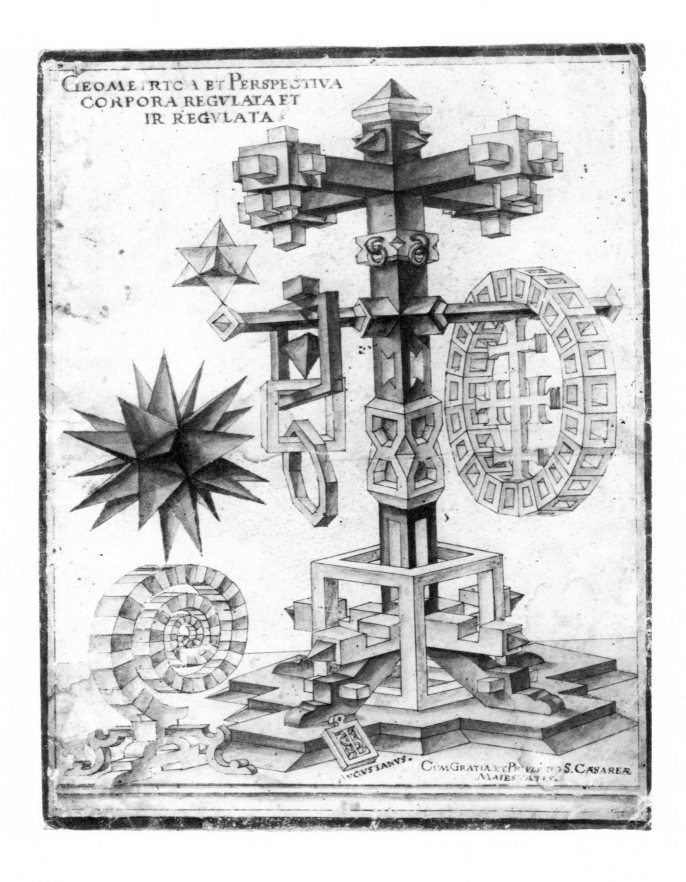

Strasbourg Glass Painter

46

Stained-Glass Design with a Fishing and Boating Party, c. 1530
(illustrated on p. 148)

Pen and brush in brown ink with light and dark gray wash and
red chalk, 112 x 263 mm

Trimmed along upper and lateral edges; detached from lower
part of design; sheet made up of two pieces of paper pasted
together; two holes near female figures on left side; repaired

loss at center of upper edge

Blind collection stamp of 1840s near lower right corner

VC: Inv. no. Z 71

References: Térey 1894-96: no. 141; Stiassny 1896: no. 34;
Kohlhaussen 1936/39: 32, fig. 17

This merry scene of aquatic activities and amorous play cre-
ated by a stained-glass painter of Strasbourg is a stylistically
interesting hybrid, which strongly reflects the influence of the
two most important stained-glass designers working in that
city, Baldung and Weiditz. The drawing is the upper part of a
larger design, of which another substantial but artistically less
compelling fragment consisting largely of derivative work is
preserved at Coburg (fig. 20). The heraldic figure in the main
image is presumably a reversed copy after a lost design by
Baldung, just as a very similar composite design at Coburg
(Térey 1894-96: no. 134) unites a reversed copy after a known
heraldic figure by Baldung (Koch 1941: nos. 74, A 231) with a
superposed scene of backgammon and cardplaying executed
by the same artist as the *Fishing and Boating Party*. The Stras-
bourg glass painter's familiarity with Baldung's work is evi-
dent in the physiognomies of his figures. For example, the
features of the nude man holding his fish net aloft at the right
repeat those of the hunter restraining a dog in Baldung's stag
hunt (cat. no. 6). The most notable difference between the lat-
ter scene and the *Fishing and Boating Party*, however, is one
of technique, which demonstrates how much stronger an im-
pression Weiditz made on the Strasbourg glass painter than
did Baldung. Brown ink with gray wash is one of the hall-
marks of Weiditz's style. The Strasbourg artist employed the
same means but with a different emphasis. The preponderance
of brush and wash over pen lines in the Coburg drawing
achieves a more exclusively tonal effect than is ever found in
Weiditz's own work. The Strasbourg artist also followed the
latter's preference for extensive, multifigured panoramas (cat.
no. 52) rather than Baldung's condensed images limited to a
few large figures (cat. no. 7). The architectural frame also
betrays Weiditz's influence in the leaflike ornamentation of the
arch (Parker 1928: pl. 59) and of the pilaster (fig. 20), in the
fine parallel hatching of shaded areas, and in the Renaissance
decorative reliefs. (An unusual miscalculation resulted in
the disparity of scale between the two nude women bending
over a wooden tub under small trees and the rest of the com-
position.)

Fishing was one of the most popular themes among the illus-
trations of sports that frequently decorated late Gothic stained
glass (Schmitz 1923: pls. 6-7). As the stained-glass genre
evolved, fishing came to be represented as an amusement
rather than a livelihood and therefore often appeared in com-
bination with boating parties, as in a sketch contemporaneous

with this drawing by Augustin Hirschvogel (Baumeister 1938/
39: fig. 5). In astrological calendars, bathers had always been
grouped among the children of the planet Venus. Thus when
bathers were added to these images of fishing and boating, the
amorous connotations of such pastimes were unambiguous
(Kohlhaussen 1936/39: fig. 16). The suggestive nature of
aquatic activities was familiar both in daily life and in popular
culture. In the richly metaphoric idioms of 16th-century Ger-
man, the erotic associations of water are manifest in expres-
sions such as "drowning in lust," or "catching fish." The latter
expression referred to love-making (Sachs 1875: 253) and was
responsible for a particularly amusing image common in Ger-
man and Swiss stained glass of this period (see Karlsruhe
1978: fig. 7), in which a nude woman lures her suitors into a
fish trap identical to that wielded by the nude woman seen
from behind in the right background of the Coburg drawing.
The double-entendre implied by the catching of fish was cer-
tainly not lost on the public for whom such stained-glass
designs were made. Indeed, the preliminaries to the metaphoric
catch are explicitly shown in this drawing.

Figure 20. Lower part of cat. no. 46. Kunstsammlungen der
Veste Coburg (Z 41).

147

Swabian Master

47

Standing Foot Soldier, c. 1480/90
(illustrated on p. 151)

Pen and brush in brown ink with gray wash, heightened with white, on gray grounded paper, 271 x 146 mm

Trimmed on top, bottom, and left sides, and diagonally at upper corners; tears at right and lower edges

Laid down on old paper bearing three lines of printed text (a Latin elegiac couplet) visible upside down on recto at both sides of figure's head: *Haenichium praesens tradit pictura verendum; / Ingenium monstrat concio docta pium / M. Georg Klein*

VC: Inv. no. Z 231

References: Lauts 1938: 13; Winzinger 1980: 28

Color plate III

The *Standing Foot Soldier* is a characteristic example of the life studies that late 15th- and 16th-century artists routinely produced and valued as workshop resources. Studies of soldiers were especially useful, since they constituted the supernumeraries in a great variety of religious pictures, particularly in scenes from the Passion and in martyrdoms of saints.

The *Standing Foot Soldier* has been attributed to Mair von Landshut (cat. nos. 168-169) in the ducal collection since the beginning of the century, but it has never been mentioned in published studies of this artist's work. The attribution was presumably arrived at by a comparison with Mair's *Standard Bearer* in the Louvre (Buchner/Feuchtmayr 1924, I: pl. 80), executed in the same chiaroscuro technique but on blue-green grounded paper. The Coburg drawing, however, has little in common with Mair's sketch other than the analogous technique and the subject, a standing soldier in armor facing left. The Louvre drawing, signed at the lower right with the initial *M*, displays Mair's characteristically rapid ductus and emphasis on strong contrasts of light and shade, while the Coburg drawing exhibits far greater precision of handling and a more varied tonal range, achieved by the addition of gray wash as a middle value and finely rendered highlights on a lighter colored ground. Stylistic and technical evidence indicate that the Coburg sketch originated in Swabia, the home of Mair von Landshut, but it is not an autograph work by him.

The Coburg drawing was recently cited by Winzinger in his attempt to distinguish armor studies made by painters from those made by armorers (Winzinger 1980: 27-29). Without questioning the attribution to Mair, Winzinger again associated the Coburg drawing with Mair's *Standard Bearer* at the Louvre, and discussed these along with additional examples of late Gothic armor studies in the Graphische Sammlung Albertina, Vienna (Schönbrunner/Meder 1896-1908, VIII: pl. 874), and in a Swiss private collection (Winzinger 1980: pl. 11). An important addition to this group not mentioned by Winzinger

is the *Standing Foot Soldier* in the Ian Woodner collection in New York (fig. 21). Very similar to the Coburg drawing in technique, it shows a suit of armor almost identical to that in the Albertina drawing but is executed by a more skillful and later hand. Noting the accuracy of technical detail shown in the study in the Swiss collection, Winzinger designates this as a working drawing by an artistically gifted armorer, while the other sketches he terms preliminary studies by painters, since in these the armor is "treated rather summarily." A lack of precise technical detail can indeed be observed in Mair's sketch at the Louvre, which clearly was executed from memory, but not in the works at Coburg and in the Albertina, whose armor is so painstakingly rendered as to allow identification of the time and place of their origin. Winzinger's distinction on the basis of technical precision between studies of armor made by armorers and those made by painters assumes that only an armorer would possess the technical understanding displayed in the more exact studies. But this assertion is contradicted by armor studies executed by painters, such as Hans Baldung's sketches made directly from the model, perhaps in an armorer's workshop (cat. no. 10). How armor studies may reveal the draftsman's profession is an intriguing question, but it cannot be answered on the basis of technical precision alone. At most these studies show whether they were made from memory or directly from the armor, to which both armorers and painters had access.

The Coburg drawing displays a degree of realism and technical accuracy typical of studies from a model. The armor is South German and was probably made in one of the prominent centers of the craft: Augsburg, Nuremberg, Landshut, or Innsbruck. This type of steel armor, which left the legs free to allow maximum mobility, was worn by foot soldiers; the weapon shown, a pole ax, is that of a captain. By contrast, the rank and file carried bayonets, as in the drawing in the Woodner collection. The armor is worn over a coat of mail, visible along the arms and on the upper legs. The breastplate, shoulder pieces, and elbow cops, or covers, are held in place by double loops threaded like shoestrings through the mail from the undershirt worn beneath it. The single rivet in the center of the overpiece fastened it loosely to the breastplate, affording the upper torso considerable mobility. The besagews, or rosettes, at the armpits were designed to protect the vulnerable area between the breastplate and shoulder piece.

The *Standing Foot Soldier* at Coburg wears a German sallet, or helmet, with a half-visor, while in the Woodner study, the more closely fitting and confining helmet with raised visor derives from Italian types. Unlike the Woodner armor, whose central folds and V-neck imitate the appearance of a tunic, the style of armor in the Coburg sketch has a purely functional design and shows no analogies to contemporary dress. The precision of execution of the Coburg study can be seen in the reflection of the gauntlet on the right side of the breastplate opposite the forearm, while the Woodner armor shows the reflection of the double Gothic windows of the studio where the drawing was made.

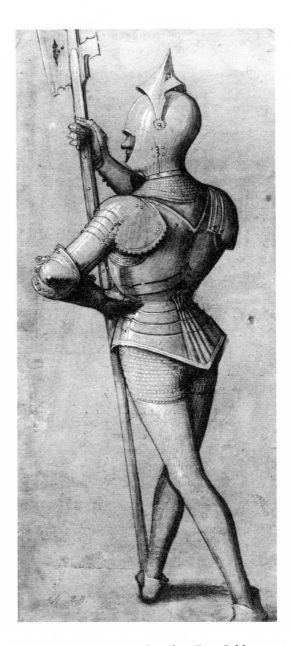

Figure 21. Anonymous, *Standing Foot Soldier*, c. 1490, pen in dark brown ink with gray wash, heightened with white, on gray-brown grounded paper, 288 x 122 mm. Ian Woodner Collection, New York.

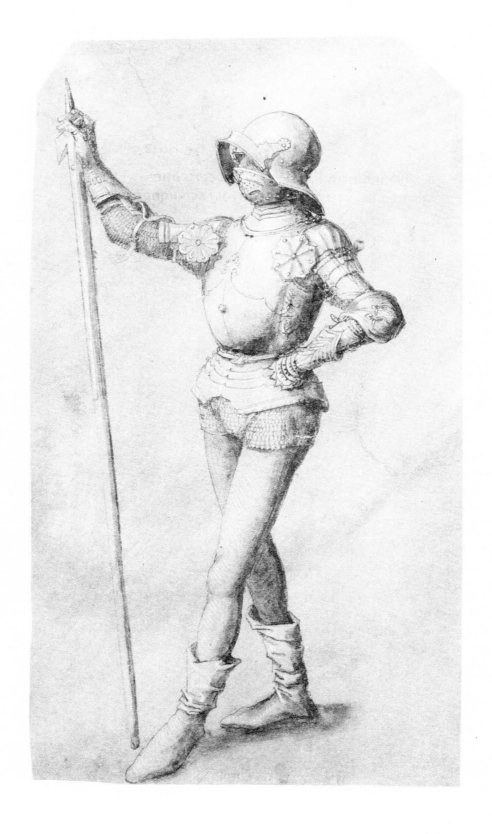

Swiss or Austrian Master

48

Vanitas, c. 1540/60

Pen in black ink heightened with white on reddish brown grounded paper, 178 x 143 mm

Trimmed on all four sides; vertical crease near right edge; old repair of vertical strip at top right; damage at bottom right corner; oxidizing of lead white at left sleeve and on quills over animal's head; hole at middle left background; several tears at right edge; large stain at upper left

VC: Inv. no. Z 3

Unpublished

This drawing typifies the allegorical images that artists of the Northern Renaissance found so appealing. Whereas the image of a woman seated frontally before a landscape was generally reserved by earlier generations for the Virgin (cat. no. 24), minimal changes in dress and attributes transformed the meaning of such figures into secular allegories. That the Coburg drawing is a symbolic image is clear from the inclusion of the skull and convex mirror, objects traditionally given moralistic significance, and from the unrealistically large scale of the figure's mount, a hedgehog. By the late Middle Ages, a convex mirror, here set in a wooden frame, had become, on the one hand, a symbol of clear-sightedness, self-knowledge, and prudence, and, on the other, of the vanity and worldliness of those who admired their own reflections. In the latter case, this motif generally expressed a moralistic warning, since self-love was thought of as a form of pride, a vice condemned by the Church. The skull symbolizes the transitoriness of human life and of all worldly endeavors.

In 16th-century art, both Vanitas and the virtue Prudence display a mirror and skull as their attributes. In the Coburg drawing, the décolletage and feathered cap, the garb of contemporary camp followers, do not convey the appearance of a virtuous woman (see cat. no. 59). Thus, Vanitas seems a more likely appellation than Prudence for this worldly creature. This interpretation is reinforced by the oversized bristly animal upon which she sits or rides. Its general proportions, small head, long snout, and hairy paws with three claws correspond exactly to the illustration of a hedgehog in Conrad Gessner's mid-16th-century treatise on animals. Hedgehogs were commonly understood as symbols of sensual indulgence in German popular culture of this period. In colloquial German, "hedgehog" referred to the female genitals in the expression, "pricking the hedgehog," a favorite humorous euphemism for love-making during the 15th and 16th centuries. By extension, "hedgehog" was also a slanderous epithet applied to philanderers. The hedgehog could also allude to intemperate drinking. In Johann Fischart's satirical treatise *Geschichtklitterung (Falsification of History)* of 1575, for example, a drunkard rationalizes his vice by explaining that he has a hedgehog in his stomach that pricks if it is not kept afloat. This explains its appearance on the banner of Aldegrever's engraved allegory of gluttony (Bartsch 1803-21, VIII: 128). The unusual association of Vanitas with a hedgehog in the Coburg drawing was evidently intended to convey a warning against both drunkenness and adultery as sins of self-indulgence.

The drawing's attribution and date are considerably more problematic than its meaning. Only faint echoes of the so-called Danube School style are evident in the Coburg *Vanitas*. For example, her physiognomy has some similarity to that of the nude princess in Wolf Huber's chiaroscuro drawing of *The Penance of Saint John Chrysostom*, dated 1518 (Winzinger 1979: pl. 52). The awkward, schematic handling of the white heightening on the skirt achieves a flat, decorative effect rather than a plastic one; usually more skillfully executed, this style is prevalent in drawings of the second half of the 16th century. The woman's costume, however, is typical of the fashion worn in southern Germany and Switzerland around 1520, as exemplified by Niklaus Manuel Deutsch's design for a woodcut of that date, in which the same leather beret with ostrich feathers, the square décolletage, and the slashed sleeves revealing the blouse underneath are worn by a camp follower (Bern 1979: pl. 134). Thus, there seems to be a chronological disparity between the figure type and the style of execution. On this basis, Winzinger has proposed that the Coburg *Vanitas* may be a very early work by Tobias Stimmer, based on an earlier prototype. The present writer, however, cannot concur with this view.

Hans Traut

c. 1460 Speyer—Nuremberg 1516

Hans Traut was a fresco and panel painter who worked for churches and patrician families in Nuremberg and neighboring towns, as well as for Duke Friedrich the Wise of Saxony. He was about ten years Dürer's senior, and his known activity extends from 1488 to 1508. A document which calls him "Hans from Speyer" identifies his native city on the Rhine and reveals that he acquired citizenship in Nuremberg in 1491. It has been suggested that Traut was trained under Martin Schongauer's brother Ludwig, traces of whose figure types, landscapes, and architectural details can be detected in Traut's painting (Stange 1934-61, IX: 73). Traut's early work reflects the influence of the mature styles of Hans Pleydenwurff and Michael Wolgemut, Dürer's teacher. The quality of the approximately 45 panels attributed to him fluctuates considerably, and it has been proposed that the better paintings were collaborations with the gifted painter Wolf Traut, presumably a relative, who also hailed from Speyer

(Strieder 1959: 473-474) and who later took over Hans' workshop (Nuremberg 1968: nos. 87-88). Both Trauts worked extensively for the former Cistercian abbey, now the cathedral, at Heilsbronn in central Franconia. Hans executed a variety of mural decorations there between 1488 and 1495, while Wolf produced several altarpieces between 1512 and 1518. Hans Traut's hand was recognized in the body of work formerly attributed to the Master of the Heilsbronn Altarpiece after a postwar restoration uncovered an inscription identifying him as the creator of the high altarpiece at Katzwang—providing for the first time an authenticated example of Traut's painted work. The identification of the Master of the Heilsbronn Altarpiece with Hans Traut is now generally accepted. Although Traut lived until 1516, the absence of any known work after 1508 lends credence to the belief that he went blind in old age, as reported by the chronicler Johann Neudörfer in 1547.

49

Holy Kinship, 1504

Pen and brown ink, 244 x 185 mm (excluding lower frame)

Repaired holes at lower left and center; torn diagonally from lower edge to upper right; two stains at top left of center

Inscriptions: on upper banderole, *hic est filius meus-quo michi cui*; on banderoles above figures and on halos, *ysmeria, ELISABETH, johs̄•ba, ELIVD, SEVATIVS, MEMELIA,*

EMINEV IOSPHI, ioachim, SALOME, CLEOPHAS, Alpheus, maria•cleophe, simon, iacobus•minor, johs•ev, maria•Salome, Zebedeus

VC: Inv. no. Z 188, Z 189 (lower frame)

References: Muchall-Viebrook 1933: 132; Nuremberg 1968: 111 (for the epitaph: Stange 1934-61, IX: 75; Fehring/Ress 1961: 101; Stange/Lieb 1967-78, III: no. 188)

The *Holy Kinship* is a preparatory drawing for the *Epitaph of Johannes Löffelholz*, dated 1504 (fig. 22), preserved in one of the south aisle chapels of the Church of Saint Lorenz in Nuremberg. The deceased was the 11-year-old son of the well-known humanist of the same name (*ADB*: 93ff.), whose arms and those of his wife, Katharine Dintner, flank the Latin distich inscribed at the bottom of the painting. Of Löffelholz's nine children, little Johannes had been the first male to survive beyond infancy. The keenly felt loss of the family's only male heir explains the dedication of so unusually lavish an epitaph to a child. In addition to the epitaph, Traut received at least one other commission from the Löffelholz family: a group of frescoes bearing the family crest that once decorated the Augustinian cloister in Nuremberg (demolished in 1872).

The Löffelholz's concern for the continuation of their family line is reflected in the choice of the epitaph's subject: the *Holy Kinship*, that is, the Virgin, Child, and Saint Anne surrounded by a multitude of their relatives, including Joachim—Saint Anne's husband and the father of the Virgin—Saint Anne's two subsequent husbands, their daughters, sons-in-law, and grandchildren, as recounted in the 13th-century *Golden Legend*. Many of the figures are identified by banderoles or inscriptions.

Although long recognized as the study for the Löffelholz *Epitaph*, the *Holy Kinship* drawing remains practically unknown. It is a pictorial expression of one of the most popular devotional traditions of the late Middle Ages in Germany, which focused on the Virgin's mother, Saint Anne, whose veneration was actively encouraged by the Franciscans beginning in the 13th century. The cult of Saint Anne, which had reached its high point in Germany by the time of the Löffelholz commission, gained its great popularity from the promise of her protection during the crucial stages of life—birth, marriage, and death. She was venerated particularly by women for her exemplary motherhood. Since Christian tradition holds that Saint Anne remained barren for many years before the birth of Mary, the saint also offered hope to childless couples, and her subsequent fertility elicited the veneration of pregnant women, for whose safe delivery masses to Saint Anne were read. As the patron saint of marriage and the family, she was called upon to aid young women in finding husbands, during wedding ceremonies to ensure ample offspring, and during childbirth. Saint Anne's patronage of married couples dictated, for example, the choice of the Holy Kinship as the subject of Lucas Cranach's altar panel executed on the occasion of his marriage (Friedländer/Rosenberg 1978: fig. 34). By 1500, the

cult of Saint Anne had acquired dynastic significance for German patricians, who appealed to the saint for the prolific continuation of their lineage. This is evident in Bernhard Strigel's Vienna portrait of Emperor Maximilian's family in the guise of members of the Holy Kinship, in which inscriptions originally identified each sitter as a relative of Christ (Kleinschmidt 1930: fig. 94). The saint's protection was also solicited in times of pestilence and at the hour of death, a custom which accounts for images of the Holy Kinship in epitaphs and memorials (Friedländer/Rosenberg 1978: fig. 18).

The Coburg sketch is the only known drawing by Traut that preserves an original composition. It is typical of preparatory work in the abbreviation or occasional omission of inscriptions on banderoles and in the cursory rendering of self-explanatory details, such as the brocade pattern of the throne. A number of changes were made between the execution of the Coburg study and the finished epitaph. Traut replaced the upper throne with a cloth of honor held aloft by angels, enlarged the figure of God the Father, and changed the angle of the balustrade in the right background. In addition, several of the figures were shifted around to clarify their family relationships; of the fourteen banderoles in the drawing, only three remain in the panel; the names of saints retain their place in halos, but the names of other figures have been transposed to clothing, hats, or to the balustrade; and the generalized physiognomies in the drawing take on specific features in the painting.

Figure 22. Hans Traut, *Epitaph of Johannes Löffelholz*, 1504, oil on panel, 157 x 121 cm. Church of Saint Lorenz, Nuremberg.

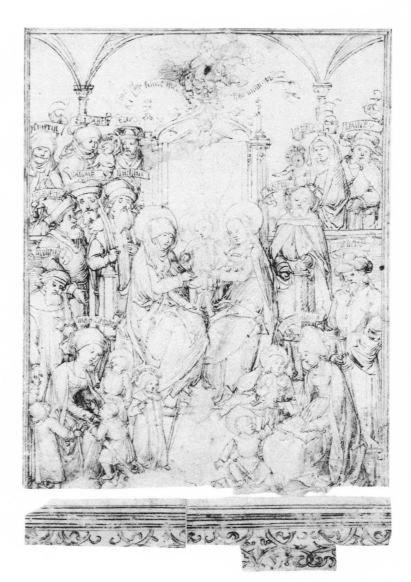

Upper Rhenish Master

50

Saint George Fighting the Dragon, c. 1494

Pen in brown ink over black chalk, 179 x 247 mm

Trimmed at upper, lower, and left edges; reinforced from verso with two strips of paper visible along lower edge, left strip bearing fragment of drawing in brown ink over black chalk; two thin areas in paper near center; repaired hole at lower left corner on backing sheet; small extraneous spots at lower edge

Spurious monogram added in brown ink at lower left by Sebald Büheler: *HBG*

VC: Inv. no. Z 251

References: Koegler 1926: 130-131 (Master of the Bergmann Offices); Roemer 1927: 178 (not Dürer); Tietze/Tietze-Conrat 1928-38, I: 302 (Master of the Bergmann Offices); Weinberger 1929: 143 (not Dürer); Oehler 1959: 96 (Baldung); Coburg 1970: no. 35 (Upper Rhenish Master); Strauss 1974, I: 30 (Hans Sebald Beham)

Because this drawing has much in common with Dürer's style of 1493-94, it entered the art-historical literature amid the controversy over the attribution of a group of book illustrations variously ascribed to the young Dürer, to the Master of the Bergmann Offices, or to Dürer's so-called *Doppelgänger* (double). The three books in question, the foremost products of Bergmann von Olpe's publishing house at Basel, were the *Knight of Turn (Ritter vom Turn)* of 1493, Sebastian Brant's *Ship of Fools* of 1494, and the *Comedies* of Terence which remained incomplete. Both Koegler and the Tietzes attributed the *Saint George* to the Master of the Bergmann Offices, who is now universally identified as the young Dürer. Once the controversy subsided, scholarly interest in the Coburg drawing vanished. Not even Winkler, despite his extensive polemics concerning Dürer's work for Basel publishers, expressed an opinion in print on this drawing.

The *Saint George* is indeed very close to Dürer in its formal vocabulary, but its execution does not reach the quality of Dürer's draftsmanship of the 1490s. The strongest potential argument in favor of Dürer's authorship is the great similarity of Saint George's steed to that in Dürer's *Courier* at the British Museum (Winkler 1936-39: no. 48), which in fact the Tietzes attributed to the Master of the Bergmann Offices. But even here, comparison reveals the Coburg drawing's shortcomings: the numerous pentimenti along the hindquarters and hind legs of the saint's mount show the artist's uncertainty. These pentimenti have a fundamentally different appearance from those in autograph drawings by Dürer, in which they

reveal the artist's vitality and propensity for experimentation, as is evident, for example, in his *Two Riders* at the Staatliche Graphische Sammlung, Munich (Winkler 1936-39: no. 53). The lacelike straps that secure Saint George's saddle in the Coburg drawing reappear in identical form on the steed that carries Dürers' *Couple on Horseback* off into the forest (Winkler 1936-39: no. 54), but in the latter work they are more precisely drawn. The trees in the left background of the Coburg drawing also display a considerable formal likeness to those in Dürer's early drawings, such as the *Saint Martin* in the Staatliche Kunstsammlungen, Kassel (Winkler 1936-39: no. 51) and numerous sketches for the Terence illustrations. However, the trees in the Coburg sketch appear somewhat tentative. Saint George's features are very similar to a physiognomic type found among Dürer's drawings for the *Comedies* of Terence, epitomized for instance by Gnatho in one of the *Andria* illustrations (Roemer 1926: pl. 15, no. 23) and by Phaedria in a sketch for *Phormio* (Roemer 1927: pl. 29, no. 4). The use of black chalk in rendering the underdrawing of the Coburg sketch, most clearly visible above Saint George's helmet, is unusual for Dürer, who in his early work customarily employed pen for underdrawing. The unfinished area of the rock above the dragon seems to have escaped the attention of earlier critics but may be significant in evaluating the *Saint George*. The drawing's obvious formal dependence on Dürer, the hesitant execution, and the unfinished area suggest that it may be a copy or adaptation of a work made by Dürer during his visit to the Upper Rhine around 1493/94 that has not survived.

157

Hans Weiditz

Active c. 1500-36 Augsburg, Strasbourg

Hans Weiditz was one of the most gifted and imaginative graphic artists of the German Renaissance, whose book illustrations compare favorably with those of Dürer and Holbein. He is now generally believed to have been identical with the artist formerly called the Petrarch Master after his most famous illustrations, which adorn the German translation of Petrarch's dialogue, *On the Remedies of Good and Bad Fortune (Von der Artzney bayder Glück,)* first published in Augsburg in 1532. The woodblocks for this book were reused to illustrate several later publications (cat. no. 214). Another of Weiditz's major achievements as designer for woodcuts is his large panorama of Strasbourg, the first German city view of its kind, created in 1521, which is second in size only to Dürer's *Triumphal Arch of Maximilian I.* Few of Weiditz's superb drawings have survived. Primarily designs for stained glass commissioned by the Alsatian nobility, hardly more than a dozen are known. Like Baldung, Weiditz had a great influence on the style of glass painters in Strasbourg, for whom he executed designs. Although he was also active as a painter and miniaturist, even less of his work in these media is preserved. His artistic activity was concentrated mainly in Strasbourg, where he was trained beginning about 1515. By 1518, he had entered Hans Burgkmair's studio at Augsburg as a journeyman, returning to Strasbourg in 1523 (Wirth 1918: 22, n. 63). His style as a draftsman successfully combines elements of the art produced in these two cities.

51

Tree of Fools, c. 1525

Pen in grayish black ink, 226 x 187 mm

Trimmed on all four sides; horizontal crease along center; traces of lifting from previous mount along left edge, verso; small hole right of center; several brown spots bleeding through from verso; paper soiled

Watermark: Imperial orb with star (similar to Briquet 3063)

Date added in brown ink at lower right by another hand: *1526*

VC: Inv. no. Z 199

References: Lossnitzer 1913: pl. 6 (Hans Leu); Schilling 1937: pl. 32 (Circle of Petrarch Master); Heise 1942: pl. 36 (Upper German Master); Washington 1955: no. 88 (Petrarch Master); Baumeister 1957: 45 (Jörg Breu); Rotterdam 1969: no. 150 (Petrarch Master); Coburg 1970: no. 33 (Petrarch Master); Munich 1972: no. 528 (Petrarch Master); Zijderveld 1976: 673, fig.; Coburg 1978: 116 (Petrarch Master); Augsburg 1980-81: no. 608 (Jörg Breu)

The *Tree of Fools* is one of the liveliest and wittiest creations in all of German Renaissance art, an unusually imaginative variation on the popular satirical theme of the power of women to make fools of men. By shaking a tree, a fashionably attired young lady causes a plentiful harvest of fools in various stages of development to fall to the ground like ripe fruit. This amusing invention is rooted in German popular culture and its richly metaphorical language. The central image of the tree was chosen in part for its connotation of abundance. In 16th-century German, anything in ample supply was said to "grow on trees," just as in English the scarcity of money is expressed by the phrase, "it doesn't grow on trees." The Coburg drawing shows what an abundance of fools an attractive woman can create. Furthermore, the tree of fools itself is one of many verbal images expressing foolishness in German proverbs. One such wry commentary describes fools wearing the foliage of the fools' tree like revelatory emblems, some openly and others attempting in vain to hide their folly. The fact that the drawing apparently depicts an apple tree adds a further nuance of meaning to an already loaded image. This oblique allusion to Eve seducing Adam was perhaps intended to underscore woman's evil nature.

The attribution of the drawing to Weiditz cannot be regarded as certain, but the extraordinarily imaginative and whimsical interpretation, the obvious mastery of allegorical themes, and the superbly spontaneous pen work are certainly worthy of the gifted creator of the illustrations to *Von der Artzney bayder Glück.* However, the unusually free and expressive style of the *Tree of Fools* has no totally convincing counterpart among Weiditz's few surviving drawings. Most of these are designs for stained glass (cat. nos. 52-55), which are rendered in the more disciplined manner required for execution by a glass painter. Also, the technique of draftsmanship in the *Tree of Fools* is unusual in Weiditz's oeuvre: the sketch was entirely executed in pen with none of the touches of wash that lend his other drawings their typical painterly effect. But the Coburg drawing shows some stylistic affinity with Weiditz's *Wheel of Fortune,* dated 1519 (Singer 1921: pl. 5), in the nervous stroke and similar details, such as the rather sketchy fingers of the figures. The rapid, round flicks of the pen delineating leaves in the *Tree of Fools* resemble the foliage of the trees at the left edge of Weiditz's design for the Eberstein arms (cat. no. 52). Elements recently cited in favor of Jörg Breu's authorship—the diagonal parallel hatching of shaded areas and the dots for eyes—in fact, do not substantially support such an attribution (see cat. no. 15), since these features occur in the work of Weiditz as well (Augsburg 1980-81: no. 608).

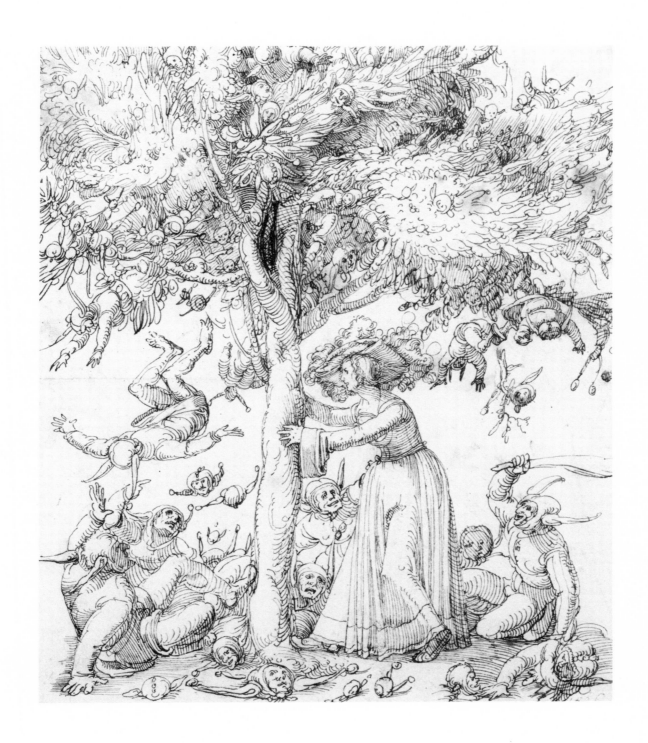

52

Stained-Glass Design with the Arms of Bernhard IV von Eberstein, 1525

Central image: Pen in light brown ink with brown and red wash and red chalk over black chalk, 289 x 255 mm

Frame: Pen in dark brown ink with gray wash and red chalk, 455 x 350 mm

Central image detached from frame; numerous small tears in upper and lower edges; long repaired tear from lower edge diagonally to left; two repaired tears in center lintel of architectural frame; repaired hole at left of red foliage around shield; glass painter's instructions along lower edge faded; extraneous red spots at right column; foxing along lower and right edges

Spurious monogram of Hans Baldung Grien added in dark brown ink by Sebald Büheler, recto, lower left: *HBG*

Glass painter's instructions in light brown ink along lower edge: *Diss sol ein täfelyn syn Eberstein* (shield with rose) *bernhart grave zů eberstein thůmherr zů strassburg*

Numerous color notations: on clothing of wrestlers, *g[elb]*, *s[chwarz]*, *r[ott]*, *v* (weiss); on frame between two scenes, *g[elb]*; on heraldic bust, *rott*; *v* (weiss); right background, ⌂ (green); on rose at lower left corner, *gel*; on left of frame around inscription, *g[elb]*

Blind collection stamp of 1840s at lower right

VC: Inv. no. Z 55 (frame), Z 56 (central image)

References: Térey 1894-96: no. 117 (central image, Baldung), no. 159 (both parts; central image by Baldung); Stiassny 1896: no. 29 (Baldung); Röttinger 1911: 47 (both parts by Weiditz); Buchner 1924: 224 (frame, Petrarch Master); Coburg 1970: no. 41 (frame, Weiditz)

This large format stained-glass design, of which only the frame was executed by Weiditz, combines a colorful but rather schematically drawn heraldic device by a Strasbourg glass painter with one of Weiditz's liveliest and most fluently sketched illustrations of sports. Whereas the glass painter's perfunctory rendering of the shield and acanthus leaves merely repeats the standard heraldic formula of the day, the style of the bearded head clearly derives from the work of Baldung (cat. no. 7). Thus this design again shows the close professional contact both Weiditz and Baldung had with the most prominent glass painters of Strasbourg (see cat. no. 46).

Almost all of Weiditz's stained-glass designs were executed during the period following his return to Strasbourg in 1523. The Coburg design, dated 1525, exemplifies his mature style in the delicate, nervous stroke of the pen, in the characteristic contrast of brown ink with gray wash, in the tonal effects achieved through the bleeding of pen lines gone over with wash, and in the conscious use of wash to organize and clarify a complex, multifigured composition—for example, in the layered articulation of the ground. Weiditz's rather dry handling of architectural forms, which he constructed with the aid of a ruler, makes the figural part of the composition seem by contrast all the more vividly portrayed. Weiditz's extensive use of wash lends his work a more painterly effect, when compared with Baldung's stained-glass designs. Unlike the few, large figures on which Baldung focuses attention in his rendering of wrestlers in the Ziegler design (cat. no. 7), Weiditz has expanded the scene into a panorama populated with six pairs of wrestlers and numerous spectators disporting themselves on the outskirts of a town. This group includes several physiognomic types and figural poses that are recurrent motifs in the artist's work; for example, the profile of the curly-haired young man being thrown by his opponent at the left edge of the sheet is identical to the features of the gentleman dining among friends in one of Weiditz's woodcuts in *Von der Artzney bayder Glück* (Scheidig 1955: pl. on p. 183). The wrestler falling over backwards at the right edge of the drawing recalls similar figures in another woodcut from the same book (Scheidig 1955: pl. on p. 189) and in Weiditz's drawing, *The Blind Leading the Blind* (Manchester 1961: no. 160).

The two parts of this design were formerly mounted separately at Coburg, and it was only at the end of the 19th century that Stiassny recognized they had once belonged together. This reconstruction, however, has been called into question by what appears to be the trimming of the acanthus leaves' lateral extensions, which suggests that they were originally larger but were cut to fit the present frame. For this reason, Buchner believed the central part of the design to be a later addition. The technical evidence, however, does not support this view. As presently mounted, the two parts of the design do not fit together exactly. But this is due only to imprecise repair of several long tears in the frame, which resulted in a slight enlargement of its size, leaving gaps between the two parts— a condition that could be rectified by careful mending. Moreover, the corner where the left and central segments of the tripartite arch meet is articulated by a line in dark brown ink which overlaps the division between the frame and the heraldic sketch, demonstrating that they were a single sheet when Weiditz drew the arch. Likewise, the red chalk lines for leading along the bases of the columns extend from the central design onto the lower frame, and the spots of red wash adjacent to the right column also overlap the division between the sheets. The same light brown ink used in the heraldic motif appears to have been employed for the color notations *g* (*gelb*: yellow) on the calves of two of the wrestlers at the right. The evidence therefore indicates that both parts of this design belonged together from its inception. The glass painter may have sketched foliage so ample that its edges would not fit within the frame to suggest a window effect, a device that further emphasizes the architecture's plasticity and that is not uncommon in Weiditz's other designs (cat. no. 55).

The Coburg design was made for Bernhard von Eberstein, son of the patron of the same name for whom Baldung designed a stained-glass panel (cat. no. 6). The younger Eberstein was designated to become bishop of Strasbourg upon the death of Wilhelm von Honstein, for whom Baldung also designed a stained-glass panel (cat. no. 2). He chose instead to leave the Church and married the daughter of another of Baldung's patrons, Nikolaus Ziegler (see cat. no. 7).

53

Stained-Glass Design with the Arms of Johann zu Isenburg,
c. 1530

Pen and point of the brush in dark brown ink with colored
wash in light and dark brown, light blue, and red, with red
chalk over black chalk, 291 x 207 mm (largest dimensions)

Central fragment of a larger design, trimmed considerably at
upper and right edges, trimmed slightly at left and lower
edges; tear above center near left edge; repaired tear above
capital of right pilaster; repaired loss at lower left corner;
water damage on right half of shield; tiny extraneous ink spots

Spurious monogram of Hans Baldung Grien added and coat of
arms identified in brown ink by Sebald Büheler, recto, below
shield: *HBG, Johann Groff zu Issenburg*

Blind collection stamp of 1840s near lower right corner

VC: Inv. no. Z 66

References: Térey 1894-96: xcix, no. 55 (not Baldung);
Stiassny 1896: no. 51 (not Baldung); Röttinger 1911: 47
(Weiditz); Buchner 1924: 226 (Petrarch Master)

Despite its fragmentary condition, the luminous coloring of
this drawing makes it especially captivating. Instead of relying
on the shorthand, written color notations habitually added to
stained-glass designs, Weiditz applied the colors projected for
the finished glass panel. Such a concern for visual effect, how-
ever, is not uniformly evident in all parts of the drawing.
Weiditz fell prey to the designer's habit of "cutting corners"
on certain repetitive parts of symmetrical designs, such as the
central blossom on the left pilaster. Although the right pilaster
and right half of the arch have been severely trimmed, what
remains of these areas shows that Weiditz did not carry them
out beyond the rudimentary contours.

The Coburg drawing displays many of the hallmarks of
Weiditz's mature stained-glass designs: architecture
viewed from below, drawn with a fine pen using a ruler,
emphatic three-dimensionality, and incorrectly constructed
perspective. Equally characteristic are the fine parallel hatch-
ing in shaded areas, the agitated leaves whose edges curl over
themselves and whose tips taper to a single flourish, and the
blossoms with five petals that resemble dogwood. Unusual
aspects of the Coburg sheet are the absence of Weiditz's pre-

ferred gray wash and the lack of a date, although the latter
may have been trimmed away at the lower edge. Comparison
with the similarly composed but far more delicately executed
Braunschweig design (cat. no. 54), which this drawing prob-
ably predates, underscores the effusive energy of the Isenburg
(old German: Issenburg) sketch. Weiditz's intention here was
to create strong contrasts rather than subtle harmonies. Thus,
the dark brown and red areas overpower the lighter brown
wash, the foliage appears massive and crowded within its
space, the composition is less carefully organized than in later
works, and the draftsmanship less disciplined, executed in
large part with a broad quill.

Johann zu Isenburg, the patron for whom this design was
made (according to the heraldic evidence and to Sebald
Büheler's inscription), was a canon at the cathedrals of Trier
and Strasbourg, but maintained his residence in the latter city.
He was the eldest son of Count Heinrich of Isenburg and
Countess Margaretha of Wertheim. After Johann's youngest
brother died childless in 1553, Johann cast off his vows, mar-
ried, and took charge of the family estate, dying childless only
two years later.

Johann Groß ḥ̄ Wonburg

54

Stained-Glass Design with the Arms of Georg von Braunschweig, 1531

Pen and point of the brush in dark brown ink with gray and brownish gray wash and red chalk over black chalk, 309 x 268 mm

Trimmed on all four sides; repaired hole at top of feathers; surface damage to paper, right of center at upper edge, at lower left corner, near upper left corner, at top of left pilaster; compass hole in center of shield; horizontal and vertical creases near center; light foxing below shield

Spurious monogram of Hans Baldung Grien added and coat of arms identified in brown ink by Sebald Büheler, recto, below shield: *HBG, Brůnschwig*

Color notations on arms: upper left quadrant, *g[old], r[ott]*; upper right, *b[lo], g[old]*; lower left, *w[eiss], b[lo]*; lower right, *v (weiss), b[lo], r[ott], g[old]*; on foliage at right, *r[ott], g[old]*

Blind collection stamp of 1840s near lower right corner

VC: Inv. no. Z 59

References: Térey 1894-96: no. 161 (not Baldung); Stiassny 1896: no. 40 (perhaps Baldung); Röttinger 1911: 47 (Weiditz); Buchner 1924: 226 (Petrarch Master)

In this quintessentially Renaissance design for stained glass, executed entirely by Weiditz himself, the artist's characteristic balance of gray and brown and his extensive use of wash to unify the composition are particularly effective. The typically delicate, wavering ductus and the slight bleeding of pen lines caused by the application of wash achieve a masterfully vibrant quality. Weiditz introduced here certain creative departures from the customary appearance of German stained-glass designs: he omitted the traditional heraldic figure supporting the coat of arms, thereby allowing a completely symmetrical arrangement, and he moved the acanthus leaves culminating in blossoms, usually located above the shield to separate the heraldic area from the upper scene (Parker 1928: pl. 59), to the bottom of the composition, where they gracefully accent the shield's semicircular form and counter the downward motion of its foliage.

Despite the incorrectly constructed perspective, the architectural frame with its delicate Italianate reliefs and small metopes achieves a pronounced three-dimensional and illusionistic effect. In keeping with its tectonic style, the top of the frame terminates in a lintel rather than in the dolphins or foliage Weiditz used in other designs of this period (cat. no. 55). Since his surviving stained-glass compositions all include a smaller scene located in the upper area, such an illustration may once have been part of this design as well. With an additional strip at the top, the drawing would more nearly conform to the proportions of height to width prevalent in such designs. An image of combat between two mercenaries adorns the top of another design produced by Weiditz in the same year (Buchner 1924: fig. 13), and a fragment from the top of one of his designs, executed in the same technique and style as the Coburg drawing (Frankfurt 1973, II: fig. 184), and illustrating a similar combat, offers a fine example of the type of image that may originally have belonged at the top of this work.

The design was probably made for Duke Georg von Braunschweig (1496-1566), who was a canon at the Cathedral of Strasbourg at the time of the commission. After the death in 1541 of the bishop of that city, Wilhelm von Honstein (see cat. no. 2), Braunschweig was considered as a possible successor, but his election was opposed by the Protestant city fathers, who feared that Braunschweig's powerful brother, Heinz von Wolffenbüttel, would interfere in local affairs. Braunschweig eventually achieved the desired ecclesiastical honor with his election as Bishop of Minden in 1553. By this time, he had adopted the Protestant faith and introduced it in his new bishopric.

55

Stained-Glass Design with the Arms of Blick von Rottenburg,
1532

Pen and point of the brush in brown ink with brown and gray
wash and red chalk over black chalk, 325 x 248 mm

Trimmed on all four sides; horizontal crease across lans-
quenet's thighs; repaired loss at top left corner; surface
damage at left edge; slight discoloration of paper

Two spurious monograms of Hans Baldung Grien, one inde-
cipherable, the other added and coat of arms identified in

brown ink by Sebald Büheler, recto, below shield: *HBG,*
Bliecken vonn Rottenburg

Single color notation in red chalk on right horn rising from
arms

Blind collection stamp of 1840s near lower right corner

VC: Inv. no. Z 44

References: Térey 1894-96: no. 160 (follower of Baldung);
Stiassny 1896: no. 41 (not Baldung); Röttinger 1911: 47; Buch-
ner 1924: 227 (Petrarch Master); Coburg 1968: no. 146

This impressive stained-glass design is one of the supreme
achievements of Weiditz's late style. It is the ultimate expres-
sion of a device basic to the visual effect of his mature draw-
ings, the bleeding of pen lines gone over with wash. The
artist's preferred medium of brown ink with gray wash is
complemented here by brown wash as well, the two colors
blending imperceptibly into each other. The wash articulating
the architecture is especially important in giving life to these
otherwise rather dryly constructed forms, laid down with a
ruler. The combination of wash with the delicate, nervous, and
at times discontinuous pen lines creates a marvelous, flickering
quality, which evokes a vibrant sense of movement.

In the Braunschweig design of 1531 (cat. no. 54), despite the
incorrectly constructed perspective, Weiditz succeeded in ren-
dering consistent, realistic Renaissance architecture. In this
design of 1532, however, he has adopted a fantasy arrange-
ment not intended to depict a real enclosing structure. Al-
though the dolphins forming the division between the central
and upper scenes qualify as a distinctly Renaissance motif, the
combination of lithic and organic forms is a holdover from the
older German tradition. The dolphins' curving forms are
echoed by analogous arabesques marking the lower corners of
the space. As is often the case in his designs, Weiditz chose a

low point of view in rendering the architecture in order to
make it appear more imposing.

The lansquenet is clad in the colorful slashed clothing and
richly plumed hat customary among members of his profes-
sion during the 16th century. The bodice is slashed twice with
the cross of Saint Andrew, the German lansquenets' identify-
ing mark, which distinguished them from their major rivals,
the Swiss mercenaries. The diagonal cross had to be highly
visible lest a soldier be attacked by his own compatriots in
hand-to-hand combat. In this design it recurs in the pattern
adorning the lansquenet's left trouser leg. The tight-fitting
trousers and stockings were usually cut open before going into
battle to allow freedom of movement. The loose jacket with
wide sleeves and the ostrich feathers on the hat were equally
impractical in combat. Such flamboyant attire, however,
catered to the mercenaries' proverbial vanity and displayed
their military prowess by showing off what the booty of war
could buy. The foot soldiers in the upper scene are similarly
clad, but in addition have strapped-on leather thigh guards for
protection in battle. The supine figure in extreme foreshorten-
ing between the opposing ranks demonstrates what Weiditz
had assimilated from Italian precedents, such as the work of
Mantegna, Uccello, and many others.

Prints and Illustrated Books

Charles Talbot

By 1483, the year of Martin Luther's birth, the practices of printing and printmaking were well established in Europe. Woodcuts had been in circulation since around 1400, and engravings since the 1430s; Gutenberg's invention of printing with movable type occurred in the mid-1450s; and a few books illustrated with woodcuts appeared in the 1460s, followed by an ever greater profusion in the succeeding two decades. Printing technology gave writers and artists the capacity, for the first time, to reach a worldwide audience, but as Luther realized when he prepared his German translation of the Bible between 1522 and 1534, the medium was only as good as what the publisher was given to print. What Luther would do for the German language in his printed translation of the Bible—establish new standards of clarity and expressiveness—Albrecht Dürer had already achieved for the graphic arts in the immediately preceding decades. Dürer's *Apocalypse*, 15 full-page illustrations of scenes from the Book of Revelation, first published in 1498, essentially redefined the expressive capacity of the woodcut. By 1517, the year that marks the beginning of the Reformation, the great printmakers of the German Renaissance—Dürer, Albrecht Altdorfer, Hans Baldung Grien, Hans Burgkmair, and Lucas Cranach the Elder—were already mature artists, and Martin Schongauer and the Master of the Housebook had preceded them by a generation.

Although one cannot separate the rise of printmaking from the historical movements that prepared the way for the Reformation, the critical developments in printmaking, or in German art as a whole for that matter, came to fruition before the Reformation had taken root. These developments in the visual arts constitute, therefore, one of the cultural facts of the time with which the Reformers had to contend. On the whole, the visual arts did not flourish under the Reformation, although Dürer and many of the great artists who were his contemporaries believed in Luther's cause. The iconoclastic tendencies within that movement placed the visual arts generally in a kind of limbo. Even when not damned outright, religious art was expected to suppress as much of its

sensuous nature as possible and become a servant of the written and spoken word. Such conditions were not likely to inspire another generation of artists to rival the accomplishments of Dürer. But neither the iconoclasts nor anyone else with a cause to promote or information to broadcast could fail to appreciate that prints, whether standing alone or in the company of the printed word, had the special ability to circulate far and wide, to arrest the attention of the beholder at a glance, and to fix an idea in his mind. Whatever prejudices the Reformers held against religious art as it had been used by the Catholic Church for centuries, the art of printing images on paper presented undeniable opportunities to anyone looking for a way to shape the future.

In principle the technical requirements for printing a visual image and for printing a text were the same. A resistant material had to be shaped in relief so that ink, when applied to it, would be distributed in the desired shapes and densities, and could then be transferred by contact to another surface many times over. Beyond that, however, the printer of words and the printer of visual images were faced with quite different challenges. Gutenberg searched for and found a way to reproduce mechanically the appearance of letters on a page as they previously could only be written with a pen. Once he commanded that technology, he could print anything, and undertook at once to print the entire Bible. It was a process of reproduction without transformation. The written word was the reality, and the type could transfer that reality intact to sheet after sheet. The printmaker, on the other hand, was required to reproduce an image that was already once removed from the reality it represented. What is more, in creating that image he was limited to lines, dots, and other graphic configurations that could be cut into a block of wood or metal plate to hold the ink in place for printing. In other words, he had to devise not only a printing technology but also a visual language with a syntax and vocabulary that had the capacity to express what the artist desired. The development of that capacity in various graphic forms gives prints a history of their own that is related to but distinct from that of

the other visual arts, such as panel painting, book illumination, or drawing.

In their range of visual properties, prints were distinctly limited as compared with the richly detailed scenes of contemporary panel painting. This is especially evident in the case of simple woodcut book illustrations like those in the *Buch der Natur* of 1475 (cat. no. 196) or the *teutsch Kalender* of 1496 (cat. no. 199). The practice of adding color by hand to such woodcuts betrays an urge on the part of artists not only to increase the decorative quality of prints but also to extend their informational range in the direction of painting. The drawbacks of handcoloring, however, were precisely those that had provided the impetus for the development of printing in the first place: high cost, limited production, and lack of uniformity. Since no one at the time knew how to print color that would approach the variation in line and fineness of detail found in painting (those developments would have to wait until the 18th century), printmakers instead had to devise a means for printing as much information as possible within the limits of their mostly black and white medium. Dürer's *Saint Eustace* of about 1500 (cat. no. 135) shows how far an engraving could go toward rivaling the detailed naturalism of panel painting and explains why Erasmus of Rotterdam would praise Dürer for having achieved with black lines alone what Apelles had done with the aid of colors (Panofsky 1948: 44; Rupprich 1956-69; I: 297, lns. 23-42).

If prints had certain limitations in comparison with paintings, they nevertheless must have offered substantial attractions as well, since the best printmakers were themselves, with rare exceptions, also outstanding painters. Only Grünewald of all the leading painters in Germany during the first quarter of the 16th century seems to have felt no calling to make prints. Dürer, by contrast, professed his impatience with painting, and in a letter to Jacob Heller, who had commissioned an altarpiece from the artist, he exclaimed, "henceforth I shall stick to my engraving, and had I done so before I should today have been a richer man by 1000 florins" (Conway 1958: 70). It is unlikely that any professional artist would have continued to make prints for long, had it not been profitable to do so. As Dürer realized by the time he published his *Apocalypse* (cat. nos. 130-132), no painter could place his original work before such a wide audience, let alone into so many hands able and willing to pay for it. What all the farflung viewers of Dürer's prints saw in addition to the incomparable work itself was the famous monogram of the artist. It no longer functioned simply in the manner of the traditional hallmark of the medieval crafts-

man but identified an artist in the modern sense. Partly as a result of his association with artists and patrons in Venice, Dürer had come to see himself and his profession in Renaissance terms. What he made and sold was an expression of his own intellectual and creative individuality. This outlook came to be shared by Altdorfer, Baldung, Cranach, and others whose reputations were also spread by prints that bore their monograms. Had the great Master of the Housebook attached the same kind of importance to his work and identified even a single drypoint with his initials, we would probably know his real name today.

The fact that a print was issued in editions of multiple copies not only made possible its wide circulation but increased the likelihood that at least some examples of the work would survive over time. A single accident or act of destruction that has in many cases removed forever our chance to know a particular painting would have had to occur hundreds of times and at different places to eliminate every impression of a print. Still, this did happen. Because the material value of paper and ink was slight, prints were easy to discard when interest in them waned. Those prints entirely lost to us today were more likely to be popular, topical prints by lesser artists than works by the great masters. Engravings, always the upper-class of graphic arts, have been preserved in relatively greater numbers and in better condition than woodcuts, at least those woodcuts not protected by the covers of a book. Being so transportable and usually not on display in vulnerable public places, prints also stood better odds than many paintings of escaping destruction through war, iconoclasm, or other random acts of violence. Also, unlike most modern papers, those made in the 15th and 16th centuries have proved to be amazingly durable. Their longevity is still undetermined, and a well-preserved sheet looks as fresh and is as strong as the year it was imprinted, something that can almost never be said for the panels and canvas upon which paintings of the same time were made. Consequently, our knowledge of a major artist's prints is much more complete than that of his paintings or drawings. We probably know all of Dürer's prints, with the possible exception of some from his youth, and the same can be supposed of the prints by his great contemporaries, Altdorfer, Baldung, Cranach, and his predecessor Schongauer as well.

The techniques of printmaking available to artists in the age of Luther remained essentially the same as those developed in the first half of the 15th century. The alternatives were relief printing—mainly woodcuts—and the intaglio processes with metal plates: engraving, drypoint,

and etching, the last of these being the one new invention of the early 16th century. While artists of this period worked with traditional methods, they often perceived a new expressive potential for them, and in every case their success as printmakers depended upon how well they were able to coordinate style and technique. The choice of technique, however, was not usually based simply upon stylistic preference but rather upon the purpose of the print and economic considerations. Moreover, there has always been a distinct correlation between the style associated with prints in a given technique and the cost of producing those prints. In a sense this is a fortuitous relationship since the cost-determining factors, namely rate of production and yield, happened to coincide with the relative fineness of cutting permitted by the physical characteristics of wood as opposed to metal. Engravings, for example, by the very nature of the medium, invited an elegant linear style that appealed to the connoisseur of fine prints and at the same time were relatively expensive because the plates were time-consuming to ink and print and the plates wore down at a rate that limited the size of an edition of high quality impressions. Woodcuts, on the other hand, could be printed in large editions which made them plentiful and cheaper, while the wood itself begrudged lines so finely cut as those engraved on metal, and encouraged instead a simple, more popular style.

In recent years the high speed offset lithopress has made relief printing something of a luxury, but before that time the woodcut and letterpress were the great democratizers of the visual image and written word. The earliest surviving woodcuts, so unpretentious that scarcely any seemed worth the bother to save, were clearly popular, mostly inexpensive, devotional images. Soon after the invention of movable type made it possible to print books and broadsheets for wide, if not to say mass, distribution, woodcuts assumed the role of providing illustrations for these publications. The relief-cut woodblock, planed to the same height as the type itself, was locked in the form with the text, and together they were printed on the page as a unit. The combination of woodcuts with letterpress not only had this practical advantage but also resulted in a visual compatibility between image and word, inked and impressed, as they both were, onto the white surface of the dampened paper.

Very few book illustrations in the 15th century were designed by artists whose names we know, and although this situation changes considerably in the 16th century, even then book illustrations and other woodcuts, too, were frequently left unsigned and consequently remain anonymous. This was primarily a result of the collabora-

tive process by which they were made. Traditionally, the artist provided only the design. He may have drawn it directly on the woodblock, but more often than not someone else transferred it to the block from the artist's sketch on a separate sheet of paper. Then the woodcutter, a specially trained craftsman, cut the design into the block, at which point it was ready for the printer. Since the artist's contribution was only one of several steps in the creation of the final product, his name was usually not singled out for special recognition. It was Dürer, once again, who departed from tradition and took a controlling hand in the woodcut from start to finish. He placed his monogram on every woodcut of the *Apocalypse* and identified himself as publisher of the whole work. Quite possibly he even cut the blocks. The quality of the woodcuts presupposes a cutter who had an understanding for the flex and energy of the lines as well as the manual skill to cut out extremely intricate passages so that they appear, when printed, as though they had been as easily rendered as with a pen. For most of his career, however, Dürer employed professional woodcutters, and it is safe to assume that other contemporary masters of the woodcut did the same.

The fact that Dürer, Altdorfer, Baldung, and Cranach, among others, raised the woodcut to the level of a subtle and complex art, capable of representing both the natural and the visionary appearance of things beyond all earlier expectations, did not diminish the medium's populist characteristics. In the 16th century, more than ever before, publishers used the woodcut to circulate inexpensive images with a broad appeal. For such prints the artist was obliged to render a design that could be cut into the block at minimum cost and was relatively simple to print. Erhard Schön's illustration of Hans Sachs' verses on the hunting of monks and clerics (cat. no. 188) would have satisfied his publisher very well on those accounts. Dürer also distinguished in his designs for woodcuts between those for which the quality of cutting and printing would be carefully controlled by himself and other more modest designs with a minimum of cross-hatching to facilitate the production of a large edition of less expensive prints. He referred to the latter group, represented by the brilliant impression of *Saint Francis Receiving the Stigmata* (cat. no. 140), as the "*schlechtes Holzwerk,*" the ordinary woodcuts.

The art of engraving maintained from the outset a special status derived from its origins as the work of goldsmiths. Schongauer and Dürer, both unsurpassed in their technical facility with the burin, were themselves sons of goldsmiths and received their first training in the family work-

shops. But the skill of the goldsmith only partially accounted for the status of his product. It was the precious, gleaming metal that put his work in a special class and limited his clientele to the individually and corporately wealthy. Not only did the designs printed from copper plates share the characteristics of line found in the floral and figural decorations of gold and silver objects, but also the glossy ink transferred from the incised lines of the plate to the surface of the paper resembled the enamel-like niello sometimes used to fill and blacken the designs of engraved plaques. The line made with the burin is, moreover, inherently elegant, and no one ever understood this better than Schongauer, whose figures seem to derive their slender grace from the very nature of the instrument with which they were rendered. The V-shaped point of the burin creates a line that widens and tapers according to how deeply the cut is made into the metal. The resistance of the metal keeps the blade from taking sudden, angular turns. From seeing the printed line one can visualize the burin's steady pace as it traced its smooth curvilinear path. The rhythmic curves, the swelling and tapering give a sense of flex to the line, not unlike that of the lithe, young bodies which are Schongauer's ideal figural type. It is not difficult to understand why engraving took its place at the head of the hierarchy of printmaking. Even today in catalogues of graphic arts, organized by technique, engravings are invariably placed before woodcuts.

To judge by the survival rate of engravings, generations of owners have tended to treat them as though they, of all prints, were the most worth caring for. Just how many good impressions could be pulled from an engraved plate, however, is hard to say and varied from case to case, depending upon the manner in which the plate was executed and printed. From his letters, we know that Dürer printed 200 impressions of his small, engraved portrait of Cardinal Albrecht of Brandenburg and 500 impressions of his larger portrait, but Dürer was especially careful in the way he engraved his plates to obtain a large edition before the copper inevitably wore down under the pressure required to print an intaglio plate. The less systematic or impractically delicate lines of most other engravers of the time, such as Cranach or the Master MZ, necessarily reduced the yield of fine impressions from their plates, but upon seeing a brilliant, early impression of the *Penance of Saint John Chrysostom* (cat. no. 122) no one would wish to fault Cranach for not having subjected his personal touch to the exigencies of a large edition of prints.

The originality of a print usually must be judged on different levels. This is obvious when the printmaker has simply transcribed the design of another artist, but there are also many degrees of such borrowing and of inventiveness in the execution. Israhel van Meckenem, for example, freely helped himself on a regular basis to other artists' ideas and compositions, which he modified or not as he saw fit. In general, such copying was not considered improper. It was common workshop practice for apprentices and assistants to make replicas of the master's works. Until the age of printing, the creator of an original work of art, or work of literature for that matter, suffered no economic loss from the copy and probably gained something from it by way of reputation. Reproduction through printing, however, eventually raised questions about how to protect one's own work from the economic exploitation of others. Artists like Dürer also became more conscious of the integrity of their artistic identity. When Marcantonio Raimondi made engravings after 17 woodcuts from Dürer's series depicting the life of the Virgin, complete with Dürer's monogram, Dürer did not like it and tried to have the Venetian authorities stop him. Marcantonio's skills were well suited to the purposes of artists like Raphael who were not themselves printmakers yet wished to have their works published, and Marcantonio did much to establish the style and practice of reproductive engraving that became so prevalent from the mid-16th century on. Dürer, by contrast, represents an approach to engraving that not only sets him apart from his Italian contemporary but also set engraving apart from the collaborative production of woodcuts. The hand of the designer and the hand of the engraver were one. There was no one else to mediate, however skillfully and unobtrusively, between the artistic invention and the execution. The engraving of the plate was as much a part of the artistic process as is the brushwork in a painting. It is impossible, therefore, to separate meaningfully the engraving style of Dürer, Cranach, Altdorfer, Schongauer, or Mair von Landshut from the style of the image they have rendered in the medium. Each of them established a distinct manner of using the burin that is an integral part of the expressive whole in their work.

The extent to which engravers extemporized with the burin may have varied from one artist to another but the process itself required careful control and planning. Engravings were predominantly formal works of art and, like panel paintings, were carefully prepared in advance with drawings of the composition as a whole and of details. Yet it was relatively easy to make a change on a

panel simply by painting over the passage in question, while the revision of an engraving required burnishing out every unwanted stroke. The two intaglio techniques that offered the greatest opportunity for spontaneity while working directly upon the plate, as Rembrandt was to demonstrate so effectively a hundred years after Dürer's death, were drypoint and etching. However, freedom of execution was neither a special value in itself nor expressive of a meaningful attitude toward life during the age of Dürer and Luther. Artists sought definitive forms and ways of stating them that would emphasize their enduring validity, just as theologians were dedicated to defining absolute truths. Such attitudes did not encourage a graphic style capable of suggesting a momentary perception of forms whose appearances were themselves ever-changing. Still, drypoint and etching offered notable advantages to some artists even though they were not yet in an historical position to exploit the full expressive potential of those techniques.

The Master of the Housebook, more than any other artist of the period, made drypoint the vehicle of his personal expression. His historical identity has remained elusive, though he may have been the artist working in Mainz, Erhard Reuwich, who had come from Utrecht (see p. 305) Because of the Netherlandish traits in his work and the fact that most of his prints are preserved at the Rijksmuseum, he used to be and still is called by some the Master of the Amsterdam Cabinet. In view of the uncertainties about his proper name and in recognition of his special achievement, one might have called him, simply, the Master of the Drypoint. None of his 91 prints seems to have survived in more than a handful of impressions and most are unique, but they could only have been printed in small editions to start with since the soft metal, copper or perhaps tin, on which he made his images with a sharp stylus, rather than with the engraver's usual burin, did not hold up long under the pressure of printing, and the burry edge of the lines wore down even faster. But what he could do with the drypoint needle and soft metal has made the rare impressions of his work as highly valued as any prints in existence. Although his manner of working on the plate resembled the deft hand of a draftsman unencumbered by the usual problems of coping with an engraver's materials, not even the pen could produce such an evocative quality of light and shadow playing gently over figures whose expressions and postures suggested that their present place in the world was neither final nor perhaps all that serious.

Etching also spared the artist from having to work his plate by the arduous and restricted movements of the engraver. Like drypoint, the medium invited a certain freehand, draftsmanlike way of working, but the linear quality of etching had little in common with that of drypoint. As an artistic process, etching seems first to have been practiced as early as the 14th century by armorers who welcomed the assistance of acid for rendering intricate designs on iron and steel. Only in the first decade of the 16th century does the technique seem to have been adopted for printmaking. In the etching process, the lines could be bitten as deeply into the metal as those cut with any burin, but etching left a rugged, wiry kind of line, especially at this early point in its history because those who first took up the medium used iron plates in accordance with what they knew from the armorers' practice. Daniel Hopfer, who got his start as an etcher of armor, helped establish etching as an essential part of the printmaker's technical repertory with prints like the *Interior of a Church* (cat. no. 167). When Altdorfer made nine landscape etchings around 1520 (cat. no. 101), he recognized that the new technique was ideally suited for the representation of this subject which was new in itself as the principal theme of a public work of art. Artists ever since have confirmed the significance of Altdorfer's achievement. In comparison with the sharp-edged, smoothly curving line of the burin, the freer movement of the etching needle and the more irregular, somewhat accidentally formed edge of the resulting line were more responsive to the natural appearances of landscape.

Whether in book form or individually, prints had an advantage over most other kinds of art, being convenient to handle and distribute. Although contemporary paintings show domestic interiors in which prints made as devotional images are shown hung on the wall, probably with a little sealing wax, most prints were intended to be held in the hand. In any case, the entire process from the manufacturing of the paper through the selection and preparation of the plate or block to the printing itself was scaled to hand-held objects. The range of possible print sizes was directly related to the size and shape of a full sheet of paper (usually no larger than 18 by 26 inches) after it had been folded once (folio), twice (quarto), three (octavo) times or more. A large woodcut would fill the page of a folio publication like the *Schatzbehalter* (cat. no. 198), the *Missale Basiliense* (cat. no. 197), or Dürer's *Apocalypse* (cat. nos. 130-132). For books of smaller quarto or octavo format, the woodcut illustrations were, of course, proportionally scaled. Woodcuts and engravings printed on individual sheets followed approximately the same sized formats, not the least because this made economical use of the paper.

Working on metal with a sharp instrument, the engraver could pack a lot more into a small space than the woodcutter, although few engravings were smaller than Altdorfer's 40 woodcuts (approximately 3 by 2 inches) for a tiny devotional picture book, the *Fall and Redemption of Mankind* (cat. nos. 60-99). On the other hand, Dürer's *Saint Eustace* (cat. no. 135), approximately 14 by 10¼ inches, was an unusually large engraving for the period, and also represents in its fine descriptive detail the artist's strongest challenge to the pictorial richness of painting.

Woodblocks were hard to manage above the size of a folio sheet, not because of the area to be cut but because of their tendency to warp or split. Woodcuts of dimensions larger than a folio were made in composite fashion, each part printed on a separate sheet of paper, then glued together. Such prints usually served a special function. For example, Emperor Maximilian, aware that printing offered new opportunities for propaganda and publicity, commissioned an unprecedented 11½-foot-high triumphal arch printed from 192 blocks; that was an undertaking not to be repeated. His *Triumphal Procession*, however, comprising 137 woodcuts connected end to end in the form of a frieze, is not an isolated example. Among the more modest endeavors of this type were Hans Burgkmair's six joined woodcuts for his reportorial view, *The King of Cochin* (cat. nos. 112-113) and Erhard Schön's seven for his *Siege of Münster* (cat. no. 189) and nine for his *Infantry Company* (cat. no. 190), which measures about ten feet in length. The height of these friezes is no greater than that of a large quarto- or small folio-sized woodcut, so even the lengthiest of them could be rolled up and viewed in the manner of a scroll. Whether this was the customary practice or whether they were meant to be shown fully extended along a wall is hard to say. There can be no doubt, however, that at least one of the exhibited woodcuts was designed to be displayed on a wall. The infinitely repeatable pattern of the double woodcut showing a family of satyrs (cat. no. 158) was intended to be used as wallpaper, despite what might, by modern standards, be considered its unusually suggestive motif.

Color in prints of the 15th and 16th centuries is a diverse subject, as the different kinds of coloring on some of the prints in this exhibition illustrate. An absence of color was undoubtedly regarded as the most serious technical limitation of printmaking, although we have already noted that Erasmus of Rotterdam expressed his admiration for Dürer's achievement solely with black and white. This was apparently a widely shared view, though it applied more generally to engravings than to woodcuts since the latter were frequently colored by hand, while engravings seldom were. Since before the end of the 15th century most woodcuts were designed with simple outlines and little internal modeling, the open areas of white paper invited the addition of color. Applied by brush, sometimes with the aid of a stencil, the colors were usually limited to three or four. The skill with which they were put on varies enormously, and not infrequently it was the work of a very amateurish hand, probably that of someone in the household of the woodcut's owner.

Since the majority of woodcuts in the 15th century were designed as book illustrations and as such were based on the tradition of illuminated manuscripts, adding color to woodcuts was a natural thing to do. The gilding on the *Crucifixion* from the *Missale Basiliense* (cat. no. 197) shows clearly an emulation of the older tradition of illumination. The touches of gold on the illustration of *David and Bathsheba* in the Luther Old Testament of 1523 (cat. no. 209) continues the same practice, although the rest of the rich color scheme reflects the style of Cranach's panel paintings. The decorative attraction of such skillful coloring cannot be denied nor at times can anything take the place of the descriptive power of color, such as the intense red and yellow flames in *The Great Beast Thrown into the Lake of Fire* from Revelation in Luther's Bible of 1541 (cat. no. 211). This coloring, too, indicates that whoever applied it to the woodcut was professionally trained and well acquainted with Cranach's style of painting.

The desire to print color and the inevitable experimentation with methods of doing so led to the development of chiaroscuro woodcuts, those in which a line block, or key block as it is also called, is printed over at least one color. Furthermore, the color block is cut in such a way as to reveal areas of white paper for highlights, resulting in an image that is tonal—thereby accounting for its name, chiaroscuro, literally light/dark. The first experiments along these lines seem to have been made in Germany around 1507 by Cranach the Elder in an attempt to reproduce the appearance of gold as applied to images by illuminators (see cat. no. 117). As early as 1508, however, Hans Burgkmair and his woodcutter, Jost de Negker, perfected the technique and produced woodcuts that resembled drawings made on paper prepared with colored grounds and heightened with white. The process of chiaroscuro printing seems to have been fully worked out in Wittenberg and Augsburg over a period of just a year or two, and by 1510, the date of *Lovers Surprised by Death* (cat. nos. 114-115), Burgkmair and de Negker had added a third block enabling them to print two colors of closely

related hues for further graduated tones. Even more remarkable than the chiaroscuro technique's having been created and perfected almost overnight is the fact that little more than a decade later German artists discontinued its use, leaving its further application in the 16th century mainly to Italian printmakers, depite its obvious visual success.

Although we are primarily concerned with the use of color that is contemporary with the period in which the prints themselves were made, there are a considerable number of engravings at Veste Coburg that were elaborately colored around 1600. Insofar as these colored impressions reveal an attitude of a later generation, we have included a few examples (cat. nos. 123, 134, 145, 156). Little is yet known about who did the coloring or for whom, but the colored impression of Dürer's *Sea Monster* (cat. no. 134) suggests that one reason for the decision to add paint might have been the poor condition of the print at that time. Taking such a step to minimize the appearance of damage to the object was probably also the purpose of cutting a tone block around 1620 to print with the woodblock of Dürer's *Rhinoceros* (cat. no. 157), by then cracked and worn. The coloring of Dürer's and Cranach's engravings, however, tends to raise modern eyebrows because the paint not only obliterates much of the original engraving, which was never intended to be colored, but also introduces a miniaturist's style of coloring from a later age. Presumably, the coloring was executed by some of the same miniature painters who also copied the works of Dürer or made pastiches of them in such numbers that one speaks today of a kind of Dürer revival in Germany and the Netherlands around 1600. The precision and astonishing detail of Dürer's engraving were an inspiration to these painters of "cabinet pictures" who worked on small wood or copper panels. The same sensibility was responsible for the decision to print a posthumous edition of Dürer's *Saint Eustace* on satin (cat. no. 136).

Most prints of the 15th and 16th centuries, like other kinds of art, represent religious subjects. Unlike painting and sculpture, however, prints lacked the material value that was clearly involved in expressing the glorious nature of the sacred subject in art of the Middle Ages. The invention of printmaking in the early Renaissance indicates in itself a nascent shift toward the attitude that the efficacy of the image resided not in its physical substance as such but rather in the knowledge and inspiration conveyed by the forms themselves, whatever the material in which they were fashioned. The fact that religious images on paper necessarily led the observer to a consideration of

the visual idea itself, and not of material substance, undoubtedly helped to persuade Luther and other reformers, who were uneasy about past religious practices involving images, that prints, like printed words, were not only an acceptable form of art but also a necessary form of communication.

Also like the printed word, the printed image carried weight by virtue of its published form. To put something in black and white suggests in itself a permanent statement subject to public verification. Beyond that, however, the printed image bore an authenticity as a consequence of each impression having derived from direct contact with the unique master form. Like a wax seal impressed with a signet, the impression of a print had authority not only because it duplicated the appearance of the original but because it did so by physical contact of the one with the other. This had special implications where devotional images were concerned. One need only recall that Saint Veronica was named for the true icon because she pressed her veil to Christ's suffering face and thereby preserved its appearance. When artists made prints of the sudarium from woodblocks and engraved plates, they used essentially the same process that was thought to have produced the holiest of images. Few prints may have been contemplated in precisely those literal terms, but there can be no question that the quality of exact transferral of the image gave prints a special kind of credibility.

The subjects of many other prints were, of course, entirely secular. Books on nature (cat. nos. 196, 216), law (cat. no. 212), sports (cat. nos. 213, 215) or calendars (cat. no. 199), for example, were illustrated with woodcuts free of the religious, thematic traditions that pertained to most panel painting and sculpture. The same was also true of many individual woodcuts and engravings, whether they were illustrations combined with texts on broadsheets or independent images based on all variety of worldly themes. In producing portraits, printmakers did take their lead from the tradition of painting and sculpture, but the portrayal of exotic people and their lands (cat. no. 112-113) or historical events (cat. no. 189) fell to printmakers not only because their art could be widely circulated but also because prints were unrestricted in their range of subjects. They could address satirical subjects (cat. nos. 163, 172, 181) or local scenes (cat. nos. 100, 119, 176) as well as highly intellectual themes (cat. no. 154). Prints, more than any other single form of art, were as ecumenical in the breadth of interests they represented as they were often partisan in the hands of spokesmen for the Reformation.

Heinrich Aldegrever

1502 Paderborn—Soest 1555/61

The career of Heinrich Aldegrever, whose family name has been alternatively given as Trippenmecker, is documented between 1527 and 1555 by many dated engravings, but there are few other sources of information about him. He was born in 1502 in Paderborn (Westphalia) and became a citizen of Soest in 1527. He was strongly influenced by the work of Dürer and his followers Georg Pencz, Sebald Beham, and Barthel Beham, but this was an influence imparted by engravings. There is no evidence that Aldegrever had direct contact with these artists or that he trained in Nuremberg. Aldegrever's other sources ranged from Lucas van Leyden and the Mannerist art of Antwerp to the Italian ornamental engravings of Zoan Andrea. Zschelletzschky (1933) has divided Aldegrever's career into three periods: 1527-30, when his dependence upon the work of Dürer was greatest; 1532-41, a period of maturity and developing Mannerist tendencies; 1549-55, late or mature style. There exist no dated works from the years between 1542 and 1548, for reasons that remain unknown. Although Aldegrever's reputation rests mainly on his engravings, he also left drawings, woodcuts, and paintings.

56
Design for a Dagger with Nude Couple on Scabbard, 1536

Engraving, 324 x 110 mm (widest dimension)

Monogram and date in plate at upper right: *1536 / AG*

VC: Inv. no. I 135, 250

57
Design for a Dagger with Floral Ornament and Two Profile Heads on Scabbard, 1537

Engraving, 298 x 102 mm (widest dimension)

Monogram and date in plate at upper left: *1537 / AG*

VC: Inv. no. I 135, 256

58
Design for a Dagger with Cain Slaying Abel and Satyr Couple on Scabbard, 1539

Engraving, 326 x 89 mm (widest dimension)

Monogram and date in plate on scabbard: *1539 / AG*

VC: Inv. no. I 135, 261

References: Zschelletzschky 1933: 200-202; Hollstein I: 122, 125, 128; Coburg 1975: nos. 145-147

About a third of Aldegrever's some 300 engravings are ornamental designs, intended in part, at least, as models for goldsmiths and other workers in metal. While these three designs for daggers and sheaths would be a costly challenge to duplicate in reality, they illustrate the close association that had always existed between goldsmiths and engravers, who were not only trained to use the same tools and materials but also produced designs whose inherent linear character derived from turning a piece of metal against the cutting edge of a burin. The curvilinear forms of floral motifs followed the natural rhythms of incised lines. The relationship of such forms to the technique of engraving also resulted in an easy continuity of style from the Gothic floral ornament in the engravings of Master E. S. or Martin Schongauer to the Renaissance motifs and patterns of Aldegrever. Where the ornament on these daggers and sheaths is concerned, one detects the new sensibility mainly in the compact organization of the forms and the geometric, symmetric partitioning of the compositions. Even though the nude figures, together with the satyrs and profile heads in medallions, are dependent upon Renaissance and classical models, one may still sense that the ornamental format and decorative floral patterns inform the design of the nude figures with their elongated proportions and mannered postures.

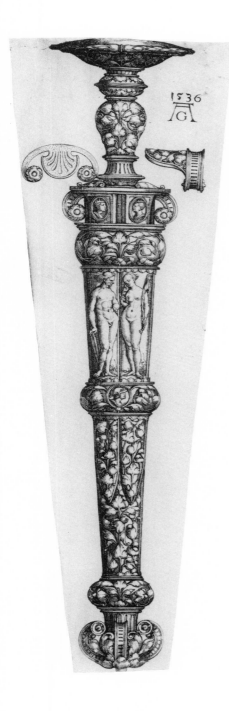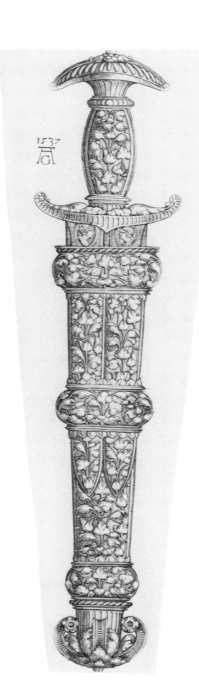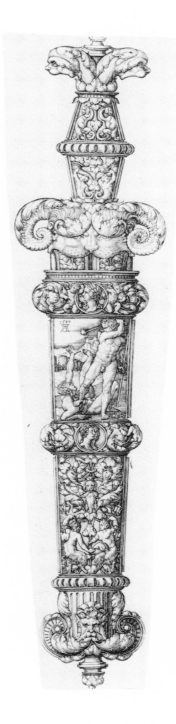

Albrecht Altdorfer

c. 1480 Regensburg 1538

It is probable that Altdorfer was born in Regensburg about 1480 and that his father was a miniaturist by the name of Ulrich, who provided him with his earliest training. The family seems to have left Regensburg when Altdorfer was a child, but he returned to become a citizen of the town in 1505 and lived there for the rest of his life. In 1509, he received a commission for a large altarpiece with scenes from the Passion of Christ and the life of Saint Sebastian for Saint Florian's, a monastery near Linz, Austria—a work that occupied him off and on for nine years.

By 1511, Altdorfer was already making vibrant sketches of Alpine landscapes, and around 1520, he produced pure landscape paintings and etchings (see cat. no. 101) that are among the first such works in Western art. Altdorfer soon became the leading artist of the so-called Danube School, a group of artists loosely connected by region,

style, and by works with an emphasis on nature. Between about 1513 and 1518, Altdorfer was also employed on several collaborative projects for Emperor Maximilian I: miniature paintings on parchment and woodcuts for the *Triumphal Procession,* marginal drawings for the *Prayer-book of Maximilian I,* and designs for the monumental woodcut of the *Triumphal Arch of Maximilian I.*

Altdorfer also pursued a political career in Regensburg; he became a member of the city council in 1517 and was elected burgomaster in 1528, but refused the office in order to paint the *Battle of Alexander* (Munich, Alte Pinakothek), commissioned by Duke Wilhelm of Bavaria. Altdorfer was also employed by the city as an architect, although his activity in this area seems to have been limited mostly to the construction of fortifications and other essentially utilitarian projects. His 20-page will reveals him to have been a prosperous man at his death in 1538.

59

Allegorical Figure, 1506

Engraving, 100 x 77 mm

Monogram and date in plate at lower right: *1506 / AA*

VC: Inv. no. I 97, 35

References: Friedländer 1923: 8-9; Hollstein I: no. 52; Winzinger 1963: no. 99; Coburg 1975: no. 108

Altdorfer's earliest engravings are dated 1506, and several, like this one, are based on Italian niello prints. The intense black background of the engraving resembles the black, enamel-like substance from which niello plaques take their name. Before the niello itself was melted into the incised lines of a silver plaque, the plaque could be inked and printed like other intaglio plates. Altdorfer's particular source in this case was a niello print by Peregrino da Cesena (active early 16th century) that shows a woman seated on a winged serpent and holding a mirror in one hand and a cornucopia in the other (Hind 1936: no. 187; Winzinger 1963: app. no. 13). Presumably she personifies Foresight or Prudence. In a somewhat later, but undated engraving (Winzinger 1963: no. 115), Altdorfer used the same Italian source and retained all the figure's attributes. In the present engraving, however, the woman has neither the cornucopia nor the demeanor of prudent Foresight. The mirror combined with the décolletage of her stylish dress indicates that she now personifies not a virtue but rather the vice of vanity. Furthermore, the winged serpent, which signifies cleverness in Peregrino's niello, has taken a different and more menacing form. Altdorfer was no doubt familiar with Dürer's *Apocalypse* series, which includes a female figure riding on a dragon, namely the *Whore of Babylon* (Washington 1971: no. 105). The deviations from Peregrino's model in the woman's

dress and shoulders follow the direction of Dürer's design in that woodcut, and the spotted-winged dragon with its scaly tail bears a distinct resemblance to Dürer's beasts and demons (cat. nos. 130-132) as well as to those in Dürer's own source, Schongauer's engraving, *The Tormenting of Saint Anthony* (Shestack 1969: no. 4).

The form of Altdorfer's monogram indicates his readiness to follow Dürer's lead, but his stylistic tendencies were so individual that whatever he borrowed took on its own character. Altdorfer always had trouble making the human figure correspond anatomically with nature. For this reason, the dragon's body seems more convincing than the woman's. Nor was the burin a precision instrument in Altdorfer's hands, at least not by comparison to Dürer. His lines are rather sketchy and fleeting, as if they outline the appearance of forms viewed in an uncertain and changing light. One form often leads into another without a clear distinction between them. The woman's dress, for example, merges ambiguously with the shape of the dragon. Yet these shadowy forms are undeniably evocative. The engraving succeeds expressively to a degree far greater than its lack of technical proficiency would seem to permit.

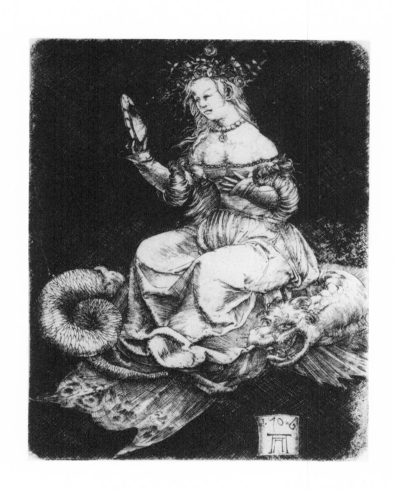

Fall and Redemption of Mankind (Sündenfall und Erlösung des Menschengeschlechtes), c. 1513

40 woodcuts, each approx. 73 x 48 mm

Each with monogram in block: *AA*

VC: Inv. nos. I 99, 90-117, I 100, 118-129

References: Winzinger 1963: nos. 25-64; New Haven 1969: nos. 28-35

These 40 miniature woodcuts were designed to be assembled one to a leaf and bound as a small devotional book of pictures without text, but only a few sets of the prints survive in book form. This program of illustrations was undoubtedly inspired by Dürer's *Small Passion,* which comprises 37 woodcuts and likewise begins with the Fall of Man, proceeds to the Incarnation and Passion of Christ, and concludes with the Last Judgment. However, no more than four of Altdorfer's compositions betray any dependence upon Dürer's designs. Traditionally, the prints have been catalogued with the *Virgin Crowned by Two Angels* at the end of the series, but the uncut sheets in Cleveland (Museum of Art) and Erlangen (Universitätsbibliothek) with four and six prints to a sheet, respectively, indicate that the *Virgin* was intended as a frontispiece. All the woodcuts were signed with the artist's monogram but none are dated. Still, it has been possible to date the series securely around 1513, based on stylistic evidence and on dated works by other artists who drew one or another motif from the prints (Winzinger 1963: 67-68). Altdorfer produced the series in the same decade in which he painted large panels portraying the events of the Passion for the Saint Florian Altarpiece. The two Passion cycles are very similar in spirit and some of the scenes, such as the *Agony in the Garden,* the *Betrayal, Christ Crowned with Thorns,* and *Christ Bearing the Cross,* are essentially smaller or larger versions of their counterparts.

It is remarkable how much action, drama, and even monumentality are contained within the limited dimensions of these compositions. Of course, conciseness was essential, but Altdorfer did not sacrifice a sense of spaciousness even when numerous figures were required by the subject, such as in the *Last Supper* or the *Raising of the Cross.* He also succeeded in accommodating a few expansive landscapes, for example, the *Flight into Egypt* and *Christ Appearing to the Magdalen.* In many of the compositions, the illusion of space is developed along strong diagonal lines of sight and by steeply foreshortened forms, but in every scene a spatious ambiance results from Altdorfer's use of linear tonal patterns, which produce the appearance of vibrating light and transparent shadows. This technique was based on the graphic style that Dürer had fully developed by 1510, exemplified in such woodcuts as the *Mass of Saint Gregory* (cat. no. 151). Yet Altdorfer applied the lines of shading in more varied and agitated patterns, so that the resulting sensation of light and shadow was keyed as much to emotional experience as to rational observation. The changing conditions of light are an inseparable part of the narrative itself, as the action progresses from daylight to a candlelit interior or to nighttime, while the capacity of light to reveal and transform the appearance of things is part of every dramatic moment throughout the series.

60. *Fall of Man*

61. *Expulsion from Paradise*

62. *Joachim's Offering Rejected*

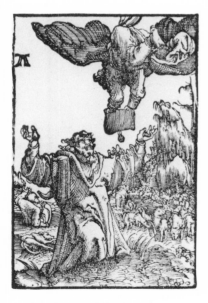

63. *Joachim and the Angel*

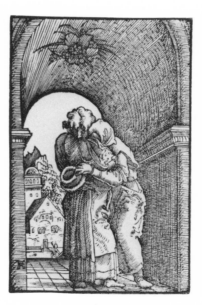

64. *Joachim and Anne at the Golden Gate*

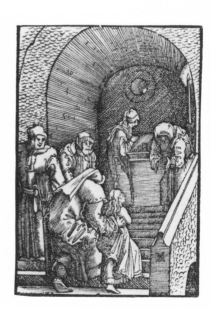

65. *Presentation of the Virgin*

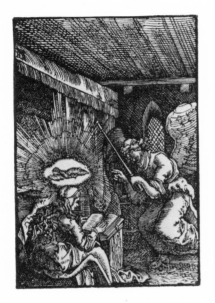

66. *Annunciation*

67. *Visitation*

68. *Nativity*

69. *Adoration of the Magi*

70. *Circumcision*

71. *Presentation in the Temple*

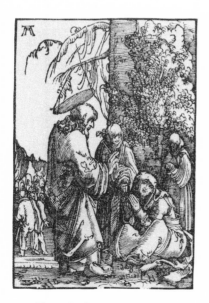

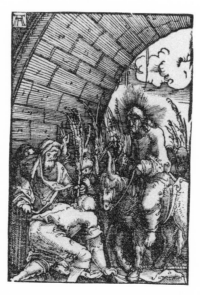

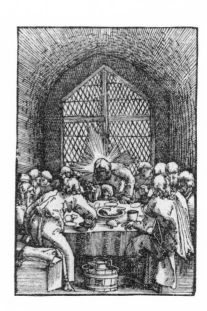

72. *Flight into Egypt*

73. *Christ among the Doctors*

74. *Transfiguration*

75. *Christ Taking Leave of his Mother*

76. *Entry into Jerusalem*

77. *Last Supper*

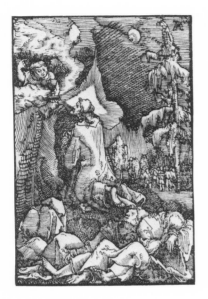

78. *Agony in the Garden*

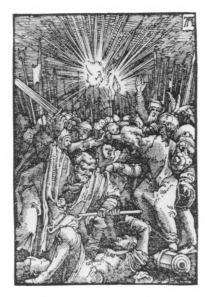

79. *Betrayal*

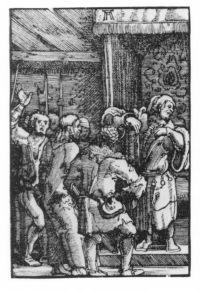

80. *Christ before Caiaphas*

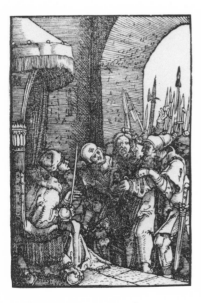

81. *Christ before Herod*

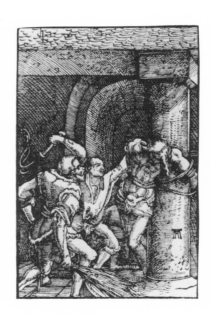

82. *Flagellation*

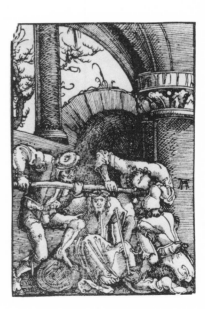

83. *Christ Crowned with Thorns*

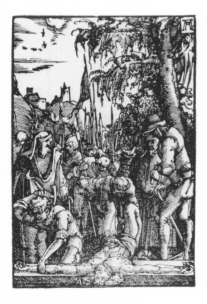

84. *Ecce Homo*

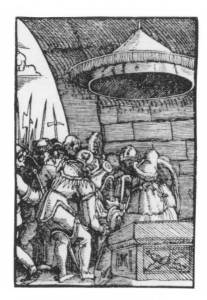

85. *Pilate Washing his Hands*

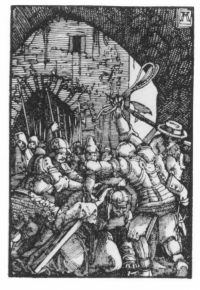

86. *Christ Bearing the Cross*

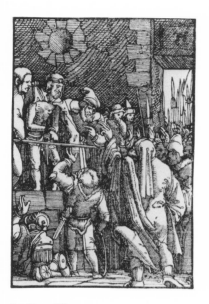

87. *Christ Nailed to the Cross*

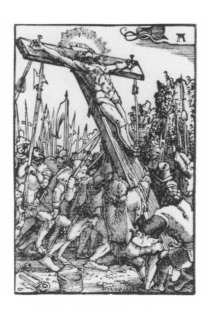

88. *Raising of the Cross*

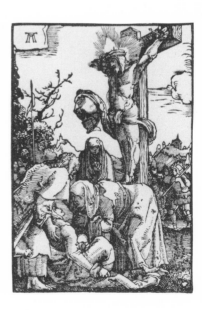

89. *Crucifixion*

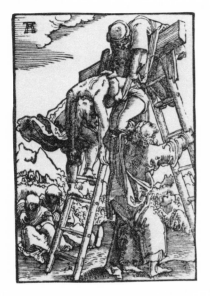

90. *Descent from the Cross*

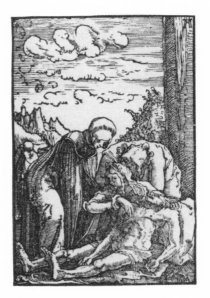

91. *Lamentation*

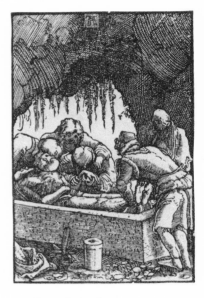

92. *Entombment*

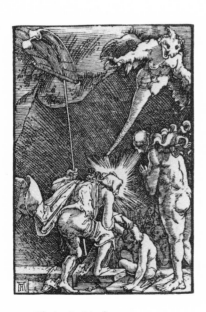

93. *Christ in Limbo*

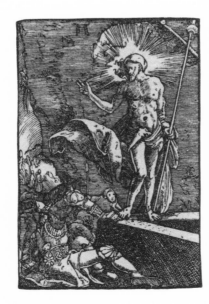

94. *Resurrection*

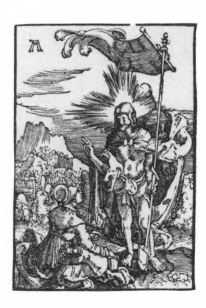

95. *Christ Appearing to the Magdalen*

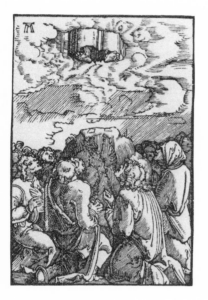

96. *Ascension*

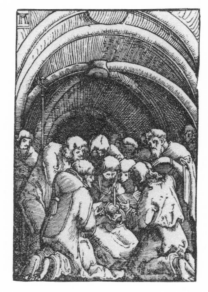

97. *Death of the Virgin*

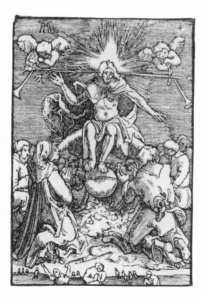

98. *Last Judgment*

99. *The Virgin Crowned by Two Angels*

100

Interior of the Synagogue in Regensburg, 1519

Etching, 172 x 126 mm

Monogram in plate at lower center: *AA*

Inscribed in plate at top: *ANNO.DN̄I.D.XIX / IVDAICA. RATISPONA / SYNAGOGA.IVSTO / DEI.IVDICIO. FVNDIT[U]S / EST.EVERSA.*

VC: Inv. no. I 98, 61

References: Hollstein I: no. 82; Krautheimer 1927: 177; Winzinger 1963: no. 173; Stahl 1968: 35-282; Winzinger 1975: 31-34, 147, 150; Hubel 1977: 199-237; Coburg 1975: no. 106; Landshut 1980: no. 69

This etching shows the empty synagogue at Regensburg just before it was demolished and replaced by a chapel dedicated to the *Schöne Maria* ("beautiful Virgin"; see cat. no. 184). Although the Jews had lived in peace in Regensburg for centuries—the community had been under the protection of the emperor of the Holy Roman Empire since 1182—during the second half of the 15th century, poor economic conditions in the city strengthened the voices of those who had, no doubt, long been impatient to speak out against them. In the late 1470s, 17 Jews were arrested on charges of having committed the ritual murder of a Christian child. The reigning emperor, Friedrich III, intervened on behalf of the accused men, and they were freed. But when Friedrich died on January 13, 1519, the city council, of which Altdorfer was a member, seized their opportunity to act. On February 21, the council decided to expel all the Jews from Regensburg, and that same day, a band of armed citizens accompanied the mayor and a few councilors, including Altdorfer, into the *Judengasse* (Jew's Alley) to announce the decree. A week later, the Jews were gone, and within a short time their quarter was reduced to rubble.

Before it was destroyed, Altdorfer executed two etchings of the synagogue. The first clearly delineates the groin-vaulted interior, divided into two aisles by a row of graceful columns down the middle. Both the *almemar* (raised platform on which stands the reading desk) in the center of the room and the blind arcades in the far east wall have round arches in the late Romanesque style. This combination of Romanesque arches and early Gothic vaulting suggests a date of around 1220 and 1230 for the building. The step at the far right marks a door leading out to a porch, which was the subject of the second etching.

Altdorfer himself was an architect and his works reveal a vivid architectural imagination, as well as skill in the use of perspective and the portrayal of light to create the illusion of an atmospheric interior space. At the time, it was unusual to show a building in a print or painting devoid of a human subject, with the exception of topographical views of cities that emphasized their architectural landmarks, such as those in the *Nuremberg Chronicle* of 1493. Obviously, the Regensburg synagogue would not have been placed in that category. Altdorfer's etchings are the only surviving authentic views of the synagogue. Whatever may have motivated him to record the doomed building, he was not oblivious to its beauty and dignity, although he did not fail to state in the inscription at the top that the synagogue was destroyed by the just will of God.

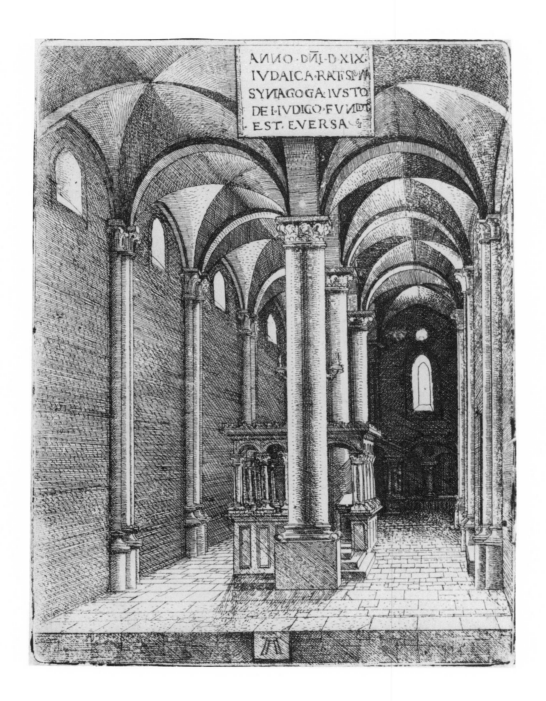

The text within the image reads:

ANNO · DŇI · D · XIX
IVDAICA · RATISPŇA
SYNAGOGA · IVSTO
DEI · IVDIGO · FVŇDT
EST · EVERSA ꝑ

101

Landscape with a Large Pine, c. 1520/23

Etching with hand-colored washes, 232 x 178 mm

Watermark: Chalice (Briquet 4547; Winzinger 1963: 151, no. 11)

Monogram in plate at upper left: *AA*

VC: Inv. no. I 99, 89

References: Hollstein I: no. 85; Winzinger 1963: no. 182; New Haven 1969: no. 60; Coburg 1975: no. 107

Color plate IV

This is one of nine landscape etchings that Altdorfer made shortly before or after 1520. Aside from topographical book illustrations, they are the first Western European prints in which landscape itself is the subject and not just the setting for a scene with figures. Because the landscapes are prints, one must assume that, despite their rarity today, they were issued for an interested public of some size. This sets them apart from either Altdorfer's or Dürer's drawings of landscapes, which were made primarily as studies and not for circulation.

Altdorfer was a trailblazer not only in making landscape an independent subject but also in recognizing etching as a medium with unique potential for conveying the irregularity and complexity of forms in nature. He was undoubtedly inspired by Dürer's experiments in the medium, especially the latter's etching of 1518, *Landscape with a Cannon*. But Dürer was not inclined to work as freely and spontaneously on the plate as were Altdorfer and later landscape artists such as Rembrandt, whose rapid notations with the etching needle could suggest the artist's optical and transitory experience of nature. Although *Landscape with a Large Pine* is carefully composed, the lines themselves have the shorthand character of a sketch, and it seems that Altdorfer, unlike Dürer, worked directly on the plate without the aid of a final, preparatory design. The darker strip along the right side of the pine suggests that the artist first made the trunk narrower by about a third, then decided it needed the extra width. As a result, it is now difficult to tell whether that additional portion even belongs to the same tree or represents part of a second one close

behind it. The modeling lines of this darker portion do seem to encircle a separate trunk. They are also drawn more densely than on the adjacent section, but fail to conceal entirely the pre-existing sketch of a distant landscape that lies beneath the artist's revision.

The colored washes make this impression appear more like a drawing than a print and raise the question whether Altdorfer intended to create this effect. His eight landscape etchings in the Albertina have been colored in a similar manner, but most surviving impressions remain purely prints: black ink on white paper. Still, it seems possible that Altdorfer himself tried a few in color. His own watercolor drawings of landscape reveal his inclination in this direction, although those drawings involve considerable body color, whereas here, the washes are thin enough not to obscure the lightly etched lines. Unlike the painters of Cranach's and Dürer's engravings (cat. nos. 123, 134, 145, and 156), who virtually transformed the prints into illuminations, the present watercolorist was wholly sensitive to the expressive character of the etching: the shaggy foliage, the sweep of the Alpine terrain, and the atmospheric veiling of the distant forms. If Altdorfer did prescribe the color or even apply it himself, he was going against the common practice for intaglio prints, and following instead the example of woodcut book illustrations that were often enlivened with color (cat. nos. 209, 211, 214, 216). In any case, as a category of art, landscape was just emerging around 1520, and whoever was responsible for the excellent coloring of this etching took a creative part in that laudable experiment.

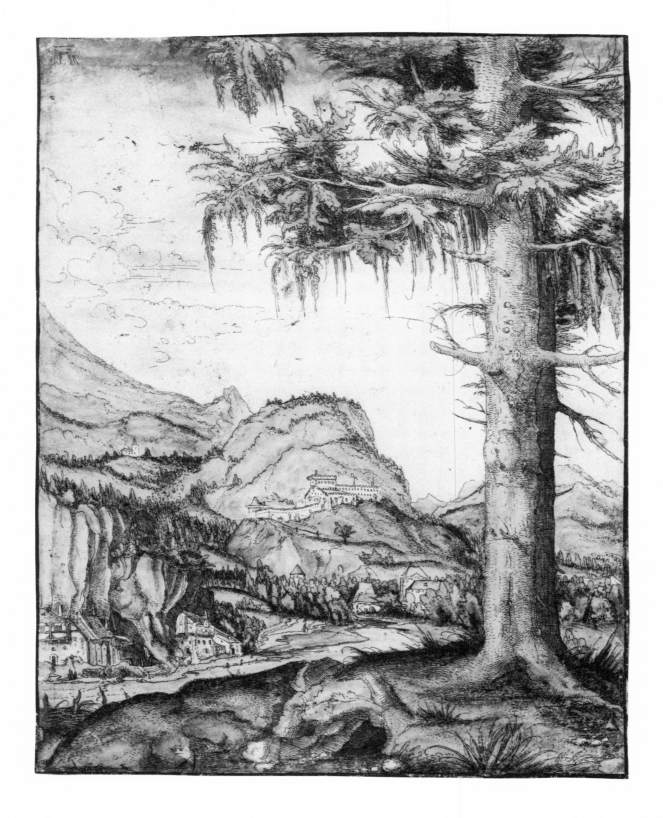

Hans Baldung Grien

(for biography, see p. 56)

102

Saint Andrew, c. 1516/19

Woodcut, 210 x 123 mm

Monogram in block at lower right: *HBG*

VC: Inv. no. I 102, 5

103

Saint John the Evangelist, c. 1516/19
(illustrated on p. 194)

Woodcut, 211 x 128 mm

Watermark: Gothic P with flower (similar to Briquet 8812)

Monogram in block at lower right: *HBG*

VC: Inv. no. I 102, 7

104

Saint Bartholomew, c. 1516/19
(illustrated on p. 195)

Woodcut, 211 x 127 mm

Watermark: Gothic P with flower (similar to Briquet 8812)

Monogram in block at lower right: *HBG*

VC: Inv. no. I 102, 9

105

Saint James Minor, c. 1516/19
(illustrated on p. 196)

Woodcut, 209 x 125 mm

Monogram in block at lower right: *HBG*

VC: Inv. no. I 102, 12

References: Bartsch 1803-21, VII: nos. 7, 10, 12, 15; Hollstein II: nos. 81, 83, 85, 88; Karlsruhe 1959: nos. II H 39, 41, 43, 46; Geisberg/Strauss 1974: nos. 90, 92, 94, 97; Mende 1978: nos. 47, 49, 51, 54; Washington/New Haven 1981: nos. 62, 64, 66, 69

As the immediate followers of Christ, the Twelve Apostles had special theological significance at the time of the Reformation. According to Catholic doctrine, they represented the authority of apostolic succession; for the Reformers, they personified the spiritual strength that came directly from the word of God, as embodied in Scripture. There is nothing in Baldung's representation of the Apostles that is more appropriate to the Protestant than to the Catholic cause. These are men to whom any Christian might turn. True saints, they are righteous, steadfast, and imbued with the Holy Spirit. Yet, one cannot be indifferent to the fact that the only two dated woodcuts in this series, *Saint Matthew* and the *Savior*, are from 1519, two years after Luther had made his decisive challenge to the authority of the Church, when he posted his 95 theses on the door of the castle church in Wittenberg. Nor can one fail to see these Apostles in relation to Baldung's woodcut portrait of Luther, dated 1521 (cat. no. 106), in which a radiance emanates from the head of the Reformer, just as it does from the Apostles themselves.

There are obvious difficulties in representing 12 relatively similar figures without incurring a certain tiresome repetitiveness. Even in dramatic situations that required the whole company of Apostles, such as the Last Supper or the Assumption of the Virgin, an artist was well challenged to convey a distinct personality and appearance for each figure. Nevertheless, the representation of the Twelve Apostles in a series must have rewarded the efforts of printmakers in Germany since many of them produced such sets. The engraved *Apostles* of the Master E. S. and Martin Schongauer were particularly influential. The four prints presented here from Baldung's *Large Apostles* show how the artist used the repetitive characteristics of the series to emphasize the idea of men united by a common faith while varying each print enough to make the viewer feel that

each is an individual. The settings are sparse, but clearly-out-of-doors—an allusion to the Apostles' mission of going forth in the world to preach. The limited space and format give the figures a feeling of monumentality. This and the strong modeling of the forms recall the sculptures, often figures of Apostles, placed on consoles against the nave columns of Gothic churches. Baldung has portrayed the Apostles as simple men; they all (with the exception of Saint Bartholomew) go barefoot and their common dress is the voluminous cloak. Yet, the Apostles wear this garment in a way that expresses their strength. Samson-like long hair and beards reinforce this image of legendary power. With one hand Saint Andrew effortlessly supports two massive logs in the form of his attribute, a cross, while with the other hand he holds a large book against his thigh. The other Apostles, too, present their attributes with the finesse of musicians addressing their instruments. Saint Bartholomew rests a knife across his forearm; Saint James Minor supports a fuller's bow as if it were a harp; and Saint John the Evangelist calls forth the evil from his poisoned cup with a benediction.

Baldung created the radiances that emanate from the Apostles' heads with purely graphic devices. He handled each instance a little differently, as if the spirituality of each saint produced its own vibration. Around the head of Saint Bartholomew, whose intent gaze is fixed straight ahead, the radiance appears to be generated in pulsating waves, while the halo of Saint James Minor looks like an explosive burst of light and those of Saint John and Saint Andrew fill the space around them. The strength of Baldung's conception, no less than his technical mastery of the medium, is clearly evident in the energy of these radiating lines, the fine modeling of the draperies, and the varied treatment of the curvilinear masses of beards and hair.

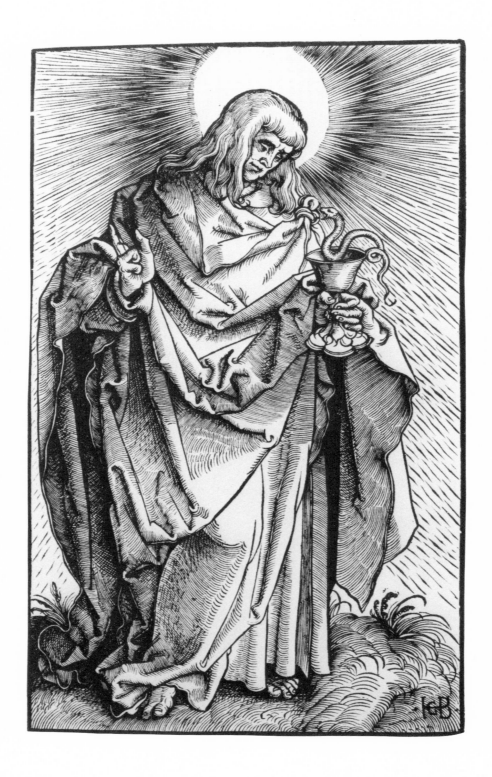

194

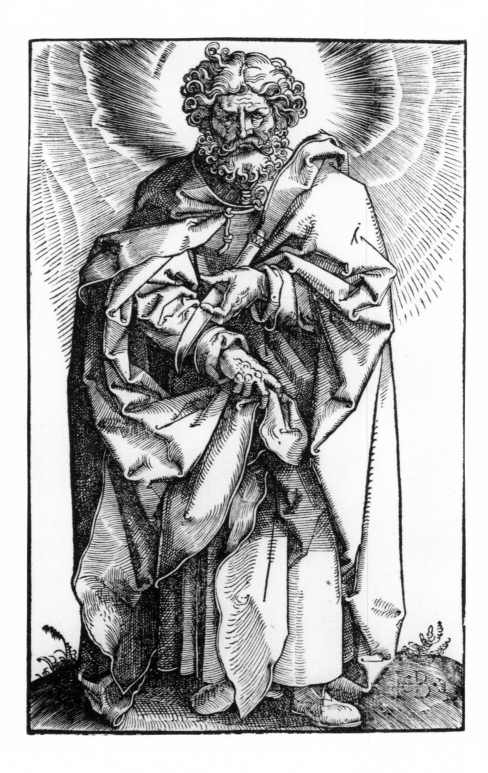

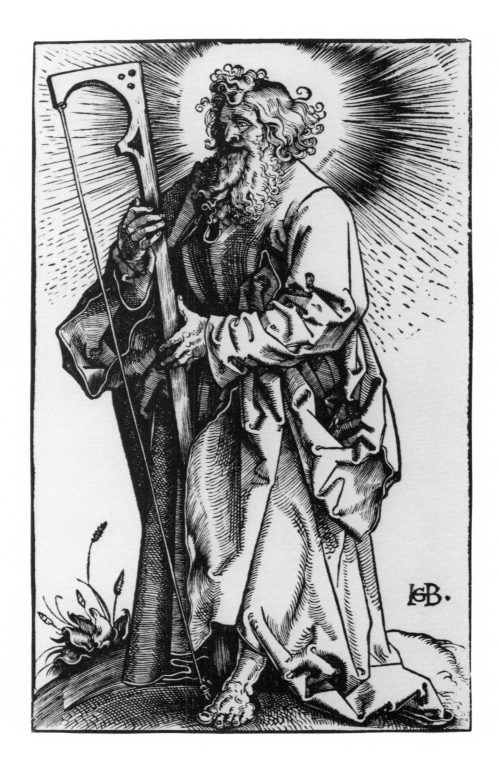

106

Martin Luther with a Nimbus and Dove, 1521

Woodcut, 155 x 115 mm

Monogram and date in block (on book): *1521 / HBG*

VC: Inv. no. I 102, 17

References: Karlsruhe 1959: no. xxxvii (1); Oldenbourg 1962: no. 358; Coburg 1967: no. 5; Princeton 1969: no. 22; Basel 1974, I: no. 37; Mende 1978: no. 437; Washington/New Haven 1981: 44

———————————————————————

Since Baldung had no chance to portray Luther from life, he was dependent upon Cranach for a likeness. Luther's gesture and the book he holds show that Baldung was using Cranach's engraved portrait of 1520, in which Luther is framed by a niche (Hollstein VI: no. 7; Basel 1974, I: no. 36). Baldung, however, has dispensed with the niche and went far beyond Cranach's restrained imagery. The explosive radiance around Luther's head makes him the spiritual equivalent of the Apostles (see cat. nos. 102-105) as does the dove of the Holy Spirit, traditionally included in portraits of the Evangelists. Although such a portrayal was destined to provoke Luther's Catholic opponents, it reveals the profound impact made by this interpreter of the faith who relied on the authority of Scripture itself and on the inspiration of the Holy Spirit. The portrait first appeared as an illustration for the title page of *Acte et res gestae Dr. Martini Luther* (*Acts and Deeds of Dr. Martin Luther* [Strasbourg, 1521]). The printer, Johann Schott, then reused the block for ten other publications between that year and 1526.

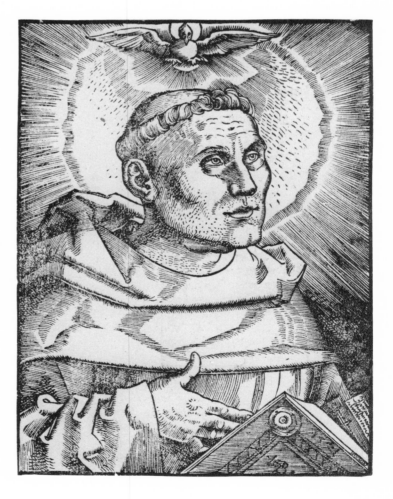

107

Wild Horses Fighting, 1534

Woodcut, 215 x 321 mm

Watermark: Gothic P with flower (similar to Briquet 8812, but flower has longer stem)

Signed and dated in block at lower right: *BALDVNG / 1534*

VC: Inv. no. I 102, 23

References: Hollstein II: no. 238; Karlsruhe 1959: no. II H 78; Coburg 1975: no. 111; Mende 1978: no. 77; Washington/New Haven 1981: no. 83

Unlike Dürer and Altdorfer, Baldung occupied himself very little with the representation of landscape, but he was deeply interested in those forces of nature, particularly as revealed in animate form, that exceeded man's control or understanding. Apart from religious subjects and portraits, which he often executed on commission, the themes to which he turned time and time again concern aging, death, and the carnal instinct responsible both for the propagation of life and, as Baldung saw it, for man's fall from grace. According to 16th-century theory, traceable in part to ancient writers, the horse is next to man the most salacious and passionate of all creatures. In art, however, the horse had traditionally been depicted as a noble animal whose size and strength were controlled by man's superior intellect. Dürer's *Small Horse* and the horse in his *Knight, Death and the Devil* (cat. nos. 143, 153), based on measured drawings developed during a search for the animal's ideal proportions, exemplify this rational and anthropocentric approach. Baldung's unprecedented woodcuts of 1534, on the other hand, show wild horses in a forest, either fighting, as in this example, or sexually aroused to a state of great excitement. These horses live outside the restraints of civilization, and their instinctive behavior reveals natural forces that are wild and turbulent. These are the same unmitigated forces that seem to possess Baldung's witches (Washington/New Haven 1981: no. 18), a subject which had a lifelong fascination for him. With abandoned, often lascivious actions and flying limbs and hair, these witches are closely related to Baldung's horses both in their passion and configuration. Moreover, the wild-eyed animals themselves, with their frenzied movements, have a demonic appearance. This is not to say that these fighting horses are necessarily possessed by a satanic influence, but rather that they—like witches—are driven by the same irresistible forces that govern carnal passion in man.

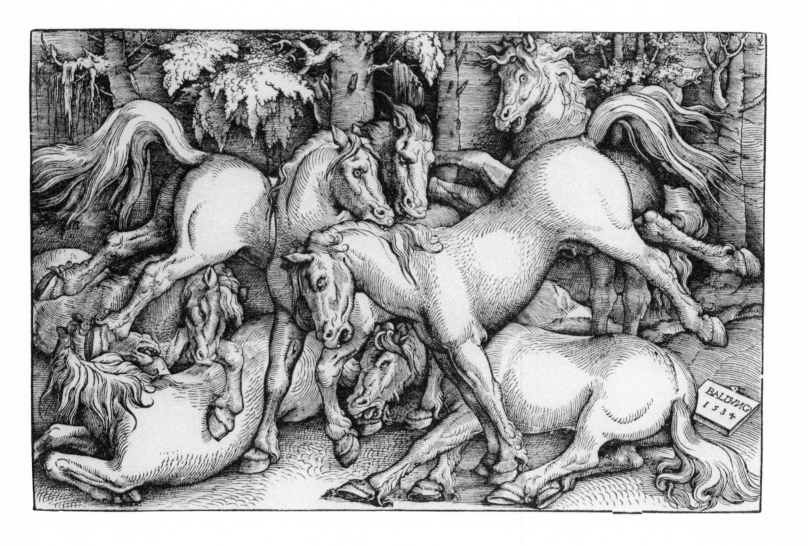

108

Bewitched Groom, c. 1544

Woodcut, 339 x 199 mm (image)

Watermark: Escutcheon with three fleurs-de-lis, a flower above and Gothic C below (Briquet 1816)

Monogram in block at lower right: *HB*

VC: Inv. no. I 103, 30

References: Radbruch 1950: 39-41; Hollstein II: no. 237; Karlsruhe 1959: no. II H 77; Hartlaub 1961: 22-24; Coburg 1975: no. 112; Hults-Boudreau 1978: 136-141; Mende 1978: no. 76; Mesenzeva 1981: 57-61; Washington/New Haven 1981: no. 87

This mysterious work is one of Baldung's most arresting compositions. The stance of the horse is familiar from Dürer's engraving of 1505, the *Large Horse* (cat. no. 144), but Baldung has transformed Dürer's obedient animal into one that is as wild as the fighting horses he represented in a forest (cat. no. 107). The groom, apparently thinking that the horse had been tamed, since it had, at least, already been shod, approached it with a currycomb in his hand. However, the demonic look in its eye and the swish of its tail leave no doubt about its true character. There is no proof that the groom has been kicked by the horse, but the proximity of his head to its hooves does suggest this. The position in which the groom is shown has ominous overtones: on the one hand, he looks like a carved recumbent effigy seen from the end of a tomb, on the other hand, the most closely related prototypes for such a foreshortened figure are images of the dead Christ, like Baldung's own woodcut of about 1515/17 (Washington/New Haven 1981: no. 48) or Dürer's drawing from 1505 in Cleveland (Museum of Art) (Washington 1971: no. XIII).

Of the many popular stories about witches and demons that circulated at the time, one has recently come to light that Baldung may have had in mind when he designed this print. It concerns a robber knight by the name of Rechenberger (or, in some versions, Seckendorf) who thought himself fearless until he beheld a band of riders from hell leading one riderless horse that, he was told, was intended for him. Rechenberger fled to a monastery, where he became a stable hand, but a year later, the prophecy was fulfilled, when the devil sent for him. There are different versions of the manner of his death, but according to two of them, he received a fatal kick from his wild fiendish mount. Around midnight, following Rechenberger's burial, a ghastly rider led the now saddled horse to the grave, and the sinful knight rose up, mounted the horse and was led away (Mesenzeva 1981: 58-61). Given the existence of Baldung's other representations of wild horses and witches, one can see that he depended upon no single story for imagery of this kind. But the tale of the robber knight does reveal what sort of demonic lore fed the artist's imagination.

The date of 1544 for this woodcut derives from the existence of a dated study in black chalk for the goom at Basel (Kunstmuseum). The woodcut was thus created in the last year of the artist's life and has a distinctly personal aspect, as if he were aware that his own death was imminent. He placed his family coat of arms, adopted from that of his ancestral town, Schwäbisch-Gmünd, on the wall, where it is about to be scorched by the witch's torch. Furthermore, although the identity is far from certain, the foreshortened groom's face bears a resemblance to Baldung's self-portrait in a drawing and woodcut of ten years earlier (Washington/New Haven 1981: no. 80). Finally, it has been noted that one point of the pitchfork on which the groom has fallen nearly touches Baldung's monogram. However, the inclusion of his escutcheon alone is enough to make it very likely that the artist was referring here in some way to himself.

Sebald Beham

1500 Nuremberg—Frankfurt 1550

Sebald Beham (old German: Peham)* was the most productive printmaker of his generation. Because his engravings are of small dimensions, he was formerly categorized as one of the so-called "Little Masters," along with his brother, Barthel Beham, Heinrich Aldegrever, and Georg Pencz. He was also a miniaturist and glass painter. Were it not for the absence of documentary proof, there would be no doubt that Beham trained in Dürer's shop, given the extent of Dürer's influence on his art. In 1525, together with his brother and Pencz, Beham was expelled from Nuremberg for his atheistic and anarchist opinions, but was allowed to return later the same year. In 1528 he was accused of having plagiarized Dürer's unpublished treatise on the proportions of the horse, and he fled the city, returning once again in 1529. In 1530 he worked in Munich and in 1530/31 in Mainz or Aschaffenburg for Cardinal Albrecht of Brandenburg. From 1532 on, he was active mainly in Frankfurt, where he died in 1550.

*The form of the artist's name that appears in 16th-century sources is Sebald Beham, as one finds in the title of cat. no. 206. However, because of the H in his monogram, he appears in most of the literature as Hans Sebald Beham.

109

Holy Family under a Tree, 1521

Woodcut, 169 x 108 mm

Watermark: Small imperial orb (similar to Meder 55)

Monogram and date in block at upper right: *1521 / HSP*

VC: Inv. no. I 121, 463

References: Pauli 1901: no. 889 I; Dodgson 1903-11, I: 462, no. 108; Hollstein III: 907, I

In this rare first state of the woodcut—for subsequent printings, the date was removed from the block—the strength of the impression accentuates the already emphatic linearity of Beham's style. The artist derived his technique and, in general, his theme for this work from prints by Dürer such as the *Holy Family with Joachim and Saint Anne* (cat. no. 150). However, Beham stiffened and weighted the modeling lines to such a degree that the figures seem almost imprisoned by them. Furthermore, the familial informality of Dürer's rendering has been lost. The figures are crowded into the foreground with a large tree blocking the way at their backs, and, despite their proximity to the viewer and to one another, there is no visual contact between any of the figures or with the beholder: Joseph makes a puzzling gesture with one hand over his head, but it goes unnoticed by his family; the Virgin stares off in one direction; the reclining child looks off in another as if bored. None of the other figures registers any legible expression. The artist, who was banished from Nuremberg four years later for his atheistic opinions has effectively drained both the spirit and spirituality from this *Holy Family*.

110

Saint Sebald, 1521

Engraving, 152 x 113 mm

Watermark: Bull's head with snake

Monogram and date in plate at lower right: *1521 / HSP*

VC: Inv. no. I 108, 84

References: Pauli 1901: no. 69; Waldmann 1910: 62; Hollstein
III: 44, I; Nuremberg 1961: 29, no. 106; Zschelletzschky 1975:
208-209

This engraving of Nuremberg's patron saint exists in two states, of which this is the first. For the second state, the plate was cut down at the top and slightly in at the sides. There is no way to be certain whether this alteration was meant to improve the composition or simply to remove a damaged edge, but as this example shows the trees in the first state are somewhat overscaled—which may have been intentional. The unusual pairing of the trees with the saint centered slightly in front of them forms a compositional structure strikingly similar to that of the model of the *Sebalduskirche* (Church of Saint Sebald) which the saint holds in his hand. Thus, Beham has gone beyond the traditional device of including the saint's attribute: the composition itself, in which the trees repeat the form of the church's twin towers, reinforces the identification of the saint's body with the church itself. The psychology of this Saint Sebald is of Beham's own devising. He has a look of suspiciousness both in his face and in the way he sits. His seems to be a spirituality more thrust upon him than innate. The Church of Saint Sebald was not only dedicated to this pilgrim saint who had lived and died in the vicinity of Nuremberg in the eighth century, it also housed his remains, contained in a silver casket for which Peter Vischer and his sons completed their celebrated bronze shrine in 1519, two years before the date of this engraving.

Beham assimilated Dürer's engraving style with remarkable speed. His earliest dated engraving is from the year 1518, and by the following year, he already commanded the burin with complete assurance. A comparison of *Saint Sebald* with Dürer's *Virgin and Child with the Pear* (cat. no. 149) shows the extent of Beham's technical and stylistic debt to his master. Yet it also reveals a very different artistic personality. Beham had little interest in the individual texture of things and used intricate cross-hatching strictly for its tonal value. Such neutral surfaces call to mind the mature engraving of Marcantonio Raimondi, and the treatment of the landscape behind Saint Sebald suggests that Beham was familiar with such prints as the *Pietà* (Lawrence/Chapel Hill 1981: no. 37) from the mid-1510s by this Italian engraver, who in his turn had also greatly profited by Dürer's example. However, both Beham and Raimondi were moving in a more classicizing direction, whereby the burin was intended above all to give shape and volume to solid form.

111

Ecce Homo, 1521

Woodcut, 327 x 249 mm

Watermark: Bull's head with snake (Piccard 1966: sect. XVI, no. 318)

Date in block at upper right: *1521*

VC: Inv. no. I 21, 195

References: Dodgson 1903-11, I: 350, no. 6; Hollstein VII: 262. no. 2; Geisberg/Strauss 1974: no. 782

Although this woodcut is usually catalogued simply as a work of the School of Dürer, there is a strong case to be made for an attribution to Sebald Beham. The machine-like regularity of the stiff hatching is indistinguishable from that seen in Beham's *Holy Family under a Tree,* also dated 1521 (cat. no. 109). Furthermore, a woodcut now customarily attributed to Beham and depicting the face of Christ (Hollstein III: 184; Geisberg/Strauss 1974: no. 192-I), shows the same countenance with only minor variations, drawn and cut in the same style. Both images confront the beholder with an unrelenting stare. Allowing for the difference of frontality, this group of figures bears considerable similarity to Dürer's *Ecce Homo* from the *Large Passion* (Washington 1971: no. 127), which contains a single staring eye peering through the crowd—like that found just to the left of Christ's shoulder in this woodcut —and a profile that looks like the old man here, with his beak nose and protruding lower lip. The source for the face of Christ, however, was surely Dürer's engraving, *Sudarium Held by Two Angels* (Washington 1971: no. 57), dated 1513.

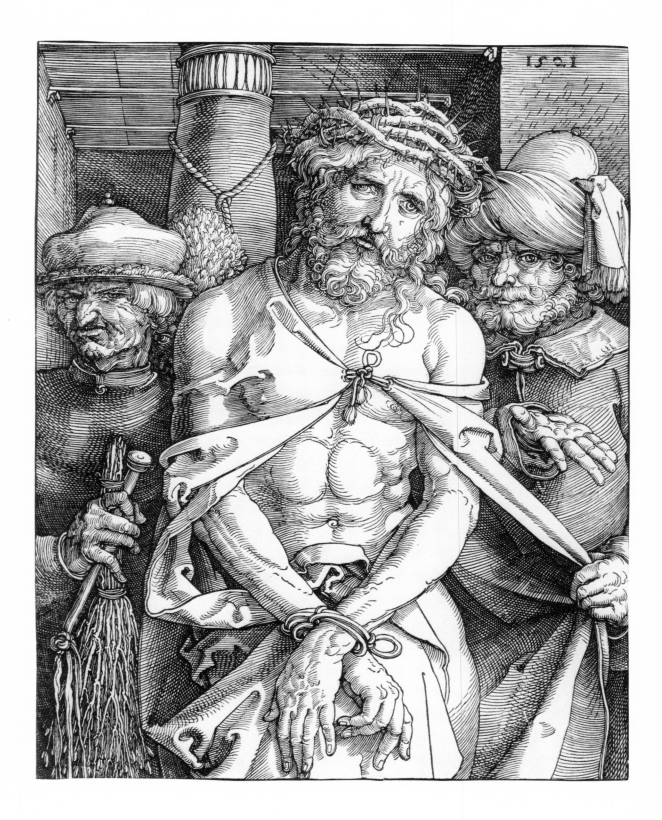

Hans Burgkmair

1473 Augsburg 1531

Hans Burgkmair received his first training from his father, the painter Thoman Burgkmair. From 1488 to 1490 he was apprenticed in Colmar to Martin Schongauer. In 1491 Burgkmair returned to his birthplace, and began designing woodcuts for the publisher Erhard Ratdolt. In 1498 he became an independent master, entitled to train his own apprentices. Of all German cities, Augsburg was the one whose art most strongly reflected the art of the Italian Renaissance, and Burgkmair, who spent at least part of 1507 in Italy, became Augsburg's dominant artistic personality. In addition to his many woodcut designs,

he received numerous important commissions for paintings. His chief patron was Emperor Maximilian, especially between 1508 and the latter's death in 1519. Together with Altdorfer, Baldung, Cranach, and Dürer, he made drawings for the *Prayerbook of Maximilian I*, and he contributed woodcuts to the emperor's principal graphic arts projects: the *Genealogy of Maximilian I, Der Weisskunig (The White/Wise King), Der Theuerdank (The Knight of Adventurous Thoughts)*, and the *Triumphal Procession*. Between 1508 and 1512, Burgkmair was a leading figure in the development of the chiaroscuro woodcut.

112

The King of Cochin (DER KVNIG VON GVTZIN)

Woodcut from two blocks, 270 x 700 mm

Watermark: Crowned shield with profile of crowned Moor's head

Initials and date in block at upper left: *1508 / H B*

VC: Inv. no. I 63, 32

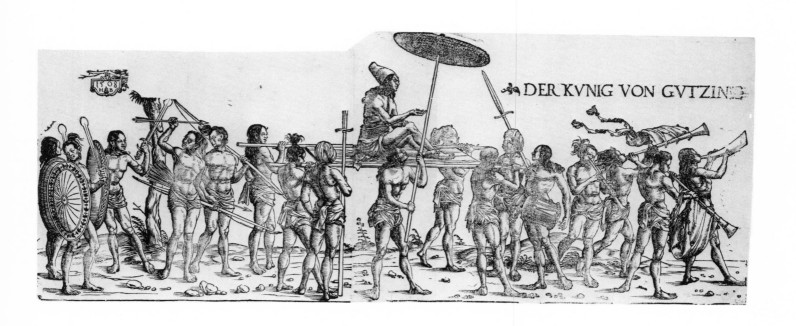

DER KVNIG VON GVTZIN

Georg Glockenden

Active Nuremberg 1484-1514

Member of a sizeable Nuremberg family of miniaturists, designers, and woodblock cutters, Georg Glockenden became a citizen of Nuremberg in 1484, where he was active until his death in 1514. He was frequently employed as an illuminator of hymnals and missals and as a painter of coats of arms. After 1500, he signed a number of woodcuts, of which he was probably only the cutter (rather than the designing artist), as he was for this copy of Burgkmair's *King of Cochin*. In 1509 he published a pirated edition of Viator's *De artificiali perspectiva*.

113

The King of Cochin

Woodcut from five blocks, 265 x 1875 mm

VC: Inv. no. I 63, 33

References: Derschau/Becker 1808-10, II: nos. B 25-B 26; Harrisse 1895: 41-45; Schulze 1902; Dodgson 1903-11, II: 71-73, nos. 11-12; Burkhard 1932: 32, no. 13; Augsburg 1955: no. 128; Falk 1968: 67-68; Augsburg 1973: nos. 23-26; Augsburg 1980-81: nos. 183-183a

In 1504, six years after Vasco da Gama had reached India by sailing around the Cape of Good Hope, a consortium of German merchants from Augsburg and Nuremberg, under the leadership of the Welser Company, gained permission from King Emmanuel of Portugal to join a Portuguese trading expedition to the Malabar coast. The Germans outfitted three of the some twenty ships in the fleet commanded by Francisco d'Almeida, which set sail from Lisbon in March 1505 and returned in November of the following year. An agent of the consortium by the name of Balthasar Springer who sailed aboard one of the ships wrote a brief report of the expedition that was published in several forms. It first appeared (1508) in an abbreviated version as the text for a frieze-like broadsheet with six woodcuts by Hans Burgkmair and a year later was published in book form as *Die Merfart und erfarung nüwer Schiffung und Wege zu viln onerkanten Inseln und Künigreichen.... (The Voyage and Experiences of New Shipping and Routes to many Unknown Islands and Kingdoms)*. This was the first German expedition to India, and the illustrated report no doubt attracted a lot of attention. Burgkmair's original frieze, now exceedingly rare, was copied by Georg Glockenden in Nuremberg, apparently as early as 1509, although the Coburg impression, like most others, bears the date 1511.

Whether Springer made any sketches to go with his report is not known. Burgkmair, in any case, was certainly acquainted with the appearance of Africans, who were often seen at this time in busy European trading cities. His representations of these natives of little-known lands are clearly not just Europeans dressed up in skimpy or exotic costumes, as was often the case in the work of other Renaissance artists.

A comparison of the two sections of Burgkmair's original woodcut preserved at Coburg with Glockenden's version, in which the frieze was reduced to five blocks in length and the printed text shortened, shows the latter to be, by and large, a faithful copy. The paragraph at the upper left introduces the woodcut:

> The following pictures of the life and customs [of the people] in the kingdoms visited, discovered and in part conquered by the help of God and of the King of Portugal, are presented accurately in this form by Balthasar Springer from Vils [in the Tirol] who experienced this himself....

Each group of figures is then identified by inscriptions giving their place of origin in capital letters and a line or two of descriptive text. Above the native family labeled *IN GENNEA* (In Guinea), the text reads: "of the naked Moors with weapons...." The caption for *IN ALLAGO* (probably Algoa Bay on the southeast coast of Africa)—"the dress and decoration of the old and young in Allago and their genitals in leather"—refers, according to Springer's account in the *Merfart*, to a leather sheath worn by the men. That account also calls attention to the wide, round leather sandals for walking in the sand. By *IN ARABIA* is probably meant the east coast of Africa from around Mozambique to Mombasa. In the *Merfart* Springer mentions that these people wear richly brocaded silk robes, such as those shown in the woodcut. The two panels at the right (three in the original) were designed in the form of a triumphal procession. The inscription announces the King of Cochin:

> Of the customs and musicians of the King of Cochin, his courtiers and subjects, and also the Kings of Cananor, Banderan, and Collam do likewise. 40 miles below Calicut.

Glockenden's version differs from Burgkmair's original in several places. The blank area to the right of the plaque bearing Burgkmair's initials (probably intended for text that was never printed) has been filled in with the upper part of a tree and several birds. The procession with the elephant and camel in the background of Glockenden's central section appeared as the first block, that is, at the extreme right, in Burgkmair's version. The reference to cannabalism in that same central section is a sensationalistic addition to the otherwise affectionately familial scene in the foreground. Glockenden's copy can also be distinguished from the original by its much stiffer modeling lines. The copyist's limited drawing skill is fully revealed by the figure of the woman reaching into a tree and the two children crouching by the entrance to a small cave in the section labeled *DAS GROS INDIA* (Great India). This figural group does not appear in Burgkmair's woodcut and the reasons for its addition are not clear.

The attribution of the copy to Glockenden is based on a reference (Dodgson 1903-11, II: 72) to an impression in Gotha, said to bear his name and the date 1509. However, this impression cannot now be located. In 1810 the blocks by Glockenden and three of those by Burgkmair were printed along with other blocks in the famous Derschau collection (see p. 21). Although the Coburg impressions are not from that printing, they are nonetheless late impressions, revealing much wear in the blocks.

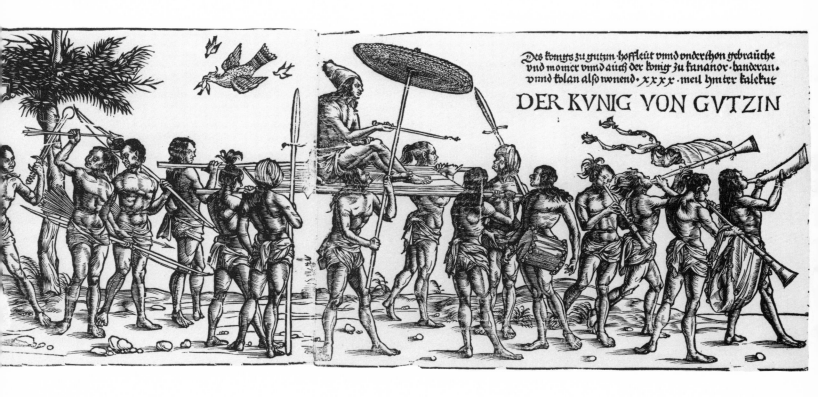

Des kunigs zu gutzin hoffleüt vnnd vnderschon gebrauche
vnd momer vnnd auch der kunig zu kunanor banderan
vnnd tolan also wonend · x x x x · meil hinter kalekut

DER KVNIG VON GVTZIN

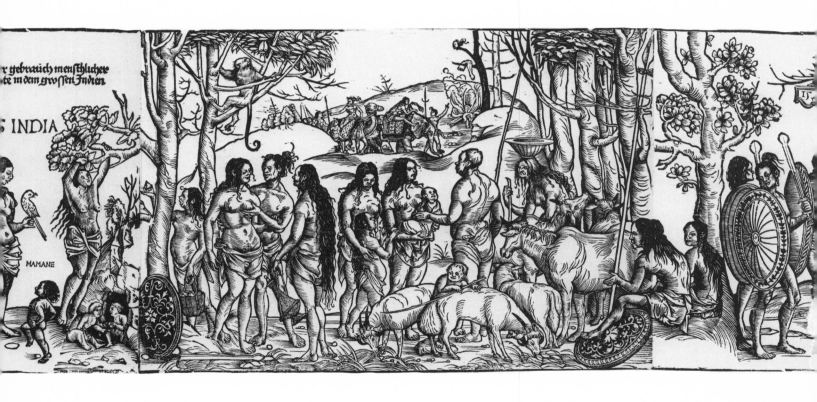

114

Lovers Surprised by Death, 1510

Chiaroscuro woodcut, printed from three blocks, one in black and two in shades of green, 213 x 150 mm

Watermark: Double-headed eagle with imperial crown (similar to Briquet 243)

Signed in block at left: *H. BVRGKMAIR*; vertically on pilaster at left with letterpress: *Jost de Negker*

VC: Inv. no. I 62, 9

115

Lovers Surprised by Death, 1510

Chiaroscuro woodcut, printed from three blocks, one in black, one in brown, and one in tan, 212 x 150 mm

Signed in block at left: *H. BVRGKMAIR*

VC: Inv. no. I 62, 8

Color plate V

References: Dodgson 1903-11, II: 85-86, nos 46 II, 46 III B; Reichel 1926: no. 9; Burkhard 1932: no. 20; Hollstein V: no. 724; Falk 1968: 57, 67; Augsburg 1973: no. 41; Geisberg/Strauss 1974: no. 475; Providence 1974: no. 42; Coburg 1975: no. 113

The graphic arts thrived in Augsburg under the patronage of Emperor Maximilian I, who established his main residence there. In this startling image the conjunction of theme, style, and technique are indicative of that city's truly international environment. Augsburg maintained close commercial ties with Venice that contributed to a strong Venetian influence in the arts. The setting of this print, which includes a canal and the prow of a boat, and its compositional organization into tonal areas show two aspects of that influence. Furthermore, the interest of Italian Renaissance artists in Antiquity is evident in the Roman costumes worn by the two figures confronted by Death as well as in the pose of the woman with arms outflung in terrified flight, an image derived from the classical story of Daphne fleeing from Apollo. But the theme itself, a disturbing reminder that death often strikes when least expected, was rooted in the traditions of Northern Europe and held a particular fascination for German artists in the early 16th century (see cat. no. 169), none of whom presented the subject with a better sense of its cruel irony than did Burgkmair. Far from the dangers of the battlefield, a soldier has fallen into the grip of Death just as he has reached the arms of his lover. Her own desperate attempt to escape is doomed because Death has snatched a corner of her dress with his teeth and is gently caressing her shoulder with his feathery wing.

This chiaroscuro woodcut (see p. 174) of 1510 is the first known example composed of three blocks, one for the outline and the others for tone, rather than just two. Unlike most German chiaroscuro woodcuts, in which the line block could be printed by itself to produce a complete image without color (as in cat. nos. 117, 157), here both tone blocks carry essential parts of the composition, the line block providing only a partial description of the forms. Printed last, the line block accentuated certain contours and contributed the darkest of four tones, the white of the paper being the first and lightest one. As can be seen by these two impressions of the same woodcut, the printer experimented with different colors but necessarily maintained the same relative light to dark values in his choice of inks. The contrast of tone heightens the drama of the scene: the line of shaded facades is broken by brightly illuminated passageways between the buildings, where light floods in to reveal Death at work and to suggest paths of escape that cannot be reached.

These two impressions represent the second and third of three states. Although the colors vary, the same three blocks were used in all three states—contrary to the recent literature (Hollstein V: no. 724; Strauss 1973: no. 13). The difference between states is limited to changes in the printed inscriptions. The first state (not shown) bears only the name, H. BVRGKMAIR, plus the date, MD.X. The second state, to which the present example in shades of green belongs, lacks the date but has the woodcutter's name, Jost de Negker, printed vertically with type at the left. In the third state, also undated, Jost de Negker's name is printed in the lower margin. However, as happened here in the impression in tones of brown and tan, it has often been trimmed off.

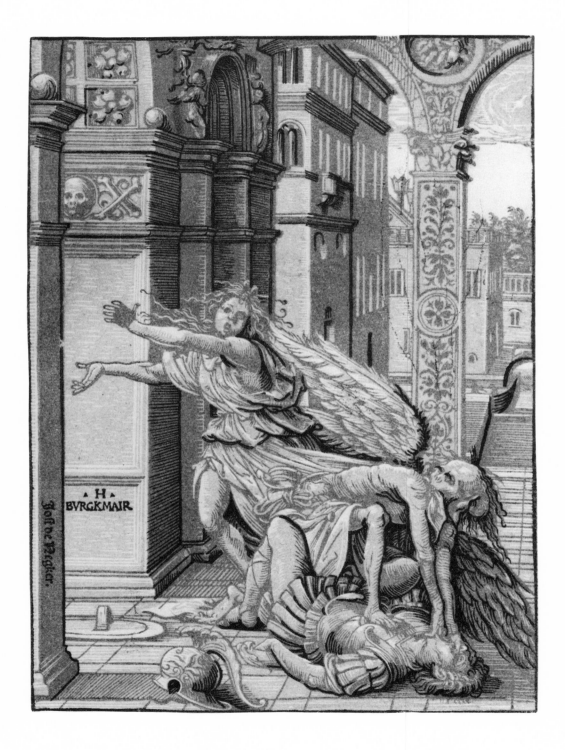

116

Venus, c. 1510

Woodcut, 305 x 185 mm

Initials in block below figure: *H.B.*

VC: Inv. no. I 64, 77

References: Dodgson 1903-11, II: 84, no. 43; Burkhard 1932: no. 23.5; Hollstein V: no. 288; Augsburg 1973: no. 65; Geisberg/Strauss 1974: no. 494; Coburg 1975: no. 114

This figure of Venus is one of seven personifications of the planets that Burgkmair compiled in the form of a continuous frieze. Each figure was cut on a separate block that fit inside the block for the architectural frame, and the two parts were then printed as a unit. When the seven sections were joined together, the frame became an arcade of alternating arches, one containing a figure, the next an urn. Burgkmair also produced two other series in the same manner with personifications of the seven Virtues and the seven Vices. He used a different repeating frame for each series, but all involved arches and Renaissance ornament. Although much imitated at the time, few impressions of the original prints have survived. Of the *Venus* complete with border, the only impressions cited in the literature are this one and one in the British Museum.

Identified by inscription as well as by the inclusion of the blindfolded Eros, Venus stands with the zodiac signs of Libra and Taurus at her feet. Her soft, flaccid body lacks the vitality of the tussling, music-making putti at the bottom. In the uppermost arch of the frame amid other classically derived figures and ornaments, Burgkmair placed a napping shepherd, seen feet first from below.

Lucas Cranach the Elder

1472 Kronach—Weimar 1553

Lucas Cranach the Elder, the foremost member of a family of artists, took his name from the town of his birth—Kronach, some 15 miles east of Coburg. Although it is likely that he trained with his father, the painter Hans Maler, there is no record of his life nor any works that can definitely be attributed to him from the period before 1501. In that year, he appealed to the city court in Coburg for payment of 20 gulden for work done there. Shortly thereafter, he went to Vienna, where he produced the first of his known works—paintings that in their vigorous brushwork and emphasis on man's relationship to nature constitute the beginning of the stylistic movement known as the Danube School. In 1504 Cranach was called to Wittenberg by Duke Friedrich the Wise of Saxony, and it was there that he developed the smooth, linear style that provided the basis for painting in Saxony throughout the 16th century. Cranach served Duke Friedrich and his two successors, Johann the Steadfast and Johann Friedrich the Magnanimous, until his death in 1553. As court artist, he was frequently employed to decorate the dukes' favorite residences, including the Veste Coburg, where he worked off and on between 1505 and 1509, although there are no surviving traces of his mural paintings at Coburg. In 1508 Duke Friedrich granted him a coat of arms with a winged serpent holding a ring in its mouth, which Cranach henceforth used as a signature on his own work and on that which he wished to identify as having originated in his shop. In the earlier form of that signature the serpent has upraised bat wings; then after 1534 the wings are shaped like those of a bird and are lowered.

Cranach prospered in Wittenberg; the tax records of 1528 reveal that he was one of the town's two wealthiest citizens. Besides running a large workshop, in which both his sons, Hans Cranach (c. 1513-1537) and Lucas Cranach the Younger (biog. p. 384) were active, he owned several houses and an apothecary that had a monopoly on the sale of medicine, herbs, and wine. In 1523 he established a publishing firm with Christian Döring that printed Reformation literature for three or four years before the business was dissolved. From 1519 to 1545, Cranach served on the Wittenberg city council and on three occasions was elected to the office of burgomaster. Despite the godfathers to one another's children) and that he was fact that Cranach was a close friend of Luther (they were court painter to the Protestant dukes of Saxony, he also filled commissions from Luther's foe, Cardinal Albrecht of Brandenburg, and from members of the Catholic (Albertine) line of Saxon princes. After Charles V took Duke Johann Friedrich prisoner at the battle of Mühlberg in 1547, Cranach followed the duke into exile in Augsburg and Innsbruck; when the duke was freed in 1552, Cranach accompanied him to Weimar, where the artist died a year later.

117

Saint Christopher, 1506 [1509?]
(illustrated on p. 217)

Chiaroscuro woodcut, printed from two blocks, one in black, the other in brownish gray, 277 x 190 mm

Initials, date, and winged-serpent emblem in block at upper left: *LC / 1506*

VC: Inv. no. I 43, 65

References: Flechsig 1900: 28-37; Dodgson 1903-11, II: 296, no. 61; Reichel 1926: no. 2; Jahn 1955: 33, no. 41; Hollstein VI: no. 791; Coburg 1972: no. 64; Augsburg 1973: nos. 21-22; Geisberg/Strauss 1974: no. 594; Basel 1974, II: nos. 402, 555; Coburg 1975: no. 104

The principal figures involved in the discovery and early development of the chiaroscuro woodcut were Lucas Cranach and Hans Burgkmair (see p. 208). There was apparently no little rivalry between them, which may help explain the mystery surrounding the chronology of this *Saint Christopher*. The print bears the same date, 1506, and has the same form of signature as another of Cranach's earliest chiaroscuro woodcuts, *Venus and Cupid* (Geisberg/Strauss 1974: no. 616). Early impressions of both woodcuts exist in black and white, printed from just the line block, and, since the line block produces a complete composition on its own, it is quite possible that the tone blocks were an afterthought. There is reason to believe, however, that Cranach did not produce a true chiaroscuro tone block—one that is cut to leave areas of the white paper exposed for highlights—until at least the end of 1508, when he returned to Wittenberg from a journey to the Netherlands and presumably saw for the first time examples of chiaroscuro printing by Burgkmair and Jost de Negker (see p. 174 and cat. nos. 114-115). But the question of dating is not limited to the tone block. Flechsig's (1900: 28-37) observations have persuaded most students of these woodcuts that Cranach did not even design the line blocks for *Saint Christopher* and *Venus and Cupid* until 1509, three years after the date that appears on them. Some of the reasons are stylistic, but the principal argument against a dating of 1506 is that only in January 1508 did Cranach receive from his patron, Friedrich the Wise, his

heraldic insignia, the winged serpent, which he used from that time forward to sign his work. Since both the *Saint Christopher* and the *Venus and Cupid* are signed with the winged serpent, it seems likely that they would necessarily postdate the beginning of 1508. If so, both the line blocks and tone blocks would have been executed close in time, if not contemporaneously.

According to a letter of 1508 sent to Friedrich the Wise by Konrad Peutinger in Augsburg, Cranach's 1507 woodcut of *Saint George on Horseback* (Geisberg/Strauss 1974: no. 598) provided the incentive for Burgkmair to begin experimenting with color printing. Cranach's *Saint George* was printed on blue prepared paper (that is, paper to which paint has been applied as a ground as opposed to paper dyed in the process of its manufacture) from two blocks, one in black for the main lines of the image and the other for the highlights. This second block, also carved in a linear manner, actually printed a white adhesive substance for the later application of powdered gold or silver. At Peutinger's expense, Burgkmair duplicated this procedure in two woodcuts of 1508, another *Saint George* and an *Equestrian Portrait of Emperor Maximilian*. With evident pride in the achievement, Peutinger sent impressions on parchment of Burgkmair's *Saint George* to both Friedrich the Wise in Wittenberg and to Duke Georg of Saxony in Leipzig. Very soon thereafter, Burgkmair and his cutter, Jost de Negker, developed a true chiaroscuro tone block to replace the highlight block, and the lead in color printing passed from Wittenberg to Augs-

burg. Perhaps Cranach in the face of that development backdated his woodcuts of *Saint Christopher* and *Venus and Cupid* in order to reestablish his claim to the leadership in this new field. Several scholars have concluded that this is what he did (Falk in Augsburg 1973: nos. 21-22; Koepplin and Falk in Basel 1974, II: no. 555; Schade 1974: 34; David Landau, letter to author, February 17, 1981). If so, it is hard to justify the action except to recognize that Cranach had been working along the same lines and may well have had the idea for a chiaroscuro block himself without anticipating a need to produce it quickly.

Although the line block printed a self-sufficient image of Saint Christopher, the tone block provided both modeling and detail, especially in the clouds. It is curious, however, that the cutting for the white clouds corresponds in only a haphazard way to the outlines established by the first block. Compared to other chiaroscuro blocks printed with Cranach's line blocks, this one seems the least well coordinated. Yet it is important to note that for the more common, later chiaroscuro impressions of the woodcut (Strauss 1973: no. 4), namely those printed after the date 1506 had been removed, a new tone block was used, not simply a recut state of the original one (Landau, letter of February 17, 1981). The describable differences between the original and substitute tone blocks are limited to many minor details, but as Landau correctly observes, the overall effect is much livelier in the original block, as can be seen in this impression from Coburg.

118

Martyrdom of Saint Erasmus, 1506

Woodcut, 227 x 158 mm

Initials and date in block at lower right: *LC / 1506*

VC: Inv. no. VI 427, 298

References: Jahn 1955: 24-25; Hollstein VI: no. 80 II; Kaltwasser 1961: no. 2; Coburg 1967: no. 73; Coburg 1972: no.66; Roch 1972: 115-116; Basel 1974, I: 114 and II: no. 401; Maedebach 1979: 2, 13

Saint Erasmus, a 3rd-century bishop of Antioch who was persecuted during the reign of Diocletian, came to be venerated—like Saint Eustace (cat. no. 135)—as one of the *Vierzehn Nothelfer*, the 14 special saints called upon in time of need. Although there is no factual basis for the story that Erasmus had his intestines drawn out, as depicted here by Cranach—who spares the viewer none of the unsavory details in showing two business-like executioners at work on the helpless man—he became the patron saint associated with stomach pains. One explanation for this belief is the sensationalizing turn of the late medieval mind, for which interest in martyrs was often directly related to the degree of suffering they had sustained. Erasmus spent the last seven years of his life near Formia, on the coast of Campania, and subsequently became a patron saint of seafarers. He supposedly acquired the attribute of a windlass with an anchor rope wound around it. The transformation of the windlass into an instrument of torture perhaps resulted from a misunderstanding of a statue of the saint, but, in any case, in its original form, the windlass as an attribute would surely have been too benign to have given Erasmus the cult standing he later enjoyed in Magdeburg, where his body was a prized relic (it was transferred in 1516 to Halle by Cardinal Albrecht of Brandenburg). The Archbishop of Magdeburg was the brother of Cranach's patron, the Saxon duke, Friedrich the Wise, a relationship that may have led to Cranach's choice of subject or the commission itself, since the two brothers had patched up a serious dispute between them in 1506, the year the woodcut was made.

Cranach has given some of the bystanders in this scene, particularly the turbaned figures, an exotic look, but the walled castle in the background was a sight familiar to the artist, since it is the Veste Coburg itself. A similar view of the castle appears in Cranach's painting, *Martyrdom of Saint Catherine*, executed in the same year. As court painter to Friedrich the Wise, Cranach worked at several ducal residences in Saxony, including Coburg, in the years 1504-05, but he was no doubt already acquainted with the city, which lies only 15 miles to the west of his birthplace. The distinctive complex of buildings, walls, and towers seen from the east, is easily recognizable by comparison with the appearance of the Veste Coburg today. Only the round tower, visible in the center of the inner wall, could not be accounted for until restoration work in 1973 exposed a Romanesque tower in that very place; it had been enclosed by a large bastion constructed later in the 16th century.

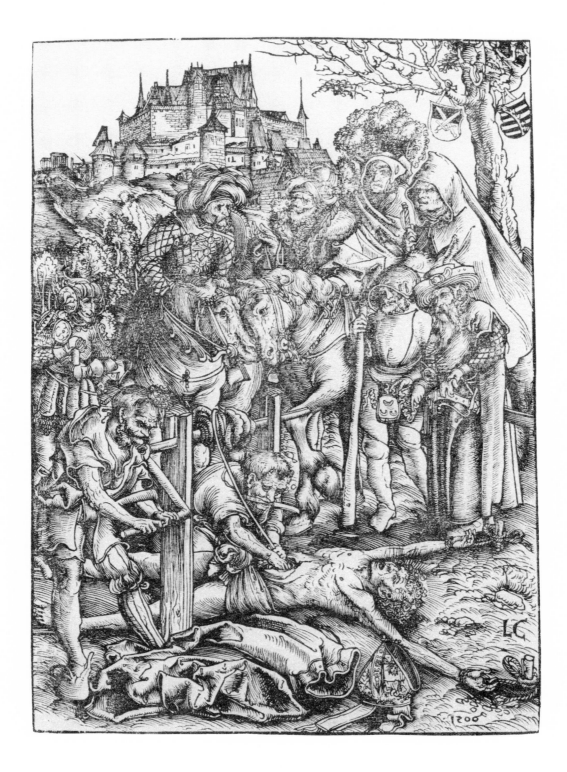

Saxon Prince on Horseback, 1506

Woodcut, 181 x 123 mm

Watermark: Unidentified crown

Initials in block at lower right: *LC*

Date in block at right: *1506*

VC: Inv. no. I 45, 111

References: Lindau 1883: 44; Appeltshauser 1950: 9-11; Föhl 1954: 20; Jahn 1955: 22; Hollstein VI: no. 110 II; Kaltwasser 1961: no. 1; Coburg 1972: no. 81; Basel 1974, I: no. 20; Koepplin 1974: 29, 33, n. 36

The young horseman depicted here has long been recognized from his dress and hair ornament as a prince, although his specific identity was questionable. The coats of arms of Electoral Saxony in the tree do not identify the figure, but rather were placed there to indicate that the print was under the ducal protection of a privilege or copyright. Nearly all of Cranach's prints from the time he entered court service in 1505 bear these arms. In the unique first state of this print in Budapest (Szépmüveszeti Múzeum), as in the almost equally rare first states of the *Martyrdom of Saint Erasmus* (cat. no. 118) and the *Stag Hunt* (cat. no. 120) in other collections, the light and dark fields (sable and silver) of the crest with crossed swords (the arms of the Lord High Marshall of the empire) are reversed, that is, the dark field is beneath the light. During 1507, the sable was placed above the silver, and Cranach's earlier prints were altered accordingly, as can be seen here.

The prince is without doubt the same boy who appears with Saint Dorothy on the left wing of Cranach's Saint Catherine Altarpiece of 1506 in Dresden. His identification as Johann Friedrich, later Duke of Saxony and known as the Magnanimous, has gained credibility with the recent publication (Koepplin 1974: 25-34; Basel 1974, II: nos. 596-597) of a double portrait by Cranach in the form of a diptych dated 1509, showing Johann Friedrich at the age of six and his father, Duke Johann the Steadfast, brother of Cranach's patron Friedrich the Wise. The boy in the woodcut looks older than three years of age, which Johann Friedrich would have been in 1506, but then Cranach was undoubtedly influenced by the fact that he was portraying the future duke and imperial elector. This would also account for the artist's choice of an equestrian portrait— a traditional way of depicting a ruler—although such a portrait for a child is unusual in German Renaissance art. The serious expression on the boy's face is in keeping with his anticipated high office, but his raised hand, with its palm upward, is not a gesture of command but of high spirits (see Basel 1974, I: no. 19).

The setting also strengthens the identification of the boy as Johann Friedrich. Although less easily recognizable than in the *Martyrdom of Saint Erasmus* (cat. no. 118), the walled castle has the essential features of the Veste Coburg, viewed from the north. From 1499 on, the Veste was the residence of Johann the Steadfast and his family. The wall with the round towers encloses a distinctive pair of buildings just to the right of the boy's face—the *Fürstenbau* (Prince's Residence) and the *Hohe Kemenate* (High Chamber). At the far right can be seen what is now called the Blue Tower, although in the woodcut it has a late Gothic half-timbered upper story and spire, which later in the century were replaced with a dome. The four smaller turrets on the corners (only two of which are visible here) are an arrangement characteristic of the region and can still be seen on the parish church in nearby Lichtenfels.

120

Stag Hunt, c. 1506

Woodcut printed from two blocks, 366 x 508 mm

Watermark: Left sheet, bull's head with tau cross (Piccard 1966: sect. x, no. 111 or 112); right sheet, bull's head with snake and tau cross (Piccard 1966: sect. x, no. 275)

VC: Inv. no. I 45, 115

References: Dodgson 1903-11, II: 282, no. 3; Weimar/Wittenberg 1953: no. 109; Jahn 1955: 22-23; Hollstein VI: no. 115 II; Coburg 1972: no. 86; Basel 1974, I: 114, 193-196, no. 138

The unusually large size of this woodcut and its panoramic format reflect similar scenes painted on panel, canvas, and the walls of Saxon castles. Cranach was highly praised for his portrayal of animals, and Friedrich the Wise employed him extensively to decorate his castles with pictures of trophies and hunts. Christoph Scheurl published an encomium of Cranach in 1509 (Basel 1974, I: no. 96), in which he described the artist's ability to match the appearance of nature itself. Such art criticism by humanistic writers of the time depended heavily upon examples from Antiquity. With reference to the great feats in illusionism attributed to ancient painters such as Zeuxis and Apelles, Scheurl claims that at Coburg the birds fell to the ground when they tried to land on the antlers that Cranach had painted on the wall, and that Duke Georg of Saxony, Friedrich's cousin, refused to believe they were not real until he felt them for himself. Scheurl said that a picture of a deer at Coburg made the dogs bark every time they saw it and the painting of a boar which Friedrich had killed was so lifelike that dogs bristled and ran in fear (Lüdecke 1953: 50-52).

In this woodcut, Cranach shows a hunt in various stages. In part this approach accounts for the complex organization of the landscape, in which the ground plane rises steeply to show all that is going on and in which the various sections of the scene deprive the whole of a central focus. These characteristics are common in landscape settings for narrative paintings involving the principle of simultaneous succession, that is to say, when several different stages of a narrative are represented at various places throughout the landscape, thereby replacing the temporal dimension of the story with a spatial one. Here, a stream flowing through the landscape provides the continuity.

At the upper left, the hunters are just picking up the trail of the game. Then, in the upper right quadrant, three stags, chased by dogs, have taken to the water, while hunters shoot at them with crossbows. The chase continues clockwise, showing a stag held at bay by dogs and men with spears, while a hunter on horseback runs him through with a sword.

The hunters with crossbows and swords who do the killing, mostly from horseback, are the aristocrats for whom the hunt was organized. Emperor Maximilian was thinking of them and not the peasants when he recommended hunting to restore the body and spirit. For the aristocracy, the hunt, like warfare or tournaments, provided a test of valor and proof, when successful, of their rightful superiority. The peasants, on the other hand, had a different outlook. They were not allowed to hunt game on their own but were pressed into service at the hunts for the aristocracy, and they had to watch helplessly as their cultivated fields were torn up by hunters galloping after terrified game. Such scenes as this woodcut were designed to entertain a public prepared to accept the prerogatives of the aristocracy, but Cranach, unlike the poets who lavished praise on the duke's achievements, strove for a portrayal that would allow the events and appearance of things to speak for themselves.

This is the second state of the print, indicated by the modified electoral coat of arms at the upper left with the sable in chief (see cat. no. 119). According to David Landau (letter to author February 17, 1981), this impression comes from the first of four editions of that state, the last of which was printed at the end of the 16th century.

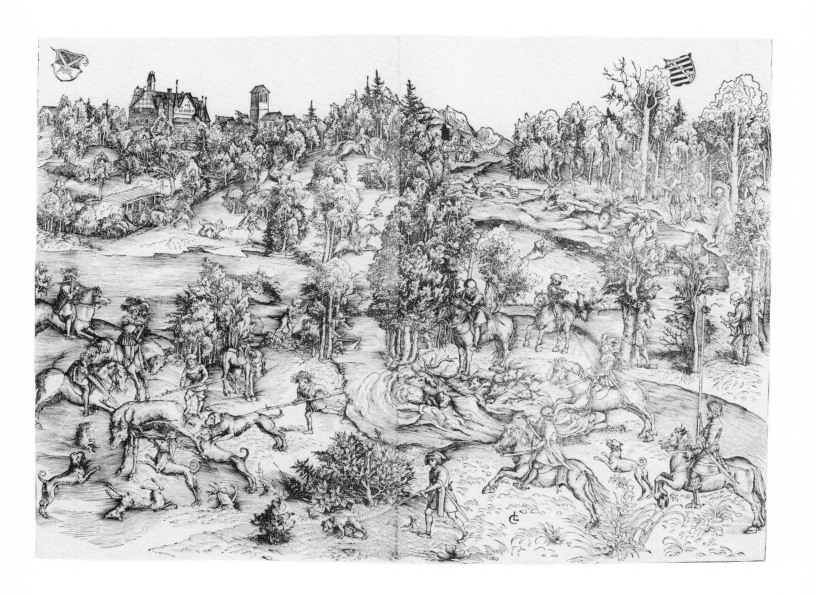

121

Saint Jerome in Penitence, 1509

Woodcut, 335 x 227 mm

Initials, date, and winged-serpent emblem in block at lower left: *LC / 1509*

VC: Inv. no. I 43, 68

References: Dodgson 1903-11, II: 295, no. 60; Weimar/Wittenberg 1953: no. 99; Jahn 1955: 32-33; Hollstein VI: no. 84; Basel 1974, II: no. 405

In this woodcut Saint Jerome's wilderness is an idyllic German image of nature both mysterious and generous, like the Christianity to which the saint devoted his life. The crucifix seems almost a part of the battered but sturdy oak against which it leans and could easily be overlooked except that the old man's gaze directs the viewer's eyes to the object of his concentration. Similar joinings of religion with nature occur between the chapel, tucked back in the woods, and the slender pine in front of it that continues the lines of the steeple skyward, and in the distant village, where the spired silhouette of a church is echoed by the steep formation of landscape behind it. Closer by is pictured the sound of life-giving water, as a spring splashes into a fresh pool. Cranach has located the saint solidly within this landscape, not simply in front of it. The lion and the stump over which the cardinal's robe and hat are draped form the base of a triangular grouping that gives the figure of the saint a position of stability and depth in the picture. Likewise, Cranach took measures to draw the beholder into the landscape, not only by the compelling vista that angles from the near left to the mountainous horizon, but also by the foreshortening of tree branches, suggesting that a canopy of foliage extends overhead toward the viewer. Just how mindful the artist was of such two-way visual movement can be seen in the lower left corner, where the lion confronts the beholder face-to-face and the tablet with the signature and date has been turned around as if for reading from within the picture.

With this woodcut and other graphic work from 1509, such as the *Penance of Saint John Chrysostom* (cat. nos. 122-123), Cranach brought to culmination a three-year period of concentrated printmaking activity. Like all German graphic artists of the time, he was inevitably indebted to Dürer for having established new standards and techniques of realistic portrayal in woodcut and engraving. This is apparent if one compares this landscape with those in Dürer's *Saint Michael Fighting the Dragon* (cat. no. 131) or *Saint Francis Receiving the Stigmata* (cat. no. 140). The comparison makes equally clear, however, that Cranach had developed his own techniques for conveying the appearance of light and the substance of nature. His line vibrates at a different frequency from Dürer's; the alternation of light and dark seems subject to quicker changes. The brightness and clarity of Cranach's design can be accurately judged in this early impression, which was printed before the appearance of breaks in the fine lines of the block (where the ribbon hangs from the coat of arms of the Saxon duchy) that can be seen in later examples.

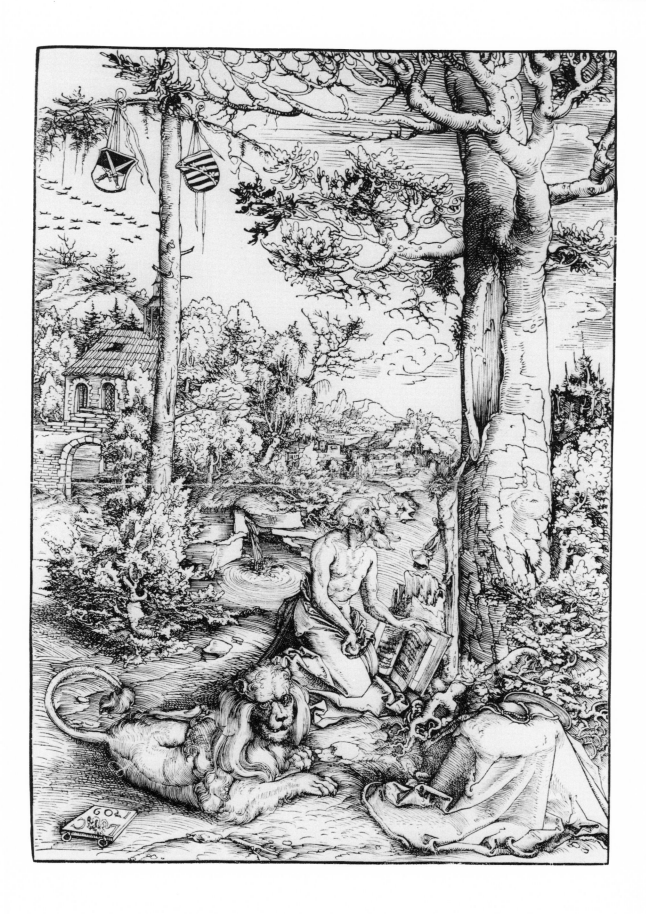

122

Penance of Saint John Chrysostom, 1509

Engraving, 254 x 199 mm

Watermark: *Rautenkranz* (variant of Briquet 1192)

Initials, date, and winged-serpent emblem in plate at lower right: *LC / 1509*

VC: Inv. no. I 41, 1

123

Penance of Saint John Chrysostom, 1509
(illustrated on p. 228)

Engraving, colored by a later hand, 256 x 203 mm

Initials, date, and winged-serpent emblem in plate at lower right: *LC / 1509*

VC: Inv. no. I 42, 2

References: Jahn 1955: 43-45; Hollstein VI: no. 1; Feinblatt 1964: 15-23; Coburg 1972: nos. 1-2; Coburg 1975: no. 101; Basel 1974, II: no. 486; New York 1980: no. 24

Cranach's subject in this print ostensibly concerns the life of Saint John Chrysostom, one of the four Greek Fathers of the Church, but the only connection between the events portrayed and the historical figure is that during his youth, Saint John lived for a while as a hermit. The balance of the scene is based on a legend that entered the popular literature on the lives of the saints during the late Middle Ages. The sources of this story are not entirely clear and the details vary, but the account best known to Cranach was probably that in *Leben der Heiligen* (*Lives of the Saints*), published in Augsburg by Günter Zainer in 1471 and subsequently in numerous other editions. It tells of an emperor's daughter who went out to pick flowers but was driven by a storm to the hermit saint's cave. The saint was overcome by carnal desire, then so regretted his transgression that he threw the innocent victim over a cliff, lest he be tempted again. From that time on, he remorsefully went about on all fours like an animal. Years later, the emperor had another child who soon after birth expressed a wish to be baptized by Saint John Chrysostom. When the saint was located, he confessed to his earlier deed. Upon searching for his daughter's body, the emperor discovered her miraculously alive and with a child.

Cranach has reduced the penitent saint to a small detail in the background of this composition and concentrated instead on the image of the mother and child living innocently in the wilderness in the company of animals. Dürer had treated this in similar fashion in an engraving of about 1497 that obviously was well known to Cranach, but the model for Cranach's figure of the woman was more particularly Dürer's nude in the *Sea Monster* (cat. no. 133). However, the relationship between Dürer's prints and Cranach's extends well beyond the formal design. Both artists gave their attention to the theme of the woman's return to nature, where she lived in a primitive state. This was ostensibly a life of hardship, a consequence of man's sinful nature. However, the woman is shown living peacefully in the wilderness, surrounded by gentle animals. Interest in the idea of a life beyond the moral and social constraints of Christian civilization was manifest in a number of themes in the art and literature of the late Middle Ages and Renaissance. Among them was the popular character of the wild man and his family. In Cranach's engraving there is a strong suggestion of the Golden Age of Hesiod, a subject to which the artist turned explicitly in at least two paintings around 1530 (Friedländer/Rosenberg 1978: nos. 261-262). Moreover, in the early 16th century, the eyewitness accounts of European travelers to Africa and India, such as that of Balthasar Springer (see cat. nos. 112-113), must have lent a new sense of reality to the image of a mother and child living naked with the animals in nature and, at the same time, rekindled an ambivalent attitude toward such primitive life, which was pagan yet so evocative of the Garden of Eden before original sin.

Although Cranach was a prolific designer of woodcuts, he was only an occasional engraver. The *Penance of Saint John Chrysostom*, dated 1509, is perhaps the earliest of his surviving works in the medium, yet it shows a skilled and highly expressive use of the burin. In keeping with the emphasis on the natural, growing forms of the forest, the lines seem to flow freely without being subject to rigid graphic patterns. Cranach also understood very well how to produce highlights that sparkle amidst dense foliage, where lines are clustered for texture as well as shadow.

The coloring added to the second impression of this print does not completely obscure the engraved lines; nevertheless, the particular graphic character of Cranach's engraving has been transformed. The agitated movement of the burin strokes in the foliage and the white-water rush of lines across the sloping ground have been subsumed by the areas of color. The fine brushstrokes indicate the hand of a trained miniaturist, and the colors, especially the rosy flesh tones with their still rosier points of emphasis, suggest that the coloring was added around 1600 (see also cat. no. 156).

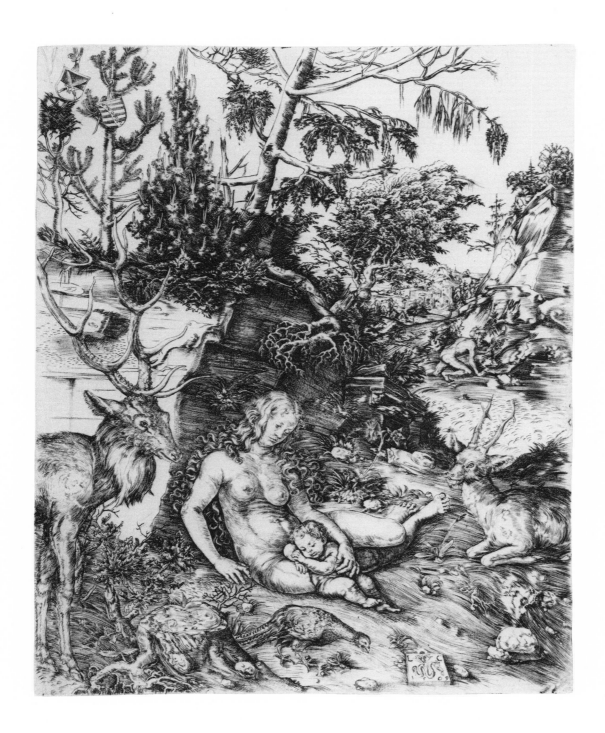

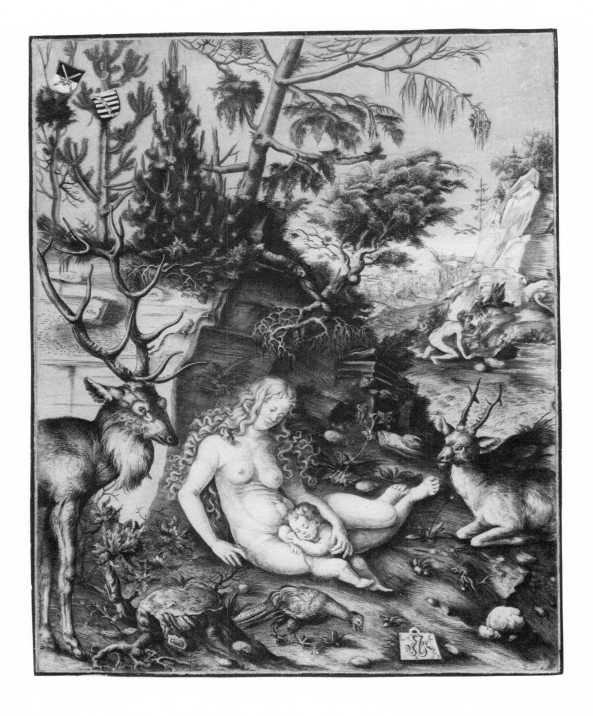

124

The Second Tournament with Lances, Staves, and Swords,
1509

Woodcut, 293 x 419 mm

Initials, date, and winged-serpent emblem in block at upper
right: *1509 / LC*

VC: Inv. no. I 45, 120

References: Dodgson 1903-11, II: 56, no. 56; Weimar/Wit-
tenberg 1953: no. 122; Jahn 1955: 29; Hollstein VI: no. 117;
Coburg 1968: no. 4; Coburg 1972: no. 88; Basel 1974, I: 190-
192, no. 110

This is one of Cranach's three woodcuts from 1509, repre-
senting a tournament that Friedrich the Wise had organized
in Wittenberg on November 15-16 of the preceding year.
The tournament had been scheduled to follow the Feast of All
Saints, when the famous Wittenberg relics were on display
in the new church that Friedrich had built and dedicated to the
Allerheiligen (All Saints). The precedent for a tournament in
connection with a pilgrimage, for which indulgences were lib-
erally dispensed, reaches back to the year 938, when Emperor
Henry I, according to Rüxner's account of 1530 (see cat. no.
213), called the knights of the Holy Roman Empire together to
compete in the first tournament as a means of preparing them-
selves for battle with the infidel in the First Crusade. The no-
tion persisted and was reinforced by Emperor Maximilian's
belief that a knight performed a kind of Christian service on
the tournament field by proving himself a brave defender of
the faith. In addition to Cranach's visual record of Friedrich's
tournament, the court poet Georgius Sibutus Darpinius wrote
an account in verse (see cat. no. 175).

Cranach's woodcut conveys much of the pomp and festivity
that characterized the tournament; it also conveys the tumult
and confusion of the contests. The figures are crowded into a
small area that looks like a courtyard, although Sibutus says
that the tournament was held in the Wittenberg market square
in the manner seen in Master MZ's engraving of 1500 (cat. no.
176). Two contests are shown at once: a joust, which has re-
sulted in a broken lance, flying armor, and the collapse of one
horse and rider; and several knights fighting with swords and
staves further back. Cranach and his shop were employed to
paint banners and to design ceremonial trappings for just such
events. An example of his manufacture is surely the tapestry-
like cloth hanging from the balcony, on which Samson or per-
haps Hercules (see Basel 1974, I: 195, no. 110) is portrayed
proving his strength and valor in combat with a lion. On sev-
eral of the horses' caparisons can be seen other decorative
figural scenes similar to those found in the drawings of the
Tournament Book (cat. no. 16).

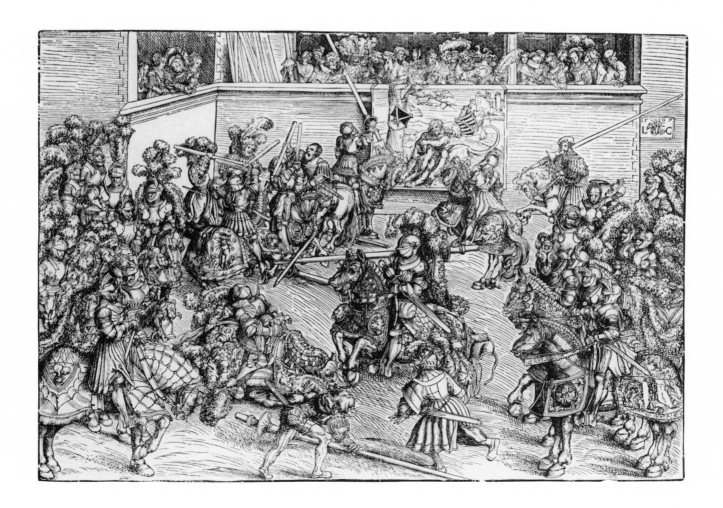

The Celestial Ladder of Saint Bonaventure, c. 1510

Woodcut, 411 x 293 mm

Watermark: Scale in circle with star (similar to Briquet 2536)

Winged serpent in block on ladder

VC: Inv. no. I 44, 82

The Damned in Hell, c. 1510

Woodcut, 176 x 293 mm

VC: Inv. no. I 43, 58

References: Flechsig 1900: 48-49; Weimar/Wittenberg 1953: no. 133; Jahn 1955: 52-53; Hollstein VI: nos. 78a I, 78b; Coburg 1972: nos. 62-63; Basel 1974, II: no. 307

This highly complex image was in fact designed to explain a mystical way to heaven in the simplest possible terms, using a diagram, pictures, and short written explanations. It is, one might say, a comic-book approach to a critical matter, namely, how to find salvation and avoid damnation. The subject is stated in the two-line title at the top: "A short, pious, celestial ladder, devised by Saint Bonaventure, on which Christians may easily ascend to heaven." The ladder that Bonaventure envisaged in his *Itinerarium mentis in Deum (The Mind's Road to God)*, a German translation of which was printed in 1506, had seven rungs, but Cranach—or perhaps his theological adviser—reduced the number to a more easily manageable three.

The ladder to heaven was a familiar image, beginning with the one that Jacob saw in his dream (Genesis 28:12-13); it recurs, for example, in a woodcut by Hans Weiditz, illustrating a German edition of Cicero's *De officiis* (cat. no. 214). The inscriptions on the ladder in Cranach's woodcut, as well as the paragraph of text, explain that the foot of the ladder signifies "fear or eternal pain" and the top indicates "desire for eternal reward." The left upright is labeled "moderation in pleasure" and the right upright, "patience in adversity." The first rung represents "disdain for the world"; the next, "disregard of oneself"; and the third, "humble love of God." On either side of the central medallion containing the Trinity are two clusters of figures who announce by way of banderoles that they have climbed the ladder to eternal happiness with God. The people in the adjoining woodcut at the bottom, to their eternal regret, did not want to climb the ladder, as their banderole explains, so they fell into hell where they must remain forever. At the head of the crowd assembled around the foot of the ladder is Friedrich the Wise, who may have commissioned the woodcut. While these people—men at the left and women at the right—wait to take their turns at the ladder, two devils enter to try to convince them that they have more to gain from pleasure than from virtue; either their arguments or their comic appearance have turned a few heads.

126

Martin Luther as an Augustinian Monk, 1520

Engraving, 143 × 98 mm

Winged serpent and date in place at lower center: *M.D.X.X.*

Inscribed in plate: AETHERNA IPSE SVAE MENTIS SIM-
VLACHRA LVTHERVS / EXPRIMIT. AT VVLTVS CERA LVCAE OCCIDVOS

VC: Inv. no. I 41, 8

References: Jahn 1955: 58-59; Hollstein VI: no. 6; Coburg 1967: no. 2; Coburg 1972: no. 5; Basel 1974, I: no. 35

This is the first of many portraits Cranach made of his friend Martin Luther. Between 1517, when Luther posted the 95 theses, and 1520, the date of the engraving, Luther's fame had spread and many were curious to know of his appearance. The Leipzig humanist Petrus Mosellanus, who saw Luther in 1519 at his debate with Johannes Eck, wrote the following description:

> Martin is of middle height, emaciated from care and study, so that you can almost count his bones through his skin. He is in the vigor of manhood and has a clear, penetrating voice. . . . He is affable and friendly, in no sense dour or arrogant. He is equal to anything. In company he is vivacious, jocose, always cheerful and gay no matter how hard his adversaries press him (Bainton 1950: 113).

The bony contours of the face in Cranach's portrait tally with this description. The engraving style, like the image itself, is simple to the point of austerity. Cranach correctly read resolve in the face of a man who would face the emperor at the Diet of Worms the following year and stand fast by his beliefs. The placement of the Latin inscription follows Dürer's model in his 1519 engraving of Cardinal Albrecht of Brandenburg (Washington 1971: no. 71). The inscription says: "Luther himself gave form to an eternal likeness of his spirit, Lucas portrayed the mortal appearance."

The curious history of this plate and the three states represented by existing impressions was properly recorded for the first time in the catalogue of the 1974 Cranach exhibition in Basel (no. 35). The first state, of which only two impressions are known to exist (Vienna, Graphische Sammlung Albertina and Washington, National Gallery of Art), has only a single horizontal line separating the area of the inscription from the portrait itself. In the second state, of which a unique impression exists in Weimar (Schlossmuseum), a second line parallels the first and has a row of short vertical hatchings along it, but far more remarkable is the addition of a small, bearded face in profile at the upper left. It is doubtful that the face was put there by Cranach, although it was apparently done during his lifetime. The Weimar impression is on paper with a type of watermark characteristic of the 1540s. In the third state, represented by some 30 impressions including this one from Coburg, the small face has been more or less burnished out. Only in this state does the plate seem to have been used to print a sizable edition, and the watermark, when it appears, indicates that the edition was prepared late in the 16th century. In other words, this portrait was not actually published at the time the plate was made. Instead, it served as the model for a second portrait of Luther from the same year and with the same inscription (Hollstein VI: no. 7; Basel 1974, I: no. 36). The second version shows Luther holding a book and standing in front of a niche. It is less severe, even rather pallid by comparison, so that its authorship, despite the presence of Cranach's emblem, has been doubted by many writers. Yet, it was this later version that was chosen for circulation and that served as the model for Baldung's woodcut portrait of Luther (cat. no. 106).

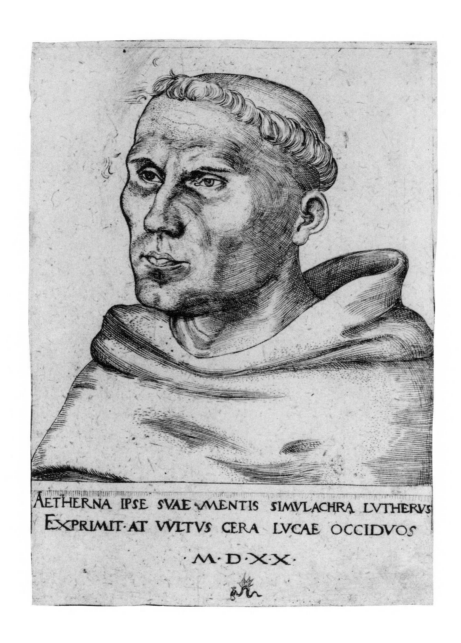

AETHERNA IPSE SVAE MENTIS SIMVLACHRA LVTHERVS
EXPRIMIT AT VVLTVS CERA LVCAE OCCIDVOS

M·D·X·X·

127

Martin Luther in Profile with Doctoral Cap, 1521

Engraving, 205 x 150 mm

Watermark: Bull's head with staff and snake (similar to Briquet 15368-15381; Piccard 1966: sect. XVI)

Winged serpent and date in plate at lower center: *M.D.X.X.I.*

Inscribed in plate: LVCAE OPVS EFFIGIES HAEC EST MORITVRA LVTHERI / AETHERNAM MENTIS EXPRIMIT IPSE SVAE

Annotated by a former owner with pen and brown ink: *Hoc opus, est hominis: sed opus fuit omne JEHOVAE! mundus enim nunquam Protulit Huic similem / Dr. Pfeil*

VC: Inv. no. I 41, 7

References: Jahn 1955: 60; Hollstein VI: no. 8 I; Coburg 1967: no. 7; Coburg 1972: no. 6; Basel 1974, I: no. 38; Coburg 1975: no. 102

By the 16th century, the profile portrait with its commemorative formality had become a standard type for honoring a man whose fame would live on in posterity, but Cranach was probably more concerned with designing an image to influence current opinion than to provide for the distant future. He clearly intended that those who looked upon this portrait should feel reassured by the strong, composed features and the steady, slightly ascending gaze, and he knew that they would recognize the cap of a learned doctor of theology. Apparently, at least one impression of the engraving, before the addition of the inscriptions, preceded Luther to the Diet of Worms. On March 7, 1521, Luther wrote to Georg Spalatin, who was already in that city, that Cranach had requested an inscription for a portrait he enclosed and Luther hoped that Spalatin would agree to devise one (Basel 1974, I: 92). All circumstances point to this engraving as the portrait that Luther enclosed with his letter. Presumably Spalatin complied with Luther's request, but the final inscription differs only slightly from the one that had already appeared with the engraved portrait of 1520 (cat. no. 126). It says: "Lucas' work is this picture of Luther's mortal form; but he himself expressed his spirit's eternal form." The idea that a person's writings provided a true self-portrait of the inner man was a humanistic convention, but in Luther's case it was not idle rhetoric, as his enemies fully realized. The Edict of Worms, issued in May 1521, condemning Luther for heresy and insurrection, decreed that, "his books are to be eradicated from the memory of man" (Bainton 1950: 189).

The Coburg impression of this engraving is a unique first state. In the second and final state (Hollstein VI: no. 8 II) Cranach darkened the background with hatching as a foil for the profile bust and made slight additions to the upper edge of the inscription area—a second horizontal line and a row of hatching —to make it seem as if an inscribed tablet were in front of the figure. Doubtless the artist was mindful that with a darkened background, the lighter image of Luther would remain strong in silhouette even as the finer modeling lines grew faint with the wearing of the plate. In this early impression the effects of wear are not yet visible, and in the absence of a heightened silhouette one can better appreciate how the volume of the forms, modeled with bold simplicity, measures up to the rugged contour of the face. As if in response to the engraved inscription, an earlier (16th-century?) owner by the name of Dr. Pfeil wrote in Latin his thoughts on Luther and on this portrait: "This picture is the work of a man but the whole [i.e., Luther] was the work of Jehovah, because this world could not produce the likes of him."

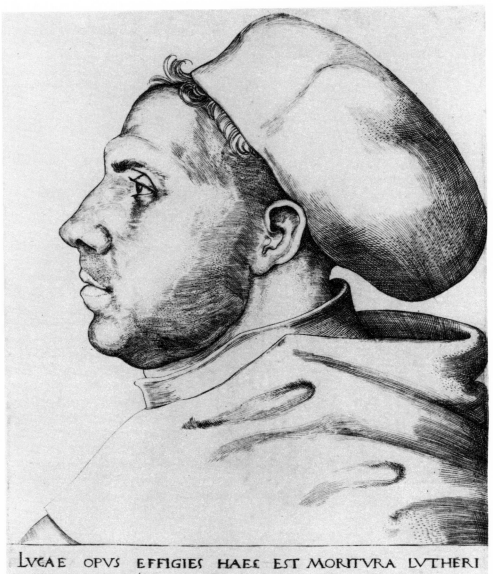

LVCAE OPVS EFFIGIES HAEC EST MORITVRA LVTHERI
AETHERNAM MENTIS EXPRIMIT IPSE SVAE
M·D·X·X·I·

128

Martin Luther as Junker Jörg, 1522

Woodcut with text in letterpress, 280 x 204 mm (image); 353 x 214 mm (sheet with inscriptions)

Watermark: Unidentified Basel crozier (?) in a cartouche (85 x 75 mm)

Inscriptions in letterpress: at the top, IMAGO MARTINI LVTHERI EO HABITV EX = / PRESSA, QVO REVERSVS EST EX PATHMO VVITTE = / BERGAM ANNO DOMINI 1522; at the bottom, *Quaesitus toties, toties tibi Roma petitus / En ego per Christum uiuo Lutherus adhuc / Vna mihi spes est, quo non fraudabor, Iesus, / Hunc mihi dum teneam, perfida Roma uale. /* ; ANNVS CONFESSIONIS VVOR = /

MACIAE 1521. *CaesarIs ante peDes, proCeres stetIt ante potentes / ACCoLa aVà RhenI VangIo LIttVs aDIt;* ANNVS PATHMI / 1521. *A Rheno properans CapItVr, bené ConsCla PathMI TeCta, P Apa e fYgIens retIa strVCta, petIt;* ANNVS REDITVS EX / PATHMO 1521. *CarLsta DII ob fVrIas aD SaXona teCta reCVrrIt, FaVCIbVs ex saeVIs rVrsVs oVesqVe rapIt*

VC: Inv. no. H 64

References: Dodgson 1903-11, II: 317, nos. 124, 124a; Jahn 1955: 60; Hollstein VI: no. 132c; Coburg 1967: no. 9; Coburg 1972: no. 92; Basel 1974, I: no. 42

Having assumed the identity of a commonplace squire, Luther lived in hiding at the Wartburg near Eisenach from May 4, 1521, until March 3, 1522, as Junker Jörg. The Edict of Worms had made Luther a wanted man and Friedrich the Wise had arranged for him to be sequestered for his own safety. In the solitude of what he termed his "Isle of Patmos," Luther wrote, among many other things, his translation of the New Testament. In December 1521 he secretly returned to Wittenberg for a week to help stabilize the swift and radical developments that were taking place there at the instigation of Andreas Carlstadt, an iconoclastic reformer who was a professor at the University of Wittenberg. It was during this short visit, most commentators believe, that Cranach made a drawing of the Reformer on which this woodcut and Cranach's painting in Leipzig (Museum der bildenden Künste) are based. Although Luther was supposedly in disguise, even the long hair and beard cannot conceal the similarity between this portrait and Cranach's engraving of 1520 (cat. no. 126). Not only are the features and position of the head identical in both, but also virtually the same pattern of modeling lines reappears in the woodcut. Cranach could easily have revised an impression of his engraving with pen and ink to produce the likeness of Junker Jörg. Presumably, he would have done this after seeing Luther with his beard and grown-out tonsure, but the hair style was sufficiently common so that even a verbal description would have been adequate for making the necessary modifica-

tions. Certainly the schematic rendering of the costume required no study from life, and the ambiguous connection between the body and the head is still another reason to suppose that the woodcut is a composite image. At this time, Cranach customarily used a neutral background in portraiture, whether paintings or prints. By making an exception in this case with a few wispy clouds, he established an outdoor setting that fits the image of a man of action.

The Latin text gives a brief account of the circumstances surrounding Luther's appearance in this guise. At the top, it reads: "This is a picture of Luther as he looked when he came back from Patmos to Wittenberg in 1522." In the quatrain beneath the portrait Luther speaks of his survival through Christ despite the threats from faithless Rome, to which he bids farewell. The three stanzas along the bottom tell of Luther's having stood before the emperor at Worms, having been spirited off to "Patmos," and having returned to Wittenberg to save the Reformation from the excesses of Carlstadt. In each of the stanzas the capitalized letters—M, D, C, L, X, V, I—when given the values of Roman numerals, form a chronogram. In the first two stanzas they add up to 1521, the year of the events described, but in the third stanza the numerals only reach a combined sum of 1512. Since the correct date is again 1521, the discrepancy probably resulted from the typesetter's having capitalized one "I" too many and one "X" too few.

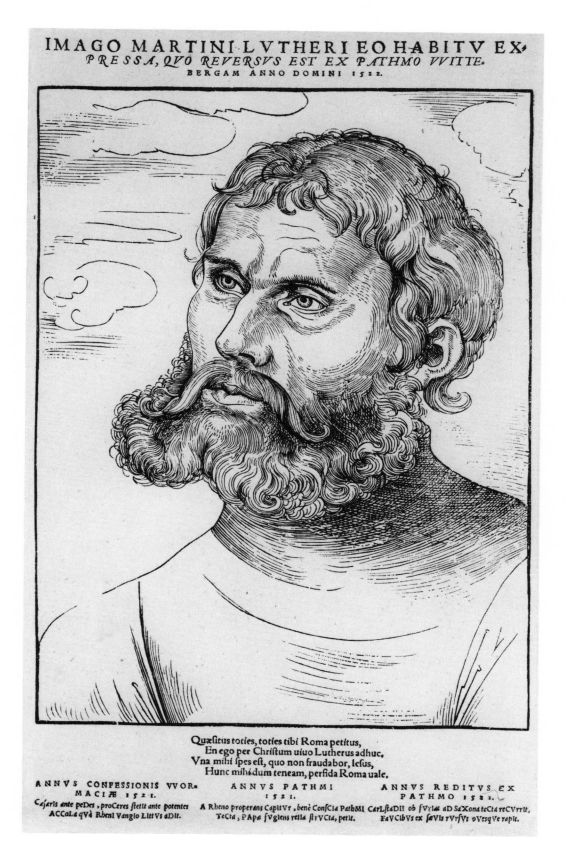

IMAGO MARTINI LVTHERI EO HABITV EX-
PRESSA, QVO REVERSVS EST EX PATHMO VVITTE-
BERGAM ANNO DOMINI 1522.

Quæsitus toties, toties tibi Roma petitus,
En ego per Christum uiuo Lutherus adhuc.
Vna mihi spes est, quo non fraudabor, Iesus,
Hunc mihi dum teneam, perfida Roma uale.

ANNVS CONFESSIONIS VVOR-
MACIÆ 1521.
Cæsaris ante peDes , proCeres stetIt ante potentes
ACCoLa qVè Rhenl Vangio LIttVs aDIt.

ANNVS PATHMI
1521.
A Rheno properans CapItVr , benè ConsCIa PathMI
TeCta , PApæ fVgIens retIa strVCta, petIt.

ANNVS REDITVS EX
PATHMO 1521.
CarLstaDII ob fVrIæ aD SaXona teCta reCVrrIt,
FaVCIbVs ex sæVIs rVrsVs oVesqVe rapIt.

Albrecht Dürer

(for biography, see p. 86)

129

Holy Family with the Butterfly, c. 1495

Engraving, 238 x 186 mm

Watermark: Corner of triangle from bull's head (Meder 62)

Monogram in plate at lower center: *AD*

VC: Inv. no. I 16, 47

References: Meder 1932: no. 42b; Panofsky 1948, I: 66-67 and II: no. 151; Coburg 1971: no. 42; Nuremberg 1971: no. 144; Washington 1971: no. 2; Coburg 1975: no. 71

The Virgin and Child in a landscape is a theme that emphasizes the humanity of the figures and their close association with nature. This type of image is the result of the confluence of two thematic traditions: the Holy Family's Rest on the Flight into Egypt and the Virgin in an Enclosed Garden. The latter derives from the *Hortus conclusus* (enclosed garden), in the Song of Songs (4:12-15), which Christian writers interpreted as a reference to the Virgin's purity. The rambling wall and gate behind the Holy Family in this print serve as reminders of this symbolic garden, although the wall is relatively inconspicuous and is certainly no visual barrier to the open landscape that extends far into the distance. What remains of these earlier traditions is the maternal image graced by natural surroundings. The beneficence of nature is no longer restricted to what lies within the protection of an enclosure, nor is the Virgin shown as if isolated from the rest of the world. No other theme, except for the Passion of Christ, recurs with such frequency in Dürer's work. This is the first of 11 intaglio prints he devoted to it, not to mention examples in drawing, woodcut, and painting. The "butterfly," sometimes called a dragonfly, grasshopper, or other similarly shaped insect, is included in the title not because this detail in the lower right corner of the composition has special significance in itself, but rather to distinguish references to this print from others depicting similar themes.

This is one of Dürer's earliest engravings and the first to bear his monogram, which in works of this time has a cramped, somewhat Gothic form as opposed to the bold Roman capitals of the later, more familiar, monogram. Compared to the artist's fully evolved engraving style, represented by the *Virgin and Child with the Pear* (cat. no. 149), for example, the burin lines here are notably more erratic and the spatial relationship of forms, such as within the drapery, lacks coherence. This is partly the result of Dürer's attempt to give a naturalistic appearance in shape and texture to the various parts of the scene without having yet developed the means to unify them through consistent modeling and perspective. Such naturalism, including the humble presence of a sleeping Saint Joseph, and the relatively spontaneous handling of the burin calls to mind the Housebook Master, whose work exercised a strong influence on Dürer, especially in the early 1490s while the young artist was passing his *Wanderjahre* along the Rhine. It was during those years that Dürer made several drawings which prepared the way for this family group outdoors (Winkler 1936-39: nos. 25, 30). But when it came to establishing the final design for the engraving, Dürer turned his sketches into a more formal, symmetrical composition and made it more explicitly religious by showing the rest of the Trinity in the clouds above. In these aspects, Dürer heeded the example of Martin Schongauer in such engravings as the *Virgin and Child on a Grassy Bench* (Shestack 1969: no. 21) and the *Baptism of Christ* (cat. no. 193). Ultimately, it was Schongauer's disciplined approach to the medium that Dürer chose to follow most closely in his further development to maturity as a printmaker.

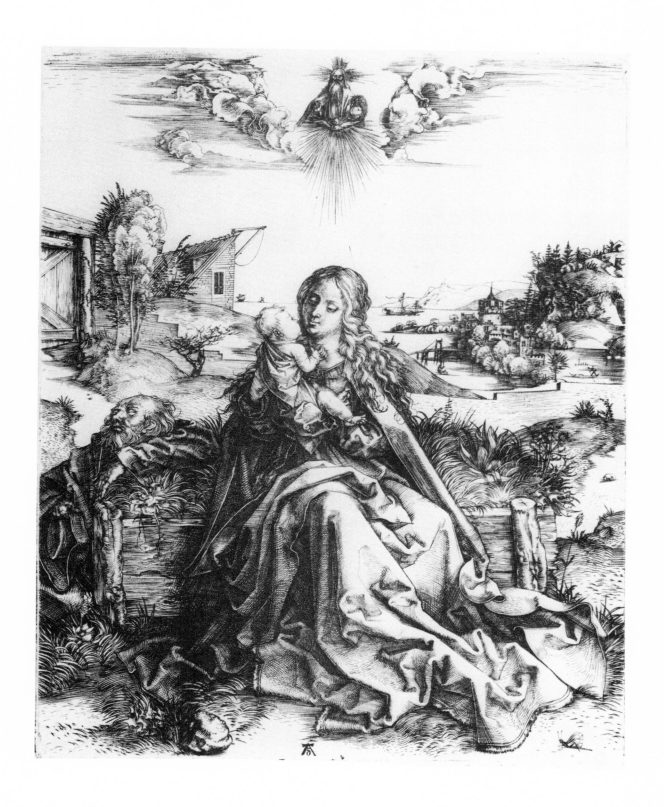

130

The Apocalyptic Woman, 1496/98
(illustrated on p. 242)

Woodcut, 392 x 279 mm

Monogram in block at lower center: *AD*

VC: Inv. no. I 21, 208

131

Saint Michael Fighting the Dragon, 1496/98
(illustrated on p. 243)

Woodcut, 392 x 283 mm

Monogram in block at lower center: *AD*

VC: Inv. no. I 21, 209

132

The Beast with Two Horns like a Lamb, 1496/98
(illustrated on p. 244)

Woodcut, 392 x 279 mm

Monogram in block at lower center: *AD*

VC: Inv. no. I 21, 211

References: Meder 1932: nos. 173-175; Panofsky 1948, II: nos. 291-292, 294; Hollstein VII: nos. 173 (2a), 174 (2a), 175 (1); Boston 1971: nos. 40-42; Coburg 1971: nos. 182-184; Dresden 1971: nos. 219-220, 222; Nuremberg 1971: no. 596; Washington 1971: nos. 101-103; Coburg 1975: no. 95

In 1498 Dürer published 15 woodcuts as full-page illustrations to the Book of Revelation. There were actually two editions, one with the text in German, the other in Latin. Another Latin edition was to follow in 1511. The publication was a revolutionary achievement on several accounts; neither the medium nor Apocalypse illustrations would ever again be regarded as before. A complete set of the *Apocalypse,* as the series was titled, exists at Veste Coburg in early impressions, of which three examples are included here. One of them, *The Beast with Two Horns like a Lamb* (cat. no. 132), was printed without the text in advance of the first editions in book form. The other two, *The Apocalyptic Woman* and *Saint Michael Fighting the Dragon* (cat. nos. 130 and 131), are from the German edition of 1498, with letterpress on the backs.

Since woodcuts in general and book illustrations in particular customarily required the collaborative efforts of three or four different people—designer, cutter, printer, and publisher—it had not been the practice for an artist to single out his share by signing the work. Up until this time, only engravings were considered sufficiently autograph in character to bear a signature. By cutting his large monogram into every block, Dürer made it clear that these woodcuts did not belong to the category of anonymous craftsmanship. In the colophon he also identified himself as the publisher, thus declaring that he had determined all aspects of the production. There is even reason to believe that he cut the blocks as well. Never had woodcuts demanded so much from the cutter—far more than manual skill alone. These designs presumed a cutter who understood precisely the function of the lines and who shared an intuition for shaping them. Dürer imposed upon the woodcut the same standards of graphic vitality that Schongauer had achieved in his engravings. But, whereas the burin with its lozenge-shaped point naturally produced an incised line with flex and taper, the woodcutter's knife could only obtain the same effect by paring away at either side of the line until a narrow, fragile ridge remained that, when printed, gave little hint of the laborious shaping process. The areas of cross-hatching that look as if they had been easily drawn with a pen required the cutter to remove from the block's surface a piece of wood for each tiny white space between the intersecting lines. The motivation for this technical feat lay in Dürer's vision of what he wanted the lines to express, which went far beyond Schongauer's example in engraving, not to mention that of Dürer's predecessors in woodcut. Dürer imbued his lines with the capacity to render simultaneously the shape, modeling, and

texture of a given form and to do this while maintaining a sense of energy in each line individually and of coherence in all the lines collectively. As the functions of shaping and shading were joined in one and the same line, so did the intervals of white paper also take on a compound function of shape defining light.

In producing the *Apocalypse,* Dürer was indebted in several respects to his godfather, Anton Koberger, who was the leading printer and publisher in Nuremberg. Koberger probably printed the text; in any case, he provided the type, and it was set in the same two-columned composition used for the Bible he had published in 1483. That Bible also contained illustrations (the blocks having originally been made for a Cologne Bible of about 1479) from which Dürer took the rough outlines for some of his woodcuts. Moreover, another of Koberger's publications, the *Schatzbehalter* of 1493 (cat. no. 198), contributed the idea for the layout, with folio-sized woodcuts placed opposite a page of text. Dürer set to work on the *Apocalypse* not long after his return from Venice in the spring of 1495. Even with such complex, visionary scenes as these, whose antecedents were medieval and Northern European, Dürer's study of Italian Renaissance art clearly paid off in fundamental ways. Measured against the Apocalypse illustrations in Koberger's Bible of 1483, Dürer's woodcuts clearly belong to an age of Renaissance values, according to which human and even celestial events are enacted with figures whose physical existence is as palpable as their emotions. Dürer strove to match the realism of Saint John's powerful descriptions and to give those awesome visions, by their very nature inaccessible to ordinary eyes, concrete form.

The Book of Revelation was written at a time of persecutions, a fact illustrated by the first woodcut in the cycle, the *Martyrdom of Saint John,* and its warnings were always taken most seriously during periods of spiritual unease, such as the years around 1000 A.D. when the Last Judgment was thought to be imminent. So, too, did the approach of the year 1500 stir similar apprehensions. In retrospect, however, it is the Protestant Reformation that Dürer's *Apocalypse* seems to foreshadow. The view that Dürer was announcing a revolt against papal Rome, as Saint John had given a warning to imperial Rome, is one that attributes more conscious prophecy to the artist than the facts can support, but he obviously saw the Apocalypse as relevant to the times, and it is also true that the Roman Church is well represented among the figures shown held in thrall by

Satan or punished by God's wrath. Luther and his followers clearly found Dürer's images much to the point. Cranach's illustrations of the Apocalypse for Luther's translation of the New Testament, first published in September of 1522, rely heavily on Dürer's precedent, but just for good measure Cranach turned the crowns worn by two of the beasts and the Whore of Babylon into the three-tiered papal tiara.

Because Saint John's description of the woman he saw in heaven who gave birth to a male child (Revelation 12:1-16) had taken a prominent place in popular Christian art as the Virgin on the Crescent Moon (see cat. no. 3), Dürer's *Apocalyptic Woman* had a certain element of familiarity. But his literal rendering of the text restored the entire astonishing context of the image, including the dragon that threatened to devour the child. In his determination to give the appearance of reality to the seer's words, Dürer found ways to render such details as the sparkling stars, the rush of water from the dragon's mouth, and the featheriness of wings.

The *Fall of the Rebel Angels* from the *Schatzbehalter* (cat. no. 198) makes an instructive comparison with *Saint Michael Fighting the Dragon,* insofar as both are two-zoned compositions showing a rout of the demons at the hands of spear- and sword-wielding angels. But Dürer has significantly concentrated the action and for contrast has replaced the scene of hell with a bright, peaceful landscape. Neither the style of drawing nor the composition in the *Fall of the Rebel Angels* from the *Schatzbehalter* does much to clarify the inherent confusion of the scene. On this point, Schongauer's engraving of the *Tormenting of Saint Anthony* (Shestack 1969: no. 4) showed Dürer how to find meaningful order within a tumultuous situation. As Saint John describes the event:

> And there was war in heaven: Michael and his angels fought against the dragon; and the dragon fought and his angels, And prevailed not; neither was their place found any more in heaven. And the great dragon was cast out, that old serpent, called the Devil, and Satan, which deceiveth the whole world: he was cast out into the earth, and his angels were cast out with him (Revelation 12:7-9).

In the *Beast with Two Horns like a Lamb,* the day has come for reaping all the worshippers of the beast whose nearest of seven heads flops back as a result of the wound it received from Saint Michael (Revelation 13:3). A bishop, a queen, and a Turk are shown kneeling together in the front rank.

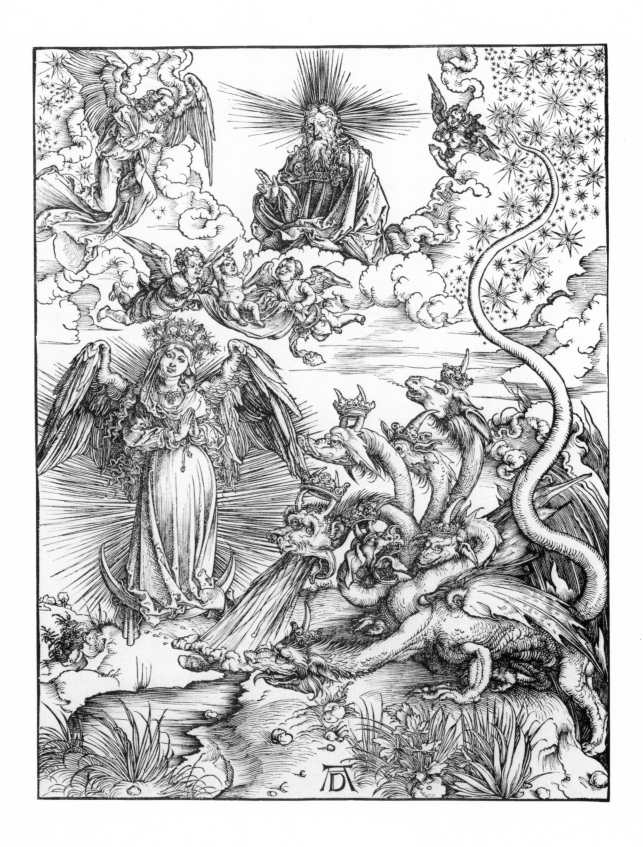

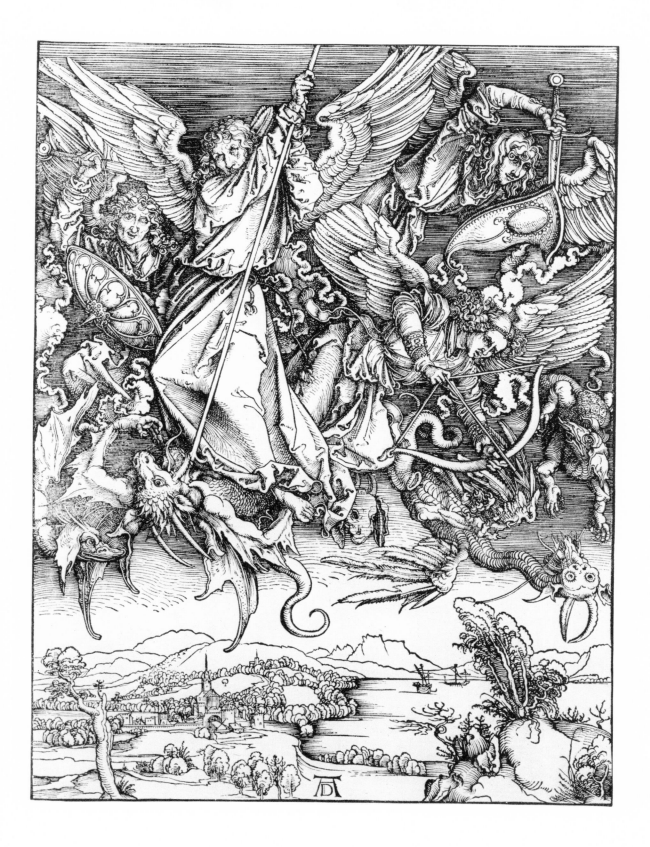

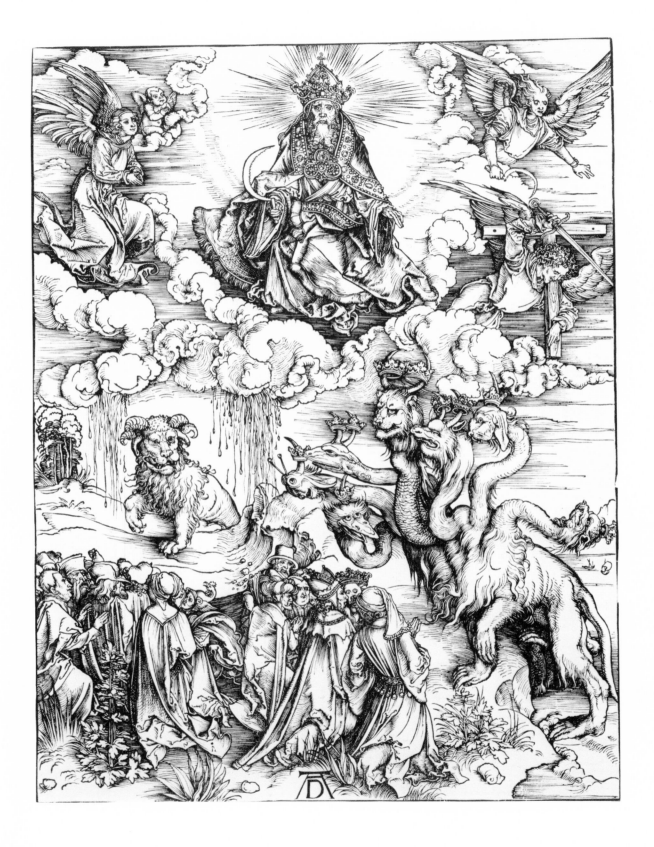

133

The Sea Monster, c. 1498
(illustrated on p. 246)

Engraving, 249 x 190 mm

Monogram in plate at lower center: *AD*

VC: Inv. no. I 17, 76

134

The Sea Monster, c. 1498
(illustrated on p. 247)

Engraving, colored by a later hand, 256 x 194 mm

Monogram in plate at lower center: *AD*

VC: Inv. no. I 17, 75

References: Lange 1900: 195-204; Lange 1925: 87-104; Meder 1932: no. 66a or 66b; Panofsky 1948, I: 73 and II: no. 178; Nuremberg 1971: no. 516; Washington 1971: no. 15; Coburg 1975: no. 83 (another impression); New York 1980: no. 59

Color plate VI

In his Netherlandish Diary, Dürer named this print *Das Meerwunder (The Sea Monster)*, which has done little to explain just who is being abducted, as the woman seems to be, judging by the activity of the people on the shore, although not by her own casual demeanor. Since the nude figure is based on a classical model, passed on to Dürer by any of several possible Renaissance intermediaries, many observers have supposed that Dürer's theme was classical as well. However, none of the suggested identifications, such as the Rape of Amymone, Achelous and Perimele, or Glaucus and Syme, have gained general acceptance. Lacking a classical text to account adequately for the particulars of the scene, Lange, Panofsky, and others have concluded that Dürer had in mind some popular tale that told of a more recent abduction. Freely mixing his references to things both familiar and exotic, he left wide latitude for locating the event. The buildings in the middle ground resemble the castle at Nuremberg, the landscape is based on the artist's Alpine studies, and the distraught man on the shore wears an oriental turban. It is quite possible that Dürer conflated several thematic sources. In 1494 he made a drawing after Mantegna's engraving, *Battle of the Sea Gods*, and, about a year later, a sketch of the *Rape of Europa*. Both drawings involve the motif of a nude woman riding on the back of a mythical creature (Winkler 1936-39: nos. 60 and 87). In the latter drawing one also finds despairing figures on a distant shore and still other riders of sea creatures. In a dated drawing of 1503 this sea-rider motif returns in the form of Venus on a fantastic dolphin (Winkler 1936-39: no. 330). Together, these works indicate Dürer's abiding interest in the motif of a woman borne upon the back of a mythical creature of nature, quite apart from any particular narrative.

Throughout his career, Dürer stood fast by the human figure as the most important subject of art, and in this engraving the woman and her aquatic abductor are placed prominently in the foreground. However, a good two-thirds of the total composition is filled by one of the most impressive landscapes that Dürer ever produced with his burin. The town on the shore, receding into the distance, is part of a view designed to sweep one's eye far off to the horizon. Then at the right, just where the mountains seem to descend into the sea, a ship under full sail carries forth the idea of leaving behind the town and all the civilization it stands for. Although the principal figures are not so compositionally integrated into the natural environment as in the work of Altdorfer or Cranach (see cat. nos. 121-122), Dürer at this time seems to have been equally as concerned with nature's mysterious, even threatening allure. His far-reaching landscape draws our vision toward the natural world, while the abduction of the woman by the sea monster takes our thoughts to an even more distant realm where natural instincts are not suppressed by civilization.

The variety of things that Dürer portrayed in his engraving was a delight to the illuminator who applied gold to the sea monster's fins, to the green scales, to the purple drapery, and silver (now tarnished) to the clouds and waves. The largely opaque pigments left little of the engraved lines visible and transformed the print into a miniature painting. The illuminator tried, however, not to deviate from Dürer's outlines, although he complicated the already ambiguous expression on the woman's face by giving her a toothy look. The sheet has suffered since the time color was added, but it was already damaged before then, and this may be why color was added to this particular impression. The style and technique of coloring resemble that of Dürer's *Saint Jerome in his Study* (cat. no. 156) and Cranach's *Penance of Saint John Chrysostom* (cat. no. 123). The coloring of all three engravings probably dates from the early 17th century, although it appears that more than one illuminator was involved (see also cat. no. 156).

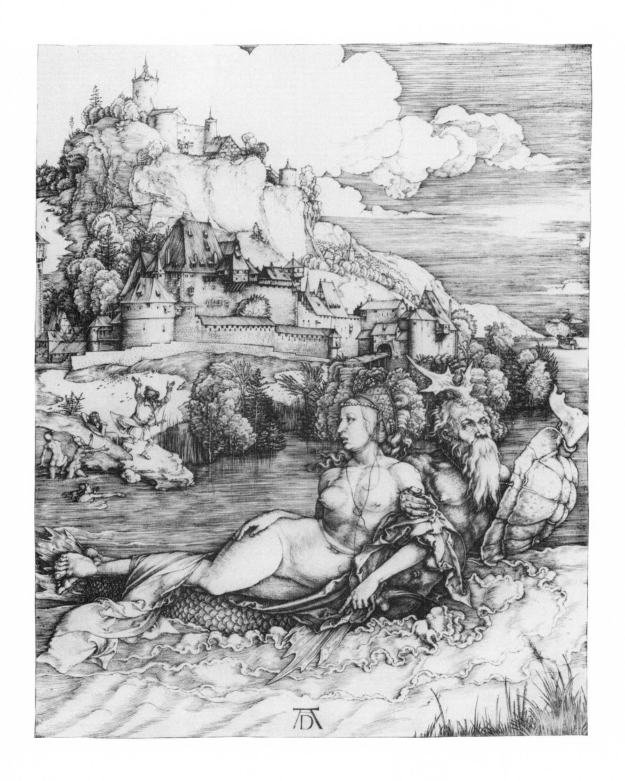

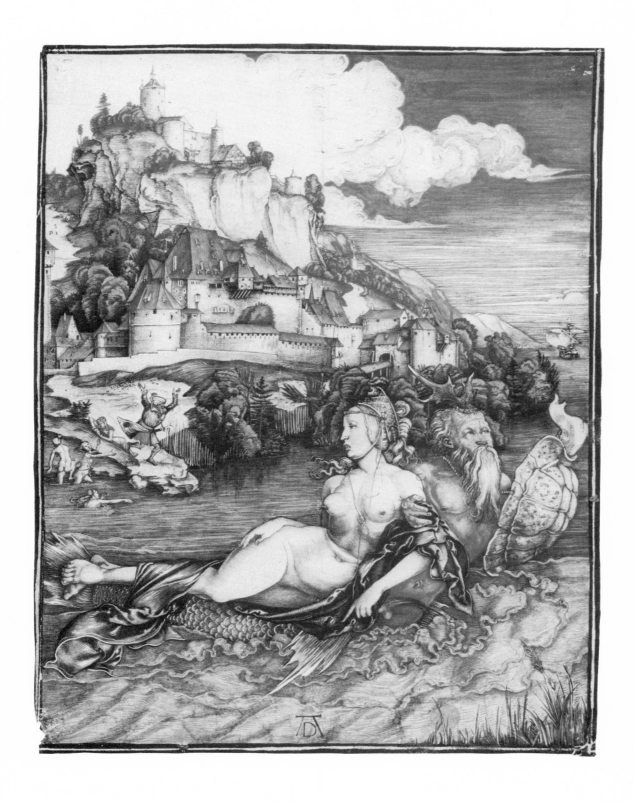

135

Saint Eustace, c. 1500/01
(illustrated on p. 250)

Engraving, 355 x 260 mm

Watermark: High crown (Meder 20)

Monogram in plate at lower center: *AD*

VC: Inv. no. I 17, 61

References: Meder 1932: no. 60b; Panofsky 1948, II: no. 164; Panofsky 1950: 2-10; Coburg 1967: no. 221; Coburg 1971: no. 62; Washington 1971: no. 24; Coburg 1975: no. 79

136

Saint Eustace, c. 1500/01
(illustrated on p. 251)

Engraving, printed on satin, 359 x 261 (plate); 375 x 292 mm (satin)

Monogram in plate at lower center: *AD*

VC: Inv. no. I 17, 62

References: Hollstein VII: no. 60; Coburg 1971: no. 63; Coburg 1975: no. 80; Strauss 1976-77: no. 34

Dürer's engraving portrays the moment when Saint Eustace was converted to Christianity by his encounter with a stag between whose antlers there miraculously appeared a crucifix. At the time of his conversion, he was a Roman general named Placidas out on a hunt, and when he saw the stag, it spoke to him with Christ's voice, saying "O Placidas, why pursuest thou me? . . ." Like Saul before him, he fell from his horse and became a Christian. The same event was later absorbed into the legend of Saint Hubert, but since Dürer referred to the "Eustachius" several times in his Netherlandish Diary, there is no doubt about which saint he intended to represent. Eustace was well known as one of the *Vierzehn Nothelfer*, 14 special saints called upon in times of need (see also cat. no. 118). However, Dürer was not concerned with making a devotional image of a popular saint, nor was he concentrating primarily on the story. In fact, the placement of the central tree makes it doubtful whether the saint can even see the stag. What mattered most to Dürer was that the beholder have a clear view of everything, to which end he carefully avoided all but the slightest overlapping of the figure or the animals with each other, posing all but one in strict profile.

This is Dürer's largest and, in its wealth of pictorial detail, most ambitious engraving. It fully justifies the comparison between Dürer and Apelles drawn by Erasmus, who praised Dürer for achieving with black lines alone what the ancient Greek painter had done with the benefit of colors. Dürer certainly intended to show how far an engraving could go toward rivaling the work of the great realist painters before him. He suppressed the inherent linearity of the medium in favor of tonal values and textures created by means of short strokes and flicks of the burin. Not surprisingly, the only surviving study used directly in this work—a drawing at Windsor Castle for the largest of the dogs in profile (Winkler 1936-39: no. 241)—was made with a brush rather than pen. The engraving's composition as well as its pictorial qualities invites comparison with certain paintings, such as the donor wings of Hugo van der Goes' Portinari Altarpiece in the Uffizi, where light falls in similar fashion over a landscape that rises behind kneeling foreground figures, or Pisanello's *Saint Eustace* in the National Gallery, London, where nearly the same cast of animals has been arranged in silhouetted, profile poses. Italian art nour-

ished Dürer's interest in geometry and the canons of proportion, and in this engraving that interest is plainly visible beneath the surface of naturalistic detail. The horse, which Dürer has made the protagonist of the composition, already embodies the essential proportions of the ideal horse in his engraving of 1505 (cat. no. 143).

Dürer's engraved plate continued to be printed into the early 17th century. By that time, it was well worn and no longer able to yield more than a pale image. This may have been one reason why an edition was printed on satin, since the glossy surface offers a distraction from what might otherwise seem to be no more than an impression from an exhausted plate (only four or five impressions of this edition survive). However, the choice of satin also implies a particular kind of taste, not so distant from that responsible for more recent souvenirs printed on the same sort of material. Around 1600, there was a fashion for glossy pictures that were frequently painted on copper and occasionally on marble. Such materials not only heightened the sheen but also made the image seem more precious than a picture on paper, canvas, or wooden panel. Guided by such taste, the next step after printing a venerable engraved plate on satin would be to gild it, and that is exactly what Bartsch said Emperor Rudolf II had done with it (Bartsch 1808-21, VII: 57). Others passed on the same information, then Thausing (1876: 229, n. 1), who examined the gilded plate in a private Austrian collection, became convinced that it was only a copy by the Monogrammist GH with the initials removed. That still leaves the matter somewhat up in the air since the Monogrammist GH's copy of *Saint Eustace* reverses Dürer's original (Nuremberg 1978: no. 82), a fact Thausing does not mention. But even assuming the gilded plate was a copy from the late 16th century, it would still represent the same approach toward glorifying Dürer's engraving.

Before printing, the piece of satin (which still has its strip of green selvage along the right edge) was laid down on a sheet of paper, so that the backing sheet was embossed with both the plate mark and the texture of the fabric. It is impossible to see whether the paper has a watermark that might allow the establishment of a more exact date for these impressions.

137

Nemesis, c. 1501/02

Engraving, 334 x 229 mm

Watermark: High crown (Meder 20)

Monogram in plate at lower right: *AD*

VC: Inv. no. I 17, 84

References: Meder 1932: no. 72 IIa; Panofsky 1948, I: 81-82 and II: no. 184; Coburg 1971: no. 77; Nuremberg 1971: no. 481; Washington 1971: no. 25; Coburg 1975: no. 85

Nemesis, a winged goddess who stands on a globe, as does the personification of Fortune (by which name this print has otherwise been known), carries in one hand a bridle to control mankind and in the other hand the traditional cup of reward. The global extent of her domination is indicated by the sweeping panorama beneath her feet, a breathtaking landscape of the kind Dürer drew with watercolors while passing through the Alps on his way to and from Venice. Equally expressive of Nemesis' awesome power is her formidable physique. That Dürer imparted such a profile to a classical goddess has demonstrated to some critics how little this German artist understood of the Italian Renaissance, let alone of Antiquity itself. This opinion was further strengthened by the apparent incongruity that such an utterly unclassical body should have been constructed, as widely supposed, according to the Vitruvian canon, whereby the head measures one-eighth of the total body length. In light of Dürer's studies of human proportions, it is quite reasonable to suppose that he did apply a proportional scheme here, but actual measurements taken from the engraving cast doubt on the hypothesis that this was a misguided attempt to demonstrate the Vitruvian ideal (see Washington 1971: 129, n. 5). Dürer had already seen enough in Venice and elsewhere in northern Italy to know better. Moreover, his engraving of Adam and Eve from 1504 (cat. no. 138)

shows an appropriate correlation between classical figural types and classical proportions, and the earliest studies related to Eve postdate the *Nemesis* by very little, if at all. Dürer was indeed creating a paradigm of a certain kind, but by 1501, he would have been the last to confuse it with a classical ideal.

It is possible to know at least some of what Dürer's figure of *Nemesis* meant in her own time by considering how other artists saw her. With varying modifications, she reappears in the works of Hans Baldung Grien, Niklaus Manuel Deutsch, Urs Graf, and others. Inevitably she turns up again as Fortune, but the same, unmistakable figural type also represents a Venus at the Judgment of Paris, a Judith with the head of Holofernes, and a Phyllis making a fool of Aristotle (see Washington/New Haven 1981: 28-30). What these subjects have in common is the power of women over men through physical attraction. The intent of these representations was often satirical, but not always. Doubtless many viewers did find Dürer's extravagant image of this woman somewhat overwhelming but not necessarily to the extent that it was impossible to accept her as a Venus or a Judith. Always, however, this figure emphasized that such women, like Nemesis, represented a formidable danger in one way or another.

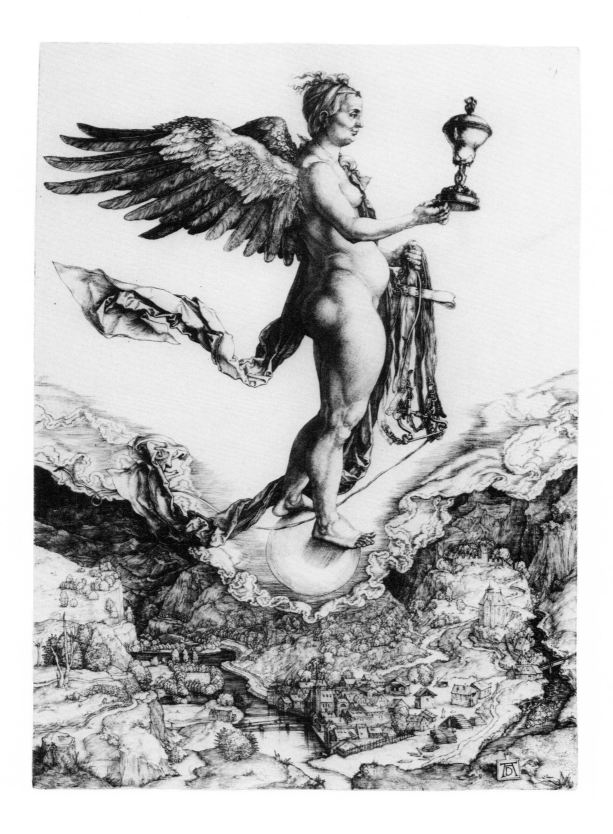

138

Adam and Eve, 1504

Engraving, 248 x 192 mm

Watermark: Bull's head (Meder 62)

Signed and dated in plate at upper left: ALBERT / DVRER / NORICVS / FACIEBAT / AD 1504

VC: Inv. no. I 15, 1

References: Meder 1932: no. 1 IIa; Panofsky 1948, I: 84-87 and II: no. 108; Hollstein VII: no. 1 IV; Coburg 1971: no. 1; Nuremberg 1971: no. 484; Washington 1971: nos. 30, XII

These figures of Adam and Eve embody the results of Dürer's struggle over the preceding three or four years to recreate the ideal forms of man and woman, as he believed they had existed in the art of Antiquity. If he was only secondarily interested in the portrayal of the Fall of Man, his engraving nonetheless left an indelible imprint on representations of mankind's first parents throughout the 16th century, especially in Northern Europe. It was a legacy matched by that of few other works in the history of art. Yet Dürer himself soon demonstrated that the ideal was relative, and that beauty resides in no single canon of proportions or figural type. The influence of Dürer's *Adam and Eve* resulted to a great extent from his extraordinary engraving skill. His technique had now reached the point, it seems, where no shape, substance, texture, or fleeting shadow could elude his burin. Within an overall, precisely controlled graphic system of fine linear and dotted patterns, he found the means to meet every visual challenge. Inevitably, with so much subtlety worked into the copper surface, the plate was unusually vulnerable to wear. By the final state, in which a small additional cleft appears in the tree just beneath Adam's left armpit, the plate had already lost much of its rich burr. To appreciate fully Dürer's achievement, one must see an early, finished impression like this one from Coburg.

A number of surviving drawings document the main lines along which the *Adam and Eve* had evolved. The pair began as two separate figures with other identities: Adam is descended from the *Apollo Belvedere*, and Eve was originally a Venus.

Their strict frontality (not the easiest way to relate two figures to one another) was intended to show the contours of the body in a classical, contrapposto stance and to indicate the geometrical construction of as much of the body as possible according to a canon of ideal, mostly Vitruvian, proportions. Only in the final stages of their development were the figures changed into an Adam and an Eve and united in a single composition that never quite overcame its bipartite origins.

In keeping with his emphasis on rational theory, Dürer sought to explain man's fall from grace in symbolic, humanistic terms. This was the function of the animals in this forested paradise. The cat, elk, rabbit, and ox each denote one of the four humors or temperaments—the choleric, melancholic, sanguine, and phlegmatic, respectively—that were believed to account for man's constitution. According to a scholastic theory in existence since the 12th century, the humors had been in perfect equilibrium before the Fall, but afterwards one or another predominated in each individual and caused the mortality and particular ills of every person. The parrot, symbolizing the Virgin Birth of Christ, is perched on a branch of the Tree of Life, in opposition to the serpent curled around the Tree of Knowledge. The mouse about to be pounced upon by the cat alludes to the fate awaiting Adam as he extends his hand for the forbidden fruit (Panofsky 1948, I: 84-85). Finally, tucked into a distant corner, the mountain goat—symbol of unbelievers—characterizes the first human pair to disregard the divine commandment.

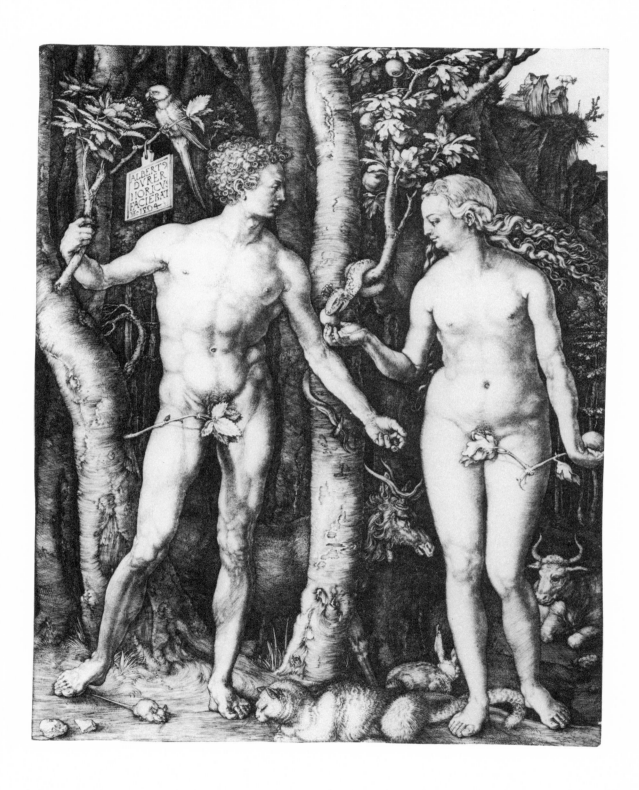

139

Calvary with the Three Crosses, c. 1504

Woodcut, 213 x 148 mm

Monogram in block at lower center: *AD*

VC: Inv. no. I 20, 177

References: Meder 1932: no. 180 Ia or b; Panofsky 1948, II: no. 279; Coburg 1971: no. 188; Washington 1971: no. 107; Strauss 1980: no. 82

Around 1504, Dürer executed several designs for paintings of the Crucifixion that, like this woodcut, portrayed the three crosses and many figures arranged against an ascending landscape. Characteristic of Dürer's preparatory drawings for paintings, two of these designs, the *Large Calvary* (Winkler 1936-39: no. 317) and the *Calvary* (Winkler 1936-39: no. 319) for the Ober-St. Veit Altarpiece, whose execution was left in the hands of Hans Schäufelein, were made on green prepared paper with black ink and heightened with white (see also cat. no. 22). It was the coloristic appearance of this drawing technique that Burgkmair (cat. nos. 114, 115) and Cranach (cat. no. 117) emulated with their chiaroscuro woodcuts printed from two blocks. As far as is known, Dürer himself never experimented with a chiaroscuro tone block, but between the late 1490s and 1510, he succeeded in developing a system of tonal gradations in black-and-white prints that was largely based on his technique of drawing on colored paper. The present woodcut, so similar to the two *Calvary* drawings in composition, also resembles them in the way the figures are highlighted against a darker ground. Although in this print the ground tone, in the form of parallel hatching, breaks up into irregular planes according to the particular surface on which it appears to lie, Dürer was well on his way to establishing the principle of tonal gradation that is responsible for the graphic and spatial clarity of his prints from 1510 on (see cat. nos. 149, 151).

This print belongs to a group of 11 undated, but contemporaneous woodcuts by Dürer, all with religious subjects, known as the *schlechtes Holzwerk*. The term is Dürer's own; he used it in reference to these prints in his Netherlandish Diary (Rupprich 1956-69, I: 162, line 32). Despite the still-lingering attitude that Dürer meant "schlecht" in the modern sense of "bad," Flechsig (1928-31, I: 283-285) has demonstrated beyond doubt that in Dürer's time the word meant "simple" or "modest," as in *schlicht*. Dürer was, therefore, referring to his simply designed, less expensive woodcuts. It is quite possible, as Meder has proposed (1932: 39-40), that Dürer had originally planned to use these woodcuts as illustrations for a *Salus Animae* (*For the Health of the Soul*), a devotional book of which an edition involving even more modest woodcuts attributed to Dürer had been published in 1503. Perhaps because it was modest work, the *schlechtes Holzwerk*, including also *Saint Francis Receiving the Stigmata* (cat. no. 140) and the *Elevation of the Magdalen* (cat. no. 141), printed brilliantly (the impressions from Coburg in particular are exceptionally fine). Because of their minimal cross-hatching, these woodcuts were apparently easier to ink and print cleanly. Sufficient care was taken at all stages of production, including their design, so that Dürer was not ashamed to place his monogram on them or to distribute them along with his most ambitious work.

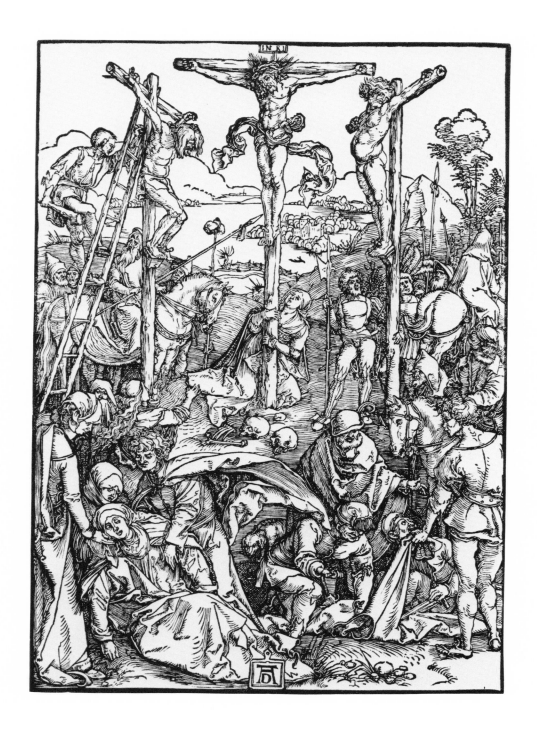

140

Saint Francis Receiving the Stigmata, c. 1504

Woodcut, 221 x 146 mm

Watermark: High crown (Meder 20)

Monogram in block at right: *AD*

Inscription in block at bottom: *VVLNERA QVAE PROPTER*

CHRISTVM FRANCISCE TVLISTI / ILLA ROGO NOSTRIS SINT MEDICINA MALIS

VC: Inv. no. I 23, 261

References: Meder 1932: no. 224a; Panofsky 1948, II: no. 330; Coburg 1971: no. 233; Nuremberg 1971: no. 342; Strauss 1980: no. 85

The subject of this print, together with the prayer that was cut into the block at the bottom, provides an insight into religious attitudes at the end of the Middle Ages and into the function of such a devotional image. The prayer, addressed to the praying figure of Saint Francis, establishes a relationship between the beholder and the saint that parallels that of the saint and Christ. "O Francis," the Latin text reads, "the wounds that you bore on behalf of Christ, I implore that they may be a medicine for our sins." Thus, the supplication for Christ's forgiveness of sins is to be mediated by the saint, who imitated Christ to the point of acquiring the physical signs of his martyrdom. The traditional portrayal of the event reinforces the similarity between Saint Francis at prayer on Mount Alverna and Christ's Agony in the Garden (Matthew 26:36-40); like the Apostles who were overcome by sleep while Christ prayed through the night, Brother Leo, the saint's companion, is shown sleeping while the miracle takes place. As Saint Francis prays, he be-holds the hovering crucifix, winged like a seraph, and at that moment receives the stigmata. For the beholder/worshipper, this image was more than an edifying illustration; it was, by analogy, the object of a visual experience that mirrored the saint's miraculous viewing of Christ.

Since the prayer is in Latin, the woodcut cannot have been designed for popular devotional usage to the degree that a prayer in German would have allowed. Flechsig (1928-31, I: 288-289) has proposed that Dürer made the woodcut specifically for the Franciscan brothers in Nuremberg or perhaps at the request of Charitas and Clara Pirkheimer, sisters of Dürer's close friend, the humanist Willibald Pirkheimer, who had become Franciscan nuns at the cloister of Saint Claire. Like the *Calvary with the Three Crosses* (cat. no. 139) and the *Elevation of the Magdalen* (cat. no. 141), this print belongs to the so-called *schlechtes Holzwerk*.

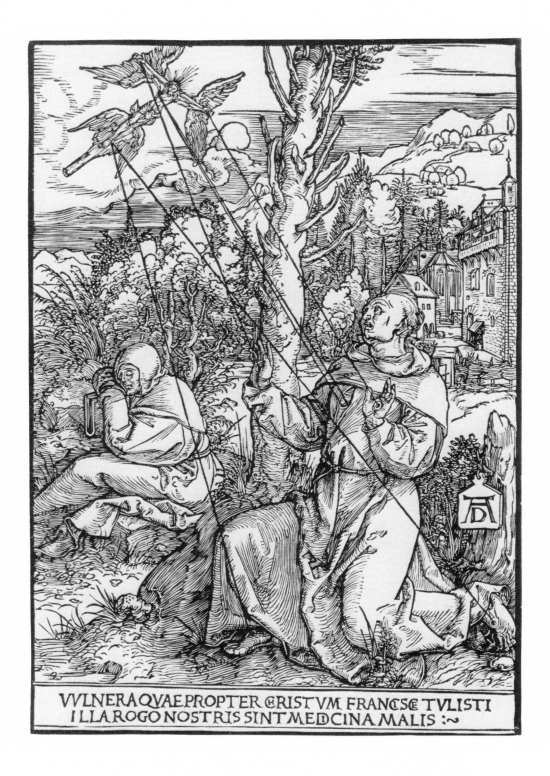

VVLNERA QVAE PROPTER CHRISTVM FRANCSCE TVLISTI
ILLA ROGO NOSTRIS SINT MEDCINA MALIS :~

141

Elevation of the Magdalen, c. 1504

Woodcut, 212 x 145 mm

Watermark: Scale in circle (Meder 169)

Monogram in block at bottom: *AD*

VC: Inv. no. I 24, 275

References: Meder 1932: no. 237b; Panofsky 1948, II: no. 341; Coburg 1971: no. 247; Washington 1971: no. 117; Strauss 1980: no. 89

According to the *Golden Legend*, Mary Magdalen spent the last 30 years of her life near Marseilles, spiritually nourished by a chorus of angels (see cat. no. 18). Toward the end of her life, a priest living nearby as a penitent happened to witness the angels raising her to heaven. It is this miraculous occasion that Dürer represented, with the priest at the left. Although the Magdalen's feet are just a step above the roof of her cave, the landscape falls rapidly away, providing an elevated per-spective that evokes her ascent heavenward. The background effectively suggests a sun-drenched Mediterranean coastal landscape and in its simplicity accords with Dürer's reference to his *schlechtes Holzwerk* (see cat. no. 139). The Magdalen herself is anything but a wasted hermit; rather, she possesses the physical attributes associated on the one hand with her reputation as the beautiful penitent and, on the other, with Dürer's studies of the ideal female nude (see cat. nos. 137-138).

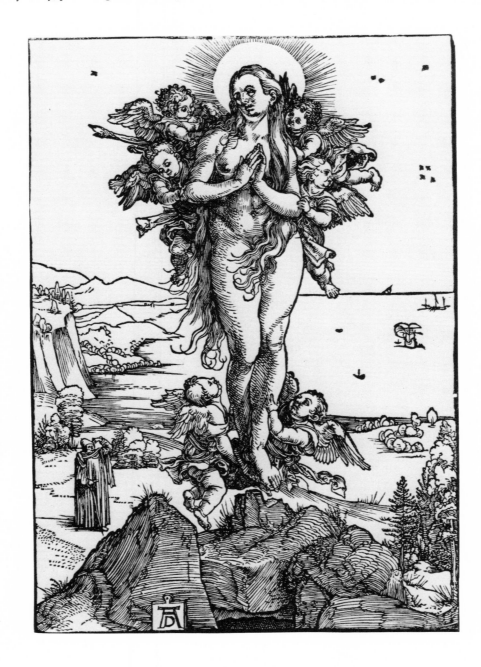

142

Satyr Family, 1505

Engraving, 118 x 72 mm

Watermark: Triangle from bull's head (Meder 62)

Monogram and date in plate at upper right: *1505 / AD*

VC: Inv. no. I 17, 73

References: Meder 1932: no. 65a; Panofsky 1948, I: 87 and II: no. 176; Boston 1971: no. 92; Coburg 1971: no. 69; Nuremberg 1971: no. 521; Washington 1971: no. 32; Coburg 1975: no. 82

Two drawings related to this engraving (Winkler 1936-39: nos. 344-345) show that Dürer first had in mind the theme of a centaur family, inspired by the Greek satirist Lucian's description of a painting by Zeuxis or perhaps by a similar passage in the *Imagines* of Philostratus (Panofsky 1948, I: 87; Washington 1971: 134). In the final, engraved version the idea of a half-human family remained, but its members became a satyr and a nymph, which changed somewhat the associations of the image. Panofsky believed that Dürer conceived this print as a pendant to the engraving *Apollo and Diana* (Washington 1971: no. 31). "Taken together," he wrote, "the two prints appeal indeed to two of the most potent impulses in the psychology of the Renaissance: to the nostalgias for the Olym-

pian and for the idyllic" (Panofsky 1948, I: 87). But it has also been suggested (Nuremberg 1971: 277-278) that the idyll is mixed with negative references to a life under the limitations of libidinous instinct. It is true that the forest here, which resembles the dense background in the engraving of *Adam and Eve* (cat. no. 138), is devoid of foliage and that the woman grasps a dead branch, rather than a branch from the Tree of Life, but it does not appear that the figures are sunk in melancholy gloom as a result of their carnal predisposition. However, when two very similar figures reappeared in an ornamental wallpaper design produced in Dürer's workshop some ten years later (cat. no. 158), the reference to their libido was accentuated in the floral pattern.

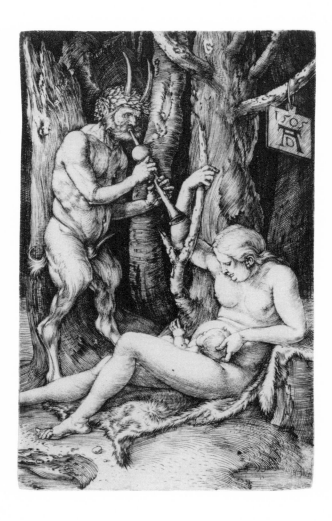

143

Small Horse, 1505

Engraving, 162 x 108 mm

Watermark: Bull's head (Meder 62)

Monogram in plate at lower center: *AD*

Date in plate at upper center: *1505*

VC: Inv. no. I 18, 105

References: David 1910: 310-312; Kurthen 1924: 88-89; Meder 1932: no. 93a; Panofsky 1948, I: 88 and II: no. 203; Coburg 1971: no. 100; Nuremberg 1971: no. 500; Washington 1971: no. 33; Winzinger 1971a: 17-21; Coburg 1975: no. 91

Concurrent with his studies of human proportions, visible in the engraved *Adam and Eve* (cat. no. 138) of 1504, Dürer was similarly engaged in a search for the ideal proportions of the horse. Whereas the proportions of man and woman could be perceived and measured most fully in a frontal view, the same concerns dictated that the horse be placed in strict profile. The horse in the engraving of *Saint Eustace* from 1500/01 (cat. no. 135) already embodies essentially the same canon of proportions as does the *Small Horse* of several years later. In the meantime, however, Dürer must have encountered Leonardo da Vinci's studies of the horse, although probably only through copies. Dürer's geometrically constructed drawing of 1503 in Cologne (Winkler 1936-39: no. 361) is clearly related both in stance and in type to Leonardo's sketches for the Sforza Monument. In this engraving the shape of the horse's head and the motif of a raised foreleg are decidedly Leonardesque. But because Dürer wanted to understand the underlying basis for such ideal proportions, he apparently devised his own geometrical schema by which to establish them. When he presented his theoretical findings in a work of art, as opposed to illustrating them with diagrams in one of his treatises, he sought to clothe the forms with an appropriate iconography. Often the precise meaning, if one ever existed, is now elusive. The halberdier, taking a giant stride in his winged boots on the far side of the horse, could be Perseus or Mercury, but there is no apparent narrative to support these identities nor to explain the equally puzzling barrel-vaulted structure in which he stands with his steed. It is significant that the horse, although unbridled, remains under human control. According to contemporary beliefs, based on traditions going back to Antiquity, the horse had an unusually passionate disposition (see cat. no. 107). With this spirited yet obedient animal Dürer may have intended to signify, as Panofsky (1948, I: 88) has suggested "Animal Sensuality restrained by the Higher Powers of the Intellect."

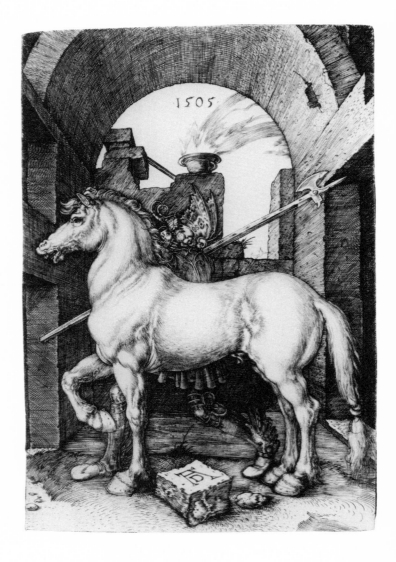

144

Large Horse, 1505
(illustrated on p. 264)

Engraving, 166 x 118 mm

Monogram in plate at lower right: *AD*

Date in plate at upper center: *1505*

VC: Inv. no. I 18, 106

145

Large Horse, 1505
(illustrated on p. 265)

Engraving, colored by a later hand, 168 x 120 mm

Monogram in plate at lower right, subsequently colored with gold: *AD*

Date in plate at upper center, colored in the same manner: *1505*

VC: Inv. no. I 18, 107

References: Meder 1932: no. 94a (?); Panofsky 1948, I: 88 and II: no. 204; Coburg 1971: nos. 101-102; Nurenberg 1971: no. 501; Washington 1971: no. 34; Coburg 1975: no. 91

The *Large Horse,* so named for the impression of massiveness it presents rather than for its actual size, was designed as a calculated contrast to its pendant of the same year (cat. no. 143). A much heavier animal, the *Large Horse* stands no higher than the *Small Horse,* if one is to judge by the relative size of the warriors in charge of them. The extreme foreshortening of the horse and its close fit within the format are the principal reasons that the horse looms so large, but its size is also magnified by the nearness of the hindquarters to the viewer. Its croup is all the more imposing as a result of the elevation of the hind feet. Even though the horse looks quite docile in comparison to the high-spirited *Small Horse,* there seems to be an implied threat in its position. The unmistakable suggestion is that there is a latent power in the foreshortened form that can be released in an instant through a lethal kick. That suspicion proves to be well justified if one looks at Hans Baldung's *Bewitched Groom* (cat. no. 108), in which Dürer's horse is reproduced in its essential features.

Although Dürer designed this image to make a sudden, overall impact one cannot help but admire the unerring course of the artist's burin close at hand. The lines seem alive to the forms and textures, stretching around the swelling contours or slackening where the heavy muscles are in a state of temporary relaxation.

It is understandable that whoever applied the color to one impression of this engraving had concluded that the horse was pure white. Dürer was not concerned with the color as such, but he did make expressive use of the pale form of the animal in contrast to the deeply shaded background. As it protrudes outward, the hefty flank seems to expand in volume as it receives the full impact of the strong light. The colorist was so impressed by the effect of this luminosity that he not only heightened the lightness of the horse with white but also subordinated competing details; a glimpse of a statue standing on the column and the foliage growing near the wall at the right have been obscured by the application of the body color. The same has happened to most of the engraved lines and to the subtlety of Dürer's modeling. At least four other engravings at Veste Coburg were colored by the same hand: two by Dürer, *Lady on Horseback with a Lansquenet* (Meder 1932: no. 84; VC: Inv. no. I 17, 89) and the *Bagpiper* (Meder 1932: no. 90; VC: Inv. no. I 18, 100); and two by the Master MZ, *Woman with an Arrow* (Lehrs 1908-34, VIII: no. 11; VC: Inv. no. K 687) and *Couple in a Landscape* (Lehrs 1908-34, VIII: no. 15; VC: Inv. no. K 692). The *Large Horse,* the *Lady on Horseback,* and the *Woman with an Arrow* have been laid down on a page from a book whose Latin text concerns the life of Saint Severin. If the book could be identified, its date would provide a *terminus post quem* for the coloring of the prints. There is no reason, however, not to place the coloring of this group of prints in the same period as the other colored impressions in this exhibition (cat. nos. 123, 134, 156), that is, during the early 1600s.

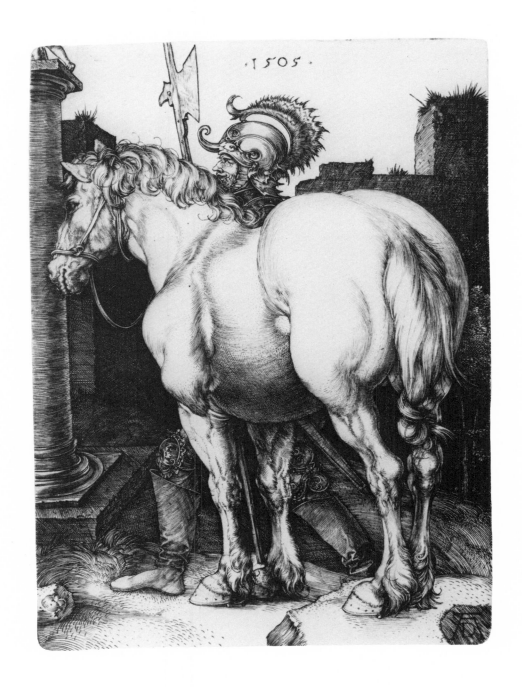

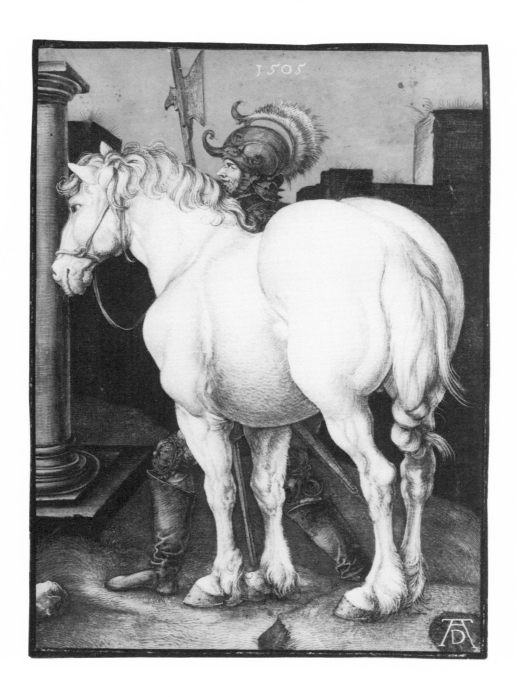

146

Lamentation, 1507

Engraving, 115 x 72 mm

Watermark: Triangle of bull's head (Meder 62)

Monogram and date in plate at lower left: *1507 / AD*

VC: Inv. no. I 15, 14

References: Meder 1932: no. 14a; Panofsky 1948, I: 141-145 and II: no. 121; Coburg 1971: no. 14; Washington 1971: no. 51; Coburg 1975: no. 67

This *Lamentation*, engraved by Dürer upon his return from Venice in 1507, was the first of what became a series of 15 small engravings of the Passion, now called the *Engraved Passion* (see also cat. no. 147). Ten of the prints were produced in 1512, the year he completed the project. In the intervening years he had worked on the series when he could, having been otherwise occupied with an overwhelming number of projects. This was not only an exceptionally productive period for Dürer but also one during which his graphic style reached its full maturity. The *Crucifixion* of 1511 (cat. no. 147) represents this point of development, which has with good reason been called a classical phase in his art .

Despite their small size, these engravings display a high degree of refinement and precise detail that exceeded the capacity of woodcuts. Dürer did not eschew the dramatic action that sweeps one through the 36 woodcut scenes of the *Small Passion* (Washington 1971: nos. 156-193), but he filled each plate with so much to see, including penetrating characterizations of each figure, that the prints require close and unhurried viewing. The *Lamentation* is the least compacted and, with the sky left simply as blank paper, the lightest composition in the series. In the prints to follow, Dürer concentrated the figures in restricted spaces and increased the total area containing middle to dark tones. The emotional element in the *Lamentation* derives primarily from the positions of the figures, particularly the despairing Mary Magdalen, and the body of Christ, slumped at the base of the cross with punctured feet protruding toward the beholder.

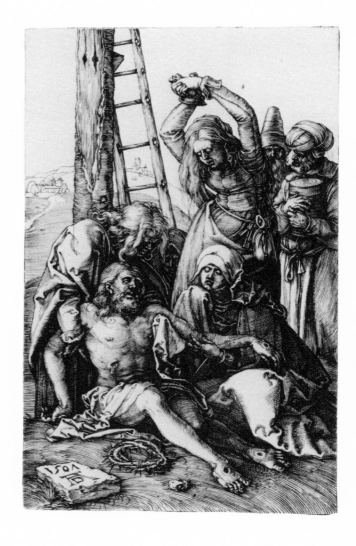

Crucifixion, 1511

Engraving, 118 x 76 mm

Watermark: Triangle of bull's head (Meder 62)

Monogram in plate at lower right: *AD*

Date in plate at lower left: *1511*

VC: Inv. no. I 15, 13

References: Meder 1932: no. 13a; Panofsky 1948, I: 141-145 and II: no. 120; Coburg 1971: no. 13; Washington 1971: no. 50; Coburg 1975: no. 66

The *Crucifixion* for the *Engraved Passion* (see cat. no. 146) followed by three years the slightly larger, single engraving that Dürer had made in 1508 of the same subject (cat. no. 148) in which the half-dark sky had proved its effectiveness in creating both a somber mood and a reference tone by which to orient a scale of light values. In this later version Dürer went even further toward abstracting the middle value from a specific representational function. In a composition in which almost no landscape is visible, the gray background serves more as a foil against which to illuminate the principal figures than as a realistic depiction of sky. With John, Christ, and Mary restored to their traditional positions of formal symmetry, the emotionalism of 1508 has been replaced by stately grandeur. Christ is serene, his muscular body no longer pulled taut by its own weight upon the cross. His human suffering, the image tells us, has been subsumed in death by his divine nature.

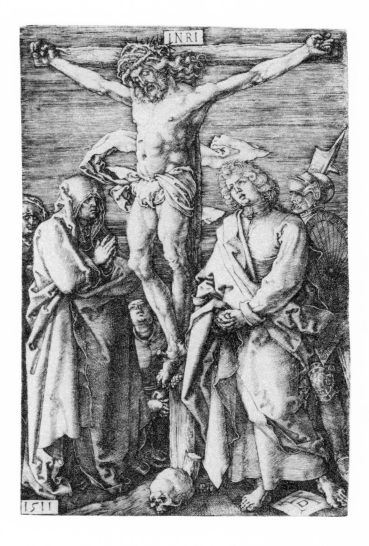

148
Crucifixion, 1508

Engraving, 136 x 100 mm

Monogram and date in plate at lower center: *1508 / AD*

VC: Inv. no. I 15, 25

References: Meder 1932: no. 23a; Panofsky 1948, I: 145-146
and II: no. 131; Coburg 1971: no. 21; Washington 1971: no.
36; Coburg 1975: no. 69

In this composition five of Christ's bereaved followers remain
gathered around the cross, each contending with his sorrow in
his own way. Dürer set the emotional tone not only by the
facial expressions and contortions of the figures themselves,
but also by the lighting and composition. The asymmetrical
organization de-emphasizes the iconic nature of the Crucifix-
ion, as it was traditionally represented frontally on a central
axis, and frees the mourning figures from their hieratic posi-
tions on either side of the cross so that they appear to react
more as humans overwhelmed by their feelings rather than as
saints reconciled to a divine plan. Similarly, the composition
addresses the beholder as if he had approached the scene by
way of a natural, irregular path from one side rather than from
straight ahead in a fixed symbolic way and thereby invites him
to respond personally to the Crucifixion as do the mourners
themselves. Around 1496, Dürer had already designed such an
asymmetrical *Crucifixion* with the same number of mourners
and the cross viewed at a diagonal (Dresden, Gemäldegalerie),
but with the exception of this engraving, he left it to others,
such as Altdorfer, Baldung, and Cranach, to develop the ex-
pressive potential of the arrangement.

The nocturnal setting, which on the one hand suggests the
feeling of spiritual darkness experienced by the mourners at
this moment and, on the other, provides the conditions for
dramatic lighting, is more consistent with the main lines of
Dürer's stylistic development. He was working at this time
toward a rational system of modeling based on a middle value,
with reference to which the relative amount of light through-
out the composition could be modulated. Whereas in drawings
he frequently used colored paper to establish the middle value,
in this engraving he found the overall nocturnal darkness as
appropriate to this purpose as it was to the expression of a
particular mood. Although such a system of carefully modu-
lated light required consummate control of the burin, it tended
to diminish the expressive importance of individual lines in
favor of areas of tone. Since Dürer controlled the tone through
patterns of line, he customarily, especially in mature work
such as this, wiped the plates clean before printing them, leav-
ing a minimum of plate tone to create any surprises. The
present impression of this engraving is a notable and beautiful
exception to the rule. It is richly inked with considerable plate
tone left in the shadowed areas. On this occasion at least,
Dürer worked with the ink on the plate as he would with black
chalk on a drawing, producing an image with unique and spon-
taneous emphasis.

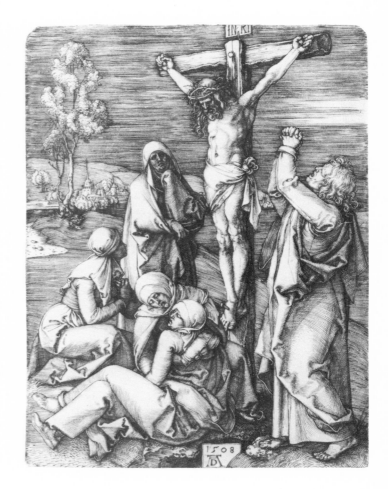

149

Virgin and Child with the Pear, 1511

Engraving, 155 x 105 mm

Watermark: Anchor in circle (Meder 171)

Monogram in plate at lower left: *AD*

Date in plate at upper center: *1511*

VC: Inv. no. I 16, 44

References: Meder 1932: no. 33a; Panofsky 1948, II: no. 148; Coburg 1971: no. 32; Washington 1971: no. 37

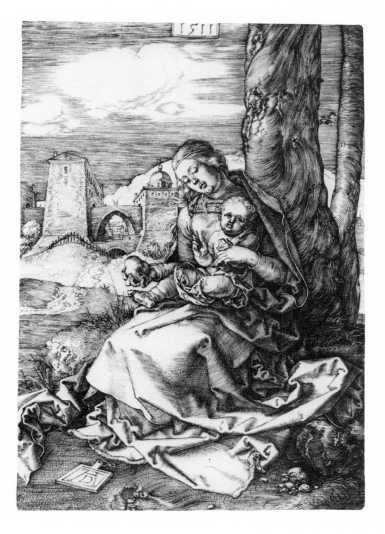

As in his earlier composition, the *Holy Family with the Butterfly* (cat. no. 129), Dürer placed this Virgin and Child in the foreground of a tranquil landscape, but made their relationship to nature even closer. The positioning of the figures to the right of center allows a more even balance between them and their surroundings, and because the Virgin is turned at a slight angle, almost parallel to the path leading into the distance, she promotes a sense of spatial continuity. Even the tilt of her head helps bridge the near space with the far. The informality of the composition contributes to the spirit of the scene: a mother and child enjoying the out-of-doors. Only the infant Christ, who raises his hand to give blessing, interjects a note of seriousness, as his mother tries to distract him with the pear.

Instead of showing nature as the sum of many varied details, Dürer has concentrated here on just a few motifs, using the quality of light to create the all-embracing mood of the landscape. Relatively little of the white paper has been left fully exposed, but those areas that are appear to be very bright indeed, like the highlights on the drapery and the faces or the billowy cloud and the distant hillside. This transformation of the paper from neutral white to vibrant luminosity derives from Dürer's graphic system, whereby light values are modulated in relation to a middle gray tone. Here the middle tone is registered in the sky and across the ground by means of thin, closely engraved parallel lines. This system, which first appears fully developed in Dürer's prints from 1510, has the effect of increasing the apparent range of values between the deepest shadow and brightest light, although the absolute range remains, of course, the same as in any other print: the black of ink to the white of paper. Also under this system the modeling is more coherent and clarifies the spatial relationships of all forms, however complicated or wherever distributed across the page. In keeping with this development, Dürer increased his emphasis on simple, solid forms at the expense of surface texture. The architecture in the background is one example of this, the trees behind the figures, another. The clarity of forms and consistency of lighting reveal Dürer's conviction at this point that the way to understand the relationship between man and nature was through rational principles. But his search for such underlying principles never dulled his instinct that the significance of everything in nature resides as much in its individuality as in its place within a universal order.

Holy Family with Joachim and Saint Anne, 1511

Woodcut, 235 x 159 mm

Monogram and date in block at upper left: *1511 / AD*

VC: Inv. no. I 22, 234

References: Meder 1932: no. 215a; Panofsky 1948, II: no. 316; Coburg 1971: no. 224; Nuremberg 1971: no. 608; Washington/New Haven 1981: 125-128

Even more than the *Virgin and Child with the Pear*, also dated 1511 (cat. no. 149), this woodcut emphasizes the purely human side of the Holy Family. All the adults attend to the playful child who does nothing at this moment to betray his divine nature. A loose symmetry governs the composition, but the relationship of the figures to one another is relaxed and informal. The devout Joachim has temporarily put his prayer beads behind him and waits to give the child a blossom that he holds in the other hand. The expansion of the familiar theme of the Virgin and Child in a landscape to include three generations of the Holy Family necessarily shifts attention from the Incarnation to the human kinship of Christ, but the impulse behind this development comes specifically from the popular devotion to Saint Anne and from the increasingly emphasized doctrine of the Immaculate Conception (see cat. no. 49). The belief that the mother of Christ was herself conceived without sin gave a special importance to Saint Anne and led to the prevalent image known as *Anna Selbdritt* (Anne shown with Mary and the Child in a group of three, often holding both on her lap). Dürer preserved that idea as the core of his composition, where the two women turn toward one another and Mary passes the Child to her mother. This woodcut undoubtedly received favorable attention at the Saxon court in Wittenberg, where the cult of Saint Anne was particularly important before the Reformation. The court enjoyed the special benefit of a relic of Saint Anne's finger, which Friedrich the Wise had brought back from Rhodes while on a pilgrimage to the Holy Land in 1493.

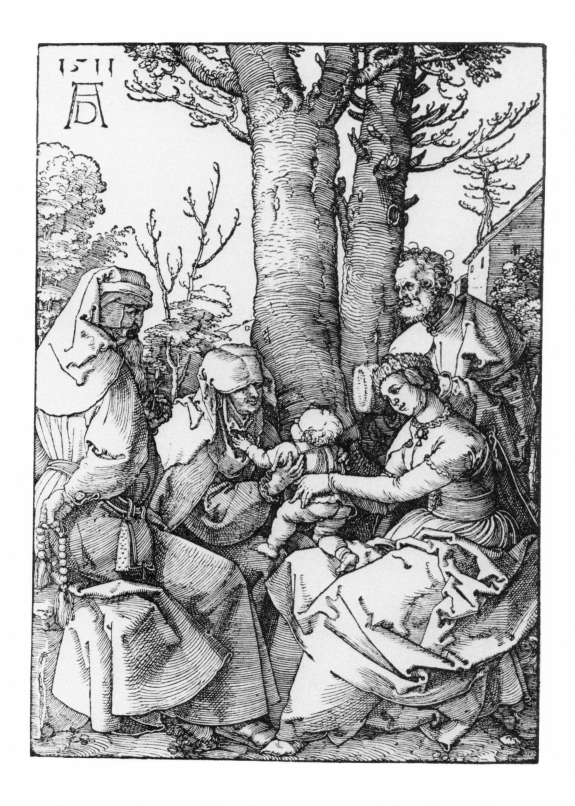

151

Mass of Saint Gregory, 1511

Woodcut, 298 x 208 mm

Watermark: High crown (Meder 20)

Monogram and date in block at lower left: *1511 / AD*

VC: Inv. no. I 20, 180

References: Meder 1932: no. 226a; Panofsky 1948, I: 137 and II: no. 343; Coburg 1971: no. 235; Washington 1971: no. 194

According to a late medieval legend, Christ as the Man of Sorrows appeared to the sixth-century pope Saint Gregory the Great as he was celebrating mass. This was said to have occurred after one of his assistants had questioned the doctrine of transubstantiation. The miraculous vision was therefore taken as proof that Christ was actually present in the Host. The legend was also a way of accounting for the origin of an early medieval image of Christ that still existed at the time in the Basilica of Santa Croce in Rome. It was an *imago pietatis*, the prototype for so many later versions of Christ displaying the wounds he suffered for man's salvation. The supposed efficacy of the image in Santa Croce to transmit an indulgence to pilgrims who prayed before it was attributed to pictures of the Mass of Saint Gregory as well. The inscriptions beneath two versions of the subject by Israhel van Meckenem promise an indulgence of 20,000 years from purgatory for recitation of certain prayers before the engravings (Washington 1967: no. 214).

Dürer's woodcut presents the standard iconography of this subject but in a totally revised form. Christ and the instru-ments of his Passion appear above an altar that is off to one side instead of on the central axis. This informal arrangement imparts a sense of unexpectedness to the scene and emphasizes the experience of the miracle over the simple fact of it. On the opposite side of the altar stand several figures holding Gregory's papal tiara and crossed staff; they represent the other three Latin Fathers of the Church. The one in a cardinal's robe is Jerome, and the bishop is probably Ambrose, while the figure holding the staff would be Augustine (both Ambrose and Augustine were bishops, but Augustine is usually shown beardless). That the miracle has occurred in visionary form is evident since no one other than Gregory notices Christ or the transformation that has come over the church. As if great clouds of smoke from the censer had suddenly filled the space, the architecture disappears, and a transcendental realm takes its place. The screen that Dürer lowered over reality is nothing more than a strict, almost mechanical pattern of cross-hatching, which also provides a dark foil that intensifies the effect of strong light reaching the figures in the foreground.

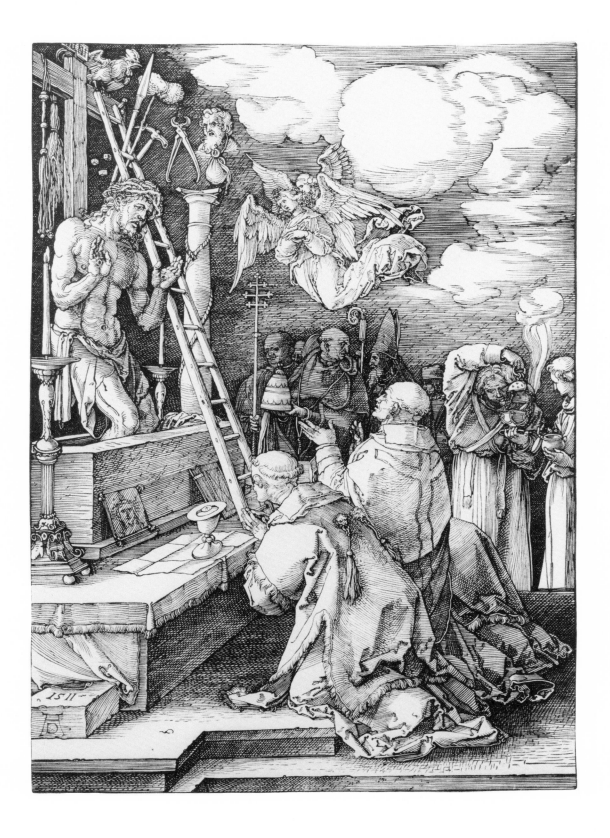

152

Christt on the Cross with Three Angels, c. 1513

Woodcut with text in letterpress, 577 x 412 mm (image),
627 x 454 mm (sheet)

Watermark: Flower with triangle (Meder 127; Briquet 6485)

VC: Inv. no. I 20, 176

References: Heller 1827-30: no. 1643; Dodgson 1903-11, I:
352, no. 8; Meder 1932: no. 182 IIA; Tietze/Tietze-Conrat
1928-38, II: no. A 209; Hollstein VII: no. 182b; Coburg 1971:
no. 190; Nuremberg 1971: no. 370; Strauss 1980: no. X-13

This image of the crucified Christ forms the focus of two prayers printed on either side of the cross. The preface to the one on the right advises that if the worshipper addresses this prayer to the martyrdom of Christ or recites it before a crucifix, he will earn great mercy and indulgence. The prayer is a list of contrasts between Christ's glory and his suffering and death upon the cross, which concludes with an appeal for eternal bliss. The other states that whoever recites it before a crucifix will receive as many days of indulgence as Christ had wounds, namely 5,475. Pope Gregory III, the text continues, granted this indulgence at the request of an English queen, and it was affirmed by many other popes. The prayer enumerates in detail Christ's sufferings on the cross and beseeches him to grant mankind salvation. These prayers were circulated in contemporary devotional literature, specifically in the *Hortulus animae (Garden of the Soul)* (Haimerl 1952: 124, 140, nn. 735, 861; see cat. nos. 187 and 208), and they reveal how closely entwined were such devotional practices with visual imagery.

In its first state the woodcut ended at the horizontal split just below Christ's feet. Then a second piece was cut to extend the cross and the lower part of the angel. The decision to do this cannot be explained simply as a desire to make room for the prayers since the first state also included a prayer, although a different one in Latin, printed beneath the woodcut. Without the lower section, the body of Christ looms closer to the viewer, and the composition has a visionary character quite like Dürer's engraving, *Sudarium held by Two Angels* (Washington 1971: no. 57), dated 1513. The extension of the cross

into the ground results in a more conventional, if not to say more prosaic, image—like the quality of drawing in that area. The addition is considerably inferior to the original part as can be seen easily in the lifeless, oversized left hand of the angel and the stiff, mechanical lines of modeling in the drapery. Although the woodcut is neither signed nor dated, Meder (1932: 162, n. 1) placed it around 1513, on the basis of his comparison with the engraving of the *Sudarium* from that year and because it was printed on the same paper used for other woodcuts issued around that time. The Coburg impression, a very early one of the second state, is on paper with a watermark that links it to Dürer's work published between 1511 and 1515. Thus, the lower section, as Meder believed (although he incorrectly reported the watermark to be a crown and tower), was presumably prepared soon after the first part. The woodblock in its second state without the text is now preserved in Berlin (Kupferstichkabinett) (Strauss 1980: app. B, pl. 28, not to be confused with app. B, pl. 27, which is the block of a close copy, also preserved in Berlin).

The question whether the original part of this woodcut is a work of Dürer's own hand has never been definitely answered. Since the date is consistent with his style at that time, he was obviously close to its production at some point. The absence of his monogram probably means that his drawing was turned over to someone else who prepared the block and published it. Lacking control of the final product, Dürer therefore did not authorize the use of his monogram, which would have guaranteed the woodcut's quality as well as affirmed his authorship.

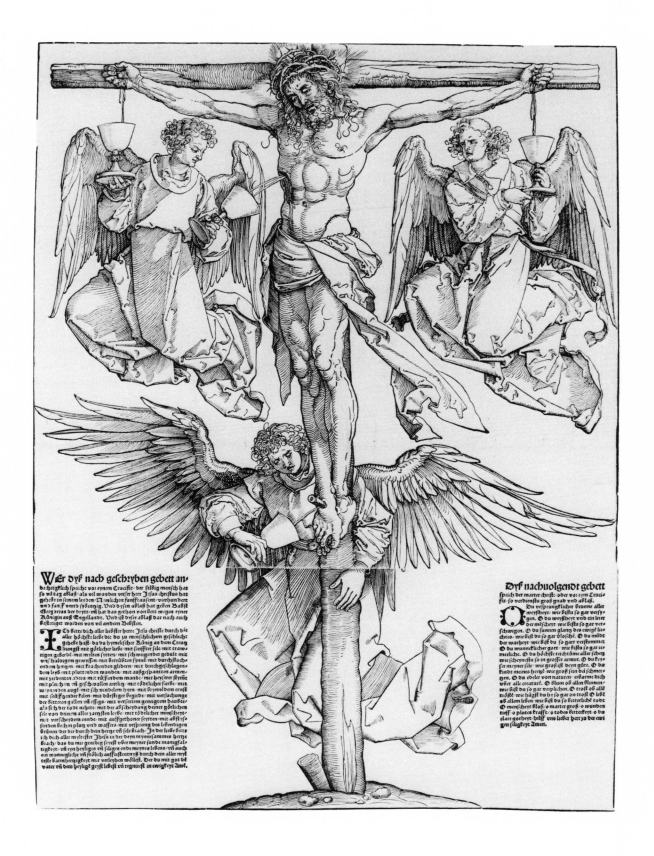

153

Knight, Death and the Devil, 1513

Engraving, 243 x 187 mm

Monogram and date in plate at lower left: *S [alus] 1513 / AD*

VC: Inv. no. I 18, 108

References: Meder 1932: no. 74c; Panofsky 1948, I: 151-153; Coburg 1967: no. 223; Coburg 1971: no. 79; Washington 1971: no. 58; Meyer 1978: 35-39; Theissing 1978

In 1513, the year he engraved *Knight, Death and the Devil*, Dürer wrote the draft of an introduction to his planned general treatise on painting, in which he said, "art serves the purpose of making discernible good and evil" (*Darczw dinen dy künst, dan sy geben zw erkennen gutz vnd pöses* [Rupprich 1956-69, II: 130, lines 44-45]). In light of that statement, what is one to make of his all-time most admired engraving, when its central figure—the mounted German knight in armor —conveys completely contradictory meanings to different observers? To most, the figure represents the good Christian knight, riding forth unswervingly despite the threats of Death and the Devil. To others, he is the evil robber-knight of the late Middle Ages who lived from plunder; Death on his nag and the Devil with his pike are either his companions or are there to warn him to mend his ways. Dürer's own reference to the print in his Netherlandish Diary is as inscrutable on this question as the expression on the knight's face. He called it simply *Reuter*, meaning rider.

Doubters of the knight's good intentions in this print have provided historical evidence that neither Dürer nor any other civilized folk would have had a kind word to say about any knight they knew of who was still in the saddle. A certain infamous knight from Rothenberg by the name of Kunz Schott, in one of whose raids Dürer's dealer had lost a package of his prints, was probably representative of the lot. However, the reality of the contemporary knight had not tarnished the luster of Saint George nor the image of knighthood in its earlier days of glory, as contemporary propaganda about Emperor Maximilian's knightly deeds plainly shows. The leading theory in support of this being a Christian knight draws upon Dürer's words of address to Erasmus of Rotterdam. In a passage of the Netherlandish Diary, Dürer appeals to Erasmus to speak up in support of Luther, who had reportedly just been kidnapped, saying, "Hear, you Christian knight, ride forth at the side of Christ, defend the truth, attain the martyr's crown!" (*Hör, du ritter Christj, reith hervor neben den herrn Christum, beschücz die warheit, erlang der martärer cron!* [Rupprich 1956-69, I:

171, lines 99-101]). According to the same theory, the engraving, like this reference, was inspired by Erasmus' *Enchiridion militis christiani (Handbook of the Christian Soldier)*, first published in 1504. Panofsky quotes a passage from this text that he regards as conveying the sense of the engraving:

> In order that you may not be deterred from the path of virtue because it seems rough and dreary, . . . and because you must constantly fight three unfair enemies, the flesh, the devil and the world, this third rule shall be proposed to you: All those spooks and phantoms which come upon you as in the very gorges of Hades must be deemed for naught after the example of Virgil's Aeneas.

"Look not behind thee" *(Non est fas respicere)* is the motto that Erasmus proposed to the Christian soldier (Panofsky 1948, I: 152, 154).

None of this external evidence has proven so weighty that it has convinced those predisposed to other conclusions. Ultimately the character of the knight must be judged according to the engraving itself. Just as Dürer said, art makes discernible good and evil. No uncertainty hovers over the figures of Death and the Devil. Dürer could reasonably have expected that the knight would at least be generally understood as standing in contrast to them. Consider the knight's horse. There is no disagreement that it represents an ideal. It is based on studies going back through the *Small Horse* (cat. no. 143) and *Saint Eustace* (cat. no. 135) to Dürer's watercolor drawing of 1498 in the Albertina, also of a mounted knight (Winkler 1936-39: no. 176). The artist's intention to show a perfectly proportioned horse in this engraving is further demonstrated by a drawing in Milan (Winkler 1936-39: nos. 617-618), where the geometric construction appears on one side and an elaborated tracing on the other. Like a Renaissance equestrian statue, this knight on his horse is undeniably heroic. Such an image is an unlikely choice for a subject of corruption. The beauty of the animal and the steadfastness of its rider would imbue even Kunz Schott with the appearance of virtue.

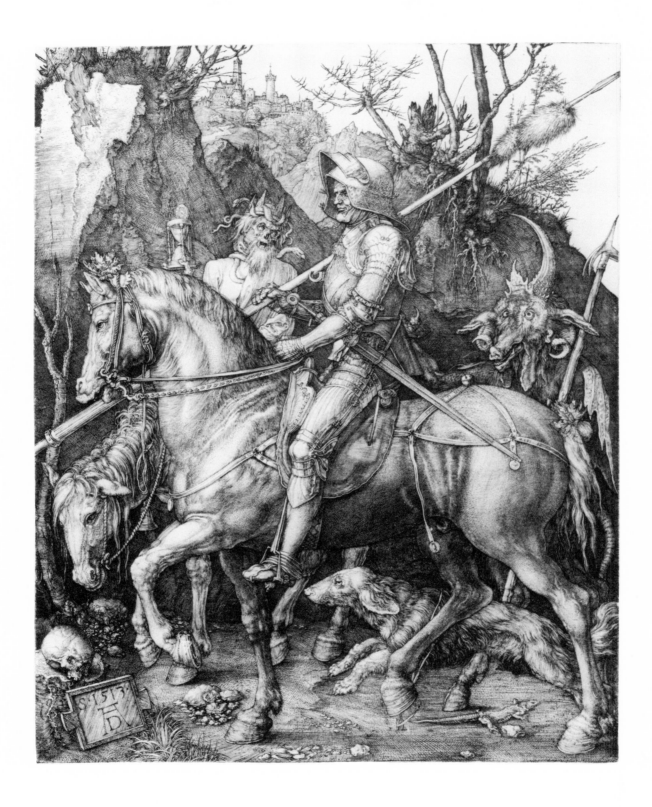

154

Melencolia I, 1514

Engraving, 239 x 186 mm

Monogram and date in plate at lower right: *1514 / AD*

VC: Inv. no. I 17, 80

References: Panofsky/Saxl 1923; Meder 1932: no. 75 IIa or b; Panofsky 1948, I: 156-171 and II: no. 181; Klibansky/Panofsky/Saxl 1964; Reuterswärd 1967: 411-436; Boston 1971: nos. 188-189; Coburg 1971: no. 80; Washington 1971: no. 59; Schuster 1974: 409-411; Finke 1976: 67-85; Heckscher 1978: 31-120; Hoffmann 1978: 33-35; Voretzsch 1980: 271-278

Determining the meaning of this print has been an unremitting challenge to iconographers of Renaissance art. Dürer's most esteemed modern interpreter, Panofsky, devoted more effort and space to this undertaking than to the elucidation of any other work of art. Yet, despite his brilliant analysis—and partly because of it, since he raised the discussion to such a high and intellectually intriguing level—new and erudite theories continue to be espoused. Most interpretations, however, proceed from a few undisputed assumptions. First, the brooding, winged figure, surrounded by tools and instruments, none of which she uses, personifies the melancholic temperament. Furthermore, it is acknowledged that in Renaissance humanist circles this temperament had come to be associated not so much with depression and madness as with exceptionally creative mental capacities. And no one doubts that the objects, so profusely arrayed in the scene, are there because Dürer intended them to mean something. The problem is that each can mean too many things; and there seem to be too many possible constellations of these symbolic objects to arrive at a single definitive interpretation. Upon reviewing the literature, one can readily sympathize with Reuterswärd, who remarked that the composition and choice of objects taken together suggest an intentionally inexhaustible number of permutations and give "the impression that Dürer would have consented to the most extreme and unexpected interpretations, if only they were sufficiently serious" (Reuterswärd 1967: 419). Apparently well aware of the potential difficulty that his subject posed for most viewers, Dürer did something he had not done since making his early woodcut *Ercules*, namely, he labeled the print. Yet the title, *Melencolia I*, written on the outstretched wings of a bat, has simply added to the controversy over his meaning.

According to Panofsky, the Roman numeral *I* in the title can be explained by reference to Agrippa of Nettesheim's *De occulta philosophia*, in which "imagination" was described as the first of three levels in an ascending hierarchy of mental faculties, the others being "reason" and "mind." For those in whom imagination was dominant, the influence of the god Saturn, with whom melancholy was directly associated, could lead to great achievements in art and craftsmanship. Dürer's Melancholy, who would then also personify geometry, finds no comfort in her exceptional gift because she "belongs in fact to those who 'cannot extend their thought beyond the limits

of space.' Hers is the inertia of a being which renounces what it could reach because it cannot reach for what it longs" (Panofsky 1948, I: 170).

Two recent alternative explanations—like Panofsky's hypothesis, difficult to treat justly in a few summarizing sentences—show how fluid the state of knowledge on the subject remains. Hoffmann (1978: 33-35) has proposed, for example, that *Melencolia I* refers not to the main figure but to the bat itself, whose symbolic value in Dürer's other works is consistently negative. In this case, Hoffmann believes, the bat, shown fleeing the light in the sky, should be understood as the antithesis to the small winged genius below the scales, and as representing the first, or despairing, side of melancholy, while the main figure personifies *melancholia generosa*, or "noble melancholy." According to another theory (Schuster 1974: 409-411), based on a certain similarity between Dürer's print and the illustration for the title page of Bovillus' *Liber de sapiente* (*Book of Wisdom*), published in 1510 in Paris, Dürer's Melancholy personifies knowledge and virtue, theory and practice, while the numeral *I* stands for Euclid's principle of mathematics wherein the unit is the basis of all numbers, *fons et origo numerorum*.

The symbolic value of some objects in the print, however, is well established. The keys and the purse, which hang from Melancholy's belt, are explained by Dürer himself in a note on a sketch that says keys mean power and the purse, wealth (Winkler 1936-39, III app. pl. xv). The magic square on the wall—all the columns of numbers add up to 34—is a talisman to attract the healing influence of Jupiter (Klibansky/Panofsky/Saxl 1964: 325-327), and the wreath of an aqueous plant around Melancholy's head is to mitigate the effects of Saturn's (i.e., the earth's) dryness. Where the symbolic function of light and darkness was concerned, Dürer's technical means of representation were as subtle as his iconographic references. Almost the entire plate was covered with extremely fine hatching and stippling in varying degrees of concentration to produce vibrating tones of all gradations. Melancholics were generally believed to have swarthy complexions due to the influence of the fluid called the black humor. In response to this belief Dürer caused a deep shadow to fall over the face of Melancholy, the whites of whose glowering eyes pierce this darkness like the comet blazing through the nocturnal sky.

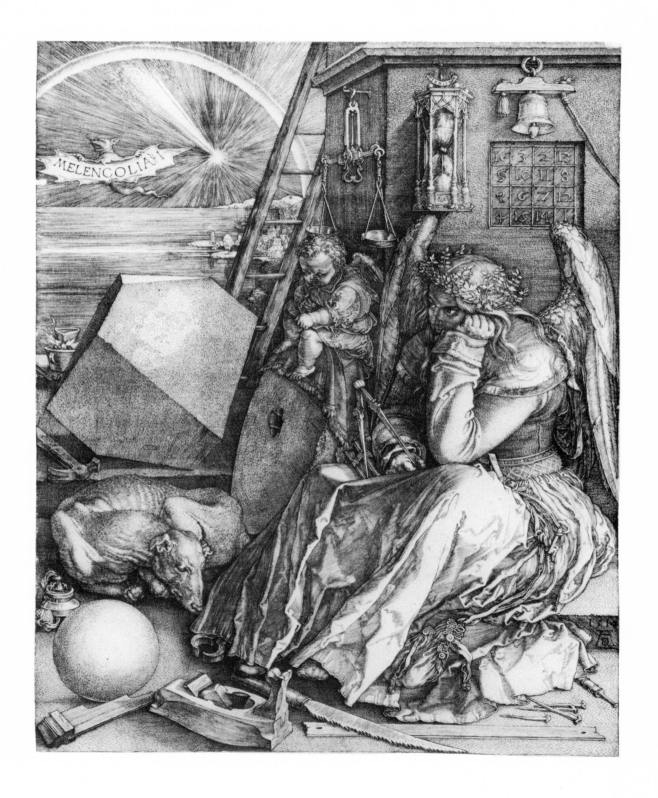

155

Saint Jerome in his Study, 1514
(Illustrated on p. 282)

Engraving, 248 × 188 mm

Monogram and date in plate at right: *1514 / AD*

VC: Inv. no. I 17, 66

156

Saint Jerome in his Study, 1514
(illustrated on p. 283)

Engraving, colored by a later hand, 246 × 187 mm (laid down on sheet, 255 × 196 mm)

Monogram and date in plate at right: *1514 / AD*

Initials in gold at bottom by the hand that added coloring:

D:R: VC: Inv. no. I 17, 67

References: Meder 1932: no. 59a (?); Panofsky 1948, I: 154-156 and II: no. 167; Reuterswärd 1967: 424-426; Coburg 1971: no. 60-61; Dresden 1971: no. 333; Nuremberg 1971: no. 273; Parshall 1971: 303-305; Washington 1971: no. 60; Behling 1972: 396-400; Coburg 1975: no. 78

The controversy over interpretation that has swirled about Dürer's two other "Meisterstiche"—Knight, Death and the Devil (cat. no. 153) and Melencolia I (cat. no. 154)—has never amounted to more than a flutter in the case of Saint Jerome in his Study. No one seems to have doubted that the engraving expresses to perfection the contentment the saint enjoyed as a result of his productive, scholarly life in the service of God. The incomparable subtlety of Dürer's engraving technique not only distinguishes all kinds of objects with their unique qualities of substance and texture, it also makes palpable the light that enters the scene through the bull's-eye windows at the left and softly bestows its warm beneficence on everything in the room. The low eye level and off-center vanishing point contribute to the sense of comfortable informality and, together with the step at the bottom of the composition, suggest that the beholder stands in an adjoining room at the threshold to the one depicted. This impression is reinforced by the warning frown of an otherwise friendly and drowsy lion who keeps outsiders from disturbing his master's privacy. Most of the clutter in the room consists of old and familiar objects associated with Jerome. His frequent preoccupation with life's transience does not concern him now. The hourglass hangs out of sight behind him and the skull has been moved off at a distance. Should he glance toward the skull, his eyes would first meet the small crucifix on the corner of his table, a reminder of Christ's triumph over death.

The calabash, which hangs conspicuously from the ceiling as if to dry, was perhaps meant as an allusion to the dispute that arose from Jerome's translation in the Vulgate of a Hebrew word from the Book of Jonah (4:6) as hedera, a type of ivy, rather than as cucurbita, or gourd (Parshall 1971: 303-305). In the passage from Jonah, God causes a calabash to grow and provide shade for Jonah after his ordeal in the belly of the whale. Since the story of Jonah was believed to prefigure the death and resurrection of Christ, the gourd came to be used as a symbol for the renewal of life after death (Reuterswärd 1967: 424-426).

The image of Saint Jerome in his study appealed greatly to the theologically minded German humanists of Dürer's generation. Cardinal Albrecht of Brandenburg went so far in his admiration of the image as to have his portrait substituted by Cranach in a painting based on the print. It is not surprising, then, that at least one artist would have thought to put Luther himself in the place of the saint, as did the anonymous Monogrammist WS (perhaps Wolfgang Stuber) in his engraved version of Dürer's model (see fig. 5).

Even though Dürer did not speak of them as such, the "Meisterstiche" form a kind of trilogy. On the one hand, the con-

templative life of Jerome contrasts with the active life of the knight upon his horse and, on the other hand, Jerome's contentment and divinely inspired productivity contrast with the restless, uncreative brooding of the melancholy genius. Several recent exhibitions have directed attention to the copies and adaptations made after prints by Dürer throughout the 16th and into the 17th centuries (Munich 1971; Williamstown 1975; Nuremberg 1978). The Wierix brothers (Jan, Jerome, and Antoine) produced no fewer than 50 copies of Dürer's prints in the decades just before and after 1600. And if Hendrick Goltzius, the leading engraver of that time, was not strictly a copyist of Dürer, he set Dürer up as the standard to match and borrowed freely from his compositions. In fact, Dürer loomed so large in the minds of many artists around 1600 that some scholars now speak of a Dürer Renaissance (see Munich 1971). The recent interest in this phenomenon has not, however, embraced the hand-coloring applied during the same period to a number of prints by Dürer. It is one thing for an artist to copy a great master of the past but quite a different matter to alter his original work. Yet the later application of color to engravings by Dürer and Cranach in this exhibition (see also cat. nos. 123, 134, 145) was obviously not done out of disrespect. On the contrary, although not a practice encouraged today, it is another sign of the high value placed on their works. The motivation to color this particular impression of Saint Jerome quite likely had to do with the damaged condition of the paper. On the other hand, the coloring is considerably more than an overly enthusiastic job of restoration. It is the work of a trained miniaturist who was predisposed to view Dürer's masterpiece as more than a mere print. According to Nagler (1858-79, II: no. 1338), the gold initials D:R: at the bottom of the sheet identify Dominicus Rottenhammer (son of the artist Johann Rottenhammer), who was active around 1612-40. There were reportedly several examples of his "illuminations," signed in the same way in the famous Derschau collection in Nuremberg (see page 21). These were hand-colored engravings by other artists, made after paintings by his father and several more painters working around 1600. Although the conspicuous gold edging around many objects in Saint Jerome's room counts as no more than pedestrian work, the sloppy gold and black border, the same as that around the hand-colored Sea Monster (cat. no. 134), was surely added by a still later, amateur hand. Otherwise the colors run to off-hues, violet for a pillow and part of the stone work, a slightly pinkish tone for the floor, and yellowish brown for the ceiling, all of which take this print well beyond the coloristic sensibility of an early 16th-century German artist.

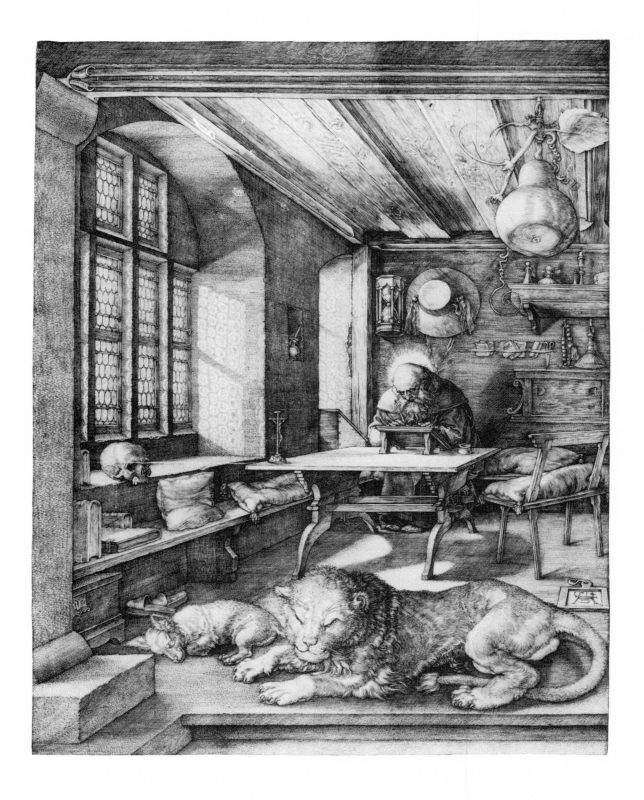

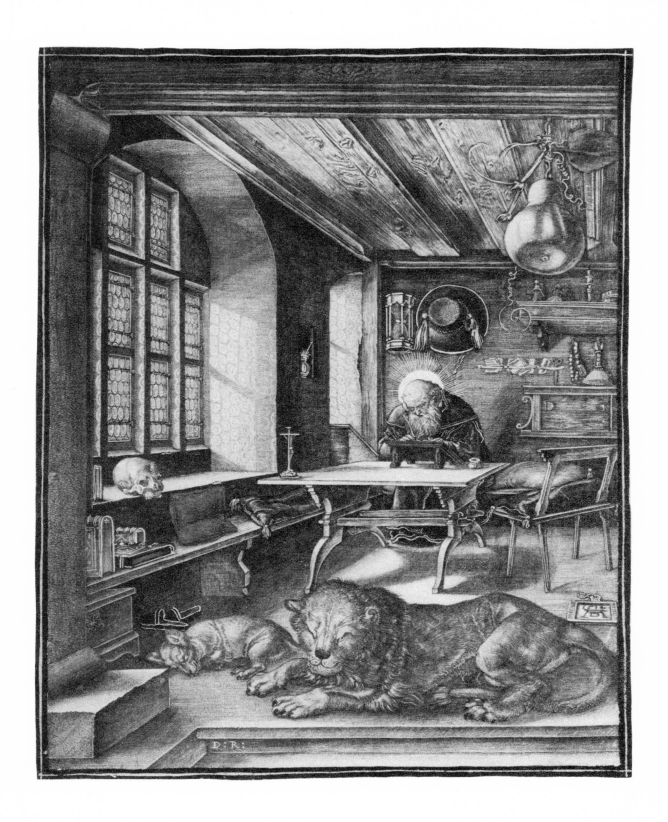

157

Rhinoceros, 1515

Woodcut, printed with chiaroscuro tone block in blue,
211 x 298 mm

Monogram, date, and inscription in block at upper right:
1515 / RHINOCERVS / AD

VC: Inv. no. I 25, 299

References: Meder 1932: no. 273 (7th edition); Fontoura da
Costa 1937; Dodgson 1938: 45-56; Panofsky 1948, II: no. 356;
Hollstein VII: no. 273g; Boston 1971: no. 203; Coburg 1971:
no. 285; Nuremberg 1971: no. 281; Washington 1971: no. 200

Although Dürer frequently made drawings on colored paper, especially studies for paintings, and although such chiaroscuro drawings played an important part in the development of his woodcut style between 1502 and 1510 (see cat. no. 139), he never made a chiaroscuro woodcut himself in the manner of those by Lucas Cranach or Hans Burgkmair (cat. nos. 114, 117). Around 1620, however, two of his woodblocks, those for the *Rhinoceros* and the *Portrait of Ulrich Varnbüler,* came into the possession of an Amsterdam publisher by the name of Willem Janssen, who reprinted them with the addition of tone blocks. This was the seventh of at least eight editions of the *Rhinoceros,* all but the first of which were posthumous. Such was the print's enduring popularity; it also served as a model for illustrations of the rhinoceros up through the 18th century. By the time Janssen acquired the block, it had developed a horizontal split at the level of the animal's knees, and the lines had lost their original crispness. The tone block was probably added as much to minimize these signs of wear as for the attraction of color. In any case, the additional modeling and decorative value of the tone block suited Dürer's imposing image remarkably well.

Dürer never saw a rhinoceros, and the present image required considerable deduction on his part, as he tried to make sense of a sketch and a verbal description sent from Lisbon, where a rhinoceros had arrived in 1515 as a gift from Sultan Muzafar of Cambay to King Emmanuel I of Portugal. The arrival of this exotic beast occurred a decade after Balthasar Springer had taken part in a Portuguese expedition to that part of India and had brought back descriptions of the natives that Burgkmair published in a woodcut (cat. nos. 112-113). The sketch that Dürer saw no longer survives, but the inscription on his own preparatory drawing for this print in the British Museum is worded as though it were a literal transcription of the report sent from Lisbon. Dürer reproduced this inscription with only minor alterations in letterpress above his woodcut. The inscription was omitted by Janssen, but the following excerpt provides a clue to Dürer's understanding of the appearance of the beast (for the complete inscription and a fuller history of the print, see Washington 1971: no. 200): "It has the color of a speckled turtle. And it is almost entirely covered by thick shells (*'von dicken Schalen überlegt'*)." The reference to *dicken Schalen* could be interpreted as any one of several possible outer coverings, and it was obviously unclear from the sketch what the material actually was. Since the color of the animal was compared to that of a turtle, Dürer understandably associated those *dicken Schalen* with a turtle's shell. In the now lost sketch from Lisbon, the animal's ribs and the folds of its loose skin must have been rendered very schematically. This is reflected in Dürer's drawing, in which he seems still to have been considering the possibility of a thick, leathery, albeit partitioned, hide. When it came to making a final decision for the woodcut, however, he emphasized the ridges and divisions and removed all doubt that the rhinoceros was not only colored but also covered like a turtle.

158

Wallpaper with Satyr Family, c. 1515

Woodcut from two blocks, 525 x 650 mm

Watermark: Unidentified coat of arms

VC: Inv. no. VI 492, 812

References: Passavant 1860-64, III: no. 206; Heller 1827-30: no. 2104; Pauli 1901: nos. 1342, 1342a; Dodgson 1903-11, I: 482, no. 155 (Beham); Röttinger 1927: app. no. 1342 (Peter Vischer the Elder); Geisberg/Strauss 1974: no. 769 (Master of the Celtis Illustrations); Hollstein III: 272; Appuhn/von Heusinger 1976: 14-16

This ornamental woodcut was printed from two separate blocks, the one half being a virtual mirror image of the other. On each block, a dense pattern of grapevines provides a perch for the music-making satyr, a demurely poised nymph with her child, and two kinds of birds. The modeling of the two halves of the woodcut corresponds to the appearance of light falling from the right, so that there is a consistent suggestion of low relief. It is not difficult to see that these paired prints could be joined to other impressions from the same blocks, and the vine pattern would connect on all sides to form a continuous, unbroken design—which was clearly the purpose of the print. A surface of any dimensions could be covered by connecting as many impressions of the print as needed. What is not so evident from seeing just two halves of the print are the alternating motifs produced by the vines. Von Heusinger (Appuhn/von Heusinger 1976: fig. 8) has illustrated the print in a montage as it would have been seen in repeated sections on a wall and has called attention to the undeniable fact that the floral pattern alternates the shape of a phallus with an image of female genitals. The satyrs are placed within the latter image and the nymphs within the former. These erotic motifs are, of course, totally in keeping with the nature of nymphs and satyrs, all the more so when the vines are heavily laden with grapes, suggestive of bacchanalian revelry. Recognized for what it is, this pattern would make an unusually spirited wallpaper. Unfortunately, neither this nor any other print made as wallpaper before the second half of the 16th century can still be seen in place.

The nymph and the satyr bear a close resemblance to those in Dürer's small engraving of 1505 (cat. no. 142), and in the 19th century Passavant and Heller accepted the woodcut as a work by Dürer even though it lacks his monogram, which, understandably, the artist might have refrained from placing on a print that was intended to be seen as a multiplied pattern. From the beginning of this century, however, virtually all commentators have excluded the print from Dürer's oeuvre, assigning it most frequently to Sebald Beham. Now von Heusinger has again argued in favor of Dürer's authorship, not merely because of the inventiveness of the design, but also because of the close similarity of style and motifs between this woodcut and the decorative designs Dürer made for the *Prayerbook of Maximilian I* (Munich, Staatsbibliothek) and for his giant woodcut of the *Triumphal Arch of Maximilian I*, both dated 1515.

Of the two halves of the wallpaper woodcut, most observers agree that the one on the left displays distinctly superior draftsmanship. The contour and modeling lines of the figures are freer and more supple when compared to those of their counterparts on the right. It seems probable that Dürer, perhaps working with a brush, drew the design on the left block. After the block was cut and ready for printing, it would have been a relatively simple procedure to take a counterproof and modify it as necessary to arrive at the design for the right half of the composition. Not surprisingly, the draftsmanship of the right side betrays something of this mechanical process, which seems not to have required the hand of the original designer.

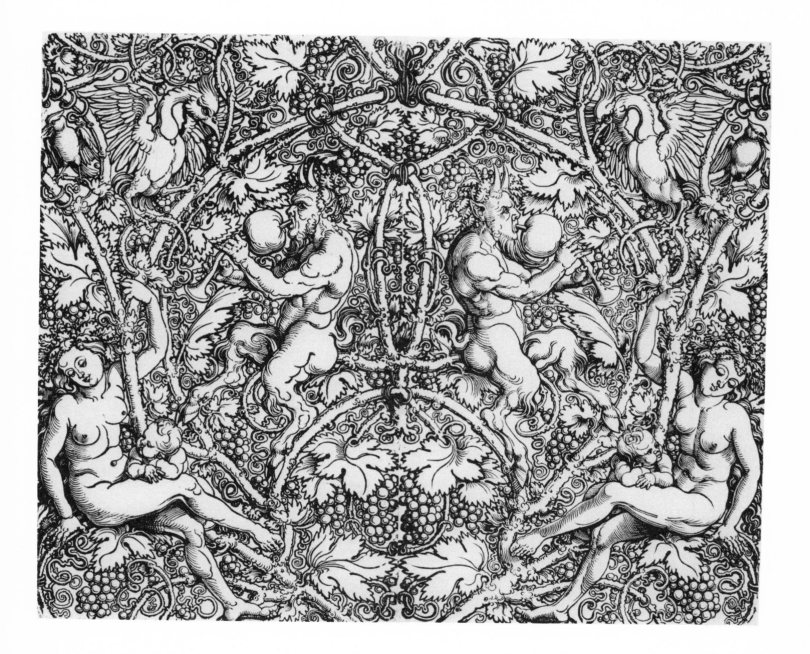

159
Virgin with the Swaddled Child, 1520

Engraving, 142 x 96 mm

Monogram and date in plate at lower left: *1520 / AD*

VC: Inv. no. I 16, 40

References: Meder 1932: no. 40a(?); Panofsky 1948, II: no. 145; Boston 1971: no. 212; Coburg 1971: no. 40; Washington 1971: no. 72

Only the bare essentials of the familiar theme of the Virgin and Child in a landscape are present in this engraving. There is no hint of the peacefulness and sense of well-being that one had come to appreciate in Dürer's earlier versions (cat. nos. 129, 149). Here, the landscape is remote and veiled by darkness. The explosive radiances about the heads of the holy figures are strangely cold, like moonlight. But the most striking change in the expressive character of the engraving has occurred in the figures themselves. The Virgin holds not a playful child but one asleep and so tightly swaddled that one looks in vain for a solitary sign of life. The similarity to a shrouded body has evidently entered Mary's mind as well. Her downcast eyes seem to behold only a mysterious and painful future. Despite the adumbration of Christ's Passion and, more specifically, of the Pietà, in this image, there is no outward display of sorrow. On the contrary, the Virgin appears as unlikely to succumb to emotion as would a figure carved in granite. She shares the qualities of solidity and durability found in Dürer's engravings of the *Apostles* from the 1520s (cat. nos. 160-161). Even in the modeling lines Dürer refrained from the slightest suggestion of decorativeness. Almost mechanical in their severe uniformity, these fine parallel lines interspersed with tiny dots resemble the traces left by a chisel in dressing a block of stone. Clearly, Dürer's attitude toward the religious image has undergone a profound change, which coincided with his increasingly deep concern for Luther's cause and with his conversion to the new faith. As Panofsky has observed of this turn in Dürer's art:

> His real interests centered more and more on religious subjects of a strictly evangelical character. The lyrical and visionary element was suppressed in favor of a scriptural virility which ultimately tolerated only the Apostles, the Evangelists and the Passion of Christ. His style changed from scintillating splendor and freedom to a forbidding, yet strangely impassioned austerity (Panofsky 1948, I: 199).

160

Saint Bartholomew, 1523
(illustrated on p. 290)

Engraving, 122 x 76 mm

Monogram and date in plate at left: *1523 / AD*

VC: Inv. no. I 16, 50

161

Saint Philip, 1526
(illustrated on p. 290)

Engraving, 121 x 75 mm

Monogram and date in plate at lower left: *1526 / AD*

VC: Inv. no. I 16, 49

References: Meder 1932: nos. 45b, 48a; Panofsky 1948, I: 230-234 and II: nos. 153-154; Coburg 1971: nos. 46, 48; Washington 1971: no. 80 (cat. no. 161 only); Harbison 1976: 368-373

In 1514 Dürer engraved a small *Saint Thomas* and *Saint Paul,* the first two of what he surely then envisaged as a complete set of *Apostles,* based on the model of Martin Schongauer or the Master E.S. However, he did not return to the project until 1523, when he produced *Saint Bartholomew, Saint Simon,* and *Saint Philip.* For reasons that have provoked considerable speculation, Dürer decided not to issue the *Saint Philip* in 1523 with the other two but to wait three years, as one can see by the change in the date, which now reads 1526.
It seems that Dürer had doubts about his plans for this set of *Apostles* from the start. The two states of the *Saint Paul* show that he first intended to present the figure standing on a simple mound of earth, as Schongauer had done, but then decided to add a wall and distant view of the sea. Both Saints Thomas and Paul appear with vibrant radiances around their heads, but when Dürer returned to the *Apostles* nine years later, he felt that no such indication of their saintliness was necessary, although his conception that these were powerful men remained constant. Simple, full-length robes accentuate their sturdiness, and stern faces leave no doubt about their inner conviction. Such expressiveness became more emphatic in the later group of three and reappeared in the paintings of 1526, known as the *Four Holy Men* (Munich, Alte Pinakothek). The massive figure of Saint Paul in the painting was based on the same drawing that Dürer had made for his engraving of Saint Philip. His picture of four representatives of unshakable faith was accompanied by passages from their own writings taken from Luther's recent translation of the New Testament. Their words warn of "false prophets" and of the "spirit that is not of God." By this time, Dürer was deeply committed to Lu-

ther's cause, but he was troubled by the demagoguery of the radical Reformers. When he presented his *Four Holy Men* to the city council of Nuremberg, which had officially broken with the Catholic Church in 1525, he was surely appealing to his fellow citizens to remain steadfast with Luther and with these holy men in times of spiritual and political turmoil.

Panofsky proposed that the history of the *Four Holy Men* also explains why Dürer changed the date on his *Saint Philip* from 1523 to 1526 (Panofsky 1948, I: 231-232). Having nearly completed the engraving by the earlier date, Dürer decided to make use of the same figure for his painting which, according to the same theory, was originally meant to be a wing for a discontinued triptych. Not wanting to publish his engraved design in advance of the painting, which he considered more important, he waited until the latter had been unveiled, then redated and issued his print. The decline in Dürer's production of religious art during these years has suggested to Harbison (1976: 368-373) that the artist was struggling with personal doubts about the proper role of images within the reformed faith and for this reason held off finishing the *Saint Philip* until he had resolved them. Given the contemporary iconoclasm in Protestant cities, no artist could have been indifferent to this question, but Dürer seems to have had no qualms about issuing the engravings of *Saint Bartholomew* and *Saint Simon* in 1523. Harbison believes, however, that Saint Philip was a special case, since he may have represented to Dürer the problem of wavering faith (John 14:8-10). Nevertheless, it should be noted that the only sign of a lack of decision in the engraving is the curious matter of its date; the saint himself looks as immovable as the mass of rock behind him.

Albrecht Dürer, School of

162

The Owl Attacked by Four Birds, after 1505

Woodcut with text in letterpress, 210 x 210 mm (image); 361 x 242 mm (sheet)

Watermark: Chalice with Host (similar to Briquet 4571)

VC: Inv. no. I 30, 419

References: Passavant 1860-64, III: 188-189, no. 199; Scheikévitch 1907: 331-336; Meder 1932: no. 240a; Tietze/Tietze-Conrat 1928-38, II: no. A 227; Panofsky 1948, II: no. 404; Rupprich 1956-69, I: 142, no. 28; Winkler 1957: 288-289; Hollstein VII: no. 240; Grote 1965: 163-169; Coburg 1971: no. 252; Borries 1972: 20; Schwarz/Plagemann 1973: col. 312; Geisberg/Strauss 1974: no. 748; Strauss 1975: 333, 338; Strauss 1980: no. 178

This broadsheet is known to exist only in the impression from Coburg. A few other impressions of just the woodcut survive, but only in this impression is the image combined with a text. Since 1862, when Passavant first published the print as a work by Dürer, it has reappeared in the literature on many occasions, a subject of discussion pertaining both to its design and its theme. Yet the question of authorship has never been settled satisfactorily, and despite the explanatory verses, the subject involves equally challenging problems. The title across the top of the sheet says: "All birds are envious of the owl and bear it a grudge." The four rhyming stanzas below tell of the miseries caused by envy and hate. Why the owl should be envied, however, is by no means clear, since by and large it was burdened with a terrible reputation during the late Middle Ages. Its ancient associations with Athena, the Greek goddess of wisdom, were at the time overshadowed by the significance attached to its nocturnal habits, which were equated with an aversion to the light of truth. The poem itself does not mention the owl by name—only the title does—but the third stanza says that here can be seen how the innocent one is maligned and mistreated. That would seem to leave no doubt that the owl in the woodcut is the victim rather than the representative of iniquity. However, the author of the verses and, more importantly, the date of their origin are unknown. The printer Hans Glaser, identified at the bottom of the sheet (Hans Glaser Briefmaler zu Nürnberg), was not active in Nurenberg until around 1540, by which time Dürer had been dead for more than a decade, and the watermark bears out a date of around 1540 for this sheet of paper. In the absence of any surviving impressions of earlier date, it cannot be determined for certain whether the image was ever printed during Dürer's lifetime, let alone whether his design was dependent on this particular text.

At the same time, there is no clear evidence that Dürer actually designed the woodcut, apart from having created the style and prototype of the individual birds. The absence of the familiar monogram is by itself not conclusive, but at the very least it would indicate that Dürer considered the woodcut no more than a limited effort on his part (for a discussion of unsigned prints by Dürer, see cat. nos. 152, 158). There are several instances where a similar owl appears in his work. A nearly identical one, dark around the eyes with wings outspread and standing on a branch, was used as a sculptural motif above the arched doorway of the synagogue in the woodcut *Betrothal of the Virgin* (Washington 1971: no. 141) of about 1505. A little chalk sketch of an owl's head on the back of the drawing *Death Riding a Boney Nag,* also dated 1505, in the British Museum (Winkler 1936-39: no. 377, app. pl. xv) was probably a first idea for this detail in the *Betrothal*. It is also worth noting that another drawing—recently republished as an original study by Dürer for this motif (Scheikévitch 1907: 331-336; Strauss 1980: nos. 97, 178, app. A, pl. 24)—is obviously a copy from the woodcut for the broadsheet. It shows the lower three birds slightly rearranged. The fact that the bird on the left lacks the tip of his wing and tail just where the border terminates the image in the woodcut reveals the source of the drawing. It was the owl, of course, as a bird of darkness that provided the Christian artist's emblem for the synagogue. The attacking bird at the upper left of the broadsheet is none other than the eagle that cries, "Woe, woe, woe," to the inhabitants of the earth in Dürer's woodcut *Seven Angels with the Trumpets,* from the *Apocalypse*. But the eagle announces the fate of a sinning mankind; it is not a persecutor of the innocent.

Still another complicating element in the history of this image is the appearance of an owl under attack by two birds in the incised gold background of Dürer's *Christ as the Man of Sorrows,* a small panel in Karlsruhe (Staatliche Kunsthalle) from about 1494. The context of the painting admits the possibility of interpreting the owl's meaning either way, good or bad: it

could signify the unenlightened evil that caused Christ to suf-
fer (Grote 1965: 166-169) or, if one takes the later broadsheet
as the main evidence for an interpretation, as does Borries
(1972: 20), the owl could symbolize the innocence of a per-
secuted Christ.

A comparison of the scene with the decorative drawings that
Dürer made in 1515 for the *Prayerbook of Maximilian I*, in
which owls reappear with equally ambiguous meaning, has led
most authorities, if they accepted the woodcut as Dürer's own
work, to date it to this period. However, there is nothing in the
woodcut that cannot already be found in Dürer's designs by
1505. One need only observe the rest of the portal decoration
in the *Betrothal of the Virgin* to see that all the ornamental
components—the banderole, the curling leaves—are there as
well as the owl itself. Then did Dürer himself do the piecing
together for the Coburg woodcut with five birds? The present
writer reluctantly concludes that he did not. The literal quo-
tations from Dürer's other works found in this woodcut be-
speak a dependence that seems inconsistent with an original
design by him. Moreover, it would have been strange indeed
for Dürer to have taken the owl from the synagogue and
recast it as an innocent victim without mitigating its darkling
stare. Surely a redesigned owl is the least that could be ex-
pected. All aspects of the woodcut are better explained with
an attribution to one of Dürer's skilled followers, all of whom
were accustomed to borrowing freely from the vast repertory
of the master's designs. Presumably, the woodcut was made
for the broadsheet, and the responsibility for reforming
Dürer's bird of darkness into an innocent victim could belong
either to the artist who borrowed Dürer's motif or to the pub-
lisher who reprinted a woodblock made for some other oc-
casion. Either way, the broadsheet cannot be accepted as a
reliable source for the meaning of the owl under attack in
Dürer's much earlier *Man of Sorrows*.

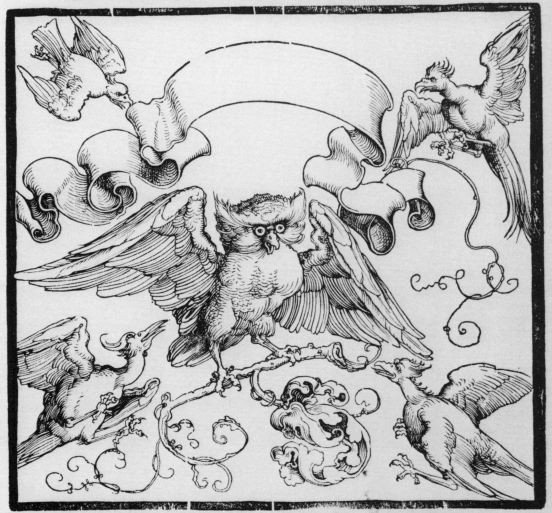

Der Eülen seyndt alle Vögel neydig vnd gram.

O neyd vnd hass in aller welt
O falsche trew / O böses gelt
Zanck vnd hader dir nymmer fælt
Ob dich schon niemant schëd noch schelt
Dein rückisch art sich selber melt
Das dir bißher nicht hat gefælt

Ich sag / wenn sich begibt ein neyd
Das einer vom andern etwas speyt
Den dritten auch der teüffel reyt
Wenn man das feür nicht lescht bey zeyt
Da hebt sich raub / krieg / mord vñ streyt
Dauon alls vnglück sich begeyt.

Als ir bey disem hass hie secht
Wie der einfeltig wirdt geschmecht
Vnd wie man sich an jm vergecht
O wer sein eygen schand bedecht
Jn andre er sich nicht fast fleche
Noch auch an niemandt sich vergecht.

O was thut aber vber das
Der heymlich rückisch neyd vnd hass
Da vntrew hat kein zyl noch maß
O herr solchs dich erbarmen laß
Dein gut des milten nie vergaß
Wo er gieng / reyt / lag / oder saß.

Gedruckt durch / Hans Glaser Brieffmaler zu Nürnberg auff der Schmelczhüten.

Peter Flötner

c. 1485/90 Thurgau (?)—Nuremberg 1546

Flötner was a versatile artist, whose origins are uncertain, but there is some evidence that he was born in the Thurgau region of Switzerland. Between 1512 and 1518, he worked on the furnishings of the Fugger Chapel in Augsburg. He arrived in Nuremberg from Ansbach in 1522 and was granted citizenship the following year. The first mention of him in Nuremberg is as a woodcarver and he worked primarily as a sculptor; his woodcuts are often signed with a mallet and chisel together with his initials. He apparently traveled to Italy on two occasions, first around 1520, then again about 1530. His bronze *Apollo Fountain* (1532) in Nuremberg shows a very classicizing style, as do his woodcuts of furniture, doorways, columns, cups, and other ornamental objects. Flötner also illustrated a number of poems by Hans Sachs (1494-1576) that were published as broadsheets.

163

The Poor, Common Ass, 1525

Woodcut on parchment, colored by hand, 165 x 395 mm (image); 286 x 406 mm (sheet)

VC: Inv. no. V 461, 167

References: Bartsch 1803-21, VII: no. 33; Pauli 1901: no. 1425; Dodgson 1903-11, I: 358, no. 26, 496, no. 10; Röttinger 1916: 34-35, 49-50, no. 18; Bange 1926: 39; Röttinger 1927a: no. 117a; Hollstein VIII: 129, no. 33; Geisberg/Strauss 1974: no. 813; Zschelletzschky 1975: 72-73; Nuremberg 1976: no. 19

Color plate VII

"Who has ever heard of greater complaint," asks Hans Sachs in the caption that runs across the top of the page. The words are spoken by the Poor, Common Ass (*der arm gemein Esel*, as the beast is named in the inscription above his head). "Tyranny spurs me frightfully," the caption continues, "presses, forces, extorts, plunders, burns, and even murders / The usurer pressures, flays all over / Yet the word of God comforts me / God will avenge me here and there." The broadsheet addresses the plight of the peasant, personified as the abused ass. Upon his back ride Tyranny and Usury. The former is a warlike knight in armor and the latter flays the hide right off the ass as he rides. But the ass does not meekly accept this; he has just toppled Hypocrisy, a figure dressed as a monk who has lost hold of his Bible or prayerbook but clings firmly to his fat purse. The ladies at the right, toward whom Tyranny prepares to hurl a flaming arrow, are identified by inscriptions as Reason, Justice, and the Word of God. In the text below, each figure speaks in turn. Clerical Hypocrisy laments his overthrow and loss of the easy ride he used to count on from the formerly obedient ass. Reason advises the ass, now that Hypocrisy is staggering, to strike at the remaining oppressors, Tyranny and Usury, before it is too late. What good, she says, is the word of God, when you are burdened just as before. Tyranny scoffs at Reason's advice and insists that the ass must labor and yield to him. Usury says there is no escape from him and warns the ass to calm down before he cuts into his flesh. The Poor, Common Ass bewails his maltreatment and appeals to Justice. But, however sympathetic, she cannot help him because she herself has been imprisoned by Usury and Tyranny. Turn to God, she says, only He can rescue you from this distress. Then the Word of God speaks. She tells the ass that Reason has blinded him with the desire to oppose Tyranny, who has been sent by God to punish the ass for his sins. With a list of references to Scripture, she instructs the ass to bear his misery since God will save the faithful and punish the wicked. Sachs makes it clear that times are changing, but the outlook for the peasant is not much different than before. He cannot expect his reward from this life. Hans Guldenmund printed this sheet in 1526; an impression in Hamburg bears the date 1525—the year of the Peasants' Revolt in Germany and of its brutal suppression (see p. 37).

The woodcut itself is unsigned and its correct attribution among Dürer's Nuremberg followers left many early writers in doubt. Röttinger's attribution to Peter Flötner in 1916 has not, however, been seriously challenged since the 1920s. The ass and the figure of Tyranny compare very closely to the mounted colonel of the *Halberdiers*, a woodcut also printed by the Nuremberg publisher Hans Guldenmund. The *Halberdiers*, in turn, belongs with another woodcut of a lansquenet, bearing Flötner's signature in the form of a mallet and chisel (Geisberg/Strauss 1974: nos. 831-832; Hollstein VIII: nos. 13-14). Although the 1525 date makes *The Poor, Common Ass* the earliest documented woodcut by Flötner, it is clearly the work of an already practiced hand. There were doubtless many more woodcuts by Flötner that no longer survive. Broadsheets like this one are now extremely rare, having been treated as works of no lasting value. The Coburg impression of *The Poor, Common Ass*, hand-colored and printed on parchment like Georg Pencz's *Envy* (cat. no. 185), is a special case. Having some characteristics of a manuscript illumination, it was preserved with special care. Guldenmund was himself an illuminator (*Briefmaler*) by profession. It would be reasonable, therefore, to attribute this coloring to him. According to Röttinger's sources (1914: 50), this impression was in the collection of the Jamnitzer family of goldsmiths and then in the von Praun collection in Nuremberg, whence it would have been acquired by Duke Franz Friedrich Anton, founder of the Veste Coburg Kupferstichkabinett.

Wer hat ye grösser clag erhort / Drungt zwingt schetzt raupt brent darzü mordt / Jdoch tröstet mich Gottes wort
Der Tyrann mich erschrecklich spört / Der wucherer dreugt schindt auff all ort / Gott wer mich rechen hie vnd dort Hans Sachs

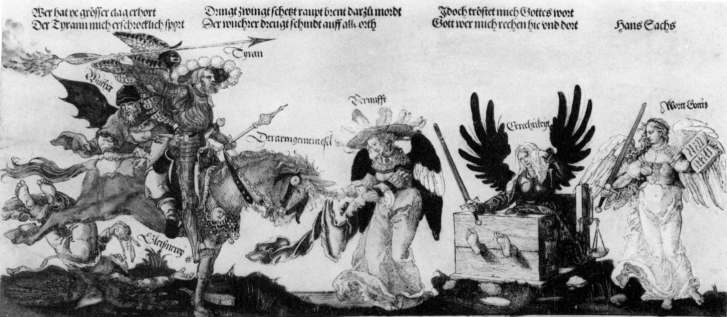

Geystliche Gleyßnerey.
Ach wie hat sich mein glück verkert
Mich hat verwundet vnd verseit
Das wort Gottes das scharffe schwert
Ich lig gantz trostlos auff der erd
Den esel bist ich gantz verwirt.
Der vor mein tyran gar gern hört
Vnd alles thet was ich jr sert
Der mich sanfft trug vnd treblich nert
Vnd mir mein schweiß gantz reichlich mert
Das ich mein zeit nit nit verzert
Jeund der esel mich auffsert
Vnd sein futter vor mir zu spert

Menschliche vernunfft
Esel schau vmb es leyt im schwanck
Gleyßnerey hie dir thet gros danck
Noch leydest du gar bitter zwanck
Vor gewalt vnd wucher arme wanck
Die haben dich an jrem stranck
Vnd reyden dich machtloß vnd kranck

Vnd verdienst doch vmb sie kein danck
Was hilfft des wort Gottes gesanck
Du bleybst beschwert wie im anfanck
Darumb schlaa dapffer mach es nit tranck
Ob du sie stürtzest wie ein tranck
Dann würd gering dein schwerer ganck

Tyrannischer gewalt
Esel du birst darzü geboren
Das du solt bawen weyß vnd koren
Vnd du doch essen distel doren
Darumb ache be a en alles moren
Wiltu nicht mürcken so mußt nit zoren
Wann ich dir gewalt rauff dir feon
Vnd schlag dich dapffer vmb die oren
Snuff dich darzü mit scharpffen sporn
Du bist mein eygen vnd geschworen
Du mußt tantzen nach meinem born
Der vernunfft rath ist gar verloren

Finantzischer wucher
O Esel schaw selb deiner heyd

Das ich dich in das flensch nit schneyt
Ich schindt vnd schab zu beyder seyt
Darumb würd ich von Rhom verleyt
Vest bistu mich dagegen lang zeyt
Gebulichlich an widerstreit
Sag was dein gumpen rein bedeyt
Du wirst darduch gar nit gefert
Wie sranck du die vernufft ern schreyt
Gewalt reich vber rücken dreyt
Vnd nymbt mit mir aleysche bent
Des halb ich sicher auff dir reyt

Der arm gemein Esel.
Kein ärmer thier auff erd man find
Ich muß arbeyten regen wind
Vnd geweien was all welt verschlint
Des haberstros man mir kaum gint
Es stöter nuff mir zwey h sleyd
Das peer schlecht mich vnd den grind
Com ausschesse schwerlich entpfint
Der hunder mich lebendig schint
Das blut täglich von mir ring

Ach Gerechtigkeyt hilff mir geschwint
Ersech in dem jamer ertrind
Schlag vmb mich vnd werd vnbesing

Natürliche gerechtigkeyt
Ach Esel erbarm mich dein
Ich merck dein rod die ist nit kleyn
Ich thet dir meiner hilffe scheyn
To schwend witter das schwerte mein
Darinnen Tarquinium bracht peyn
Von wücher tyranney vircon
Jr hertz ist verkert wie ein stein
Ich darff gar niemand reden ein
Dein rüd mein ellend dich beweyn
Darumb so schlag es Gott allein
Der ker auff net der beissen seyn

Das wort Gottes.
Esel dir hat vernunfst verplent
Das du den gwalt wilt widerstont
Den Gott zu straff deiner sünd hat gesent

Darumb so sey nit wider spent
Trag den selb creutz in dein ellend
Wer vberwind der wirt gekrönt
Hast du Gott still bist dir dir wend
Wücher tyrannisch regiment
Laß jm die rach in seine hend
Die rach ist sein die scheint bekent
Die zwelag ehe mit traffi zutent
Pharao stürst ehe in meeres grund
König Salon würd tödtlich wund
Jn Israel jr neber schund
Also noch heüt zü diser stund
Der tyrannen wie geraisent schent
Auch von des wüchers schwinden sind
Macht Gott sein armes volck gesünde
Als auch der gleyßfierer geschk wund
Baldt sie Gott rüret durch sein mun
Gott helt trewlich seinen bund
 Hans Güldenmund. 1 7 6

164

Samson and Delilah, David and Bathsheba, Solomon's Idolatry, Aristotle and Phyllis, c. 1534

Woodcut, 129 x 364 mm (cut into four pieces, glued together; 129 x 91 mm, 129 x 92 mm, 129 x 93 mm, 129 x 88 mm)

VC: Inv. no. XIII 7, 77-80

References: Röttinger 1916: no. 23; Bange 1926: 17, no. 23; Röttinger 1927a: 63, no. 633; van Marle 1931-32, II: 480; Boesch 1947: 28; Hollstein VIII: nos. 7-10; Basel 1974, II: 563-565; Geisberg/Strauss 1974: no. 818; Nuremberg 1976: no. 145

In 1534 Hans Sachs published an epigrammatic verse entitled "The four excellent men, together with many others, are deceived because of their love of women, and continue to be deceived" (*Die vier trefliche menner sampt ander vilen, so durch frawenlieb betrogen sind und noch betrogen werden*). Sachs' four "excellent men" were the same as those represented in this woodcut, and on the strength of that correspondence and the apparently contemporaneous Nuremberg origins of both works, Röttinger (1916: no. 23), who also attributed the print to Flötner, concluded that the woodcut had been made to illustrate the verse. Although no one has disputed that conclusion, the only impression of the woodcut known to Röttinger or mentioned in the literature is the present one from Coburg, and it bears no text at all. Whether or not artist and poet were collaborating at the time, both were expressing an age-old notion. During this period, however, the idea that the strongest man could be made weak and the wisest foolish by his desire for a woman struck a particularly responsive chord. Ostensibly, these themes were widely portrayed because they had a moral lesson to teach, but one hardly need scratch their surface to perceive the underlying misogyny. Whatever the circumstances of the story, the woman gets the blame for man's fall, folly, or sinfulness, even if some would disagree with Sachs that David was deceived in the episode with Bathsheba. In their visual, as opposed to verbal, forms these themes were circulated primarily in prints but also in the decorative arts, where subjects concerning love had always been welcome. Samson and Delilah and David and Bathsheba became familiar in painting as well, not least through the auspices of Cranach and his shop (Friedländer/Rosenberg 1978: nos. 200, 212, 213, 357), but Solomon's Idolatry (see cat. no. 177) and the spurious tale of Aristotle and Phyllis (see cat. no. 172) continued to receive their most inspired representation in the graphic arts. Flötner was undoubtedly acquainted with several different versions of these subjects, but his compositions suggest that he gave special attention, as perhaps did Sachs, to Hans Burgkmair's woodcuts of the same four subjects from 1519 (Burkhard 1932: no. 51; Hollstein V: nos. 2, 3, 5, 283).

Matthias Gerung

c. 1500 Nördlingen—Lauingen 1569

Gerung was born in Nördlingen and probably served an apprenticeship there with Dürer's former pupil, Hans Schäufelein. By 1525, he had moved to Lauingen, where he appears annually in the tax register from that year through 1568. Between 1531 and 1567, he served the city as weighmaster. In 1530 Duke Ottheinrich at nearby Neuburg on the Danube commissioned Gerung to illuminate a German translation of the New Testament in manuscript (now preserved in the library in Gotha), and between 1533 and 1543, Gerung also provided tapestry designs for the duke. In 1542, when Ottheinrich turned to Protestantism, Gerung illustrated a book of the new church rules; between 1544 and 1546, he designed a series of woodcuts allegorizing the triumph of the new faith over Rome. When Charles V encamped with his army outside Lauingen, Gerung seems to have switched his allegiance to the Catholic side. His painting of 1551 in the Lauingen Rathaus represents the town council paying homage to the emperor on that occasion, and in 1555 he designed the illustrations for a missal printed at Dillingen by order of the Bishop of Augsburg. Next to the Protestant allegories, his most extensive series of woodcuts were 28 scenes from the Apocalypse, mostly executed between 1544 and 1547, but with a few sheets dated 1553 and 1558. His surviving paintings are dated between 1540 and 1557.

165

Shipwreck of the Catholic Clergy, 1545

Woodcut, 233 x 164 mm

Watermark: Unidentified (crown?)

Monogram in block at upper right: *MG*

Date in block at upper left: *1545*

VC: Inv. no. I, 349, 2

166

Sale of Indulgences, 1546
(illustrated on p. 300)

Woodcut, 235 x 163 mm

Monogram in block at lower left: *MG*

Date in block at upper left: *1546*

VC: Inv. no. I, 349, 7

References: Dodgson 1908: 212, 214, nos. 37, 49; Hollstein x: nos. 44, 56; Strauss 1975: 267, 269, nos. 13, 15

These two woodcuts belong to a group of 32 allegorical scenes by Gerung, all having approximately the same dimensions. Twenty-one of them are explicitly anti-Catholic, and they were made soon after Duke Ottheinrich of Neuburg had embraced Protestantism for his duchy. In the earlier of the two woodcuts, dated 1545, Gerung used an image popularized by Sebastian Brant in his allegory *Ship of Fools* (see page 31). The boat in the foreground carries the pope, a bishop, a priest, and three cardinals, all of whom seem oblivious to the impending shipwreck. Although the distant landscape is calm, the sea erupts in the foreground and threatens to dismast and sink them. The same storm has also caught the emperor's ship at the left. In the other woodcut, dated 1546, Gerung shows two devils, dressed as cardinals, selling indulgences, while the pope with another little devil on his lap rakes in the money. Above this scene appears a contrasting vision in the clouds, where Protestants occupy themselves with communion, baptism, and preaching under God's approving eye.

At the same time as these woodcuts were made, Gerung was engaged in producing a set of woodcuts of the Apocalypse. Representations of that theme had clearly worked their way into his thinking about the allegories presented here. His Apocalypse owes more to Cranach's than to Dürer's model, although on the whole there is relatively little residue of either artist's linear vitality. Gerung's dispassionate style of drawing derives in part from his presumed teacher, Hans Schäufelein, but it is also characteristic of a generation that included Sebald Beham and Hans Holbein the Younger. Irrespective of their individual talent, they shared a certain sensibility founded on Renaissance classicism as it was understood in Northern Europe, resulting in clarity of outline and moderation in tonal contrasts.

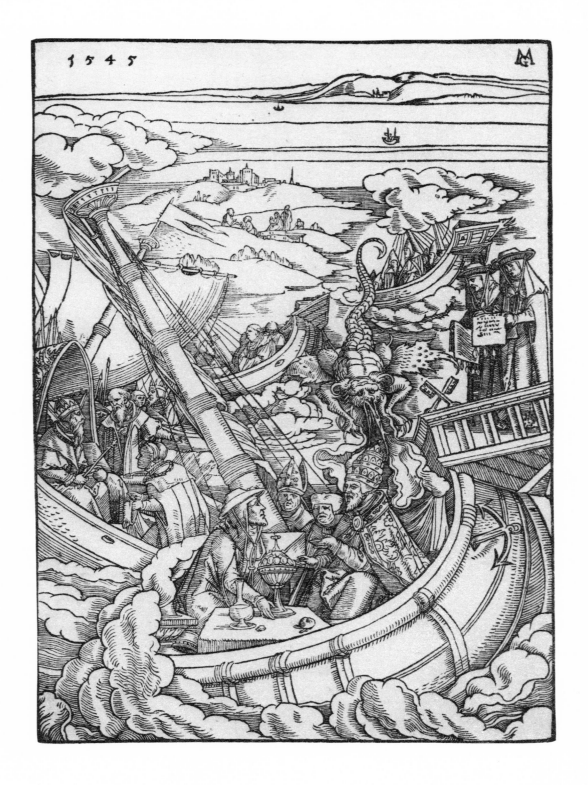

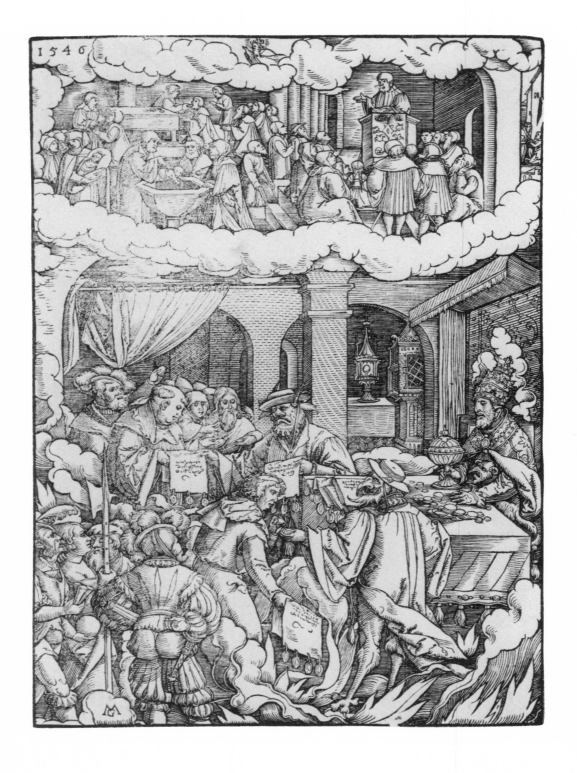

Daniel Hopfer

c. 1470 Kaufbeuren—Augsburg 1536

Daniel Hopfer became a citizen of Augsburg in 1493. His first profession was that of an etcher of armor, which would account for his move to Augsburg, the main residence of Emperor Maximilian and center of armor manufacturing. Hopfer was one of the first artists to adapt etching on iron for the making of prints. His two sons, Jerome and Lambert, extended the family reputation in this branch of printmaking. In 1524, Maximilian's successor, Charles V, conferred a coat of arms upon Hopfer for his "true accomplishments in the service of the emperor and the empire," but that did not prevent the artist from becoming an active supporter of Luther and the Reformation.

167

Interior of a Church with the Parable of the Beam and the Mote, c. 1525

Etching on iron, 297 x 198 mm

Watermark: Escutcheon with three stars (Briquet 1464)

Initials and pinecone in plate at lower right: *D.H*

VC: Inv. no. I 397, 22

References: Bartsch 1803-21, VIII: no. 25; Eyssen 1904: no. 25; Tietze-Conrat 1935: 105-106; Coburg 1975: no. 115; Augsburg 1980-81: no. 12

This is one of three etchings by Daniel Hopfer illustrating New Testament parables within spacious church interiors of a similar type. The parables in the other two prints—"the pharisee and the publican" and "the widow's mite" (Illustrated Bartsch 1981, XVII: nos. 26-27)—could easily be overlooked, whereas the beam from the parable of "the beam and the mote" (Matthew 7:3-5; Luke 6:41-42) understandably draws the attention of several surprised bystanders, who are shown in early 16th-century German dress. Nevertheless in this print, as in the other two etchings, the artist was primarily concerned with the architecture. A precedent for such an architectural etching, and surely Hopfer's inspiration in this case, was Altdorfer's *Interior of the Synagogue in Regensburg* of 1519 (cat. no. 100). The church on which Hopfer modeled his interior was probably not, despite frequent references in the literature, the Dominican Church in Augsburg, but rather the neighboring church built for the convent of Saint Catherine in 1517 (Tietze-Conrat 1935: 105-106). Although extensively remodeled during the 17th century, it was originally a double-aisled hall church in which seven slender columns and half-columns along the side walls supported groin vaults. At the end of the nave, Hopfer shows giant Renaissance pilasters and in the apse an arch enframing a scene of the Last Judgment.

The ornamental design in the vaults and the stippling of the shaded wall reveal both the patterns and technique that Hopfer knew as an etcher of armor. In the 17th century a Nuremberg book and art dealer by the name of David Funck acquired Hopfer's plates, etched a number in each, and reprinted them. Most surviving impressions bear the Funck number and were printed by him or even later. The Coburg impression, however, is from the early 16th century.

Mair von Landshut

Active c. 1485-1510

This artist is known by the name Mair, which he signed on most of his twenty-two engravings and on one of his three known woodcuts, and by the town of Landshut, whose coat of arms appears on the *Hour of Death* (cat. no. 169). This engraving and nine others are dated 1499, at which time Mair was presumably active in Landshut. To judge from stylistic evidence, he assisted Jan Polack around 1490 in painting an altarpiece for the Church of Saint Peter in Munich. In the Munich tax records for 1490, there is an entry for a "Mair Maler von Freising." This most likely refers to the same artist, especially since he also worked in Freising, where in 1495 he painted a large panel of the *Last Supper* for the sacristy of the cathedral. If the Munich tax record does refer to this Mair, it is the only known documentary reference to him and suggests that he originally came from Freising. His latest dated work is a drawing of 1504.

168

Nativity, 1499

Engraving on greenish brown paper, heightened with white and yellow, 201 x 137 mm

Signed in plate at lower center: *MAIR*

Date in plate at upper center: *1499*

VC: Inv. no. I 13, 1

References: Lehrs 1908-34, VIII: no. 5; Schubert 1930: 63-65; Washington 1967: no. 142; Coburg 1975: no. 45

By comparison with the works of Schongauer or the young Dürer, this engraving of 1499 appears extremely naive, yet an artist who signed the plate with his name, instead of using initials as was customary, cannot be dismissed as a simple, unselfconscious craftsman. Moreover, there are aspects of the design that touch upon important developments in illusionistic representation in Germany and the Netherlands. And, if the artist was not a ranking technician in the medium, he was nonetheless technically inventive. He anticipated by close to a decade the experiments of Cranach and Burgkmair in making prints look like drawings on colored paper (see cat. nos. 114-115, 117). Whereas the latter artists achieved that appearance by printing with two or more woodblocks, Mair printed his engraved plate on paper that had been prepared with a color in advance—in this case, greenish brown—just as if the sheet were to be used for a drawing. Then he brushed on the white highlights, as well as the yellow for the nimbuses and starlight, by hand. The color plays an essential part in the modeling system —without it, the highlights would have no brilliance—but it also has a decorative appeal of its own and creates an appropriate nocturnal ambiance for the *Nativity*.

The architecture shows both a spirit of fantasy and a concern for the representational. The buildings seem like stage scenery; obviously not based on any actual structures, they create nevertheless the illusion of a functional space. One views the scene through a kind of proscenium arch, a device well known in Northern European painting since the time of Roger van der Weyden half a century earlier. There is no evidence that Mair ever saw Roger's prototypes, but he used the arch in the same manner—as a means of transition into the pictorial space. However, the figures that are part of the architecture and those within the scene are scarcely distinguished from each other except by size. The plain surfaces and building-block shapes of the architecture are not unusual in Bavarian painting of the late 15th century; they can also be found in the work of Gabriel Mälesskircher or Jan Polack (see Stange 1934-61, X: figs. 114ff.). But this aspect of Mair's design is also related to the disarmingly simplified, yet geometrically bold architectural forms of Conrad Witz, who was working in Basel and Geneva in the 1430s and 1440s. Witz had developed his style in response to the new realism of Robert Campin and Jan van Eyck in the Netherlands. Although Mair's acquaintance with the work of Witz may have been indirect, he shared Witz's inclination to reduce complex architectural forms and, in a larger sense, all reality, to essential solids and voids.

169

Hour of Death, 1499

Engraving, 240 x 321 mm

Watermark: Bull's head with crown and flower (Lehrs 1908-34, VIII: 422, fig. 23)

Signed in plate at lower right: *MAIR*

Date in plate at upper right: *1499*

VC: Inv. no. I 13, 2

References: Lehrs 1908-34, VIII: no. 19; Schubert 1930: 129, no. 14; van Marle 1931-32, I: 468; Coburg 1975: no. 46

This engraving takes its title from the skeletal intruder holding a bow and arrow under the balcony, who has yet to be noticed by the leisurely couples indifferent to all but their own enjoyment. The nature of such worldly pleasure is indicated by the ape at the lower right, a traditional reference in Garden of Love scenes to carnal desire. Thus, the figure of Death does not make his appearance at this moment simply by chance as he usually does in representations of the Dance of Death, where he links arms with the young and old alike, whatever their stations in life. Rather, he comes because he is attracted to those guilty of the sin of *luxuria* ("lust"). In earlier representations of lovers and Death, and perhaps here as well, the women were intended to be recognized as living by their easy virtue (Janson 1939/40: 244-245). Mair's interest in that subject is evident from another engraving of 1499 where he represents a brothel (Lehrs 1908-34, VIII: no. 20). In the present engraving a group of onlookers in the background—soldiers and two young women—consider the pleasures of the others with apparent longing. The threat of death to the soldiers, should they enter this garden of love, relates the print to Burgkmair's *Lovers Surprised by Death* of 1510 (cat. nos. 114-115). Both works warn that carnal pleasure may be more deadly than the battlefield.

The artist modeled the central couple in this composition on Dürer's engraving, called the *Promenade*, of about 1497, in which a figure of Death also lurks in the background. Characteristically, Mair simplified Dürer's couple and altered their positions to the point where the resemblance is easily overlooked, but the costumes are too similar to be coincidental. Less likely to have been known to Mair, yet thematically and compositionally closely related to his print, is Dürer's earlier drawing in Oxford (Ashmolean Museum) of about 1493/94, called *The Pleasures of the World* (Winkler 1936-39: no. 163). Both artists were probably inspired by other, no longer extant, versions of the theme. Although Mair's architecture is obviously pure fantasy, he placed the Landshut coat of arms on the building at the right in reference, it seems, to the town of which he was a citizen.

Master of the Housebook

Active c. 1465-1500

Although he takes his name from a manuscript illustrated with drawings, the Master of the Housebook owes his reputation primarily to 91 intaglio prints made with the drypoint needle. The technique enabled this keen observer of human nature to sketch his subjects with almost the same freedom allowed by the pen, but the soft metal plates wore down much more quickly than did engraved copper ones. Consequently, the editions of his prints were small to begin with; 70 of his 91 drypoints exist in only one impression and altogether there are only 123 surviving impressions. Since 80 of these are preserved in the Rijksprentenkabinet, Amsterdam, he has also been called the Master of the Amsterdam Cabinet. Like his contemporary Martin Schongauer, he was a painter and worked in the area of the Rhine, apparently in Heidelberg and

Mainz. It seems quite likely that he is identical with the documented artist Erhard Reuwich, whose woodcut illustrations for Bernhard von Breydenbach's *Peregrinationes in terram sanctam* (*Journey to the Holy Land* [Mainz, 1486]) bear distinct similarities to some of the drypoints. Reuwich had accompanied Breydenbach to the Holy Land for the specific purpose of making drawings of places and people along the way in preparation for this book. Reuwich came from Utrecht, and such a northern Netherlandish origin might account for some of the stylistic traits in the Housebook Master's prints, especially their atmospheric quality. None of the drypoints are dated, but stylistically they appear to have been executed over a period of at least three decades, from about 1465 to 1495/1500.

170

Christ Bearing the Cross, c. 1480
(illustrated on p. 306)

Drypoint, 134 x 195 mm (plate); 157 x 214 mm (sheet)

VC: Inv. no. I I D, 1

References: Lehrs 1908-34, VIII: no. 13; Bierens de Haan 1947: no. 13; Stange 1958: no. 13; Hutchison 1972: 27-28; Coburg 1975: no. 29

The oblong format of this print accords with late Gothic representations of the subject that emphasize the long procession to Calvary, but the Master of the Housebook was not interested in crowds or epics. He usually concentrated on individual figures and the relation of people to one another in groups of two and three. His handling of this theme is characteristic. He has simply put the majority of the soldiers out of sight, making instead a ragtag procession of their spear tips visible in the background. The whole breadth of the composition is given over to Christ and the handful of figures around him. The cross is improbably long and its construction impossibly angled, but it has the powerful effect of visually catapulting Christ forward into the center of the picture. There is nothing heroic or notably spiritual about this Christ, except for his composure, which not only contrasts with the barbarous faces around him, but probably contributes to their fury. While two men prod and pull at Christ, another angrily threatens with his fist an equally outraged Simon of Cyrene, who has been forced to

shoulder one end of the cross. Wedged into a corner of the composition are Christ's mother, John, and another woman or two. Their compositional counterpart at the far right stands with his back to Christ and is as indifferent to his suffering as they are wrenched by it.

Despite the losses along the vertical and horizontal axes of the print, where it was folded before having been laid down on a sheet of parchment, the impression has the strength of an early printing when the burr of the drypoint lines was still intact. Consequently, the deeper shadows tend to become areas of pure, rich tone. Elsewhere, the shading ranges from rather simplified cross- or parallel hatching to fine, short strokes with all the delicacy of a silverpoint, to which the Housebook Master's printed lines have often been compared. This is one of only three surviving impressions of the print, the other two being in Amsterdam (Rijksprentenkabinet) and in the Art Institute of Chicago.

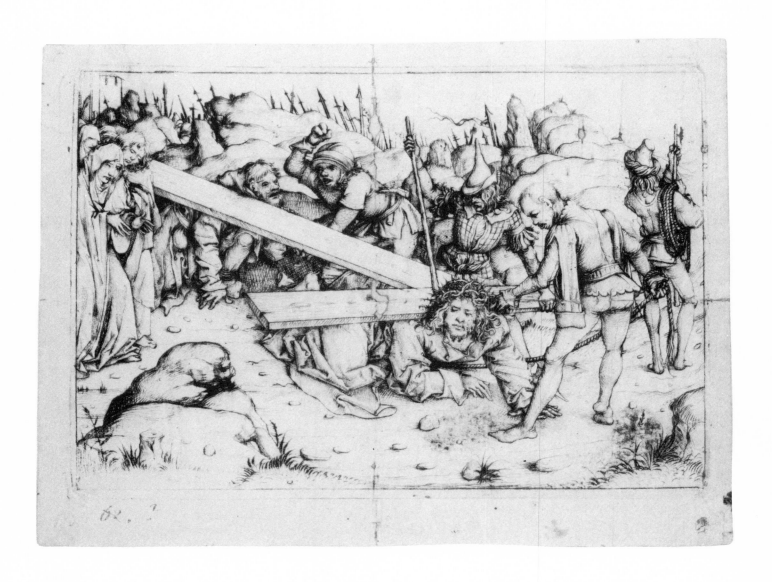

Lovers, c. 1480/88

Drypoint, 167 x 107 mm

VC: Inv. no. I I, D, 5

References: Lehrs 1908-34, VIII: no. 80; Bierens de Haan 1947: no. 80; Stange 1958: no. 80; Hutchison 1972: 63-64; Coburg 1975: no. 32, Coburg 1978: 109

The many copies made after this print attest to its popularity, but the original now exists in only two impressions, this superior one and another in the Bibliothèque Nationale, Paris. The theme was already well established in the decorative and graphic arts of the late Middle Ages, but never had an artist struck a note so pure and true. The young woman shyly keeps her lover's hand in place on her knee and somewhat protectively pulls her little dog—which symbolizes fidelity—close to her. The fashionably dressed romantic youth waits for her to meet his gaze, having gently slipped his arm around her waist. An unspoken accord between the two seems also to be expressed by the way the folds of her dress run exactly parallel to the lines of his legs. Carnations, symbolic of betrothal, appear in a flowerpot at the left. A pitcher of wine in the cooler was as appropriate to such a moment then as it would be now. The figures are enframed by a portal that arches overhead in the form of a delicate bower. This simple frame provides a visual threshold into the picture, as it appears that the foliage extends into the viewer's own space; the toe of the young man's long, pointed shoe stops just short of doing the same thing. It is also in the nature of the drypoint lines with their soft edges and of the way the Housebook Master has used them for shading that the figures and everything else seem to exist within a real atmosphere that knows no bounds between one side of the framing arch and the other.

The print was made no later than 1488, since the female figure was taken as a model for a book illustration published that year (Johannes Thurocz, *Chronica Hungarorum*, Augsburg, 1488).

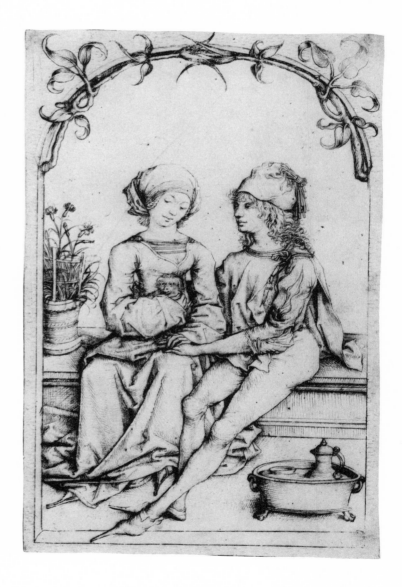

172

Aristotle and Phyllis, c. 1480

Drypoint, 156 mm (largest diam.)

Spurious monogram of Martin Schongauer added by a later hand at lower center: M⊄S

VC: Inv. no. I I, D, 2

References: Lehrs 1980-34, VIII: no. 57; van Marle 1931-32, II: 483, 494; Bierens de Haan 1947: no. 13; Stange 1958: no. 57; Hutchison 1966: 73-78; Hutchison 1972: 50-52; Coburg 1975: no. 31

The story of Aristotle and Phyllis had provided entertainment in art and literature since its origins in the 13th century, but never so frequently as during the late 15th and early 16th centuries. The tale was a satire concocted to discredit Aristotelian philosophy, and, in the opinion of Hutchison (1966: 73-78; 1972: 51), the Housebook Master's print was intended as a jab at the neo-Thomist *via antiqua* movement in Heidelberg, which was based on the work of Aristotle. By this time, however, the theme was generally appreciated as a good example of women's power over men and was often grouped with other famous cases, such as Solomon praying to his foreign wife's idols, Samson and Delilah, and David and Bathsheba (see cat. no. 164). In this instance, in fact, the print is one of a pair; its pendant in the same round format and size represents Solomon's Idolatry (for Master MZ's version of this subject, see cat. no. 177).

Phyllis, according to the story, was the beautiful wife of Alexander the Great. She set out to prove that his teacher Aristotle was not so immune to the distraction of women as Alexander had praised him for being. Indeed, she caught Aristotle's fancy immediately, and when he proposed instructing her in the liberal arts, she suggested instead a rendezvous in the garden, which she secretly invited Alexander to witness. There Aristotle's wisdom left him. He succumbed to her charms and consented, as proof of his love, to let her ride on his back. The second figure standing by the wall enabled Hutchison to identify the Housebook Master's particular source, namely a carnival play of the 15th century, called *Ain Spil von Maister Aristotiles (A Play of Master Aristotle)*, in which a scribe comes with a king to see what will happen.

The artist's touch was exceedingly deft both in drawing and interpretation. Aristotle's expression is a masterpiece of sheepish infatuation, while Phyllis' arched brows and satisfied smile say all that is necessary about who is in charge. At this point in his career, the Housebook Master used the drypoint needle with the precision of a master engraver like Martin Schongauer. Yet, while the strokes are carefully placed, they are still the short, delicate ones of a draftsman who subordinates the individual line to the exigencies of light and shade on a variety of animate surfaces. The *terminus ante quem* of 1488 established for the *Lovers* (cat. no. 171) applies here as well, since both works are very close stylistically.

One of four surviving impressions (the others being in the Rijksprentenkabinet, Amsterdam, the Ashmolean Museum, Oxford, and the Graphische Sammlung Albertina, Vienna), this print was once in the hands of an owner who considered it the work of Schongauer and placed his monogram at the bottom with pen and ink. About four millimeters have been trimmed from both sides of the originally circular image.

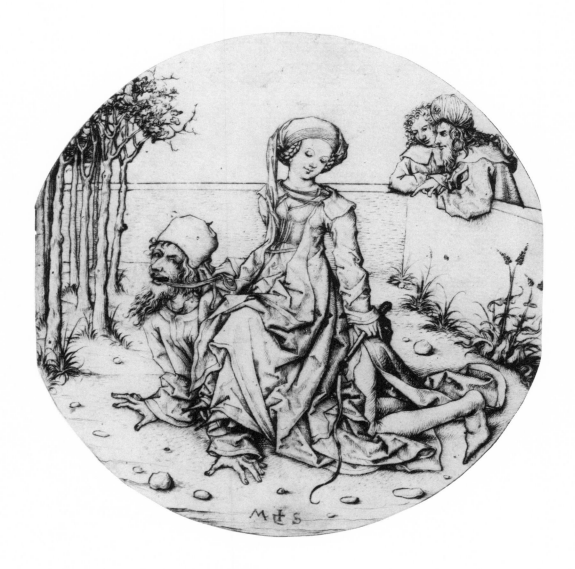

173

Coat of Arms with Boy Standing on his Head, c. 1490

Drypoint, 135 × 84 mm

Watermark: Bull's head with staff and flower (Piccard 1966: sect. XII, nos. 501ff.)

VC: Inv. no. I I, D, 6

References: Lehrs 1908-34, VIII: no. 91; Bierens de Haan 1947: no. 91; Stange 1958: no. 91; Hutchison 1972: 72; Coburg 1975: no. 34

This print plainly suggests that the Housebook Master was mindful of the ostentatious display of heraldry common in his time, when escutcheons were surmounted by evermore flamboyant crests, but the artist's satiric purpose went beyond this to a broader point about the upside down state of the world. While the rising artisan and merchant classes might aspire to their own coats of arms, heraldry for peasants was as clearly a perversion of the natural order as the submission of a husband to a henpecking wife. The woman who does her spinning seated upon the back of her howling mate lacks Phyllis' charm in dominating Aristotle, but the results are more or less the same, and the Housebook Master obviously designed this version of the theme with the other one in mind (cat. no. 172). The boy who stands on his head presents his backside to the established social order, and his inverted position signifies just how wobbly was the whole heraldic structure, as does the couple's unsteady perch upon a helmet balanced on an unsupported escutcheon. For all the topsy-turvy uncertainty expressed by the image, the artist controlled the figures with consummate sureness so that each figure appears natural and convincing despite its difficult pose, and the informal, sketch-like manner of engraving with the stylus is perfect for the subject at hand.

This print survives in three impressions: the other two are in Amsterdam (Rijksprentenkabinet) and London (British Museum).

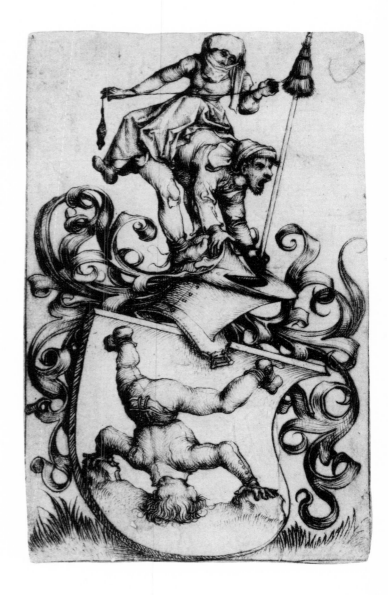

Turk on Horseback, c. 1490

Drypoint, 167 x 108 mm

Spurious monogram of Martin Schongauer added by a later
hand at bottom: *MS*

VC: Inv. no. I I, D, 4

References: Lehrs 1908-34, VIII: no. 79; Bierens de Haan 1947:
20, no. 79; Stange 1958: no. 79; Hutchison 1972: 62-63;
Coburg 1975: no. 33

The Housebook Master counts as an important early modern
artist because, on the one hand, he represented secular
subjects now known as genre and, on the other, he recorded
life from a subjective point of view. The *Turk on Horseback*
may have referred to some specific person or occasion, but no
one can now be certain, and it is hard to believe that the artist's
main point was not, in fact, the portrayal of this exotic but
very human figure in a landscape for its own sake, not unlike
Rembrandt's mysterious *Polish Rider* (New York, Frick Col-
lection). No other printmaker of the master's generation came
close to matching this softly atmospheric landscape; not even
the landscape views of Dürer or Altdorfer supersede its com-
pelling aerial perspective. Indeed, the Housebook Master's
naturalism had a formative influence on Dürer when he was a
journeyman artist in the early 1490s. Although the Turk has
reigned his horse to a standstill, his posture and the turn of his
head give the unmistakable expression of a state of alertness.

This particular figure has contributed to the theory that the
Housebook Master is identical with Erhard Reuwich, who
made the illustrations for *Peregrinationes in terram sanctam*,
published in 1486 (see biography). One of the woodcuts in that
book shows a band of Turks on horseback. The figure in front,
beating a drum attached to his saddle and turning his head, is
very similar to the turbaned rider in this print.

This sheet, one of four surviving impressions of the print
(others are in Amsterdam [Rijksprentenkabinet], London
[British Museum], and Vienna [Graphische Sammlung Alber-
tina]), has been somewhat rubbed, which partially accounts
for the softness of the image, but the forms remain clear and
the condition does not conflict with the original atmospheric
quality intended by the artist.

Master MZ

Active c. 1500

The initials MZ appear on twenty-two engravings, six of which are dated 1500, 1501, or 1503 (see cat. nos. 175-178). The artist's work owes much to Dürer's engravings of the 1490s, but it is more closely related stylistically to the painting of southern Bavaria and Austria around 1500. Two of the prints (see cat. nos. 175, 176) indicate that the artist was active in Munich, and the same hand probably engraved a reliquary plaque, commissioned by the Munich Brotherhood of Butchers, at Cloister An-

dechs. This evidence that the engraver was a goldsmith has revived the hypothesis, in existence since the 17th century, that Master MZ is identical with the goldsmith Matthäus Zasinger, who is documented as having been in Munich between 1498 and 1555 (Fritz 1966: 219-222, 445-446). It is hardly certain, however, that the plaque is by Zasinger, and the artist's style suggests that he was also trained as a painter.

175

The Ball, 1500

Engraving, 219 x 313 mm

Watermark: Bull's head with snake and cross (Piccard 1966: sect. XVI; Lehrs 1908-34, VIII: 421, no. 21)

Initials in plate at lower center: *MZ*

Date in plate at upper center: *1500*

VC: Inv. no. I 14, 12

References: Hofmann 1924: 120-128; Lehrs 1908-34, VIII: no. 17; Washington 1967: no. 152; Basel 1974, I: no. 119; Vienna 1974: no. 171; Coburg 1975: no. 53

176

The Tournament, 1500
(illustrated on p. 314)

Engraving, 222 x 312 mm

Watermark: Two coats of arms, one above the other (Lehrs 1908-34, VIII: 425, no. 40)

Initials in plate at lower center: *MZ*

Date in plate near upper right: *1500*

VC: Inv. no. I 14, 13

References: Lehrs 1908-34, VIII: no. 18; Vienna 1963: no. 309; Washington 1967: no. 153; Lenz 1972: 7-9, 67; Coburg 1975: no. 52

These two engravings were designed as companion pieces to represent two parts of a court festival in Munich, presumably held in 1500, the year the works are dated, or shortly before. The focal event, at least for the knights, would have been the tournament, which was followed by a ball. A similar festival is described by the Wittenberg court poet, Georgius Sibutus Darpinius, who eulogized a two-day tournament and ball that Friedrich the Wise of Saxony organized in November 1508 and that provided Lucas Cranach with the subject of his three tournament prints, dated in the following year (see cat. no. 124). That the engravings by the Master MZ represent scenes at the court of Munich is evident from the presence of the Bavarian coat of arms on one of the buildings in *The Tournament* and from the fact that the couple playing cards in *The Ball* has been identified as Duke Albrecht IV of Bavaria and his wife, Kunigunde, on the basis of known portraits. Furthermore, based on a wooden model of the town of Munich, made in 1571, Hofmann (1924: 120-128) concluded that *The Ball* shows a room in the Neuveste (now destroyed), part of the ducal residence in Munich, and that the three main streets seen through the window of the alcove were identifiable as the Burgstrasse, Dienerstrasse, and Weinstrasse.

The Master MZ was evidently concerned with making individual parts of his engravings as true to life as possible, but his understanding of perspective was limited—he had a curious habit of making the figures in the front smaller than many of those in the background. Despite its disjointedness, his space accommodates a lot of activity.

In *The Tournament* the Bavarian coat of arms can be seen above the open window of an apothecary shop in the building near the upper right, and the two spectators on the central balcony, which is draped with a cloth of honor, are doubtless meant to be the duke and duchess, who appear together more recognizably in *The Ball*. The contests are taking place in a market square, from which two streets angle back into the town and a central passageway opens into a courtyard. The tournament in the foreground and the city view behind are simply stuck together without spatial transition. The confusion of the tournament scene and to a certain extent the erratic space and high angle of view are also characteristic of the tournament scenes by Cranach, and it may be more than coincidence that a running figure occupies the center foreground in both this engraving and Cranach's *Second Tournament with Lances, Staves, and Swords* (cat. no. 124). However, whether the Master MZ had any influence on Cranach's tournament prints beyond thematic precedent is uncertain.

In *The Ball*, in addition to the assorted couples, servants, musicians, and dogs, a crowd can be seen trying to force its way in through the door at the left, while the doorkeeper prepares to beat them back with a stick. To emphasize that this social event was taking place in connection with a tournament, the artist has shown a few mounted contestants in a sketchy view through the window at the right.

177

Solomon's Idolatry, 1501

Engraving, 186 x 159 mm

Watermark: Bull's head with staff and snake (similar to Piccard 1966: sect. XVI, no. 145)

Monogram in plate at lower center: *MZ*

Date in plate at upper center: *1501*

VC: Inv. no. I 14, 1

References: Lehrs 1908-34, VIII: no. 1; Lenz 1972: 72; Coburg 1975: no. 47

Although King Solomon was a wise man, he had a weakness for women. He had 700 wives and 300 concubines, many of them foreign, and when he grew old, his foreign wives turned his heart from Jehovah to other gods. Solomon even built altars to some of these gods (I Kings 11:1-13) and his idolatry earned him the wrath of God. Depictions of this episode from the history of Solomon were virtually unknown in the visual arts until the end of the 15th century, when they acquired sudden popularity (see cat. no. 164). The Master MZ's version follows by little more than a decade the precedent-setting work by the Housebook Master, whose drypoint engraving of *Solomon's Idolatry* had as a companion piece the scene of *Aristotle and Phyllis* (cat. no. 172), both subjects illustrating how women make fools of men. The Master MZ followed this precedent, and his own *Aristotle and Phyllis* (VC: Inv. no. K 694) does to a certain degree reflect the Housebook Master's design, but the present engraving shows quite an independent interpretation of the theme. The pagan shrine is a simple vaulted interior, devoid of all furnishings save the idol and a shelf on which lie a few items of scholarly paraphernalia. The woman's size alone gives a sense of her domination over the old king. She places one hand on his shoulder and points with the other to the statue of a naked goddess, before which Solomon has fallen to his knees in prayer.

As a man with a thousand women in his life, it is entirely appropriate that Solomon should find himself humbled before an idol that bears an unmistakable resemblance to Dürer's *Nemesis* (cat. no. 137), although the artist was probably thinking more about a figural model than about irony. The Master MZ was schooled on the early prints of Dürer and through the windows of the shrine can be seen sections of landscape that are quite familiar from engravings such as the *Holy Family with the Butterfly* (cat. no. 129). But this anonymous engraver had an utterly different sensibility from Dürer's. He tended toward exaggeration both in forms and in his burin technique. The almost sinister darkness of the shadowed drapery in the foreground is deeply engraved with dense cross-hatching, but elsewhere the lines grow faint and thin as spider webs, with little comprehensible modulation of tone between the two extremes. This characteristic is even more pronounced in the master's engraving of *Saint Christopher* (cat. no. 179).

178

The Embrace, 1503

Engraving, 156 x 117 mm

Monogram in plate at lower right: *MZ*

Date in plate above window: *1503*

VC: Inv. no. I 14, 14

References: Lehrs 1908-34, VIII: no. 16; Washington 1967:
no. 149; Coburg 1975: no. 49

Of the Master MZ's 22 engravings, half represent secular
subjects, and in this respect a comparison can be drawn with
the work of the Housebook Master. Passages of MZ's faintly
engraved lines also suggest his acquaintance with the drypoint.
But a comparison of these two artists serves mainly to draw
attention to the disquieting feeling that characterizes many
of the Master MZ's prints, partly due to the pecularities of
perspective and scale in his compositions. Here, for example,
the edges of open doors project at impossible angles. Far more
telling, however, is the scene's emotional tenor. The House-
book Master's *Lovers* (cat. no. 171), like the figures through-
out his work, seem natural and human. The Master MZ's fig-
ures, on the other hand, look apprehensive, uncertain, and
convey a general state of unease. Nothing is explicitly out of
order in this scene of two lovers, yet there is something furtive
and shadowed about their embrace, suggested not least, per-
haps, by the actual darkness down the man's back and the
front of the woman's dress where it appears between his legs.
Indeed, the alternation of the lights and darks in this area is
one of the most impressive aspects of the engraving. The
man's face is unseen and our knowledge of him limited to his
gesture of desire. Although the woman faces us, she is almost
as inscrutable. Certainly, she conveys no warmth or passion.
Her embrace is so lacking in enthusiasm that it fails to make a
dent in the rippling folds of the man's cape, and the expression
on her face suggests something unseen on her mind. Even the
chandelier—a curious type known as a *Leuchterweibchen*,
made of real antlers and a wooden carving of a bust-length
female figure—seems to keep an uneasy watch on the scene.
The convex mirror, an eye of sorts, also introduces a note of
watchfulness. It is possible to relate this engraving in theme
and setting to a late 15th-century Lower Rhenish painting in
Leipzig (Museum der bildenden Künste) that shows a nude
woman in a similar kind of room performing magic on a heart
contained in a small casket (Cologne 1970: no. 17), but in that
picture there are many details to reveal the nature of the
activity. For an interpretation of *The Embrace*, the Master
MZ leaves us dependent upon our own subjective response to
the image.

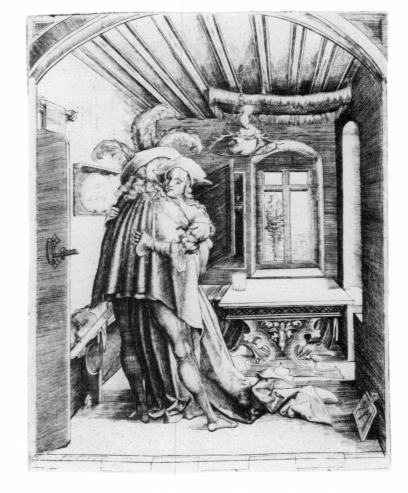

179

Saint Christopher, c. 1500

Engraving, 188 x 131 mm

Watermark: Indecipherable, possibly a small Gothic P

Monogram in plate at lower center: *MZ*

VC: Inv. no. I 14, 4

References: Lehrs 1908-34, VIII: no. 3; Washington 1967: no. 143; Coburg 1975: no. 48

The generation of German artists whose activity commenced about 1500 shunned the attenuated, delicate forms of the late 1400s, as a comparison of this *Saint Christopher* with Martin Schongauer's refined giant (cat. no. 192) demonstrates. The change was both sudden and turbulent. The Master MZ's massive saint is fraught with a restless energy that is hardly kept under control. The horizon line, waist high on the saint, was calculated to accentuate the fact that Christopher was a man who would tower above us. His powerful, awkward body seems to lurch forward under the unnaturally heavy weight of the young Savior and against the force of a wind that whips his cape into a mass of agitated folds. This figure belongs stylistically to a group of works originating in Bavaria and Austria around 1500. It is especially close to the style of Jörg Breu from the period when he was working in lower Austria. His panels for an altarpiece dated 1501 (now at Stift Herzogenburg and Nuremberg) contain strong, exaggerated figural types of a similar kind (Stange 1964: fig. 71; von der Osten/ Vey 1969: fig. 101). One also encounters in Breu's work the same abrupt shifts in scale and distance. It is one of the odd characteristics of the Master MZ that his modeling of the principal figure and especially the drapery is almost sculptural, while everything else in the picture is given only a faint, hairline kind of existence. (For a discussion of the subject matter of this engraving, see cat. no. 192.) The little sea creatures were apparently added to the scene just for fantasy.

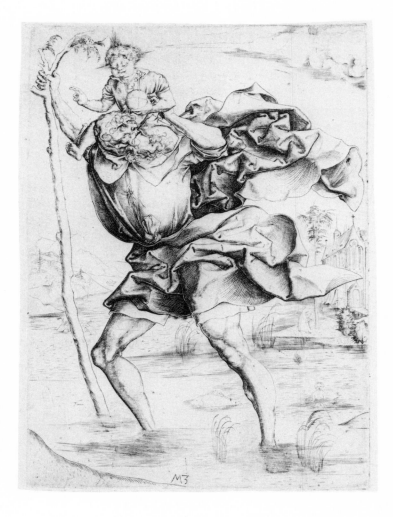

Master N.H.

Active c. 1518-1526

Based on the recurrence of the initials N.H. and on similarities of certain details found in the prints on which these initials appear, Musper (1942: 171-179) and subsequently Winkler (1964: 54-64) have identified the author of the *Battle of Nudes and Peasants in a Forest* (cat. no. 180) with the engraver Nicolaus Hogenberg, who came from Munich and was active in Malines during the 1520s and 1530s. If these prints are indeed by the same hand, the artist underwent a sudden and profound stylistic change when he moved from southern Germany to the Netherlands. Such change is already present in another woodcut, *The Leavetaking of the Apostles* (Musper 1942: fig. 7; Winkler 1964: fig. 3), bearing the same date as that of the *Battle of Nudes and Peasants* and signed with the same initials. The prints most closely related to the *Battle of the Nudes and Peasants* are book illustrations published in Augsburg:

Büchlein von Complexion der Menschen (Little Book on the Humors of Man), 1518; Maximilianus Transilvanus' *Legatio ad sacratissum Caesarum Carolum (Legation to the Holy Roman Emperor)*, 1519-20; and Apuleius' *Ain ... gedichte Lucij Apuleij von ainem gulden Esel (A Poem by Lucius Apuleius about a Golden Ass)*, 1538 (the woodcuts by N. H. in the last book were designed in the early 1520s). Since some impressions of the *Battle of the Nudes and Peasants* bear the woodcutter's name, Hans Lützelburger, who worked with Hans Holbein the Younger in Basel between 1522 and 1526, it has also been thought that the Master N.H. was active there. It remains a possibility that this artist did move to the Netherlands in 1522, since no works later than that from southern Germany or Switzerland have been identified as his, but it is still difficult to subsume such stylistic diversity under a single personality.

Both the subject of this woodcut and the artist's identity are a source of puzzlement. We are best informed about the name of the block cutter since some impressions of the work, as in the Staatliche Graphische Sammlung, Munich, were issued with two tablets printed from small separate blocks just below the battle scene, one at each corner. The tablet at the left contains the cutter's imprint and date: HANNS/LEVCZELL-BVRGER/FVRMSCHNIDER/1522. The tablet at the right contains a specimen alphabet of Roman majuscules. Lützel-burger, as his name is usually spelled today, cut an alphabet first used by the printer Peter Schöffer at Mainz in 1522, but he is principally known as the cutter of the blocks for woodcuts by Hans Holbein, including the *Dance of Death*. The *Battle of Nudes and Peasants* was probably executed just before Lützelburger left Augsburg, where the Master N.H. seems to have been working, to begin his association with Holbein in Basel in 1522.

On an apparently unique impression of the print in the Dresden Kupferstich-Kabinett, the woodcut is accompanied by an equally curious, anonymous poem of 68 lines. This impression is without the two tablets, and judging from breaks in the border of the woodcut, it cannot be counted among the earliest editions .The poet, however, insinuates a familiarity with the subject of the print and with the artist himself. Written in an Augsburg dialect, the poem begins:

> An island called Utopian,
>> Which lies not far from Morian,
> Where occurred an awful slaughter.
>> I heard a hundred thousand perished,
> Yet that was many years ago,
>> And I believe it was not so,
> For how could a naked man
>> An armed peasant withstand?
> (*Ain Insel haisst Vtopion*
>> *Die leyt nit ferr von Morian*
> *Da gschach ain sollichs schlagen*
>> *Hundert tausent hort ich sagen*

> *Doch ist es eben vil der Jar*
>> *Das ich gelaub es sey nit war*
> *Wann wie wolt ain nackend man*
>> *Ain angelegten pawren bstan)*

The first couplet alludes to Thomas More's *Utopia*, of which two editions were published in Basel by Johann Froben in 1518, although More describes no battle of the sort illustrated. A scene of battling peasants rather calls to mind the uprisings of 1524 and 1525 in Germany, but the woodcut precedes those events by two or three years, and since the men fighting the peasants are nude, this was surely no historical encounter. More than likely the battle scene was fabricated along the lines of Antonio Pollaiuolo's famous engraving of 1470/75, *Battle of the Nudes,* to give the artist an occasion to demonstrate his skill in representing both the nude and clothed figure in action and in a German setting. The poem does in fact go on to say that the artist who designed this woodcut intended to show what the high art of painting could achieve (for the complete, original text of the poem see Dodgson 1903-11, II: 196-197, or Geisberg/Strauss 1974: no. 954). Then the verses continue, speaking of the esteem in which painting was held by ancient writers and of the ability and training required by a true master. The concluding lines are a reference to the artist himself:

> This artist was such a master
>> But he cares more for the wine glass
> Which he uses for a long spear
>> Let him whom that annoys try to do as well.

As Dodgson observed (1906/07: 322), the man pointing a stick at the monogram, N.H., is also eyeing the glass with a long neck that he holds. Furthermore, unlike the other nude figures, this man carries neither sword nor spear. The poet, at least, was certain that this figure represented the artist, and he may well have had reason to know since his words of praise for the demanding art of painting and his challenge to critics of the artist's drinking habits sound very much as if the poet were actually the painter speaking for himself.

180

Battle of Nudes and Peasants in a Forest, 1522

Woodcut, 150 x 295 mm

Watermark: High crown with cross and star (similar to Meder 1932: no. 31)

Initials in reverse in block at lower left: *N.H.*

VC: Inv. no. H 54

References: Passavant 1860-64, III: 443-444; Dodgson 1903-11, II: 200-201, no. 1; Dodgson 1906-07: 319-322, Geisberg/Strauss 1974: no. 954; Musper 1942: 171-179; Winkler 1964a; 54-56, fig. 7

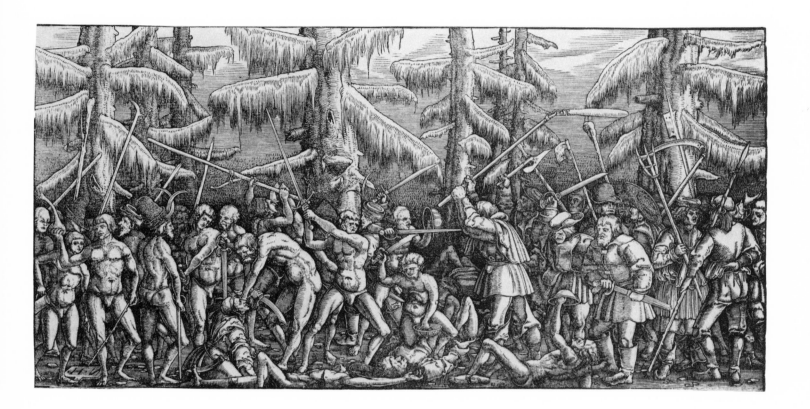

Israhel van Meckenem

c. 1445 Bonn (?)—Bocholt 1503

Van Meckenem followed the career of his father, Israhel van Meckenem the Elder (identical with the Master of the Berlin Passion), a goldsmith and engraver. Although the younger van Meckenem may have been born elsewhere, perhaps in Bonn, he spent most of his life in the Westphalian town of Bocholt, where he became a prosperous citizen. He traveled in southern Germany from shortly after 1465 until the mid-1470s. Around 1467/68, he seems to have worked in the shop of the anonymous engraver Master E. S. in the area of the Upper Rhine, since he made 200 copies of the Master E.S.'s engravings and acquired 41 of his plates, which he reworked and printed. Of some 625 engravings attributed to van Meckenem, most of which are signed, the vast majority are copies after the works of other artists, including Martin Schongauer, the Master of the Housebook, Hans Holbein the Elder, and Dürer. However, that does not lessen his importance as an observer of contemporary life, which he recorded in many engravings of his own design, such as the three examples from Coburg.

These three engravings are part of a series of 12 by van Meckenem that represent different aspects of the relationship between man and woman. Six of the engravings present a couple against a plain, dark background, while the others show each couple in an interior setting.

Despite the fact that men controlled virtually all aspects of public life, whether religious or secular, in the late Middle Ages, the graphic arts offer many examples, like the *Battle for the Trousers*, to suggest that men felt themselves to be at the mercy of the power of women (see also cat. nos. 164, 172, 177). The battle for the trousers is still a familiar metaphor for this situation, but in van Meckenem's time it implied an even more unnatural assumption by women of a male prerogative, since the trousers, lying on the ground in the engraving, were undershorts—a garment not yet included among women's apparel (Andersson 1980: 281). The man is clearly outmatched by this woman who flails him with her distaff (see also cat. no. 183) and steps on his foot with her modishly long, pointed shoe in in a gesture of domination (Andersson 1978: 61-62). The presence of the demon reveals the source of her unnatural behavior. Her face shows a devilish pleasure in humiliating the man, and her hair flies back in a manner characteristic of women portrayed as witches around this time. Even her little lap dog takes an aggressive stance, having recognized that the man is no longer capable of reprisal.

In the *Couple Playing Cards,* the woman's satisfied expression as she plays her card and the man's gesture of distress leave no doubt about how the game has turned out. The only question is whether this outcome pertains to the card game alone or whether the woman's triumph may not have broader implications in keeping with the theme of the power of women. The setting, in any case, is entirely hospitable, and both figures are dressed for pleasure and to please. The wine cooler, like the one in the *Lovers* by the Housebook Master (cat. no. 171), shows that preparations had been made for an agreeable occasion. Although he did not have an engraving technique as refined as that of Schongauer, nor so subtle and spontaneous as that of the Housebook Master, both of whose works he copied, van Meckenem nevertheless handled the burin as a precision instrument, and his interest in describing the manners and culture of his contemporaries makes such engravings lively documents of the times.

Many of van Meckenem's engravings are valued most highly as illustrations of contemporary domestic life. Precisely what the engraving showing a woman spinning and a visitor represents, however, is open to question. Since the man is dressed for the outdoors, it may be assumed that he has recently arrived (or is about to depart), and considering the panache in his turban, that he intends to make an impression. The activity of spinning might seem simply to indicate the woman's domestic occupation, however, Andersson (1980: 279) cites references to carnival plays and other pictures in which spinning and the distaff are used as expressions of lascivious conduct.

181

Battle for the Trousers, c. 1495

Engraving, 159 x 109 mm

Monogram in plate below borderline: *I.M.*

VC: Inv. no. I 6, 42

References: Geisberg 1905: no. 406; Lehrs 1908-34, IX: no. 504; van Marle 1931-32, II: 473; Kohlhaussen 1953: 31; Washington 1967: no. 238

182

Couple Playing Cards, c. 1495

Engraving, 159 x 109 mm

Watermark: Jug (similar to Lehrs IX: 499, fig. 13)

Monogram in plate at bottom: *IVM*

VC: Inv. no. I 6, 53

References: Geisberg 1905: no. 412; Lehrs 1908-34, IX: no. 510; Kohlhaussen 1953: 32-34; Vienna 1963: no. 289; Coburg 1975: no. 40

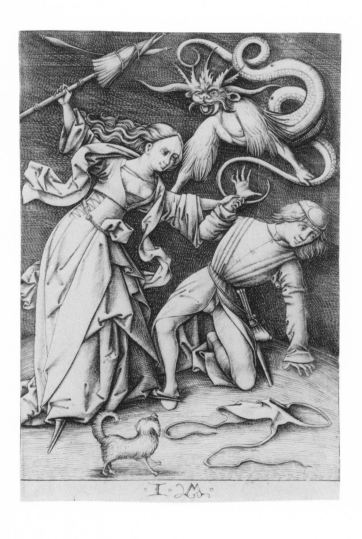

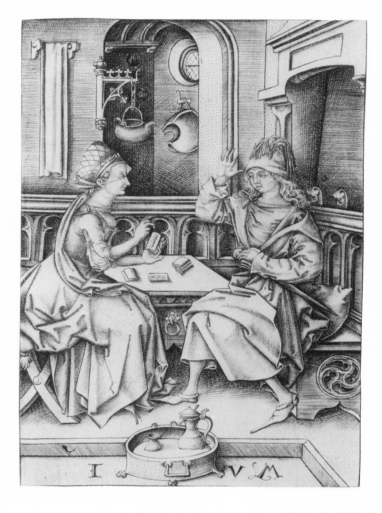

183

Woman Spinning and Visitor, c. 1495

Engraving, 161 x 111 mm

Monogram in plate at bottom: *IVM*

VC: Inv. no. I 6, 49

References: Geisberg 1905: no. 411; Lehrs 1908-34, IX: no.
509; Kohlhaussen 1953: 32-34; Washington 1967: no. 243;
Coburg 1975: no. 39

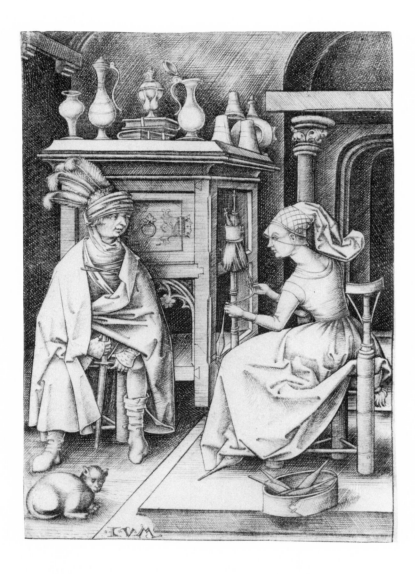

Michael Ostendorfer

c. 1494 Regensburg 1559

Ostendorfer is first mentioned as a master in Regensburg in 1519, and the following year he acquired citizenship in the town. About the same time, he produced the most important of his surviving works, two woodcuts representing the Church of the "Schöne Maria," or "Beautiful Virgin," in Regensburg. The first depicts the pilgrimage to the church (cat. no. 184); the second, a new church proposed for the site, which was never completed. In

1536 Ostendorfer moved to Neumarkt near Regensburg in the Upper Palatinate, and three years later became court painter to the Count Palatinate Friedrich. Between 1544 and 1549, he was in Amberg working as a designer of woodcuts for the Nuremberg publisher Hans Guldenmund. In 1549 he returned to Regensburg, where he died impoverished ten years later.

184

Pilgrimage to the Church of the Beautiful Virgin in Regensburg, c. 1520
(illustrated on p. 325)

Woodcut with text in letterpress, 580 x 391 mm (block); 635 x 391 mm (sheet)

Watermark: Large imperial eagle with crown (Briquet 1457)

Monogram in block on shed at left: *MO*

Latin inscription below image: *.O.insignem.et.benignam. dexterae.excelsi.mutationem.qua.iudaicae.superstitionis. sunagoga.Ratisponeñ.in.aedem.deo.sacram.iuxta.imaginem. hanc.est. / conuersa.vbi.lapis.perpetuae.virginitatis.sanctae. et.vndecumque.pulchrae.Mariae.diu.a.perfidis.reprobatus. nunc.factus.in.caput.anguli.a.christi.fidelibus / passim.et. cateruatim.magno.ac.inaudito.deuotionis.feruore.confluentibus.pia.et.debita.veneratione.colitur.miraque.operatur*

Inscribed by Albrecht Dürer with pen at bottom of sheet: *Dis gespenst hat sich widr by heilig geschrift erhebst zw Regenspurg / vnd ist vom bischoff verhengt worden czeitlichs / nutz halben nit abgestelt / Gott helff uns das wir / sein werde muter nit / also unern sundr / in Cristo Jesu / amen / AD*

VC: Inv. no. I 100, 147

References: Dodgson 1903-11, II: 244-246; Rupprich 1956-69, I: 210, no. 76; Winzinger 1963: no. 245; Coburg 1967: no. 228; Stahl 1968: 35-282; Nuremberg 1971: no. 393; Geisberg/Strauss 1974: no. 967; Hubel 1977: 199-237: Coburg 1978: 114; Nuremberg 1979: no. 130; Munich 1980, II/2: no. 3

At the time it was made, Ostendorfer's woodcut was the closest thing to a tabloid illustration. It portrays a scene of religious hysteria at the church of the "Schöne Maria" (the "Beautiful Virgin") in Regensburg. Like the stories of miracles said to have occurred there, it is sensationalistic and was widely circulated. This particular impression of the woodcut is all the more remarkable because it once belonged to Albrecht Dürer and provoked him to write at the bottom of the sheet about his feelings concerning these events.

The church was built on the site of the synagogue that had been destroyed when the Jews were driven from the city in February 1519 (see cat. no. 100). The ruins behind the church indicate what was left of the Jewish quarter. While at work tearing down the synagogue, a stonemason by the name of Jakob Kern fell from the high vaults and was then struck by pieces of falling stone. He was carried home, seemingly a dying man, but managed to reappear as a spectator at the site the following morning. This was taken as a great miracle (although the man died within the year) and as a sign that a chapel should be built and dedicated to the "Schöne Maria," the name given to a cult image in Regensburg of Byzantine type that provided the model for many replications at the time of these events. Apparently, the erection of a shrine had originally been the intention of Balthasar Huebmaier, the fanatic preacher who had done so much to stir hatred against

the Jews, whom he accused of creating the city's economic problems. However, it was well known that a miracle-working pilgrimage site could go far toward alleviating financial difficulties.

Construction on the wooden church, a provisional building to be replaced as soon as possible by a stone one, was started on March 21, 1519. Four days later, an altar was consecrated, and the church was in business. In the first year, 10,172 lead and 2,430 silver souvenir medallions were sold. In 1520 the count rose to 109,198 lead and 9,763 silver. Publicity surrounding the church kept pace with sales. In 1519 a list was published of 74 miracles reported to have taken place at the site. Within three years, several publications recorded as many as 731 miracles. Pilgrims poured in from all over. On Whitsuntide in 1520, 27,000 pilgrims were counted in Regensburg, and on Saint George's Day of the same year, there were 50,000.

Ostendorfer's print shows crowds of people lined up to go into the church. Through the open door can be seen the principal cult object: the painting of the "Schöne Maria" on the altar. A dozen or so pilgrims have fallen in ecstasy around the statue of the Virgin and Child that had been carved in 1516 by the cathedral master mason, Erhard Heydenreich, and set up in the square in front of the chapel. Still another image of the "Schöne Maria," painted by Altdorfer, is displayed from the bell tower on a large banner. The pilgrims have come with all

kinds of votive offerings—tools, articles of clothing, baskets—which they have attached to the building. Most are dressed as common people, but there is one knight in armor near the doorway and behind him, two men in hairshirts.

The cult withered as quickly as it had flourished. By 1523, the year Dürer made his comments on the print, the number of pilgrims had declined drastically, and by 1525, the remarkable episode was essentially over. Dürer was dismayed both by what he had heard about the cult and what he saw in the woodcut. "This spectre has arisen against the Holy Scripture in Regensburg," he wrote, "and is permitted by the bishop because it is useful for now. God help us that we do not dishonor the worthy mother of Christ in this way but [honor] her in His name, Amen." Dürer's words echo Luther's reproach against this and other such pilgrimages in his *Address to the Christian Nobility of the German Nation*, published in 1520. It was probably in the same year that Ostendorfer made this woodcut.

The stone church, designed by the Augsburg architect Hans Hieber, never progressed beyond the choir, though the wooden model for it (from which Ostendorfer made his woodcut) still exists in the Städtisches Museum, Regensburg. The partial building was consecrated in 1540, and two years later it became a Protestant church, the Neupfarrkirche.

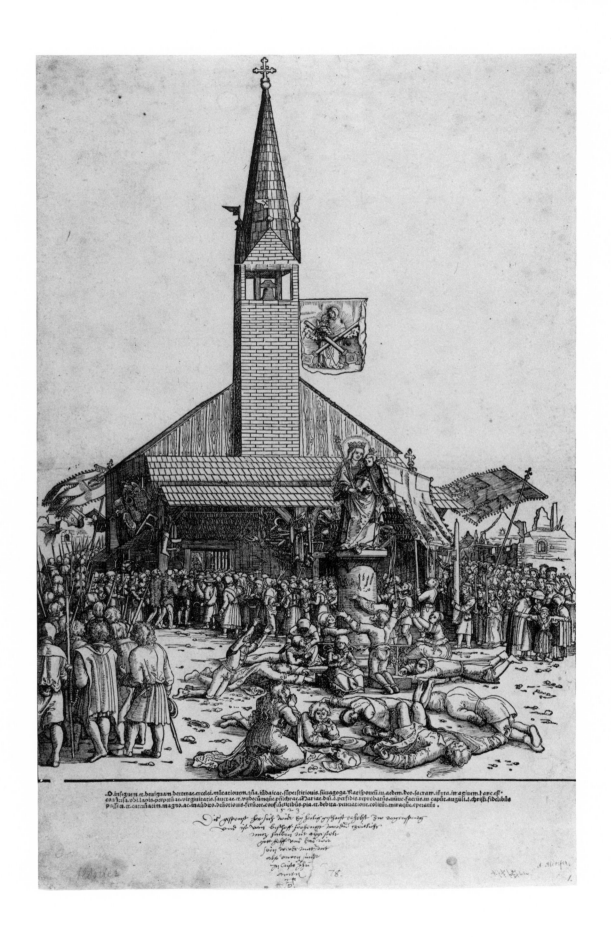

Georg Pencz

c. 1500—Leipzig 1550

Pencz worked most of his life in Nuremberg, where he became a citizen in 1523. He was probably active for a while in Dürer's workshop and is believed to have executed Dürer's designs for the since destroyed decorations in the main hall of the Nuremberg Rathaus. In January 1525, Pencz was expelled from the city, along with Barthel Beham and Sebald Beham, for his atheistic and revolutionary opinions, but he was allowed to return in September. Seven years later, Pencz was appointed to the post of city painter. He probably traveled to Italy in the late 1520s and perhaps again in 1539/40. His career as an engraver does not seem to have begun until around 1530, unless he is identical, as many believe, with the otherwise anonymous Nuremberg artist who signed his engravings with the initials *IB*. Those who assign the works of the Master IB to Pencz assume that during the early part of his career, the artist spelled his name Jörg Benz, following local orthographic practice. Despite that possibility and the general stylistic similarity of both groups of engravings, the identification is still difficult to accept since the engraving technique of the Master IB was more refined in the 1520s than was that of Georg Pencz in the early 1530s. In 1550 Pencz was hired as court painter to Duke Albrecht of Prussia, but he died on the way to Königsberg, reportedly in Leipzig, before he could assume the post.

185

Envy, 1534

Woodcut on parchment, colored by hand, 214 x 114 mm (image); 272 x 337 mm (sheet)

VC: Inv. no. I 212, 1

References: Heinze 1912: 63-64; Röttinger 1914: no. 32; Röttinger 1927a: 61, no. 600; Geisberg/Strauss 1974: no. 1009; Nuremberg 1976: no. 139; Landau 1978: no. 145

This woodcut follows point by point Hans Sachs' poem, "The Malignant Vice, Secret Envy, with its Twelve Properties." The poet tells how he fell asleep one night wondering why there was so much discord among people, whether princes or common men. Then a terrible image of an old woman appeared before him. She said she was Secret Envy, born of the devil, and she explained her appearance. She was old and wizened, signifying that once envy enters the heart, it does not readily depart, and the longer it remains, the colder the heart becomes. She had horns like a stupid but dangerous animal, and she was blind because her neighbors' good fortune stung her eyes so that she could not look joyfully upon them. The bat's wings mean that like a nightbird, she did not like to be seen openly, but her nakedness indicated that her shame could not be kept hidden. Secret Envy devoured her own hand because envy is self-destructive. The other hand was empty because envy possesses nothing praiseworthy or useful. A spider sat on her right breast, for envy poisons the heart, and from the left breast came forth pus because envy is like a sickness. One foot trampled a pair of hands joined in trust, while a snake crawled up the other leg, indicating that the treachery intended for others would strike Envy herself. Finally, a scorpion born of this figure lay on the ground, signifying that wherever envy reigns there will only be diabolical offspring. The wise man, Sachs continues, will guard against this damnable Secret Envy who is a companion to all evil. She is the beginning of all discord and by her cunning drives out love, which has almost died among us already. Hans Sachs, the last line reads, wishes that God preserve us from this misfortune and eternal affliction.

Röttinger's 1914 attribution of the print to Penz has been followed in the subsequent literature without objection, although the evidence on the question is limited to style and hardly conclusive. Wolfgang Resch identified himself at the bottom of the broadsheet as its printer and added the date of 1534. Yet he called himself not printer but *Formschneider*, that is, a woodblock cutter. He could, therefore, just as well have cut the block for this woodcut. However, there is no hint about the identity of its designer. Unlike his engravings, the woodcuts attributed to Pencz, with a couple of uncertain exceptions, lack the artist's monogram. The designer of the woodcut followed much the same scheme for presenting the allegorical figure as the one seen in Flötner's woodcut, *The Poor, Common Ass* (cat. no. 163). The figure stands directly in the foreground on a narrow strip of landscape. Despite the contrasting figural types, there is considerable stylistic similarity between Envy and the figures in Flötner's woodcut. Certain poses and patterns of modeling, as well as the limited spatial illusion, are characteristics that were well suited to the design of Sachs' broadsheets, which had to combine text with image. This particular impression is another rare instance of the otherwise cheaply produced broadsheet having been specially printed on parchment and then hand-colored. Like the similarly printed and colored *Poor, Common Ass*, this impression came from the von Praun collection in Nuremberg that was sold around 1797, about the time the broadsheet came to Coburg.

Das feindtselig laster/der heymlich Neyd/mit seinen zwelff aygenschafften.

Eins nachtes ich lag vnd mir gedacht
Von wann doch kem so vil zwitracht
Bey Fürsten vnd bey grossen Herren
In allen landen nach vnd ferren
Des gleich bey dem gemeynen man
Als ich der vrsach lang nach san
Zu let in den gedancken tieff
Ich also senfftigklich entschlieff
Da erschyn ein feindtselig bild
Nur gleich ein alten weyb/gantz wild
Het grab har auff sein haubt zwey hörer
Sein augen jn verplendet woren
Het fledermauß
Sein leyb gantz nacket war durchauß
Gerun̄elt/mager/dürr vnd gelb
Sein lincke hand fraß es jn selb
Darvon das blüt kam abgeflossen
Sein rechte hand het es frey offen
Auff sein rechten prust saß ein spinnen
Auß der lincken ward ayter rinnen
Mit den rechten füß thet es stossen
Von jm ein trew zusam geschlossen
Stünd mit dem lincken auff einer schlanz
Die jn ein schenckel het vmbfange (gen
Vnd es heckt mit wütigem zoren
Hinder dem bild lag new geboren
Ein herb vergiffter Scorpion
Ich erschrack/doch ein hertz gewon
Vnd sprach wer bist es antwort/ich
Bin das/nach dem du fleyssigklich
Geforschet hast auff dise nacht
Das auff erd macht so vil zwitracht
In geystlich/weltlich regimenten
In hohen vnd in ndern stenden
Ich sprach wie heyst du mich bescheyd
Es sprach/ich bin der heymlich neyd
Vom teüffel ich geboren warde
Darnach das bild mir all sein art
Durch die zwelff aygenschafft erklert
Wie jr sie hernach hören werde.

Die erst aygenschafft.
Erstlich das bild ist grab vnd alt
Bedeut wo der neyd mit gewalt
Dem menschen in sein hertz einwurtz
Lest er sich nit austreyben kurtz
Sonder wechset nur teglich seer
Vnd nymet zu ye lenger mer
Als dann des nechsten lieb erkaltet
Wo neyd in dem hertzen eraltet.

Die ander aygenschafft.
Des bildes hörner auch bedeuten
Das sich der neyd gen frumen leuten
Entpöret vnd sie machet stürtzig
Böcklich/hönnisch/stöckig/vnd trützig
On allen verstand vnuerschembt
Als güt im ergsten er auffnembt
Vnd kan sich gar nit moderieren.
Gleich den wild gehürneten thieren.

Die dritt aygenschafft.
Das dises bild auch ist gantz blinde
Deut wo der neyd merckt vnd empfinde
Das sein nechster zu nemet seer
An wolfart/glück/kunst/güt/vnd eer
Das thüt jn in die augen stechen
Im möcht sein pitter hertz zupsrechen
Weyl er niemande keins güten gan
Sicht er auch niemande frölich an.

Die vierdt aygenschafft.
Des bilds fledermauß flügel wist
Deut der neyd ein nachtuogel ist
Der nur heymlich vnd dückisch fleügt
Bey dem tag sich tücket vnd schmeügt
Lest sich frey offen sehen niche
Allein vnter dem hürlein stiche
Wil seiner dück kein wort niche han
Weyl neyd mit recht nit mag bestan.

Die fünfft aygenschafft.
Das aber das bild steet gantz nacket
Bedeut das neyd teglichen wacket
Sein nechsten durch heymliche dück
Mit wort vnd wercken hinder rück
Die er übet nach seiner art
Darmit er sich selbs offenbart
Kan sich nit leng verbergen niche
Dadurch sein schand kumbt an das liecht.

Die sechst aygenschafft.
Das bild sein lincke hand frist selb
Vnd ist von leyb mager vnd gelb
Deut das der neyd nit grünen mag
Er frißt sich selber über tag
Er wachet/trawert/seuffzet/vnd wüt
Macht gantz vnrüwig das gemüt
Vnd leyt offt williglich ein schaden
Darmit der nechst auch werde beladen.

Die sybend aygenschafft.
Des bilds rechte hand offen stat
Bedeut das der neyd nichtzet hat
Das doch an jm zu preysen wer
Er ist gantz alles güten ler
On eer/nutz/freüd/wollust/vnd kunst
Ein schendlich laster gar vmb sunst
Bey Got vnd bey der welt verache
Das sich on nutz feindtselig mache.

Die acht aygenschafft.
Des bildes rechte prust vergisse
Deut wo der neyd ein hertz betrisst
Das vergisst er vnd macht es wundt
Vergisst die zungen vnd den mundt
Das er sein nechsten letz geserlich
An glimpff vnd eer/mit nachred schwer/ (lich
Gen ander leuten mit argwon
Sein gisst vergisset yedermon.

Die neünd aygenschafft.
Des bildes lincke brust hat eyter
Bedeut der neyd beschedigt weyter
Sich selb/ist schwermütig vn schwirig
Schwindsüchtig vnd allzeyt begirig
Des nechste vnglück/schand vn schade
Wenn der nechst würde damit beladen
Das ist sein freüd/vnd lache nit ee
Ein schiff mit leuten vntergee.

Die zehend aygenschafft.
Das bild mit dem ein füß onscherw
Stet auff einer verschlossen trew
Bedeut das der neyd alle zeyt
Wider recht vnd die billigkeyt
Eer/gwalt/trew/tugent/glück vn kunst
Vnd alles was ist löblich sunst
Mit seinen füssen vntertrit
Verschonet keines güten nit.

Die eylffte aygeschafft.
Das bild sein lincken füß außstrecket
Auff ein schlangen/vnd würdt gehecket
Bedeut so der neyd fürher drit
Sein nechsten zu beschedung mit
List/jm ein grüben richt vnd stelt
Das er darein doch selber fele
Das vntrew jren Herren trifft
Vnd sich mit eygnem gisst vergisst.

Die zwelfft aygenschafft.
Endtlich das von dem bild ist woren
Ein gifftig Scorpion geboren
Bedeutet wo der neyd regirt
Er eytel teüffelsch früchte gepirt
Nachred/eer abschneyden vnd liegen
Verreterey/todschlag vnd kriegen
Auffrür vnd fal der regimente
Neyd gepirt ein verderblich endt.

Der beschlus.
Auß dem entweyser merck hie wol
Das er sich fleyssig hüten sol
Vor dem heymlich verfluchten neyd
Weyl er bringt heymlich hertzenleyd
Vnd ist ein eyter dem gebein
Wie Salomo bezeugt sein
Vnd ist so gantz teüffelscher art
Helt allem güten widerwart
Vnd alles argen ist ein gsel
Des ist der neyd ein rechte hell
Ein finster hauß sol trawrigkeyt
Von dem Ouidius vns seyt
Der gleich schreyben auch Tulius
Asensius Virgilius
Des neydes art wie oberzelt
Er sey ein kranckheyt die hart quele
Des König Saul hat wol empfunden
Kain/Esau/hat er verschlungen.

So hat er noch kein rast noch thü
Er richtet alles vnglück zu
Bey allen stenden hoch vnd nider
In allen landen hin vnd wider
Das wol der neyd ist ein anfanck
Aller zwitracht/hader vnd zanck
Des yetz die gantze welt steckt vol
Ein yeder sicht es layder wol

Das wenig güts zu hoffen ist
Weyl neyd durch sein vntrewe list
Die lieb auß treybet mit gewalt
Welche schier bey vns ist erkalt
Wo Got nit selber siche darein
Hab wir zu warten hie allein
Vnglücks dort ewigs vngemache
Vor dem bhüt vns Got/wünsche Hans
(Sachs

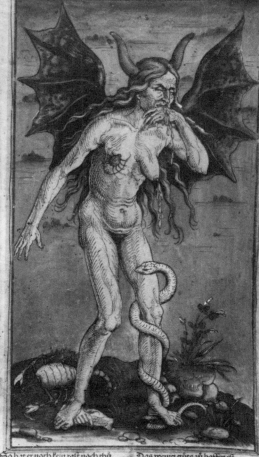

Wolffgang Resch Formschneyder. 1 5 3 4.

186

Duke Johann Friedrich the Magnanimous of Saxony, 1543

Engraving, 405 x 311 mm

Monogram and date in plate at lower right: *GP / 1543*

Inscribed in plate at bottom: SPES MEA IN DEO EST / JOHANNES FRIDERICVS DEI BENEFICIO SAXONIAE DVX / SACRI ROMANI IMPERII ARCHIMAR SCHALCHVS ET / ELECTOR LANDGRAVIVS

THVRINGIAE, MARCHIO MISNIAE / ET BURGGRAVIVS MAGDEBVRGI ETO: / VERBVM DOMINI MANET IN AETERNVM

VC: Inv. Inv. no. I 142, 145

References: Kurzwelly 1895: 92; Coburg 1967: no. 116; Coburg 1975: no. 141; Landau 1978: no. 124

Although portraiture makes up a large part of Pencz's painted oeuvre, this is his only engraved portrait (excluding those by the Monogrammist *IB* doubtfully identified with Pencz; see biography). He was probably inspired to make this exception in 1543 by a public eager for an image of the leading Protestant prince and defender of Luther. Johann Friedrich's father, Johann the Steadfast, and his uncle, Friedrich the Wise, had also been staunch supporters of Luther.

Johann Friedrich's face in the Pencz engraving is clearly based on a portrait by Cranach, of which there were numerous versions both in painting and woodcut, rather than upon a study from life. The style of the engraving, on the other hand, and the arrangement of a bust portrait placed above an inscribed tablet follow Dürer's model, such as his engraving of Friedrich the Wise from 1524. The hands, not shown in Dürer's engraving, correspond once again to Cranach's portrait type, and Pencz has widened the top of the tablet to provide a ledge upon which they rest. This suggestion of depth in an otherwise neutral setting is further developed by the projecting frame, to which 14 coats of arms are attached. Although escutcheons were often painted on picture frames, the plain, rectilinear form of this illusionistic frame looks more like a stone window than the moldings carved for pictures. Pencz's actual source for this idea, however, was neither painting nor architecture, but rather the border design for the title page of a book. The complete Luther Bible of 1541 (cat. no. 211), published under the protection of the Saxon elector, has a title page with a plain border displaying the same 14 coats of arms, surrounding the title itself, while Johann Friedrich's portrait appears on the next page. Like the inscription on the tablet of the engraving —following the motto *Spes mea in Deo est* (My hope is in God) —the coats of arms identify the duke's principal territorial titles (for a listing, see Luther 1972, app.: 145*). The two central arms at the top signify the Saxon title of imperial elector. Johann Friedrich inherited this office in 1532, then lost it in 1547 to his cousin, Duke Moritz of the Albertine line of the Wettin dynasty, after his defeat by Charles V in the Schmalkaldic War (see p. 20).

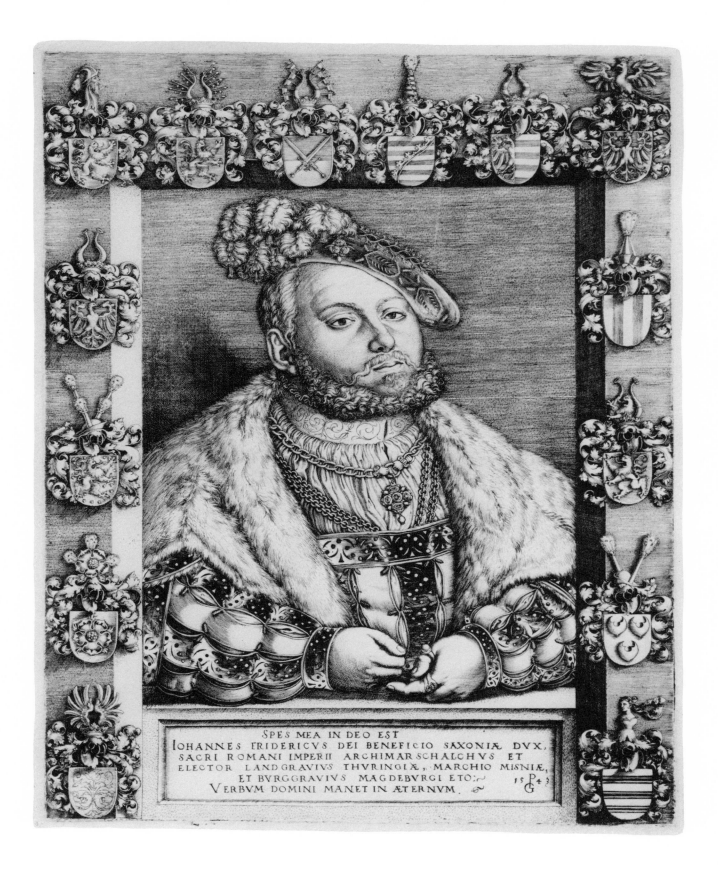

SPES MEA IN DEO EST
IOHANNES FRIDERICVS DEI BENEFICIO SAXONIÆ DVX,
SACRI ROMANI IMPERII ARCHIMARSCHALCHVS ET
ELECTOR LANDGRAVIVS THVRINGIÆ, MARCHIO MISNIÆ,
ET BVRGGRAVIVS MAGDEBVRGI ETO. 15 P 43
VERBVM DOMINI MANET IN ÆTERNVM. G

Erhard Schön

c. 1491 Nuremberg 1542

Schön was a prolific designer of woodcuts (more than 1,200 have been attributed to him), but there is little information about his life. He was born in Nuremberg in 1491 or soon after, and his earliest designs, made for book illustrations, were published in 1513. He was trained in the circle of Dürer, although there is no evidence that he was ever a member of Dürer's shop. However, around 1515/16, Schön worked closely with Hans Springenklee, who is documented as having been an artist in Dürer's shop. Schön produced designs for nearly all the publishers of books and broadsheets in Nuremberg and was the most frequent illustrator of the verses of Hans Sachs. To some extent, Schön was also active as a painter, but only one signed panel and a handful of attributed ones are known today.

187

Devotional Image with the Names of Jesus, Mary, and Saint Anne, c. 1515

Woodcut printed from six blocks, 170 x 292 mm

Watermark: High crown (Meder 20)

VC: Inv. no. VI 429, 103

References: Dodgson 1909: 9-10; Röttinger 1925: no. 134; Geisberg/Strauss 1974: no. 1134

This extremely rare, possibly unique, impression (it is the only one mentioned in the literature) of a woodcut made as a votive image has survived in a state of remarkable freshness. It comprises six woodblocks—five separate blocks (each measuring 78 x 55 to 56 mm) for the figures, plus the large block (88 x 288 mm) above, with the xylographic, decorative text—that were joined together and printed as a single composition. The praying figures in the outermost panels are arranged like donors on the wings of an altarpiece with father and son on the dexter (that is, to the right of the sacred personages), mother and daughter on the sinister side. The escutcheons hanging from columns above them have been left blank so that the owner could enter his family coat of arms. Although Saint Sebastian occupies the central position of honor, neither he nor Saint Roch in the next panel are mentioned in the inscriptions above. The top line of text in Roman letters, IESVS NAZARENVS REX IVDEORVM (Jesus of Nazareth, King of the Jews), refers, of course, to the mocking identification of Christ on the cross, where a plaque was nailed with the initials, INRI. The words, *Jesus.Maria,* in large Gothic letters are visually the most arresting part of the entire sheet. The bottom line is a short prayer directed to the image of *Anna Selbdritt,* the group of Saint Anne, the Virgin, and the Christ Child (see cat. no. 150): "Holy woman, Saint Anne, together with the two others, help us from all difficulty." The blocks with Saint Sebastian and Saint Roch were reprinted sometime later on a broadsheet with prayers to ward off the plague (Geisberg/ Strauss 1974: no. 1137). These two woodcuts and the *Anna Selbdritt* are based on illustrations from Dürer's shop in a devotional book, the *Salus animae (The Health of the Soul),* published by Hieronymus Hölzel in 1503 in Nuremberg (Dodgson 1909: nos. 84, 86, 89). About 1515 Erhard Schön made illustrations for another edition of the *Salus animae* (Oldenbourg 1973: 117 ff), which bear enough similarity to the woodcuts on this devotional sheet to have resulted in an attribution of the latter to Schön as well, although this remains rather hypothetical.

IESVS ❀ NAZARENVS ❀ REX ❀ IVDEORVM

Iesus Maria

Heilige fraw ❀ S: Anna ❀ Hilff vns selb dritte ❀ aus all' not.

188

The Monk and Cleric Hunt, c. 1525

Woodcut printed from two blocks, colored by hand, 370 x 490 mm (image); 450 x 547 mm (sheet)

VC: Inv. no. VI 457, 124-125

References: Pauli 1901: no. 1431; Dodgson 1903-11, I: no. 19; Röttinger 1925: no. 143; Röttinger 1927a: 20, 73, no. 1576; Coburg 1967: no. 151; Geisberg/Strauss 1974: no. 1143; Nuremberg 1976: no. 17

According to the printed text, the woodcut illustrates a scene that appeared to Hans Sachs in a frightful dream. He was in a dark wilderness where nets had been placed as if for a boar hunt. There was a cave, and from deep within it shone a bright fire. Then he heard dogs and hunting horns and the crashing of a great crowd of monks and cooks and clerics running hither, pursued by ill-shapen hunters chasing them into hell. (The reference to cooks [*Kellnerin*] was clear enough to Sachs' public since that was the common euphemism for the clergy's concubines.) He asked one of the clerics who ran toward him why they were being pursued, what wrongs they had done. The reply was a rehearsal of the favorite complaints against the clergy: broken vows of poverty and chastity, and fleecing the laity through threats of damnation. Showing the tables turned on these hypocrites, the broadsheet's title suggests that they will all be punished: "The Monk and Cleric Hunt / No one too good nor too bad" (*Das Münich and Pfaffen Gaid / Nyemand zu lieb noch zu laid*).

The woodcut elaborates upon Sachs' description of the scene. The fiery cleft has literally become the mouth of hell in the form of a pig's head, in which the pope sits as if in a place of honor. The drawing is lively but schematic, involving mostly outlines of general shapes with little hatching—a simple style that facilitated the rapid and inexpensive production of the woodcut. The coloring, too, consisting of bright, contrasting hues—yellow, red, orange, two shades of green, gray, and black—was applied in a rudimentary and hasty manner. This was a popular, ephemeral print of which many copies were produced and almost none saved. No early impressions seem to exist, and this one, like other surviving impressions, shows the breaks typical of a block that has undergone hard use. The left and right halves of the woodcut were printed from two blocks, then the sheets were glued together. The text, once part of the same sheet as the woodcut, was cut off, then rather carelessly glued back on.

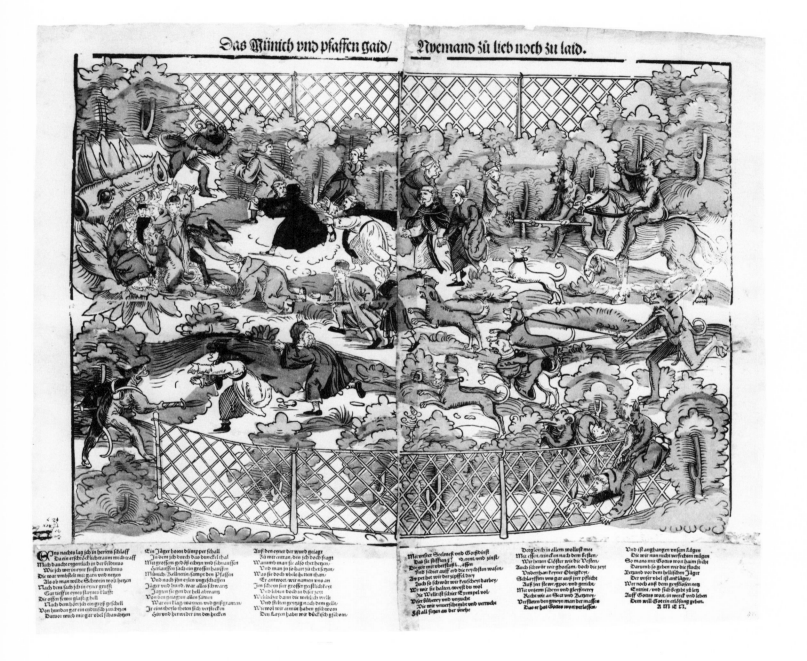

Das Münich und pfaffen gaid/ Niemand zu lieb noch zu laid.

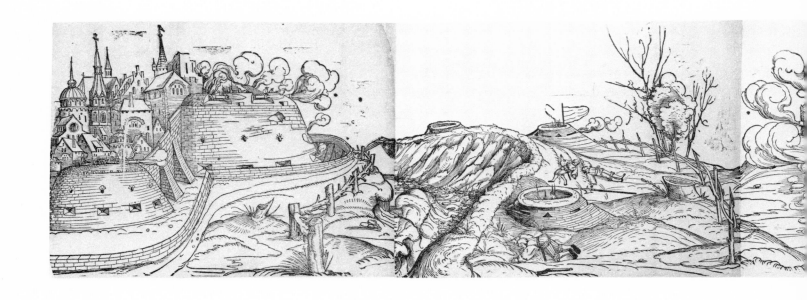

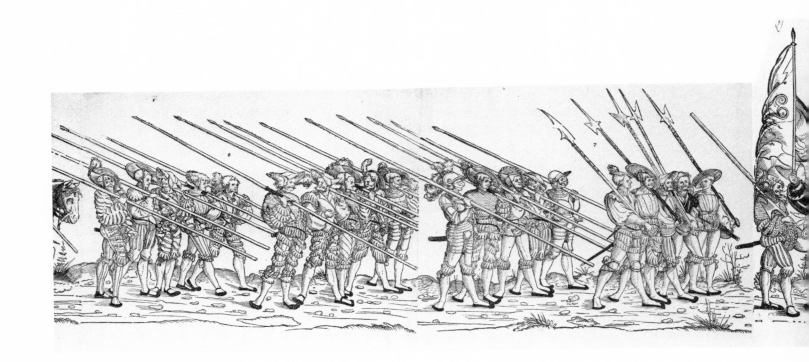

189

Siege of Münster, 1534/35

Woodcut from seven blocks, 295 x 2680 mm

VC: Inv. no. VI 457, 127

References: Hirth 1882-90: nos. 869-875 (unknown master);
Pauli 1901: no. 1454 (Pseudo-Beham); Röttinger 1925: no.
249; Geisberg 1932: 3-4; Geisberg/Strauss 1974: nos.
1258-1264

The seven woodcuts, printed from as many blocks and glued
together in the form of a frieze, seem to give a cross section of
the impending battle, extending from the fortified city at the
left, all the way through the besieging army, to the kitchen
area behind the lines. Based on a comparison with another
woodcut, identified by an inscription as the city of Münster
under siege, Geisberg (1932: 3-4; Geisberg/Strauss 1974: nos.
1256-1257) was able to recognize this print as a different view
of the same event. In addition to the shape of the fortifications,
the distinctive cupola of Saint Lambert's Church and the large
gable of the town hall confirm the identification.

Münster lay under siege by the army of its prince-bishop,
Franz von Waldeck, from March 1534 until June 25, 1535,
when the city was re-taken. The defenders were the Anabap-
tists, under the leadership first of Johann Mathijs of Haarlem
and then, after he was killed, of Johann Beukels of Leiden. The
Anabaptists had expelled all residents of the city who refused
to be rebaptised and had established a communistic theocracy.
After he came to power in April 1534, Beukels had himself
crowned king of this "new Zion," imposed polygamy upon his
subjects, and made punishable by death such sins as "scolding
one's parents, disobeying one's master in a household, adul-
tery, lewd conduct, backbiting, spreading scandal and com-
plaining" (Williams 1962: 371). There had been two unsuc-
cessful efforts to take the city by assault, when two disgruntled
followers within the city opened one of the gates to the bishop
and Münster fell.

The beleaguered Anabaptists have constructed formidable
defenses, which we seem to view from somewhere in no man's
land. The defenders are returning cannon fire from positions
atop their large rounded bastions. Outside the fortified walls,
a deep ditch and then a row of bunkers, from which protrude
the tips of halberds, keep the enemy lines at a distance. As for
the offensive lines, a battery of the bishop's cannons has been
laid behind the protection of wicker gabions. The infantry,
standing amidst a forest of their own pikes, presumably awaits
an order to attack. Finally, at a distance beyond reach of the
shelling can be seen the camp with its tents, provisions, and
great cauldrons over the fire. Such scenes were characteristic
of much warfare during the Reformation period, and this print
was easily taken as a generalized representation of a siege un-
til Geisberg identified the city. Public interest in military sub-
jects seemed to keep pace with the belligerency of the times.

190

Infantry Company, c. 1535

Woodcut, 300 x 2930 mm (approximately 90 mm missing
at left)

VC: Inv. nos. I 95, 489, I 95, 489a-f

References: Pauli 1901: no. 1451; Röttinger 1925: no. 236;
Röttinger 1927a: no. 533; Geisberg/Strauss 1974: nos. 1226-
1234; Appuhn/von Heusinger 1976: 79; Nuremberg 1976:
no. 157

This frieze of nine sheets glued together shows a marching
company of lansquenets, known as a *Fähnlein* (literally, a
banner). It was printed from eight woodblocks with one repe-
tition; the fourth and the eighth sheets are from the same
block. Part of the last figure on the ninth sheet has been torn
off. The impression of the frieze preserved in the Herzog
August Bibliothek at Wolfenbüttel has an explanatory text of
140 verses by Hans Sachs printed across the top (see Geis-
berg/Strauss 1974: nos. 1226-1234, although with the com-
posite illustration in reverse order). The numbers printed on
the Coburg impression were probably keyed to that text,
issued separately, and now lost. The text identifies each group
of soldiers, describes their responsibilities, and states their
relative pay. The size of a *Fähnlein* was usually 400 men,
although the frieze shows only a representative 71. The march
is led by the captain on horseback, who is followed by his two
sergeants with halberds. Then come the soldiers with muskets
and three ranks of pikemen. The first ranks were paid double
in recognition of their greater vulnerability in battle. Next
follow halberdiers, swordsmen, drummers, and the standard
bearer. Sachs' text reports that the standard bearer was paid
three times the basic wage, indicative of his dangerous posi-
tion. The flag served as an inspiration to the soldiers during the
fighting and the enemy undoubtedly made special efforts to
bring this man down. The rear guard is made up of more hal-
berdiers, pikemen, and finally a few soldiers who are mounted
so that they can move quickly for communication among the
ranks.

The frieze-like portrayal of a company in marching formation
is based on the precedent of a triumphal procession, of which
the best-known German examples in woodcut are those made
for Emperor Maximilian—Dürer's *Triumphal Chariot*, printed
from eight woodblocks, and the *Triumphal Procession*, de-
signed by Burgkmair, Altdorfer, and others, which comprises
137 woodblocks and extends some 57 yards in length. The
difficulty of exhibiting such unwieldy prints did not prevent
this format from inspiring other kinds of processional or
sequential scenes, such as battles (see cat. no. 189), dances,
festivals, and allegories (Appuhn/von Heusinger 1976: 78-
86). These compositions stretched the capacity of the woodcut
to function in dimensions previously associated only with
monumental art.

In addition to the text, the Wolfenbüttel impression bears the
name of the printer, "Hans Guldenmundt zu Nürmberg," but
has no artist's signature. Pauli (1901: no. 1451) catalogued the
work as by Sebald Beham, but it is Röttinger's attribution
(1925: no. 236) on stylistic grounds to Erhard Schön that has
gained general acceptance, if no further verification.

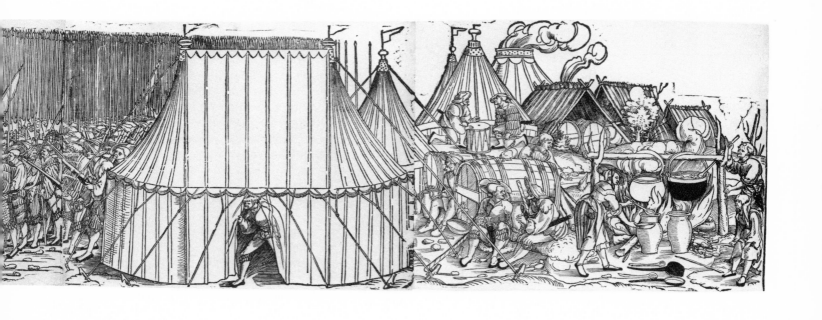

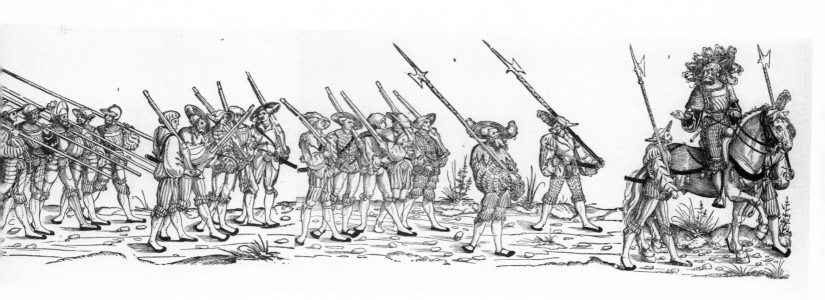

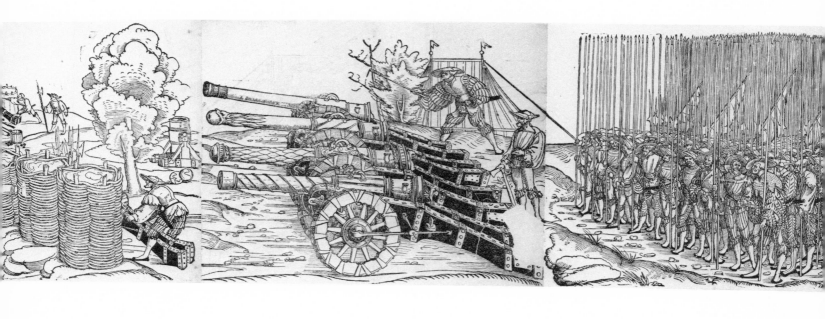

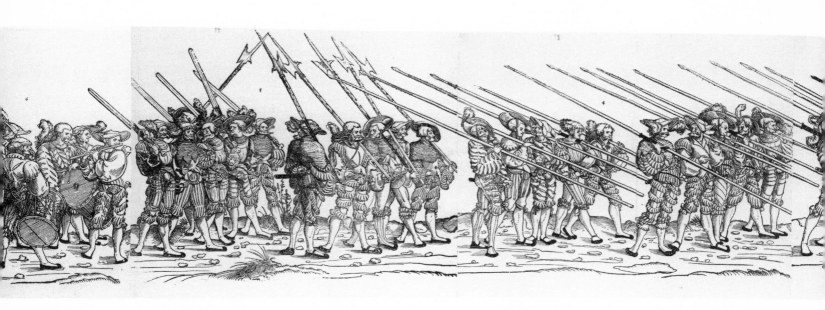

Martin Schongauer

c. 1450 Colmar—Breisach 1491

Schongauer was born in the Alsatian town of Colmar, where he worked most of his life. His father, Caspar Schongauer, was a goldsmith, from whom he doubtless first learned to engrave in metal. In 1465 Martin enrolled at the University of Leipzig, but he seems not to have stayed there long. By 1469, he was a journeyman painter, probably having served an apprenticeship to Caspar Isenmann in Colmar. Schongauer traveled in Burgundy, where he made a drawing of Christ from Roger van der Weyden's *Last Judgment* in Beaune, then in the Netherlands, and perhaps in Spain. Sometime before 1473, he was back in Colmar, since in that year he dated his painting of the *Virgin in a Rose Arbor* for the Church of Saint

Martin there. Around the same time, he executed the first of his 116 engravings.

In the course of two decades, Schongauer developed the most refined engraving style of the 15th century. His figural types and several of his compositions are based on Netherlandish painting, especially that of Roger van der Weyden. In 1488 he received a commission to paint a large fresco, the *Last Judgment*, in the Minster at Breisach. This fresco, although it survives in a ruined state, is evidence that the engraver was also a painter of monumental works as well as of altarpieces and small panels. Nevertheless, it is his engravings upon which Schongauer's reputation is mainly based.

191

Saint John the Evangelist on Patmos, c. 1480

Engraving, 162 x 115 mm

Monogram in plate at lower center: M✝S

VC: Inv. no. I 2, 49

References: Lehrs 1908-34, V: no. 60; Baum 1948: no. 26; Flechsig 1951: 235; Washington 1967: no. 45; Shestack 1969: no. 22; Minott 1971: 46; Coburg 1975: no. 26

The standard iconography of Saint John on Patmos includes his evangelical attribute, the eagle, and the Woman of the Apocalypse. Of all the visions he recorded in the Book of Revelation, it was she—the "woman clothed with the sun, and the moon under her feet, and upon her head a crown of twelve stars" and delivered of a son (Revelation 12:1-5)—who was singled out by tradition to represent his miraculous experience while banished to the Island of Patmos. She is the prototype of countless images of the Virgin and Child (see also cat. nos. 3, 130), and this is how she appears to Saint John in this engraving. Like Saint Luke, who, according to legend, was a painter and made the first portrait of the Virgin and Child (when they appeared to him in a vision) and consequently became the patron saint of painters, Saint John on Patmos was revered as the witness who recorded for posterity the image of the Virgin in glory.

By the mid- to late 1470s, Schongauer had developed an extremely refined engraving style that was based on three prin-

ciples. First, it was essentially a linear style, in accord with the burin's natural cut into the metal; second, the lines were systematized into regular, coherent patterns; and third, the technique served a pictorial function. The lines, especially the longer ones, like contours or strands of hair, are dynamic in themselves. They flow and flex, swell and taper in response to the burin's movement through the copper, leaving an incision not only of lateral dimension but also of varying degrees of depth. The deeper the lozenge-shaped point was made to cut into the copper, the wider the line. As the burin emerged from the metal, the line tapered to a sharp point. Even where lines are concentrated in fine networks of cross-hatching, one senses the energy and rhythm of their movement. It was Schongauer's great achievement to use this technique so effectively for the naturalistic representation of figures, drapery, landscape, etc., and yet maintain a balance between the interest of the represented forms and the expressiveness of the abstract linear patterns themselves.

192

Saint Christopher, c. 1480

Engraving, 160 x 113 mm

Watermark: Gothic P with flower and horizontal stroke (Lehrs 1908-34, v: 407, no. 64)

Monogram in plate at lower center: M c+S

VC: Inv. no. I 2, 45

References: Lehrs 1908-34, v: no. 56; Baum 1948: no. 58; Flechsig 1951: 235, 285-288; Washington 1967: no. 81; Shestack 1969: no. 39; Minott 1971: 45; Coburg 1975: no. 25

The fabulous giant who wanted to serve the mightiest ruler in the world and eventually found him in the person of a child whom he ferried across a river changed his name to Christopher—"Christ-bearer"—after the child identified himself. The powerful ferryman had nearly been crushed by his young passenger whose weight grew miraculously heavy as they made their way through the water. Because of his enormous size and strength, Christopher was an obvious choice to be a protector saint, especially for travelers. Given the literal-mindedness that pertained in the making of images in the late Middle Ages, he was frequently portrayed on a colossal scale, as can be seen in some surviving statues and paintings, such as the giant fresco, dated 1491, in the Cathedral of Augsburg. In this engraving, the essential fact of Christopher's size runs into conflict with the artist's slender—almost delicate—figural type. In an effort to give his Christopher more bulk, Schongauer wrapped him in yards of beautifully engraved drapery, but that does not prevent a bony pair of legs from revealing the truth about the figure's physique. The fine, blade-like leaves of the lily in the foreground are characteristic of the sensibility of the artist, who perceived even this giant of legendary strength in gracefully elongated terms. Schongauer epitomizes the refined elegance of a stylistic trend at the end of the 15th century, which can be traced back to the courtly art of the International Gothic around 1400. Especially along the Rhine, the grace and elegance of the International Gothic were never entirely superseded by the realism that entered the art of the mid-1400s in Germany.

However, Schongauer's engraving unquestionably belongs to a late phase of this stylistic tradition. The emotional and formal delicacy of Schongauer's art could not stand up to the new and often coarse sensibility of the early 16th century. By around 1500, an artist such as the Master MZ, despite all his late Gothic mannerisms, would produce a hulking wild man of a Saint Christopher (cat. no. 179) with whom Schongauer's serene figure could scarcely be expected to coexist.

193

Baptism of Christ, c. 1480/90

Engraving, 157 x 157 mm

Monogram in plate at lower center: M✝S

VC: Inv. no. I 1, 7

References: Lehrs 1908-34, VIII: no. 8; Baum 1948: no. 27; Flechsig 1951: 225, 233, 250, 289; Washington 1967: no. 76; Shestack 1969: no. 97; Minott 1971: 38; Coburg 1975: no. 20

Schongauer was deeply influenced by the art of the Netherlands, especially the painting of Roger van der Weyden. The high-pitched sensitivity of Roger's contours, his ethereal figure types, and his balanced, rhythmic compositions were ideally suited to Schongauer's temperament and to the medium of engraving. The *Baptism of Christ* is based on Roger's painting of the same subject for the Saint John triptych in Berlin (Gemäldegalerie der Staatlichen Museen) although Schongauer shifted the emphasis from pictorial to linear expression. The background is reduced to a few schematic landscape forms coordinated to reinforce the visual continuity of the foreground figures. These figures are distilled from Schongauer's late Gothic sensibility. They seem not even to be burdened by the weight of their own bodies. Hardly more than a single foot or leg is shown touching the ground, as if this were the extent of their terrestrial limitations. How fluid are their positions is signified by the free end of Christ's drapery that floats upon the rippling water. Flowing beyond the figures' bodies, the drapery stretches out their already elongated proportions. And just where Saint John's kneeling leg threatens to give the figure a firm horizontal base, a corner of animal skin laps over his calf and continues the up-and-down angles of his body. There is no overlapping between the figures, and even though the angel stands slightly deeper in space than the others, the compositional lines of motion are predominantly lateral, in keeping with the actuality of the engraved lines on the paper. Yet the shading of the forms and the angled placement of Christ and John create a certain degree of spatial illusion. To this extent, the design has the appearance of relief sculpture, Schongauer's ever elastic lines seeming to bend on a surface of three dimensions.

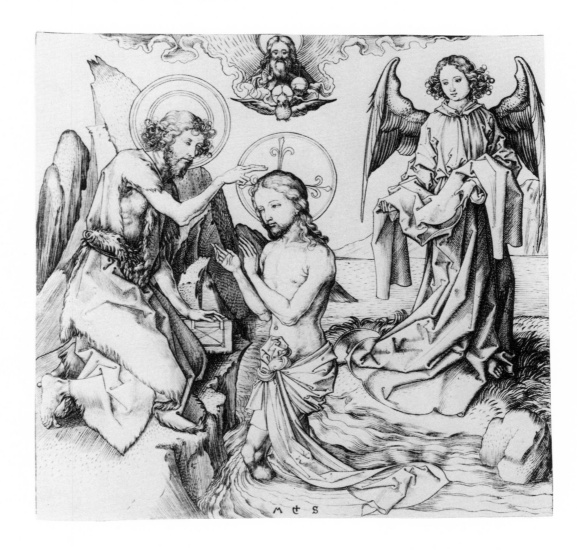

Lorenz Stoer

(for biography, see p. 145)

194

First Geometric Design, c. 1555
(illustrated on p. 344)

Woodcut with beige and pink washes, 223 x 167 mm

Monogram in block at lower right: *LS*

Number cut in border at lower center: *1*

VC: Inv. no. I 351, 2

195

Eleventh Geometric Design, c. 1555
(illustrated on p. 345)

Woodcut, 220 x 163 mm (image); 238 x 165 mm (sheet)

Monogram in block at lower center: *LS*

Number cut in border at lower center: *11*

Text in letterpress at bottom: FINIS / *Getrückt zü Aügsbürg dürch Hanns Rogel Formschneider*

VC: Inv. no. I 351, 10

References: Andresen 1864-78, III: 287-288; Möller 1956: 17, 49, 67; Nuremberg 1969: nos. 66-76; Munich 1972: nos. 563-564; Descargues 1977: 50-53

These are two of eleven woodcuts that Stoer published as a book in 1567, under the title: *Geometria et Perspectiva. Hierjnn Etliche zerbrochne Gebew, den Schreinern In eingelegter Arbait dienstlich, auch vil andern Liebhabern zu sondern gefallen geordnet unnd gestelt Durch Lorentz Stöer Maller Burger Inn Augsburg (Geometry and Perspective/ Herein are a few ruined buildings, useful to cabinetmakers working in inlaid wood, and for the special pleasure of many other amateurs, arranged and presented by Lorenz Stoer, painter and citizen of Augsburg).* The title page also says that the book was protected by an imperial privilege, against unauthorized reprint (see cat. no. 45). Beneath the 11th woodcut, a line of text declares that the work was printed at Augsburg by Hans Rogel; the designation *Formschneider* indicates that he presumably also cut the blocks. Stoer received the imperial privilege in 1555, and apparently first published the book in 1556 with the title, *Perspectiva Laurentio Stoero in lucem produta* (Norbert Lieb in Thieme-Becker XXXII [1938]: 91), although the scant literature on Stoer does not locate a copy of that edition.

The study of perspective, in theory as well as practice, and the projection of geometric solids illusionistically in two dimensions had occupied German artists since the time of Dürer, whose treatise on the subject, *Underweysung der Messung mit dem Zirckel und Richtscheyt . . . (A Course in the Art of Measurement with Compass and Ruler),* first appeared in 1525. As early as 1514, in his engraving, *Melencolia I* (cat. no. 154), Dürer had not only applied his study of perspective to the representation of geometric forms but had also made such forms an essential part of his portrayal of artistic creativity. Following Dürer by two generations, Stoer had later models to which he could also turn, such as Hieronymus Rodler's 1531 book on perspective, *Eyn schön nütlitz büchlin und underweisung der Kunst des Messens . . . (A nice, useful little book and instruction on the Art of Measurement),* with its illustrations of architectural forms as complex as a spiral staircase in perspective (Descargues 1977: 46).

Instead of simply providing a sequence of different three-dimensional shapes, as one might expect from a standard pattern book, Stoer used his repertory of forms to create imaginary scenes of architectural ruins and surprisingly abstract sculptures that look as if they were the remains of an ancient civilization. Despite the complexity of these structures, the individual segments of which they are composed are simple in shape and texture. Stoer intended these illustrations to be useful to cabinetmakers working with inlaid wood, which as it turns out they were (Möller 1956: 17 ff., fig. 50-57). The fragmentary buildings seen in his woodcuts were popular motifs in designs for inlaid furniture made in Augsburg around 1560 (Augsburg 1980-81: nos. 856-858). Examples of Renaissance intarsia with their elaborate architectural illusions, going back at least to the last quarter of the 15th century in Italy, reveal that Stoer owed as much to that tradition as he contributed to it.

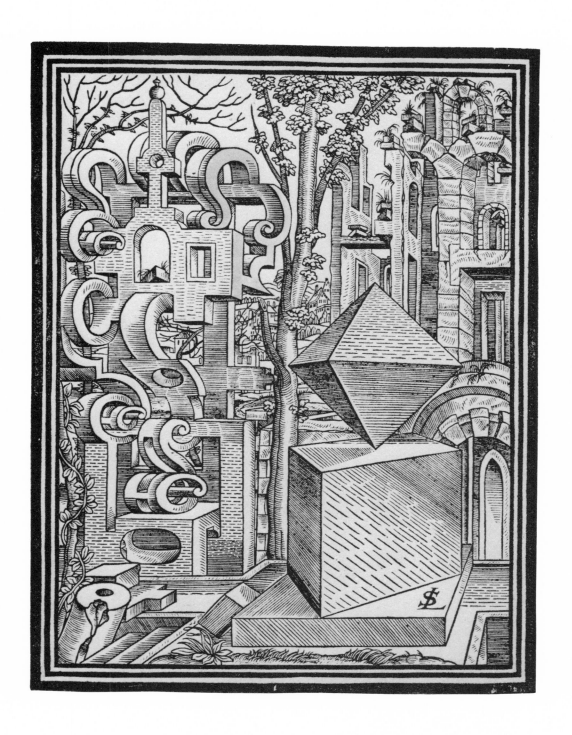

344

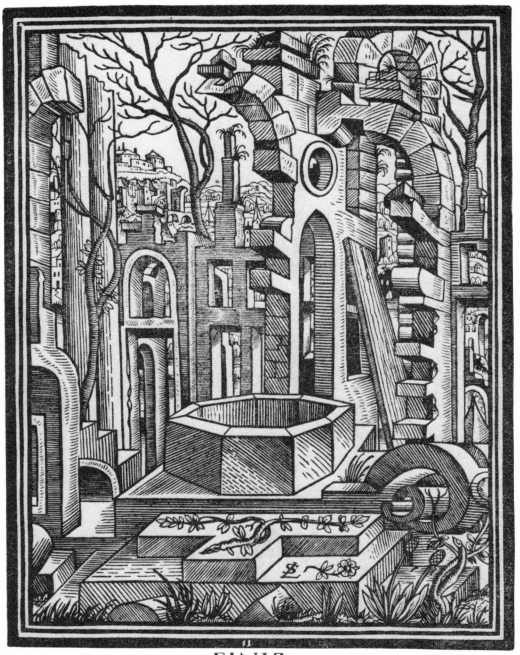

FINIS.

Getruckht zů Augspurg durch: Hannß Rogel Formschneider.

Incunabula

196

Konrad von Megenberg, *Buch der Natur*, Augsburg, Hans
Bämler, 1475

Late Gothic binding in brown calf over wooden boards,
290 x 192 mm

LbC: Sig. Inc 22

References: Dodgson 1903-11, I: 214-216; Davies 1913: no.
124; Schramm 1922-43, III: 14, pl. 63; Coburg 1954: no. 74;
Munich 1972: no. 351; Kunze 1975, I: 242

Concerning Insects in General

Hand-colored woodcut (165ᵛ), 184 x 124 mm

This is one of the earliest books on natural history to have
been written in German. Based upon a Latin book, *De naturis
rerum (Of the Natures of Things)* by the 13th-century author
Thomas of Chantimpré, the text was prepared by Konrad von
Megenberg around 1350. Megenberg, a canon of the Church
of Saint Ulrich in Regensburg, was a naturalist himself, al-
though, like most writers of such encyclopedic works up
through the 15th century—such as Hartmann Schedel, author
of the *Nuremberg Chronicle*—he freely mixed reports based
upon direct observation with those derived from superstition
and myth. Of his twelve chapters, two are devoted to monsters
and equally fictitious deformed creatures. The book had al-
ready achieved wide popularity in manuscript form by the
time the Augsburg publisher, Hans Bämler, gave it a new life
in print. Bämler issued three editions; the Coburg copy belongs
to the first (1475).

A full-page hand-colored woodcut appears at the beginning of
each chapter. The anonymous illustrator tried to fit the various
plants and animals into an appropriate setting, although he
was equally concerned with giving a clear, representative view
of each one and with maintaining the overall decorative ap-
pearance of the design. The illustration of insects is a good
example of his ingenuity in solving all these problems at once.
With just enough indication of landscape to evoke depth and
atmosphere, he provided the ants with an anthill, the worms
with a dark patch representing underground, the bees with a
hive, and the butterfly with a flower. A scattering of grass-
hoppers and flies fill most of the sky, while a spider is repre-
sented as having quite naturally attached its web in a corner of
the picture.

197

Missale Basiliense, Basel, Michael Wenssler, 1488

Late Gothic binding in brown calf over wooden boards,
362 x 245 mm

LbC: Sig. Inc 36

References: Heitz 1910: no. 14; Schramm 1922-43, XXI: 5,
pl. 4, no. 8; Coburg 1954: no. 80

> *Crucifixion*
>
> Hand-colored woodcut, 243 x 163 mm
>
> Color plate VIII

Even after the printed missal had begun to supersede its
manuscript prototype, the page facing the Canon of the Mass
was sometimes left blank so that the traditional *Crucifixion*
could be painted there by hand. Starting in the 1480s, wood-
cuts took over the function of providing that sacred image,
and they were often colored and gilded, as in this example, to
approximate an illumination. Furthermore, certain letters were
rubricated to imitate the appearance of a manuscript. In this
example there is a blank space at the beginning of the Canon
where the large capital T of "Te igitur" is missing; the in-
tended illumination was never executed. The publisher, Wens-
sler, was able to use this same woodcut for all 11 editions of
the missal that he issued from 1486 to about 1490. The anony-
mous woodcut was based on a *Crucifixion* that appeared in
missals printed by Peter Schöffer in Mainz between 1483 and
1499 (Heitz 1910: no. 28). Schöffer's woodcut, however,
shows Christ on a taller cross against a cloudy sky. Wenssler's
Crucifixion in turn served as the model for the *Crucifixion* in a
missal published by Johannes Prüss in Basel in several edi-
tions between 1504 and 1511 (Heitz 1910: no. 39).

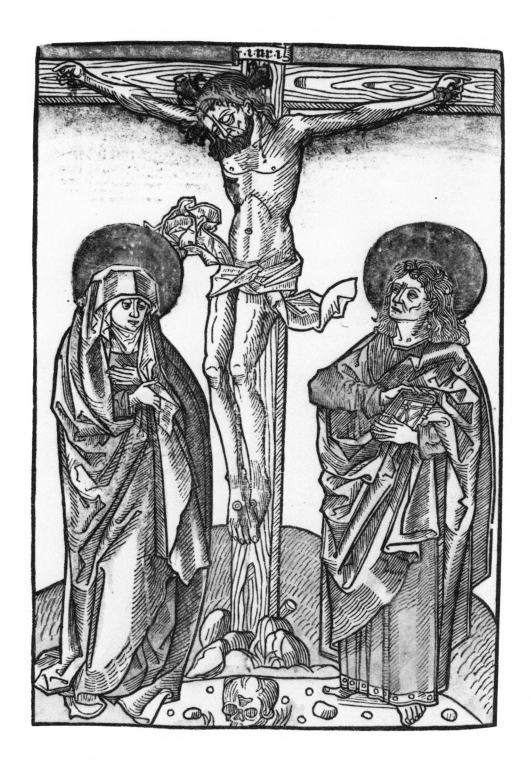

198

[Stephan Fridolin], *Schatzbehalter oder schrein der waren reichtuemer des hails vnnd ewyger seligkeit*, Nuremberg, Anton Koberger, 1491

Late Gothic binding in pigskin over wooden boards, 349 x 250 mm

LbC: Sig. Inc 41

References: Dodgson 1903-11, I: 241-245; Schramm 1922-43, XVII: pl. 110, no. 319; Coburg 1954: no. 49; Bellm 1962; Nuremberg 1971: no. 115; Kunze 1975, I: 362-368; Nuremberg 1979: no. 50

Michael Wolgemut (attrib.)

Fall of the Rebel Angels

Woodcut (fol. gi^v), 249 x 173 mm

The *Schatzbehalter* (full title: *Treasure Box or Shrine of the True Riches of Salvation and Eternal Blessedness*) with its 91 full-page woodcuts is one of the most richly illustrated books of the 15th century and was Dürer's closest model for the layout of his *Apocalypse* (cat. nos. 130-132). The *Schatzbehalter* belongs to the category of devotional and edifying books produced in the 14th and 15th centuries that primarily concern the life and suffering of Christ, in which the reader was encouraged to submerge himself mentally. The sub-title refers to the shrine of Christ's Passion, to which man owes his only chance for salvation. The author's name, Stephan Fridolin (c. 1430-1498), does not appear in the book, but it was written into one copy now belonging to the Bayerische Staatsbibliothek in Munich. Fridolin was a Franciscan preacher who, at the request of the Sisters of Saint Claire in Nuremberg, expanded and compiled a series of sermons that he had delivered to them in a written form intended primarily for the laity. As the text explains, the pictures were added as aids to the understanding of the examples set forth.

The names of the designers of the woodcuts are nowhere provided in the book, but the style identifies them with the same artists, principally Michael Wolgemut (1434-1519) and his stepson, Wilhelm Pleydenwurff, who produced the illustrations for the *Nuremberg Chronicle* of 1493, also published by Anton Koberger. Wolgemut, a painter with whom Dürer did his apprenticeship in 1486-90, ran a large workshop in Nuremberg that he, in effect, inherited from Hans Pleydenwurff upon marrying the latter's widow in 1473. In the contract of 1491 for the encyclopedic *Nuremberg Chronicle*, as the *Liber Chronicarum* is usually called in English, Wolgemut and Wilhelm Pleydenwurff are named jointly responsible for the illustrations, of which there are 1,809, printed from 645 different blocks. Although a clear distinction between the hands remains a speculative matter for both the *Schatzbehalter* and the *Nuremberg Chronicle*, the page of the former showing the *Fall of the Rebel Angels* (Revelation 12:7-9) belongs to a group of woodcuts attributed to Wolgemut. This artist imposed upon the woodblock a tremendously active and complicated design. A swirl of lines fills the entire surface except for a slight gap between heaven and hell where the demons are falling through space before plunging head first into the fiery abyss. The design reflects the ambitions of a painter seeking to expand the descriptive capacity of the woodcut, but the results are confusing and underscore the value of Dürer's graphic discipline for bringing coherence and focus to so much visual information (see cat. no. 130).

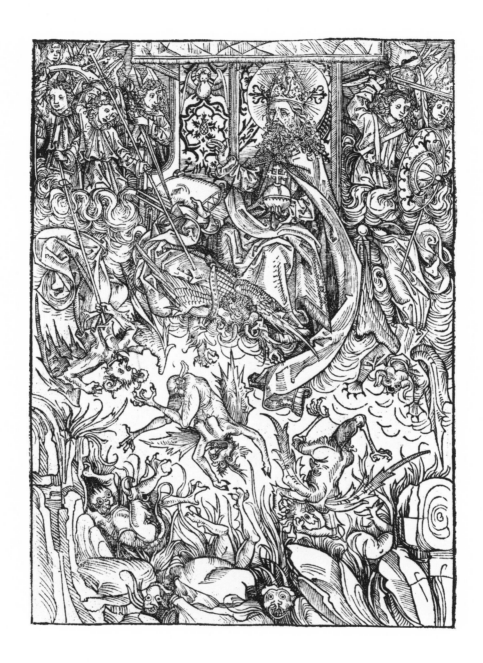

199

Das ist ein teutsch Kalender, Augsburg, Hans Schaur, 1496

18th-century binding in brown paper over boards, 163
x 125 mm

LbC : Sig. Inc 1

References : Hain 1826-38 : no. 9747 ; Schreiber 1910-11 : no.
4428 ; Coburg 1954 : no. 73 ; Amelung 1978 : 119-159

May

Woodcut (biiᵛ), 85 mm (diam.)

The straightforward title, *This is a German Calendar,* covers
only part of this book's contents. More than half of it contains
astrological advice on how to stay healthy. The calendar
proper, with four pages devoted to each month, is followed by
sections on the influence of the zodiacal signs, the planets, the
temperaments, and the four winds, as well as rules for phle-
botomy and for bathing. This combination of calendar and
guide to healthy living can be found in manuscripts dating
from the first half of the 15th century. The first printed *teutsch
Kalender* was published by Johannes Blaubirer in Augsburg
in 1481. When Blaubirer realized what a demand there was for
the book, he brought out a new edition with greatly improved
illustrations in 1483. The woodblocks were then acquired by
two other Augsburg publishers : Johannes Schobser, who
printed the calendar in 1488 ; and Hans Schaur, the first to
make use of this title, who printed the woodblocks for the
present edition in 1496. Other publishers, equally desirous of
producing the book, had to settle for copies of the original
woodcuts. The calendar was still popular over four decades
later, when the last of many editions was issued by yet another
Augsburg publisher, Johannes Froschauer, in 1522.

The main illustrations, like the one for the month of May, are
in the form of medallions. In Schaur's edition the blocks were
trimmed slightly so that a small section of the outer bordering
ring is missing. The custom of illustrating each month with a
picture had a long tradition in illuminated manuscripts, which
continues up to the present time in the ubiquitous wall cal-
endar. Beginning in the early 15th century, landscapes were
combined with figural subjects to characterize particular times
of year. For example, two lovers meeting in a garden was the
time-honored image for May. Most of the months were asso-
ciated with seasonal labor, but May was considered a time to
be enjoyed, as the quatrain accompanying the illustration
proclaims :

> Here come I proud May
> With bright flowers in profusion
> In this month one should bathe
> Dance, sing, leap and live well.

Since this is a perpetual calendar, the dates and days of the
week are indicated in only a relative way, using the alphabet
instead of numbers, and only those feasts and saints whose
days did not change from year to year are listed by each
month. Twenty-seven repeating letters in the right hand col-
umn indicate the days of the month, and seven repeating let-
ters on the left give the day of the week. By knowing which
letter was Sunday in a given year, the rest of the days could
easily be determined. The Roman numerals at the far left were
called golden numbers and pertain to the lunar cycle. On the
basis of these numbers and the letter for Sunday, the date of
Easter for a particular year could be calculated using a table at
the end of the months section. Two lines at the top of the cal-
endar page for May declare that the month has thirty-one
days, the days are sixteen hours long, and the nights eight.

Hye kum ich stolzer mey
Mit klügen blůmen mangerley
In diſem monat man baden ſol
Tantzen ſingen ſpringen vnd leben wol.

	b	Philip vnd Jacob	n	
xvij	c	Sigmundus künig	o	
v	d	Des heyligen kreütz findung	p	
xviij	e	Florian ein martrer	q	
ij	f	Gothardus ein biſchoff	r	
	g	Johannes vor der gulтin porten	ſ	
	A	Juuenalis	t	
xviij	b	Xiſtor ein martrer	v	
vij	c	Erhebung Nicolai	x	
	d	Gordian Epimach	y	
xv	e	Mamertus	z	
	f	Nerus vñ Pangraci	x	
iiij	g	Seruacius ein biſchof	a	
xij	A	Bonifacius ein balſt	b	
	b	Sophia ein junckfraw	c	
j	c	Poncius ein martrer	d	
ix	d	Yſidorus ein martrer	e	
xvij	e	Peregrinus ein martrer		
	f	Potenciana ein junckfraw		
	g	Bernhardus beychtiger		
vj	A	Valentin ein martrer		

b iij

200

Beichtbüchlein, [Leipzig], Melchior Lotter, 1500

New white vellum binding, 210 x 156 mm

LbC: Sig. Inc 61

References: Schramm 1922-43, XIII: pl. 6, no. 45; Hind 1935: 226, n. 1; Coburg 1959: no. 2; Coburg 1970a: 23

Confession

Woodcut, 145 x 93 mm

The *Beichtbüchlein (Little Confessional Book)* is a short manual on confession belonging to a large body of late medieval literature addressed to both confessors and the laity (Tentler 1977: 28-53). At this time, the confessional box was not yet in use. Instead, the confessor, as in this book's single illustration, sat in the open, and the penitent took his place nearby, usually kneeling (Tentler 1977: 82-83). This particular woodcut was first used to illustrate another kind of book that became very popular in the 15th century and also concerned the state of one's soul, namely the *Ars Moriendi (Art of Dying).* The *Ars Moriendi* first appeared in the 1460s in the form of a block-book—an early type of printed book in which the text was cut into the woodblocks along with the illustrations. *Confession* was not one of the original 11 illustrations in the *Ars Moriendi.* Conrad Kachelofen in Leipzig was one of several publishers who had the illustrations copied and printed with a text in movable type. He issued several such editions in German and Latin between 1493 and 1500, to which he added three new illustrations, including this one. The others were *Last Rites* and *Saint Michael Weighing Souls.* Melchior Lotter of Leipzig then acquired the woodblock of the *Confession* from his fellow publisher and sometime collaborator in order to illustrate the *Beichtbüchlein.*

The anonymous designer of the *Confession* adhered closely to the style and composition of the other *Ars Moriendi* prints. Characteristic of these scenes is the competition for the dying man's soul that is waged between the devil and those who advise him on the right way to salvation. Here, the devil proposes a game of dice to a young man whom an angel has escorted to a place next in line at the confessional.

Jn dem namen gotes amen Tzu seligkeyt der
selen vñ tzu gotes ere mit gotlicher hulffe, wil
ich machen vñ setzen vñ schreiben eine grunt
liche vñ rechtfertige beichte aller sunde noch menschli
cher muglichkeit yn d weiße ein itzliche sin tzu vorfure
durch die syben todt sunde Vñ itzlicher tod sunte drey
erley weiße. des hertzes des mudes. vñ d werck Vnnd
wen man wil erkennen irn kein sunde so sehe her an
dieße heilige beichte Wiltu wissen die hoffertige sunde
des hertzes so schawe vñ sich an die sunde der hoffart
des hertzens Wiltu aber wissen die hoffertige sunde
des mudes. so sich an die hoffart des mundes Wiltu
wissenn die hoffertige sunde der wergk. so sich an die
hoffart der wergk Also vorstehe auch von allen an
dern sunden als Geyerheyt Neydt Tzorn.
Jch gebe mich gote schuldigk von meine funff sinnē
wie das ich die nicht behut vnd bewart habe yn der
forchte gotes tzu meiner selen seligkeit. vnd leybes not
Sund sie misgebraucht hab one forchte gotes wider
meiner sele seligkeit vnd leybes noth noch fleischlicher
eyngebunge tzu eytelkeyt vnnd vorwitzigkeyt dießer
werlt. Tzum erstenn gebe ich mich gote schuldig von
meinen augen wie das ich mancherley weyße von der
nehesten beichte habe gesundiget mit meinem gesichte
¶ Hoffart. wen ich hab gesehen das mich ymant hat
geeret so hab ich gefrolockt yn meinem hertzen vnnd
habe mich des selbigen vberhaben vnd nicht gote die
ere gegeben Vnd das ist gescheen drey ader vier ader
funff mal Jch habe offt gesehen ader wē ich habe ge
sehen ere ander menschen die habe ich auch begert võ
hoffart meines hertzens vnnd byn do von vrsachlich
betrubet wordenn. Ere. herschafft. gewalt Ammecht

201

Martin Luther, *Von der Freyheyt eynisz Christenmenschen*, Wittenberg, Johannes Grunenberg, 1520

New white vellum binding, 222 x 159 mm

LbC: Sig. LuIa 1520, 10

References: Luther 1883-1978, VII: 12-38 (Edition A); Dommer 1888: no. 70 A; Dodgson 1903-11, II: 328, no. 6; J. Luther 1909-13: pl. 3; Jahn 1955: 64-65, pl. 107b; Hollstein VI: 171, no. 40; Kaltwasser 1961: no. 334; Basel 1974, I: no. 215

Lucas Cranach the Elder, Workshop of

Title border

Woodcut, 156 x 117 mm

Although considered a minor category in the history of graphic art, woodcut title borders underwent a noteworthy efflorescence during the early part of the Reformation, which raises some interesting questions about their design and meaning. For most publications of the time, and especially for the short polemic and theological tracts that Luther produced in such profusion, the title border was the only illustration or, more accurately, the only decoration. Since the borders were reused for any number of different titles, they seem not to have been designed to accompany a specific text. Occasionally, however, as in the case of this border from the Cranach workshop, it is tempting to make a connection between the imagery of the woodcut and the text. Within the border, composed mainly of fanciful and ornamental motifs, there are two figures, one a ragged old man holding a rosary with a squirrel perched upon his shoulder, and the other a stocky, younger man, almost nude, drinking from a flask as several bees swarm about him. In the treatise, *The Liberty of the Christian Man*, Luther offers the following passage to demonstrate his point that nothing external can determine Christian righteousness or freedom:

> What can it profit the soul if the body is well, free, and active, and eats, drinks, and does as it pleases? For in these respects even the most godless slaves of vice may prosper. On the other hand, how will poor health or imprisonment or hunger or thirst or any other external misfortune harm the soul? Even the most godly men, and those who are free because of clear consciences, are afflicted with these things (Luther 1955-76, XXXI: 345).

Now, it is understandable that one might associate this passage with the poor old man in prayer and the fleshy, drinking youth, although neither the squirrel nor the bees are easy to explain satisfactorily. On the other hand, one remains cautious, knowing that the drinker is a motif that appears in other title borders from Cranach's workshop and that this border was used in at least two other publications of the same year and not necessarily here for the first time. Still, it is almost certain that the two figures were designed to illustrate the contrast between spiritual and carnal activity. However, knowing how Luther felt about the outward show of piety, some doubt about the meaning of the man with the rosary is bound to linger.

Grunenberg used the border in this state for at least ten of his publications between 1520 and 1522. Sometime in 1522, both Saxon coats of arms were removed from the woodcut, the one above the title and the small escutcheon between the towers in the Wittenberg coat of arms beneath it. This was presumably done at the request of Duke Friedrich of Saxony, who may have preferred at that moment not to have his personal coat of arms on the title pages of all the controversial tracts for which the border was used. In its second state the border was used until 1525. The figures and ornament of the design have been shaded, not unlike those in Dürer's *Wallpaper with Satyr Family* (cat. no. 158), to provide a slight illusion of relief.

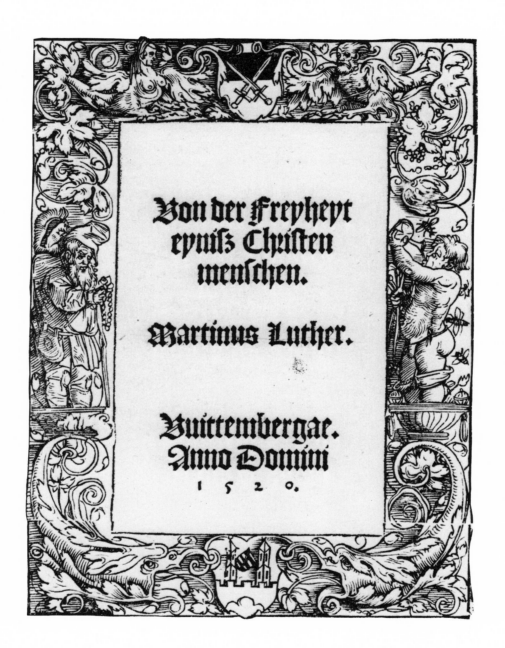

Von der Freyheyt
eynis Christen
menschen.

Martinus Luther.

Vuittembergae.
Anno Domini
1 5 2 0.

Passional Christi und Antichristi, Wittenberg, Johannes
Grunenberg, 1521

18th-century binding in brown paper over boards,
209 x 153 mm

LbC: Sig. LuIa 1521, 35

References: Luther 1883-1978, IX: 676-715 (Edition A2);
Dommer 1888: 124, no. 236; 236-237, no. 72; Dodgson 1903-
11, II: 324, no. 3; 329, no. 13; Zimmermann 1924: 8ff.; Holl-
stein VI: no. 66a-z; Jahn 1955: 64, pls. 105-106; Saxl 1957, I:
255-266; Kaltwasser 1961: no. 203; Zschelletzschky in

Weimar 1972: 139-147; Fleming 1973: 351-368; Basel 1974, I:
322-324, no. 218

Lucas Cranach the Elder, Workshop of

Christ Washing the Feet of the Apostles

Woodcut (fol. Aiiiv), 116 x 94 mm

Lucas Cranach the Elder, Workshop of

The Emperor Kissing the Pope's Foot

Woodcut (fol. Aiiiir), 116 x 94 mm

This booklet, first published around the middle of May 1521,
and widely circulated, shows at a glance the disdain felt by the
early Protestants for the papacy. Following a short text, 13
illustrated examples contrast the pope, identified as the Anti-
christ, with the true Christ. Among these polemical examples
are: Christ crowned with thorns and the pope crowned with
the triple tiara; Christ washing the Apostles' feet and the
emperor kissing the pope's foot; Christ healing cripples and
lepers and the pope watching a tournament; Christ and Peter
walking barefoot along a path (this woodcut was replaced in
a later edition of the same year with Christ bearing the cross)
and the pope being carried in a litter; Christ driving the money
changers from the temple and the pope in church taking
money for indulgences; and, finally, the Ascension opposite
the fall of the Antichrist into hell. Although these antitheses
do represent Luther's attitude, his direct contribution to the
publication was apparently limited to giving advice. None of
the editions printed in Wittenberg by Grunenberg name the
author, publisher, or place of publication, but some of Luther's
letters have provided clues for crediting Philipp Melanchthon
and Johann Schwertfeger, a jurist sympathetic to the Prot-
estant cause, with preparing the text, the former probably

having chosen the biblical passages and the latter having
offered the references to papal decretals.

The Lutheran protesters were not the first to deride the pope
as the Antichrist. Similar polemics had been written by earlier
reformers such as John Wycliffe (c. 1320-1384) and Jan Hus
(c. 1369-1415). The Hussite literature may have been an in-
spiration here, but it was thanks mostly to the woodcuts and
the printing press that this *Passional Christi und Antichristi*
had such a far-reaching impact and remains today a vivid doc-
ument of the times. Cranach himself probably provided the
general design for all the woodcuts, but their execution was
left to others in the workshop. In the woodcuts contrasting
Christ washing the feet of the Apostles with the emperor
kissing the pope's foot it is easy to recognize the work of two
distinct hands. On the left page, the lines are crinkly and ener-
getic while those on the opposite page are much stiffer. The
hurry to get the booklet out could explain the extensive in-
volvement of the workshop, but then these woodcuts fall into
the category of popular imagery, not unlike political cartoons
today, and the standards of high art would not have troubled
Cranach's thinking about their execution.

Paſſional Chriſti vnd

Chriſtus.

Szo ich ewre ſueſſe habe gewaſchen d ich ewir herr vñ meyſter
bin/ vill mehr ſolt yr einander vnter euch dieſuße waſchen . Hie=
mit habe ich euch ein anzeygüg vñ beyſpiel geben/ wie ich yn
than habe / alſo ſolt ir hinfur auch thuen . Warlich warlich
ſage ich euch/ d knecht iſt nicht mehr dan ſeyn herre/ ſo iſt auch
nicht d geſchickte Botte mehr dã d yn geſandt hat/ Wiſt yr das?
Selig ſeyt yr ſo yr das thuen werden. Johan. 13.

Antichriſti.

Antichriſtus.

Der Babſt maſt ſich an itzlichen Tyrannen vnd heydniſchen
furſten/ ſo yre fueß den leuten zu kußen dar gereicht/ nach zu=
volgen/ damit es waer werde das geſchrieben iſt. Wilcher dieſer
beſtien bilde nicht anbetet/ſall getödt werden Apocalip. 13.
Ditz kuſſens darff ſich der Bapſt yn ſeynë decretalen vnuor=
ſchembt rühmen.c.cũ oli de pri.cle. Si ſummus pon.de ſen.excõ

203

Martin Luther, *XII. Predig D. Martin Luthers. Uff etliche Unser Frauwen und der Heyligen Fest*, Strasbourg, Johann Schott, 1523/24

New binding, brown marbled paper over boards, 229 x 165 mm

LbC: Sig. 56, 2062

References: Luther 1883-1978, x/III: xvi (Edition xiia); Oldenbourg 1960; Oldenbourg 1962: 108, no. 340; Kaltwasser 1961: no. 450; Basel 1974, i: no. 273; Mende 1978: no. 433

Hans Baldung Grien

Title border with the Mass of Saint Gregory

Woodcut, 174 x 129 mm

Three main types of German title borders can be distinguished. Cranach's design for Luther's treatise on the Eucharist (cat. no. 204) combines two of them: an essentially planar, ornamental type and a pictorial kind in which scenes appear to reach back into space. A third category is comprised of architectural borders where arches supported by flanking columns enframe the title. The title page of Luther's first complete Bible, printed by Hans Lufft in 1534, is an engaging example of this type. The design makes it seem as though the title has been written on a giant scroll, which a flock of little angels is busy tacking onto a monumental proscenium-like, Renaissance structure. Such illusionism, aside from being eye-catching, points to the future in that it shows architecture in the service of the written word and gives, albeit not consciously so at the time, fair warning of the growing dominance of the printed page over other material forms of communication such as architecture, sculpture, and painting.

In this booklet, containing one of Luther's sermons, Baldung devised a different kind of architectural border for the Strasbourg publisher Johann Schott, but one with similar implica-tions. The border, first used in 1519, shows an interpretation of a familiar subject, the Mass of Saint Gregory (see cat. no. 151). The miraculous appearance of Christ has been incorporated into a large triptych placed above the altar. But instead of occupying the center of the altarpiece, the image of Christ is on one of the wings, while the Virgin of Sorrows is represented on the opposite side. The central panel, or shrine, is now given over to the title of the book. Thus, the printed word has taken the place of the devotional image, accurately representing the relative value of words to pictures or sculpture in the minds of Luther and all the Reformers. Baldung's use of the winged altarpiece as a motif for enframing a book title is typical of his surprising innovations with traditional subjects. But no one could have known just how prophetic this design would be. Although not completely opposed to religious images, Protestants developed their own variants of the traditional altarpiece. For the Reformers, an altarpiece, like an illustration to the Bible, served an instructional instead of devotional purpose and took its lead from the words that issued from the pulpit and the printing press.

XII. Predig D.
Martin Luthers.

¶ Uff etliche Unser Frauwen/
vnd der Heyligen Fest.

Zü letst mit seim
Register.

Allein Gott
die eer.

Martin Luther, *Das diese wort Christi (Das ist mein leib etce) noch fest stehen wider die Schwermgeister*, Wittenberg, Michel Lotter, 1527

New binding, brown marbled paper over boards, 203 x 153 mm

LbC: Sig. LuIa 1527, 6

References: Luther 1883-1978, XXIII: 47-283 (Edition A); Dodgson 1903-11, II: 325, no. 9; J. Luther 1909-13: pl. 17;

Weimar/Wittenberg 1953: no. 171; Jahn 1955: 65; Hollstein VI: 173, no. 45; Kaltwasser 1961: no. 90; Basel 1974, I: 378-379, no. 257

Lucas Cranach the Elder

Title border with deer

Woodcut, 170 x 134 mm

The title page of Luther's treatise, *That these Words of Christ, ("This is My Body") Still Stand Firm against the Fanatics*, from 1527 provides a telling example of the co-existence of three cultural forces in Wittenberg: Reformation theology, the classicism of the Renaissance, and the contemporary interest in nature. The enframed title introduces the theological issue at hand, while in the upper half of the border grotesque figures and floral ornaments are silhouetted relief-like against a neutral gray background—indicative of Cranach's appropriation of classical sources. In contrast to this formal, planar design, the lower section of the border contains an illusionistic landscape in which three stags and a doe appear as if suddenly encountered in the woods. One stag lowers its head to scratch it with a hind hoof and thereby just happens, it seems, to duck under the window of the border. Classical ornament and an interest in nature were, of course, two sides of the same Renaissance coin. Whether these images had more than a decorative pur-

pose is uncertain. In the context of Christian art, especially in conection with baptism, the stag has a symbolic meaning derived from Psalm 42: "As the hart panteth after the water brook, so panteth my soul after thee, O God." If Cranach had this reference in mind, he made no effort to reinforce it by showing a brook in the landscape or by giving any hint that these deer signify more than those he represented, with the eye of a naturalist, in paintings, drawings, and prints.

Michael Lotter, the printer of Luther's sermon, first used this border for the publication of Luther's *German Liturgy (Deudsche Messe und Ordnung Gottis Diensts)* in 1526. Koepplin and Falk (Basel 1974, I: 378-379) have pointed out that this liturgy was initiated at Christmas of 1525 in Wittenberg, which suggests that Cranach was already working on the woodcut border by that time.

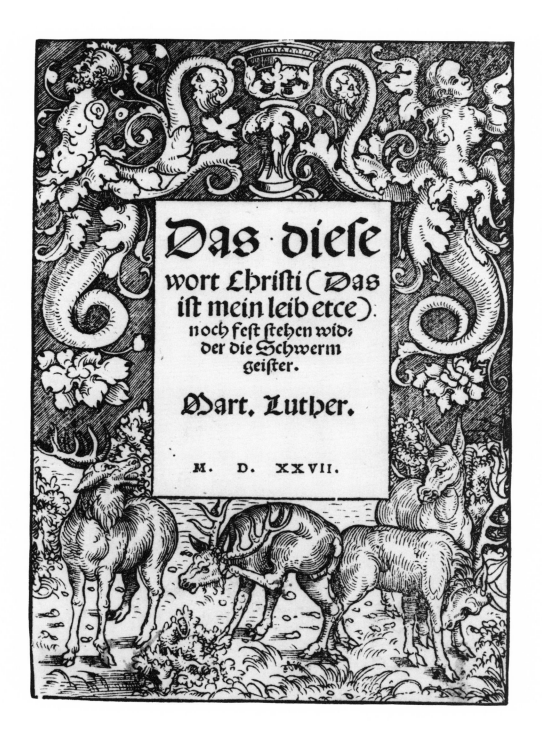

Das · diese wort Christi (Das ist mein leib etce): noch fest stehen wid: der die Schwerm geister.

Mart. Luther.

M. D. XXVII.

205

Das Babstum mit seynen gliedern gemalet und beschryben, gebessert und gemehrt, Nuremberg, Hans Guldenmund, 1526

New white vellum binding, 203 x 165 mm

LbC: Sig. LuIa 1526, 11

References: Luther 1883-1978, XIX: 1-43 (Edition 2); Pauli 1901: nos. 1124-1196; Dodgson 1903-11, I: 441, no. 6; Hollstein III: 236-237; Nuremberg 1961: no. 138; Kaltwasser 1961: no. 202; Geisberg/Strauss 1974: nos. 226-233; Basel 1974, I: no. 252; Gotha 1976: pl. 4

Sebald Beham

The Papacy

Hand-colored woodcut (fol. Aii), 80 x 60 mm

This Protestant tract is a kind of illustrated catalogue of the Catholic clergy and its corruption. The 73 woodcuts (each approximately 80 x 60 mm) by Sebald Beham portray, in descending order, the ranks of the clergy and representatives of different religious orders, each accompanied by a text describing their identifying dress and misdeeds. The author of the text that goes with each figure remains anonymous, but the preface and conclusion were written by Luther. He accuses the pope and all his subordinates of greed and of deceiving the people by promising salvation through their church offices; but all this, he continues, is coming to an end, thanks to God who has revealed these false teachers for what they are. Beham was evidently more concerned with showing how these figures looked in their particular habits than with suggesting their character. There is little hint in his representations of the offenses described in the text. These woodcuts are based on a series of 57 similar figures, prepared in Cranach's workshop and published in Wittenberg with the same text at the beginning of 1526. The title of the Nuremberg edition alludes to the earlier and slightly shorter publication, but claims its own superiority in the final three words, *The Papacy with its members, illustrated and described, improved and expanded.*

Beham eliminated the border line and the background clouds found in the Cranach models, leaving each figure on its little clump of landscape, silhouetted directly against the page. Compared to their Wittenberg forerunners, Beham's figures are more compact and more crisply drawn. The same text and woodcuts were also printed in the form of broadsheets. This copy of *Das Babstum mit seynen gliedern* is especially striking for its contemporary hand-coloring, which has been applied with unusual care and skill.

Vorred

Christlicher leser merck vnd sihe
Wie dir seind fürgemalet hie
Der verderlichen Secten schar
Vor den vns Petrus warnet klar .2.Pet.2
Die des herzen verleucknet hand
Vnd durch jre werck Sect vnd stand
Haben gesucht der seelen heyl
Auch vns verfürt den maysstentheyl
Auff menschen ler gesetz vnd gepot
Dar durch wir hand gelestert gott
Vnd sein wort/den weg der warheyt
Hand wir verlassen lange zeyt
Auch hand sie mit erdichten wortten
Mit vns handirt an allen orthen
Durch geytz sie vns betrogen hand
Vmb eer vnd gut lewt vnd land
Bytz auff das hinderst dise secten
Wie in Egypto die Heüschrecken Exodi.10
Allenthalb abfretzten das feld
Also diß secten vnerzelt
Auch bey den jren früchten kene Matth.7.
Der hernach zwo vnd siebentzig stehnt
Die seind des Babsts schifft außleger
Der voran steht/vnd ist jr pfleger
Christus het zween vnd siebentzig fürst
Lerten das Euangelium Luc.10.
Aber dise das volck betrygen
Dem Babst heücheln schmaychlen vnd liegen
Auff das bestan seyn regiment
Wie wol es fast ist an dem end
Gott sey lob das man sie itzt kent

Des Babsts standt

Ach herr gott wem söllen wirs klagen.
Wie erbärmlich ist es zü sagen
Das lange zeyt vnd manches jar
Verfürt ist worden grosse schar
Auß allem land vnd nation
Der man nicht wol eyn zal mag han

A ij

Biblisch Historien, Figürlich fürgebildet, Durch den wolberuemten Sebald Behem, von Nuermberg, Frankfurt, Christian Egenolph, 1533

18th-century binding in brown paper over boards, 181 x 139 mm

VC: Sig. B 5 (I 116-119, 328-405)

References: Rosenthal 1882: 379-380, no. 11; Pauli 1901: nos. 271, 277-356; Dodgson 1903-11, I: 440, no. 1; Hollstein III: 166; Schmidt 1962: 175-178; Vienna 1969: no. 50

Sebald Beham

Samson Pulling Down the Temple

Woodcut (fol. fiᵛ), 51 x 70 mm

Sebald Beham

Samuel Anointing David

Woodcut (fol. fiiʳ), 51 x 70 mm

This small quarto volume, *Bible Stories illustrated by the famous Sebald Beham from Nuremberg,* contains 80 woodcuts plus an illustrated title page. Captions are the only text. According to Dodgson, this edition of 1533 survives in only three complete copies, the one in Coburg and those in the British Museum and in the Universitätsbibliothek, Göttingen. All but five of the woodcuts represent scenes from the Old Testament. The exceptions are four woodcuts of the Evangelists and one of Saint Paul. The publisher, Christian Egenolph, used the same blocks in 1534 for his Bible, most of which was based on Luther's translations and which came off the press some six months before the first complete Luther Bible was published in Wittenberg. It seems likely that Egenolph commissioned the woodcuts primarily with the Bible in mind, especially since Old Testament scenes in woodcut were normally intended for such use. Furthermore, the oblong format was standard for Bible illustrations, except for those that filled the whole page. Hans Holbein the Younger's Old Testament woodcuts of about 1529/30, not much larger than these, are a case in point, although their publication was delayed until 1538. There were, however, ample precedents for publications devoted primarily to woodcuts of scenes from the New Testament, notably Dürer's *Apocalypse* and both his *Large Passion* and *Small Passion.*

In Beham's illustration, *Samuel Anointing David,* there are vivid reminders of Dürer's woodcuts, in particular the *Noli me tangere* from the *Small Passion* (Washington 1971: no. 188), first published in 1511, including the figure of Samuel with his pointing gesture in the foreground, the landscape, the radiant sun on the horizon, and, of course, the graphic style in general. Yet, it is against the classicizing style of Holbein rather than against the complex and emotional designs of Dürer that Beham's interpretations must be measured. Held to such a standard, Beham's figures lack a certain monumentality and natural, expressive movement, but within the miniature format the compositions are admirably clear and concise.

Samson bringt sich vmb mitt den Phili=
stern. Judic. xvi.

Samuel salbt Dauid zum künig.
i. Reg. xvi.

S ij

[Johannes Walther] *Epitaphium Des Ehrwirdigen Herrn und Vaters Martini Luthers, der Heiligen Schrifft Doctorn, und des reinen wahren Evangelions trewen Lehrers und Predigers,* Wittenberg, Georg Rhau, 1546

New white vellum binding, 190 x 153 mm

LbC: Sig. LuIa 1546, 5

References: Schuchardt 1851-71, II: nos. 171 (178?), 182, 185; Dodgson 1903-11, II: 345, no. 25a; Clemen 1921-22; Stammler 1924: 326-328; Hollstein VI: 148, no. 44

Lucas Cranach the Elder, Workshop of

Duke Johann Friedrich the Magnanimous of Saxony

Woodcut (fol. Ai^v), 113 x 89 mm

In 1546, the year of Luther's death, Georg Rhau published this memorial leaflet, *Epitaph of the Honorable Gentleman and Father. Martin Luther. Doctor of the Holy Scripture, faithful Teacher and Preacher of the pure, true Gospels.* Luther's portrait appears twice: on the title page in a small medallion, below which there is the rhymed slogan, *"Gott und sein Wort bleibt ewig stehn / Des Babsts gewalt wird bald vergehen"* ("God and his word will stand forever / The pope's might will soon be gone"), and on the back in a woodcut, also dated 1546, by Lucas Cranach the Younger. When opened, the leaflet shows a portrait from the Cranach workshop of Luther's protector, Johann Friedrich the Magnanimous of Saxony, surrounded by six of his ducal coats of arms (see cat. no. 186). The six rhymed couplets on the facing page are written as if spoken by Luther himself. They tell of his birth at Eisleben, his move to Wittenberg, and explain that God broadcast his words through Luther and thereby brought the papal empire and its tyranny to an end. Although the verses are unsigned, Stammler (1924: 326-328) has shown persuasive evidence that their author must be Johann Walther, the choirmaster at Torgau who arranged Luther's most famous hymn "A Mighty Fortress is Our God." Rhau, a Protestant publisher of music in Wittenberg, was well acquainted with Walter, some of whose work he had already published. It is understandable that these two men should have collaborated on this occasion in memory of their mutual, musical friend and spiritual leader.

The *Epitaphium* is exceedingly rare in this leaflet form and represents an early example of what one might call an offprint. The standard references to this title (Schottenloher 1956-66: no. 10, 953a; and Holzmann/Bohatta 1902-28, VII: no. 3210) describe a publication comprising two quarto signatures, as reproduced in facsimile by Clemen in 1921. The first four pages of that publication are identical to this leaflet, but the former continues for 12 more pages containing another poem about Luther, also written in the first person. According to Stammler, that poem, too, was composed by Walther. Because of the way quarto signatures are normally printed and folded, it is not possible to remove the first four pages as a single sheet of paper. Therefore, the printer had to take extra steps to produce this leaflet, either by re-imposing the type and woodcuts before printing it, or by printing the first quarto of the 16-page *Epitaphium* so that those pages could be cut and assembled as two four-page signatures. Whichever way Rhau proceeded (and one would have to examine the signatures of the 16-page pamphlet to be certain), his ingenious plan resulted in a publication that could be issued in two independent forms, the shorter one simply extracted from the other.

EPITAPHIVM
Des Ehrwirdigen Herrn / Doctoris Martini Lutheri:

ZV Eislebn ist mein Vaterland
In Sachssen hat mich Gott gesand
Aus Wittemberg der werden Stad
Durch mich / sein wort / Gott geben hat
Dardurch das Bebstlich Reich gestürtzt
Vnd seine Tiranney verkürtzt
Im lieben Vaterlande mein
Bin ich inn Gott entschlaffen sein
Zu Wittemberg lig ich im grab
Gott lob fur sein gegebne gab
Balt werd ich widder Aufferstehn
Mit Jhesu Christ zur freud eingehn

A ij

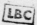

Georg Rhau, *Hortulus animae. Lustgarten der Seelen*, together with *Das Symbolum der Heiligen Aposteln, darin der Grund unsers Christlichen Glaubens gelegt ist, Ausgelegt durch, D. Mart. Luth., Mit schönen lieblichen Figuren*, Wittenberg, Georg Rhau, 1548

18th-century half-leather binding with marbled paper over boards, 203 x 165 mm

LbC: Sig. R II 8/10

References: Dodgson 1903-11, II: nos. 91a-102a; Ficker 1923: 59-68; Zimmermann 1929; Jahn 1955: 48-50; Hollstein VI: 79, nos. 53-64; Geisberg/Strauss 1974: nos. 581-592; Basel 1974, I: 395-398, nos. 274-276 and II: 425-436

Lucas Cranach the Elder

The Beheading of Saint Matthias

Woodcut (fol. giv), 162 x 126 mm

The *Hortulus animae (Garden of the Soul)* is the title given to a type of illustrated devotional book published in numerous editions from the end of the 15th century (see Oldenbourg 1973). Known in German as the *Lustgarten der Seelen*, it was an anthology of prayers with devotional images, not unlike the French Books of Hours. The *Hortulus animae* was a late medieval, catholic work, and as such did not survive the Reformation, but Georg Rhau, the Protestant publisher of music in Wittenberg, compiled a new version under the same title with texts by Luther, Melanchthon, and others, which he dedicated to his five daughters as a book of instruction and inspiration. For most of the illustrations, he reused blocks that Cranach had made for the *Heiligtumsbuch*, an illustrated catalogue of reliquaries in Wittenberg, published in 1509. Rhau issued his *Lustgarten der Seelen* together with a book that had been first published in 1539, called *Das Symbolum der Heiligen Aposteln* "in which," as the title continues, "lies the basis of our Christian belief, interpreted by Dr. Martin Luther, with beautiful, pleasing images." Those images, so described, are 12 painfully explicit scenes of the Apostles' martyrdoms. Cranach had produced these woodblocks around 1512, and by the time of this edition in 1548 the signs of their wear are plainly visible.

The Apostle in the last of the 12 woodcuts is identified as Saint Matthias, whose usual attribute in representations at this time is an ax, in reference to his beheading. Here, one encounters his martyrdom by the unusual, though not unprecedented, means of the guillotine (see Basel 1974, I: no. 274 and II: no. 436). Opposite the picture are printed the words," I believe that after the resurrection will be an eternal life for the saints and an eternal death for the sinners. . . ."

Vnd ein ewiges Leben/Amen.

ICh gleube/ das nach der Aufferstehung
sein wird/ein ewiges Leben der Heiligen/ vnd
ewiges sterben der Sünder/ Vnd zweiuel
an dem allen nicht/Der Vater durch den
Son Jhesum CHRistum vnsern
HErrn/ mit vnd in den Heiligen
Geist/ werden mir die stücke alle
lassen geschehen/ das heist
Amen/ das ist/Das ist
trewlich vnd ge=
wis war.

g ij

Luther Bibles

209

Das Allte Testament deutsch. M. Luther, Wittenberg, Melchior and Michel Lotter, 1523; *Das Ander teyl des alten Testaments*, Wittenberg, Christian Döring and Lucas Cranach the Elder, 1524; *Die Propheten alle Deudsch. D. Mart. Luth.*, Wittenberg, Hans Lufft, 1532

Contemporary binding in pigskin over wooden boards, 318 x 247 mm

LbC: Sig. P I 3/2:1-3

References: Luther 1883-1978: *Die deutsche Bibel*, Edition nos. *5, *11, (3), *38; Schramm 1923: 6-7, 10-12, nos. 36-53, 120-144; Kaltwasser 1961: nos. 679, 680, 682; Schmidt 1962: 137-146; Hollstein VI: 13-15; Luther 1972, I: 62*-70*; Basel 1974, I: 331-336; Volz 1978: 94-106, 111-130

Lucas Cranach the Elder

David and Bathsheba from *Das Ander teyl des alten Testaments*

Woodcut (fol. Pii^r), 120 x 157 mm

Color plate IX

The enormous impact made by Luther's translation of the Bible is in itself an indication that his work was urgently needed. He was by no means, however, the first to undertake the task. Between 1466 and 1522, no fewer than 18 editions of the Bible were printed in German. Luther's translation had three advantages over those of his predecessors. It was consistent, rather than being pieced together from the work of various anonymous translators of uneven ability. It was based on the original Greek and Hebrew texts (although Luther consulted the Vulgate, he was not dependent upon it as earlier translators had generally been). And finally, as every student of the German language knows, it was written in a clear, powerful, and evocative style that became the standard for High German for the future. Although Luther was an astonishingly fluent translator, 12 years passed from the beginning of the project until the first complete Bible was published in 1534. The New Testament, which Luther translated in only 11 weeks while he was living in the security of the Wartburg (see cat. no. 128), was published in Wittenberg in September 1522 and consequently has become known as the September Testament. Most of the Old Testament was published the following two years in three parts. The present volume contains the first two parts (the Pentateuch [1523] and the Books of Joshua through Esther [1524]), bound together with Luther's translation of the Books of the Prophets, which was not published until 1532.

The illustrations for these first editions of Luther's New and Old Testament were produced in the workshop of Lucas Cranach. Some, like *David and Bathsheba* qualify as the work of the master himself, although the question of attribution for all these woodcuts remains unsettled. In the September Testament only the Apocalypse is illustrated. It contains twenty-one full-page woodcuts, six more than Dürer's influential series (see cat. nos. 130-132). In three of these the papal tiara is prominently worn by the Beast of the Apocalypse and the Whore of Babylon, although for subsequent editions this blatant reference was modified in the woodblocks. The first part of the Old Testament contains 11 illustrations, and the second part (*Das Ander teyl . . .*), 23 plus a title page bearing a military figure, presumably Joshua, dressed in a full suit of contemporary German armor. (For this section, Luther himself indicated in five places in the margin of his manuscript which passages from the story of Samson he wished to be illustrated.)

Cranach and the goldsmith Christian Döring had undertaken the financial responsibilities of publishing the September Testament, and the following year, they installed a press in Cranach's house and served as printers and publishers for *Das Ander teyl des alten Testaments*. With many assistants working on book illustrations as well as on paintings, Cranach was also in a position to have the books hand-colored. Not all the coloring in this volume was done with equal care, but the choice of colors is consistent with that seen in paintings from Cranach's shop.

Das eylfft Capitel.

Left margin column (partial text):
```
r dar;
10 er;

bart
d lies
egen/
f sage
r.

fend
ufes
lcks/
weiff
itzen
keten
von

vnd
ustet
r die
Ams
myr
h dir
lck/
yhm

r/zu
kin;
isssf/
Ams
e ges
Eser
uret
roch

ael/
uste
hen
gen
slug
wa
mit
sich
itel.
```

Nd da das iar vmb kam/zur zeyt wenn die könige pflegen aus zuzihen/ sandte Dauid Joab vnd seyne knechte mit yhm/vnd das gantze Israel/das sie die kinder Ammon ver derbeten/vnd belegten Rabba/Dauid aber bleyb zu Jerusalem.

Vnd es begab sich/ das Dauid vmb den abent auff stund von seynem lager/vnd gieng auff dem dach des königs hause/ vnd sahe vom dach eyn weyb sich wasschen/Vnd das weyb war seer schoner gestalt. Vnd Dauid sandte hyn vnd lies nach dem weybe fragen/ Vnd sagen/ ist das nicht BathSeba die tochter Eliam das weyb Vria des Hethiters? Vnd Dauid sandte boten hyn vnd lies sie holen/vnd da sie zu yhm hyneyn kam/ schlieff er bey yhr/ Sie aber heyliget sich von yhrer vnreynickeyt/ vnd keret widder zu yhrem hause.

Vnd d is weyb wart schwanger/ vnd sandte hyn vnd lies Dauid verkundigen vnd sagen/ Ich byn schwanger worden. Dauid aber sandte zu Joab/Sende zu myr Vria den Hethiter/ Vnd Joab sandte Vria

P ij

210

Das Newe Testament Mar Luthers, Wittenberg, Hans Lufft, 1530

Contemporary binding in brown calf, 190 x 153 mm

LbC: Sig. P I 6/12

References: Luther 1883-1978: *Die deutsche Bibel* (Edition no. *34); Schramm 1923: 17-18, nos. 190-225, 227; Zimmermann 1924: 37-41; Kaltwasser 1961: no. 686; Luther 1972, I: 84*-86*, app. 160*, no. 127; Volz 1978: nos. 225-226

Master AW

Gog and Magog

Woodcut (fol. rviii^v), 117 x 80 mm

During the year 1529, Luther, together with Philipp Melanchthon, worked on a revision of the New Testament that Hans Lufft printed three times in 1530. The present volume is from the third printing of that year. Cranach and Christian Döring had given up their printing business in 1525 or 1526, and about the same time Melchior Lotter, who had printed the September Testament and the first part of the Old Testament, returned to Leipzig. Luft soon emerged as the principal printer of Luther's Bible. This handy octavo edition follows Lotter's 1524 printing of the New Testament both in format and in illustrations. Those illustrations had been designed by Georg Lemberger, whose vigorous woodcut style owed much to Albrecht Altdorfer and Wolf Huber of the Danube School. Lufft's anonymous illustrator, called the Master AW because those initials appear on some woodcuts he made for Luther's exegetical *Kirchenpostille,* published by Lufft in 1528, derived his style and many specific designs from Lemberger. Of the 21 woodcuts by Lemberger for the Book of Revelation, no fewer than 18 were adopted with only slight changes for the illustrations in this edition of the New Testament. However, the Master AW was not incapable of inventiveness. He designed a new version of the *Opening of the Seventh Seal* (Revelation 8:1-6) and added four woodcuts of the first four angels with trumpets, in which the angels appear as lively Renaissance putti dressed in a sort of Roman soldier's outfit. The Master AW's angels and, to an extent, his compositions themselves subsequently inspired the illustrator of the first complete Luther Bible, published in 1534 (see cat. no. 211).

Of particular historical interest is the woodcut illustrating the story of Gog and Magog (Revelation 20:7-9):

> And when the thousand years are expired, Satan shall be loosed out of his prison,
>
> And shall go out to deceive the nations which are in the four quarters of the earth, Gog and Magog, to gather them together to battle: the number of whom is as the sand of the sea.
>
> And they went up on the breadth of the earth, and compassed the camp of the saints about, and the beloved city: and fire came down from God out of heaven, and devoured them.

In September 1529, the Turkish Sultan, Suleiman, had laid siege to Vienna, but on October 14, after several unsuccessful assaults and with heavy losses, the Ottoman army withdrew. The news of this event was instantly translated into the image seen here: the city is identified as Vienna by the prominent tower of Saint Stephan's Cathedral as well as by the inscription on its outer wall, and the turbaned sultan, one of whose tents bears the words GOG / MAGOG, falls into the abyss with some of his troops under a rain of fire.

211

Biblia: das ist die gantze Heilige Schrifft: Deudsch Auffs New zugericht. D. Mart. Luth. Begnadet mit Kürfürstlicher zu Sachsen Freiheit, Wittenberg, Hans Lufft, 1541

Contemporary binding in dark brown morocco over wooden boards, 406 x 330 mm

LbC: Sig. P I 1/10

References: Luther 1883-1978: *Die deutsche Bibel* (Edition no. *69; Dodgson 1903-11, II: 404-405; Schramm 1923: 22-27, 38, nos. 249-265; Zimmermann 1927: 70-75; Kaltwasser 1961: no. 673; Schmidt 1962: 179-193; Luther 1972: 104*-111*, app. 145*-160*; Volz 1978: 154-156

Master MS

The First Four Angels with the Trumpets
(illustrated on p.p. 374-375)

Hand-colored woodcuts (fols. xiiiv-xvr), approx. 106 x 145 mm each

Master MS

The Great Beast Thrown into the Lake of Fire

Hand-colored woodcut (fol. yvir), approx. 106 x 145 mm

Color plate X

This Bible of 1541 follows by seven years the first complete Luther Bible, but it is distinguished from the preceding editions in that the translation had just been thoroughly revised through the collaborative efforts of Luther, Philipp Melanchthon, Justas Jonas, Johann Bugenhagen, and others. It utilizes the same woodcuts that had been prepared for the 1534 edition. The proofreader, Christoph Walther, reported that Luther had taken a special interest in the woodcuts, selecting certain passages for illustration and giving instructions on how they should be done (Volz 1978: 154). He wanted the illustrations to conform to Scripture in a simple and direct manner and would not tolerate elaboration that was unjustified by the text. Whether Luther also had a part in choosing the illustrator, is unknown, and the artist's name remains a mystery. He is called simply the Master MS after the initials that appear on some of the woodcuts.

Aside from the Evangelist portraits, the illustrations in this New Testament are restricted, as is customary in Luther Bibles, to the Book of Revelation. There are 26 woodcuts of the Apocalypse in this edition, depicting the same scenes as in the octavo Bible of 1530 (cat. no. 210). The four woodcuts representing the first four angels with trumpets have been laid out two to a page on facing pages. The accompanying text narrating each scene is from Revelation 8:6-13.

> The first angel sounded, and there followed hail and fire mingled with blood . . .

> And the second angel sounded, and as it were a great mountain burning with fire was cast into the sea . . .

> And the third angel sounded, and there fell a great star from heaven, burning as it were a lamp . . .

> And the fourth angel sounded, and the third part of the sun was smitten, and the third part of the moon, and the third part of the stars; so as the third part of them was darkened . . .

The artist used the traditional oblong format to create expansive landscapes that suggest the worldwide dimensions of the events taking place. Although some of the other compositions in the series are based on those from the Apocalypse woodcuts in the September Testament, the graphic style of the Master MS has little to do with that in the illustrations from the Cranach shop. The Master MS's clearly defined, compact forms are much closer to Hans Holbein the Younger's *Apocalypse* woodcuts (also made after Cranach's), which accompanied an octavo reprint of Luther's translation published in Basel by Thomas Wolff in 1523. The influence of Cranach is strongly present, however, in the coloring of the illustrations in this Bible, for example, the combustious reds and yellows applied to the illustration (pl. X) of the great beast being "cast alive into a lake of fire burning with brimstone (Revelation 19:20).

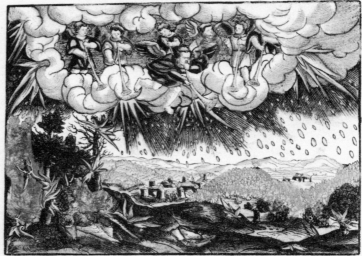

H.

Das ist Ta-
tianus / vnd die
Encratite / welche
die Ehe verboten
vnd Werckheilli-
gen waren / wie
hernach mals / die
Pelaglaner.

VND die sieben Engel mit den sieben Posaunen hatten sich gerüstet zu po-
saunen. VND der erste Engel posaunete / Vnd es ward ein Hagel vnd
Fewer mit Blut gemenget / vnd fiel auff die Erden / Vnd das dritte teil der
Bewme verbrandte / vnd alles grüne Gras verbrandte.

H.
TATI-
ANVS.

I.

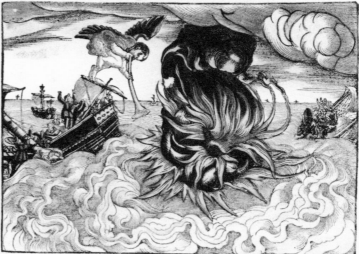

Das ist
Marcion / Ma-
nicheus mit sei-
nen Cataphrygen.

VND der ander Engel posaunete / Vnd es fuhr wie ein grosser Berg mit
Fewer brennend ins Meer. Vnd das dritte teil des Meers ward Blut /
vnd das dritte teil der lebendigen Creaturen im Meer storben / vnd das dritte
teil der Schiff wurden verderbet.

I.
MAR-
TION.

Das ist Ori
genes.

VND der dritte Engel posaunete / Vnd es fiel ein grosser Stern vom Himel
der brandte wie eine Fackel / vnd fiel auff das dritte teil der Wasserströme
vnd vber

K.
ORIGE-
NES.

K.

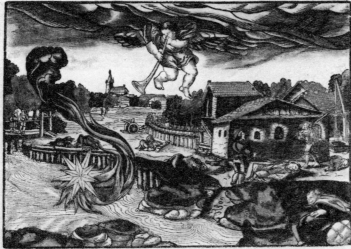

vnd vber die Wasserbrünne/vnd der name des Sterns/heisst Wermut. VND das dritte teil ward wermut/ Vnd viel Menschen storben von den Wassern/ das sie waren so bitter worden.

L.

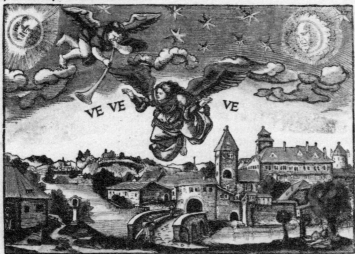

VE VE VE

VND der vierde Engel posaunete/Vnd es ward geschlagen das dritte teil der Sonnen/vnd das dritte teil des Monden/ vnd das dritte teil der Sternen/das jr dritte teil verfinstert ward/vnd der tag das dritte teil nicht schein/ vnd die nacht desselbigen gleichen. VND ich sahe/vnd höret einen Engel fliegen mitten durch den Himel/vnd sagen mit grosser stimme/WEH/ weh/ weh/ denen die auff Erden wonen/ fur den andern stimmen der Posaunen der dreier Engel/die noch posaunen sollen.

L.
Drey
VVEH.

NOVA-
TVS.
Das ist No-
uatus vnd die Ca-
thari/Die die Bu-
sse leugnen/ vnd
sonderliche Heili-
gen sind fur an-
dern.

VND der

212

[Johann Freiherr von Schwarzenberg], *Bambergische Halsgerichts Ordenung*, Mainz, Johann Schöffer, 1508

Contemporary half-leather binding in pigskin over wooden boards, 277 x 208 mm

LbC: Sig. Cas A 717

References: Kohler/Scheel 1902; Wolf 1963: 102-137; Anzelewsky 1965: 134-136; Nuremberg 1979: no. 68; Merzbacher in Hinckeldey 1980: 181-187

Inquisition by Torture

Woodcut (fol. Biv^v), 129 x 135 mm

The *Bambergische Halsgerichts Ordenung* was designed to make the administration of German criminal justice fairer and socially more beneficial. As a magistrate in the diocese of Bamberg, its author, Johann Freiherr von Schwarzenberg, was well aware of the shortcomings in a legal system that lacked consistent standards and procedures. He did not seek to write new law but to consolidate the best of what existed. His code was in many ways very traditional, following procedures of harsh inquisition and judgments, as suggested by the daunting title, *Halsgerichtsordnung* (modern spelling), literally "Code of the Neck Court." The inclusion of a woodcut of the *Last Judgment* near the beginning of the book shows that the concept of divine judgment was still inseparable from contemporary ideas about penal law. Schwarzenberg was neither a jurist nor a humanist by training, yet he was guided in his outlook by the Ciceronian ideals of justice and utilitarian ethics, which had been revived by Renaissance scholars. His interest in Cicero also led him to prepare a German edition of *De officiis* (cat. no. 214).

Georg, Bishop of Bamberg, who wrote the preface to the *Halsgerichtsordnung*, considered the woodcuts to be an important part of the book. He explains that the illustrations and accompanying rhymes are coordinated with the text for the benefit of the common man. Presumably, the woodcut of the man being prepared for questioning under torture was intended as a warning not only to stay out of trouble but to give a free and truthful confession if guilty of a charged crime. In addition to the judge, who holds the staff of his office, an assessor of the court and a court clerk assist at the questioning, as was required by court procedure. The accused, whose hands are being tied behind his back, is about to be winched into the air by the chain in the background. If what he says still does not satisfy the judges, they may order the large weight to be tied to his feet while he is still suspended. The rhymed caption to the illustration says: "Since there has been found fair evidence that you have committed the crime, and you cannot prove your innocence according to counsel, the questioning under torture shall take place." Although he did not try to abolish this sort of questioning, Schwarzenberg objected to the thoughtless application of torture, and one of his reforms was to lay down strict limitations on its use. He defined eight circumstances, at least two of which had to apply before an accused who denied his guilt could be questioned in this way. These included a previous conviction and certifiably bad reputation; presence at the scene of a crime; personal gain from the crime; attempted flight; and sworn accusation by the injured party.

The *Halsgerichtsordnung* was first published in 1507 by Hans Pfeil in Bamberg. It went through nine editions by 1580, of which this is the second. The woodcuts in this edition were copied with minor changes from those by Wolfgang Katzheimer in the first edition.

sunst/ausserhalb des diebstals seyn vermögen sein möchte. Vnnd der verdacht
nit ander güt vrsache anzeigen kan/wo ym das angezeygt arckwenig güt her
kumpt. Ist es dañ ein sölche person zü der man sich der myssetat versehen mag.
So ist redliche anzeygung der myssetat wider sie verhanden.

Von zauberey genugsame anzeygung.

lv
Wo dise sunderlich
anzeygüg d'myssat
wid' eyn verdachte
person nit gnügsa
erfundē werdē mö+
gen: so such weiter
douoin in den Ar+
tickeln die zügemei
ner anzeygung al+
lerley myssetat ge+
satzt seint an dem.
xxxv. artickeln an
fahent.

Item So yemandt sich erbeüt andere menschen zauberey zulernen/od' yemãt
zubezaubern drouwet/Auch sunderliche gemeynschafft vñ geselschafft mit zau
beren oder zauberin hat/oder mit sölchen verdechtlichen dingen geberden/wor
ten vnd weisen vmbgeet/die zauberey auff jne tragen/das gibt ein redlich an
zeygung/der zauberey.

Seyt sich auff dich er funden hat Redlich anzeyg der myssethat
Fürstu nit vnschuldt auß nach rade Die peynlich frag soll haben statt.

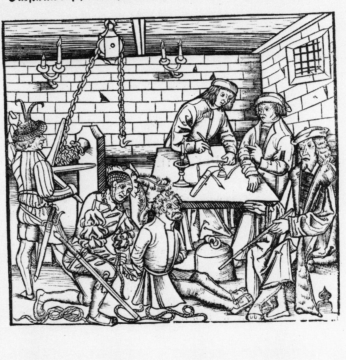

213

Georg Rüxner, *Anfang, Vrsprung, vnnd Herkommen des Thurnirs in Teutscher Nation. Wieuil Thurnier biss vff den letsten zu Worms, auch wie vnd an welchen Ortten die gehalten, vnd durch was Fürstenn, Grauen, Herrn, Ritter vnnd vom Adel, sie ieder Zeit besucht worden sindt . . .*, Simmern, Hieronymus Rodler, 1530

Contemporary binding in black leather over wooden boards, 333 x 220 mm

VC: Sig. B 19a

References: Nagler 1858-79, III: no. 1039; Davies 1913: no. 373; Benzing 1963: 391; Spohn 1973: 79-81; Washington 1977: no. 658

Tournament

Woodcut (fol. hiir), 241 x 349 mm

Rüxner's book is a history of the tournament in Germany from the first competition, held at Magdeburg by Emperor Heinrich I, the Fowler, in the year 942, up through the tournament held at Worms in 1487. It covers 36 tournaments altogether. In the introduction, addressed to Johann, Count Palatine and Duke of Bavaria, Rüxner acknowledges his debt to a treatise by Marx Wirsung, merchant and publisher in Augsburg, for the early history of his subject. In 1527 the book received a copyright privilege for six years from Charles V, whose imperial coat of arms fills an entire page. The woodcuts, many of which are repeated, illustrate the tournaments themselves, the presentation of prizes to the victors, and the banquets, dances, and other festivities that were held on such occasions. The participants and the town where the tournaments took place are represented by nearly 250 coats of arms. This double-page woodcut of a tournament, as well as the page with the arms of Charles V, is signed with the initials HH. This artist's woodcut style is closely related to that of Hans Burgkmair and other designers of woodcuts in Augsburg who prepared the illustrations for the *Weisskunig* and *Theuerdank* (see Burgkmair biography). There is some evidence that the artist is identical with the Count Palatine himself, who frequently appears in contemporary documents as Hans von Hunsrück or Herzog Hans (Spohn 1973: 81-94). The setting of the tournament in a town square with spectators viewing the event from the balconies and windows of surrounding buildings gives a generally realistic picture of such events, as one also sees them represented in Cranach's first tournament woodcut of 1506 and in the engraving by the Master MZ (cat. no. 176).

Diß ist ein Figur vnd eygentliche anzeygung eyns gantzen Thurniers / wie der vorzeiten / durch die Ritterschaffe vnd vom Adel gehalten.
Wie vnd was darin mit Seyl abhawen durch die griesswerel / Empahung / Thurnierung mit den kolben / Cleynoter abhawung mit
den schweeren Geraffung deß schlagens / schranckenfetzens vnd außziehens rc. gehandelt worden.

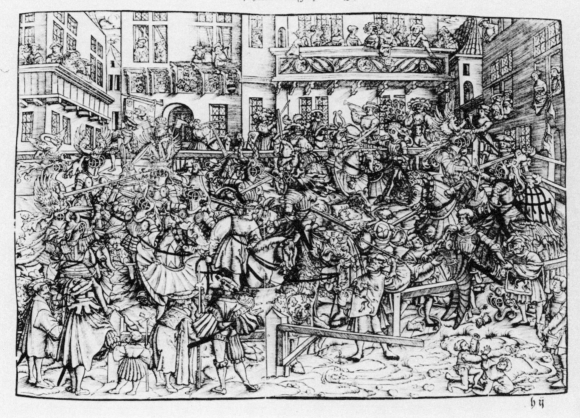

h ij

Marcus Tullius Cicero, *Officia M.T.C. Ein Buch, So Marcus Tullius Cicero der Römer, zu seynem Sune Marco, Von den tugentsamen emptern, und zugehörungen, eines wol und rechtlebenden Menschen, in Latein geschriben, Welchs auff begere, Herren Johansen von Schwartzenberg rc. verteutschet, Und volgens, Durch ine, in zyerlicher Hochteutsch gebracht, Mit vil Figuren, unnd Teutschen Reymen, gemeynem nutz zu gut, in Druck gegeben worden*, 2nd ed., Augsburg, Heinrich Steiner, 1532

Contemporary binding in black calf over wooden boards, 330 x 229 mm

LbC: Sig. Cas A 1725

References: Röttinger 1904: no. 43; Dodgson 1903-11, II: 143, no. 12; Ivins 1926: 39-51; Musper 1927: nos. 516-517; Fraenger 1930; Scheidig 1955: 24-26

Hans Weiditz

A Knight Climbing a Ladder to Heaven

Woodcut (fol. XLIII^v), 155 x 95 mm

Hans Weiditz

Robbers Dividing Their Plunder

Woodcut (fol. XLIX^r), 94 x 155 mm

Cicero's treatise on moral duties *(De officiis)*, composed as a letter to his son Marcus, was one of the first classical texts made widely available to Renaissance humanists by means of the printing press, when Johann Fust and Peter Schöffer published their Latin edition at Mainz in 1465. By the early 16th century, however, the audience for classical texts in Germany extended well beyond Latin-reading humanists. Johann Freiherr von Schwartzenberg (see cat. no. 212) belonged to this larger group. With the aid of a translation prepared by his chaplain, Johann Neuber, Schwartzenberg reworked the German and provided rhymes to accompany the illustrations of the present version, first published in 1531. The impulse to make classical texts available in the vernacular and to enliven them with illustrations is similar to Luther's determination to put the Bible in the hands of all German Christians. Of course, Luther was struggling above all to break the clergy's hold on the Scriptures, but beyond that he had, as did Schwartzenberg, a deep commitment to his own language and culture.

The text as well as Weiditz's illustrations of this German edition of Cicero's work were ready for the press ten years before the book was actually published. The preface, written in 1530, conveys a sense of frustration as it explains the repeated delays. Only after Heinrich Steiner had acquired the project and the woodblocks from the original publishers, Sigmund Grimm and Marx Wirsung, did the book materialize in print. It was Steiner who first published (in 1532) Petrarch's dialogue, *On the Remedies of Good and Bad Fortune (Von der Artzney bayder Glück)*, also known as the *Trostspiegel*, which had likewise been an unrealized project of Grimm and Wirsung, with woodcuts by Weiditz. The art of this prolific illustrator was as modern as the German of the translated texts.

Weiditz doubtless drew with a pen directly on the blocks, filling the entire format with animated figures and settings. His style owes much to Hans Burgkmair, with whom he was once confused, but no other book illustrator's work presents such a far-reaching picture of contemporary life. In the *Officia* there are 97 woodcuts, not including the ones repeated, of which 33 were also used in the *Trostspiegel*. The illustration at the left pertains to Cicero's admonition that to obtain glory and the esteem of others one must:

> be free from all dishonour and also from those vices which others do not easily resist. For sensual pleasure, a most seductive mistress, turns the hearts of the greater part of humanity away from virtue; and when the fiery trial of affliction draws near, most people are terrified beyond measure. Life and death, wealth and want affect all men most powerfully (Book II: x [trans. by W. Miller, Loeb Classical Library III, London, 1921]).

Weiditz's interpretation shows a German knight climbing a ladder toward a vision of heaven, while the figures of Poverty, Sickness, Lust, and Death pull at him with ropes. On the right hand page is an illustration of Cicero's observation that even robbers must live by a code of justice among themselves, and if one robber does not divide the plunder fairly among his companions, he will be deserted or killed by the others (Book II: xii).

The strong reds, blues, and greens of the coloring in this copy of the *Officia* reveals a contemporary, if not particularly careful, hand. While the color adds brightness and definition to individual figures, the dense linear style would certainly have made the illustrations self-sufficient in black and white.

Wer sich left halten / solche band /　　Im rechten weg / hat nit bestand.
Die dise gleychnus / macht bekant.

Die wollust als aller sänfftteste herscherin / ziehe den mern teil d gemüt von tugenten / und werden noch mer erschrecket / so sie die fackeln d schmerzen anrüren / Dañ das leben / der todte / dye reychtumb / und armüt / bewegen allermaist die menschen. Aber wöllche glück uñ vnglück / mit hohem grossem gemüt verschmehen / und sich kainerley [weder lieb noch layd]ᵉ von grossen erbarn sachen / wenden lassen / wer ist dañ der / dé der schein vnd zier / solche er bestentliche tugent / nit wundert / daardurch wollust veracht / vñ ir ansechtung beider gerechtigkeit (dauon allein dye gütten männer iren namé haben) beharret wirt / vñ solche eygenschafft / hat der gütten menschen namen / nit vnbillich. Dañ nyemant mag gerecht sein / der schmerzen / tod / elend / ob armüt also fürcht / dz er dye

Armüt /　Kranckheit /　Wollust /　Tod.

ding / die dé selben wider seind (als dz lebé vñ die wollust)der billicheit fürgesetzt. Aber das gemain volck [dz die grossen wyrdé d gerechtikeit nit gnüg betracht vñ versteet]ᶠ verwundt sich allermeyst des / der von dé gelt mit bewegt wirt / Vnd in welchem mañ sie solches erkennen / den achten sie der ee zu regieren wyrdig ᵍ [Got der allmechtig geb / das wir in vnsern Christlichen regimenten / von solchen aller schedlichsten menschen / die sich mit gelt widerden gerechtigkeit bewegen lassen / gnediglich behüte vnd erlediget werden]ʰ also fundet sich auf voriger erzelung / das gerechtigkayt / alle vorgemelte drey ding zu der hohenn Gloria (als obsteet) gehörig volbringet / wann nach dem gerechtigkeit / vilen nützer / wirt dauon güttwilligkayt geporen. Aber daß vmb der gerechtigkayt willen / vnerbar sachen (darzü viler menschen begyrde inbrünstiglich gezogen)verschmecht vnnd veracht werden / Darauf volgt bey den leütten verwunderung vnnd gütter glaub.

Gerechtigkait

Gerechtigkeyt hat solchen wert /　　Erwürgens / so er nicht empfleücht.
Das ir zum teil der rauber gert.　　Drum / vnbestand der regiment /
Und wer auf in die raub entzeucht.　On gleich / vnd recht wirt leicht erkent.

Fürwar ein yeder stand menschlichs lebens / begert menschlicher hilff / vñ zu forderst gesellschafft / damit die gerechtigkeyt / nit leben vnd vertrawlich reden müg. Aber solche gesellschafft ist dir (so du die eygenschafft eines güttem gerechtem mans / vor an dir hast) bey andern gar schwer zu vberkommen. Es ist auch einem menschen / der sein leben einig im feld verbringt / nott / das er gerecht sey / vnd für gerecht gehalten werde. Dann ob solche eynige leut / nit gerecht zu sein gelaubt wurden / müsten sie irer vngerechtigkeyt halb / sonderlich so ir wonung mit kainer befestigung versorgt / von andern vil gesäligkeyt wartenn. Die gerechtigkeyt ist auch den kauffern / verkauffern / hinleyhen / bestellen / vnd zu regierung aller hendel vnd geschäfft not. Wañ gerechtigkeyt so groß krafft hat / das auch die / die sich mit vbelthaten vnd lassernneeren / on etliche teil der gerechtigkeyt / nit leben mügen / Dann welcher vnder den / die mit einander rauben / morden oder stelen / dem andern etwz mit gwalt nimpt / ob stilt / dé geben sie bey ine kein stat / vnd leiden in nit in irer gesellschafft. Desogleychen so ein ertzrauber ᵉ [der ander rauber vnd vbelthäter vns seinem gebot hat]den raub nit gleich teilet / der wirt darumm von seinen gesellen eintweder ertödt / oder durch verlassen / Dañ die rauber haben etliche satzung vnder in / den sie vnderthänig seind / vnd die gehalten haben wöllen. Vnd vmb gemelter gleichen theilung willen des raubs / der rauber Bargulus Illyricus (als bey dem Theopompo geschribenn ist)grosse

J　　Reych

Lucas Cranach the Younger

1515 Wittenberg—Weimar 1586

Lucas Cranach the Younger was trained in his father's workshop and worked there throughout his life. Until 1550, three years after Cranach the Elder followed Duke Johann Friedrich of Saxony into exile, the work of the son, signed with the same winged serpent used to identify other products of the shop, is difficult to isolate. He apparently took on additional responsibilities in the shop, however, after the death of his older brother Hans in 1537, the same year his father first became burgomaster of Wittenberg. Like his father, Lucas the Younger was a member of the city council of Wittenberg (1549-68), and in 1565 he, too, served as burgomaster. He perpetuated the distinctive, late Cranach style until his death at Weimar in 1586.

215

Fabian von Auerswald, *Ringer Kunst: fünff und achtzig Stücke, zu ehren Kurfürstlichen Gnaden zu Sachsen*, Wittenberg, Hans Lufft, 1539

18th-century binding in brown paper over boards, 298 x 207 mm

VC: Sig. B 2

References: Schmidt 1869; Dodgson 1903-11, I: 339, no. 1; Davies 1913: no. 48; Hollstein VI: no. 21; Coburg 1968: no. 23; Vienna 1971: no. 71; Basel 1974, I: no. 121

Lucas Cranach the Younger

Bruch uber Bruch des Habens einlauff and
Ein Bruch uber den Haben und Riegel

Woodcuts, 290 x 192 mm each

Ringer Kunst (The Art of Wrestling) was written by Fabian von Auerswald, who served as wrestling master at the court of Wittenberg and dedicated his book on this "honorable and noble sport of knights" to Duke Johann Friedrich. Auerswald explains in the foreword that he is now an old man, having been born in 1462—a statement which corresponds to his apparent age in the signed woodcut portrait by Lucas Cranach the Younger at the beginning of the book (fol. Aiii^r). On the basis of the portrait not only can the illustrations of the wrestling holds be attributed to the same artist, but the confident teacher who bests a much younger opponent in each of the demonstrations can also be identified as Auerswald himself. The illustrations and accompanying written instructions, not to mention Auerswald's smiling look of effortlessness, make the holds appear easy to learn, but like most books of instructions on athletics, it was undoubtedly enjoyed most by those who were already practiced at the sport. Despite his claim about the nobility of such exercise, Auerswald includes a few ways to break someone's arm or leg.

This treatise was preceded by three other printed books on wrestling (Davies 1913: no. 48; Basel 1974, I: no. 121), the earliest being a blockbook by Hans Worm of Landshut from about 1505 (Kunze 1975, I: 111). None of these, however, is nearly as extensive as Auerswald's book of 86 illustrations, the title notwithstanding. (In 1512 Dürer had also prepared at least part of a treatise on wrestling and fencing, but it was never printed, and only one of Auerswald's demonstrations corresponds to any of Dürer's 120 drawings of wrestling holds [Dörnhöffer 1907/09: xx, n. 4].)

Bruch vber Bruch des Hakens einlauff.

Ich bleib vnten jnn der wage stehen / vnd schlahe mit meinem rechten Arm seinen lin=
cken aus / vnd thu gleich / als wolt ich jm jnn Haken lauffen / vnd bleibe mit meinen
Beinen stehen / Daraus lerne ich / ob er den bruch des einlauffs des Haken kan / Kan
er jn / so kompt er selbst / so kom ich mit meinem rechten vber sein brust / vn dring jn vber
mein recht knie vberrück / kan er jn aber nicht / so nem ich den haken mit sein gehülffen.

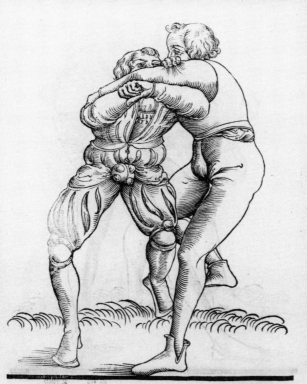

Ein Bruch

Ein Bruch vber den Haken vnd Riegel.

Wenn er mir jnn Haken gelauffen ist / so streck ich mein linck bein / so mus er jnn Rie=
gel / Er bleib nu im Riegel oder lauff mir jnn Haken / so trette ich mit meinem
lincken schenckel wol hinder jn hinaus / vnd gebe mich gantz nider jnn
die wage / vnd greiff mit meiner rechten hand nach seinem lincken
bein / vber seinem knöchel / so hat er keinen behelff mehr.

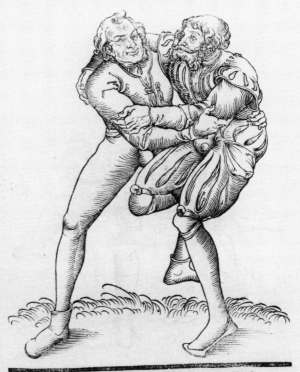

Bruch

216

Pedacius Dioscorides, *De medicinali materia libri sex . . . ,*
Frankfurt, Christian Egenolph, 1549

Contemporary binding in half-pigskin and black-dyed vellum,
325 x 220 mm

LbC: Sig. Cas A 696

References: Röttinger 1933: 64; Nissen 1951, II: no. 496

Pages 106-107 from Book Two, 313 x 190 mm each

The 786 woodcuts that illustrate this edition of Dioscorides'
De medicinali materia (Of Medicinal Substance) were taken
from or based on other books, such as Rösslin's *Kreutterbuch
(Book of Herbs)* of 1533, also published by Christian
Egenolph, and the 1542 *De historia stirpium (On the History
of Plants)* by Leonard Fuchs. In the history of illustrated
herbals, therefore, it is minor in comparison with these sources
or other forerunners, especially Brunfel's *Herbarum vivae
eicones* (Living Pictures of Herbs), published 1530-36, with its
magnificent woodcuts after drawings by Hans Weiditz. How-
ever, the practical design of the present book, which combines
a small illustration with each corresponding passage of text,
is essentially the arrangement found in modern encyclopedias
and dictionaries. Egenolph, who also established the first type
foundry in Frankfurt, set the small woodblocks at the begin-
ning of each short chapter of the text in a manner that is remi-
niscent of the small figural scenes that often appeared within
the large initials of illuminated manuscripts, but with two
significant differences, one functional and the other technical.
The illustrations were not intended primarily to enhance the
appearance of the page but rather to provide a necessary visual
complement to the written information. And, as opposed to
the sequential steps of scribe and miniaturist in preparing a
manuscript, the woodblock, like a large piece of type itself,
was placed into the printing form along with the letters so that
illustrations and text could be printed all at once. Of course,
unlike the illuminations of a treatise circulated in manuscript,
there were no discrepancies in the illustrations of the printed
book from copy to copy. The color, however, was still applied
by hand.

The Latin translation of this edition of Dioscorides' Greek
text from the first century A.D. was prepared by Jean Ruel
(1474-1537), a physician and professor at the University of
Paris. Although the plants and other substances whose medi-
cal application Dioscorides explained were those known to
him in Asia Minor, the treatise was the principal authority on
the subject throughout Renaissance Europe. For example,
Pierandrea Mattioli's commentaries on Dioscorides' *De medi-
cinali materia,* first published in 1544, went through more than
50 editions in various languages (Arber 1938: 11).

A Locuſtæ Germanis, Zwſchrecken. Gallis ſaulterelles dicuntur.
Locuſta eſt inſecti genus, uolucre animal. Italis uulgò Cabaleta dicta, quæ pedes ultimos habet longiſsimos, & cætera.

Oſsifragus. Caput XLV.

VEnter eius auis quam Latini oſsifragum appellant, particulatim potus, calculos cum lotio pellere proditur.
Oſsifraga auis ex genere aquilarum, Germanæ peregrina eſt, hanc quoque ideò quam illi Dioſcorides attribuit, noſtri medici notauillæ adſcribunt.

Galerita. Caput XLVI.

GAlerita auicula eſt parua, apicem in uertice, pauonis modo, geſtans, quæ aſsa in cibo ſumpta, coeliacos adiuuat.
Galeritam alij alaudam, Germani uerò, ein Woldlerch uocant, hæc auis Romanæ legioni nomen dedit: nam apud Romanos alauda dicta eſt. Galli galeam ſiue galeritum, alaudam uocant, quare milites galeati à Romanis dicti alauda. Itaque cùm Cæſar ex Gallis conſcriberet legionem, alaudam appellauit. Omnia uerò quæ hoc capite Dioſcorides de alauda ſcribit, illud falſò attribuit Serapion Arabs upupæ.

Alauda.

Hirundines. Caput XLVII.

DIſſectis creſcente luna pullis hirundinis, qui primo partu excluſi ſunt, in uentre eorum lapillos oſtendes: è quibus duos, unum colore uarium, alterum purum eximes. ij priuſquam terram attigerint, in iuuencæ corio, aut ceruina pelle brachio aut collo adalligati, comitialibus proderunt, & ſæpe prorſus eos recreabunt. Hirundines, uti ficedulæ, in cibo, acriti uſus medicamentum præbent. tam pulli rum quàm matrum in fictili olla crematarum cinis cum melle oblitus, oculis claritatem adfert. anginæ eo commodè perunguntur. uuæ & tonſillarum inflammationibus hoc cinere ſuccurritur. & ipſæ & pulli exiccati, ſi drachmæ pondere ex aqua bibantur, hos iuuant qui anginæ morbo conflictantur.

NOMINA ET EXPLICATIO.

Cinis recens hirundinum in diabeſaſa recipitur. Pulli hirundinum cum primis in fictili ſuper prunas uſti, diæ chelidonium ſtomachici ad Anginas Andromacho ſiccant, apud Galenum. Hirundinum ſtercus acre, & digerens, ut aliorum animalium magis, minus.
Ariſtoteles ait in ſeno albã naſci Hirundinem, cuius oculos ſi quis pupugerit, ſtatim quidem excæcatur, poſt uerò uiſum recipit, & ſicut ille dicit, ſic acutè quemadmodum à principio uidet.
Cinis pullorum hirundinum medetur anginæ, ut hoc loco Dioſcorides teſtatur, & Celſus lib. 4. ſcriptum reliquit. Hirundinis cerebrum ex melle illitum, ad ſuffuſiones facit.
Hirundo Germanis, ein Schwalb, dicitur.

Ebur. Caput XLVIII.

EBoris ſcobe illito paronychia ſanantur. Vim adſtringendi ebur obtinet.
Ebur tota ſubſtantia cor roborat, & conceptum iuuare, graecis ſcribitur. frigidæ ſiccam primæ gradu. Germanis, Helffantbeyn.

Suillus talus. Cap. XLIX.

SVis talus comburitur, dum è nigro albeſcat, qui tritus & potus inflationibus coli, longiſque torminibus medetur.

Ceruinum cornu. Caput L.

Ceruini

CEruini cornus cinis elotus, binis ligulis A cepotus prodeſt dyſentericis, excreantibus ſanguinem, coeliacis, regio morbo, & ueſicæ doloribus cum tragacantha. foeminis fluxione uuluæ laborantibus, cum liquore huic rei accommodato. Cerui cornu contuſum, crudo fictili luto circumlito, & in furnum indito: uritur donec albeſcat. id cadmiæ modo elotum, ulceribus oculorum & deſfuxionibus ſalutare eſt, infrictum dentes expurgat. crudi cornus ſuffiti nidore ſerpentes fugantur. feruefactum in aceto, ſi eo gingiuæ colluantur, maxillarum à dentitione dolorem adimit.

NOMINA ET EXPLICATIO.

Cornibus cerui & capræ uſtis, & (ſi opus eſt) lotis utimur ad dentium candorem, gingiuæ mollitie fluidæ, dyſenteriæ, fluxionem in oculos, oculorum ulcera, quia tergunt ſine roſione: tamen nec dolorem lenimus, nec coquunt, quia frigida ſicca.
Ceruinum cornu, Germanis Hirſchhorn. Gallis corne de cerf.

Eruca. Caput LI.

ERucis quæ in oleribus gignuntur, cum oleo peruncti, à uenenatis beſtijs ſeriri negantur.

EXPLICATIO.

Erucæ uermes ſunt frondes arborum erodentes, quare ab erodendo erucæ dictæ uolunt; aliqui Græcorum erucam Chryſelidem uocant. Germani ein Raup, & Holgwurm.

Cantharides. Caput LII.

FRumentis cõgeſtæ cantharides ad recondendum idoneæ ſunt. quæ fictili uaſe non picato conduntur, & raro linteo obligato ore, & deorſum conuerſo ſuſpenduntur ſuper aceti feruentis quàm acerrimi halitum, donec æſtu examinentur, poſtea lino transfixæ reponuntur. Potentiſsimæ omnes uariæ, luteis lituris, quas in pennis transuerſas habent, promiſſoque corpore craſsæ, ac blattarum modo perpingues, ſed inertes ac imbecillæ, quæ unius ſunt coloria. B

EXPLICATIO.

Totis utitur Galenus ad pſoras, lepras. Hippocrates caput & pedes aufert, lib. de foeminarum morbis, t& euſicam ulcerant ſole, uretica autem ſalubriter miſcentur.

Bupreſtes, & pinorum erucæ. Caput LIII.

SImili modo recondunter bupreſtes, genera quædam cantharidum, & pinorum erucæ, quæ ſupra cribrum ſuſpenſum feruenti cinere pauliſper intoſtæ, reponuntur. uis omnium communis erodere, ulcerare, calorem elicere. qua de cauſa admiſcentur medicamentis, quæ lepras, feraſque lichenas & carcinomata ſanant. menſes ciunt peſsi emollientibus addita. Aliqui cantharidas antidotis impoſitas, aquæ ſubter cutem auxiliari prodiderunt: argumento, quòd urinam moueant. Alij pennas pedeſque contra potarum ueneficia remedio eſſe tradiderunt.

NOMINA ET EXPLICATIO.

Bupreſtes uulgo ein Brölliſter, quòd boues rumpentur hoc animante, ſic dictæ. Pini erucæ, die wilten von Sicheten appellatæ, non ut cætera, pini frondes, ſed ipſum lignum ſub cortice erodunt. Luſciniis gratiſsimus cibus.

Salamandra

Excursus: The Master of the Coburg Roundels

Christiane Andersson

The Master of the Coburg Roundels is poorly known relative to his importance for Upper Rhenish art and for the history of early German drawing. The scholarly literature on the master is widely dispersed among numerous publications and virtually none of it has appeared in English. The source usually cited even today in connection with the master's work, Winkler's article of 1930, is long since out-of-date. The following remarks are appended here as a brief review of the relevant literature and as an attempt to reconsider problems of connoisseurship regarding his drawings.

The master was initially considered to be a Middle Rhenish artist by Buchner, who first identified the artist in 1927 on the basis of three panel paintings and a dozen drawings, in which Buchner saw a stylistic kinship with the Housebook Master. This association, frequently cited in the early literature on the Master of the Coburg Roundels (see cat. no. 28), no longer holds in light of a more precise definition of the Housebook Master's oeuvre as a draftsman and of Stange's refutations in 1955 of Buchner's attribution of the panels to the Coburg Master (Stange 1934-61, VII: 31-33). Of the panels in question, one in particular (Buchner 1927: fig. 50) reflects the Housebook Master's style very strongly, but it is not the work of the Coburg Master (see Cologne 1969: fig. 80). Fischel was the first to convincingly locate the artist in Strasbourg, thus restoring him to his rightful place in Upper Rhenish art (Fischel 1934: 27ff.). Strasbourg had of course already been mentioned in 1930 by Winkler in his article on the "Rhenish Master" in connection with the collection of Sebald Büheler, but it was Fischel who assembled the evidence to prove a substantial activity of the master in that city. She was able to attribute other panel paintings to the master beyond those cited by Buchner and to prove that they had all been commissioned by patrician families of Strasbourg for local churches. Fischel considered the influence of the Housebook Master to have been minimal and emphasized rather the importance of Martin Schongauer in the formation of the master's style. Fischel's new attributions have been accepted by later scholars, including Stange.

Fischel was also the first to recognize the master's close relationship to the most important painter working in Strasbourg during the mid-15th century, the Master of the Karlsruhe Passion (Hans Hirtz) (Fischel 1934a: 41ff).

She identified as the work of the Coburg Master a drawing, formerly in the Koenigs collection, that Buchner (1928:314f.) had published as an anonymous copy after a panel by the Master of the Karlsruhe Passion. On the basis of this association, she succeeded in pointing out other instances of the Coburg Master's dependence on the Master of the Karlsruhe Passion, including other copies after lost panels. She correctly concluded that the Coburg Master had been a pupil of the Karlsruhe Master, thus locating both his training and his activity as a painter in Strasbourg.

It was some time, however, before the results of Fischel's research gained general acceptance. In 1939, for example, Stafski (1936/39: 125, fig. 2) combined the old wisdom with the new in his assumption that the Coburg Master was a Middle Rhenish artist who had merely visited the Upper Rhine to study with the Master of the Karlsruhe Passion. The height of confusion, however, had already been achieved in 1935 by Naumann, who proposed that the Coburg Master, the Housebook Master, and Matthias Grünewald were actually one and the same person. Despite its shortcomings, however, Naumann's publication is useful for its many illustrations of drawings by the Coburg Master and as a stepping stone for subsequent research. Naumann noted that the scenes of the Flagellation and the Carrying of the Cross in a drawing by the Coburg Master in Berlin were copied after two stained-glass panels dated 1461 in the parish church at Walburg in Alsace (Naumann 1935: figs. 45-46). Without referring to Naumann's discovery, Bergsträsser (1942/43: 5ff.) again pointed out the dependence of the Berlin drawing on the Walburg glass panels and published an additional group of drawings discovered by Schöne in Madrid, which are copies after other glass panels belonging to the same cycle at Walburg and to a related cycle in the Church of Saint William in Strasbourg, produced by the same workshop. The stained-glass panels whose compositions the Coburg Master recorded in his drawings were at that time attributed to the Master of the Karlsruhe Passion, thus supporting Fischel's view regarding the close association of these two artists. Once Naumann and Bergsträsser had identified the sources of the Coburg Master's drawings in Berlin and Madrid, Fischel (1952: 27, 31, pl. 23) also recognized one of the master's drawings at Coburg to be a copy after a glass panel at Walburg as well (see also Wentzel 1949: figs. 26-27).

The Alsatian stained-glass painter, Peter Hemmel of Andlau (c. 1422-after 1501), was introduced into the scholarly debate concerning the Coburg Master's work in 1949, when Hans Wentzel (1949: 61) attributed the Walburg cycle to Hemmel. Whereas Bergsträsser (1942/43: 6) had previously ascribed this cycle to the Master of the Karlsruhe Passion, Wentzel's view gained acceptance in the subsequent literature, including Fischel's book (1952: 25) on the Karlsruhe Master and Frankl's book (1956) on Hemmel. Both Wentzel and Fischel called attention to the fact that the Coburg Master must have had access to Hemmel's designs in the workshop, since once the stained-glass panels were installed in the church at Walburg, they were located so high in the windows that such faithful copies as the Coburg Master's drawings in Berlin, Madrid, and Coburg could not have been made from them *in situ*. In 1964 Anzelewsky published another instance of the Coburg Master copying details from a composition by Hemmel (Anzelewsky 1964: 43ff., fig. 6; Frankl 1956: pl. 168). Since the Coburg Master is known to have made designs for glass painters (cat. nos. 28, 43), it is not unusual that he should have been acquainted with Hemmel's work; he may even have produced designs for Hemmel's workshop.

The scholarly debate on the Master of the Coburg Roundels virtually ceases with the publication of Anzelewsky's article in 1964. Since then the Coburg Master's work has occasionally been shown in exhibitions, such as those in Manchester (1961: no. 25), Berlin (1967-68: no. 15), Rotterdam (1974: 18ff.), Los Angeles (1976: no. 168), and Paris (Fryszman 1976: 261, fig. 85), and more frequently in the sale rooms. For example, in 1922 a study sheet bearing the kneeling figures of a male saint and a praying donor, incorrectly attributed to Michael Wolgemut, appeared in a sale in Amsterdam (Amsterdam 1922: lot 621, pl. VI). The drawing appears to be the counterpart to the master's sketch of two nearly identical but reversed kneeling figures, formerly in the Geiger collection, Vienna (Planiscig/Voss n.d.: pl. 2), where it was incorrectly ascribed to the School of Nuremberg. The versoes of these sheets typically also show drapery studies, in addition to an archangel and a study of a hand. Three other drawings by the master, illustrating a reclining apostle or prophet, studies of the Virgin and Child with a sleeping man, and an Ecce Homo, were offered for sale at Colnaghi's in 1952 and 1972 respectively (London 1952: lots 4, 6; London

1972: lot 21). The last of these was acquired by the Houston Museum of Fine Arts (Houston 1981: no. 60). In 1981 Sotheby's offered for sale a drawing from the collection of Tobias Christ in Basel, bearing two sketches of the Mystic Winepress on the recto (London 1981: lot 1). All five drawings are new additions to the master's oeuvre.

Since the master was first identified by Buchner in 1927 on the basis of a dozen drawings, his oeuvre has grown steadily. In 1930 Winkler cited five times that number and today approximately 150 drawings are known. Winkler (1932: 11) surmised that they were jotted down in sketchbooks during the master's travels as a journeyman. Indeed, some of the sketches after Flemish works of art may have been executed in Flanders, such as the *Symbolum Apostolicum* series (cat. nos. 30-31). These drawings appear to have been copied from a continuous series of images, which due to the original's immobility had to be sketched *in situ*. But since the drawings do not follow the correct recto-verso sequence that they ought logically to have if the sheets had been bound into a sketchbook, Winkler's theory does not seem very likely and must be abandoned.

An attempt to characterize the master's style is difficult due to its extraordinary variety. Subtle differences distinguish his independent drawings from those in which he copied another work of art (see cat. nos. 28, 34). The greatest variety naturally exists among the derivative work, since the disparate nature of the models introduces an almost infinite number of stylistic variables. The purpose of a given drawing also had a considerable effect on its appearance, as did the circumstances of the artist's access to his model. In addition, the master's style naturally varies somewhat as a result of the techniques he used. Although all of his drawings were executed with pen and ink, some were sketched with a fine pen (Berlin 1921: pl. 124, nos. 4465, 4332) and others with a broad one (Berlin 1921: pl. 125, no. 4296), some are drawn on tinted paper, usually light red (cat. no. 35; Frankfurt 1973: fig. 205), some are washed in brown, gray (cat. no. 43) or even green, and a few are heightened with white (Paris 1937-38: pl. cxxvII, no. 402). The drawings do not reveal a clear stylistic development. The stylistic spectrum, however, ranges from a great delicacy and finesse in sketches that appear to be early works (cat. nos. 28, 30-31) to a slapdash exuberance in others, which seem to be

mature works (cat. no. 42). It is noteworthy that the master's style changes even within the same category of drawing. For example, his copy after the *Madonna and Child in a Chapel*, an engraving by Master E. S. (Naumann 1935: figs. 20-21), displays round flicks of the pen in imitation of the engraved prototype, while a further copy after another engraved Madonna by Master E. S. is executed quite differently (cat. no. 39).

But what allows the identification of this large group of disparate drawings as the work of a single artist is their extraordinary vitality of ductus; the autograph drawings consistently display a lively, vigorous stroke. Also, his practice of assembling on the same sheet various studies executed from different models and in varying techniques helps define the limits of his style through the juxtaposition of its disparate manifestations: the nervous line, rapid execution, a "shorthand" approach to the subject, typical physiognomies, the relatively dry application of ink, and the resulting discontinuous lines. Many sketches made from other works of art bear brief notations in German, designating colors or objects which appear on the model (cat. nos. 31 recto, 39). In sketching figures, he generally lavished more attention on the drapery than on the heads or hands (cat. no. 34). The master's best work reveals that he was indeed a very fine draftsman. The less inspiring passages in his drawings are usually due to the particular purpose and circumstances of their creation, such as when he traced parts of a composition from another source (cat. no. 39).

The unusually varied nature of the master's drawings has given rise to some attributions that do not seem warranted to the present writer. In particular, the abundance of copies by the Coburg Master of works of art by other artists has led to unclear distinctions in the literature between derivative compositions and derivative execution. An example is the series of drawings at Coburg illustrating scenes from the Passion, first published by Kaemmerer (1927: 347ff.). Winkler's attribution of the series to the Master of the Coburg Roundels in 1930 has never been questioned. Of the entire series at Coburg, however, this attribution seems justified to the present writer only for the *Christ on the Mount of Olives* (Kaemmerer 1927: fig. 1). The remaining drawings[1] are so lifeless in their execution as to suggest that they are workshop copies of the master's drawings. Winkler based his belief in their autograph status on the existence of a chalk underdrawing on each sheet, taking this as evidence of originality. In general, Winkler relied too heavily on the evidence of technique, size of paper, and the like, while style was often the last criterion to be considered.

Fischel was able to identify the source of one of the compositions, the *Christ Nailed to the Cross*, as a panel by the Master of the Karlsruhe Passion (Fischel 1934: 36, figs. 5-6) and her assumption that the other drawings also reflect lost compositions by the Karlsruhe Master is quite plausible. But she did not distinguish between the master's copies of such panels and his assistants' copies of these copies. Stange was the first to consider the workshop context in relation to the question of attributions, pointing out that not only the master but also his assistants must have made copies of other work (Stange 1934-61, VII: 31). But he did not state which of the surviving drawings might fall into this category. The master's own copies of foreign models can be distinguished from his assistants' copies of his drawings by the master's characteristically rapid, vigorous stroke. The difference in style between the work of master and pupil may be observed in the master's drawing *Christ Taken Prisoner*, *formerly* in the Koenigs collection (Winkler 1932: pl. 30; Cologne 1969: fig. 82), copied from a panel at Cologne by the Master of the Karlsruhe Passion, and a drawing of the same theme (Fischel 1934a: fig. 4) belonging to the Coburg series of Passion scenes by workshop assistants.

In addition to the Passion series, a number of other drawings ascribed by Winkler to the Coburg Master must be reconsidered, including two others at Coburg: *Joseph, the Virgin, and Six Female Saints* and *Two Kneeling Female Donors* (Winkler 1930: 151). The *Annunciation to the Virgin* and the *Crucifixion,* both in Berlin, and the *Virgin and Child with Saints James and Ursula* in Paris (Winkler 1939a: 23, fig. 3; Winkler 1930: fig. 135; Paris 1937-38: pl. CXXVI, no. 401) are also not by the master in the view of the present writer. New additions to the master's oeuvre have come to light in the sale rooms, as noted above. Also, a number of sketches in public collections must be added to the corpus of the master's drawings. The unpublished *Christ Appearing to Mary Magdalen* in the Metropolitan Museum of Art, New York (fig. 23) is a typical mature work, similar in style to the *Virgin and Child with Angels* (cat. no. 43) and to the roundel in the Ashmolean Museum, Oxford (Oxford 1949: pl. XII). The *Mourners at the Grave* in the Biblioteca Reale, Turin (fig. 24), previously ascribed to Israhel van Meckenem (Turin 1974: no. 411), is presumably a copy after a Netherlandish model and bears on the verso a slight sketch of a façade, with figures looking out from a loggia. The *Mourners* is stylistically comparable to the master's *Virgin and Saint John with Two Mourning Women* in the Boymans-van Beuningen Museum, Rotterdam (Rotterdam 1974: no. 10). An unpublished drawing bearing studies of figures

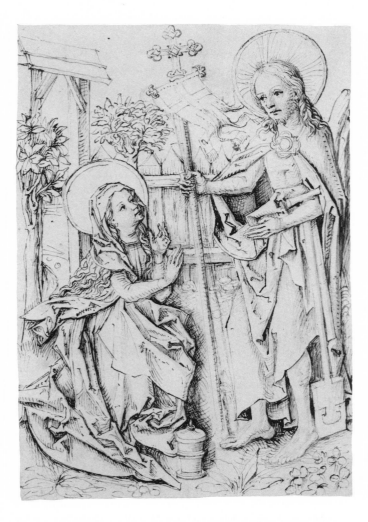

Figure 23. Master of the Coburg Roundels, *Christ Appearing to Mary Magdalen*, c. 1490, pen and brown ink with gray wash over black chalk, 251 x 165 mm. The Metropolitan Museum of Art, New York.

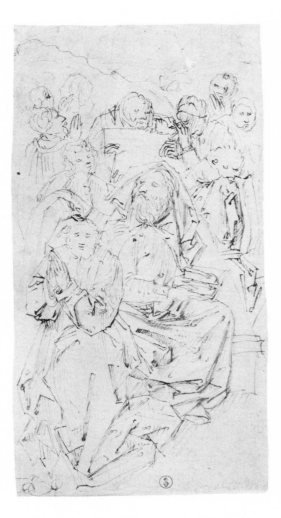

Figure 24. Master of the Coburg Roundels, *Mourners at the Grave*, c. 1480, pen and brown ink, 210 x 107 mm. Biblioteca Reale, Turin.

with drapery on the recto and verso, in the Württembergische Staatsgalerie, Stuttgart (figs. 25-26), is a typical example of this type of study sheet, so common in the master's oeuvre. The *Saint John the Baptist* in the Crocker Art Gallery *Sacramento* (Sacramento 1971: no. 4), until now attributed to an anonymous German master of about 1480, is close in style to the figure of Saint Paul in a sketch by the master at Coburg (Z 242). Finally, an unpublished sheet in an Austrian private collection (figs. 27-28) displays 11 studies of Christ's loincloth, distributed over the recto and verso, and two sketches of books elaborately bound with metal mountings. Very likely additional drawings by the master will continue to turn up.

NOTE

1. There are more drawings belonging to this group at Coburg than Kaemmerer included in his article. The others are also by workshop assistants: *Christ Nailed to the Cross* (Fischel 1934: fig. 6), and *Christ at Gethsemane* (Fischel 1935: fig. 4). The *Crucifixion* in Darmstadt (Fischel 1934a: fig. 5) and the *Christ Crowned with Thorns*, formerly in the Victor Bloch collection (Montreal 1953: fig. 94), may also have belonged to the group of copies at Coburg after the master's Passion drawings.

Figure 25. Master of the Coburg Roundels, *Study Sheet with Six Standing Figures*, c. 1490, pen in brown ink with light brown wash on reddish grounded paper, 278 x 184 mm. Staatsgalerie, Stuttgart (Inv. no. C 1921/24).

Figure 26. Master of the Coburg Roundels, *Study Sheet with Three Standing Figures*, c. 1490 (verso of fig. 25).

Figure 27. Master of the Coburg Roundels, *Study Sheet with Christ's Loincloth*, c. 1490, pen in light and dark brown ink with grayish brown wash, 209 x 208 mm. Private Collection, Austria.

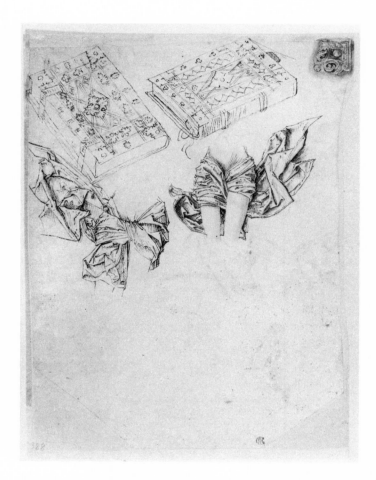

Figure 28. Master of the Coburg Roundels, *Study Sheet with Christ's Loincloth and Two Books*, c. 1490 (verso of fig. 27).

General Works

Ann Arbor, University of Michigan Museum of Art. *Images of Love and Death in Late Medieval and Renaissance Art*. Exh. cat. by William R. Levin with essays by Clifton C. Olds and Ralph G. Williams. 1975

Brant, Sebastian. *The Ship of Fools*. Introduction and commentary by Edwin H. Zeydel. New York, 1944.

Celtis, Conrad. *Selections from Conrad Celtis, 1459-1508*. Edited with translation and commentary by Leonard Forster. Cambridge, 1948.

Christensen, Carl C. *Art and the Reformation in Germany*, Athens, Ohio, and Detroit, 1979.

Dickens, A. G. *The German Nation and Martin Luther*. New York, 1974.

Eisenstein, Elizabeth L. *The Printing Press as an Agent of Change, Communication and Cultural Transformation in Early-modern Europe*. 2 vols. London, New York, and Melbourne, 1979.

Grimm, Harold J. *The Reformation Era 1500-1650*. London, 1965.

Haile, H. G. *Luther/An experiment in Biography*. Garden City, 1980.

Iserloch, Erwin. *The Theses Were Not Posted*. London, 1968.

Nauert, Charles G., Jr. *The Age of Renaissance and Reformation*. Hinsdale, Illinois, 1977.

Olivier, Daniel. *The Trial of Luther*. St. Louis, 1978.

Ozment, Steven. *The Age of Reform 1250-1550/An Intellectual and Religious History of Late Medieval and Reformation Europe*. New Haven and London, 1980.

San Francisco, California Palace of the Legion of Honor. *The Triumph of Humanism/A Visual Survey of the Decorative Arts of the Renaissance*. Exh. cat. 1977.

Schwiebert, Ernst. *Luther and His Times*. St. Louis, 1950.

Spitz, Lewis W. *Conrad Celtis, the German Arch-humanist*. Cambridge, 1957.

Spitz, Lewis W. *The Religious Renaissance of the German Humanists*. Cambridge, 1963.

Spitz, Lewis W. *The Protestant Reformation*. Englewood Cliffs, 1966.

Spitz, Lewis W. *Interpretations of the Reformation*. Lexington, Mass., 1972.

Spitz, Lewis W. *The Renaissance and Reformation Movements*. 2 vols. St. Louis, 1980.

Thulin, Oskar, ed. *An Illustrated History of the Reformation*. St. Louis, 1967.

Tuchman, Barbara W. *A Distant Mirror/The Calamitous 14th Century*. New York, 1978.

Bibliography

ADB
Allgemeine deutsche Biographie. 56 vols. Leipzig, 1875-1912.

Amelung 1978
Amelung, Peter. Introduction to *Das ist der teutsch Kalender mit den figurē*. Facsimile edition. Zurich, 1978.

Ames 1944
Ames, Winslow. "A Drawing by Hans Baldung Grün at the Pierpont Morgan Library." *Gazette des Beaux-Arts* 25, 928 (1944): 371-373.

Amsterdam 1922
Amsterdam, DeVries Co. *Prince de S . . . -B . . . Collection*. Sale cat. Jan. 24-25, 1922

Andersson 1978
Andersson, Christiane. *Dirnen, Krieger, Narren: Ausgewählte Zeichnungen von Urs Graf*. Basel, 1978.

Andersson 1980
Andersson, Christiane. "Symbolik und Gebärdensprache bei Niklaus Manuel und Urs Graf." *Zeitschrift für schweizerische Archäologie und Kunstgeschichte* 37 (1980): 276-288.

Andresen 1864-78
Andresen, Andreas. *Der Deutsche Peintre-Graveur/oder die deutschen Maler als Kupferstecher*. 5 vols. Leipzig, 1864-78.

Anzewlewsky 1964
Anzelewsky, Fedja. "Peter Hemmel und der Meister der Gewandstudien." *Zeitschrift des deutschen Vereins für Kunstwissenschaft* 18, 1/2 (1964): 43-53.

Anzelewsky 1965
Anzelewsky, Fedja. "Eine spätmittelalterliche Malerwerkstatt. Studien über die Malerfamilie Katzheimer in Bamberg." *Zeitschrift des deutschen Vereins für Kunstwissenschaft* 19, 3/4 (1965): 134-150.

Appeltshauser 1950
Appeltshauser, Herbert ."Ein unbekanntes Bild der Veste von 1506." In *Coburg in Bayern/Festschrift der Stadt Coburg*. Coburg 1950: 9-11.

Appuhn/von Heusinger 1976
Appuhn, Horst, and von Heusinger, Christian. *Riesenholzschnitte und Papiertapeten der Renaissance*. Unterschneidheim, 1976.

Arber 1938
Arber, Agnes. *Herbals, their Origin and Evolution*. 2nd ed. Cambridge, 1938.

Arndt 1964
Arndt, Karl. "Zum Werk des Hugo van der Goes." *Münchner Jahrbuch der bildenden Kunst* 15 (1964): 63-98.

Augsburg 1955
Augsburg, Städtische Kunstsammlungen. *Augsburger Renaissance*. Exh. cat. with intro. by Norbert Lieb. 1955.

Augsburg 1973
Augsburg, Städtische Kunstsammlungen. *Hans Burgkmair/Das graphische Werk.* Exh. cat. 1973.

Augsburg 1980-81
Augsburg, Rathaus and Zeughaus. *Welt im Umbruch: Augsburg zwischen Renaissance und Barock.* Exh. cat. 3 vols. 1980-81.

Bächtold-Staubli/Hoffmann-Krayer 1886-1941
Bächtold-Staubli, Hanns, and Hoffmann-Krayer, E. *Handwörterbuch des deutschen Aberglaubens.* Berlin and Leipzig, 9 vols. 1886-1941.

Bainton 1950
Bainton, Roland H. *Here I Stand/A Life of Martin Luther.* New York and Nashville, 1950.

Baldass 1928
Baldass, Ludwig von. "Hans Baldungs Frühwerke." *Pantheon* 2 (1928): 398-412.

Baldass 1941
Baldass, Ludwig von. *Albrecht Altdorfer.* 2nd ed. Vienna, 1941.

Bange 1926
Bange, E. F. *Peter Flötner.* Meister der Graphik 14. Leipzig, 1926.

Bartsch 1803-21
Bartsch, Adam. *Le Peintre Graveur.* 21 vols. Vienna, 1803-21.

Basel 1926
Basel, Öffentliche Kunstsammlung. *Beschreibendes Verzeichnis der Basler Handzeichnungen des Urs Graf.* Exh. cat. 1926.

Basel 1974
Basel, Kunstmuseum. *Lukas Cranach/Gemälde, Zeichnungen, Druckgraphik.* Exh. cat. by Dieter Koepplin and Tilman Falk. 2 vols. 1974.

Basel 1978
Basel, Kunstmuseum. *Hans Baldung Grien im Kunstmuseum Basel.* Exh. cat. by Paul H. Boerlin, Tilman Falk, Richard W. Gassen, and Dieter Koepplin. 1978.

Basel 1979
Basel, Kupferstichkabinett. *Das 15. Jahrhundert.* Katalog der Zeichnungen des 15. und 16. Jahrhunderts im Kupferstichkabinett Basel I. Compiled by Tilman Falk, 1979.

Baum 1948
Baum, Julius. *Martin Schongauer.* Vienna, 1948.

Baumeister 1924
Baumeister, Engelbert. "Über einige altdeutsche Zeichnungen." In *Beiträge zur Geschichte der deutschen Kunst.* Edited by Ernst Buchner and Karl Feuchtmayr. Augsburg, 1924, I: 176-185.

Baumeister 1938/39
Baumeister, Engelbert. "Zeichnungen Augustin Hirschvogels aus seiner Frühzeit." *Münchner Jahrbuch der bildenden Kunst* n.s. 13, 4 (1938/39): 203-211.

Baumeister 1957
Baumeister, Engelbert. "Unbekannte Zeichnungen von Jörg Breu d. Ä." *Zeitschrift für Kunstwissenschaft* 11 (1957): 45-54.

Baumgarten 1904
Baumgarten, Fritz. *Der Freiburger Hochaltar.* Studien zur deutschen Kunstgeschichte 49. Strasbourg, 1904.

Behling 1972
Behling, Lottlisa. "Eine 'ampel'-artige Pflanze von Albrecht Dürer: Cucurbita lagenaria L. auf dem Hieronymus-Stich von 1514." *Pantheon* 30, 5 (1972): 396-400.

Bellm 1962
Bellm, Richard. *P. Stephan Fridolin/Der Schatzbehalter.* 2 vols. Wiesbaden, 1962.

Benzing 1963
Benzing, Joseph. *Die Buchdrucker des 16. und 17. Jahrhunderts im deutschen Sprachgebiet.* Wiesbaden, 1963.

Bergsträsser 1941
Bergsträsser, Gisela. *Caspar Isenmann/Ein Beitrag zur Oberrheinischen Malerei des 15. Jahrhunderts.* Ph.D. diss, University of Frankfurt, Colmar, 1941.

Bergsträsser 1942/43
Bergsträsser, Gisela. "Der Meister der Karlsruher Passion und der Meister der Gewandstudien." *Die Graphischen Künste* n.s. 7 (1942/43): 5-12.

Berlin 1921
Berlin, Staatliche Museen, Kupferstichkabinett. *Die deutschen Meister/Beschreibendes Verzeichnis sämtlicher Zeichnungen.* Edited by Elfried Bock and Max Friedländer. 2 vols. Berlin, 1921.

Berlin 1967-68
Berlin, Dahlem Museum. *Dürer und seine Zeit, Meisterzeichnungen aus dem Berliner Kupferstichkabinett.* Exh. cat. 1967-68.

Bern 1979
Bern, Kunstmuseum. *Niklaus Manuel Deutsch: Maler, Dichter, Staatsman.* Exh. cat. edited by Hugo Wagner and Hans Christoph von Tavel. 1979.

Bernhard 1978
Bernhard, Marianne, ed. *Hans Baldung Grien/Handzeichnungen, Druckgraphik.* Munich, 1978.

Bierens de Haan 1947
Bierens de Haan, J. C. J. *De Meester van het Amsterdamsch Kabinet.* Amsterdam, 1947.

Bock 1924
Bock, Elfried, ed. *Holzschnitte des Meisters D. S.* Berlin, 1924.

Bock 1929
Bock, Elfried. *Die Zeichnungen in der Universitätsbibliothek Erlangen.* 2 vols. Frankfurt, 1929.

Boesch 1947
Boesch, Paul. "Aristoteles und Phyllis auf Glasgemälden." *Zeitschrift für schweizerische Archäologie und Kunstgeschichte* 9 (1947): 21-30.

Borries 1972
Borries, Johann Eckart von. *Albrecht Dürer: Christus als Schmerzensmann.* Karlsruhe, 1972.

Bossert/Storck 1912
Bossert, Helmuth, and Storck, Willy. *Das mittelalterliche Hausbuch.* Leipzig, 1912.

Boston 1971
Boston, Museum of Fine Arts. *Albrecht Dürer: Master Printmaker.* Exh. cat. by the Dept. of Prints and Drawings. 1971.

Bravo 1964
Bravo, Giuseppe. *Storia del cuoio e dell'arte conciaria.* Torino, 1964.

Brietzmann 1912
Brietzmann, Franz. "Die böse Frau in der deutschen Literatur des Mittelalters." *Palaestra* 42 (1912): 129ff.

Briquet 1923
Briquet, Charles Moïse. *Les filigranes: dictionnaire historique des marques du papier, dès leur apparition vers 1282 jusqu'en 1600. . . .* 4 vols. 2nd ed. Leipzig, 1923.

Buchner 1924
Buchner, Ernst. "Der Petrarkameister als Maler, Miniator und Zeichner." In *Festschrift Heinrich Wölfflin/Beiträge zur Kunst- und Geistesgeschichte zum 21. Juni 1924 überreicht von Freunden und Schülern.* Munich, 1924: 209-231.

Buchner 1927
Buchner, Ernst. "Studien zur mittelrheinischen Malerei und Graphik der Spätgotik und Renaissance III. Der Meister der Coburger Rundblätter." *Münchner Jahrbuch der bildenden Kunst* n.s. 4, 3 (1927): 284-300.

Buchner 1928
Buchner, Ernst. "Über eine mittelrheinische Zeichnung der Spätgotik." *Pantheon* 1 (1928): 314-315.

Buchner/Feuchtmayr 1924
Buchner, Ernst, and Feuchtmayr, Karl, eds. *Beiträge zur Geschichte der deutschen Kunst.* 2 vols. Augsburg, 1924-28.

Burkhard 1932
Burkhard, Arthur. *Hans Burgkmair d. A.* Meister der Graphik xv. Berlin, 1932.

Clemen 1921-22
Clemen, Otto, ed. *Flugschriften aus der Reformationszeit in Facsimiledrucken.* 6 nos. in 1 vol. Leipzig, 1921-22.

Coburg 1954
Coburg, Landesbibliothek. *Die Wiegendrucke in Coburg.* Edited by Friedrich Schilling. 1954.

Coburg 1959
Coburg, Landesbibliothek. *Die Wiegendrucke in Coburg: Nachtrag.* Edited by Friedrich Schilling. 1959.

Coburg 1961
Coburg, Kunstsammlungen der Veste Coburg. *Das Bild der Veste Coburg/seine künstlerische Wiedergabe in Vergangenheit und Gegenwart.* Exh. cat. 1961

Coburg 1967
Coburg, Kunstsammlungen der Veste Coburg. *Martin Luther Ausstellung/zur Erinnerung an die 95 Thesen Martin Luthers vom Jahre 1517.* Exh. cat. 1967.

Coburg 1968
Coburg, Kunstsammlungen der Veste Coburg. *Die Fechtkunst 1500-1900/Graphik, Waffen.* Exh. cat. 1968.

Coburg 1970
Coburg, Kunstsammlungen der Veste Coburg. *Ausgewählte Handzeichnungen von 100 Künstlern aus fünf Jahrhunderten, 15.-19. Jh.* Exh. cat. edited by Heino Maedebach, 1970.

Coburg 1970a
Coburg, Landesbibliothek. *Kostbarkeiten der Landesbibliothek Coburg.* Exh. cat. by Jürgen Erdmann. 1970.

Coburg 1971
Coburg, Kunstsammlungen der Veste Coburg. *Albrecht Dürer 1471-1528/Holzschnitte, Kupferstiche, Eisenradierungen aus dem Kupferstichkabinett der Kunstsammlungen der Veste Coburg.* Exh. cat. 1971.

Coburg 1972
Coburg, Kunstsammlungen der Veste Coburg. *Lucas Cranach d. Ä. und seine Werkstatt: Gemälde.* Exh. cat. edited by Heino Maedebach. 1972.

Coburg 1973
Coburg, Landesbibliothek. *Druckschriften der Reformation.* Exh. cat. by Jürgen Erdmann. 1973.

Coburg 1975
Coburg, Kunstsammlungen der Veste Coburg. *Meisterwerke europäischer Graphik 15.-18. Jh./aus dem Besitz des Kupferstichkabinettes Coburg/Ausstellung zur 200-Jahrfeier des Coburger Kupferstichkabinettes 1775-1975.* Exh. cat. compiled by Dr. Heino Maedebach and Dr. Minni Maedebach. 1975.

Coburg 1978
Coburg, Kunstsammlungen der Veste Coburg. *Ausgewählte Werke.* Edited by Heino Maedebach. 2nd ed. rev. 1978.

Cologne 1969
Cologne, Wallraf-Richartz-Museum. *Katalog der deutschen und niederländischen Gemälde bis 1550 im Wallraf-Richartz-Museum.* Compiled by Irmgard Hiller and Horst Vey. 1969.

Cologne 1970
Cologne, Kunsthalle. *Herbst des Mittelalters/Spätgotik in Köln und am Niederrhein.* Exh. cat. edited by Gert von der Osten. 1970.

Conway 1958
Conway, William Martin. *The Writings of Albrecht Dürer.* New York, 1958.

Curjel 1923
Curjel, Hans. *Hans Baldung Grien*. Munich, 1923.

Dacheux 1888
Dacheux, L. "La Chronique de Sébald Büheler." *Bulletin de la société pour la conservation des monuments historiques d'Alsace*. 2nd ser., 13 (1888): 23-150.

David 1910
David, Harry. "Zum Problem der Dürerschen Pferdekonstruktionen." *Repertorium für Kunstwissenschaft* 33 (1910): 310-317.

Davies 1913
Davies, Hugh W. *Catalogue of a Collection of Early German Books in the Library of C. Fairfax Murray*. 2 vols. 1913. Reprint. London, 1962.

Descargues 1977
Descargues, Pierre. *Perspective*. New York, 1977.

Derschau/Becker 1808-10
Derschau, Hans Albrecht von, and Becker, Rudolf Zacharias. *Holzschnitte alter deutscher Meister in den Original-Platten gesammelt*. 2 vols. Gotha, 1808-10.

Dodgson 1903-11
Dodgson, Campbell. *Catalogue of Early German and Flemish Woodcuts preserved in the Department of Prints and Drawings in the British Museum*. 2 vols. London, 1903-11.

Dodgson 1906/07
Dodgson, Campbell. "Hans Lützelberger and the Master N.H." *Burlington Magazine* 10 (1906/07): 319-322.

Dodgson 1908
Dodgson, Campbell. "Eine Holzschnittfolge Matthias Gerungs." *Jahrbuch der königlich preussischen Kunstsammlungen* 29 (1908): 195-216.

Dodgson 1909
Dodgson, Campbell, ed. *Holzschnitte zu zwei: Nürnberger Andachtsbüchern aus dem Anfange des XVI. Jahrhunderts*. Berlin, 1909.

Dodgson 1911
Dodgson, Campbell, "Sketch of a Horse and Rider." *The Dürer Society* 12 (1911): 7-8.

Dodgson 1926
Dodgson, Campbell. *Albrecht Dürer, Engravings and Etchings*. 1926. Reprint. New York, 1967.

Dodgson 1938
Dodgson, Campbell. "The Story of Dürer's Ganda." In *The Romance of Fine Prints*. Edited by Alfred Fowler. Kansas City, 1938: 45-56.

Dommer 1888
Dommer, Arrey von. *Lutherdrucke auf der Hamburger Stadtbibliothek, 1516-1523*. Leipzig, 1888.

Dörnhöffer 1907/09
Dörnhöffer, Friedrich, "Albrecht Dürers Fechtbuch." *Jahrbuch der kunsthistorischen Sammlungen des allerhöchsten Kaiserhauses* 27 (1907/09): 1-81.

Dresden 1971
Dresden, Albertinum. *Deutsche Kunst der Dürer-Zeit*. Exh. cat. 1971.

Eichenberger/Wendland 1977
Eichenberger, Walter, and Wendland, Henning. *Deutsche Bibeln vor Luther/die Buchkunst der achtzehn deutschen Bibeln zwischen 1466 und 1522*. Hamburg, 1977.

Ephrussi 1882
Ephrussi, Charles. *Albert Dürer et ses dessins*. Paris, 1882.

Eyssen 1904
Eyssen, Ed. *Daniel Hopfer von Kaufbeuren, Meister zu Augsburg, 1493 bis 1536*. Heidelberg, 1904.

Falk 1968
Falk, Tilman. *Hans Burgkmair/Studien zu Leben und Werk des Augsburger Malers*. Munich, 1968.

Falk 1978
Falk, Tilman. "Baldungs jugendliches Selbstbildnis: Fragen zur Herkunft des Stils." *Zeitschrift für schweizerische Archäologie und Kunstgeschichte* 35 (1978): 217-223.

von Falke 1930
Falke, Otto von, ed. *Die Sammlung Dr. Albert Figdor, Wien*. 4 vols. Berlin, 1930.

Fehring/Ress 1961
Fehring, G. P., and Ress, A. *Die Stadt Nürnberg*. Bayerische Kunstdenkmale. Munich, 1961.

Feinblatt 1964
Feinblatt, Ebria. "Cranach's 'Penitence of S. John Chrysostom.'" *Los Angeles County Museum of Art Bulletin* 16, 2 (1964): 15-23.

Ficker 1923
Ficker, Johannes. "Hortulus Animae." In *Buch und Bucheinband/Aufsätze und graphische Blätter zum 60. Geburtstage von Hans Loubier*. Leipzig, 1923: 59-68.

Finke 1976
Finke, Ulrich. "Dürers 'Melancholie' in der französischen und englischen Literatur und Kunst des 19. Jahrhunderts." *Zeitschrift des deutschen Vereins für Kunstwissenschaft* 30 (1976): 67-85.

Fischel 1934
Fischel, Lilli. "Die Heimat des Meisters der Koburger Rundblätter." *Oberrheinische Kunst* 6 (1934): 27-40.

Fischel 1934a
Fischel, Lilli. "Der Meister der Karlsruher Passion/Sein verschollenes Oeuvre." *Oberrheinische Kunst* 6 (1934): 41-60.

Fischel 1935
Fischel, L[illi]. "Le Maître E. S. et ses sources strasbourgeoises." *Archives alsaciennes d'histoire de l'art* 14 (1935): 185-229.

Fischel 1952
Fischel, Lilli. *Die Karlsruher Passion und ihr Meister.* Karlsruhe, 1952.

Fischer 1939
Fischer, Otto. *Hans Baldung Grien.* Munich, 1939.

Flechsig 1900
Flechsig, Eduard. *Cranachstudien.* Leipzig, 1900.

Flechsig 1928-31
Flechsig, Eduard. *Albrecht Dürer, sein Leben und seine künstlerische Entwicklung.* 2 vols. Berlin, 1928-31.

Flechsig 1951
Flechsig, Eduard. *Martin Schongauer.* Strasbourg, 1951.

Fleming 1973
Fleming, Gerald. "On the Origin of the Passional Christi and Antichristi and Lucas Cranach the Elder's Contribution to Reformation Polemics in the Iconography of the Passional." *Gutenberg-Jahrbuch* (1973): 351-368.

Föhl 1954
Föhl, Walther. *Die Geschichte der Coburg.* Coburg, 1954.

Fontoura da Costa 1937
Fontoura da Costa, A. *Deambulations of the Rhinoceros (Ganda) of Muzafar, King of Cambaia, from 1514 to 1516.* Lisbon, 1937.

Fraenger 1930
Fraenger, Wilhelm. *Altdeutsches Bilderbuch / Hans Weiditz und Sebastian Brant.* Denkmale der Volkskunst II. Leipzig, 1930.

Frankfurt 1973
Frankfurt am Main, Städelsches Kunstinstitut. *Katalog der deutschen Zeichnungen: Alte Meister.* Compiled by Edmund Schilling and Kurt Schwarzweller. 3 vols. Munich, 1973.

Frankl 1956
Frankl, Paul. *Peter Hemmel, Glasmaler von Andlau.* Berlin, 1956.

Friedländer 1922
Friedländer, Max J. *Holzschnitte von Hans Weiditz.* Berlin, 1922.

Friedländer 1923
Friedländer, Max J. *Albrecht Altdorfer.* Berlin, (1923).

Friedländer/Rosenberg 1978
Friedländer, Max J., and Rosenberg, Jakob. *The Paintings of Lucas Cranach.* Rev. ed. London, 1978.

Fritz 1966
Fritz, Johann Michael. *Gestochene Bilder / Gravierungen auf deutschen Goldschmiedearbeiten der Spätgotik.* Beihefte der Bonner Jahrbücher 20. Cologne and Graz, 1966.

Fryszman 1976
Fryszman, Jacques. "Drawings from Dijon at the Louvre." *Burlington Magazine* 118 (1976): 260-261.

Gallonio 1591
Gallonio, Antonio. *Trattato de gli instrvmenti di martirio, e delle varie maniere di martoriare, vsate da' gentili contro Christiani, descritte et intagliate in rame.* Rome, 1591.

Ganz 1905
Ganz, Paul, ed. *Handzeichnungen schweizerischer Meister des XV.-XVIII. Jahrhunderts,* Vol. I. Basel, 1905.

Ganz 1937
Ganz, Paul. *Die Handzeichnungen Hans Holbeins d. J. Kritischer Katalog.* Berlin, 1937.

Geisberg 1905
Geisberg, Max. *Verzeichnis der Kupferstiche Israhels van Meckenem.* Strasbourg, 1905.

Geisberg 1908
Geisberg, Max. "Un nouveau dessin du Maître du 'Hausbuch.'" *Starye Gody* (May 1908): 302-305.

Geisberg 1924
Geisberg, Max, ed. *Die Kupferstiche des Meisters E. S.* Berlin, 1924.

Geisberg 1924a
Geisberg, Max. *Der Meister E. S.* Meister der Graphik 10. Edited by Hermann Voss. 2nd ed. Leipzig, 1924.

Geisberg 1932
Geisberg, Max. *Die Stadt Münster.* 6 parts. Bau- und Kunstdenkmäler von Westfalen XLI. Münster, 1932.

Geisberg/Strauss 1974
Geisberg, Max. *The German Single Leaf Woodcut: 1500-1550.* 4 vols. Revised and edited by Walter L. Strauss. New York, 1974.

van Gelder 1966
Gelder, Jan Gerrit van. "Enige Kanttekeningen bij de Gerechtigheidstafeleren van Rogier van der Weyden." In *International Colloquium, Rogier van der Weyden en zijn tijd.* Brussels, 1966.

Götze 1963
Götze, Alfred. *Die hochdeutschen Drucker der Reformationszeit.* Forward by Martin von Hase, 2nd ed. Berlin, 1963.

Gotha 1976
Gotha Schlossmuseum. *Flugblätter der Reformation und des Bauernkrieges . . . aus der Sammlungen des Schlossmuseums.* Cat. edited by Hermann Meuche, text by Ingeburg Neumeister. 2 vols. Leipzig, 1976.

Grote 1933
Grote, Ludwig. *Georg Lemberger.* Aus Leipzigs Vergangenheit II. Leipzig, 1933.

Grote 1965
Grote, Ludwig. "Dürer-Studien." *Zeitschrift des deutschen Vereins für Kunstwissenschaft* 19, 3/4 (1965): 151-169.

Habich 1929-34
Habich, Georg. *Die deutschen Schaumünzen des XVI. Jahrhunderts.* 2 vols. (each in 2 parts). Munich, 1929-34.

Hackenbroch 1979
Hackenbroch, Yvonne. *Renaissance Jewellery*. Munich, 1979.

Haenel 1910
Haenel, Erich, ed. *Der Sächsischen Kurfürsten Turnierbücher in ihren hervorragendsten Darstellungen auf vierzig Tafeln*. Frankfurt, 1910.

Haimerl 1952
Haimerl, Franz Xaver. *Mittelalterliche Frömmigkeit im Spiegel der Gebetbuchliteratur Süddeutschlands*. Münchner theologische Studien I. Munich, 1952.

Hain 1826-38
Hain, Ludovici, *Repertorium Bibliographicum. . . .* 4 vols. Stuttgart and Paris, 1826-38.

Harbison 1976
Harbison, Craig. "Dürer and the Reformation: The Problem of the Re-dating of the 'St. Philip' Engraving." *The Art Bulletin* 58, 3 (1976): 368-373.

Harrisse 1895
Harrisse, Henry. *Americus Vespuccius; A Critical and Documentary Review of Two recent English Books concerning that Navigator*. London, 1895.

Hartlaub 1961
Hartlaub, G. F. *Hans Baldung Grien/Hexenbilder*. Stuttgart, 1961.

Haug 1936
Haug, Hans. "Notes sur Pierre d'Andlau, peintre-verrier à Strasbourg, et son atelier." *Archives alsaciennes d'histoire de l'art* 15 (1936): 79-123.

Haupt 1871
Haupt, Moriz, ed. *Von dem übelen Wib*. Leipzig, 1871.

Hayward 1965
Hayward, J. F. "The Mannerist Goldsmiths: 4/England Part 1. The Holbein designs." *The Connoisseur* 159, 640 (1965): 80-84.

Heckscher 1978
Heckscher, W. S. "Melencholia (1541). An Essay in the Rhetoric of Description by Joachim Camerarius. . . . " In *Joachim Camerarius (1500-1574)/Beiträge zur Geschichte des Humanismus im Zeitalter der Reformation*. Humanistische Bibliothek 1, XXIV. Edited by Frank Baron. Munich, 1978.

Heinze 1912
Heinze, Helene. *Die Allegorie bei Hans Sachs mit besonderer Berücksichtigung ihrer Beziehungen zur graphischen Kunst*. Hermaea/Ausgewählte Arbeiten aus dem Germanischen Seminar zu Halle XI. Edited by Philipp Strauch. Halle, 1912.

Heise 1942
Heise, Carl Georg. *Altdeutsche Meisterzeichnungen von Dürer bis Holbein*. Munich, 1942.

Heitz 1910
Heitz, Paul. *Christus am Kreuz/Kanonbilder der in Deutschland gedruckten Messbücher des fünfzehnten Jahrhunderts*. Strasbourg, 1910.

Heller 1827-30
Heller, Joseph. *Das Leben und die Werke Albrecht Dürers*. 2 vols. Bamberg, 1827-30.

Hinckeldey 1980
Hinckeldey, Ch. *Strafjustiz in alter Zeit*. Schriftenreihe des mittelalterlichen Kriminalmuseums Rothenburg ob der Tauber III. 1980.

Hind 1935
Hind, Arthur M. *An Introduction to a History of Woodcut*. 2 vols. 1935. Reprint. New York, 1963.

Hind 1936
Hind, A. M. *Nielli/Chiefly Italian of the XV Century/Plates, Sulphur Casts and Prints Preserved in the British Museum*. London, 1936.

Hind 1938
Hind, Arthur M. *Florentine Engravings and Anonymous Prints of Other Schools*. Early Italian Engravings II/1. London, 1938.

Hirth 1882-90
Hirth, Georg, ed. *Kulturgeschichtliches Bilderbuch aus drei Jahrhunderten*. 6 vols. 1882-90. Reprint (as *Picture Book of the Graphic Arts, 1500-1800*). New York, 1972.

Hoffmann 1978
Hoffmann, Konrad. "Dürer's 'Melencholia.' " *The Print Collector's Newsletter* 9, 2 (1978): 33-35.

Hofmann 1924
Hofmann, Friedrich H. "Der gotische Tanzsaal in der 'Neuveste.' Ein Beitrag zur Baugeschichte der Münchener Residenz." In *Beiträge zur Geschichte der deutschen Kunst*. Edited by Ernst Buchner and Karl Feuchtmayr. Augsburg, 1924, I: 120-128.

Holborn 1961
Holborn, Hajo. *A History of Modern Germany/The Reformation*. New York, 1961.

Holl 1972
Holl, Wilhelm. *Hans von Kulmbach/Das Werk und sein Leben*. Kulmbach, 1972.

Hollstein
Hollstein, F. W. H. *German Engravings, Etchings, and Woodcuts*. 16 vols. Amsterdam 1954—.

Holzmann/Bohatta 1902-28
Holzmann, Michael, and Bohatta, Hanns. *Deutsches Anonymen-Lexikon*. 7 vols. Weimar, 1902-28.

Houston 1981
Houston, Museum of Fine Arts. *The Museum of Fine Arts, A Guide to the Collection*. Edited by William C. Agee. 1981.

Hubel 1977
Hubel, Achim. "Die Schöne Maria von Regensburg." In *850 Jahre Kollegiatstift zu den Heiligen Johannes Baptist und Johannes Evangelist in Regensburg/1127-1977 Festschrift*. Edited by Paul Mai. Munich and Zurich, 1977: 199-237.

Hugelshofer 1928
Hugelshofer, Walter. *Schweizer Handzeichnungen des* xv. *und* xvi. *Jahrhunderts.* Die Meisterzeichnung I. Freiburg im Breisgau, 1928.

Hults-Boudreau 1978
Hults-Boudreau, Linda. *Hans Baldung Grien and Albrecht Dürer: A Problem in Northern Mannerism.* Ph.D. diss. University of North Carolina, Chapel Hill, 1978.

Hutchison 1966
Hutchison, Jane Campbell. "The Housebook Master and the Folly of the Wise Man." *The Art Bulletin* 48, 1 (1966): 73-78.

Hutchison 1972
Hutchison, Jane C. *The Master of the Housebook.* New York, 1972.

Huth 1923
Huth, Hans. *Künstler und Werkstatt der Spätgotik.* Augsburg, 1923.

Huth 1935
Huth, Hans. "Ein verlorener Stich des Meisters ES." In *Festschrift Adolph Goldschmidt zu seinem siebenzigsten Geburtstag.* Berlin, 1935: 74-76.

Innsbruck 1969
Innsbruck, Zeughaus des Kaisers. *Ausstellung Maximilian I.* Exh. cat. 1969.

Ivins 1926
Ivins, William M., Jr. "Hans Weiditz." In *Prints and Books.* Cambridge, Mass., 1926: 39-51.

Jahn 1955
Jahn, Johannes. *Lucas Cranach als Graphiker.* Leipzig, 1955.

Janson 1939/40
Janson, Horst W. "A 'Memento Mori' among early Italian Prints." *Journal of the Warburg and Courtauld Institutes* 3 (1939/40): 243-248.

Johnson 1929
Johnson, Alfred Forbes. *German Renaissance Title-Borders.* Facsimiles and Illustrations I. Oxford, 1929.

Kaemmerer 1925
Kaemmerer, Ludwig. "Eine frühe graphische Zeichnung Dürers in Coburg." *Mitteilungen der Gesellschaft für vervielfältigende Kunst* 48, 1 (1925): 49-50.

Kaemmerer 1927
Kaemmerer, Ludwig. "Fünf Federzeichnungen aus der Passionsgeschichte im Kupferstichkabinett der Veste Coburg." *Münchner Jahrbuch der bildenden Kunst* n.s. 4, 4 (1927): 347-355.

Kaltwasser 1961
Kaltwasser, Franz Georg. *Die zeitgenössischen Luther-Drucke der Landesbibliothek Coburg.* Coburg, 1961.

Karlsruhe 1959
Karlsruhe, Staatliche Kunsthalle. *Hans Baldung Grien.* Exh. cat. with foreword by Jan Lauts, introduction by Carl Koch. 1959.

Karlsruhe 1978
Karlsruhe, Staatliche Kunsthalle. *Heilige, Adlige, Bauern: Entwürfe zu Kabinettscheiben aus der Schweiz und vom Oberrhein.* Exh. cat. edited by Elke Bratke. 1978.

Kauffmann 1954
Kauffmann, Hans, "Albrecht Dürer in der Kunst und im Kunsturteil um 1600." In *Vom Nachleben Dürers/Beiträge zur Kunst der Epoche von 1530 bis 1650.* Anzeiger des Germanischen Nationalmuseums 1940 bis 1953. Berlin, 1954: 18-60.

Kehrer 1909
Kehrer, Hugo, "Eine neue Zeichnung vom Meister des Hausbuches auf der Veste Coburg." *Zeitschrift für bildende Kunst* n.s. 20 (1909): 112-113.

Kleinschmidt 1930
Kleinschmidt, Beda. *Die Heilige Anna, ihre Verehrung, Geschichte, Kunst und Volkstum.* Düsseldorf, 1930.

Klibansky/Panofsky/Saxl 1964
Klibansky, Raymond, Panofsky, Erwin, and Saxl, Fritz. *Saturn and Melancholy/Studies in the History of Natural Philosophy, Religion and Art.* London, 1964.

Koch 1941
Koch, Carl. *Die Zeichnungen Hans Baldung Griens.* Berlin, 1941.

Koegler 1926
Koegler, Hans. "Die Basler Gebetbuchholzschnitte vom Illustrator des Narrenschiffs und Ritters vom Turn." *Gutenberg Jahrbuch* 1 (1926): 117-131.

Koegler 1947
Koegler, Hans. *Hundert Tafeln aus dem Gesamtwerk des Urs Graf.* Basel, 1947.

Koepplin 1974
Koepplin, Dieter. "Zwei Fürstenbildnisse Cranachs von 1509." *Pantheon* 32, 1 (1974): 25-34.

Koepplin 1980
Koepplin, Dieter. "Zwei Bemerkungen zu Italienischem bei Niklaus Manuel." *Zeitschrift für schweizerische Archäologie und Kunstgeschichte* 37, 4 (1980): 269-275.

Kohler/Scheel 1902
Kohler, J., and Scheel, Willy, eds. *Die Bambergische Halsgerichtsordnung in niederdeutscher Übersetzung Hermann Barkhusens 1510, zusammen mit einer Auswahl der strafrechtlichen Articel des Lübischen rechts.* Die Carolina und ihre Vorgängerinnen II. Halle an der Saale, 1902.

Kohlhaussen 1936/39
Kohlhaussen, Heinrich. "Bildertische." *Anzeiger des Germanischen Nationalmuseums* (1936/39): 12-45.

Kohlhaussen 1953
Kohlhaussen, Heinrich. "Israhel van Meckenem als Schilderer niederrheinisch-westfälischen Lebens." In *Israhel van Meckenem/Goldschmied und Kupferstecher ... zur 450. Wiederkehr seines Todestages*, Bocholt, 1953: 31ff.

Koschatzky/Strobl 1971
Koschatzky, Walter, and Strobl, Alice. *Die Dürer Zeichnungen der Albertina.* Salzburg, 1971.

Krautheimer 1927
Krautheimer, Richard. *Mittelalterliche Synagogen.* Berlin, 1927.

Kristeller 1907
Kristeller, Paul. *Decalogus, Septimania Poenalis, Symbolum Apostolicum/Drei Blockbücher der Heidelberger Universitätsbibliothek.* Berlin, 1907.

Kunze 1975
Kunze, Horst. *Geschichte der Buchillustration in Deutschland: das 15. Jahrhundert.* 2 vols. Leipzig, 1975.

Kurthen 1924
Kurthen, Joseph. "Zum Problem der Dürerschen Pferdekonstruktion." *Repertorium für Kunstwissenschaft* 44 (1924): 77-106.

Kurzwelly 1895
Kurzwelly, Albrecht. *Forschungen zu Georg Penz.* Leipzig, 1895.

Landau 1978
Landau, David. *Catalogo completo dell' opera grafica di Georg Pencz.* Milan, 1978.

Landolt 1971/72
Landolt, Hanspeter. "Zur Geschichte von Dürers zeichnerischer Form." *Anzeiger des Germanischen Nationalmuseums* (1971/72): 143-156.

Landshut 1980 (see also Munich 1980)
Landshut, Burg Trausnitz. *Wittelsbach und Bayern I/Die Zeit der frühen Herzöge von Otto von Wittelsbach zu Ludwig dem Bayern.* Exh. cat. edited by Hubert Glaser. 1980.

Lange 1900
Lange, Konrad. "Dürers 'Meerwunder.'" *Zeitschrift für bildende Kunst* 11, 9 (1900): 195-204.

Lange 1925
Lange, Konrad. "Dürers Kupferstich 'Das Meerwunder.'" *Repertorium für Kunstwissenschaft* 46, 2 (1925): 87-104.

Lauts 1938
Lauts, Jan. *Alte deutsche Waffen.* Heimbücher der Kunst VI. Burg bei Magdeburg, 1938.

Lawrence/Chapel Hill 1981
Lawrence, University of Kansas, The Spencer Museum of Art, and Chapel Hill, University of North Carolina, The Ackland Art Museum. *The Engravings of Marcantonio Raimondi.* Exh. cat. with essays by Innis H. Shoemaker and Elizabeth Broun. 1981.

Lehrs 1908-34
Lehrs, Max. *Geschichte und kritischer Katalog des deutschen, niederländischen und französischen Kupferstichs im XV. Jahrhundert.* 9 vols. (each in 2 parts). Vienna, 1908-34.

Lehrs 1914
Lehrs, Max. *Martin Schongauer/Nachbildungen seiner Kupferstiche.* Graphische Gesellschaft/Ausserordentliche Veröffentlichung v. Berlin, 1914.

von Leitner 1880-82
Leitner, Quirin von, ed. *Freydal, des Kaisers Maximilian I. Turniere und Mummereien.* 3 vols. Vienna, 1880-82.

Lenz 1972
Lenz, Angelika. *Der Meister MZ, ein Münchner Kupferstecher der frühen Dürerzeit.* Ph.D. diss. University of Munich, Giessen, 1972.

Lieb 1958
Lieb, Norbert. *Die Fugger und die Kunst im Zeitalter der hohen Renaissance.* Munich, 1958.

Lieske 1973
Lieske, Reinhard. *Protestantische Frömmigkeit im Spiegel der kirchlichen Kunst des Herzogtums Württemberg.* Munich, 1973.

Lindau 1883
Lindau, M. B. *Lukas Cranach/Ein Lebensbild aus dem Zeitalter der Reformation.* Leipzig, 1883.

Lippmann/Winkler 1883-1929
Lippmann, Friedrich, and Winkler, Friedrich. *Zeichnungen von Albrecht Dürer in Nachbildungen.* 7 vols. Berlin, 1883-1929.

London 1951
London, Victoria and Albert Museum. *European Armour.* Cat. by J. F. Hayward. 1951.

London 1952
London, P. & D. Colnaghi & Co. *Exhibition of Old Master Drawings.* April 29-May 30, 1952.

London 1972
London, P. & D. Colnaghi & Co., Ltd. *Exhibition of Old Master Drawings.* June 27-July 29, 1972.

London 1980
London, Victoria and Albert Museum. *Princely Magnificence/Court Jewels of the Renaissance, 1500-1630.* Exh. cat. with essays by Fritz Falk, Janet Arnold, and Shirley Bury, introduction by Anne Somers Cocks. 1980.

London 1981
London, Sotheby Parke Bernet & Co. *Highly Important Old Master Drawings from the Collection of Tobias Christ.* Sale cat. April 9, 1981.

Los Angeles 1976
Los Angeles County Museum of Art. *Old Master Drawings from American Collections.* Exh. cat. edited by Ebria Feinblatt, 1976.

Lossnitzer 1913
Lossnitzer, Max. "Hans Leu der Jüngere. Ein Mädchen schüttelt Narren vom Baum." *Archiv für Kunstgeschichte* 1 (1913): unpaginated.

Lossnitzer 1913a
Lossnitzer, Max. "Lukas Cranach der Ältere/Brustbild eines bärtigen jungen Mannes." *Archiv für Kunstgeschichte* 1 (1913): unpaginated.

Lüdecke 1953
Lüdecke, Heinz, ed. *Lucas Cranach der Ältere im Spiegel seiner Zeit/aus Urkunden, Chroniken, Briefen, Reden und Gedichten.* Berlin, 1953.

Lüdecke/Heiland 1955
Lüdecke, Heinz, and Heiland, Susanne. *Dürer und die Nachwelt/Urkunden, Briefe, Dichtungen und Wissenschaftliche Betrachtungen aus vier Jahrhunderten.* Berlin, 1955.

J. Luther 1909-13
Luther, Johannes. *Die Titeleinfassungen der Reformationszeit.* Leipzig, 1909-13.

Luther 1883-1978
Luther, Martin. *D. Martin Luthers Werke. Kritische Gesamtausgabe.* 93 vols. Weimar, 1883-1978.

Luther 1955-76
Luther's Works. Edited by Jaroslav Pelikan and Helmut T. Lehmann. 55 vols. Saint Louis and Philadelphia, 1955-76.

Luther 1972
Luther, Martin. *D. Martin Luther/Die gantze Heilige Schrifft Deudsch 1545.* Edited by Hans Volz. 2 vols. with supplement. Munich, 1972.

Maedebach 1979
Maedebach, Heino. *Veste Coburg.* 7th ed. Munich and Zurich, 1979.

Major/Gradmann 1941
Major, Emil, and Gradmann, Erwin. *Urs Graf.* Basel, [1941].

Manchester 1961
Manchester (England), City of Manchester Art Gallery. *German Art 1400-1800 from Collections in Great Britain.* Exh. cat. 1961.

van Marle 1931-32
Marle, Raimond van. *Iconographie de l'art profane au moyen-âge et à la renaissance, et la décoration des demeures.* 2 vols. The Hague, 1931-32.

Martin 1950
Martin, Kurt, ed. *Skizzenbuch des Hans Baldung Grien/ 'Karlsruher Skizzenbuch'.* 2 vols. Basel, 1950.

Martin 1968
Martin, Paul. *Armour and Weapons.* Translated by Renbe North. London, 1968.

Meder 1932
Meder, Joseph. *Dürer-Katalog/ein Handbuch über Albrecht Dürers Stiche, Radierungen, Holzschnitte, deren Zustände, Ausgaben und Wasserzeichen.* Vienna, 1932.

Mende 1978
Mende, Matthias. *Hans Baldung Grien/Das graphische Werk/Vollständiger Bildkatalog der Einzelholzschnitte, Buchillustrationen und Kupferstiche.* Unterschneidheim, 1978.

Mesenzeva 1981
Mesenzeva, Charmian A. " 'Der behexte Stallknecht des Hans Baldung Grien." *Zeitschrift für Kunstgeschichte* 44, 1 (1981); 57-61.

Meyer 1978
Meyer, Ursula. "Political Implications of Dürer's 'Knight, Death and Devil.' " *The Print Collector's Newsletter* 9, 2 (1978): 35-39.

Minott 1971
Minott, Charles Ilsley. *Martin Schongauer.* New York, 1971.

Möhle 1941/42
Möhle, Hans. Review of *Zeichnungen Hans Baldung Griens* (Berlin, 1941) by Carl Koch. *Zeitschrift für Kunstgeschichte* 10 (1941/42): 214-221.

Möhle 1959
Möhle, Hans. "Hans Baldung Grien/Zur Karlsruher Baldung-Ausstellung Sommer 1959." *Zeitschrift für Kunstgeschichte* 22, 2 (1959): 124-132.

Möller 1956
Möller, Liselotte. *Der Wrangelschrank und die verwandten süddeutschen Intarsienmöbel des 16. Jahrhunderts.* Berlin, 1956.

Mone 1841
Mone, Franz Joseph. *Altdeutsche Schauspiele.* Quedlinburg and Leipzig, 1841.

Montreal 1953
Montreal, Museum of Fine Arts. *Five Centuries of Drawing.* Exh. cat. 1953.

Moser-Rath 1959
Moser-Rath, Elfriede. "Das streitsüchtige Eheweib." *Rheinisches Jahrbuch für Volkskunde* 10 (1959): 40-50.

Muchall-Viebrook 1933
Muchall-Viebrook, Thomas. "Ausstellung von Zeichnungen aus den Kabinetten Koburg und Stuttgart in der Graphischen Sammlungen München." *Pantheon* 11, 4 (1933): 131-134.

Münster 1937
Münster, Landesmuseum der Provinz Westfalen für Kunst und Kulturgeschichte. *Der Maler Derick Baegert und sein Kreis.* Exh. cat. 1937.

Munich 1947
Munich, Bayerisches Nationalmuseum. *Meisterwerke alter deutscher Glasmalerei/Leihgaben des Hessischen Landesmuseums Darmstadt; Leihgaben der Kunstsammlungen der Veste Coburg und des Staatlichen Graphischen Sammlung München.* Exh. cat. compiled by E. Baumeister. 1947.

Munich 1963
Munich, Alte Pinakothek. *Altdeutsche Malerei*. Cat. compiled by Christian A. zu Salm and Gisela Goldberg. 2 vols. Munich, 1963.

Munich 1971
Munich, Alte Pinakothek. *Dürer-Renaissance*. Exh. cat. by Gisela Goldberg. 1971.

Munich 1972
Munich, Stadtmuseum. *Bayern/Kunst und Kultur*. Exh. cat. 1972.

Munich 1980 (see also Landshut 1980)
Munich, Residenz. *Wittelsbach und Bayern II/Um Glauben und Reich*. Exh. cat. edited by Herbert Glaser. 1980.

Musper 1927
Musper, Theodor. *Die Holzschnitte des Petrarkameisters/Ein kritisches Verzeichnis*. Munich, 1927.

Musper 1942
Musper, Theodor. "Die Holzschnitte des Nicolaus Hogenberg aus München." *Jahrbuch des preussischen Kunstsammlungen* 63 (1942): 171-179.

Nagler 1858-79
Nagler, Georg Kasper, ed. *Die Monogrammisten. . . .* 5 vols. 1858-79. Reprint. Nieuwkoop, 1966.

Naumann 1935
Naumann, Hans Heinrich. "Le premier élève de Martin Schongauer, Mathis Nithart." *Archives alsaciennes d'histoire de l'art* 14 (1935): 1-158.

New Haven 1962
New Haven, Yale University, Art Gallery. *Color in Prints/European and American Color Prints from 1500 to the Present*. Exh. cat. prepared by a graduate seminar in the history of art, under the direction of E. Haverkamp-Begeman. 1962.

New Haven 1969
New Haven, Yale University, Art Gallery. *Prints and Drawings of the Danube School/South German and Austrian Graphic Art, 1500 to 1560*. Exh. cat. prepared by a graduate seminar in the history of art, under the direction of Charles Talbot and Alan Shestack. 1969.

New York 1980
New York, Metropolitan Museum of Art, The Cloisters. *The Wild Man: Medieval Myth and Symbolism*. Exh. cat. by Timothy Husband with the assistance of Gloria Gilmore-House. 1980.

Nickel 1969
Nickel, Helmut. *Warriors and Worthies/Arms and Armor Through the Ages*. New York, 1969.

Nissen 1951
Nissen, Claus. *Die botanische Buchillustration/ihre Geschichte und Bibliographie*. 2 vols. Stuttgart, 1951.

Nuremberg 1910
Nuremberg, Germanisches Nationalmuseum. *Die Werke plastischer Kunst*. Cat. by Walter Josephi. 1910.

Nuremberg 1937
Nuremberg, Germanisches Nationalmuseum. *Die Gemälde des 13. bis 16. Jahrhunderts*. Cat. compiled by Eberhard Lutze and Eberhard Wiegand. 2 vols. Leipzig, 1937.

Nuremberg 1961
Nuremberg, Germanisches Nationalmuseum. *Meister um Albrecht Dürer*. Exh. cat. 1961.

Nuremberg 1968
Nuremberg, Germanisches Nationalmuseum. *Die Handzeichnungen bis zur Mitte des 16. Jahrhunderts*. Die Deutschen Handzeichnungen I. Cat. compiled by Fritz Zink. 1968.

Nuremberg 1969
Nuremberg, Albrecht Dürer Gesellschaft. *Jamnitzer, Lencker, Stoer. Drei Nürnberger Konstruktivisten des 16. Jahrhunderts*. Exh. cat. 1969.

Nuremberg 1971
Nuremberg, Germanisches Nationalmuseum. *Albrecht Dürer, 1471-1971*. Exh. cat. 1971

Nuremberg 1976
Nuremberg, Stadtgeschichtliche Museen. *Die Welt des Hans Sachs*. Exh. cat. 1976.

Nuremberg 1978
Nuremberg, Germanisches Nationalmuseum. *Vorbild Dürer: Kupferstiche und Holzschnitte Albrecht Dürers im Spiegel der europäischen Druckgraphik des 16. Jahrhunderts*. Exh. cat. 1978.

Nuremberg 1979
Nuremberg, Germanisches Nationalmuseum. *Reformation in Nürnberg/Umbruch und Bewahrung*. Exh. cat. 1979.

Nuremberg 1980
Nuremberg, Germanisches Nationalmuseum. *Nützliche Anweisung zur Zeichenkunst/Illustrierte Lehr- u. Vorlagenbücher aus den Bibliotheksbeständen*. Exh. cat. by Gerlind Werner. 1980.

Oehler 1943
Oehler, Lisa. *Das 'geschleuderte' Dürermonogramm*. Ph.D. diss. University of Munich, 1943.

Oehler 1959
Oehler, Lisa. "Das 'geschleuderte' Dürer-Monogramm." *Marburger Jahrbuch für Kunstwissenschaft* 17 (1959): 57-191.

Oettinger/Knappe 1963
Oettinger, Karl, and Knappe, Karl-Adolph. *Hans Baldung Grien und Albrecht Dürer in Nürnberg*. Nuremberg, 1963.

Oldenbourg 1960
Oldenbourg, M. Consuelo. "Eine unbeschriebene Titeleinfassung von Hans Baldung Grien." *Philobiblon* 4, 3 (1960): 195-198.

Oldenbourg 1962
Oldenbourg, M. Consuelo. *Die Buchholzschnitte des Hans Baldung Grien.* Studien zur deutschen Kunstgeschichte 335. Baden-Baden and Strasbourg, 1962.

Oldenbourg 1973
Oldenbourg, M. Consuelo. *Hortulus animae/(1494)-1523/ Bibliographie und Illustration.* Hamburg, 1973.

von der Osten 1981
Osten, Gert von der. *Hans Baldung Grien/Gemälde und Dokumente.* Berlin, 1981.

von der Osten/Vey 1969
Osten, Gert von der, and Vey, Horst. *Painting and Sculpture in Germany and the Netherlands/1500 to 1600.* The Pelican History of Art. Edited by Nikolaus Pevsner. Harmondsworth, 1969.

Oxford 1949
Oxford, Ashmolean Museum. *Annual Report of the Visitors of the Ashmolean Museum.* 1949.

Panofsky/Saxl 1923
Panofsky, Erwin, and Saxl, Fritz. *Dürers 'Melencolia I.' Eine quellen- und typengeschichtliche Untersuchung.* Studien der Bibliothek Warburg II. Leipzig and Berlin, 1923.

Panofsky 1948
Panofsky, Erwin. *The Life and Art of Albrecht Dürer.* 2 vols. 3rd ed. Princeton, 1948.

Panofsky 1950
Panofsky, Erwin. "Dürer's 'St. Eustace.' " *Record of the Art Museum, Princeton University* 9, 1 (1950): 2-10.

Panofsky 1953
Panofsky, Erwin. *Early Netherlandish Painting/Its Origin and Character.* 2 vols. Cambridge, 1953.

Panofsky 1955
Panofsky, Erwin. "Albrecht Dürer and Classical Antiquity." In *Meaning in the Visual Arts/Papers in and on Art History.* Garden City, 1955: 236-294.

Paris 1937-38
Paris, Musée du Louvre, Cabinet des Dessins. *Inventaire général des dessins des écoles du nord, écoles Allemande et Suisse.* Published under the direction of L. Demonts. 2 vols. Paris, 1937-38.

Parker 1922
Parker, Karl T. "Zu den Vorbildern Urs Grafs." *Anzeiger für schweizerische Altertumskunde* 24 (1922): 227-235.

Parker 1928
Parker, K[arl] T. *Elsässische Handzeichnungen des XV. und XVI. Jahrhunderts.* Die Meisterzeichnung II. Freiburg im Breisgau, 1928.

Parker 1945
Parker K[arl] T. *The Drawings of Hans Holbein in the Collection of his Majesty the King at Windsor Castle.* 2nd ed. Oxford and London, 1945.

Parshall 1971
Parshall, Peter V. "Albrecht Dürer's 'St. Jerome in His Study': A Philological Reference." *The Art Bulletin* 53, 3 (1971): 303-305.

Passavant 1860-64
Passavant, J. D. *Le Peintre-Graveur.* 6 vols. Leipzig, 1860-64.

Pauli 1901
Pauli, Gustav. *Hans Sebald Beham. Ein kritisches Verzeichnis seiner Kupferstiche, Radierungen und Holzschnitte.* Studien zur deutschen Kunstgeschichte 33. Strasbourg, 1901.

Pauli 1910
Pauli, Gustav. "Drei neue Dürerzeichnungen." *Jahrbuch der königlich preussischen Kunstsammlungen* 31 (1910): 57-58.

Peartree 1906
Peartree, S. M. "Christ Stripped of His Raiment." *Dürer Society* 9 (1906): 13-14.

Peartree 1906a
Peartree, S. M. "A Centauress suckling her Young." *Dürer Society* 9 (1906): 14-15.

Perseke 1941
Perseke, Helmut. *Hans Baldungs Schaffen in Freiburg.* Freiburg im Breisgau, 1941.

Philadelphia 1967
Philadelphia, Philadelphia Museum of Art. *Master E. S.* Exh. cat. by Alan Shestack. 1967.

Piccard 1966
Piccard, Gerhard, ed. *Die Ochsenkopfwasserzeichen.* Die Wasserzeichenkartei Piccard im Hauptstaatsarchiv Stuttgart II. 3 vols. Stuttgart, 1966.

Piccard 1977
Piccard, Gerhard, ed. *Wasserzeichen Buchstabe P.* Die Wasserzeichenkartei Piccard im Hauptstaatsarchiv Stuttgart IV. 3 vols. Stuttgart, 1977.

Planiscig/Voss n.d.
Planiscig, Leo, and Voss, Hermann. *Handzeichnungen alter Meister aus der Sammlung Dr. Benno Geiger.* Zurich, Leipzig, Vienna, n.d.

Princeton 1969
Princeton, Princeton University, The Art Museum. *Symbols in Transformation: Iconographic Themes at the Time of the Reformation/An exhibition in memory of Erwin Panofsky.* Exh. cat. with intro. by Craig Harbison. 1969.

Providence 1974
Providence, Rhode Island School of Design, Museum of Art. *Europe in Torment: 1450-1550.* Exh. cat. by the Department of Art, Brown University. 1974.

Radbruch 1950
Radbruch, Gustav. "Hans Baldungs Hexenbilder." In *Elegantiae Juris Criminalis.* 2nd ed, Basel, 1950.

Reichel 1926
Reichel, Anton. *Die Clair-obscur-Schnitte des XVI., XVII., und XVIII. Jahrhunderts.* Zurich, Leipzig, Vienna, 1926.

Reuterswärd 1967
Reuterswärd, Patrik. "Sinn und Nebensinn bei Dürer/Randbemerkungen zur 'Melencolia I.'" In *Gestalt und Wirklichkeit/Festgabe für Ferdinand Weinhandl.* Berlin, 1967: 411-436.

Roch 1972
Roch, Irene. "Zu Burgen- und Schlossdarstellungen bei Cranach." In *Lucas Cranach, Künstler und Gesellschaft, Referate des Colloquiums.* . . . Wittenberg, 1972: 114-118.

Roemer 1926
Roemer, Erich. "Dürers ledige Wanderjahre." *Jahrbuch der preussischen Kunstsammlungen* 47 (1926): 118-136.

Roemer 1927
Roemer, Erich. "Dürers ledige Wanderjahre; der Basler Terenz." *Jahrbuch der preussischen Kunstsammlungen* 48 (1927): 156-182.

Röttinger 1904
Röttinger, Heinrich. *Hans Weiditz der Petrarkameister.* Studien zur deutschen Kunstgeschichte 50. Strasbourg, 1904.

Röttinger 1911
Röttinger, Heinrich. "Neues zum Werke Hans Weiditz." *Mitteilungen der Gesellschaft für vervielfältigende Kunst/Beilage der Graphischen Künste* (1911): 46-52 .

Röttinger 1914
Röttinger, Heinrich. *Die Holzschnitte des Georg Pencz.* Leipzig, 1914.

Röttinger 1916
Röttinger, Heinrich. *Peter Flettners Holzschnitte.* Studien zur deutschen Kunstgeschichte 186. Strasbourg, 1916.

Röttinger 1921
Röttinger, Heinrich. *Beiträge zur Geschichte des Sächsischen Holzschnittes (Cranach, Brosamer, Der Meister MS, Jakob Lucius aus Kronstadt).* Studien zur deutschen Kunstgeschichte 213. Strasbourg, 1921.

Röttinger 1925
Röttinger, Heinrich. *Erhard Schön und Niklas Stör, der Pseudo-Schön.* Studien zur deutschen Kunstgeschichte 229. Strasbourg, 1925.

Röttinger 1927
Röttinger, Heinrich. *Ergänzungen und Berichtigungen des Sebald Beham-Kataloges Gustav Paulis.* Studien zur deutschen Kunstgeschichte 246. Strasbourg, 1927.

Röttinger 1927a
Röttinger, Heinrich. *Die Bilderbogen des Hans Sachs.* Studien zur deutschen Kunstgeschichte 247. Strasbourg, 1927.

Röttinger 1933
Röttinger, Heinrich. *Der Frankfurter Buchholzschnitt 1530-1550.* Studien zur deutschen Kunstgeschichte 293. Strasbourg, 1933.

Rosenberg 1960
Rosenberg, Jakob. *Die Zeichnungen Lucas Cranach d. Ä.* Berlin, 1960.

Rosenthal 1882
Rosenthal, Ludwig. "Hans Sebald Behams alttestamentarische Holzschnitte und deren Verwendung zur Bücher-Illustration 1529-1612." *Repertorium für Kunstwissenschaft* 5 (1882): 379-405.

Rotterdam 1969
Rotterdam, Museum Boymans-van Beuningen. *Erasmus en zijn tijd,* Exh. cat. 2 vols. 1969.

Rotterdam 1974
Rotterdam, Museum Boymans-van Beuningen. *Duitse Tekeningen 1400-1700 (German Drawings from Dutch Public Collections).* Exh. cat. 1974.

Rowlands 1976
Rowlands, John. "Notes on selected acquisitions in 1974: Some notable early prints." *The British Museum Yearbook* 1 (1976): 260-269.

Rupprich 1956-69
Rupprich, Hans, ed. *Dürer/Schriftlicher Nachlass.* 3 vols. Berlin, 1956-69.

Sachs 1875
Sachs, Hans. "Schwank zwischen einem jungen gesellen und einer frawen zu bulen." *Bibliothek des litterarischen Vereins in Stuttgart* 125 (1875): 251-255.

Sacramento 1971
Sacramento, E. B. Crocker Art Gallery, *Master Drawings from Sacramento.* Exh. cat. 1971.

Saint Florian/Linz 1965
Saint Florian, Stift Saint Florian, and Linz, Schlossmuseum. *Die Kunst der Donauschule 1490-1540/Ausstellung des Landes Oberösterreich.* Exh. cat. 1965.

Saxl 1957
Saxl, Fritz, "Reformation Pamphlets." In *Lectures.* 2 vols. London, 1957: 255-266.

Schade 1974
Schade, Werner. *Die Malerfamilie Cranach.* Dresden, 1974.

Scheidig 1955
Scheidig, Walther. *Die Holzschnitte des Petrarca-Meisters. Zu Petrarcas Werk von der Artzney bayder Glück, des guten und widerwärtigen (Augsburg 1532).* Berlin, 1955.

Scheikévitch 1907
Scheikévitch, S. "Un dessin inédit d'Albert Dürer." *Gazette des Beaux-Arts* 37 (1907): 331-336.

Schilling 1937
Schilling, Edmund. *Altdeutsche Meisterzeichnungen.* 2nd ed. Frankfurt am Main, 1937.

Schmid 1898
Schmid, H. A. Review of *Die Handzeichnungen des Hans Baldung gen. Grien* by Gabriel von Térey. *Repertorium für Kunstwissenschaft* 21 (1898): 304-313.

Schmidt 1869
Schmidt, G. A. *Die Ringer-Kunst des Fabian von Auerswald*. Introduction by K. Wassmannsdorff. Leipzig, 1869.

Schmidt 1962
Schmidt, Ph. *Die Illustration der Lutherbibel/1522-1700/ein Stück abendländische Kultur- und Kirchengeschichte mit Verzeichnissen der Bibeln, Bilder und Künstler*. Basel, 1962.

Schmitz 1913
Schmitz, Hermann. *Die Glasgemälde des königlichen Kunstgewerbemuseums in Berlin*. 2 vols. Berlin, 1913.

Schmitz 1922
Schmitz, Hermann. *Hans Baldung gen. Grien. . . .* Künstlermonographien 113. Bielefeld and Leipzig, 1922.

Schmitz 1923
Schmitz, Hermann, ed. *Deutsche Glasmalereien der Gotik und Renaissance/Rund- und Kabinettscheiben*. Sammelbände zur Geschichte der Kunst und des Kunstgewerbes IV. Edited by Adolf Feulner. Munich, 1923.

Schöne 1937
Schöne, Wolfgang. "Über einige altniederländische Bilder, vor allem in Spanien." *Jahrbuch der preussischen Kunstsammlungen* 58 (1937): 166-168.

Schöne 1938
Schöne, Wolfgang. *Dieric Bouts und seine Schule*. Berlin and Leipzig, 1938.

Schonbrunner/Meder 1896-1908
Schönbrunner, Jos., and Meder, Jos., eds. *Handzeichnungen alter Meister aus der Albertina und anderen Sammlungen*. 12 vols. Vienna, 1896-1908.

Schottenloher 1956-66
Schottenloher, Karl, ed. *Bibliographie zur deutschen Geschichte im Zeitalter der Glaubensspaltung 1517-1585/im Auftrag der Kommission zur Erforschung der Geschichte der Reformation und Gegenreformation*. 7 vols. 2nd ed. Stuttgart, 1956-66.

Schramm 1922-43
Schramm, Albert. *Der Bilderschmuck der deutschen Frühdrucke*. 23 vols. Leipzig, 1922-43.

Schramm 1923
Schramm, Albert. *Die Illustration der Lutherbibel*. Leipzig, 1923.

Schreiber 1910-11
Schreiber, W. L. *Catalogue des incunables à figures imprimés en Allemagne, en Suisse, en Autriche-Hongrie et en Scandinavie*. 2 vols. Leipzig, 1910-11.

Schubert 1930
Schubert, Franz. *Mair von Landshut/ein niederbayerischer Stecher und Maler des ausgehenden xv. Jahrhunderts. . . .* Landshut, 1930.

Schuchardt 1851-71
Schuchardt, Christian. *Lucas Cranach des Älteren/Leben und Werke*. 3 vols. Leipzig, 1851-71.

Schürer 1937
Schürer, Oskar. "Wohin ging Dürers 'Ledige Wanderfahrt'?" *Zeitschrift für Kunstgeschichte* 6 (1937): 171-199.

Schulze 1902
Schulze, F. *Balthasar Springers Indienfahrt 1505-06. Drucke und Holzschnitte des xv. und xvi. Jahrhunderts in getreuer Nachbildung*. Strasbourg, 1902.

Schuster 1974
Schuster, Peter-Klaus. "Melencolia. I, Studien zu Dürers Melancholiekupferstich und seinem Humanismus." *Das

Schwarz/Plagemann 1973
Schwarz, Heinrich, and Plagemann, Volker. "Eule." In *Reallexikon zur deutschen Kunstgeschichte VI*. Edited by Otto Schmitt. Stuttgart, 1973: 267-322.

Shestack 1969
Shestack, Alan, ed. *The Complete Engravings of Martin Schongauer*. New York, 1969.

Singer 1921
Singer, Hans Wolfgang, ed. *Zeichnungen aus der Sammlung Friedrich August II in Dresden*. Munich, 1921.

Smith 1978
Smith, Susan L. '*To women's wiles I fell.' The Power of Women Topos and the Development of Medieval Secular Art*. Ph.D. diss. University of Pennsylvania, 1978.

Sonkes 1969
Sonkes, Micheline. *Les Primitifs Flamands, Dessins du XVᵉ siècle/Groupe van der Weyden*. Brussels, 1969.

Spohn 1973
Spohn, Georg R. "Der Simmerner Meister H. H. und der Autor der 'Kunst des Messens' (Simmern, 1531): Herzog Johann II. von Pfalz-Simmern?" *Zeitschrift des deutschen Vereins für Kunstwissenschaft* 27 (1973): 79-94.

Stadler 1936
Stadler, Franz. *Hans von Kulmbach*. Vienna, 1936.

Stafski 1936/39
Stafski, Heinz, "Zur künstlerischen Herkunft des Veit Stoss." *Anzeiger des Germanischen Nationalmuseums* (1936/39): 123-134.

Stahl 1968
Stahl, Gerlinde. "Die Wallfahrt zur Schönen Maria in Regensburg." In *Beiträge zur Geschichte des Bistums Regensburg*. Regensburg, 1968, II: 35-282.

Stammler 1924
Stammler, Wolfgang. "Johannes Walther als Verfasser des Epitaphiums Martini Luthers (1546)." *Beiträge zur Geschichte der deutschen Sprache und Literatur* 48, 2 (1924): 326-328.

Stange 1934-61
Stange, Alfred. *Deutsche Malerei der Gotik.* 10 vols. Munich and Berlin, 1934-61.

Stange 1958
Stange, Alfred. *Der Hausbuchmeister.* Studien zur deutschen Kunstgeschichte 316. Baden-Baden and Strasbourg, 1958.

Stange 1964
Stange, Alfred. *Malerei der Donauschule.* Munich, 1964.

Stange/Lieb 1967-78
Stange, Alfred. *Kritisches Verzeichnis der deutschen Tafelbilder vor Dürer.* 3 vols. (Vols. II and III edited by Norbert Lieb.) Munich, 1967-78.

Stiassny 1895
Stiassny, Robert. "Baldung-Studien: III. Glasgemälde." *Kunstchronik* n.s. 6, 21 (1895): col. 325-327.

Stiassny 1896
Stiassny, Robert. *Wappenzeichnungen Hans Baldung Griens in Coburg. Ein Beitrag zur Biographie des oberrheinischen Meisters.* 2nd ed. Vienna, 1896.

Storck 1909
Storck, Willy F. "Die Zeichnungen des Hausbuch-Meisters." *Monatshefte für Kunstwissenschaft* 2, 5 (1909): 264-266.

Strauss 1973
Strauss, Walter L. *Chiaroscuro, the Clair-Obscur Woodcuts by the German and Netherlandish Masters of the XVIth and XVIIth Centuries.* Greenwich, 1973.

Strauss 1974
Strauss, Walter, ed. *The Complete Drawings of Albrecht Dürer.* 6 vols. New York, 1974.

Strauss 1975
Strauss, Walter L. *The German Single-Leaf Woodcut, 1550-1600.* 3 vols. New York, 1975.

Strauss 1976-77
Strauss, Walter L., ed. *The Intaglio Prints of Albrecht Dürer: Engravings, Etchings and Drypoints.* New York, 1976-77.

Strauss 1980
Strauss, Walter L., ed. *Albrecht Dürer Woodcuts and Wood Blocks.* New York, 1980.

Strieder 1959
Strieder, Peter. Review of *Deutsche Malerei der Gotik* by Alfred Stange. *Mitteilungen des Vereins für Geschichte der Stadt Nürnberg* 49 (1959): 468-474.

von Tavel 1978
Tavel, Hans Christoph von. "Hans Baldung und die Anfänge Niklaus Manuels." *Zeitschrift für schweizerische Archäologie und Kunstgeschichte* 35 (1978): 224-233.

Tennant 1981
Tennant, Elaine. "An Overdue Revision in the History of Early New High German: Niclas Ziegler and the Hapsburg Chancery Language." *Deutsche Vierteljahresschrift für Literaturwissenschaft und Geistesgeschichte* 55 (1981): 248-277.

Tentler 1977
Tentler, Thomas N. *Sin and Confession on the Eve of the Reformation.* Princeton, 1977.

Térey 1894-96
Térey, Gabriel von, ed. *Die Handzeichnungen des Hans Baldung gen. Grien in Originalgrösse . . . Lichtdrucke aus der Anstalt . . . J. Kramer. . . .* 3 vols. Strasbourg, 1894-96.

Thausing 1876
Thausing, Moritz. *Dürer, Geschichte seines Lebens und seiner Kunst.* Leipzig, 1876.

Theissing 1978
Theissing, Heinrich. *Dürers Ritter, Tod und Teufel.* Berlin, 1978.

Thieme/Becker
Thieme, Ulrich, and Becker, Felix. *Allgemeines Lexikon der bildenden Künstler.* 37 vols. Leipzig, 1907-50.

Thöne 1975
Thöne, Friedrich. *Daniel Lindtmayer, 1552-1606/07, Die Schaffhauser Künstlerfamilie Lindtmayer.* Zurich, 1975.

Thomas/Gamber/Schedelmann 1964
Thomas, Bruno; Gamber, Ortwin; and Schedelmann, Hans. *Arms and Armour/Masterpieces by European Craftsmen from the Thirteenth to the Nineteenth Century.* Translated by Ilse Bloom and William Reid. London, 1964.

Thorlacius-Ussing 1926/28
Thorlacius-Ussing, V. "Nogle aeldre tyske Haandtegninger i Kobberstiksamlingen." *Kunstmuseets Aarsskrift* 13-15 (1926/28): 137-155.

Tietze/Tietze-Conrat 1928-38
Tietze, H., and Tietze-Conrat, E. *Kritisches Verzeichnis der Werke Albrecht Dürers.* 2 vols. (Vol. II in 2 parts.) Augsburg, Basel, Leipzig, 1928-38.

Tietze-Conrat 1935
Tietze-Conrat, E. "Die Vorbilder von Daniel Hopfers figuralem Werk." *Jahrbuch der Kunsthistorischen Sammlungen in Wien* n.s. 9 (1935): 97-110.

Turin 1974
Turin, Biblioteca Reale. *I Disegni di Maestri Stranieri della Biblioteca Reale.* Cat. by Gianni Carlo Sciolla. 1974.

Ulrich 1972
Ulrich, Gerhard. *Schätze deutscher Kunst.* Munich, 1972.

Vienna 1969
Vienna, Graphische Sammlung Albertina. *Die Zeichnungen der deutschen Schulen bis zum Beginn des Klassizismus.* Cat. by Hans Tietze, E. Tietze-Conrat, Otto Benesch, and Karl Garzarolli-Thurnlackh. Edited by Alfred Stix. 1933.

Vienna 1963
Vienna, Graphische Sammlung Albertina. *Das 15. Jahrhundert/Werke aus dem Besitz der Albertina.* Exh. cat. 1963.

Vienna 1969
Vienna, Österreichisches Museum für angewandte Kunst. *Albrecht Dürer und die Graphik der Reformationszeit.* Exh. cat. by Hanna Dornik-Eger. 1969.

Vienna 1971
Vienna, Österreichisches Museum für angewandte Kunst. *Albrecht Dürer und die Druckgraphik für Kaiser Maximilian I.* Exh. cat. by Hanna Dornik-Eger. 1971.

Vienna 1974
Vienna, Graphische Sammlung Albertina. *Spielkarten/ihre Kunst und Geschichte in Mitteleuropa.* Exh. cat. by Fritz Koreny. 1974.

Volz 1978
Volz, Hans, *Martin Luthers deutsche Bibel (Entstehung und Geschichte der Lutherbibel).* Edited by Henning Wendland. Hamburg, 1978.

Voretzsch 1980
Voretzsch, Adalbert. "Die Himmelsrichtung in Albrecht Dürers Meisterstich 'Melencolica I' [sic]." *Kunstspiegel* 2 (1980): 271-278.

Waldmann 1910
Waldmann, Emil. *Die Nürnberger Kleinmeister.* Meister der Graphik v. Leipzig, 1910.

Ward 1971
Ward, J. L. "A proposed Reconstruction of an Altarpiece by Roger van der Weyden." *Art Bulletin* 53 (1971): 27-35.

Washington 1955
Washington, D.C., National Gallery of Art, et al. *German Drawings, Masterpieces from Five Centuries. A loan exhibition sponsored by the Federal Republic of Germany.* Exh. cat. 1955.

Washington 1967
Washington, D.C., National Gallery of Art. *Fifteenth Century Engravings of Northern Europe.* Exh. cat. by Alan Shestack. 1967.

Washington 1971
Washington, D.C., National Gallery of Art. *Dürer in America: His Graphic Work.* Exh. cat. edited by Charles W. Talbot, notes by Gaillard F. Ravenel and Jay A. Levenson. 1971.

Washington 1977
Washington, D.C., Library of Congress. *The Lessing J. Rosenwald Collection.* 1977.

Washington 1978
Washington, D.C., National Gallery of Art, et al. *The Splendor of Dresden: Five Centuries of Art Collecting. An exhibition from the State Art Collections of Dresden, German Democratic Republic.* Exh. cat. 1978.

Washington/New Haven 1981
Washington, D.C., National Gallery of Art, and New Haven, Yale University Art Gallery. *Hans Baldung Grien/Prints and Drawings.* Exh. cat. edited by James H. Marrow and Alan Shestack, essays by Shestack, Charles W. Talbot, and Linda C. Hults. 1981.

Weimar/Wittenberg 1953
Weimar and Wittenberg, Deutsches Lucas Cranach Komitee. *Lucas Cranach.* Exh. cat. 1953.

Weimar 1972
Weimar, Schlossmuseum. *Lucas Cranach. Ein grosser Maler in bewegter Zeit.* Exh. cat. 1972.

Weinberger 1921
Weinberger, Martin. *Nürnberger Malerei an der Wende zur Renaissance und die Anfänge der Dürerschule.* Studien zur deutschen Kunstgeschichte 217. Strasbourg, 1921.

Weinberger 1929
Weinberger, Martin, "Zu Dürers Lehr- und Wanderjahren." *Münchner Jahrbuch der bildenden Kunst* 6 (1929): 124-146.

Weixlgärtner 1920
Weixlgärtner, Arpad. "Bemerkungen zu den umstrittenen Jugendarbeiten Albrecht Dürers." *Mitteilungen der Gesellschaft für vervielfältigende Kunst* 43 (1920): 37-52.

Wentzel 1949
Wentzel, Hans. "Glasmaler und Maler im Mittelalter." *Zeitschrift für Kunstwissenschaft* 3, 3/4 (1949): 53-62.

Wescher 1938
Wescher, Paul. "Nicolaus Kremer of Strassburg." *Art Quarterly* 1 (1938): 204 ff.

Williams 1962
Williams, George Huntston. *The Radical Reformation.* Philadelphia, 1962.

Williamstown 1975
Williamstown, Sterling and Francine Clark Art Institute. *Dürer Through Other Eyes: His Graphic Work Mirrored in Copies and Forgeries of Three Centuries.* Exh. cat. by students in the Williams College graduate program in art history. 1975.

Winkler 1929
Winkler, Friedrich. "Verkannte und unbeachtete Zeichnungen des Hans von Kulmbach." *Jahrbuch der preussischen Kunstsammlungen* 50 (1929): 11-44.

Winkler 1929a
Winkler, Friedrich. "Dürer und der Ober St. Veiter Altar." *Jahrbuch der preussischen Kunstsammlungen* 50 (1929): 148-166.

Winkler 1930
Winkler, Friedrich. "Skizzenbücher eines unbekannten rheinischen Meisters um 1500." *Wallraf-Richartz-Jahrbuch* n.s. 1 (1930): 123-152.

Winkler 1932
Winkler, Friedrich. *Mittel-, niederrheinische und westfälische Handzeichnungen des XV. und XVI. Jahrhunderts.* Die Meisterzeichnung IV. Freiburg im Breisgau, 1932.

Winkler 1936-39
Winkler, Friedrich. *Die Zeichnungen Albrecht Dürers.* 4 vols. Berlin, 1936-39.

Winkler 1939
Winkler, Friedrich. *Hans Baldung Grien / ein unbekannter Meister deutscher Zeichnung.* Burg bei Magdeburg, 1939.

Winkler 1939a
Winkler, Friedrich. "Die Sammlung Ehlers." *Jahrbuch der preussischen Kunstsammlungen* 60 (1939): 21-46.

Winkler 1941
Winkler, Friedrich. "Nürnberger Vierpassscheiben und ihre Entwerfer." *Pantheon* 28, 11 (1941): 243-249.

Winkler 1942
Winkler, Friedrich. *Die Zeichnungen Hans Süss von Kulmbachs und Hans Leonhard Schäufeleins.* Berlin, 1942.

Winkler 1949
Winkler, Friedrich. *Albrecht Dürer / 80 Meisterzeichnungen.* Zurich, 1949.

Winkler 1957
Winkler, Friedrich. *Albrecht Dürer, Leben und Werk.* Berlin, 1957.

Winkler 1959
Winkler, Friedrich. *Hans von Kulmbach, Leben und Werk eines fränkischen Künstlers der Dürerzeit.* Kulmbach, 1959.

Winkler 1964
Winkler, Friedrich. *Das Werk des Hugo van der Goes.* Berlin, 1964.

Winkler 1964a
Winkler, Friedrich. "Die deutschen Werke Nicolaus Hogenbergs von Munchen." *Zeitschrift des deutschen Vereins für Kunstwissenschaft* 18 (1964): 54-64.

Winzinger 1952
Winzinger, Franz. *Albrecht Altdorfer / Zeichnungen.* Munich, 1952.

Winzinger 1963
Winzinger, Franz. *Albrecht Altdorfer Graphik / Holzschnitte, Kupferstiche, Radierungen.* Munich, 1963.

Winzinger 1968
Winzinger, Franz. "Studien zur Kunst Albrecht Dürers." *Jahrbuch der Berliner Museen* 10 (1968): 151-180.

Winzinger 1971
Winzinger, Franz. "Umstrittene Dürerzeichnungen." *Zeitschrift des deutschen Vereins für Kunstwissenschaft* 25 (1971): 51-68.

Winzinger 1971a
Winzinger, Franz. "Dürer und Leonardo." *Pantheon* 29, 1 (1971): 3-21.

Winzinger 1972
Winzinger, Franz. "Dürers Verhältnis zu Martin Schongauer." *Kunstchronik* 25 (1972): 185-186.

Winzinger 1975
Winzinger, Franz. *Albrecht Altdorfer, Die Gemälde / Tafelbilder, Miniaturen, Wandbilder, Bildhauerarbeiten, Werkstatt und Umkreis.* Munich, 1975.

Winzinger 1979
Winzinger, Franz, ed. *Das Gesamtwerk Wolf Huber.* 2 vols. Munich, 1979.

Winzinger 1980
Winzinger, Franz. "An Unknown German Drawing of the Gothic Period." *Master Drawings* 18, 1 (1980): 27-29.

Wirth 1981
Wirth, Jean. "Le dogme en image: Luther et l'iconographie." *Revue de l'Art* 52 (1981): 9-23.

Wittkower 1977
Wittkower, Rudolf. *Sculpture, Processes and Principles.* New York, San Francisco, London, 1977.

Witzleben 1977
Witzleben, Elisabeth von. *Bemalte Glasscheiben / Volkstümliches Leben aus Kabinett- und Bierscheiben.* Munich, 1977.

Wölfflin 1971
Wölfflin, Heinrich. *The Art of Albrecht Dürer.* Translated by Alastair and Heide Grieve. London, 1971.

Wolf 1963
Wolf, Erik. *Grosse Rechtsdenker der deutschen Geistesgeschichte.* 4th ed. Tübingen, 1963.

Wolff 1914
Wolff, August. *Die frauenfeindlichen Dichtungen in den romanischen Literaturen des Mittelalters bis zum Ende des 13. Jahrhunderts.* Halle an der Saale, 1914.

Zijderveld 1976
Zijderveld, A. C. "De Hofnar als instituut, deel 3." *Spiegel Historiael, Maandblad voor geschiedenes en Archeologie* 11 (1976): 667-763.

Zimmerman 1924
Zimmerman, Hildegard. *Beiträge zur Bibelillustration des 16. Jahrhunderts.* Studien zur deutschen Kunstgeschichte 226. Strasbourg, 1924.

Zimmerman 1927
Zimmerman, Hildegard. "Der Monogrammist M. S." *Jahrbuch des deutschen Vereins für Buchwesen und Schrifttum* 1 (1927): 70-91.

Zimmerman 1929
Zimmermann, Hildegard. *Lukas Cranach d. Ä. Folgen der*

Wittenberger Heiligtümer und die Illustrationen des Rhau'schen Hortulus animae. Schriften der Gesellschaft der Freunde der Universität Halle-Wittenberg I. Halle an der Saale, 1929.

Zschelletzschky 1933
Zschelletzschky, Herbert. *Das graphische Werk Heinrich Aldegrevers.* Studien zur deutschen Kunstgeschichte 292. Strasbourg, 1933.

Zschelletzschky 1975
Zschelletzschky, Herbert. *Die 'drei gottlosen Maler' von Nürnberg: Sebald Beham, Barthel Beham und Georg Pencz/ historische Grundlagen und ikonologische Probleme ihrer Graphik zu Reformations- und Bauernkriegszeit.* Leipzig, 1975.

Index of Artists